汀江

THE TINGJIANG RIVER

大型影像文化创作工程全记录

THE FULL RECORD OF
THE LARGE-SCALE IMAGE CULTURAL CREATION PROJECT

主 编　赖小兵

海峡出版发行集团 | 海峡书局

THE STRAITS PUBLISHING & DIBLISHING GROUP

CONTENTS

目 录

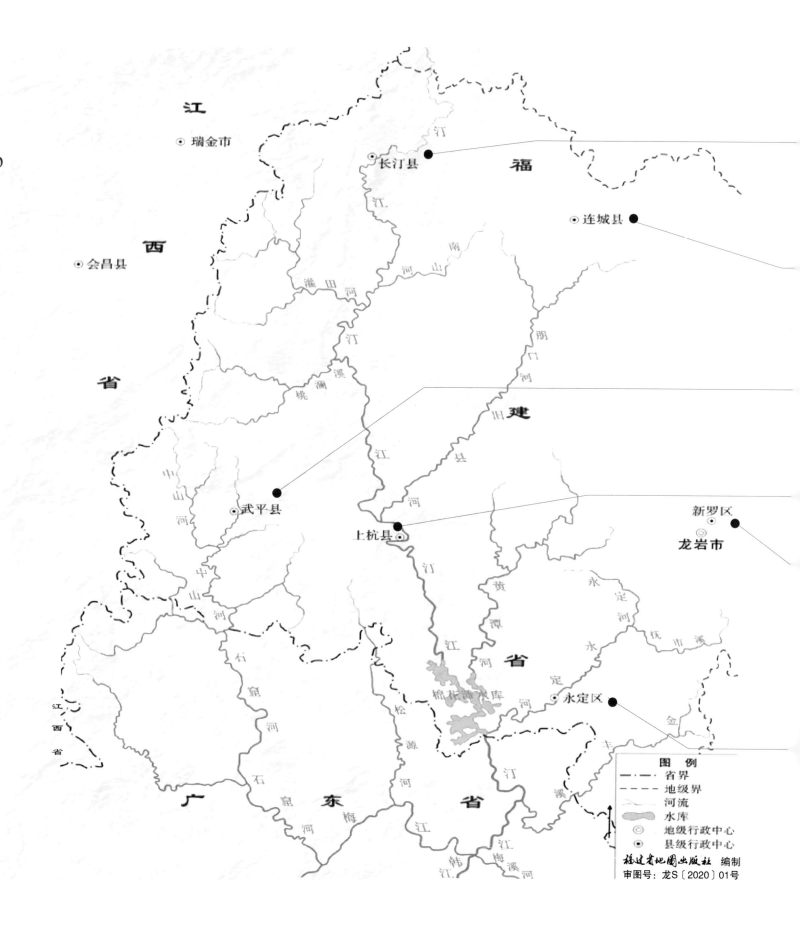

汀江流域水系图

The Tingjiang River Basin Water System Map

瑞金市

长汀县

连城县

江

西

省

会昌县

旧

建

武平县

新罗区

龙岩市

上杭县

永定区

江

西

省

棉花滩水库

省

广

东

省

福建省地图出版社 编制

审图号：龙S〔2020〕01号

图 例

省界
地级界
河流
水库
地级行政中心
县级行政中心

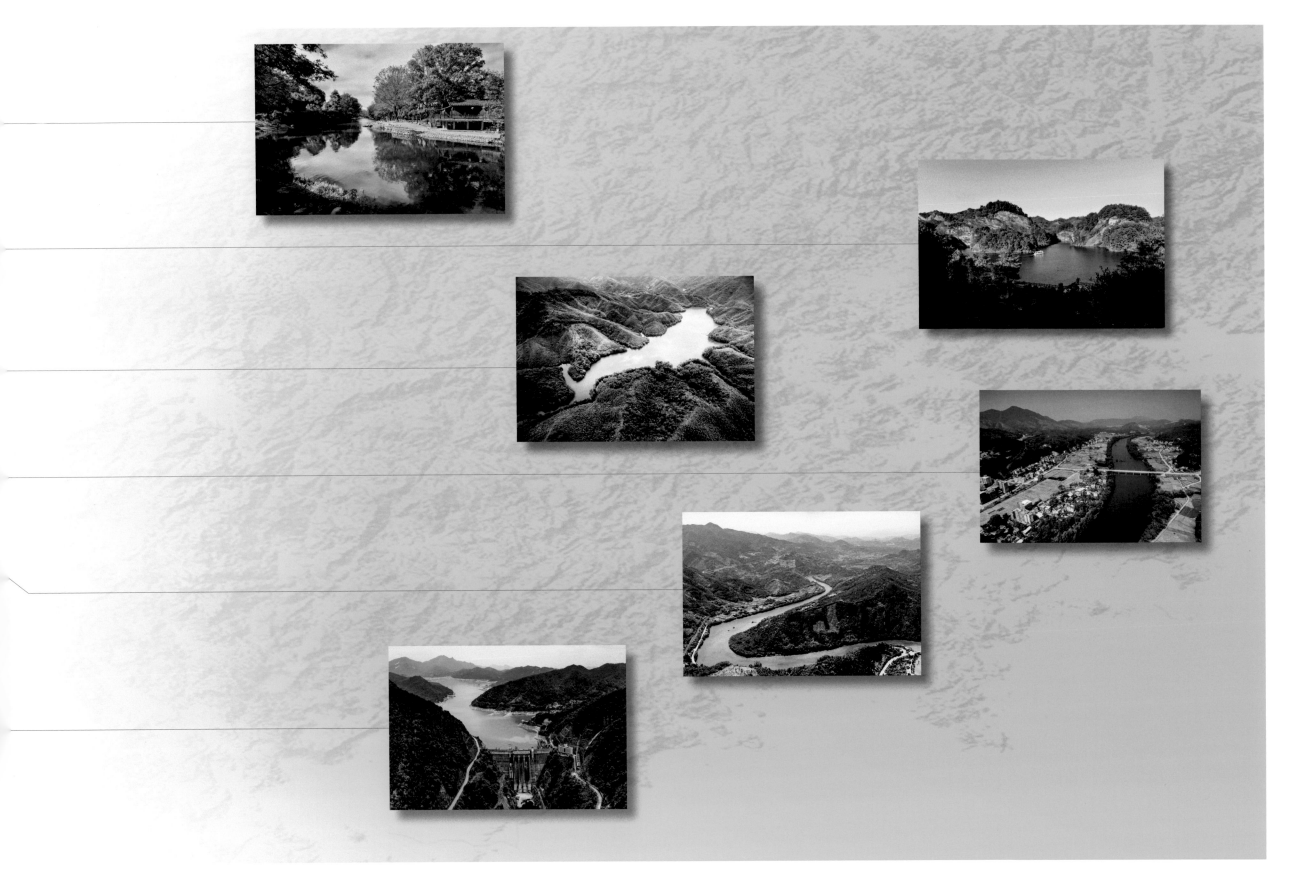

Preface

序

汀江，发源于武夷山南段东南一侧的宁化县治平乡境内木马山北坡，流经长汀、武平、上杭、永定4县区，汇众山之水，在长汀庵杰乡龙门形成源头，在永定区峰市镇进入广东省，至大埔县三河坝与梅江汇合后称韩江。作为福建四大水系之一，汀江干流全长285公里（武平县志220公里），支流众多，流域大于500平方公里以上的支流有：濯田河、桃澜溪（又名小澜溪）、旧县河、黄潭河、永定河、金丰溪等6条。

中国的地形西高东低，江河之水向东流淌，故有"一江春水向东流"的诗句，而汀江之水却是曲折有致、浩浩荡荡地向南流去。按八卦方位，南流之水称为"丁水"，后"丁"加水成"汀"，"汀江"得名。也许正因为这种流向，造就了它独特的色彩、形成了它灿烂的文化。从瘴气弥漫的南蛮之地到先人开发、后人发展，从客家摇篮到将客家送向远方，从中央苏区的形成、发展直到万里长征，无不与一江碧水向南流有关，或者说正是由于它的南流，确立了汀江的特殊地位。

汀江流域自东晋以来，历经世代先民的开发，成为客家生息、繁衍的富庶之地后，日渐形成了独特的地域文化；在历经战乱、走向和平的岁月中，留下了无数可歌可泣的事迹；共和国的建立尤其是四十年的改革开放中，汀江两岸发生了翻天覆地的变化，新容新貌新人新事，日新月异，层出不穷。党的十八大春风，又绿汀江两岸，注入青春活力。因而，完整地记录汀江的历史与现实、地理与文化、民俗与风情的影像，是一代人不可推卸的责任，也是一项光荣的使命。

2017年5月，福建画报社组织"汀江大型影像文化创作工程"摄影团队，第一次走进了汀江两岸的山山水水，面对这片土地上创造的一个又一个奇迹，从古至今，从历史到现代，进行了详细的记录。迁徙族群、神奇土楼、美味佳肴、斗争风云、红色经典、茂密丛林、飘香茶叶、幽雅兰花、威猛华南虎等，都在长枪短炮的镜头下，一一得到了展示。

生活与文化，首先在于创造，同时也在于记录与积累，没有记录便没有积累，没有积累便不具今日多样的灿烂文化。记录的方式因时因地因人而各异，结绳、文字、歌谣、绘画等等，我们对先人、前辈创造的文化，均从那些记录中获得印象、受到影响、得到营养。"汀江大型影像文化创作工程"的意义就在于，以现代的摄影方式，以纪实的手法，将汀江的文化符号，忠实地记录下来。拍摄团队中的每一个摄影家，跋山涉水、走街串巷，细致而微地捕捉和记录客家人创造的文化与业绩，记录下历史的陈迹、革命的旧址、自然的色彩。这种记录不仅是建筑、物体、人物等细节，同时运用航拍技术，从空中俯瞰汀江、俯瞰两岸的自然、山色与土地。参加这个活动多为资深的摄影家，他们都有很高的艺术造诣，这一回又以辛勤的步伐、虔诚的姿态、朝圣的精神，面对着这片神奇的土地，一次次按下了快门。是不是可以这样说，汀江南流千年，如此大型、全面、宏观而又微距记录两岸的文化符号，该是第一回吧！也许，这里的一些文化符号，不被记录下来，将在时间的长河中渐渐消失。

党的十九大再次提到文化自信，并且将其与道路自信、理论自信与制度自信并列在一起。文化自信的内涵应包括中华民族的传统文化、革命文化与社会主义的先进文化，"汀江"工程中，以土楼为象征的客家文化、以古田会议为代表的革命文化、以绿色生态为标志的现代文化，恰好切入文化自信的内涵之中，也可以说，包含在自信的文化之中。

一百年后，当后人打开这个"汀江"第一次的全记录，便可直观地面对"那个时代"。"啊，那时的汀江，原来是这个样子。"

王炳根

Preface

The Tingjiang River, originating from the north slope of Muma Mountain in Zhiping Township of Ninghua County on the southeast side of the south section of Wuyi Mountain, flows through Changting, Wuping, Shanghang and Yongding counties. It enters Guangdong Province at Fengshi Town of Yongding County, and is called Hanjiang River after the confluence of Meijiang River at Sanhe Dam in Dapu County. The main stream is 285 kilometers long (220 kilometers according to *Wuping County Annals*), one of the four major water systems in Fujian Province. There are many tributaries of the Tingjiang River. The tributaries with a basin of more than 500 square kilometers are Zhuotian River, Taolanxi Brook (also known as Xiaolanxi Brook), Jiuxian River, Huangtan River, Yongding River and Jinfeng Brook. Merging waters of many mountains, the Tingjiang River got its source at Longmen, Anjie Township, Changting County.

High in the west and low in the east, the topography of China makes the water of rivers flow eastward. Hence the ancient poem line said "the spring water in river is flowing east". However, the water of the Tingjiang River flows southward in a tortuous and magnificent way. In accordance with the ideology concerning directions in the Eight Diagrams, the water flowing south was called "Ding (丁) water", after which the structural part " 氵 " meaning water was added to "Ding(丁)" and a new Chinese character Ting (汀) was formed. In this way the Tingjiang River got its present name. Perhaps it is this particular flow direction that has ushered in its unique and splendid culture. Such stories are concerned with the history of the Tingjiang River flowing southward include the development

from the so-called land of southern barbarians permeated with miasma to the descendants' development of what ancestors pioneered, from the cradle of Hakka to the sending of Hakka to the distant places, and from the formation and development of the Central Soviet Area to the Long March. In another word, it is precisely because of its southward flow that the Tingjiang River has established its special status.

Since the Eastern Jin Dynasty, after the development of generations of ancestors and the prosperity of Hakka, the Tingjiang River Basin has gradually formed a regional culture, leaving countless greatly moving deeds in the years of war and peace. The establishment of the Republic, and especially the reform and opening-up in the past 40 years, have witnessed earth-shaking changes along the Tingjiang River, with more and more new features, new people and new events. The Eighteenth National Congress of the Communist Party of China injected new concepts and energy into both sides of the Tingjiang River. Therefore, it is an unshirkable responsibility and a glorious mission for our generation to record the image of Tingjiang's history and reality, geography and culture, folk customs and flavor.

In May 2017, the photography team of the large-scale cultural creative activity *The Tingjiang* organized by Fujian Pictorial entered the mountains and rivers along the Tingjiang River for the first time. Facing one miracle after another created on this land, we recorded in detail from ancient times to present, from history to modern times. Migratory ethnic groups, magical earthen buildings,

delicious dishes, stones of struggling times, red classics, dense jungle, fragrant tea, elegant orchids, powerful South China tigers and so on are all displayed by the miraculous professional lens.

Life and culture, first of all, lie in creation, but also in recording and accumulation. Without recording, there will be no accumulation. Without accumulation, there couldn't have been today's diverse and splendid culture. The way of recording may be knotting ropes, writing, ballads, paintings and so on, varying with the corresponding time, place and people. Through these records we are impressed, influenced and nourished by the cultures created by our ancestors and predecessors. The significance of the large-scale cultural creative activity *The Tingjiang* lies in faithfully recording the cultural symbols of the Tingjiang River by modern photography and documentary method. The photographers climb mountains, cross rivers and walk through streets and alleys, and enter rooms. They carefully capture and record the culture and achievements created by Hakka people, and record them by shooting the historical traces, the old revolutionary sites and the natural scenes. This record not only catches the details of buildings, objects and people, but also means the use of aerial photography technology to overlook the Tingjiang River and the natural scenes, mountains and lands on both sides of the river from the air. Most of the photographers participating in this activity are senior photographers with high artistic attainments. This time, with hard work, pious attitude and pilgrimage spirit, they press the shutter again and again in the face of this magical land. It can be said that as the Tingjiang River flows southward for thousands of years, this is the first time that the cultural symbols of the river have been recorded in such a large, comprehensive, macroscopic and micro way. Perhaps some of the cultural symbols here, if not recorded, would gradually disappear in the long river of time.

The Nineteenth National Congress of the Communist Party of China once again referred to cultural self-confidence, and put it side by side with road self-confidence, theoretical self-confidence and institutional self-confidence. The connotation of cultural self-confidence should include the traditional culture of the Chinese nation, revolutionary culture and the advanced culture of socialism. In the large-scale cultural creative activity *The Tingjiang*, Hakka culture symbolized by earthen buildings, red culture represented by Gutian Conference and modern culture symbolized by green ecology just fit in with the connotation of cultural self-confidence, or in another word, are included in the culture of self-confidence.

A hundred years later, when later generations open the first full record of this "Tingjiang", they could face "that era" we are in intuitively and say "Ah, the Tingjiang River at that time was like this."

Wang Binggen

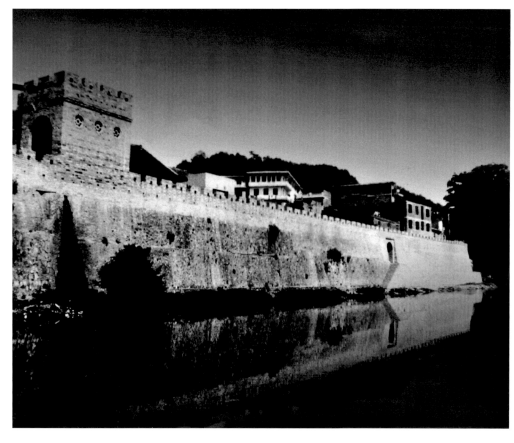

汀州古城墙是汀城历史的见证，始建于唐代，宋、明、清均有扩建

The ancient wall of Tingzhou is the witness of its history, which was built in the Tang Dynasty and expanded in the Song, Ming and Qing Dynasties

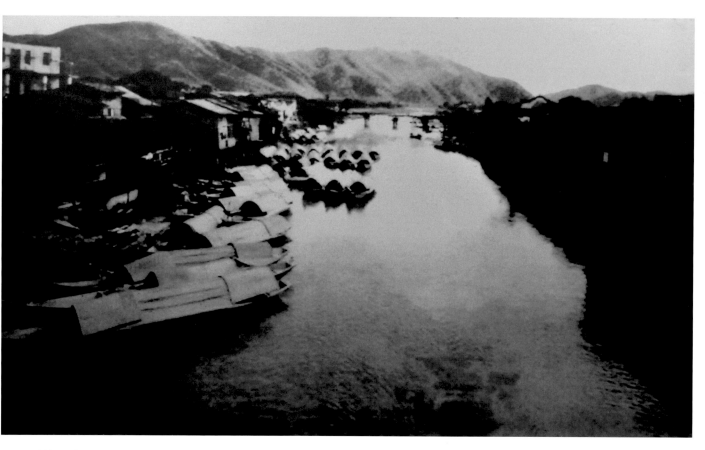

19世纪，大批客家人沿着汀江南迁广东，并由此走向海外。这是当年汀州城码头 ／ 长汀县博物馆提供

In the 19th century, a large number of Hakkas moved southward along the Tingjiang River to Guangdong Province, and from there they went overseas. This was the wharf of Tingzhou City in those years /Provided by Changting County Museum

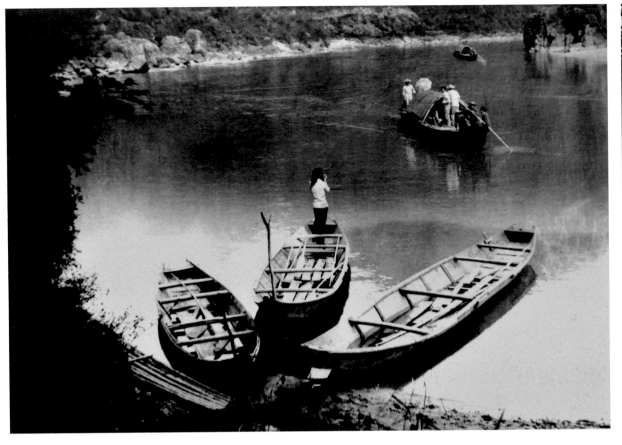

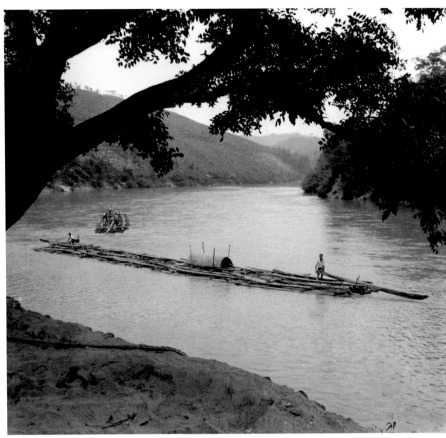

当年的客家人穿越重重险滩乘坐的木篷船 ／ 长汀县博物馆提供
The wooden canopy boat that Hakkas used to cross numerous dangerous shoals in those years /
Provided by Changting County Museum

20 世纪 50 年代，汀江上游羊牯乡放排的场景 ／ 袁松树 摄
The scene of rafting in Yanggu Township in the upper reaches of the
Tingjiang River in the 1950s /Photographed by Yuan Songshu

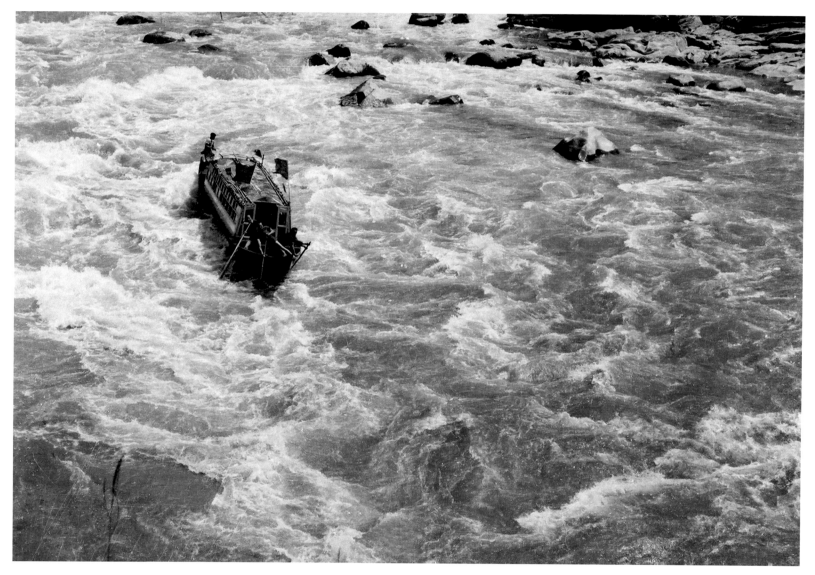

1986 年，汀江恢复通航。机动木船顺利闯过险滩，结束了棉花滩自古不过舟的历史 ／ 袁松树 摄

In 1986, the Tingjiang River resumed navigation, and the motorized wooden boat successfully crossed the dangerous shoal, ending the history that no boat has ever crossed the Cotton Shoal since ancient times /Photographed by Yuan Songshu

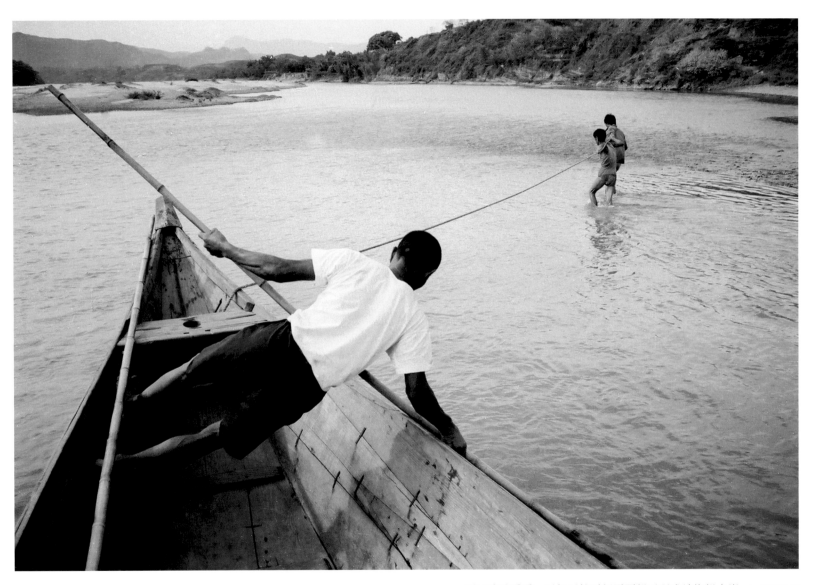

汀江险滩重重，早年返航时都需要船工艰难地拖船上岸 / 袁松树 摄
There are many dangerous shoals on the Tingjiang River. When sailing for home in the early years, the boatmen had
to pull the boat hard to get on the shore /Photographed by Yuan Songshu

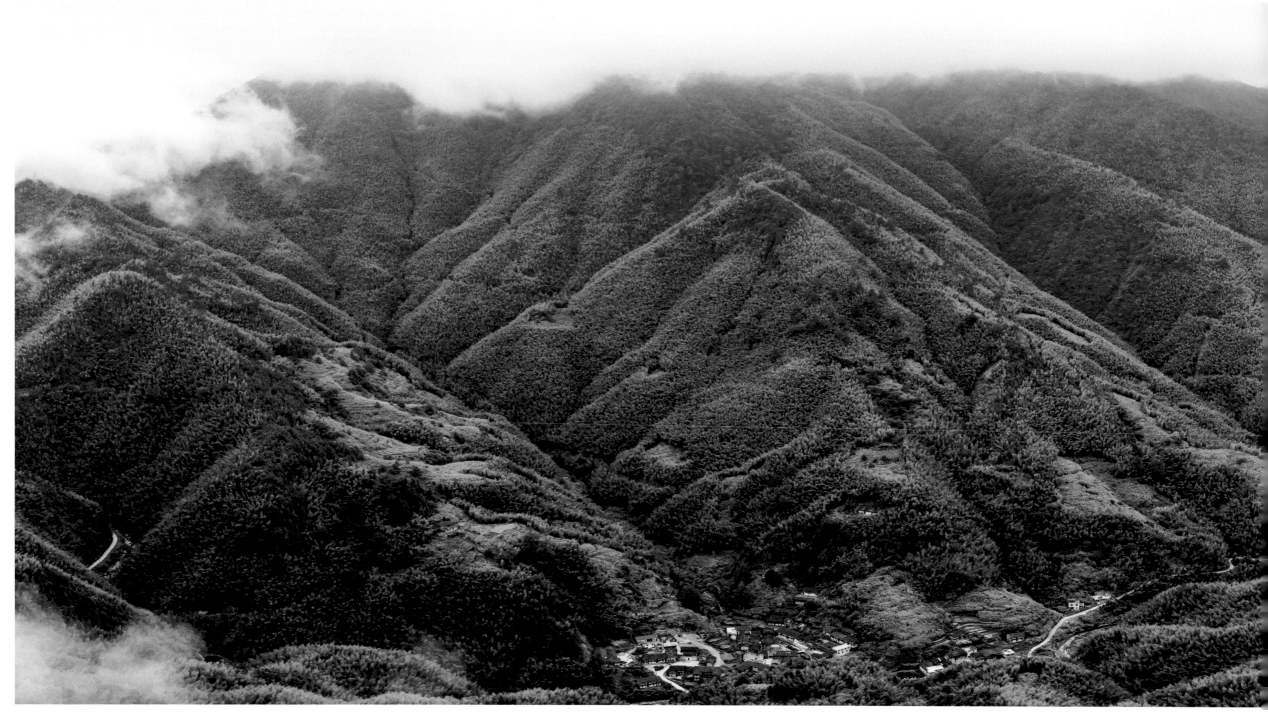

汀江发源于三明市宁化县治平乡境内的崇山峻岭之中 / 朱晨辉 严硕 摄
The Tingjiang River, originating in the high mountains in Zhiping Township of Ninghua County, Sanming City /Photographed by Zhu Chenhui, Yan Shuo

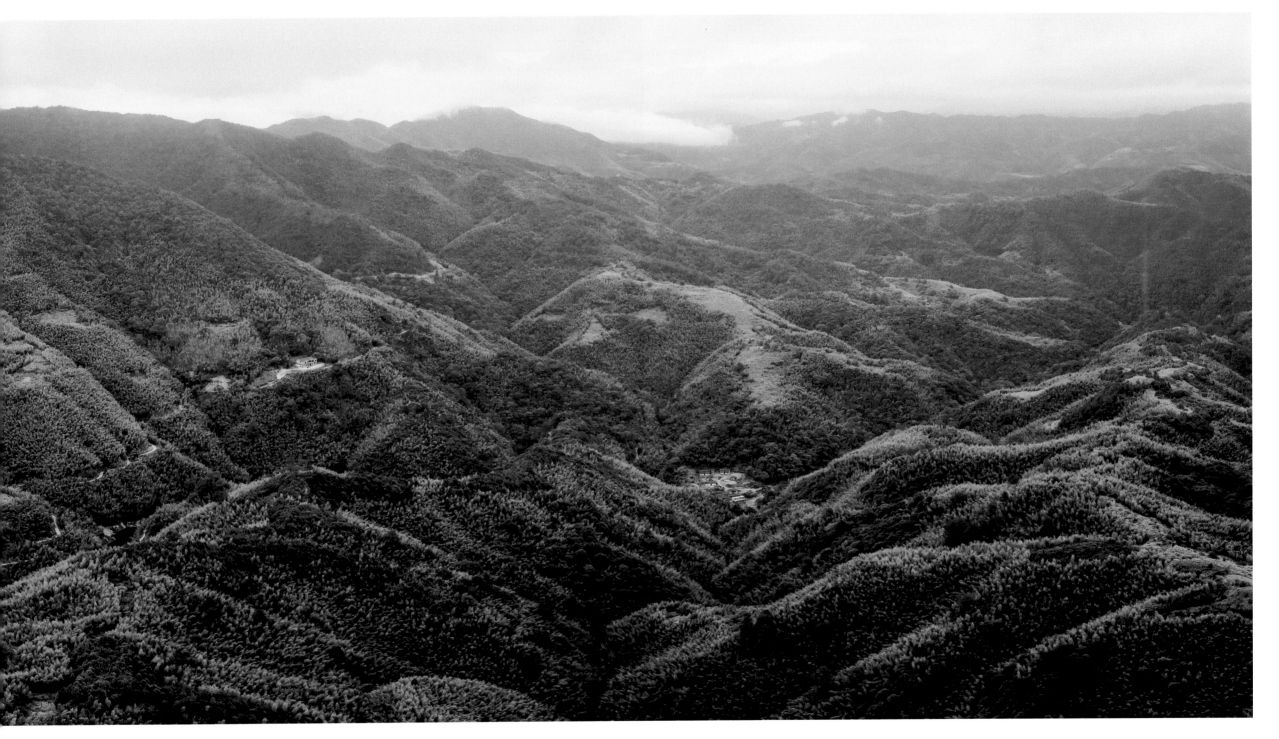

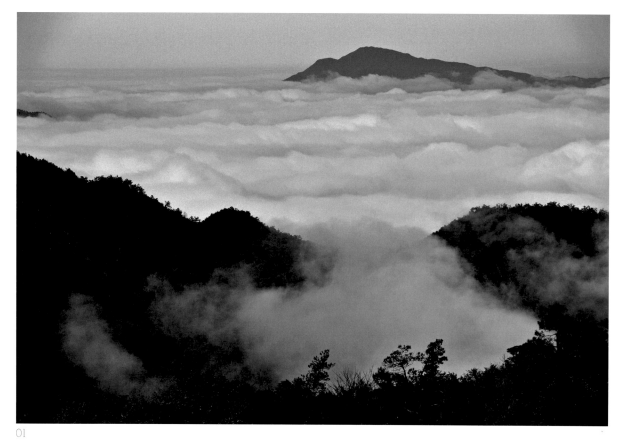

01

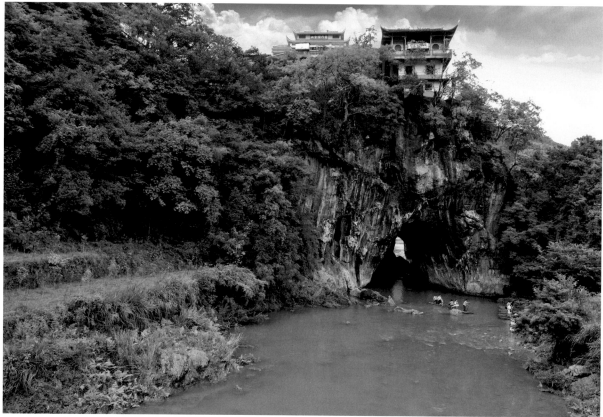

02

01 汀江发源地福建省三明市宁化县治平乡赖家山，这里重峦叠嶂，云雾缭绕

Laijia Mountain located in Zhiping Township, Ninghua County, Sanming City, Fujian Province, is the source of the Tingjiang River, where is covered with mountains and cloud-wrapped

02 汀江源龙门位于长汀县庵杰乡涵前村。这里有一座神奇的岩石冲天而立，似石门高耸，清澈的汀江水从石门中穿流而出，奔涌向南 300 公里，直下韩江，汇入南海。由此形成"独我汀江跨龙门"的奇特景观 / 吴军 摄

Longmen at the source of the Tingjiang River is located in Hanqian Village, Anjie Township, Changting County. There is a magical rock rising in the sky like a towering stone gate. The clear water of the Tingjiang River flows out through the stone gate and flows 600 miles to the south, rushes down the Hanjiang River and merges into the South China Sea. From then on, the unique landscape of "only the Tingjiang River can cross Longmen" was formed / Photographed by Wu Jun

03 汀江，发源于武夷山南麓的宁化县治平乡，汇众山之水为一溪，蜿蜒流经长汀县庵杰乡龙门，成为客家母亲河的源头 / 吴军 摄

The Tingjiang River originates from Zhiping Township of Ninghua County at the southern foot of Wuyi Mountain, converging the water of all mountains into a stream, which winds through Longmen of Anjie Township in Changting County and becomes the source of the Hakka Mother River /Photographed by Wu Jun

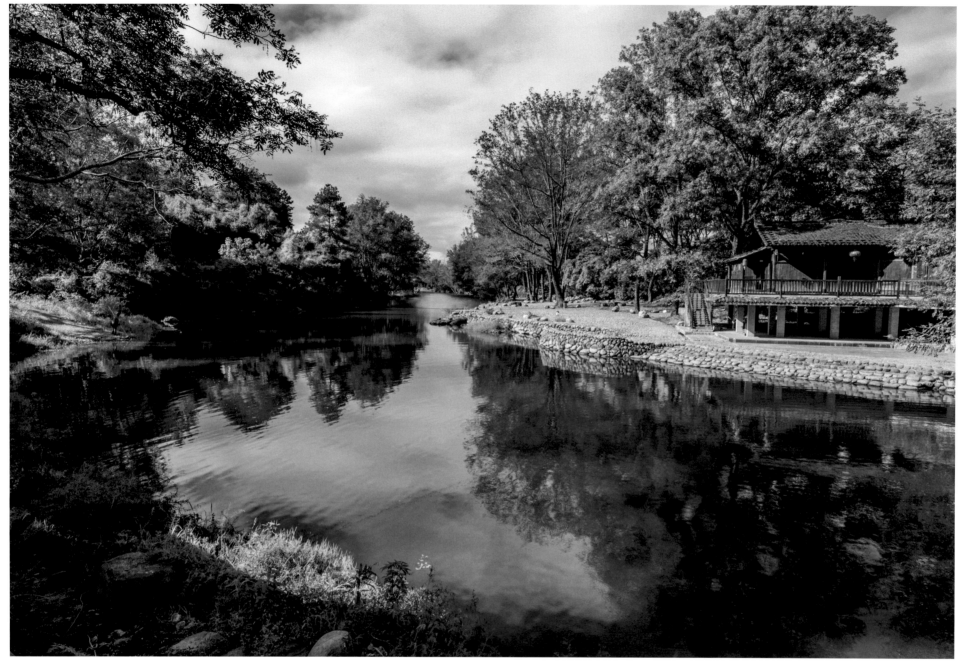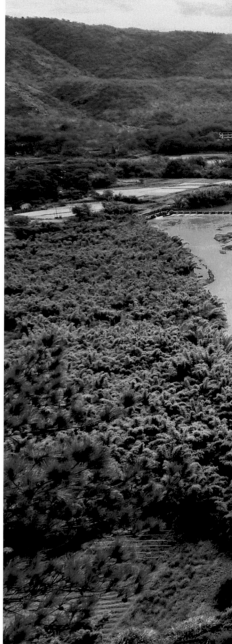

汀江上游的曲凹哩码头，位于长汀县新桥镇新桥村，景色优美。江水从密林中穿越而出，在湘洪桥一带与龙门之水合二为一流向汀江 / 吴军 摄

The Quaoli wharf in the upper reaches of the Tingjiang River is located in Xinqiao village, Xinqiao Town, Changting County, with beautiful scenery, which crosses through a dense forest and flows to the Tingjiang River with the water of Longmen along the Xianghong Bridge /Photographed by Wu Jun

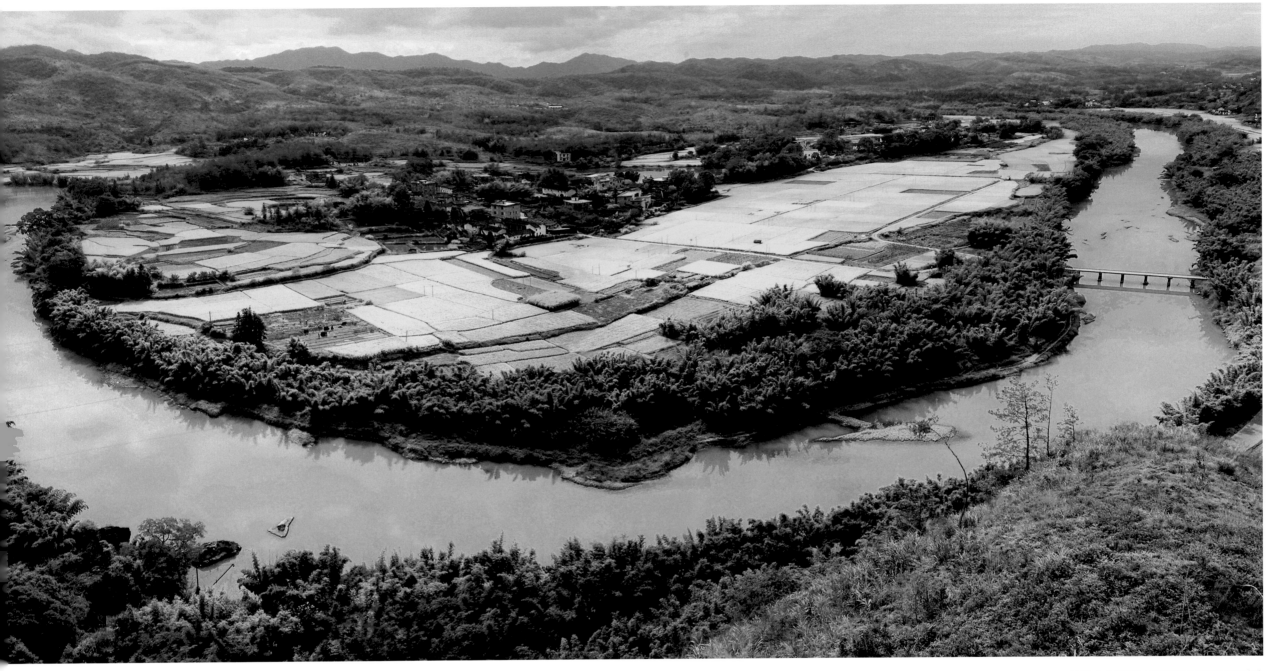

长汀中山镇阳民村汀江流域的绿野平畴
The Tingjiang Reach in Yangmin Village, Zhongshan Town, Changting

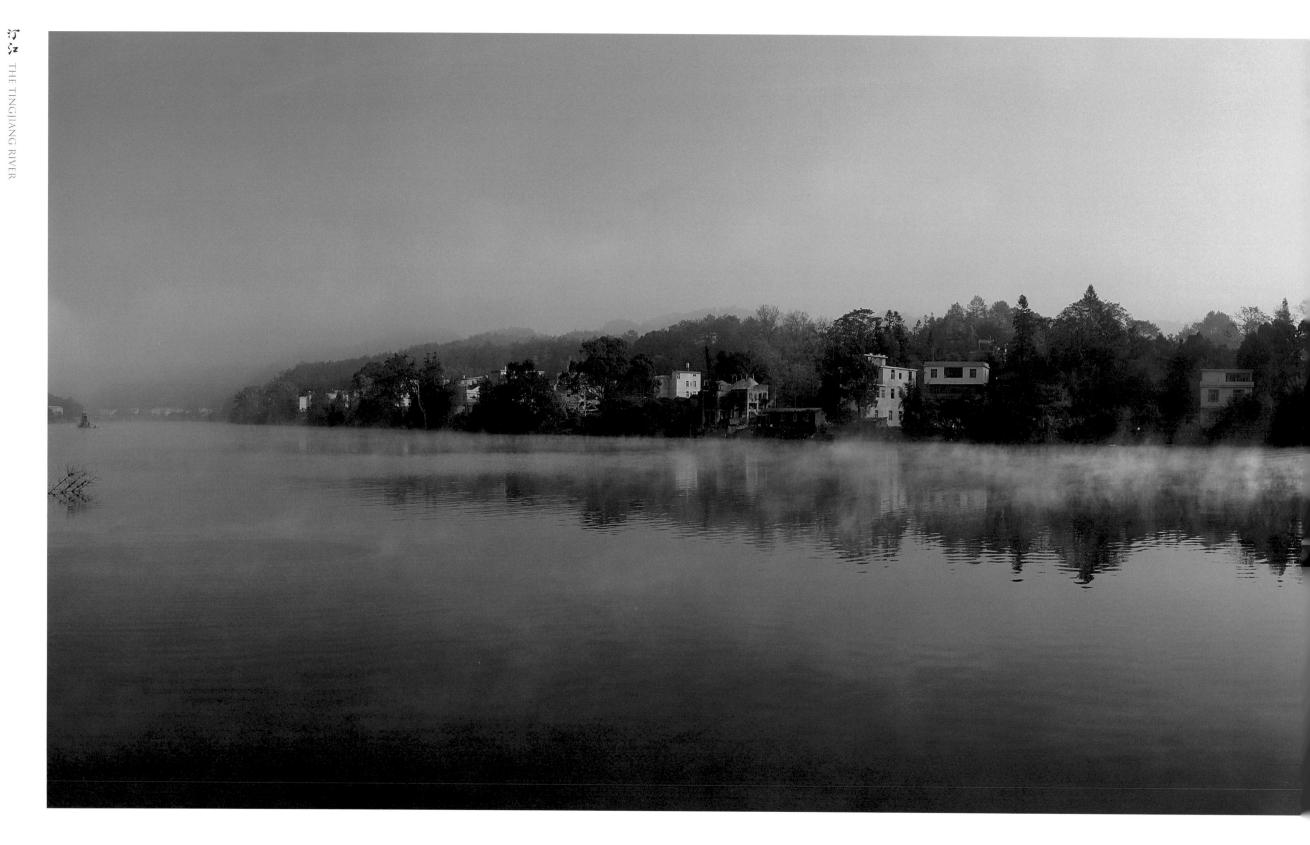

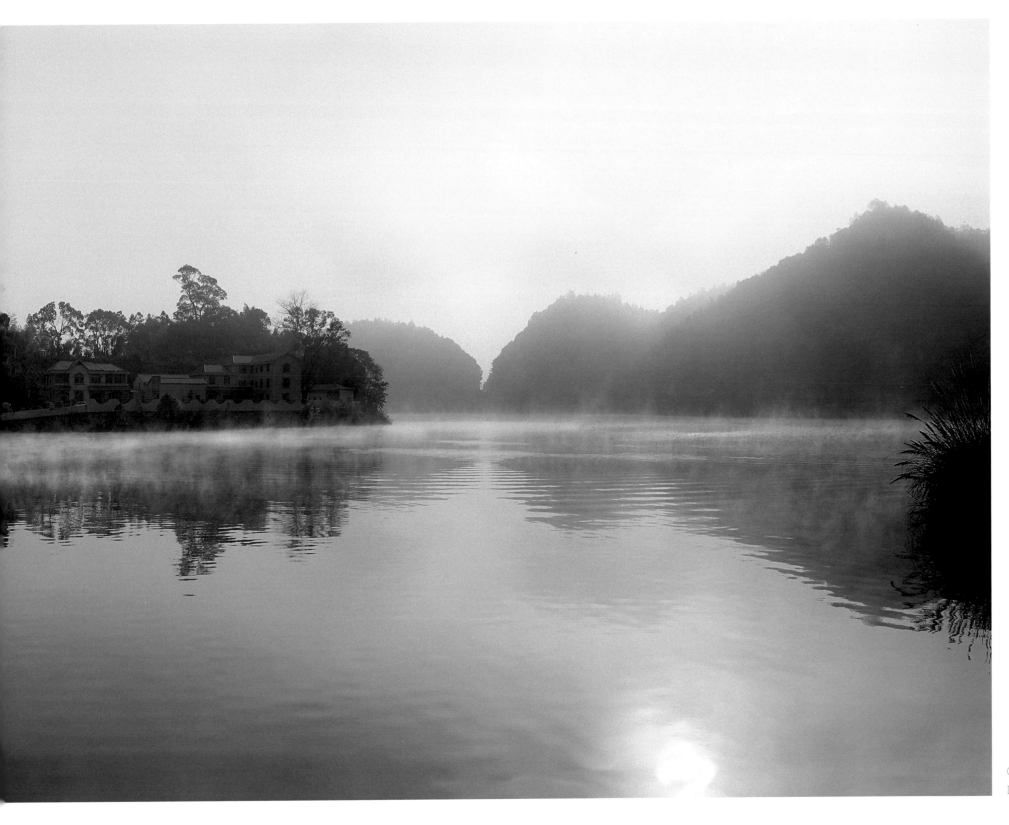

武平县境内汀江流域湘店乡河段 / 练才秀 摄
Xiangdian Township Reach within Wuping
County of the Tingjiang River /Photographed by
Lian Caixiu

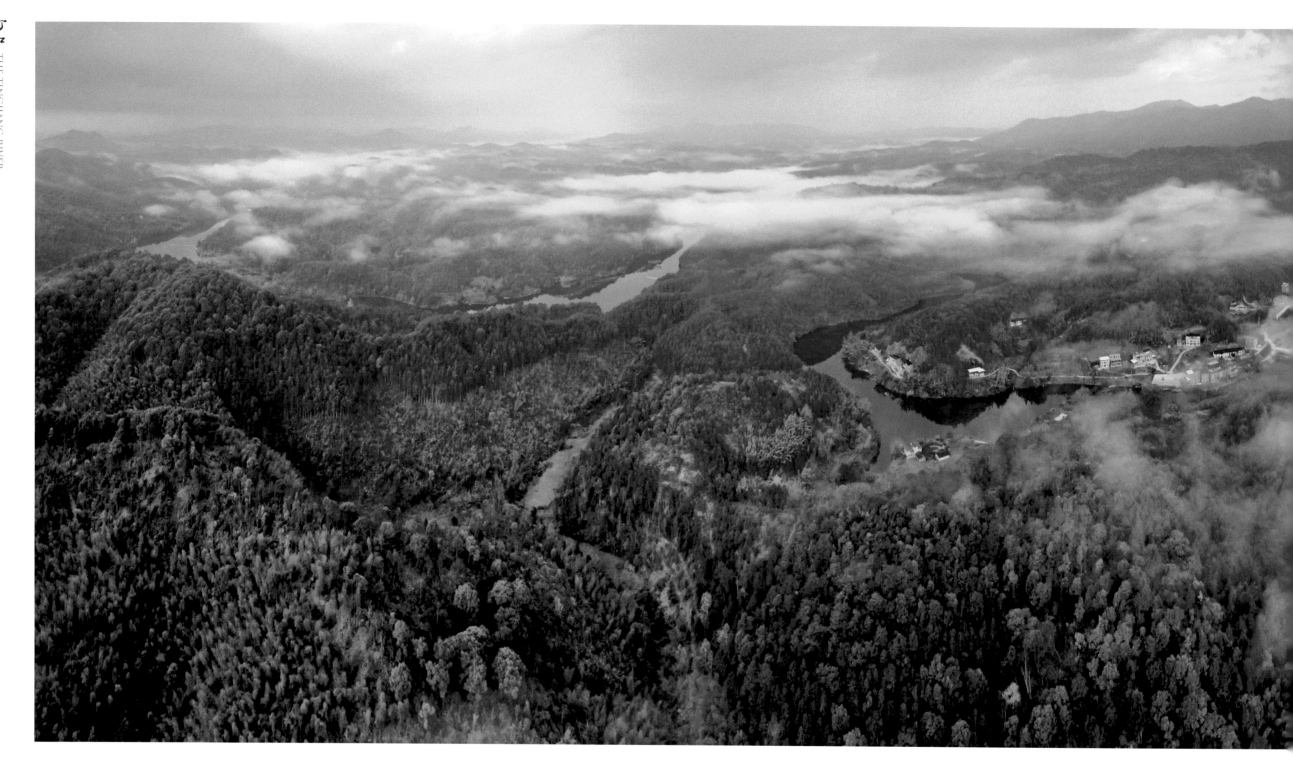

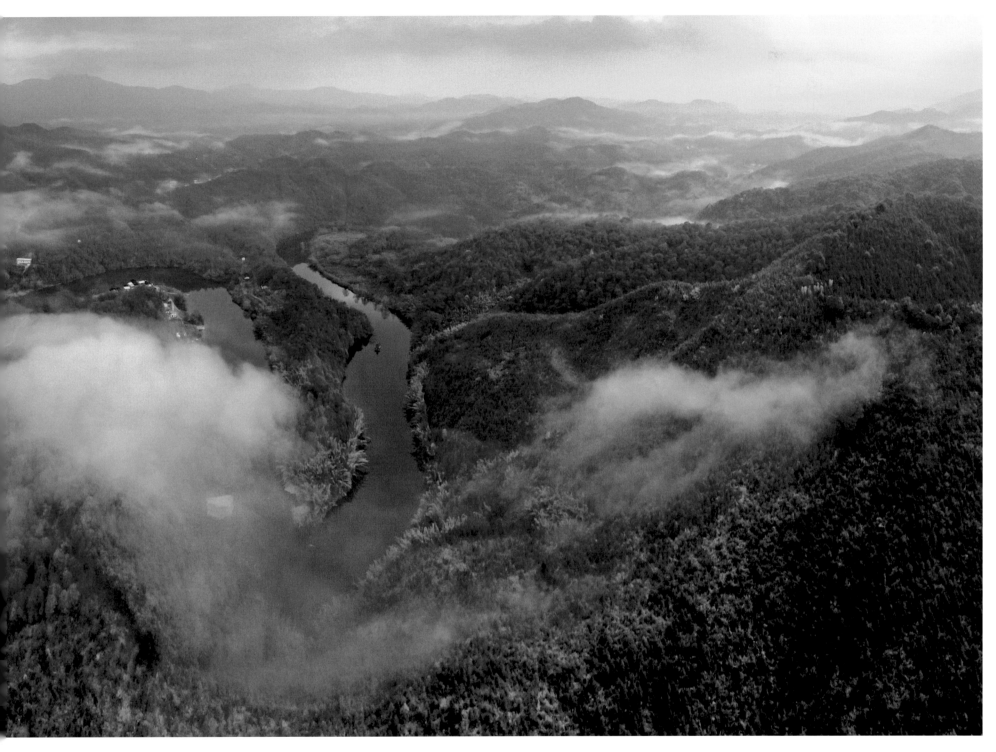

武平县河口乡群山逶迤，汀江从这里流入武平。境内绿水青山，成为全国绿色发展的县域样本 / 钟炎生 摄

From Hekou Township of Wuping County, the Tingjiang River flows into Wuping County with winding mountains. There are lucid waters and lush mountains within Wuping, which make it a county sample of green development / Photographed by Zhong Yansheng

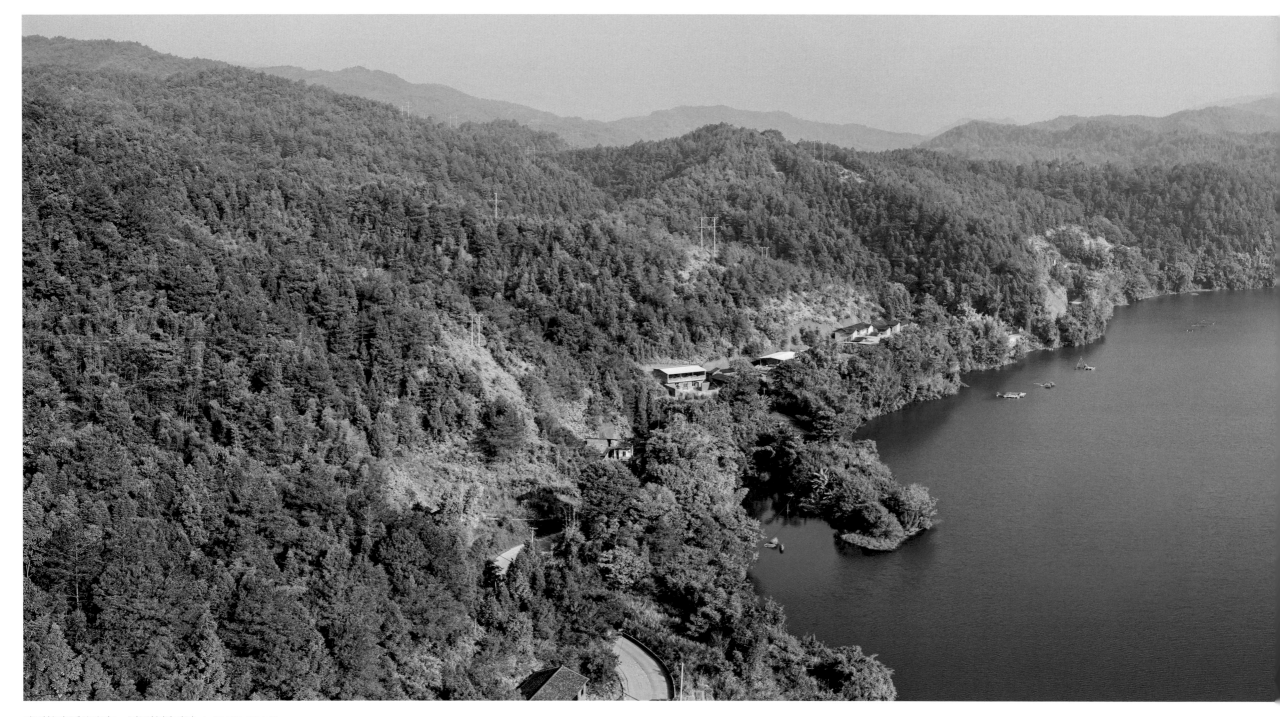

武平境内溪流密布，汀江蜿蜒而过 / 朱晨辉 严硕 摄
There are many streams densely covered in Wuping, with the Tingjiang River wiggling by /Photographed by Zhu Chenhui, Yan Shuo

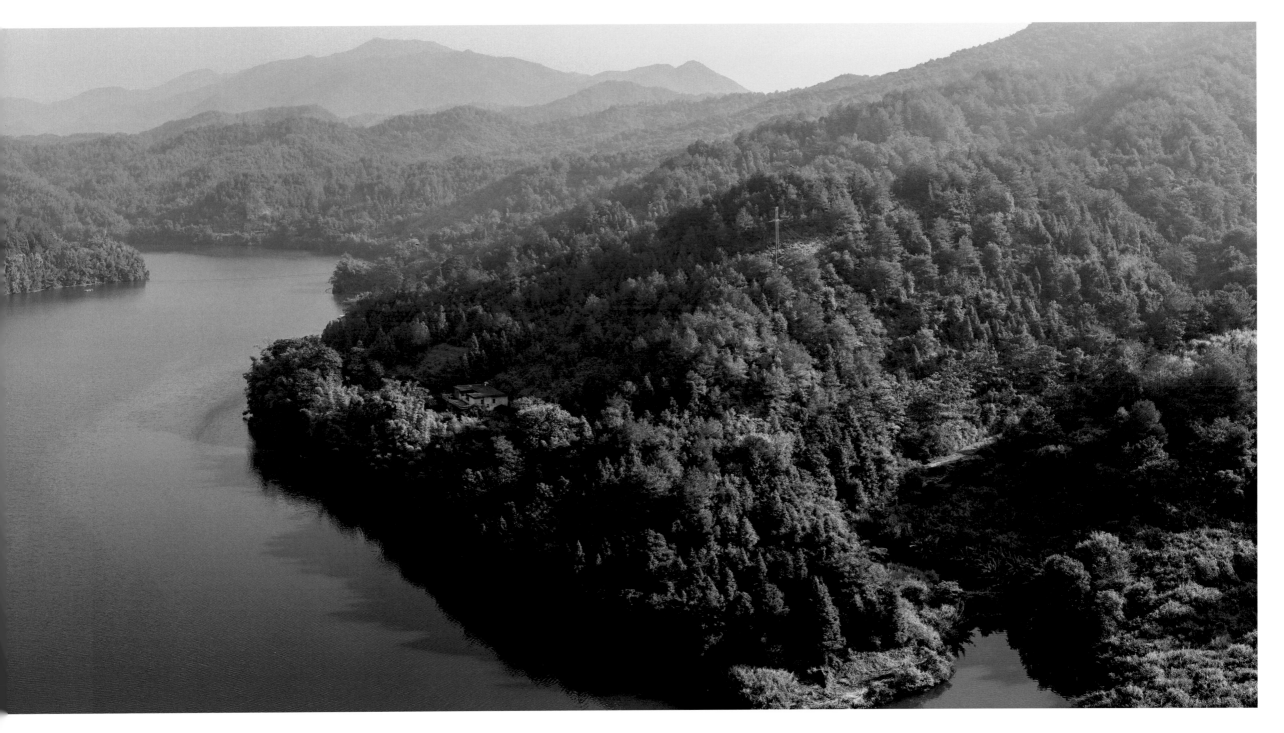

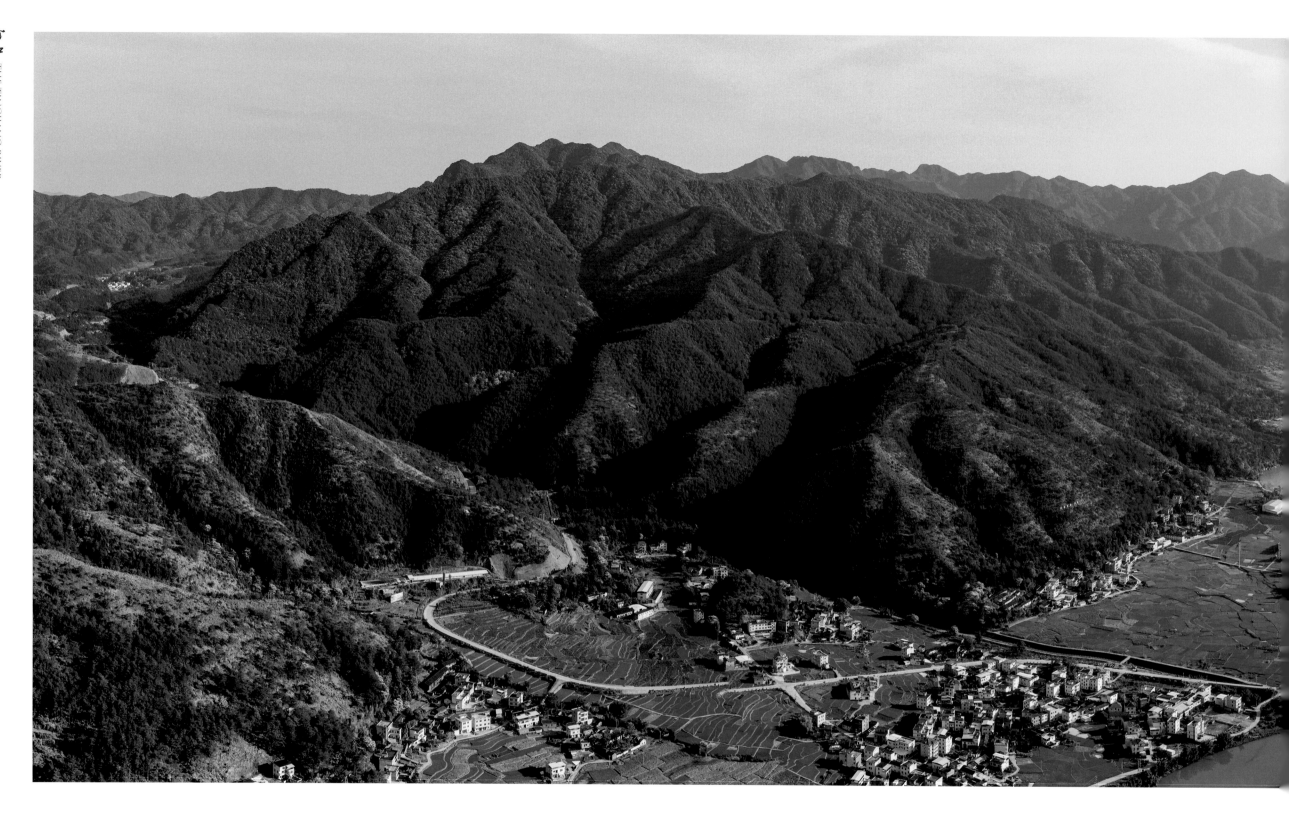

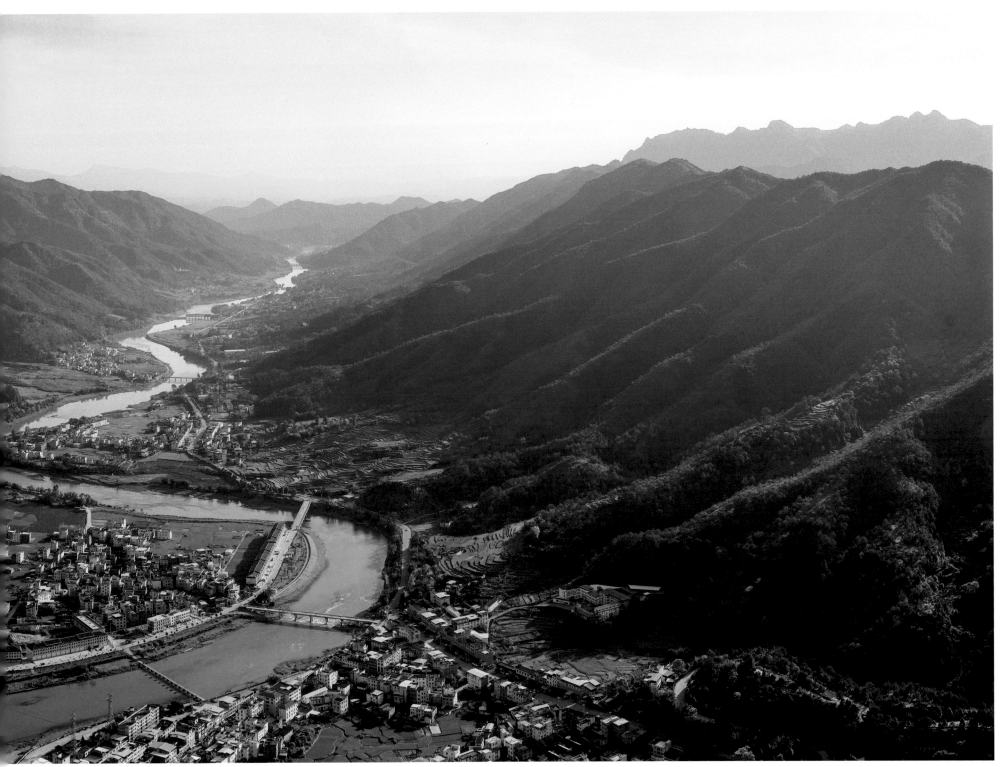

旧县河为汀江中游的一条主要支流，发源于连城县曲溪乡黄胜村，由北向南流经连城县朋口镇、新泉镇，于新泉镇车头村进入上杭县，经南阳乡、旧县乡后，在上杭县临城镇九洲村汇入汀江干流 / 朱晨辉 严硕 摄

The Jiuxian River is a main tributary of the middle reach of the Tingjiang River, originating from Huangsheng Village, Quxi Township, Liancheng County, and flows from north to south through the towns of Pengkou and Xinquan in Liancheng County, and enters Shanghang County in Chetou Village, Xinquan Town. After passing through Nanyang Township and Jiuxian Township, it converges into the main stream of the Tingjiang River in Jiuzhou Village, Lincheng Town, Shanghang County /Photographed by Zhu Chenhui, Yan Shuo

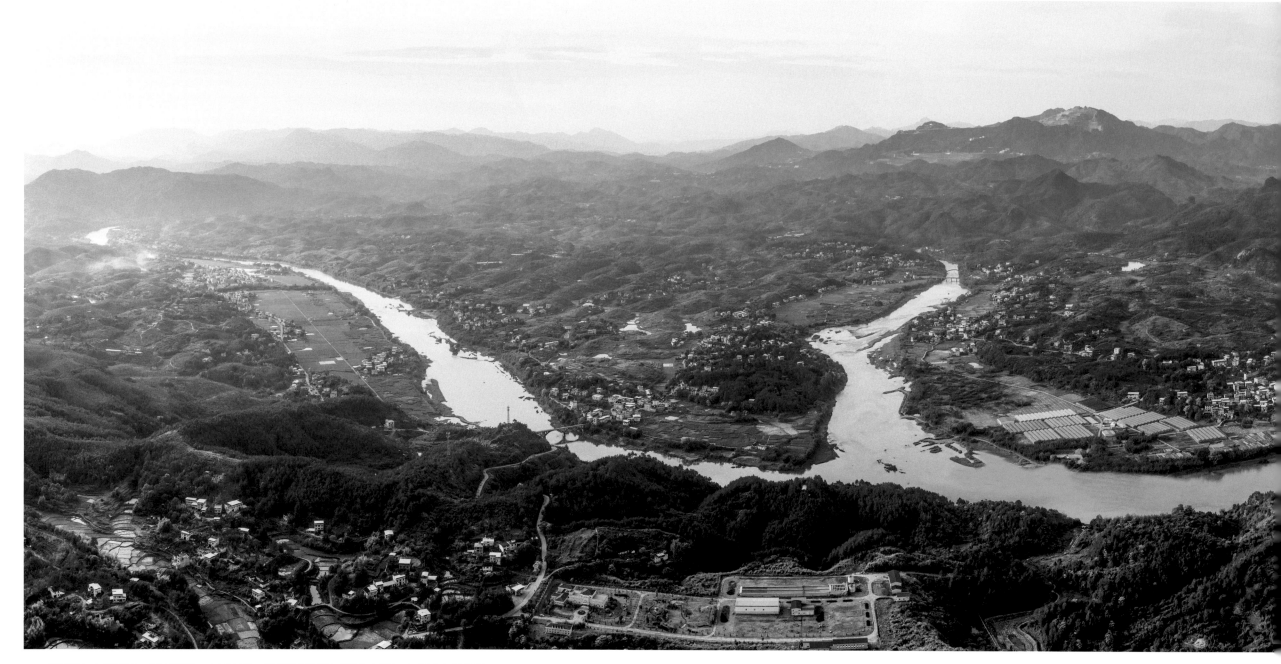

汀江进入上杭境内，河面宽阔，水量充沛，被誉为汀江的"黄金水段" / 朱晨辉 严硕 摄
The Tingjiang River enters the territory of Shanghang, with a broad river surface and abundant water, which is known as the "golden water section" of the Tingjiang River /Photographed by Zhu Chenhui. Yan Shuo

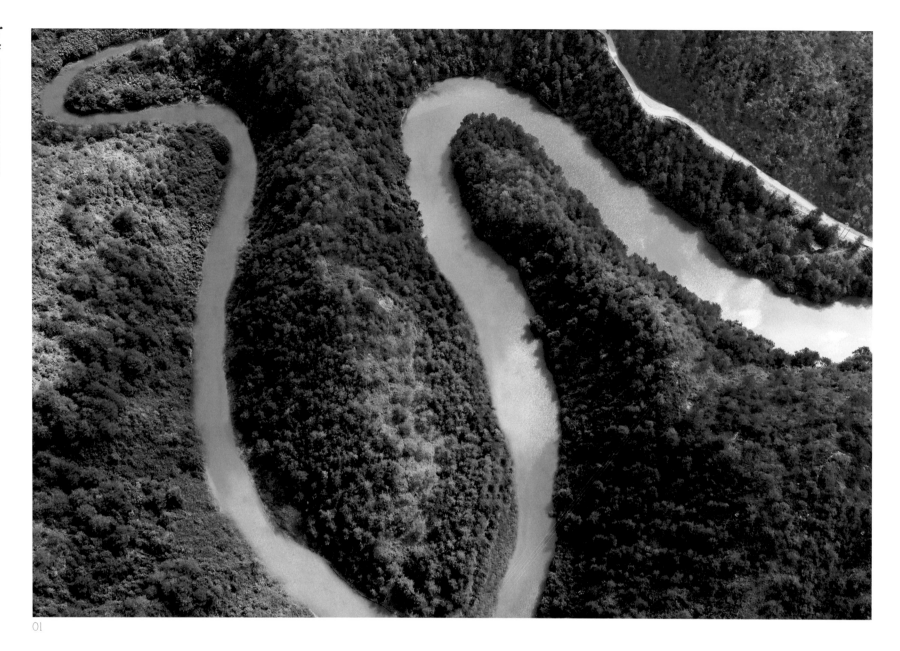

01

01 汀江中游，长汀与上杭交界处的回龙段蜿蜒曲折，百转千回 ／ 严硕 朱晨辉 摄

In the middle reach of the Tingjiang River, the junction of Changting and Shanghang is winding, with innumerable twists and turns /Photographed by Yan Shuo, Zhu Chenhui

02 上杭庐丰畲族乡摩陀寨，曾是一座设防的古城堡，汀江环抱两岸，绿树葱茏 ／ 邱开勇 摄

Motuo Village located in Lufeng She Nationality Township of Shanghang County, was once a fortified ancient castle, both sides of which is surrounded by the Tingjiang River with the mountain forest rising straight up and verdant trees /Photographed by Qiu Kaiyong

03 汀江流域上杭河段绿树成荫，生态环境优美 ／ 朱晨辉 严硕 摄

The Shanghang reach of the Tingjiang River Basin is covered by green trees and has a beautiful ecological environment / Photographed by Zhu Chenhui, Yan Shuo

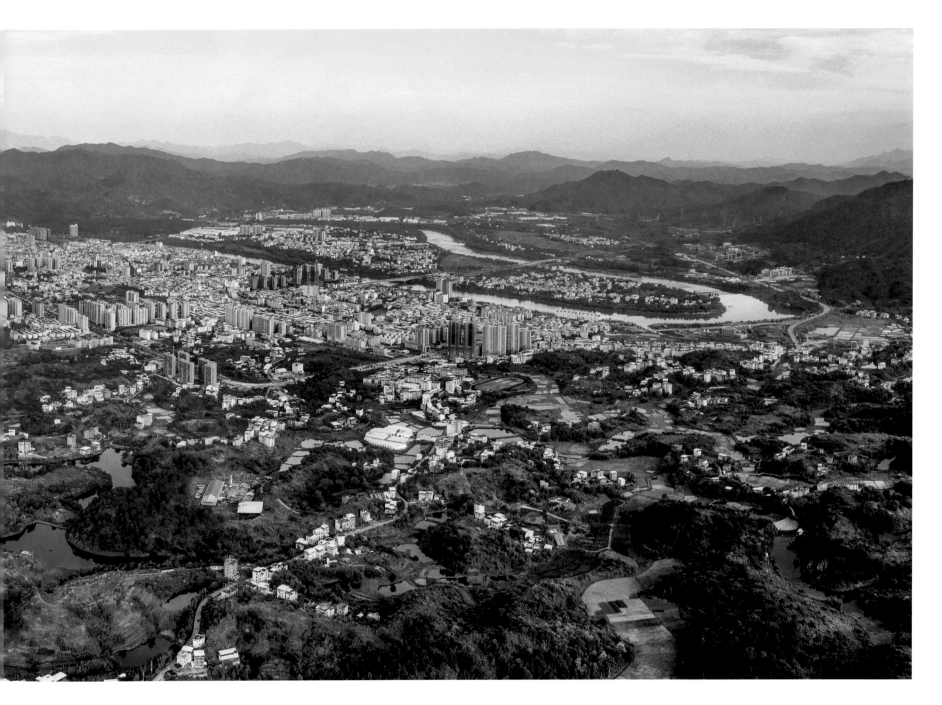

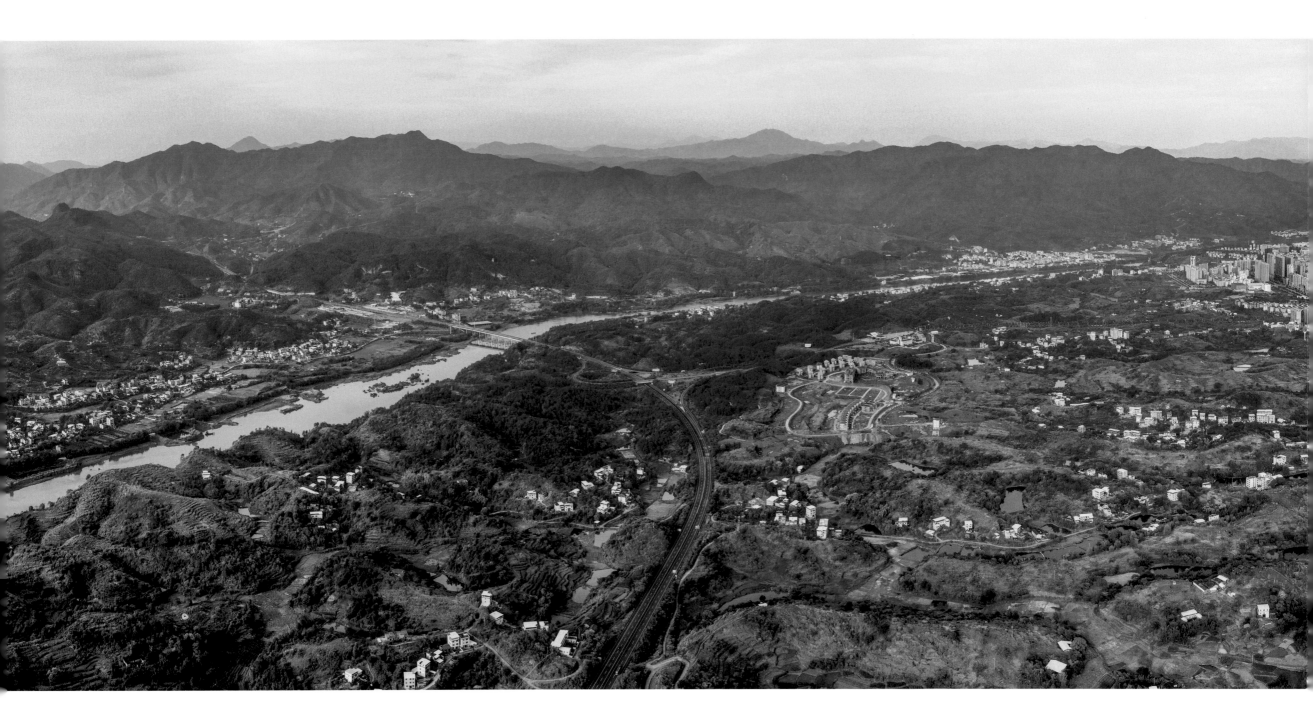

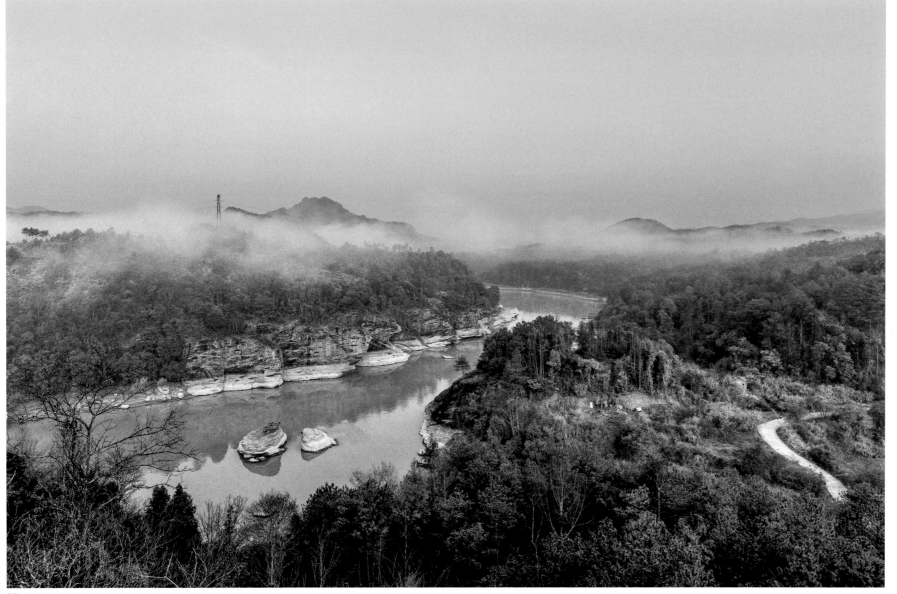

02

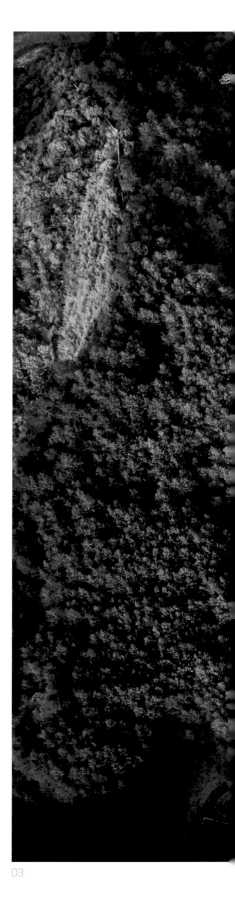

03

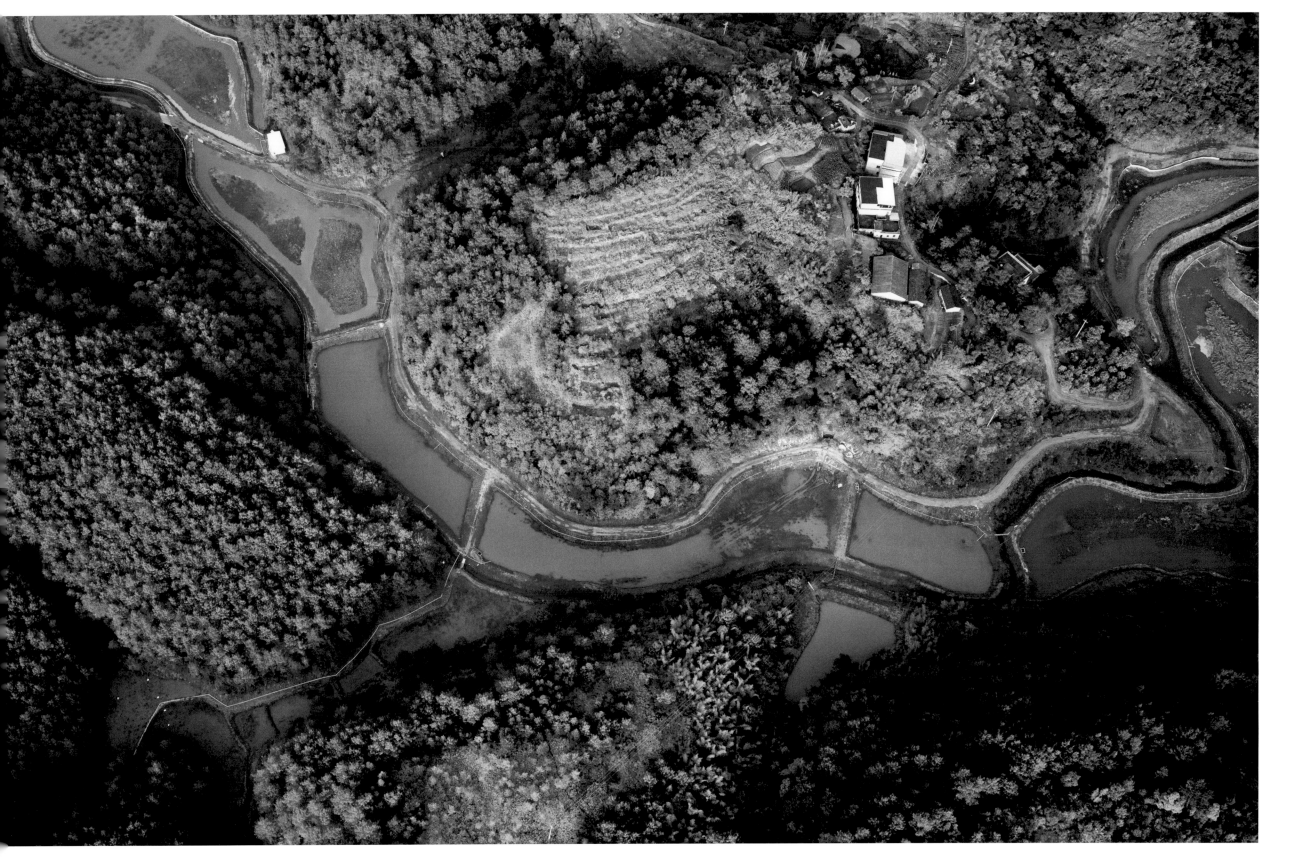

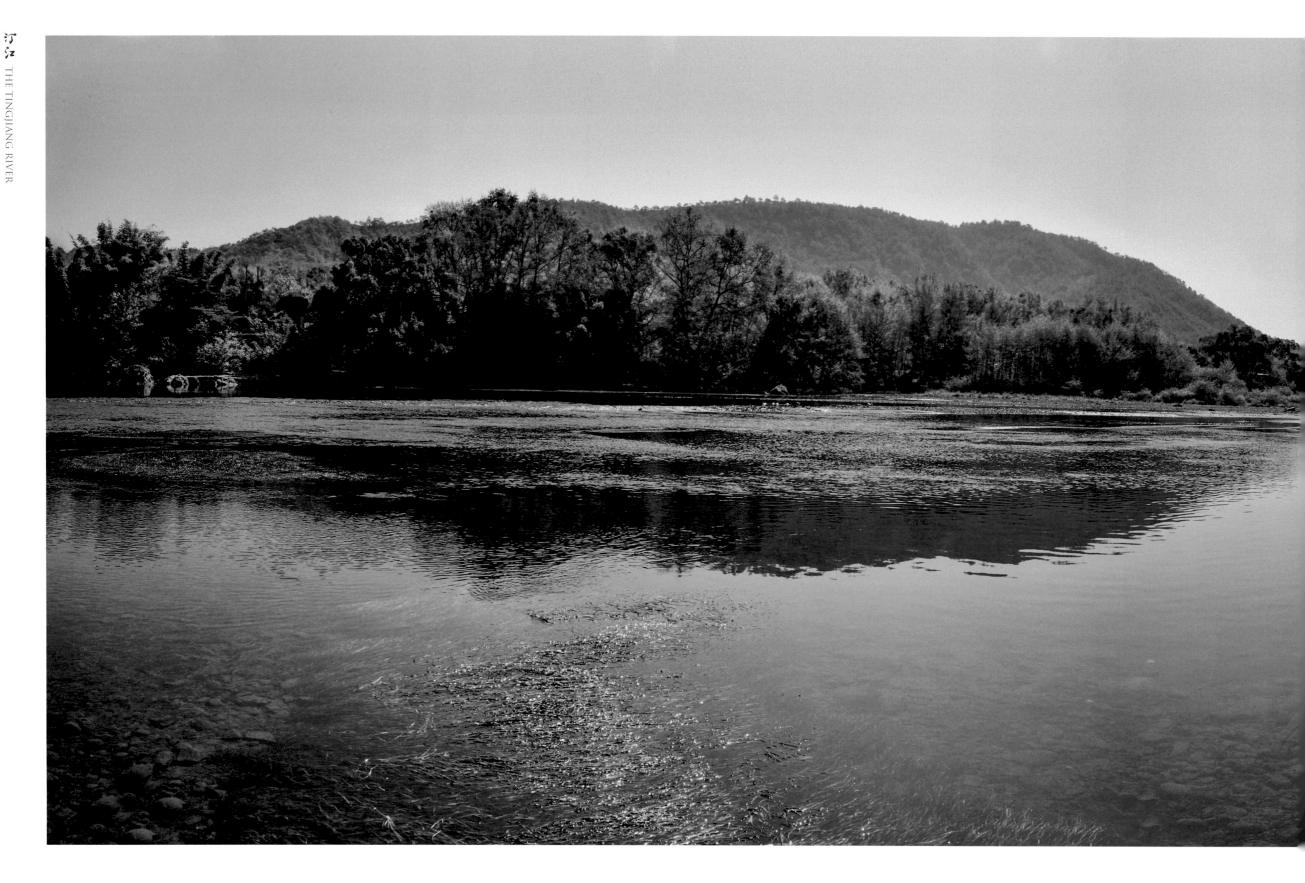

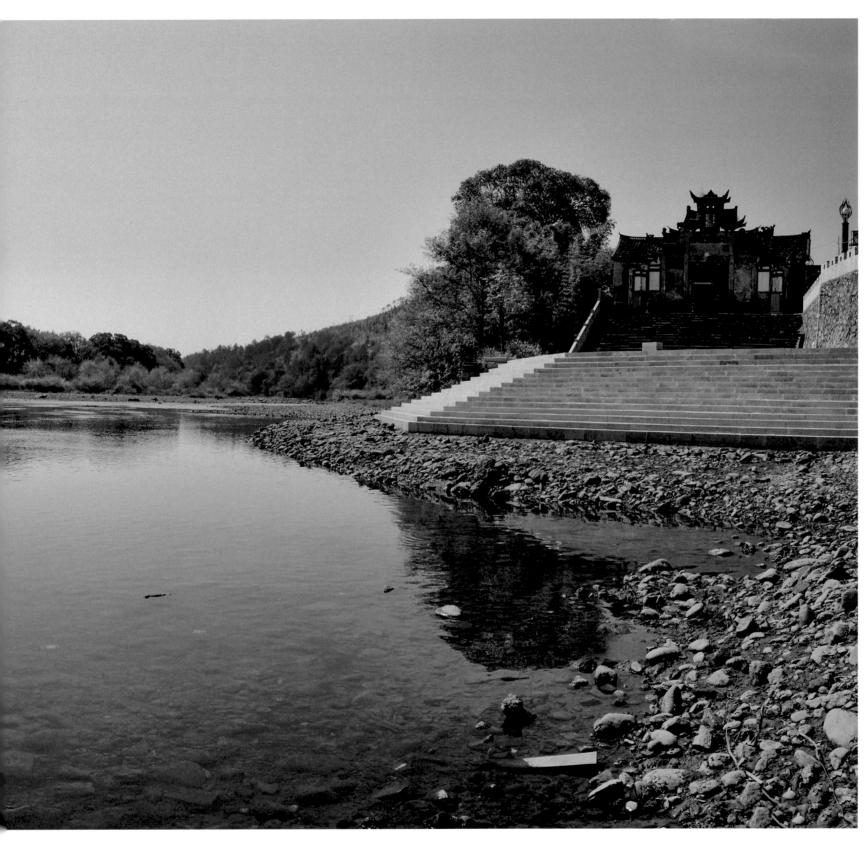

上杭回龙镇天后宫与隔江相望的古码头。
这里曾是汀江繁忙的水上航运点 / 吴军 摄
Tianhou Palace in Huilong Town,
Shanghang and the ancient wharf across the
river. It used to be a busy shipping spot of the
Tingjiang River /Photographed by Wu Jun

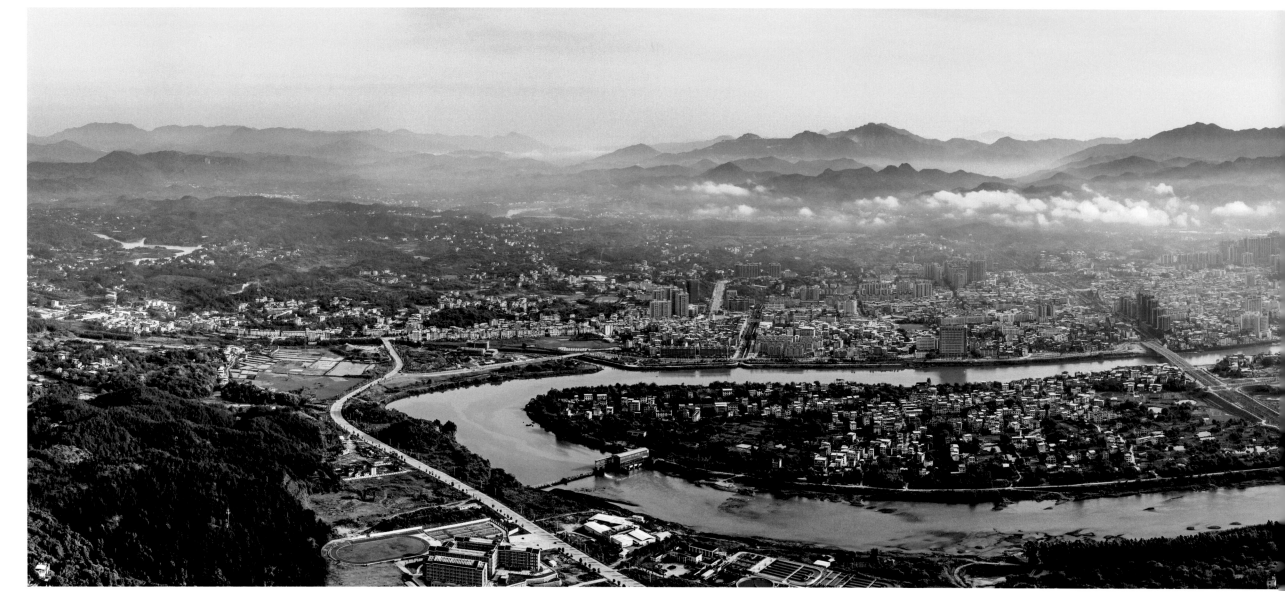

汀江奔腾而来，在上杭县境内蜿蜒回转，穿城而过 / 朱晨辉 严硕 摄
The Tingjiang River is surging forward, winding in Shanghang County and crossing through the city /Photographed by Zhu Chenhui, Yan Shuo

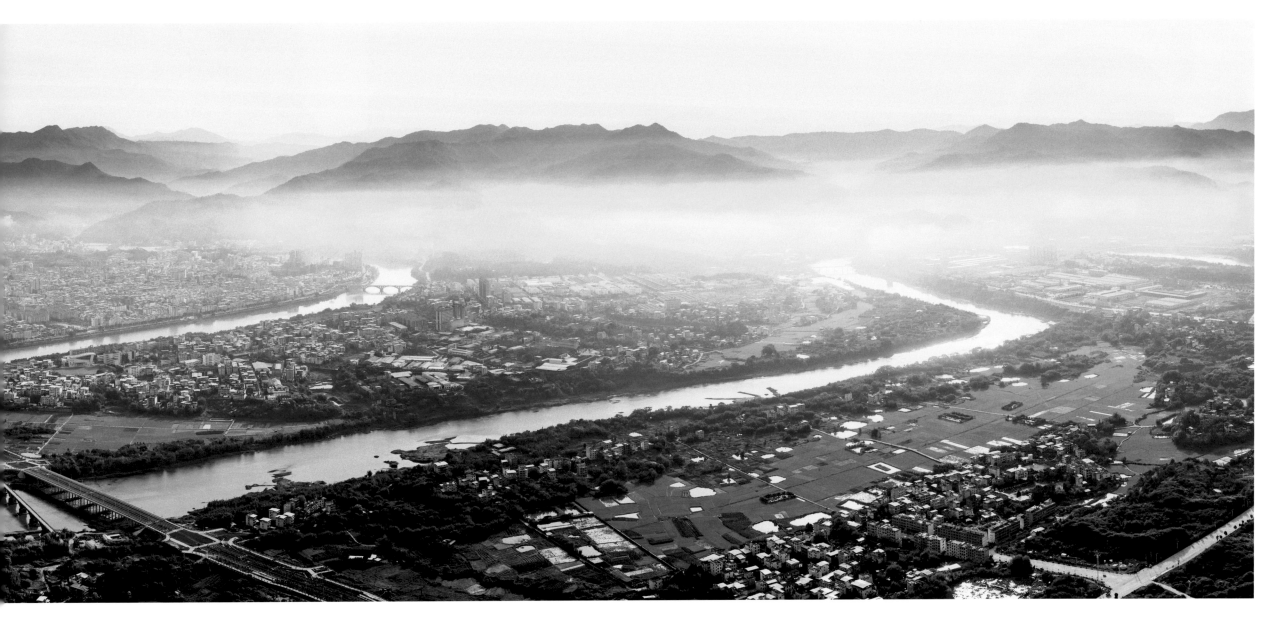

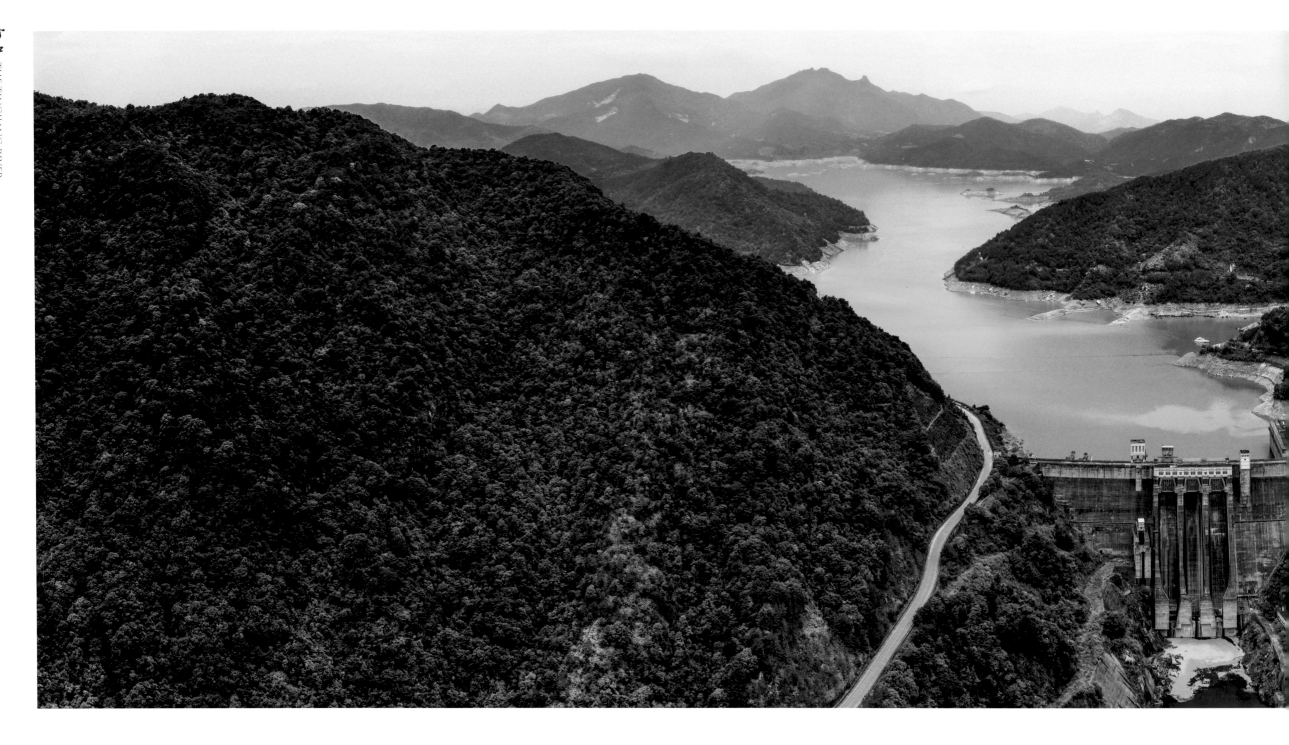

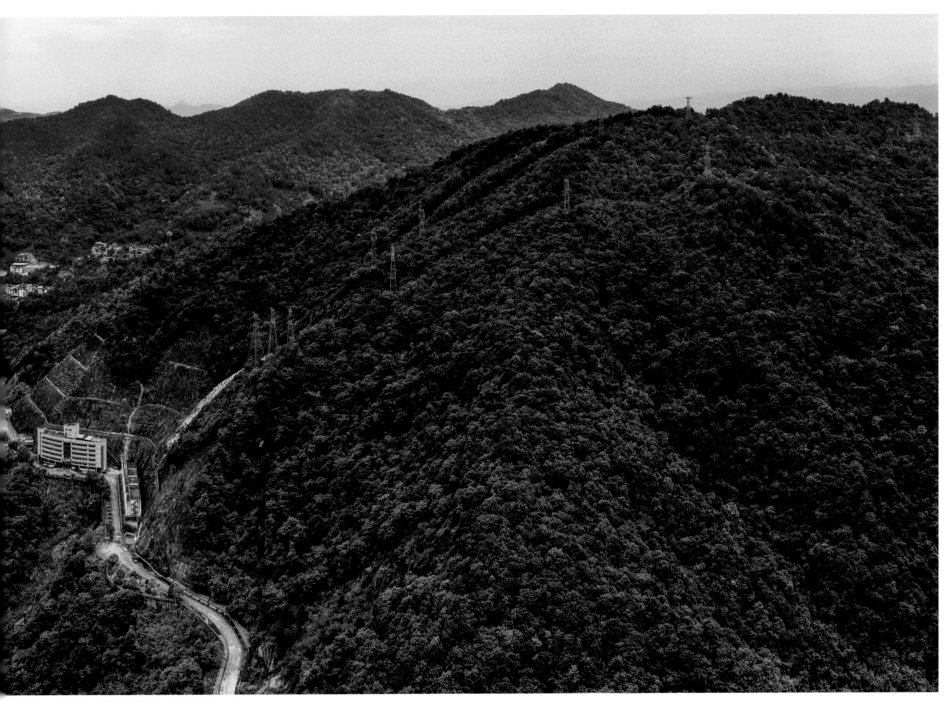

永定区棉花滩水电站，是国家"九五"重点建设项目，总装机容量60万千瓦，年发电量15.2亿千瓦时，坝高115米，水库容量20.35亿立方米。该电站的建成，大大提升了汀江流域的防洪标准 / 朱晨辉 严硕 摄

The Cotton Shoal Hydropower Station in Yongding District is a national key construction project of the Ninth Five-Year Plan, with a total installed capacity of 600,000 kilowatts, an annual power generation capacity of 1.52 billion kwh, a dam height of 115 meters, and a reservoir capacity of 2.035 billion cubic meters. The completion of the hydropower station has greatly improved the flood control standard of the Tingjiang River Basin /Photographed by Zhu Chenhui. Yan Shuo

01　国家地质公园连城冠豸山风景区被誉为"客家神山" ／ 胡文 摄
　　The National Geopark, Liancheng Guanzhai Mountain Scenic Spot is hailed as "Hakka Holy Mountain" /Photographed by Hu Wen

02　俯瞰万安溪、雁石溪交汇处，人们傍水而居，绿树碧水小村交融 ／ 朱晨辉 严硕 摄
　　Overlooking the intersection of Wan'an Stream and Yanshi Stream, people live by the water, with green trees and clear water mingling with the small village /Photographed by Zhu Chenhui, Yan Shuo

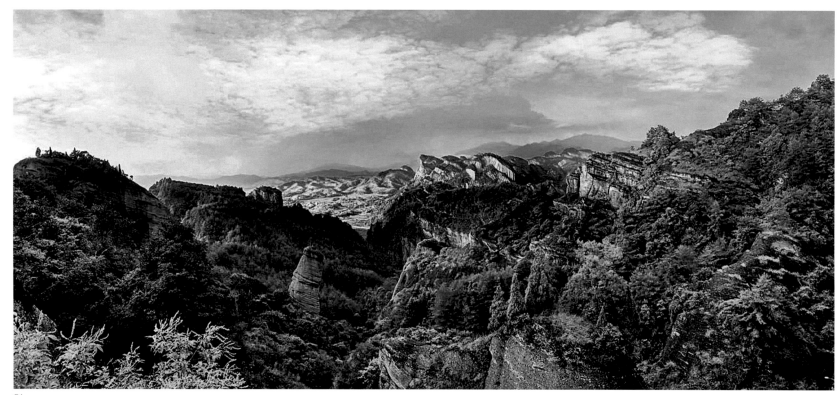

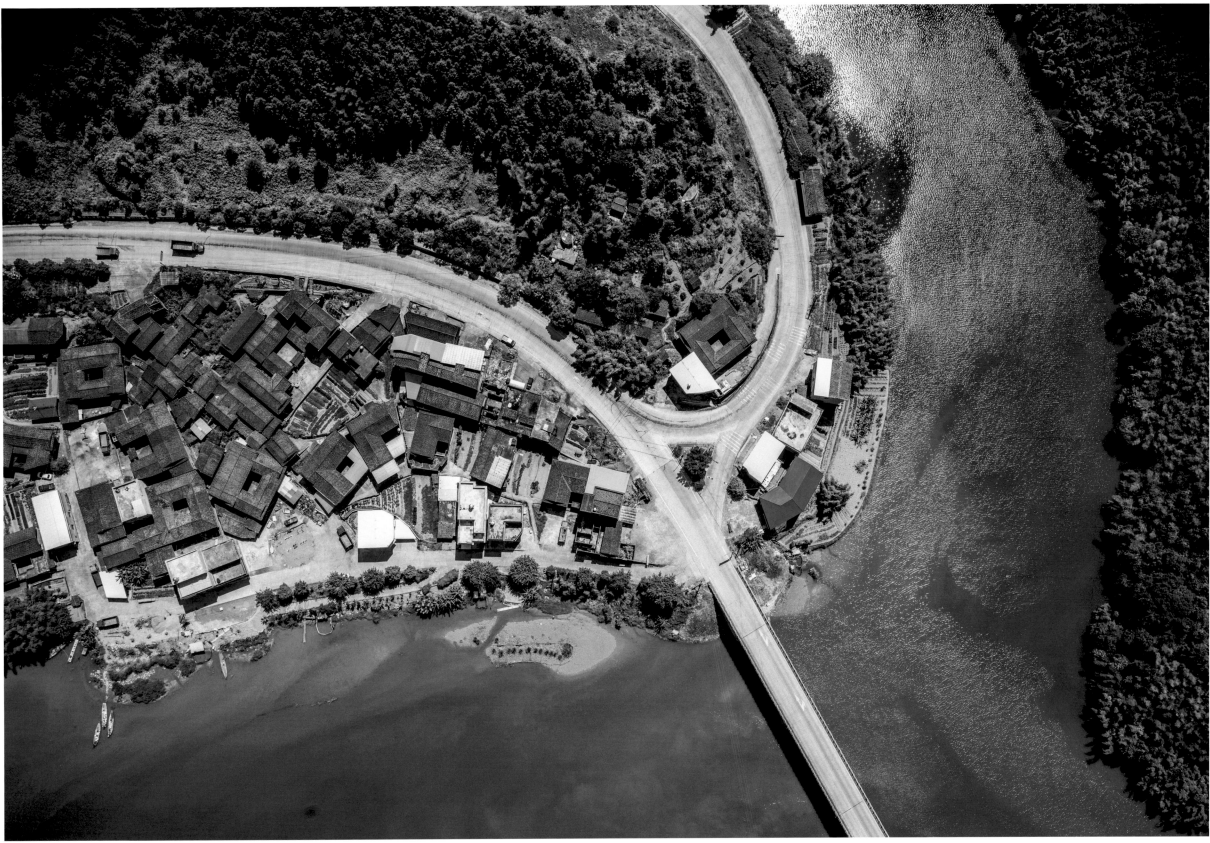

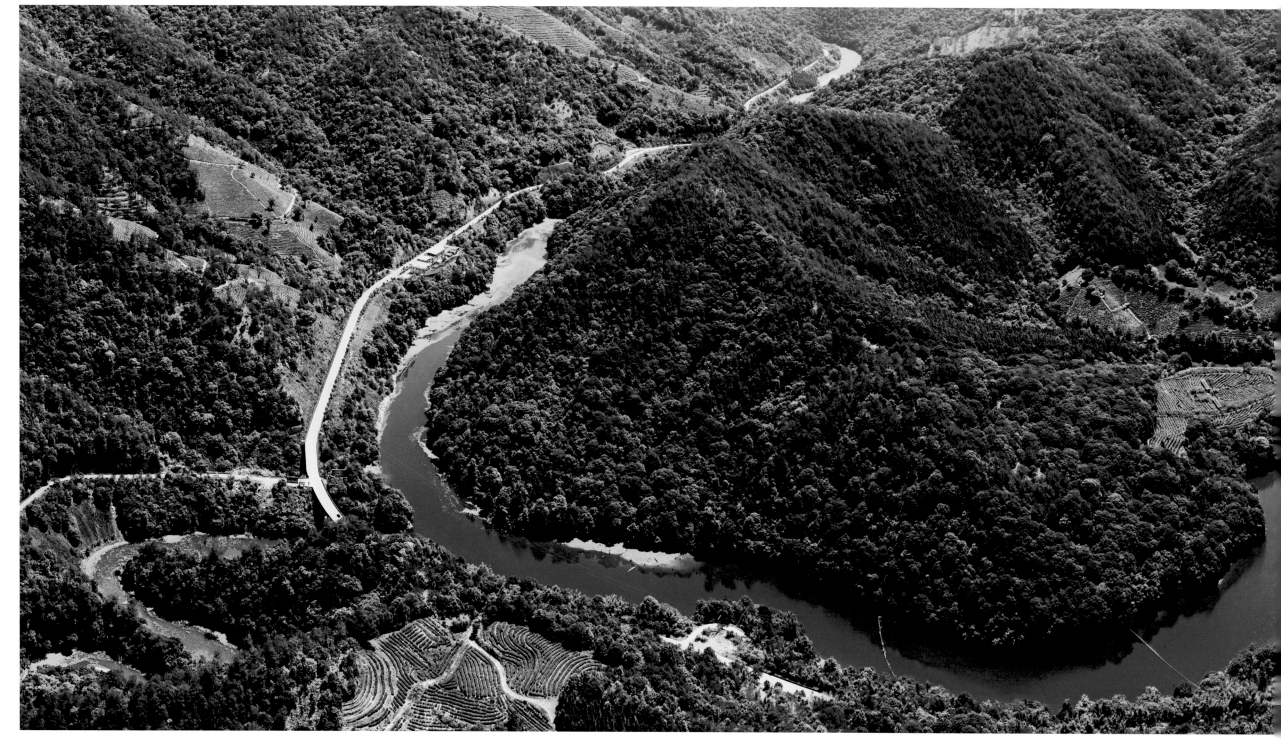

潭平市九龙溪国家森林公园 ／ 朱晨辉 严硕 摄

Jiulongxi National Forest Park in Zhangping City /Photographed by Zhu Chenhui. Yan Shuo

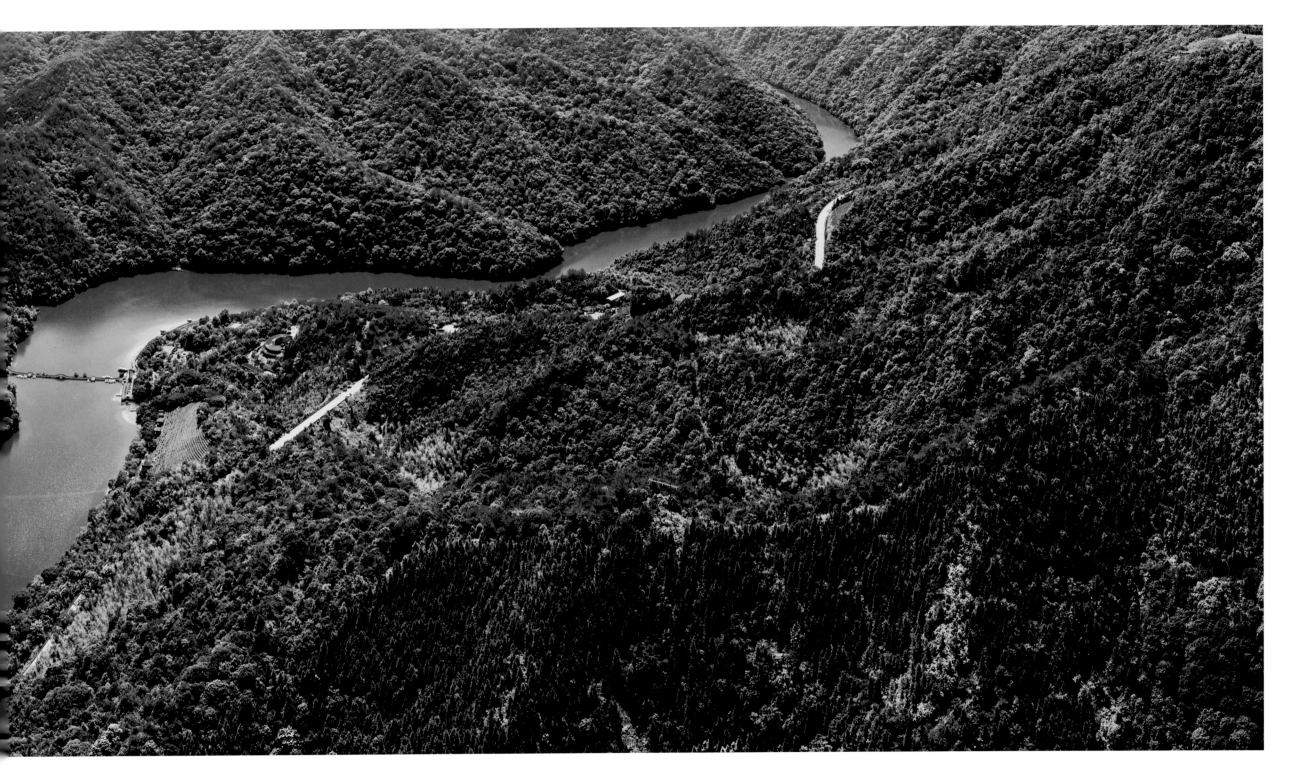

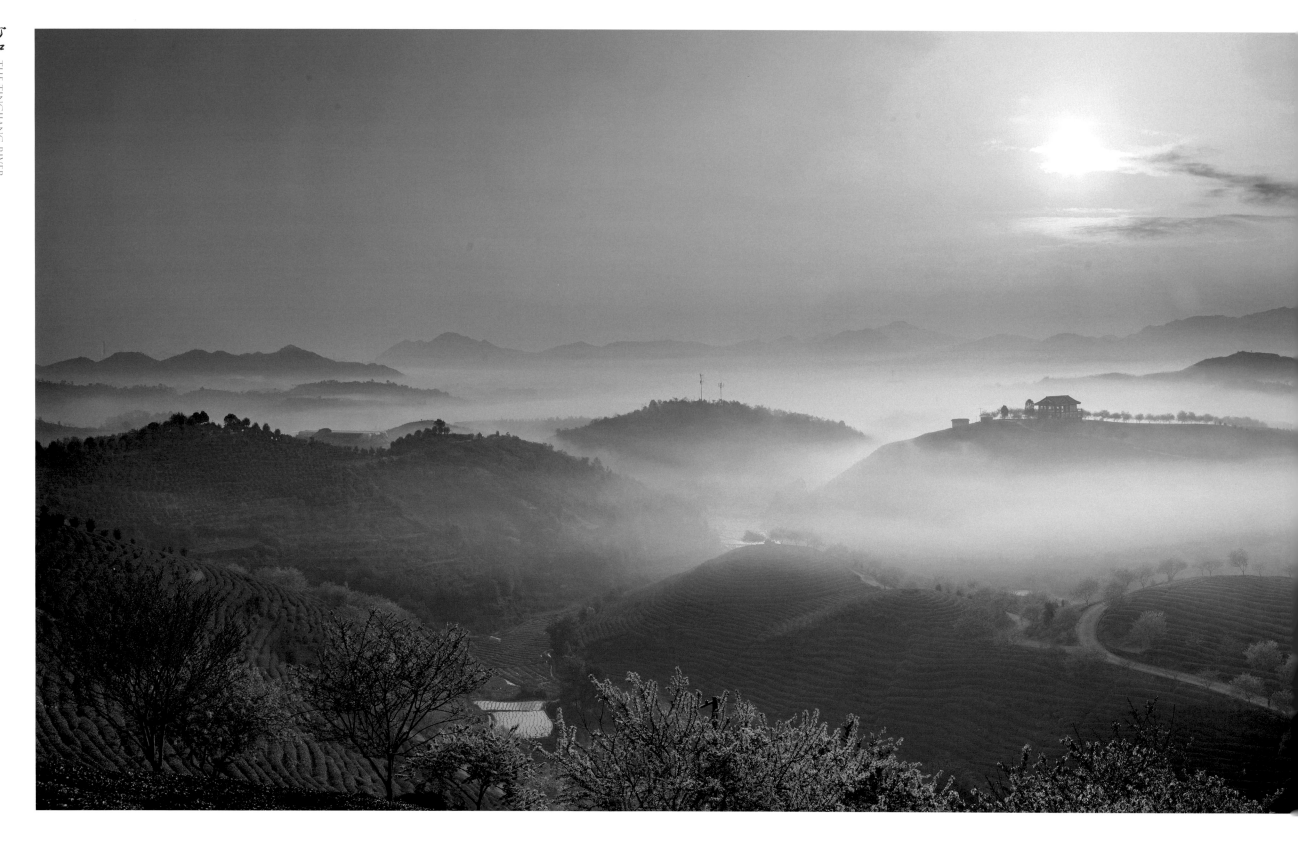

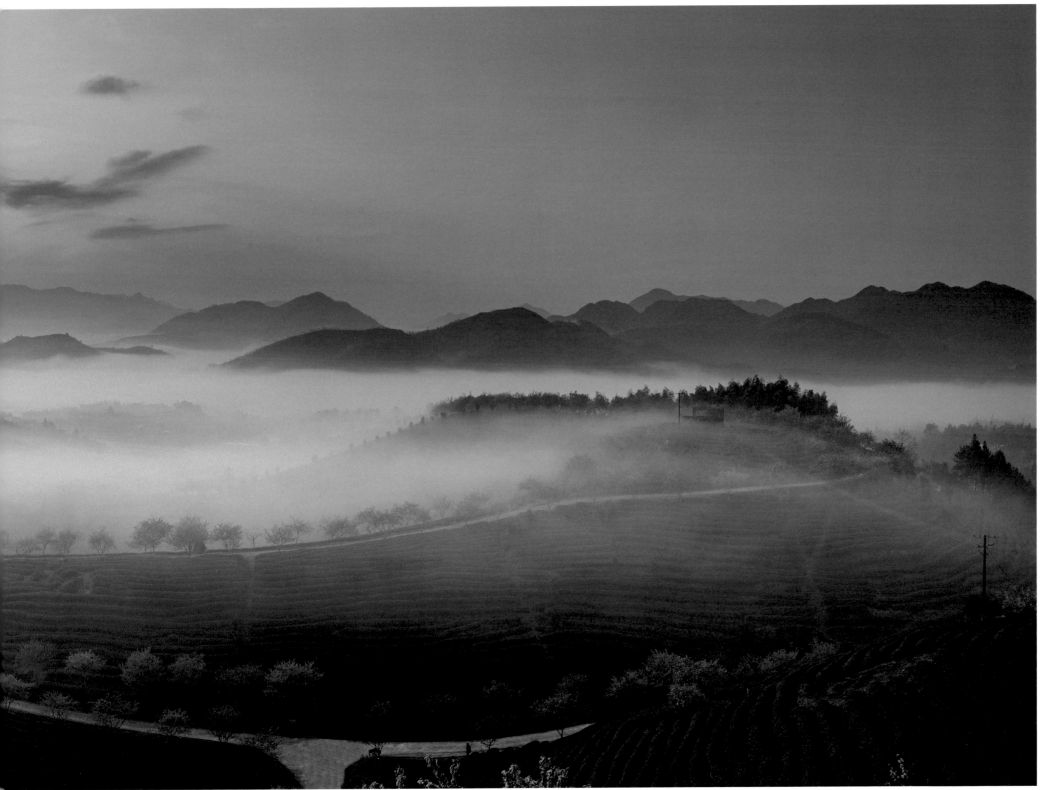

漳平永福高山茶场。四周群山绵延，云雾缭绕，每逢三月樱花盛放时节，花团锦簇，游人如织 / 林长全 摄

Gaoshan Tea Plantation in Yongfu Town, Zhangping City. It is surrounded by rolling mountains and mist-shrouded. Every March is the season of cherry blossoms, and it is full of flowers and tourists /Photographed by Lin Changquan

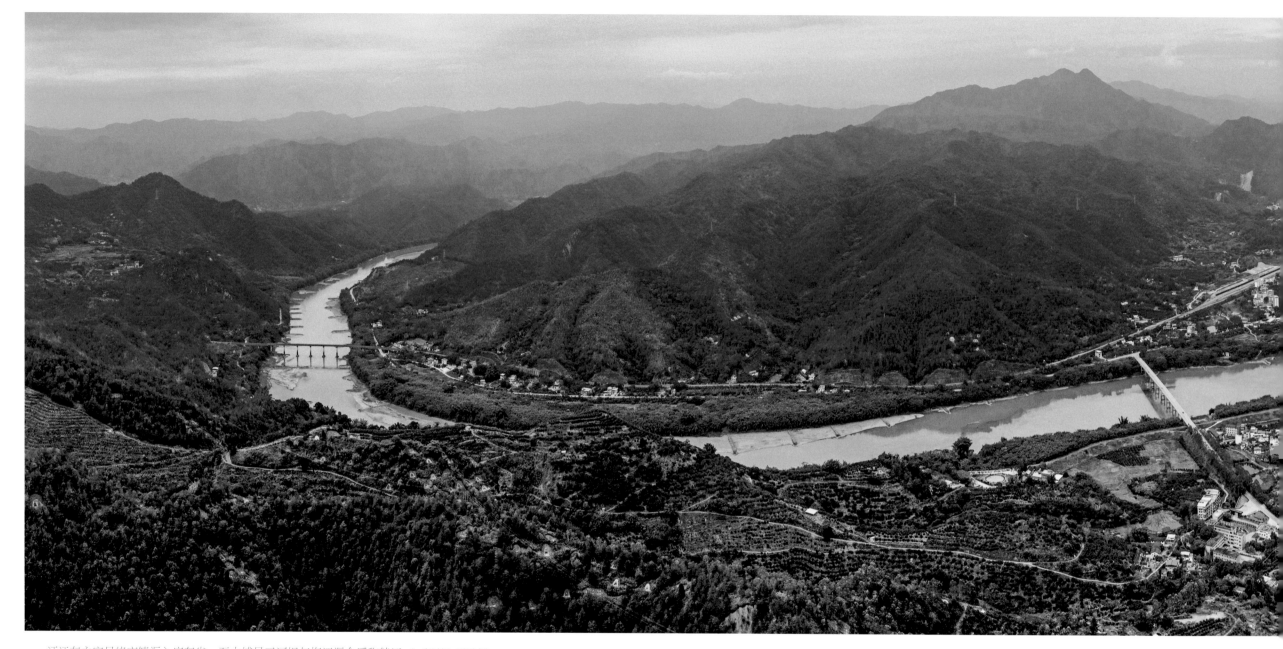

汀江在永定县峰市镇汇入广东省，至大埔县三河坝与梅江汇合后称韩江 / 朱晨辉 严硕 摄

After innumerable twists and turns, the Tingjiang River enters Guangdong Province at Fengshi Town of Yongding County, and is called Hanjiang River after the confluence of the Meijiang River at Sanhe Dam in Dapu County / Photographed by Zhu Chenhui, Yan Shuo

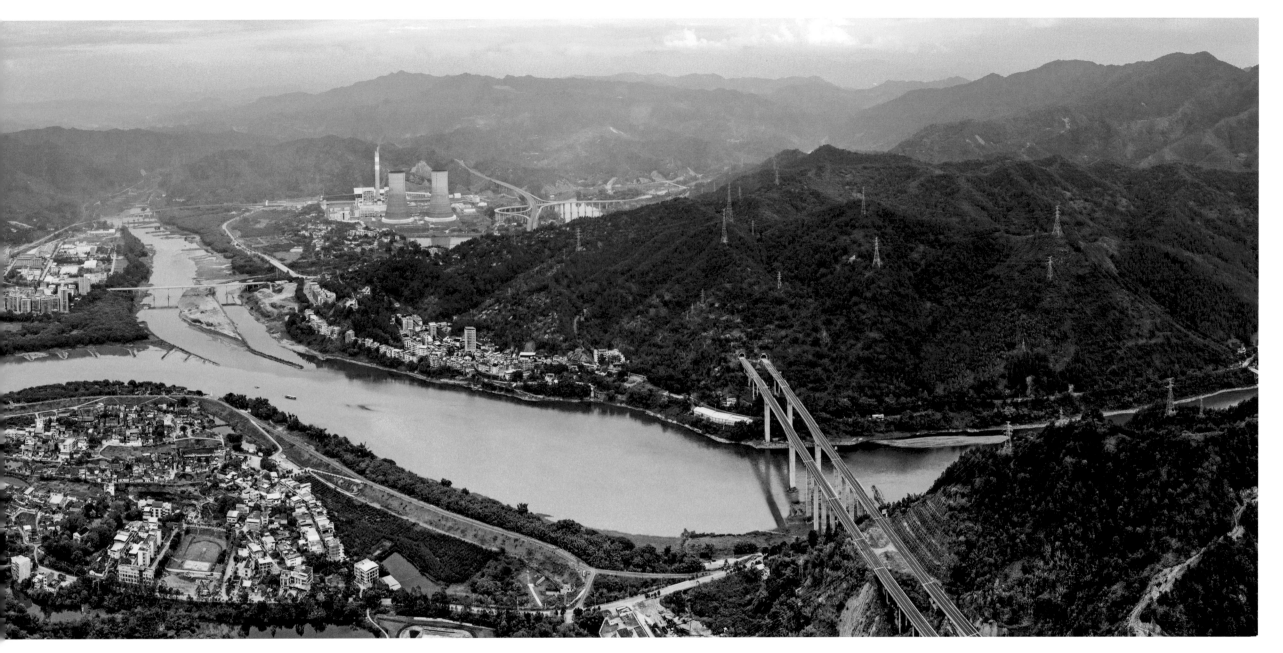

Red Flag
Leaps over
the Tingjiang
River

第一章 红旗跃过汀江

"红旗跃过汀江，直下龙岩上杭。收拾金瓯一片，分田分地真忙。"这是毛泽东《清平乐》词中的下半阕，描写了闽西的革命景象。1929 年 3 月，毛泽东、朱德、陈毅率领的中央红军第四军第一次入闽，击溃福建省防军第二混成旅，歼敌 2000 余人，乘胜解放了汀州城，成立中央苏区第一个红色县级政权。从此，打土豪，分田地，扩大地方赤卫队，建立各级革命政权，开辟与发展了闽西革命根据地。著名的新泉整训、古田会议、南阳会议、汀州整编、后田会议、才溪乡调查等均发生在闽西大地、汀江两岸。闽西，成了中国革命的红色堡垒，成为中央苏区的重要组成部分。如今这里的山水之间，到处留有毛泽东等老一辈无产阶级革命家的足迹。在中国人民解放军发展壮大的历史上、在新中国革命与建设的征程中、在改革开发的大潮里，无不烙下这里的印记。

"The red flag jumps over the Tingjiang River and goes straight to Longyan Shanghang Cleaning up the homeland, it is really busy to divide the fields. "This is the second half of Mao Zedong's. *Qingping Le* and describes the revolutionary scene in Western Fujian. Since March 1929, the Fourth Army of the Central Red Army led by Mao Zedong, Zhu De, and Chen Yi entered Fujian for the first time, defeated the second mixed brigade of the Fujian Provincial Defense Forces, killed more than 2,000 people and liberated Tingzhou. The city established the first red county-level regime in the Central Soviet Area. Since then, he has played local tyrants, divided fields, expanded local Red Guards, established revolutionary regimes at all levels, and opened up and developed the revolutionary base areas in Western Fujian. The famous Xinquan Training, Gutian Conference, Nanyang Conference, Tingzhou Reorganization, Houtian Conference, and Caixi Township Investigation all took place on Western Fujian and the banks of the Tingjiang rivers. West Fujian has become a red fortress of the Chinese revolution and has become an important part of the Central Soviet Area. Today, between the mountains and rivers, Mao Zedong and other older generations of proletarian revolutionaries have left their footprints everywhere. The Tingjiang was imprinted in the history of the Chinese People's Liberation Army developing, in the journey of Chinese revolution and construction, and in the trend of reform and opening up.

Light
of
Gutian

古田之光

1929 年 12 月 28 日至 29 日，120 多位红四军代表聚集在上杭县古田镇廖氏宗祠，举行中国共产党红军第四军第九次代表大会——史称"古田会议"。会场中间数堆熊熊炭火，驱散闽西的寒冷。会议先听取毛泽东、朱德、陈毅的报告，展开了热烈讨论，确立了人民军队建设的基本原则：即党指挥枪，重申了党对红军绝对领导，规定了红军的性质、宗旨和任务等根本性问题。会议通过了毛泽东起草的《中国共产党红军第四军第九次代表大会决议案》，即著名的《古田会议决议案》。

围绕着古田会议会址，近年古田修缮了一批革命文物、新建与开放了一批红色旅游景点，包括毛泽东才溪乡调查纪念馆等。如今的古田会议会址，已与闽西的许多红色景点连成一片。

From December 28th to 29th, 1929, more than 120 representatives of the Fourth Red Army gathered at Liao's ancestral hall in Gutian Town, Shanghang County to hold the Ninth Congress of the 4th Red Army of the Communist Party of China, historically known as "Gutian Conference". In the middle of the venue, a number of burning charcoal fires dispersed the cold in Western Fujian. First of all, the meeting heard the reports of Mao Zedong, Zhu De and Chen Yi, launched a heated discussion, and established the basic principles of the construction of the People's Army, i.e. the Party commands guns, not guns to command the Party. The absolute leadership of the Party over the Red Army was reiterated. The fundamental issues of the nature, purpose and task of the Red Army were stipulated. The Conference adopted *The Resolution of the Ninth Congress of the Fourth Red Army of the Communist Party of China* drafted by Mao Zedong, namely the famous *Resolution of the Gutian Conference*.

Around the old site of Gutian Conference, a number of revolutionary cultural relics and scenic spots have been renovated, newly built and opened in recent years, including Mao Zedong Caixi Township Investigation Memorial Hall, etc. Today, the site of Gutian Conference has been linked with many red scenic spots in Western Fujian.

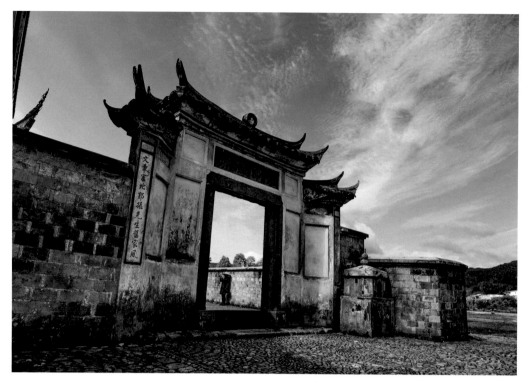

古田会议会址原为"廖氏宗祠"，始建于清道光年间 / 那兴海 摄
The site of the Gutian Congress was originally "The Ancestral Hall of Liao Family", which was built in the Daoguang period of the Qing Dynasty /Photographed by Na Xinghai

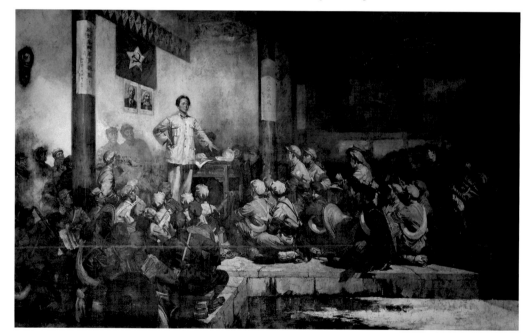

古田会议纪念馆内的《古田会议》巨幅油画再现了那个重要历史时刻 / 赖小兵 摄
The giant oil painting of *The Gutian Congress* in the Gutian Congress Memorial Hall reappears the important historical moment of the Gutian Congress /Photographed by Lai Xiaobing

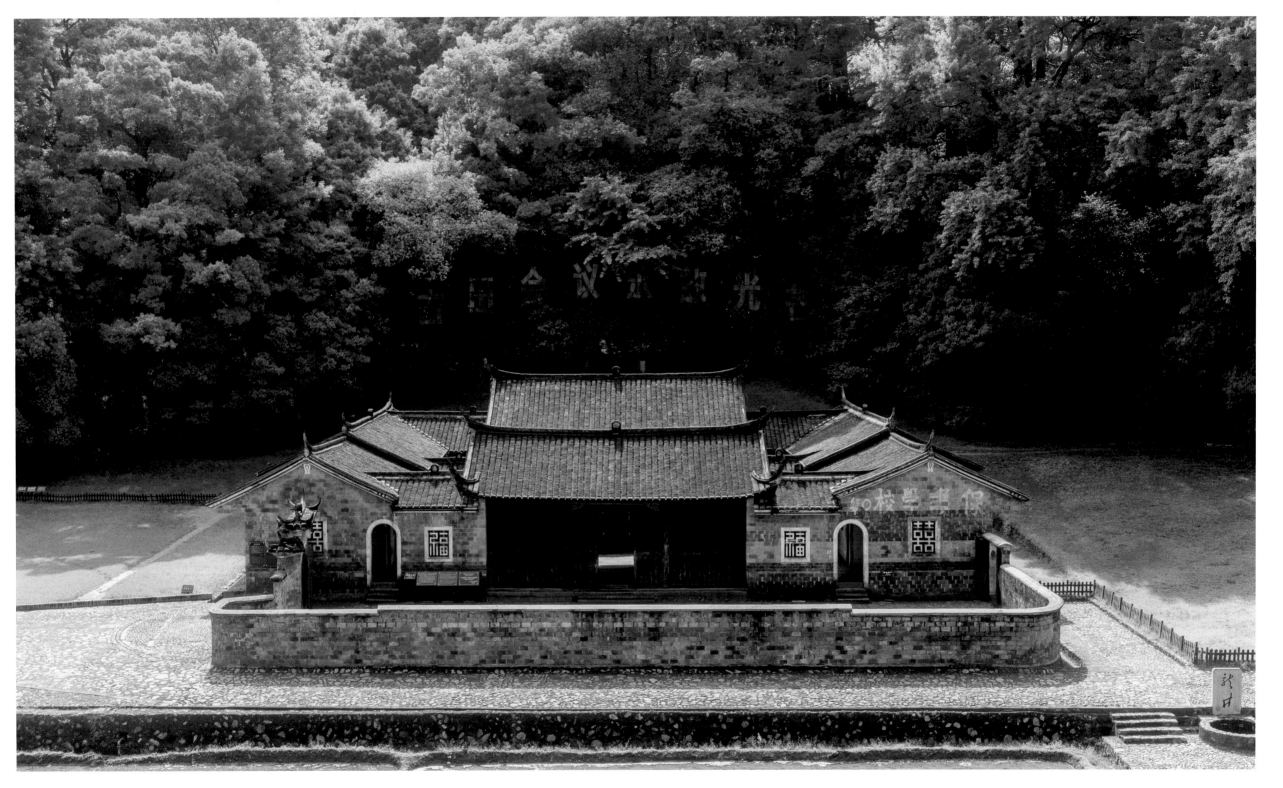

1929 年 12 月，毛泽东同志主持的红四军第九次代表大会在占田镇廖氏宗祠召开，通过了具有历史意义的《古田会议决议案》 / 宋晨辉 严硕 摄
In December 1929, the 9th Party Congress of the 4th Army of the Chinese Workers' and Peasants' Red Army, presided by Comrade Mao Zedong, was held in Gutian Liao Family's Ancestral Hall and the proposal with historic significance at the Gutian Congress was adopted /Photographed by Zhu Chenhui. Yan Shuo

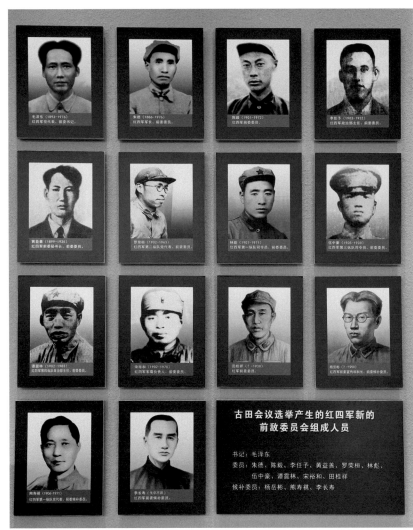

01

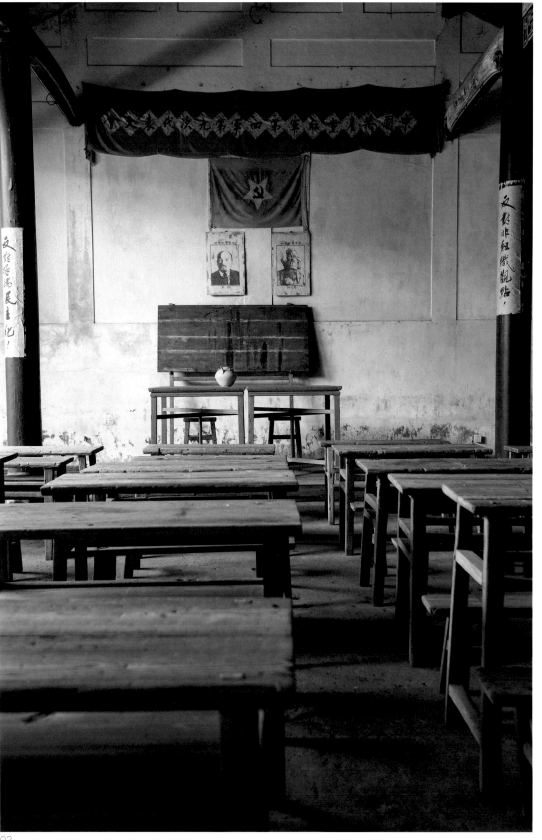

01 古田会议选举产生的红四军新的前敌委员会 / 赖小兵 摄

The new party's committee in front of enemy of the 4th Red Army elected by the Gutian Congress /Photographed by Lai Xiaobing

02 古田会议是我党我军历史上的一个里程碑，体现了党在理论和实践上的创新，是留给后人珍贵的精神财富 / 赖小兵 摄

The Gutian Congress is a milestone in the history of our Party and our army, which embodies the Party's innovation in theory and practice and is a precious spiritual wealth for future generations /Photographed by Lai Xiaobing

03 古田会议纪念馆 / 姜克红 摄

The Gutian Congress Memorial Hall /Photographed by Jiang Kehong

02

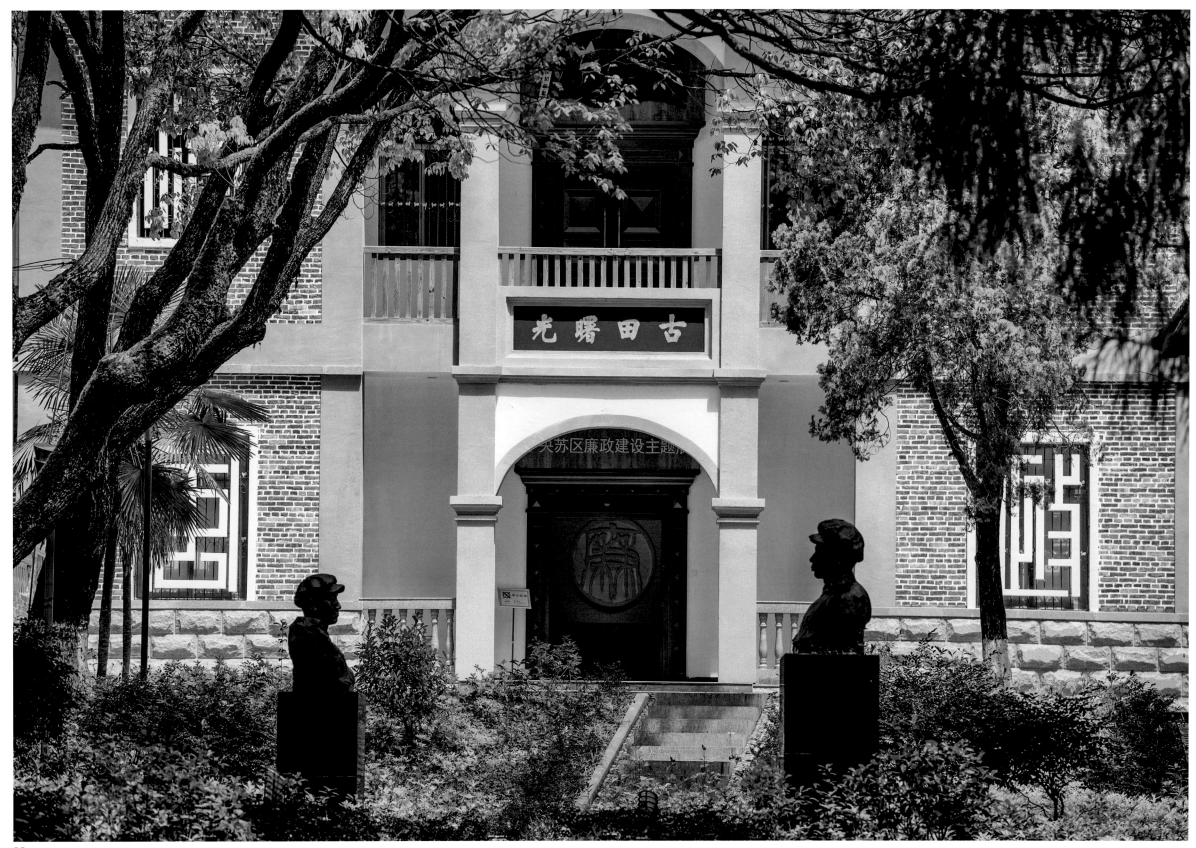

01　　　古田毛主席纪念园已成为后人瞻仰缅怀毛主席
丰功伟绩的革命圣地 / 陈扬富 摄
　　　The Memorial Garden of Chairman Mao in
Gutian has become a revolutionary holy place
for future generations to pay tribute to Chairman
Mao's tremendous achievements /Photographed by
Chen Yangfu

02　　　古田毛主席纪念园位于古田会议会址后山右
侧，这里松竹茂盛，群山环抱 / 朱晨辉 严硕 摄
　　　The Memorial Garden of Chairman Mao in
Gutian is located on the right side of the mountain
behind the site of the Gutian Congress, where
pines and bamboos are flourishing, surrounded by
mountains /Photographed by Zhu Chenhui, Yan Shuo

01

02

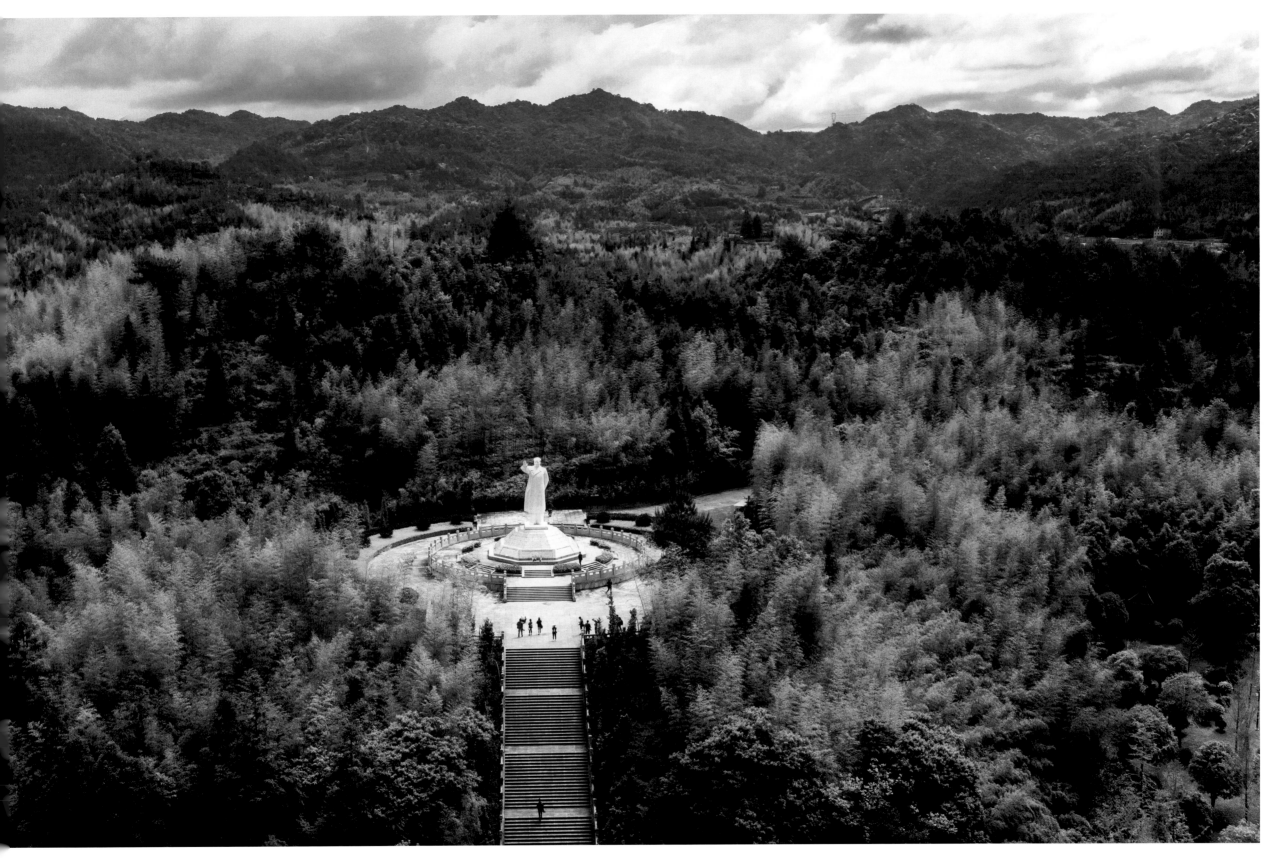

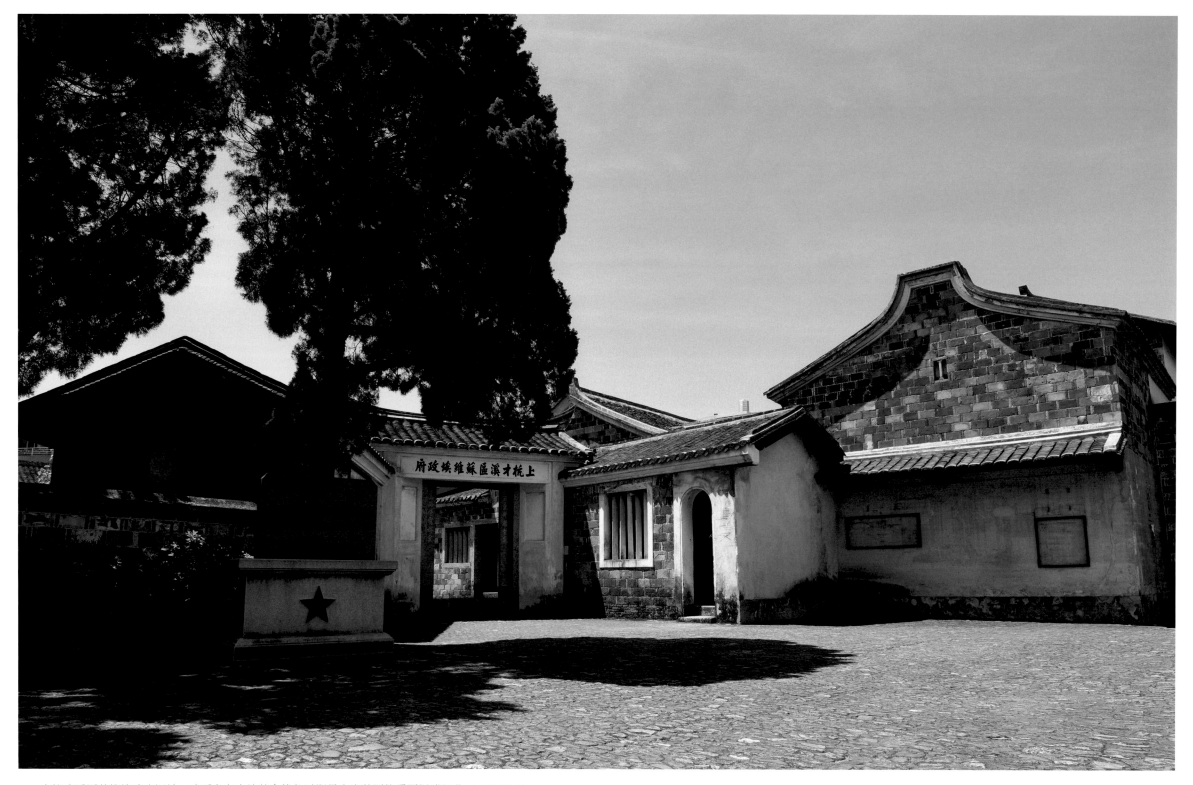

上杭才溪区苏维埃政府旧址。才溪乡在土地革命战争时期是中央苏区的重要组成部分 / 焦红辉 摄

The former site of the Soviet Government in Caixi Area, Shanghang. Caixi Township was an important part of the
Central Soviet Area during the Agrarian Revolutionary War /Photographed by Jiao Honghui

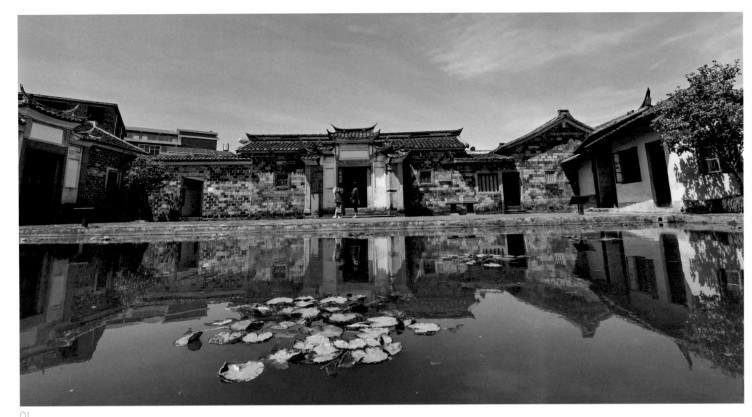

01

02

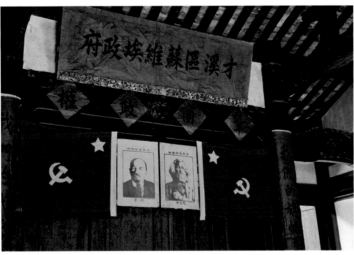

03

01 　　才溪区苏维埃政府旧址是典型的客家民居。1930 年 6 月，才溪区苏维埃政府在此办公 ／ 关建东 摄

The former site of the Soviet Government in Caixi Area is a typical Hakka residential house. In June 1930, the Soviet government in Caixi Area worked here /Photographed by Guan Jiandong

02 　　毛泽东同志当年坚持 "没有调查就没有发言权"，三赴才溪从事革命实践，并写下著名的《才溪乡调查》。这是毛泽东同志在土地革命时期的一次重要调查，为建立农村革命根据地提供了宝贵的经验 ／ 赖小兵 摄

Comrade Mao Zedong insisted that "No investigation, no right to speak" in that year, went to Caixi Township three times to engage in revolutionary practice, and wrote the famous article *Investigation on Caixi Township*. This is an important investigation conducted by Comrade Mao Zedong during the Agrarian Revolution, which provides valuable experience for the establishment of rural revolutionary bases /Photographed by Lai Xiaobing

03 　　列宁堂原为才溪区工会办公地点，1930 年，才溪区工会为纪念列宁诞辰 60 周年更名为列宁堂 ／ 赖小兵 摄

Lenin Hall was the office of the Laber Union in Caixi Area. In 1930, the Labor Union in Caixi Area changed its name to Lenin Hall to commemorate the 60th anniversary of Lenin's birth /Photographed by Lai Xiaobing

01 才溪乡调查纪念馆是毛泽东在才溪重要革命实践的专题纪念馆 / 赖小兵 摄

The Investigation Memorial Hall of Caixi Township is a thematic memorial hall for Mao Zedong's important revolutionary practice in Caixi /Photographed by Lai Xiaobing

02 才溪乡调查纪念馆内景 / 赖小兵 摄

Interior view of the Investigation Memorial Hall of Caixi Township /Photographed by Lai Xiaobing

03 才溪光荣亭是 1933 年春，由福建省苏维埃政府为表彰才溪人民的光荣业绩而建的。1955 年，毛泽东同志亲笔题写了 "光荣亭" 三个大字。毛泽东同志为亭题词在全国唯有两处，另一处是湖南的爱晚亭 / 焦红辉 摄

Guangrong Pavilion of Caixi Township was built in the spring of 1933 by the Soviet Government of Fujian Province in recognition of the glorious achievements of the Caixi people. In 1955, Comrade Mao Zedong wrote the inscription for "Guangrong Pavilion (光 荣 亭)" in his own handwriting. Comrade Mao Zedong only wrote inscriptions for pavilions in two places throughout the country, the other is the Aiwan Pavilion in Hunan Province /Photographed by Jiao Honghui

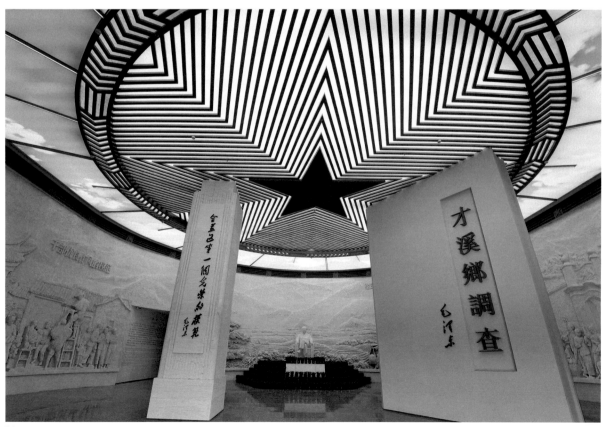

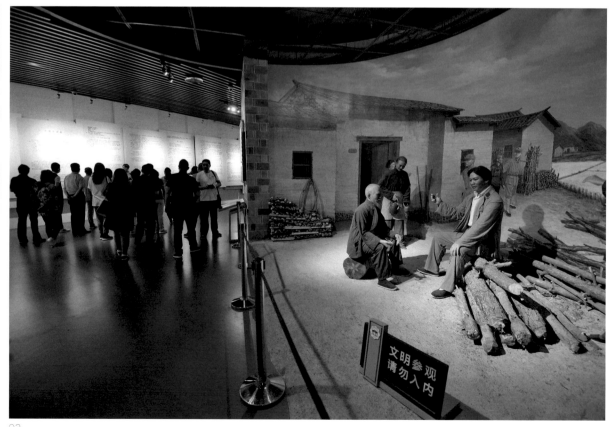

03

01 红四军司令部旧址位于古田八甲村中兴堂，1929 年 12 月，毛泽东、朱德、陈毅率领红四军进驻古田，曾在此入住 / 赖小兵 摄

The former site of the headquarters of the 4th Red Army is located in Zhongxing Hall, in Bajia Village, Gutian. In December 1929, Mao Zedong, Zhu De and Chen Yi led the 4th Red Army to garrison in Gutian, where they once lived /Photographed by Lai Xiaobing

02 红四军进驻古田八甲村中兴堂后，曾在此召开各级党代表联席会议 / 赖小兵 摄

After garrisoning Zhongxing Hall in Gutian, the 4th Red Army once convened joint meetings of party representatives at all levels / Photographed by Lai Xiaobing

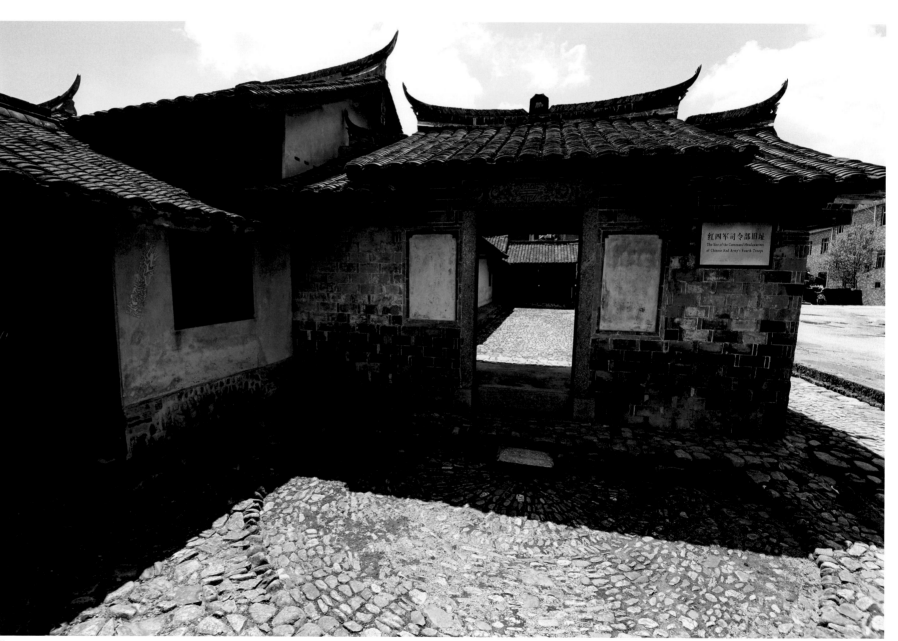

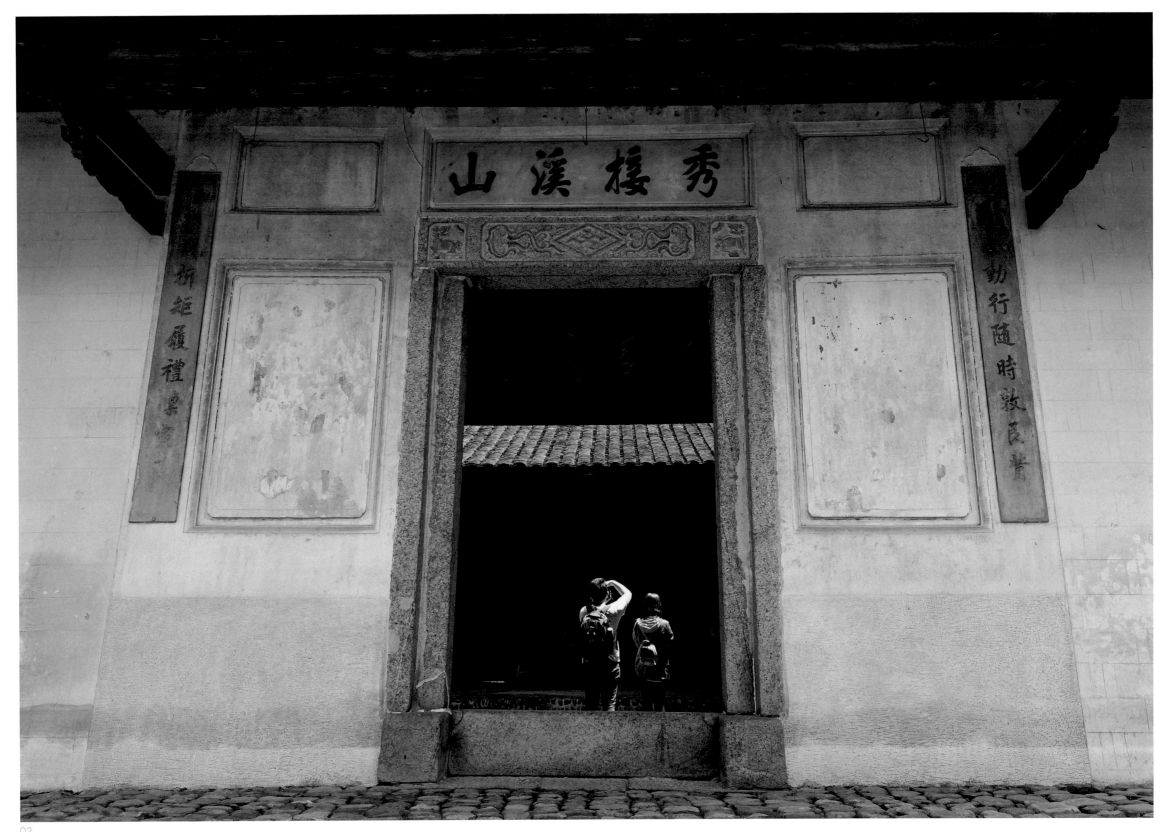

02

01　登上临江楼，推窗而望，汀江烟波荡漾，1929 年 10 月重阳节前夜，毛泽东同志曾在此居住 / 吴军 摄

Climbing up the Linjiang Tower and looking out of the window, the Tingjiang River is full of mist and ripples. In October 1929, Comrade Mao Zedong once lived here on the eve of the Double Ninth Festival /Photographed by Wu Jun

02　蜿蜒的汀江穿城而过，在百年老榕树的映衬下，这栋三层小楼临江而立

The winding Tingjiang River passes through the city. Against the backdrop of the hundred-year-old banyan tree, this three-story small building stands by the river

03　汀江畔，临江楼前，毛泽东同志于朱德同志曾在此对弈谈心 / 吴寿华 摄

At the bank of the Tingjiang River, in front of the Lianjiang Tower, Comrade Mao Zedong and Comrade Zhu De once played chess and had a heart-to-heart chat here /Photographed by Wu Shouhua

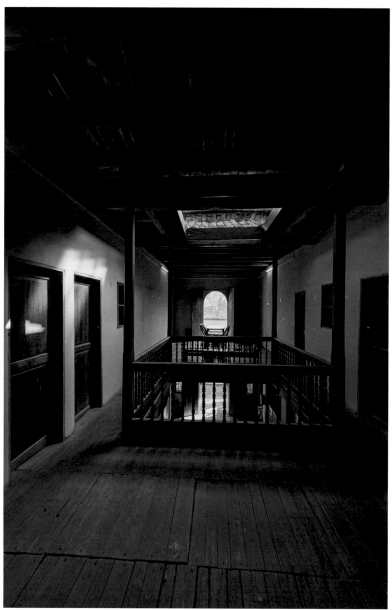

01

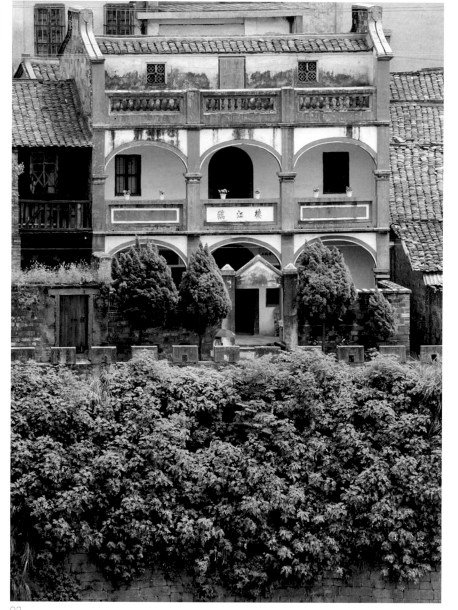

02

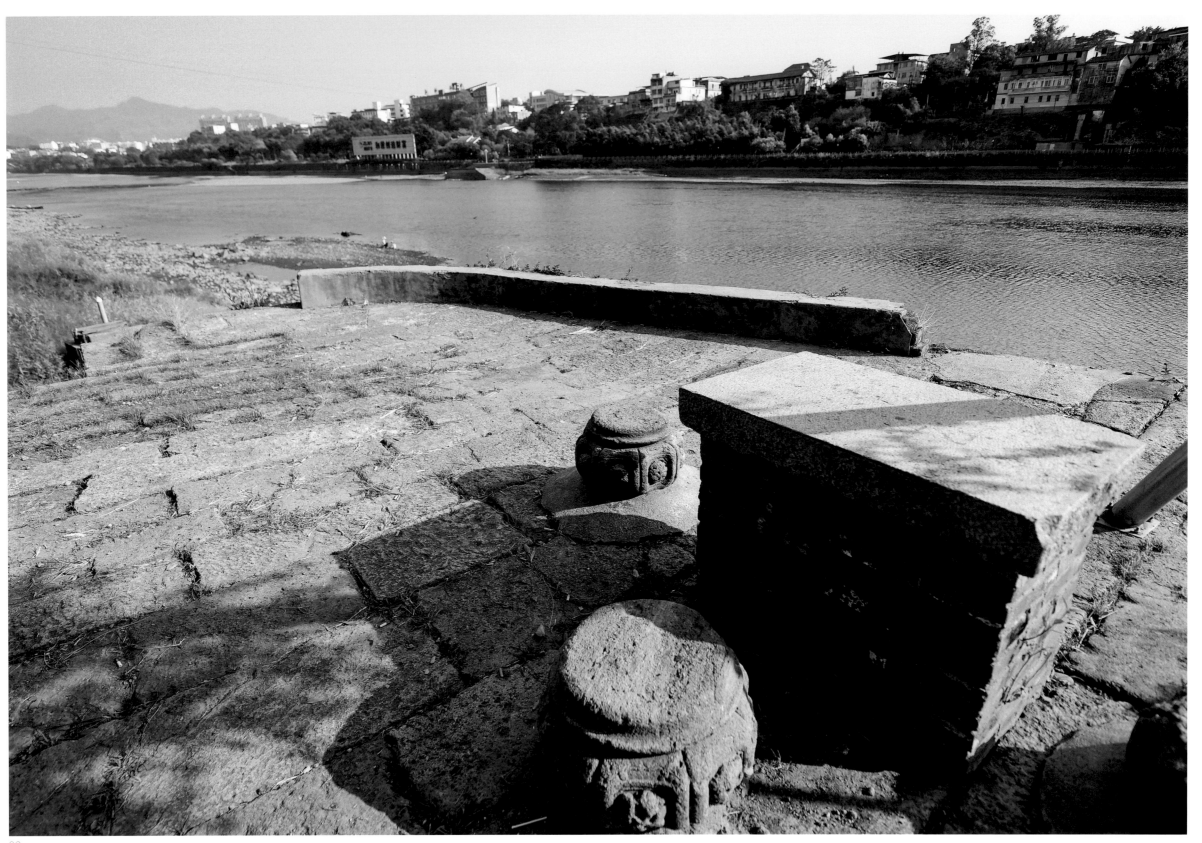

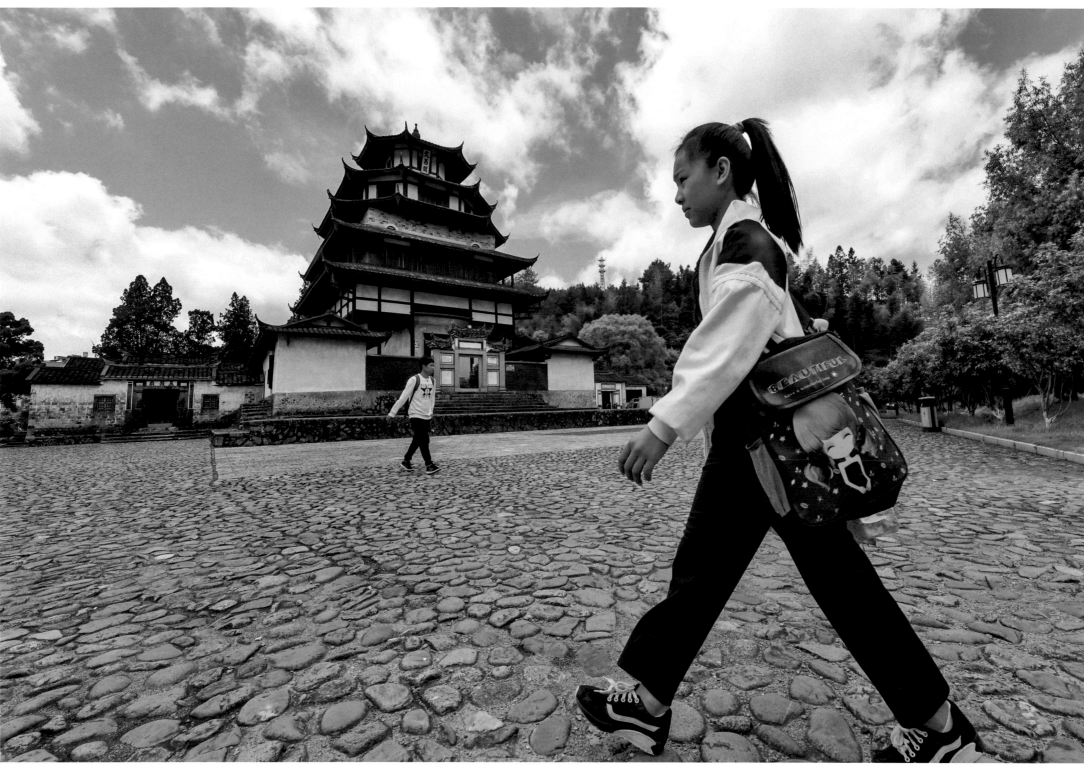

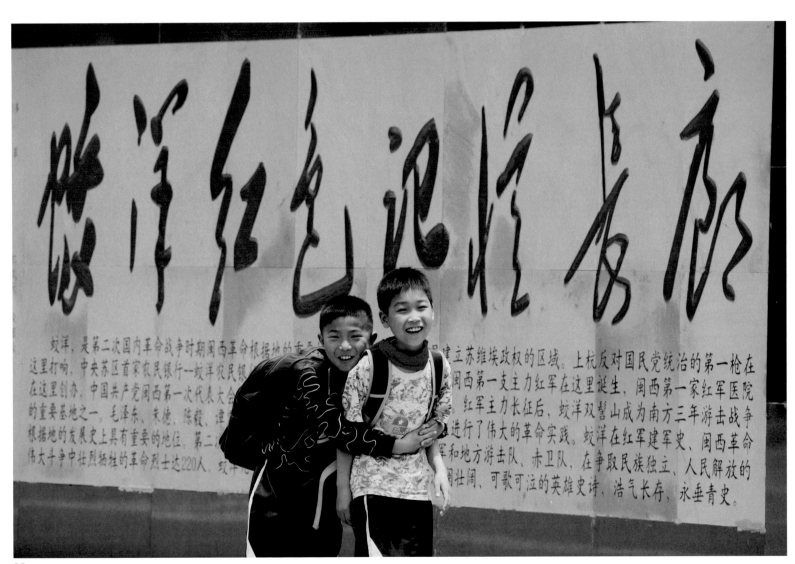

02

01　文昌阁外观六层，实为四层。一至三层分别安奉了孔子、文昌帝君、文魁星的神像，顶层为伞状悬柱结构。据说，蛟洋自从建了文昌阁后，文运亨通，才士辈出。1929年7月中旬毛泽东同贺子珍、蔡协民、江华、曾志等人前往上杭蛟洋文昌阁指导召开了中共闽西第一次代表大会，大会通过了毛泽东亲自修改的政治决议案。大会之后，闽西各地认真贯彻"闽西一大"，呈现出一派"收拾金瓯一片，分田分地真忙"的喜人景象 / 福建楠 摄

Wenchang Pavilion has six floors in appearance, actually four. From the first to the third floor, the statues of Confucius, Emperor Wenchang and Wenkuixing were enshrined respectively, and the top floor is an umbrella-shaped suspended column structure. It is said that after the establishment of the Wenchang Pavilion, Jiaoyang has been prosperous in culture as expected and a large number of talented people came out in succession. In mid-July, 1929, Mao Zedong, together with He Zizhen, Cai Xiemin, Jiang Hua, Zeng Zhi and others, went to Wenchang Pavilion of Jiaoyang in Shanghang to guide and convene the First Congress of the Communist Party of China in Western Fujian, and the political resolution revised by Mao Zedong himself was adopted at the congress. After the congress, all parts of Western Fujian conscientiously implemented the "the First Congress of the Communist Party of China in Western Fujian", presenting a happy scene of "carrying out the land reform and distributing lands busily" /Photographed by Cui Jiannan

02　蛟洋红色文化长廊记载着革命先辈的抗争历史、镌刻着蛟洋人民在红色年代的奋斗历程。长廊与文昌阁交相辉映，成为蛟洋红色文化一道新的风景线

Jiaoyang Red Culture Corridor records the struggle history of revolutionary ancestors and engraves the struggle course of the Jiaoyang people in the red age. The corridor and Wenchang Pavilion add radiance and beauty to each other, becoming a new landscape of Jiaoyang Red Culture

Changting
Ancient
Well

长汀古井

长汀建立红色苏区时，是闽西革命的中心。在这里，成立了中央苏区第一个红色政权，召开了福建省第一次苏维埃代表大会，正式宣告成立福建省苏维埃政府；傅连暲的福音医院，成了中国工农红军第一家正规医院，毛泽东曾在此治病，与门前的那口古井结下了渊源。同时红军第一次在长汀统一了军装，第一次在长汀发放了军饷，中央苏区第一批国有企业——中华贸易公司、中华纸业贸易公司、红军斗笠厂、红军被服厂等在长汀成立。现在走在长汀的大街小巷，随时都可能与这些革命旧址相遇。1934年9月，松毛岭战役失利之后，在中复村观寿公祠堂门前大草坪上，红九军团举行庄严的告别大会，开始了战略大转移，踏上了漫漫的长征之路。红军主力走了，瞿秋白不幸被捕，单独关押、审讯。瞿秋白利用方寸之间的"自由"，在室内写字、读书，在庭院里思考、行走，在留下《多余的话》之后，从容就义。

When Changting established the Red Soviet Area, it was the center of the revolution in Western Fujian. Here, the first Red Regime of the Central Soviet Area was established, the first Soviet Congress of Fujian Province was held, and the Soviet Government of Fujian Province was officially proclaimed. Fu Lianzhang's Gospel Hospital became the first regular hospital of the Red Army of Workers and Peasants in China, where Mao Zedong had recovered from illness and began to have a connection with the ancient well in front of its gate. At the same time, for the first time, the Red Army unified its military uniforms and paid military salaries in Changting. The first batch of state-owned enterprises of the Central Soviet Area, such as China Trading Company, China Paper Trade Company, Douli Factory of the Red Army and Red Army Bedding Factory, were established in Changting. When you walk along the streets and lanes of Changting now, it is possible to meet these old revolutionary sites at any time. In September 1934, after the defeat of the Songmaoling Campaign, on the lawn in front of Guanshou Temple in Zhongfu Village, the Ninth Red Army held a solemn farewell meeting, started a strategic shift and embarked on a long march. When the main force of the Red Army left, Qu Qiubai was unfortunately arrested, detained and interrogated alone. Qu Qiubai hardly had "freedom" to read and write in the room, and think and walk in the courtyard. After leaving *The Superfluous Words*, he died a martyr fearlessly.

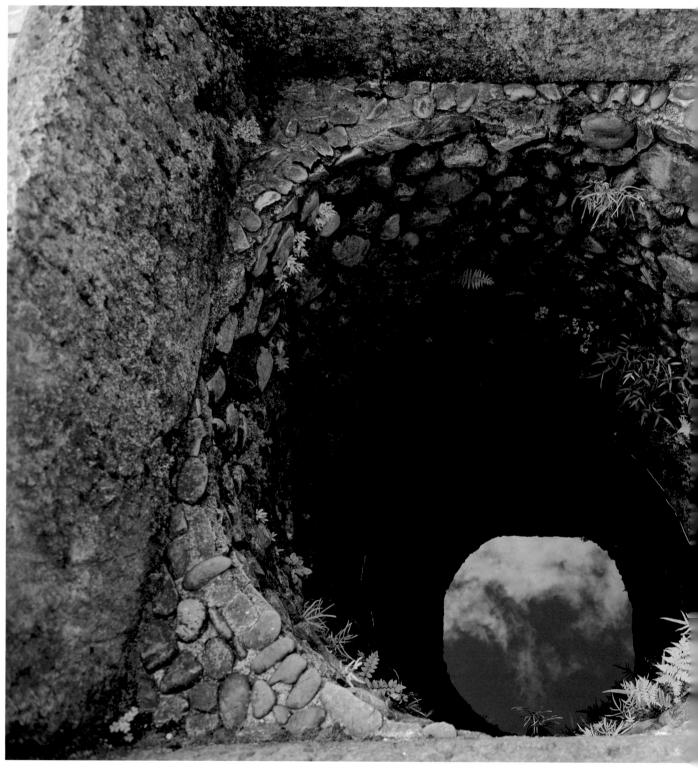

毛泽东旧居旁的古井，如今依然清澈见底，还是周边的居民水源 / 曾璜 摄
The ancient well next to Mao Zedong's former residence is still crystal clear now, and is also the source of water for the surrounding residents /Photographed by Zeng Huang

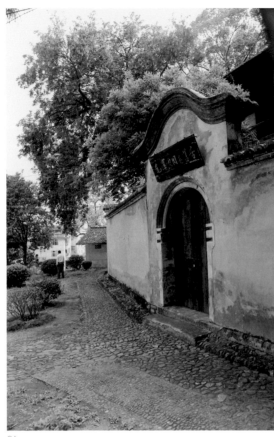

01

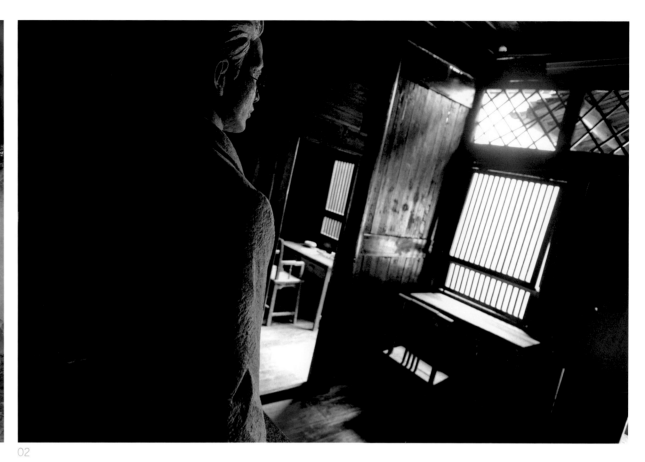

02

01　　毛泽东旧居，1932 年毛泽东曾在此休养 / 曾璜 摄
　　　Mao Zedong's former residence, where he has recuperated in
　　　1932 /Photographed by Zeng Huang

02　　　　瞿秋白是中共早期领导人之一，1935 年 2 月在长汀被国民党逮捕，
　　　同年 6 月 18 日从容就义，时年 36 岁。瞿秋白以自己的思想理论和革
　　　命实践奠定了他作为伟人的马克思主义者、无产阶级革命家的历史地
　　　位。图为长汀试院内关押瞿秋白的小屋 / 曾璜 摄
　　　Qu Qiubai, one of the early leaders of the Communist Party of
　　　China, was arrested by the Kuomintang in Changting in February
　　　1935 and died unflinchingly on June 18 in the same year, at the age
　　　of 36. Qu Qiubai established his historical position as a great Marxist
　　　and proletarian revolutionist with his own ideological theory and
　　　revolutionary practice. The picture shows the Changting Examination
　　　Hall where he was imprisoned /Photographed by Zeng Huang

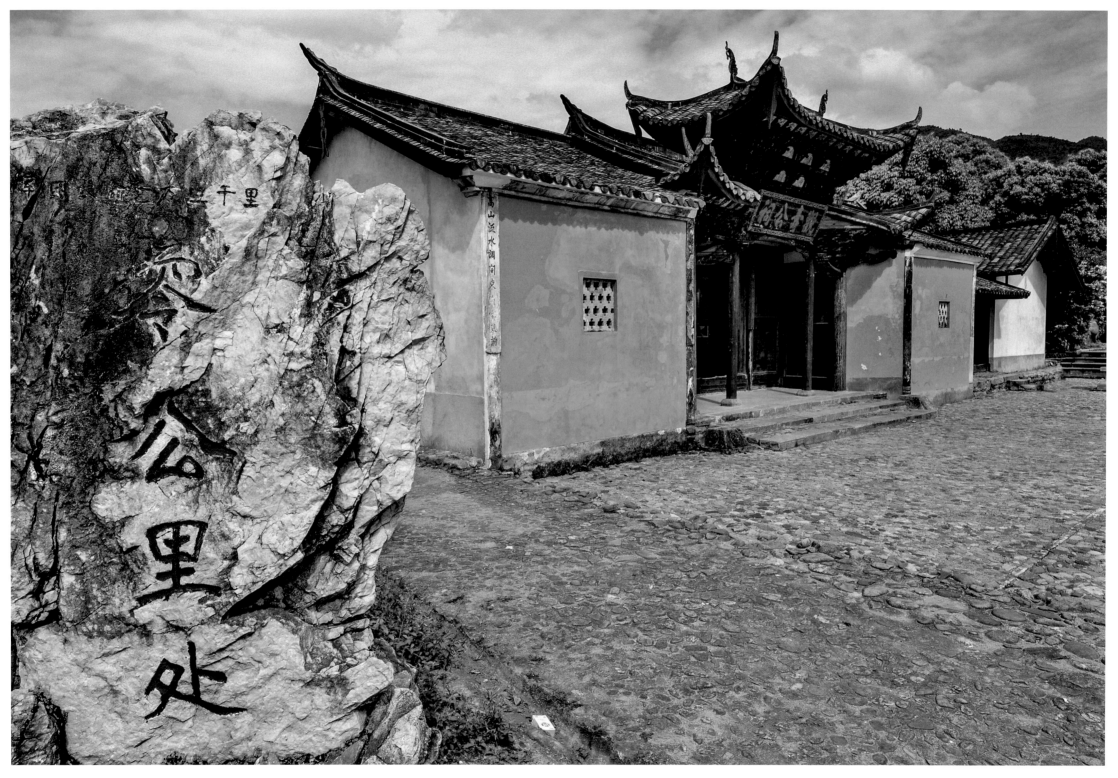

红军长征出发地——观寿公祠 / 陈扬富 摄

The departure place of the Red Army's Long March—Guanshougong Temple /Photographed by Chen Yangfu

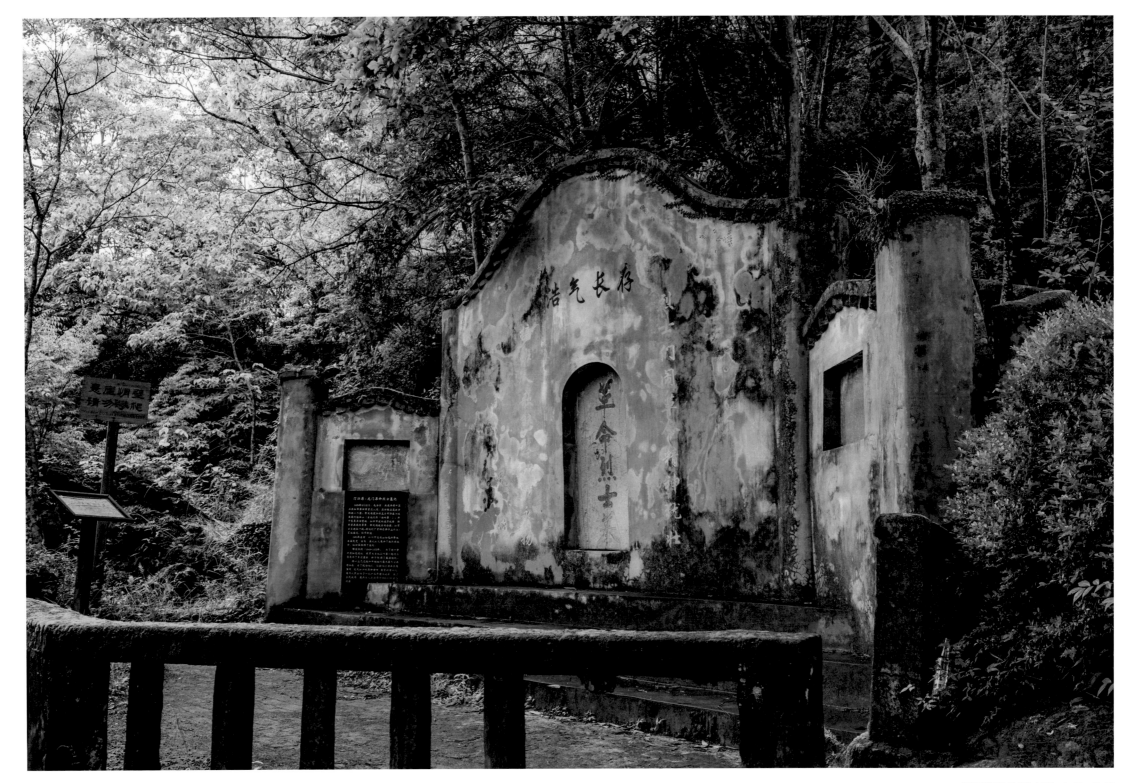

汀江源头的烈士墓 / 那兴海 摄
The tomb of martyrs at the headstream of the Tingjiang River /Photographed by Na Xinghai

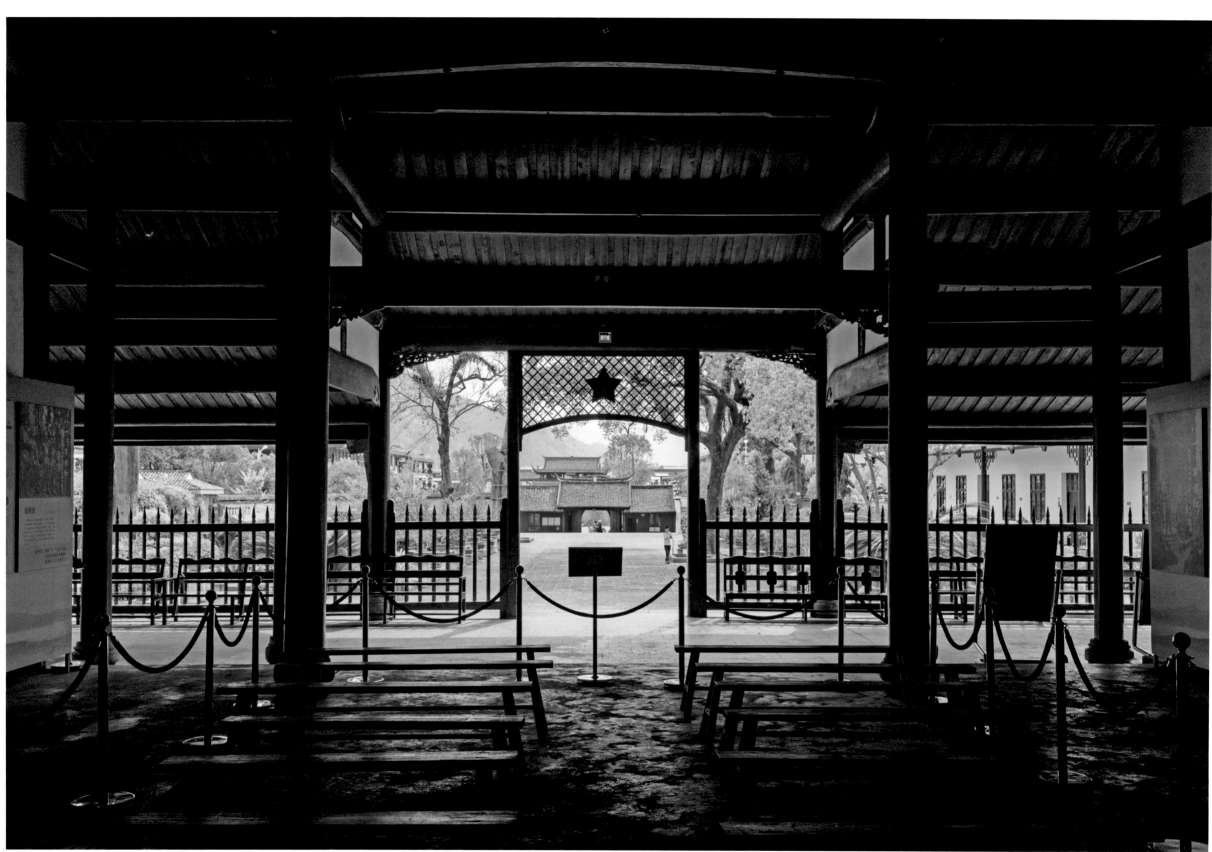

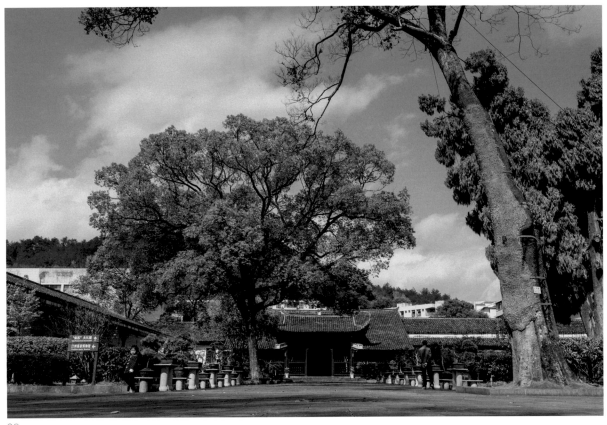

02

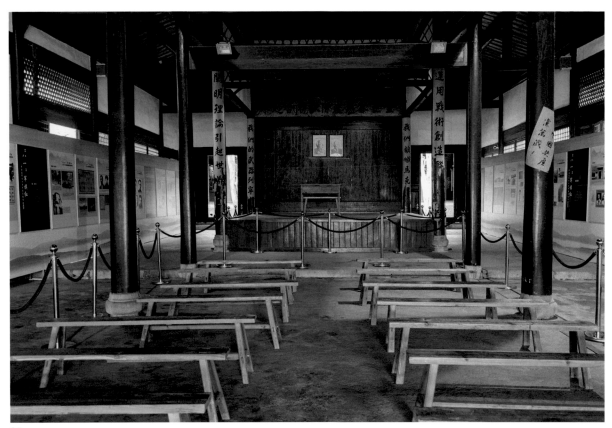

03

01 　　福建省苏维埃旧址。1932年3月18日，福建省第一次工农代表大会在此隆重召开，正式宣告成立福建省苏维埃政府 / 赖小兵 摄

　　The former site of the Soviet Government in Fujian Province. On March 18, 1932, the First Congress of Workers and Peasants in Fujian Province was solemnly held here, officially announcing the establishment of the Soviet Government in Fujian Province /Photographed by Lai Xiaobing

02 　　福建省苏维埃旧址历史悠久，宋代为汀州禁军署地，明清两代为试院，院内唐代的双柏树，已有1200多年，纪晓岚曾留下"参天黛色常如此，点首朱衣或是君"的诗句 / 赖小兵 摄

　　The former site of the Soviet Government in Fujian Province has a long history, which was the headquarters of imperial guards of Tingzhou in the Song Dynasty and the examination hall in the Ming and Qing Dynasties. The two cypress trees of the Tang Dynasty have been in the courtyard for more than 1200 years. Ji Xiaolan once wrote a poem that "The cypress trees are always with luxuriant foliage and spreading branches, which maybe the man in red bowing to me "/Photographed by Lai Xiaobing

03 　　福建省苏维埃政府的成立，标志着福建省苏区的革命斗争进入了一个全盛时期 / 赖小兵 摄

　　The establishment of the Soviet Government in Fujian Province marked that the revolutionary struggle in the Soviet Area of Fujian Province has entered a heyday / Photographed by Lai Xiaobing

02

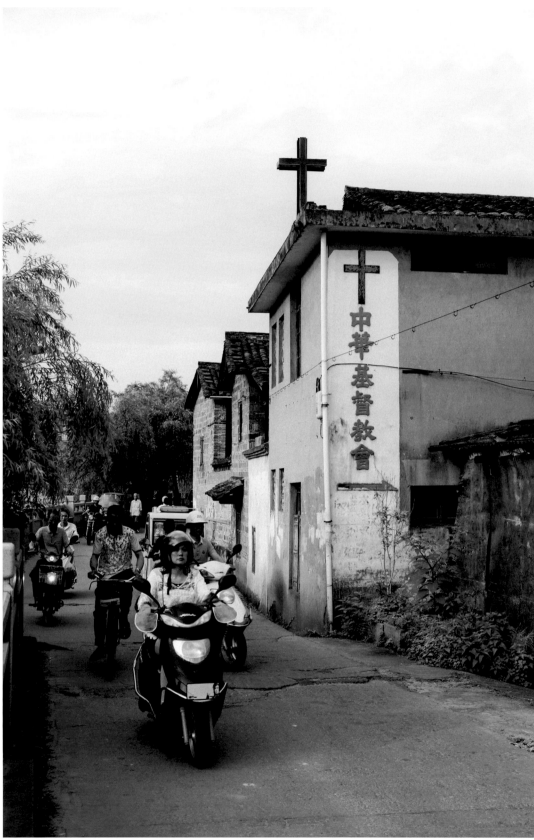

01

01　　　长汀中华基督教曾是中共福建省委旧址，周恩来、陈云曾在此住宿、办公 / 曾璜 摄

　　　Chinese Christian Church of Changting County was once the site of Fujian Provincial Committee of the Communist Party of China, where Zhou Enlai and Chen Yun lived and worked /Photographed by Zeng Huang

02　　　1929 年 3 月 14 日，红四军司令部和政治部设于此处，毛泽东、朱德、陈毅在此召开了红四军前委扩大会议，确定了开辟中央革命根据地的战略方针 / 赖小兵 摄

　　　On March 14, 1929, the headquarters and political section of the 4th Red Army were set up here. Mao Zedong, Zhu De and Chen Yi held an enlarged meeting of the Front Committee of the 4th Red Army here, and determined the strategic policy of opening up the central revolutionary base area /Photographed by Lai Xiaobing

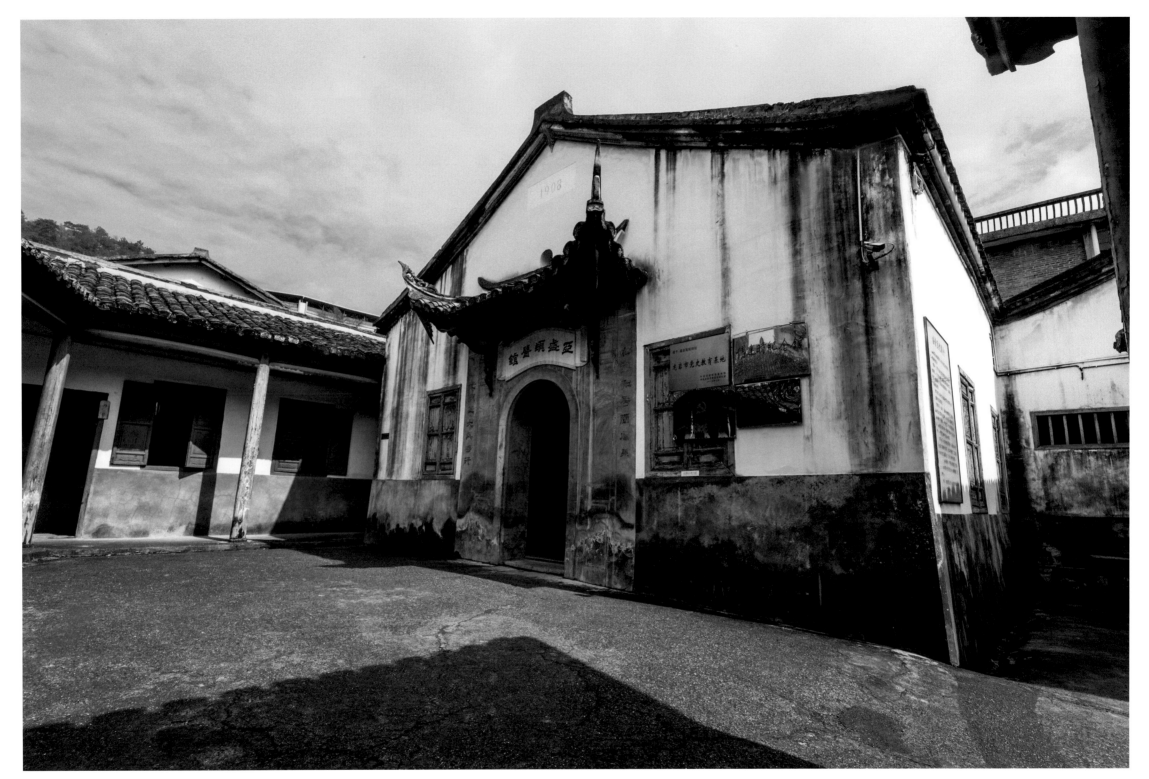

长汀福音医院原为教会开办，后由傅连暲主持院务，成为第一个为红军服务的医院 / 赖小兵 摄
The Evangelical Hospital of Changting County was originally opened by the church and then chaired by Fu Lianzhang, which became the first hospital to serve the Red Army /Photographed by Lai Xiaobing

Hometown of Ya Lou

亚楼故里

1929 年春天，红四军第一次入闽，取得了长岭寨战斗的胜利，长汀的红色革命风起云涌，此时的刘亚楼"诞生"，在加入中国共产党后改刘振东之名为刘亚楼——表示跟党革命，更上一层楼。刘亚楼等先在湘洋、尧山等村将青年组成农民自卫军，发动农民实行减租减息，声震汀南武北，此后编入红四军第四纵队第八支队，刘亚楼被送到红军随营学校学习，毕业后任连长，之后是营长、团政委、师政委等，随红四军转战闽赣，参加长征。这位出生在湘洋村农民的儿子，一直追随革命，成长为中国人民解放军第一任空军司令、开国将领。刘亚楼出生的那座小院，已修整为纪念馆，门前广场立有"飞将军"之碑，那是他儿时玩耍的地方。

In the spring of 1929, the 4th Red Army entered Fujian for the first time and won the battle of Changling Village. Changting's Red Revolution surged. At that time, Liu Yalou was "born", which means after joining the Communist Party of China, Liu Zhendong was renamed Liu Yalou, deciding to follow the Party's revolution and go up to a higher level. Liu Yalou and others first formed a peasant self-defense army in villages such as Xiangyang and Yaoshan, mobilized peasants to make rent reduction and interest reduction, forming strong local revolutionary atmosphere, and then joined the eighth detachment of the Fourth column of the Red Army. Liu Yalou was sent to the Red Army Camp School to study. After graduation, he became the Company Commander, then battalion commander, member of Regiment Political Committee, member of Division Political Committee, etc. He joined the Long March with the 4th Red Army in Fujian and Jiangxi. The son of a peasant born in Xiangyang Village has been following the revolution and grew up to be the first Air Force Commander of the People's Liberation Army of China and a founding General.

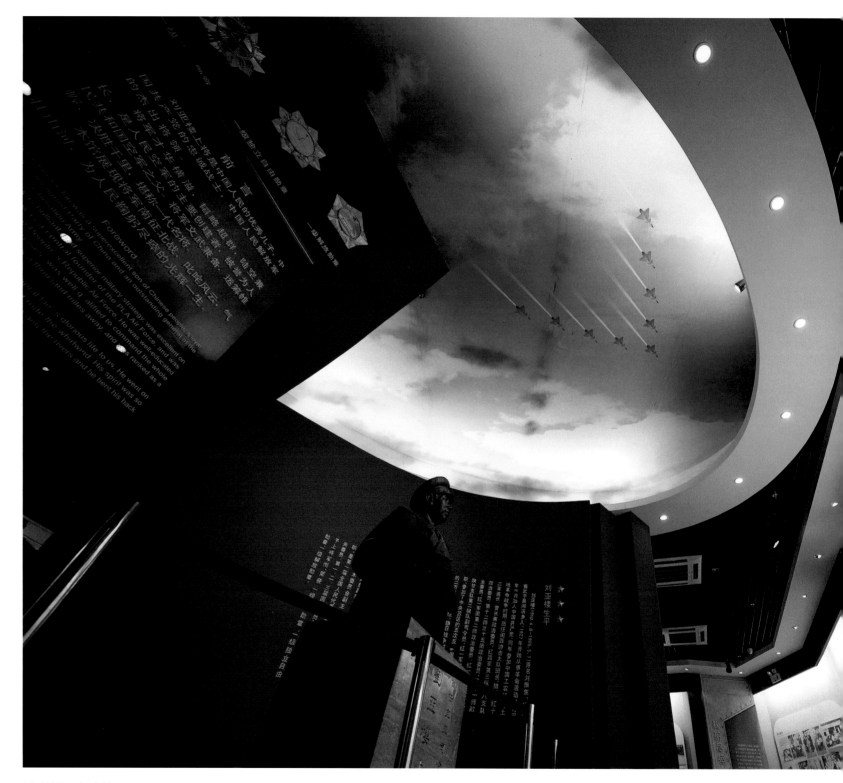

刘亚楼将军纪念馆 / 朱晨辉 摄　Memorial Hall of General Liu Yalou /Photographed by Zhu Chenhui

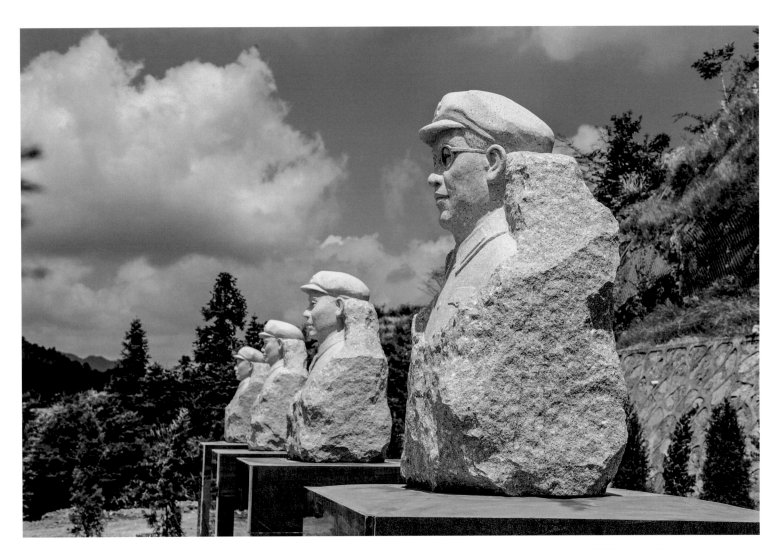

上湖福建党政军烈士陵园 / 李国潮 摄

Martyrs' cemetery of the party, government and army of Fujian Province in Shanghu Village /
Photographed by Li Guochao

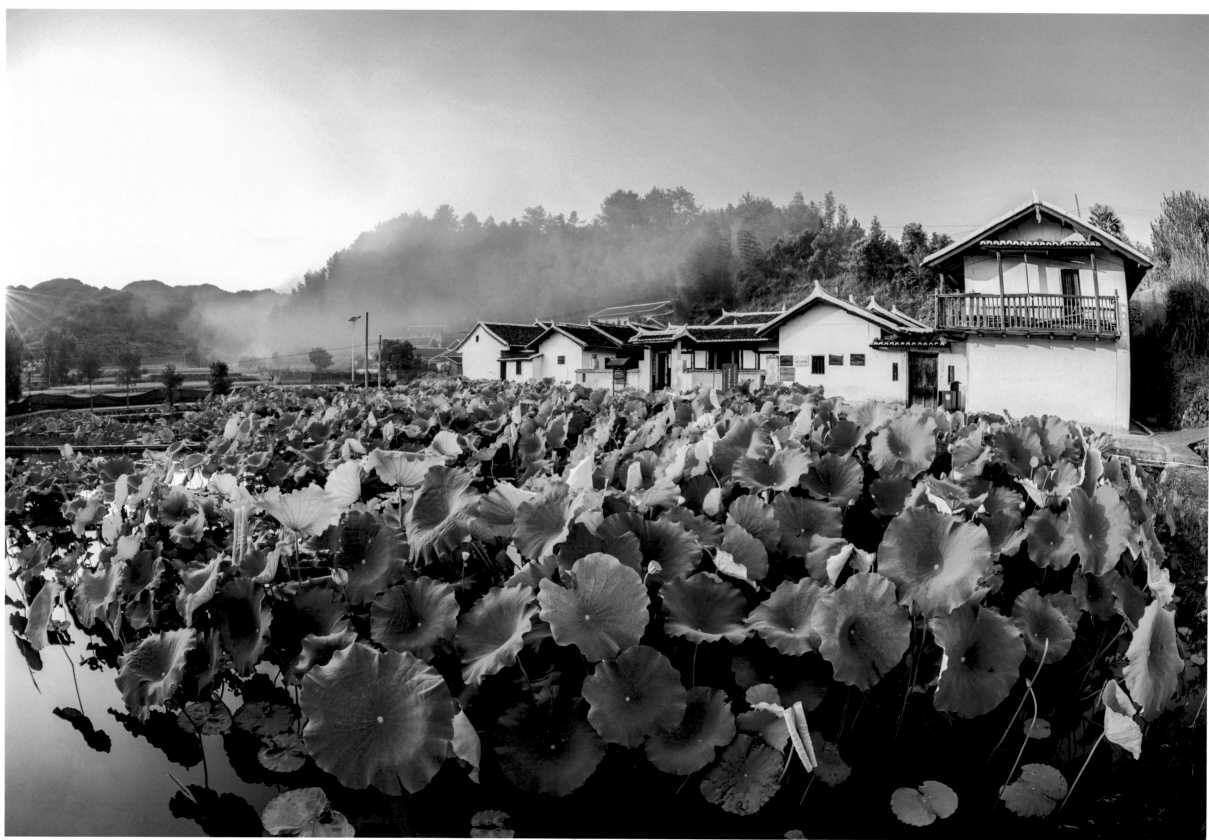

01　刘亚楼故居 / 张乃彬 摄
　　Former Residence of Liu Yalou /Photographed by Zhang Naibin

02　梁山书院——红四军前敌委员会旧址 / 李国潮 摄
　　Liangshan Academy—the former site of the party's committee in front of enemy of the 4th Red Army /Photographed by Li Guochao

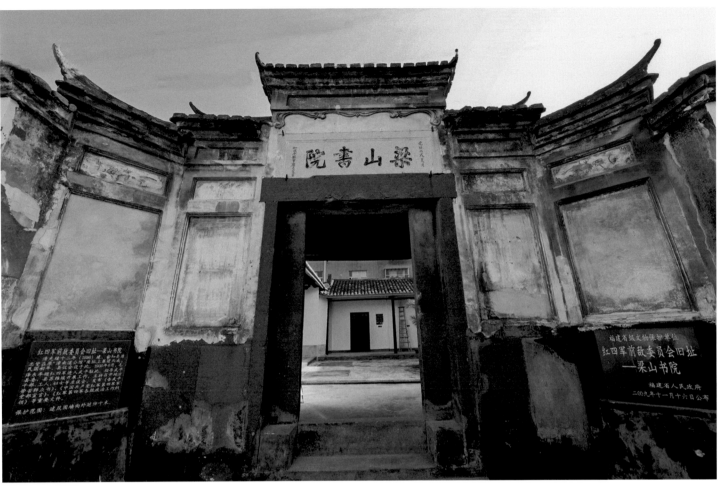

02

Underground
Routes

地下航线

创建于闽赣的红色政权，从地图看去，几乎是一座孤岛，周围均被白色包围，而作为根据地的红军与苏区政权，又必须与外界取得联系，得到指导与支援。当时的红四军尚无一部电台，南流的汀江，承担起红色交通线的任务。在永定红色交通纪念馆中，有这样一张地图，红色的箭头自莫斯科始，之后是上海 - 香港 - 汕头 - 大埔 - 永定 - 长汀 - 瑞金，将那片红色的孤岛与世界链接了起来。仅仅是通过这条地下航线从莫斯科、上海等地进入中央苏区的领导干部就达 200 多位，包括叶剑英、项英、王稼祥、徐特立、张爱萍、萧劲光、舒同、肖向荣、周恩来、刘少奇、聂荣臻、邓小平、博古、王首道、李德生、李克农、潘汉年、毛泽民、邓颖超、何叔衡、刘伯承、陆定一、伍修权、石联星、李德（奥托·布劳恩）、杨尚昆、张闻天、谢觉哉、瞿秋白、沙可夫、钱之光等，还有数千吨的军用、民用物资（包括向上海党中央运送的黄金、白银），大量的文件和情报资料。汀江的流水，就像红色政权血管里的鲜血，只有它不息地流动，才能保障红色政权的运作！毛泽东曾形象地说："交通线就像我们身上的血脉"，没有血脉，一个人还能生存么？没有汀江为主导的这条地下交通航线，中国革命能由星星之火达到燎原之势么？永定是这条地下航线的中枢，从白区进入苏区的必经之地，而到白区去迎接护送的地下交通员，也多从永定中心站派出。

From the map, the red regime founded in Fujian and Jiangxi was almost an isolated island surrounded by white, and the Red Army and the Soviet regime, as base areas, must contact the outside world and receive guidance and support. At that time, the 4th Red Army did not have a radio station. The Tingjiang River flowing south undertook the task of the red transportation line. In the Yongding Red Traffic Memorial Hall, there is a map. The red arrow starts from Moscow, then Shanghai - Hong Kong - Shantou - Dapu - Yongding - Changting - Ruijin, which links the red island to the world. More than 200 leading cadres from Moscow and Shanghai entered the Central Soviet Area through this underground route alone, including Ye Jianying, Xiang Ying, Wang Jiaxiang, Xu Teli, Zhang Aiping, Xiao Jinguang, Shu Tong, Xiao Xianglong, Zhou Enlai, Liu Shaoqi, Nie Rongzhen, Deng Xiaoping, Bo Gu, Wang Shoudao, Li Desheng, Li Kenong, Pan Hannian, Mao Zemin, Deng Yingchao, He Shuheng, Liu Bocheng, Lu Dingyi, Wu Xiuquan, Shi Lianxing, Li De (Otto Braun), Yang Shangkun, Zhang Wentian, Xie Juezai, Qu Qiubai, Sha Kefu, Qian Zhiguang and so on. Also transported through this underground route was thousands of tons of military and civilian materials (including gold and silver transported to the Shanghai Party Central Committee) and a large number of documents and information materials. The running water of the Tingjiang River was like blood in the blood vessel of the red regime. Only by its continuous flow could the operation of the red regime be guaranteed. Mao Zedong once said vividly, "The traffic line is like the blood of our body." Without blood, can a person survive? Without the underground transportation route dominated by the Tingjiang, could the Chinese revolution have reached a prairie fire from a spark? Yongding was the center of this underground route. It was a necessary place to enter the Soviet Area from the White Area. The underground messengers who went to the White Area to receive the escorted were mostly sent from the Yongding Central Station.

金砂乡的古木督中央红色交通线，为中央红军的发展壮大做出了不可磨灭的贡献 ／ 赖小兵 摄
The Gumudu Central Red Communication Line in Jinsha Township has made an indelible contribution to the development and expansion of the Central Red Army /Photographed by Lai Xiaobing

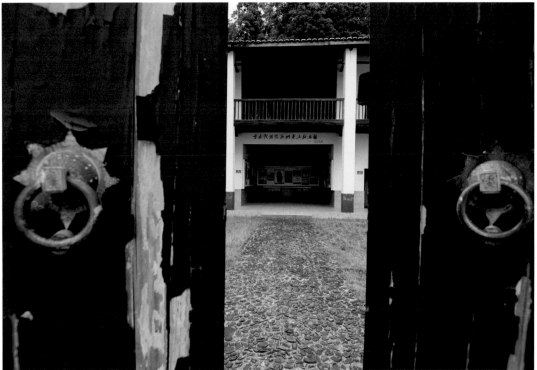

永定中央红色交通线纪念馆，毛泽东同志的题词："交通线就像我们身上的血脉" / 赖小兵 摄

The inscription of Comrade Mao Zedong at Yongding Central Red Communication Line Memorial Hall: "The Red Communication Line is the blood vein of us" /Photographed by Lai Xiaobing

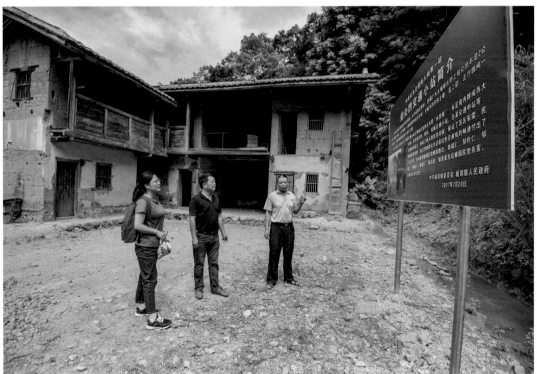

伯公凹交通站是中央红色交通线的入闽第一站，为了保障红色交通线的顺畅，伯公凹涌现了许多英雄事迹 / 赖小兵 摄

Bogong'ao Communication Station is the first station of the Central Red Communication Line into Fujian. In order to ensure the smooth flow of the Red communication line, many heroic deeds have emerged in Bogong'ao /Photographed by Lai Xiaobing

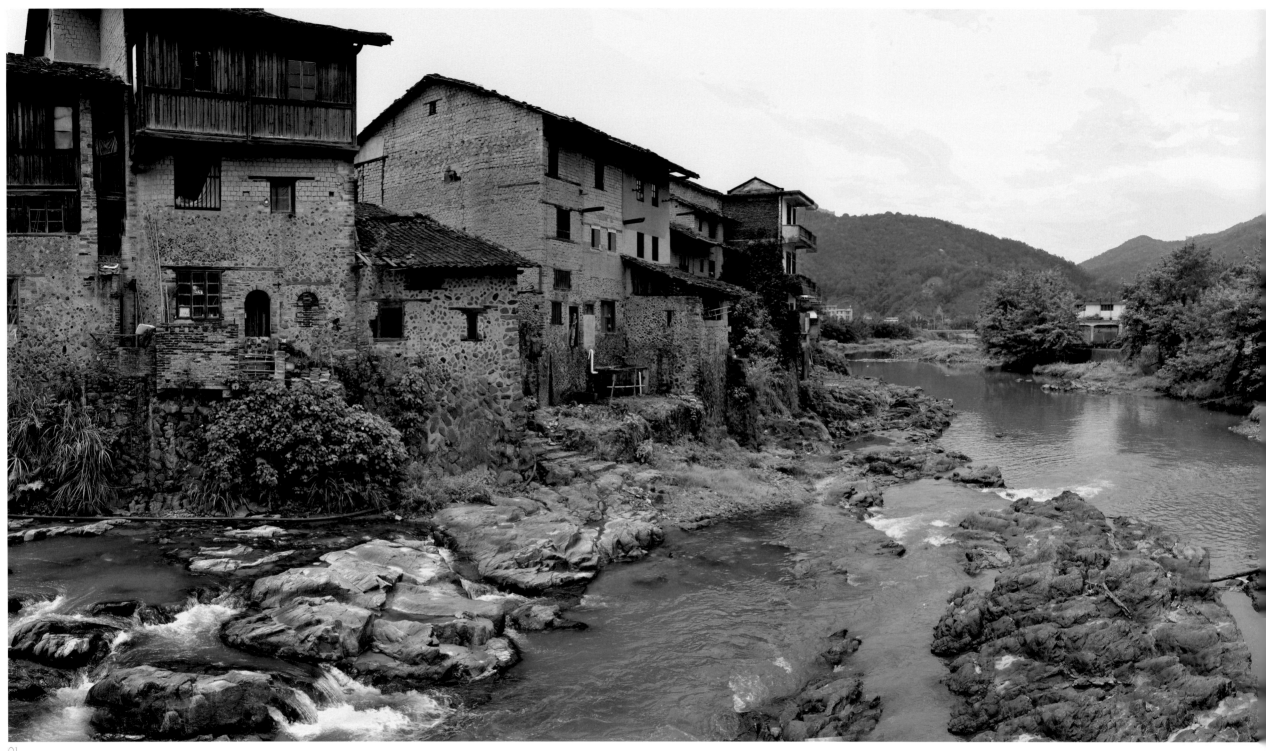

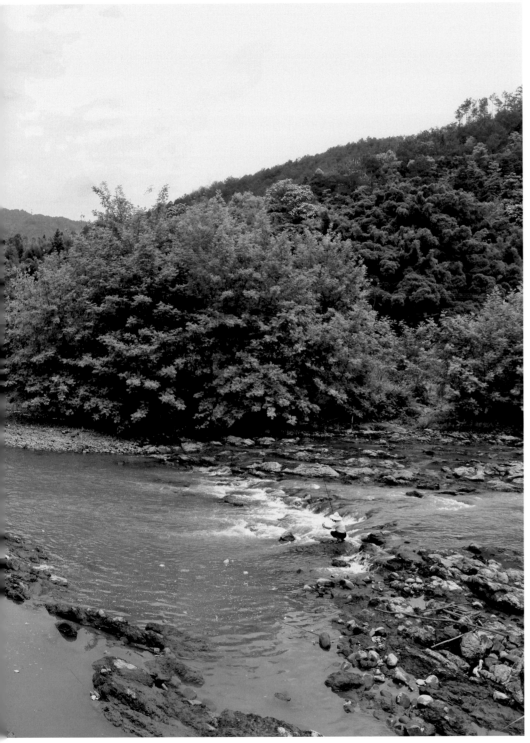

02

03

01 　　湖雷位于永定河中游，这里曾是汀江的水上航线，也是闽西中央革命根据地的红色航线 / 赖小兵 摄

　　Located in the middle reach of the Yongding River, Hulei Town used to be the water route of the Tingjiang River and also the red route of the central revolutionary base in Western Fujian /Photographed by Lai Xiaobing

02 　　永定湖雷河码头遗址，地下交通线到达此地，便是苏区 / 赖小兵 摄

　　The ruins of Hulei Wharf of the Yongding River, where the underground communication line arrives, is the Soviet area /Photographed by Lai Xiaobing

03 　　红四军政治部旧址——新盛昌店位于永定区湖雷镇湖雷街。1929 年 5 月 24 日，红四军解放湖雷，红四军政治部入驻此店。毛泽东在此主持召开红四军前委会议，讨论有关红四军前委之下设不设军委的问题，史称"湖雷会议" / 赖小兵 摄

　　The former site of the political section of the 4th Red Army—New Shenchang Store is located in Hulei Street, Hulei Town, Yongding County. On May 24, 1929, Hulei Town was liberated by the 4th Red Army, and the political section of the 4th Red Army garrisoned in the store. Mao Zedong presided over the meeting of the Front Committee of the 4th Red Army here to discuss the issue of whether or not to establish a Military Commission under the Front Committee of the 4th Red Army, which was historically known as the "Hulei Conference" /Photographed by Lai Xiaobing

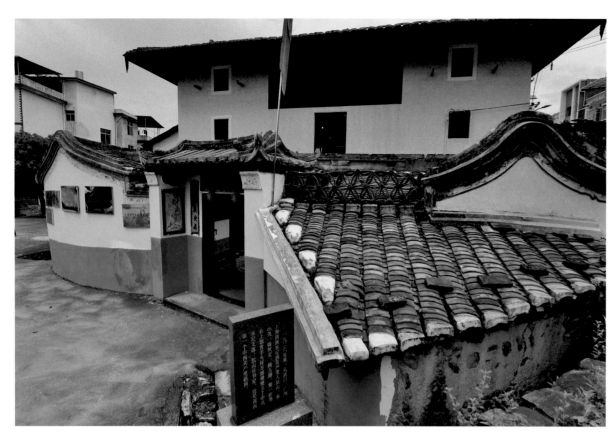

红色土楼万源楼，见证了福建革命史上规模最大、范围最广、时间最长、影响最深的农民武装暴动——永定暴动 / 赖小兵 摄

Wanyuan Building, the earth building, witnessed the largest, widest, longest and most influential peasant armed riot in the history of the Fujian people's revolution—the Yongding Riot /Photographed by Lai Xiaobing

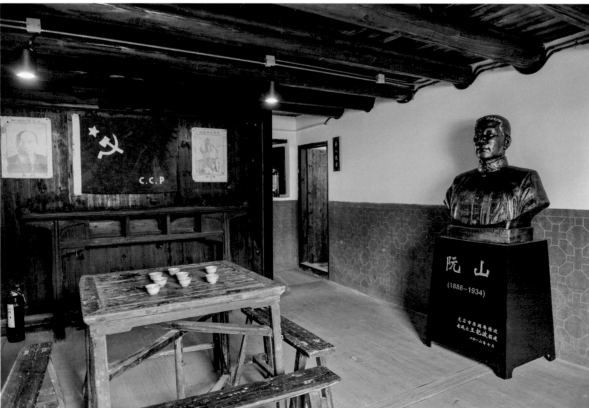

90 年前，在万源楼成立了福建省第一个农村党支部——中共永定支部委员会，阮山当选为首任支部书记 / 焦红辉 摄

90 years ago, Yongding Branch Committee of the Communist Party of China—the first rural Party branch in Fujian Province, was established in Wanyuan Building, and Ruan Shan was elected as the first Secretary of the branch /Photographed by Jiao Honghui

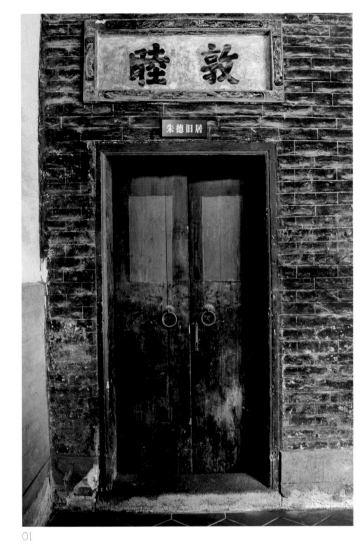

01

02

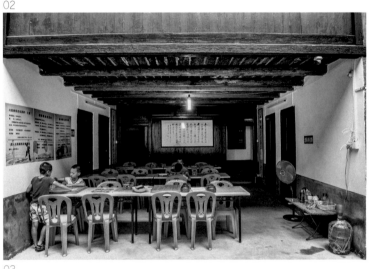

03

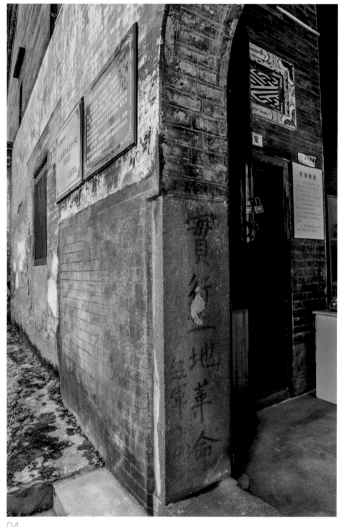

04

01　永定张氏宗祠曾经是朱德旧居　/ 严硕 摄
The Ancestral Hall of Zhang Family in Yongding City used to be the former residence of Zhu De / Photographed by Yan Shuo

02　金砂乡的金谷寺是著名的永定暴动所在地，1928 年 8 月这里成立了福建省第一个区苏维埃政府　/ 赖小兵 摄
Jingu Temple in Jinsha Township is the site of the famous Yongding Riot, and the first district of Soviet Government of Fujian Province was established in August 1928 /Photographed by Lai Xiaobing

03　永定张氏宗祠的毛泽东旧居，少年们平时在此学习围棋技艺　/ 严硕 摄
The former residence of Mao Zedong in the ancestral hall of Zhang Family in Yongding city, where young people usually learn the skills of Go /Photographed by Yan Shuo

04　赖家祠是福建省第二个革命政权——永定区革命委员会成立旧址。毛泽东曾在此居住，指导永定革命斗争　/ 严硕 摄
The Ancestral Hall of Lai Family is the former site of the establishment of Yongding Revolutionary Committee—the second revolutionary regime in Fujian Province. Mao Zedong once lived here to guide the struggle of the Yongding Revolution /Photographed by Yan Shuo

Guanting
Conference

官厅会议

连城的水流入汀江，连城的山也连着汀州，松毛岭连接着长汀与连城，长汀松毛岭阻击战指挥部设在中复村观寿公祠堂内，连城的松毛岭战斗指挥部，设在培田官厅，著名的"官厅会议"，便是在连城召开。1934年9月，农历中秋节前，由朱德总司令组织布置，在彭德怀、聂荣臻、罗炳辉等军团首长的主持下，召开松毛岭保卫战军事会议。红一、红四、红九军团、工人师、瑞金模范师、红九团、红四团等主力红军团以上百位领导参加会议。会议持续一天两夜。连同7月6日的军事部署会议，官厅三个月内召开过两次重要军事会议，见证了中国革命进行战略大转移的历史事件。

Liancheng's water flows into the Tingjiang, and Liancheng's mountains are connected with Tingzhou. Songmaoling connects Changting and Liancheng. Changting's Songmaoling Blockade Command is located at Guanshougong Temple of Zhongfu Village. Liancheng's Songmaoling Combat Command is located at Guanting, Peitian. The famous Guanting Conference was held in Liancheng. In September 1934, before the Mid-Autumn Festival of the lunar calendar, General Zhu De organized and arranged a military conference on Songmaoling Defence War chaired by Peng Dehuai, Nie Rongzhen and Luo Binghui. More than 100 leaders of the main Red Army corps, including the First, Fourth, Ninth, Workers' Division, Ruijin Model Division, Ninth and Fourth Regiments, attended the meeting. The meeting lasted two nights a day. Together with the military deployment meeting on July 6, Guanting held two important military meetings in three months, witnessing the historical events of the great strategic shift of the Chinese revolution.

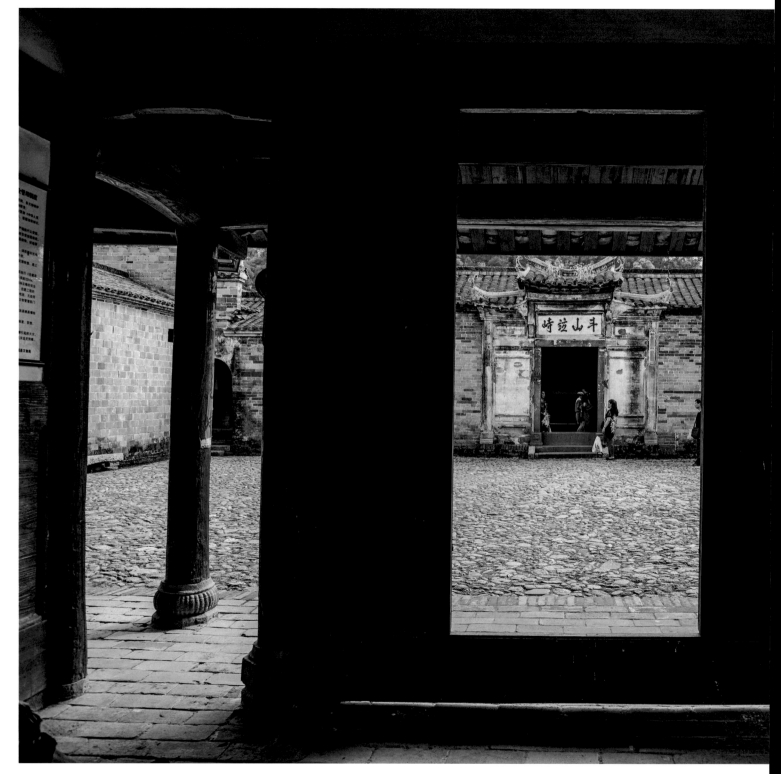

1934年9月，在朱德的布置下，松毛岭保卫战前的军事会议在培田官厅召开 / 曾磺 摄
In September 1934, under the arrangement of Zhu De, the military conference before the Songmaoling Defense War was held in the government office of Peitian /Photographed by Zeng Huang

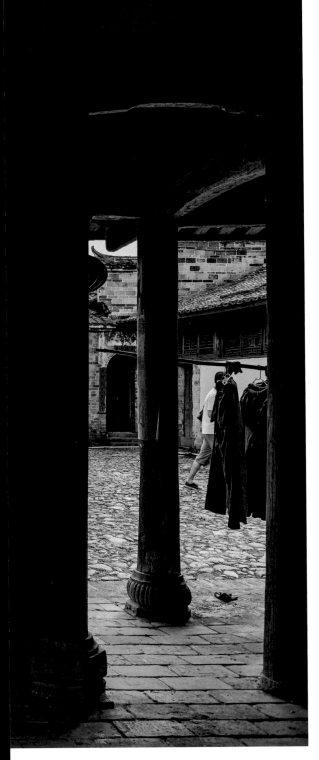

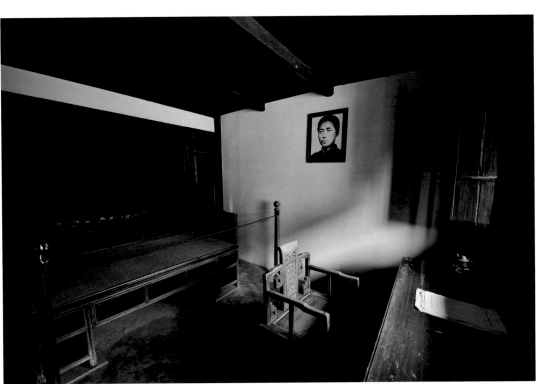

01

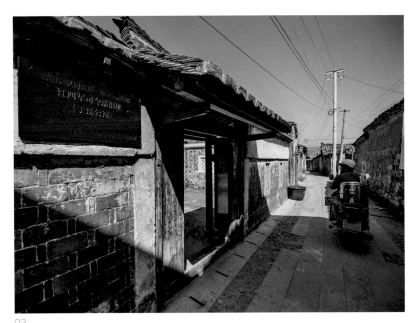

03

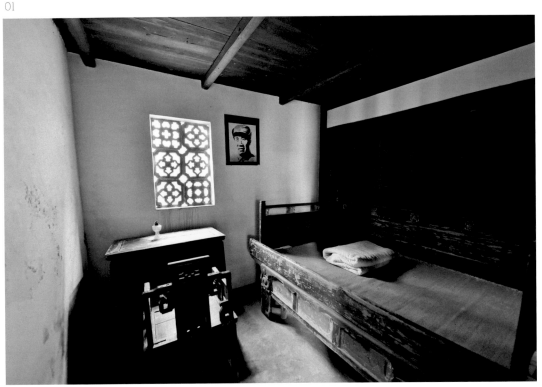

02

01　毛泽东当年在连城塈云草室的办公室 / 吴军 摄
Mao Zedong's office in Wangyun Room, Liancheng County in that years /Photographed by Wu Jun

02　朱德当年在连城塈云草室的办公室 / 吴军 摄
Zhu De's office in Wangyun Room, Liancheng County in that years /Photographed by Wu Jun

03　连城红四军司令部旧址 / 朱晨辉 摄
The former site of the headquarters of the 4th Red Army in Liancheng County /Photographed by Zhu Chenhui

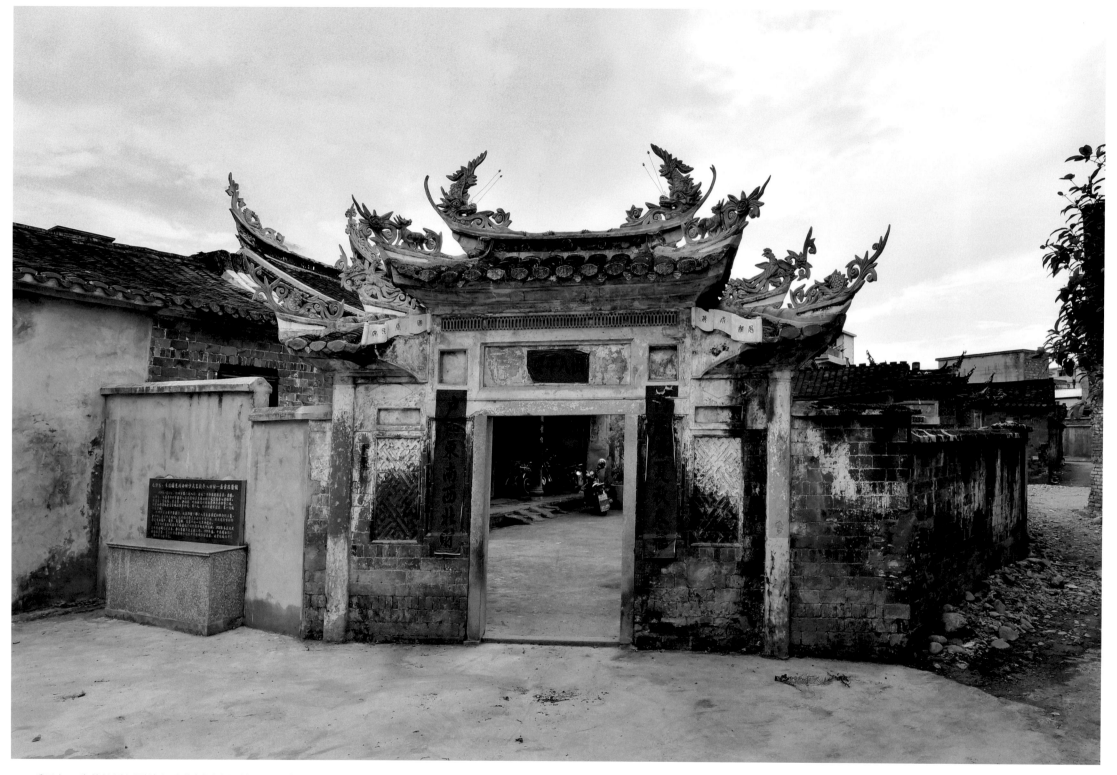

毛泽东、朱德接见闽西地方武装领导人旧址——孔清祠。在这里，毛泽东同志作出了挥师龙岩的最后决策 / 吴军 摄

Kongqing Temple—the former site where Mao Zedong and Zhu De received the leaders of the local armed forces in Western Fujian. Here Comrade Mao Zedong made the final decision of commanding Longyan /Photographed by Wu Jun

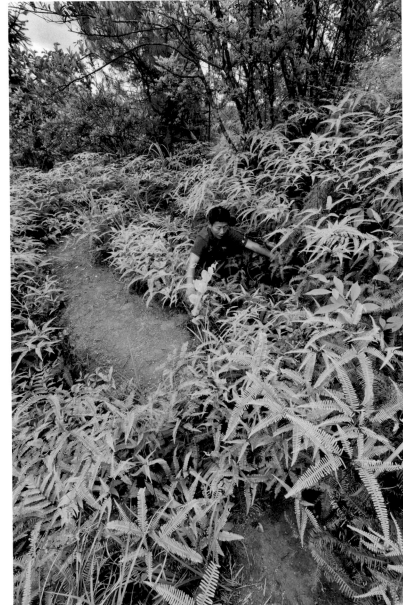

01

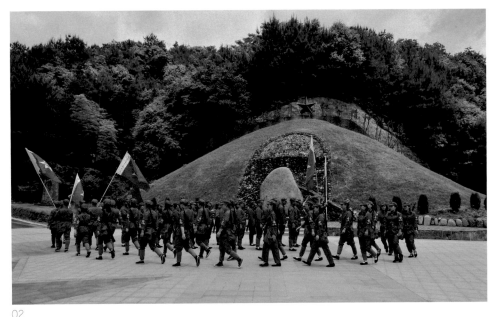

02

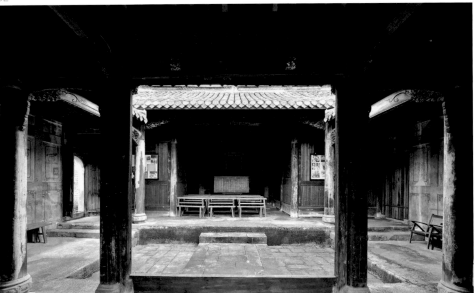

03

01 松毛岭战役的战壕依然清晰可辨 / 吴军 摄
The trenches of the Songmaoling Battle are still recognizable /Photographed by Wu Jun

02 连城县松毛岭无名烈士墓 / 吴军 摄
Tomb of Unknown Martyrs in Songmaoling, Liancheng County /Photographed by Wu Jun

03 张家祠是闽西历史上第一座妇女夜校——新泉工农妇女夜校旧址 / 吴军 摄
The Ancestral Hall of Zhang Family is the former site of Xinquan Night School for Women Workers and Peasants—the first night school for women in the history of Western Fujian /Photographed by Wu Jun

Houtian
Riot

后田暴动

中央红军入闽之前，由邓子恢、张鼎丞、郭滴人、阮山等地方党的领导人，在闽西开展了一系列的革命活动。1928年，全国白色恐怖，但革命的火种却在闽西传播着。这一年的4月3日，郭滴人、邓子恢等领导了龙岩后田暴动，提出烧田契、不交租、分田地的战斗口号，成为福建土地革命之先声。同月8日，朱积垒领导了平和暴动，6月25日，郭柏屏（后叛变）、邓子恢、傅柏翠领导上杭蛟洋暴动，打死打伤国军官兵20余人，后转到大沟山开辟游击战争。同月底，张鼎丞、阮山、卢肇西等领导闽西规模最大的暴动——永定暴动，攻占了永定区城。随后，农民武装转入溪南里乡村，成立闽西第一支工农红军部队——红军营，由张鼎丞任营长、邓子恢任党代表。7月15日，龙岩、永定、上杭、平和4县党组织负责人在永定古木督开会，成立中共闽西临时特委，同时成立闽西暴动委员会。8月，溪南里在13个乡苏维埃政权的基础上成立了区苏维埃政府，全区2万多人完成了土改分田工作。

Before the Central Red Army entered Fujian, leaders of local Party such as Deng Zihui, Zhang Dingcheng, Guo Diren and Ruan Shan carried out a series of revolutionary activities in Western Fujian. In 1928, the whole country was in white terror, but the fire of Revolution spread in Western Fujian. On April 3 of this year, Guo Diren and Deng Zihui, etc. led the Longyan Houtian Uprising, and put forward the slogan of burning land deeds, not paying rent and dividing land, which became the forerunner of the Fujian Agrarian Revolution. In August of the same year, Zhu Jilei led a peaceful riot. On June 25, Guo Baiping (later betrayed), Deng Zihui and Fu Baicui led Shanghang Jiaoyang Riot, killing and wounding more than 20 officers and soldiers of the Kuomintang army, and then turned to Dagoushan Mountain to open guerrilla warfare. At the end of the same month, Zhang Dingcheng, Ruan Shan and Lu Zhaoxi led the largest riot in Western Fujian, the Yongding Riot, and seized Yongding County. Subsequently, the peasant armed forces transferred to the villages of Xinanli, and the first Red army of workers and peasants in Western Fujian, the Red Army Barracks, was established. Zhang Dingcheng was the battalion leader and Deng Zihui was the party representative. On July 15, the leaders of the Party organizations of the four counties Longyan, Yongding, Shanghang, and Pinghe met in Gumudu, Yongding to set up the CPC Interim Special Committee for Western Fujian and the Fujian Riot Committee. In August, on the basis of the Soviet regimes of 13 townships, Xinanli set up a Soviet government in the district. More than 20,000 people in the region completed the work of field dividing of land reform.

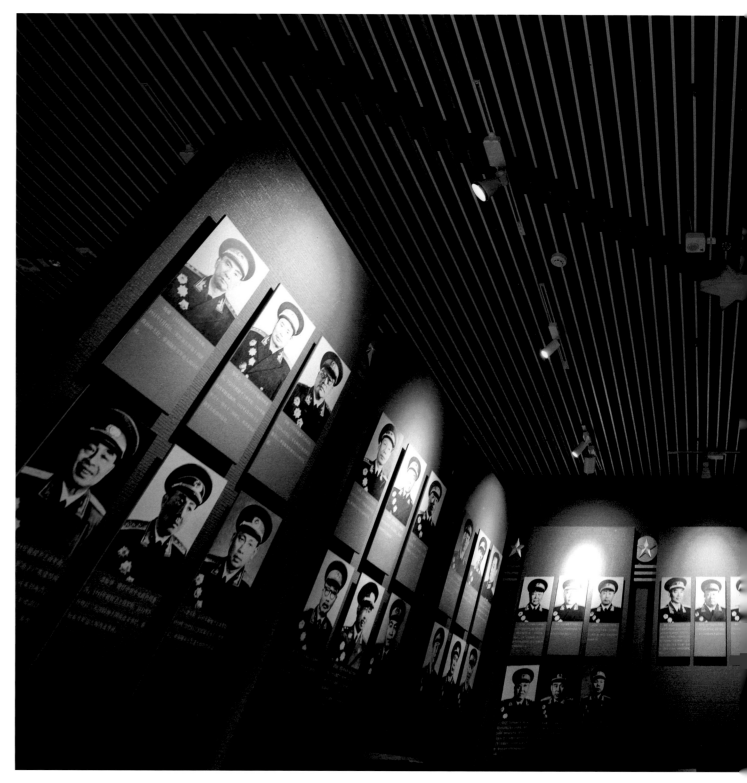

龙岩闽西革命烈士纪念馆 ／ 陈伟凯 摄
Memorial Hall of Revolutionary Martyrs of Western Fujian in Longyan /Photographed by Chen Weikai

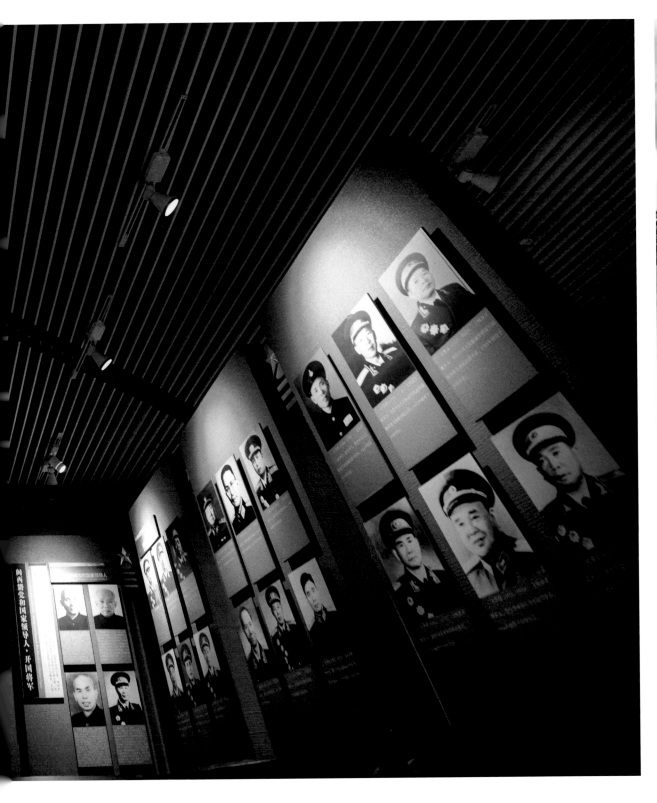

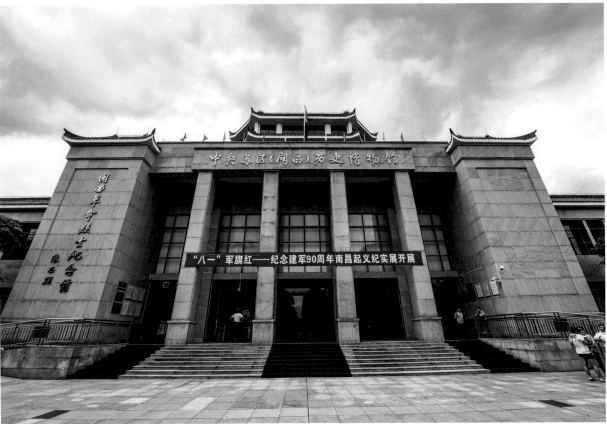

中央苏区（闽西）历史博物馆是一座全面反映闽西革命史、重点凸显中央苏区（闽西）历史的综合性革命博物馆 / 朱晨辉 严硕 摄

The History Museum of the Central Soviet Area (Western Fujian) is a comprehensive revolutionary museum which reflects the revolutionary history of Western Fujian and highlights the history of the Central Soviet Area (Western Fujian) /Photographed by Zhu Chenhui, Yan Shuo

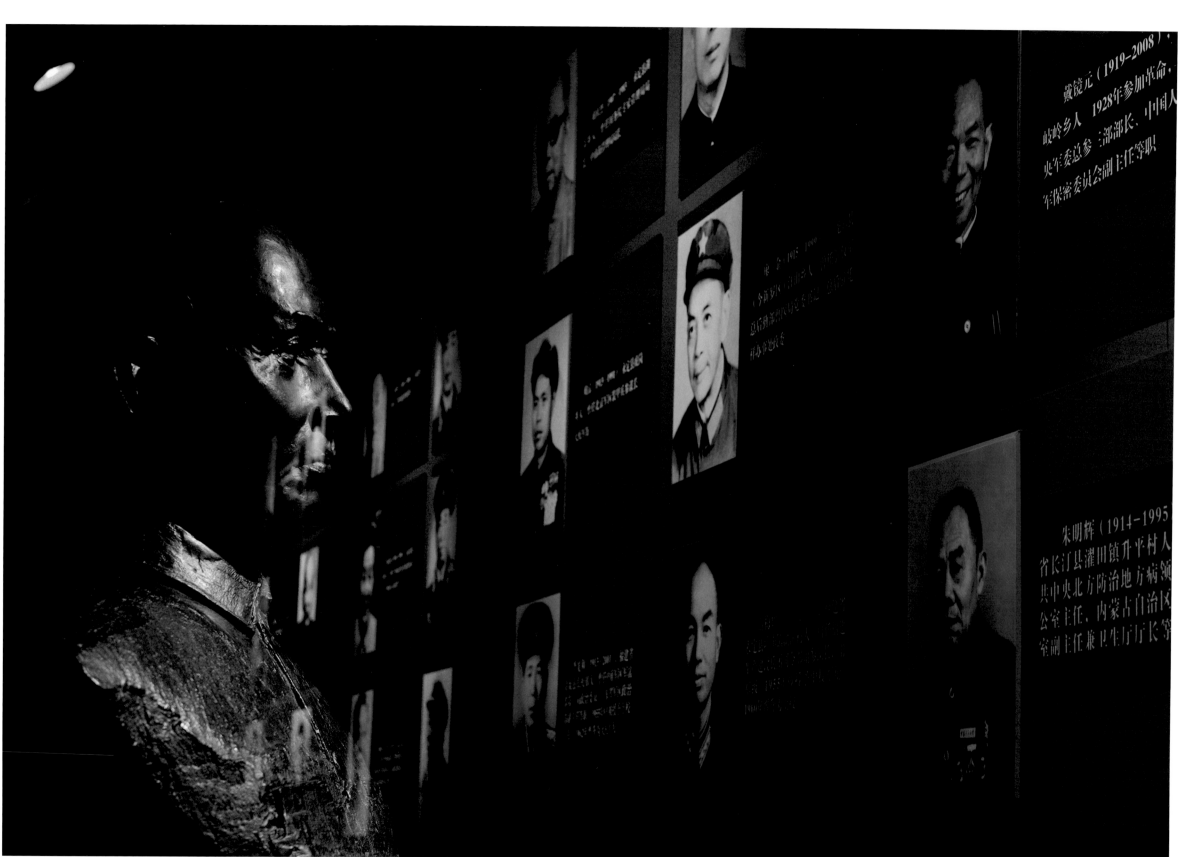

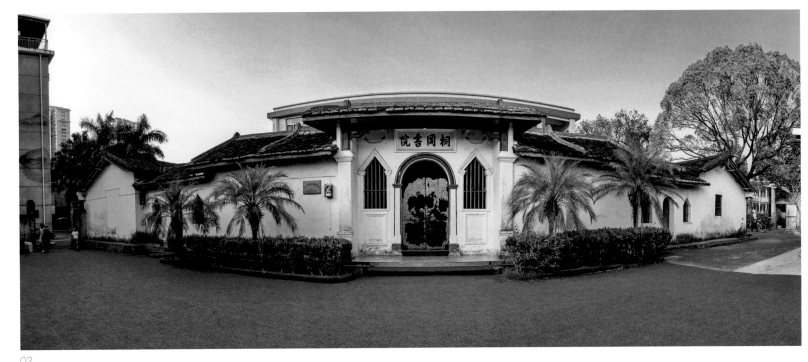

02

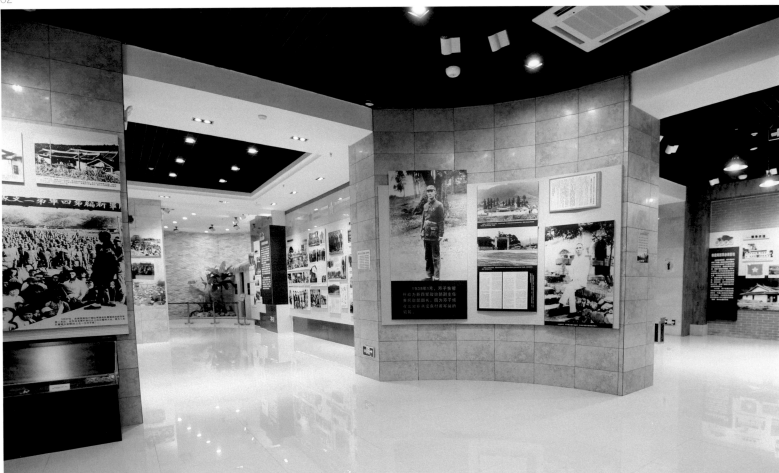

03

01　　龙岩闽西革命烈士纪念馆 / 陈伟凯 摄
　　Memorial Hall of Revolutionary Martyrs of Western Fujian in Longyan /Photographed by Chen Weikai

02　　邓子恢同志曾经在桐岗书院任教，在这里创办了闽西第一个宣传马列主义的刊物《岩声》报 / 严硕 摄
　　Comrade Deng Zihui once taught in Tonggang Academy, where he founded the first publication to disseminate Marxism-Leninism in Western Fujian—*The Sound of Longyan* /Photographed by Yan Shuo

03　　邓子恢，龙岩新罗区人，是闽西革命根据地和苏区的主要创建者和卓越的领导人之一。新中国成立后曾任中共中央农村工作部部长、国务院副总理、全国政协副主席等职。被誉为党内的农业、农村工作专家，图为新罗区的邓子恢纪念馆 / 赖小兵 摄
　　Deng Zihui, a native of Xinluo District, Longyan, was one of the main founders and outstanding leaders of the revolutionary base and the Soviet Area in Western Fujian. After liberation, he served as the Minister of the Rural Work Department of the CPC Central Committee, the vice premier of the State Council, and the vice chairman of the CPPCC National Committee, who was regarded as an expert in agriculture and rural work within the Party. The picture shows Deng Zihui Memorial Hall in Xinluo District /Photographed by Lai Xiaobing

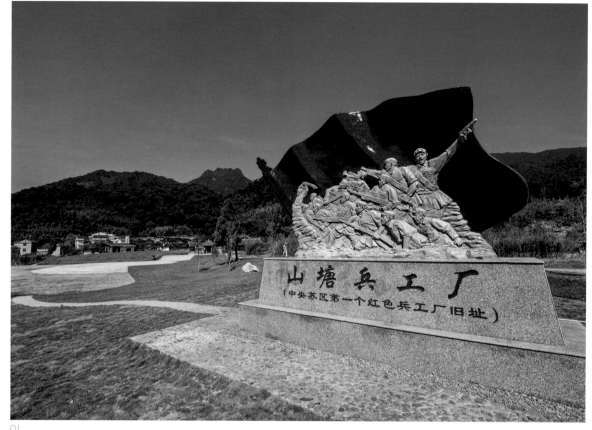

01

01　中央苏区第一个红色兵工厂，朱德曾
经在这里指挥过军械生产 / 严硕 摄

The first red armory in the Central
Soviet Area, where Zhu De once
commanded the production of ordnance
/Photographed by Yan Shuo

02　中央苏区第一个红色兵工厂，利铁科
房内还原了抗战时期的兵器 / 严硕 摄

The first red armory in the Central
Soviet Area, the weapons of the Anti-
Japanese War was restored in Litie
Room /Photographed by Yan Shuo

03　山塘兵工厂旧址 / 严硕 摄

The former site of Shantang Armory
/Photographed by Yan Shuo

04　中央苏区第一个红色兵工厂务本堂全
景 / 严硕 摄

Overall view of Wuben Hall of the
first red military factory in the Central
Soviet Area /Photographed by Yan Shuo

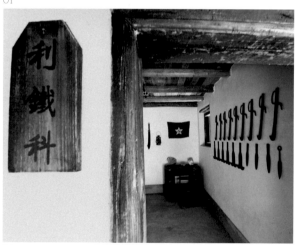

02

03

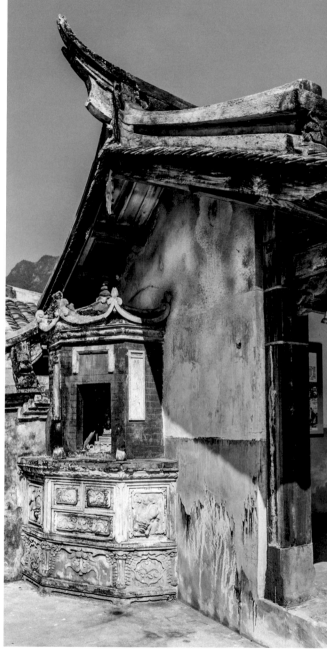

04

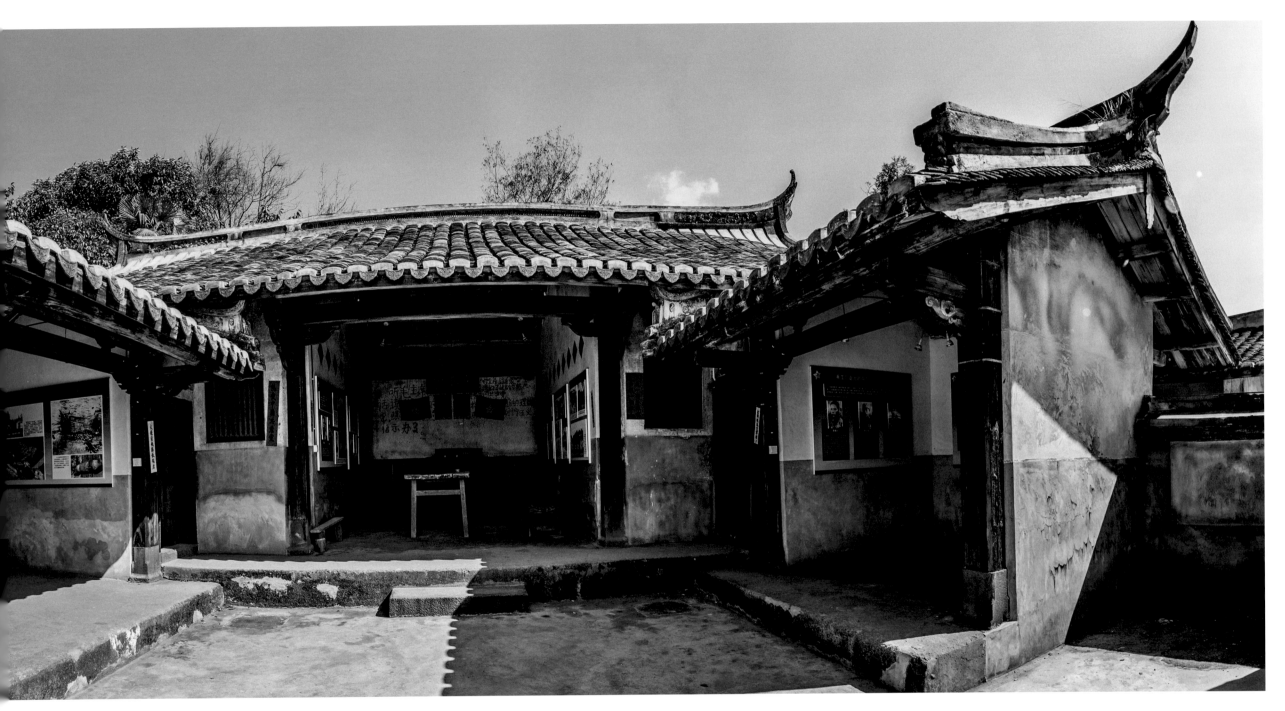

Xianghu
with Reputation
of the
Red Army

象 湖 流 芳

　　这是一个流传至今的红色佳话。红军入村，民众躲避，为解饥饿，继续进军，自取一农户家的大米26斤，墙上留言，留言曰：老乡你不在家，你的米我买了，二十六斤，大洋两元……并将大洋置于屋中。主人回家，见之感动，红军的纪律与宗旨，一时传扬民间。

　　This is a popular story. When the Red Army entered the village, the people fled and the Red Army continued to march in order to relieve hunger. They took 13 kilograms of rice from a farmer's family and put 2 silver dollars in the house, leaving a message on the wall saying, "My fellow-townsman, you are not at home. I would buy your rice. I leave you 2 silver dollars for 13 kilograms of rice…" When the host returned home, he was moved by what he saw. And the discipline and purpose of the Red Army were spread among the people.

象湖镇杨美村红色革命旧址群。1929年8月20日，朱德率红四军军部和第二、三纵队出击闽中大田、永春等县，进驻杨美村买米付款时，在荣福堂左厝题壁墨书"红军留款信" ／赖小兵 摄

The Red Revolutionary Sites in Yangmei Village, Xianghu Town. On August 20, 1929, Zhu De led the 4th Red Army Headquarters and the 2nd and 3rd Columns to attack Datian, Yongchun and other counties in Central Fujian Province. When garrisoning in Yangmei Village to pay for rice, he wrote "letter of money left by the Red Army" in ink on the wall of Zuocuo in Rongfu Hall ／Photographed by Lai Xiaobing

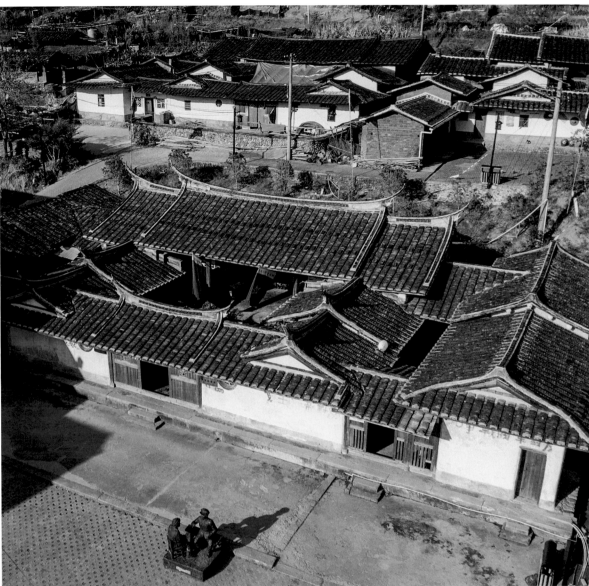

01

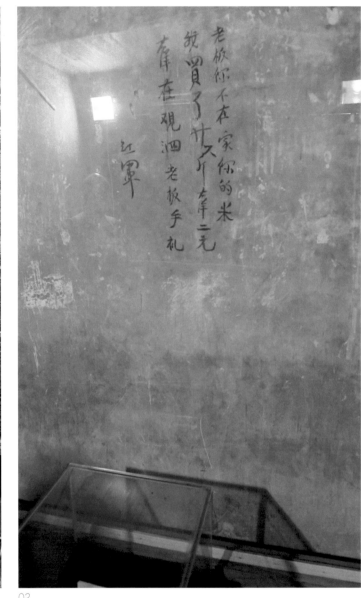

02

01　　　漳平象湖红色革命旧址群位于漳平市象湖镇杨美村，拥有多处珍贵的红色革命旧址 ／ 吴军 摄

　　　　Zhangping Xianghu Red Revolutionary Sites is located in Yangmei Village, Xianghu Town, Zhangping City, with many precious former red revolutionary sites /Photographed by Wu Jun

02　　　全国唯一保存最完整的"红军留款信" ／ 赖小兵 摄

　　　　The only "letter of money left by the Red Army" with the most complete preservation in China /Photographed by Lai Xiaobing

Dream
Back to
Cradle
Hakka

第二章 梦回摇篮客家

　　汀江是绿色的。被绿色汀江吸引、从黄土中原迁徙而来的客家，给绿色汀江增添了一道深沉的青。你看客家人居住的围屋、土楼，屋顶都是青色的，平实、稳重、扎实而低调，纵是在阳光之下也不显眼，青色成了客家人异地生存发展的保护色。据史料记载，从晋代开始，成千上万中原汉人为躲避战乱、灾荒，纷纷南迁，开始定居于汀江流域，形成中国汉民族中一支独特的民系——客家。客家在长期与本土相融的过程中，其语言、宗教、文化、住宅、饮食、劳作方式、生活习惯、民情风俗等等，都有其鲜明的特点。南宋时，随着汀江航运的开通，汀江成为海上丝绸之路的重要延伸和组成部分，汀州城成为连接赣州、梅州的中心枢纽和商贸重镇，"阛阓繁阜，不减江浙中州"。尔后，无数客家人又从这里起步，顺着滔滔的汀江水漂洋过海，不断向外迁移，播衍海内外，开拓新的生存空间，先是向上杭、武平、粤东、广西、云南、台湾等地迁徙，明清时又有大批客家人迁往东南亚以及欧美各地。汀江以鲜嫩的绿色养育了客民，成为天下客家的摇篮，被称为"客家母亲河"，汀州则被尊为客家之首府。

　　The Tingjiang River is green. The Hakkas attracted by the green Tingjiang river to migrate from the Loess Central Plains have infused a deep cyan to the green Tingjiang River. Look at the enclosures and earthen buildings where the Hakkas live. The roofs are all cyan. Even in the sunshine, they are not conspicuous. They are flat, steady, solid and low-key. Cyan has become the protective color for the survival and development of the Hakkas in distant places. According to historical records, at the Jin Dynasty, thousands of Han people in the Central Plains began to move southward to avoid war and famine, and settle in the Tingjiang River Basin. In the process of integration with the local indigenous people, they formed a unique family of Hakkas among the Chinese Han people, whose language, religion, culture, residence, diet, working style, living habits, customs, etc. preserved distinctive characteristics of Hakka in their adaptation to the local conditions. In the Southern Song Dynasty, with the opening of Tingjiang shipping, the Tingjiang River became an important extension and component of the Silk Road on the sea, and accordingly Tingzhou City became a central hub connecting Ganzhou and Meizhou, and a major commercial and trade town. The prosperity was even extolled by ancient lines. Afterwards, countless Hakkas started from here, drifting across the sea along the torrential Tingjiang River, migrating outward continuously, spreading abroad and at home, and exploiting new living space. First, they moved to Shanghang, Wuping, Eastern Guangdong, Guangxi, Yunnan, Taiwan and other places. During the Ming and Qing Dynasties, a large number of Hakkas moved to Southeast Asia and Europe and America. The Tingjiang River nurtured the Hakka people with fresh green, and became the cradle of Hakka in the world, known as the "Hakka Mother River", while Tingzhou was respected as the capital of Hakka.

A New
Hometown

他乡故乡

在永定的客家族谱博物馆内，陈列着自晋以来，中原人氏入闽前后的家族史，每一个姓氏、家族，都可在族谱中找到他们的先祖、繁衍及自己的位置。从中原而来的先民，不仅带来了生活方式与习俗，也带来了文化与宗教，同时又与本土的信仰相融合，传承创造、接纳本土的文化与宗教信仰，形成鲜明的客家特色。

In the Hakka Genealogy Museum in Yongding, the family history of the Central Plains people before and after entering Fujian since the Jin Dynasty is displayed. Every family name and family can find their ancestors, reproduction and their position in the genealogy. The ancestors from the Central Plains brought not only lifestyle and customs, but also culture and religion. At the same time, they integrated with local beliefs, inherited, created, and accepted local culture and religious beliefs, and formed Hakka's distinctive characteristics.

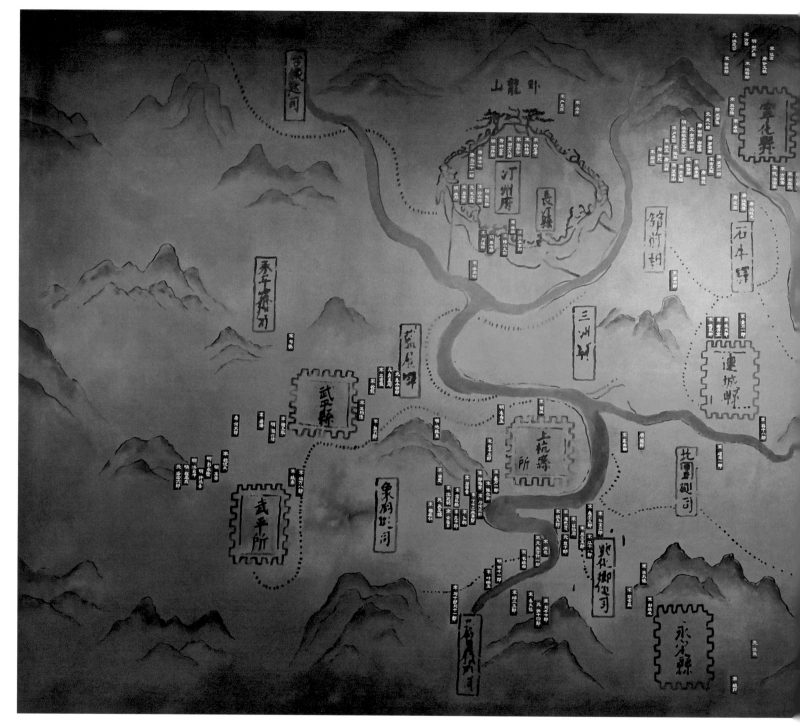

汀属八县客家开基始祖分布图 / 赖小兵 摄
Distribution Map of Hakka Original Ancestors in Eight Counties of Tingzhou /Photographed by Lai Xiaobing

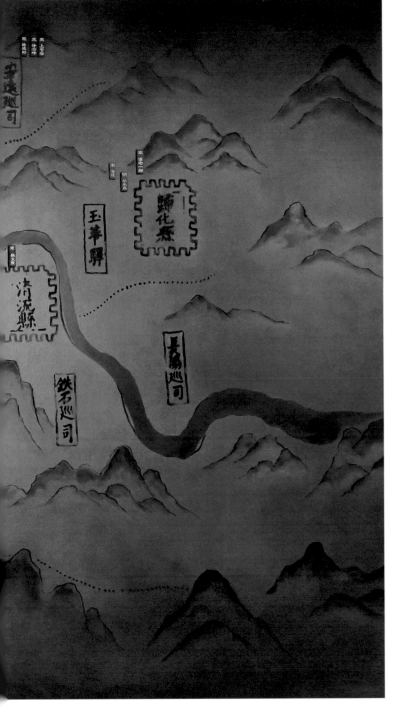

01

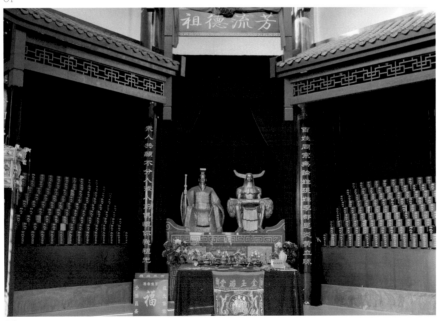

02

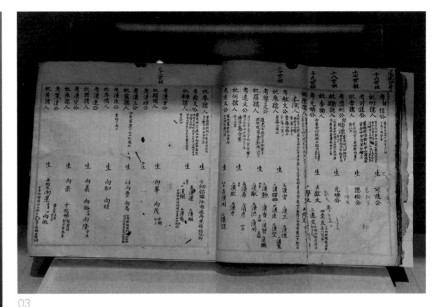

03

01　　客家族谱博物馆内保存的皇家族谱 / 赖小兵 摄
　　　Royal Genealogy preserved in Hakka Genealogy
Museum /Photographed by Lai Xiaobing

02　　武平是一个纯客家县，在中山镇境内就有一百多个姓
氏居住，是名副其实的百姓镇，图为百姓博物园内供奉的
姓氏牌位 / 朱晨辉 摄
　　　Wuping is a county only inhabited by Hakkas. There
are more than 100 surnames living in Zhongshan Town,
which is a veritable town of hundred surnames. The
picture shows the memorial tablet of surnames enshrined
in the Museum of Hundred Surnames /Photographed by
Zhu Chenhui

03　　客家族谱博物馆内保存的手写族谱 / 赖小兵 摄
　　　Handwritten Genealogy preserved in Hakka
Genealogy Museum /Photographed by Lai Xiaobing

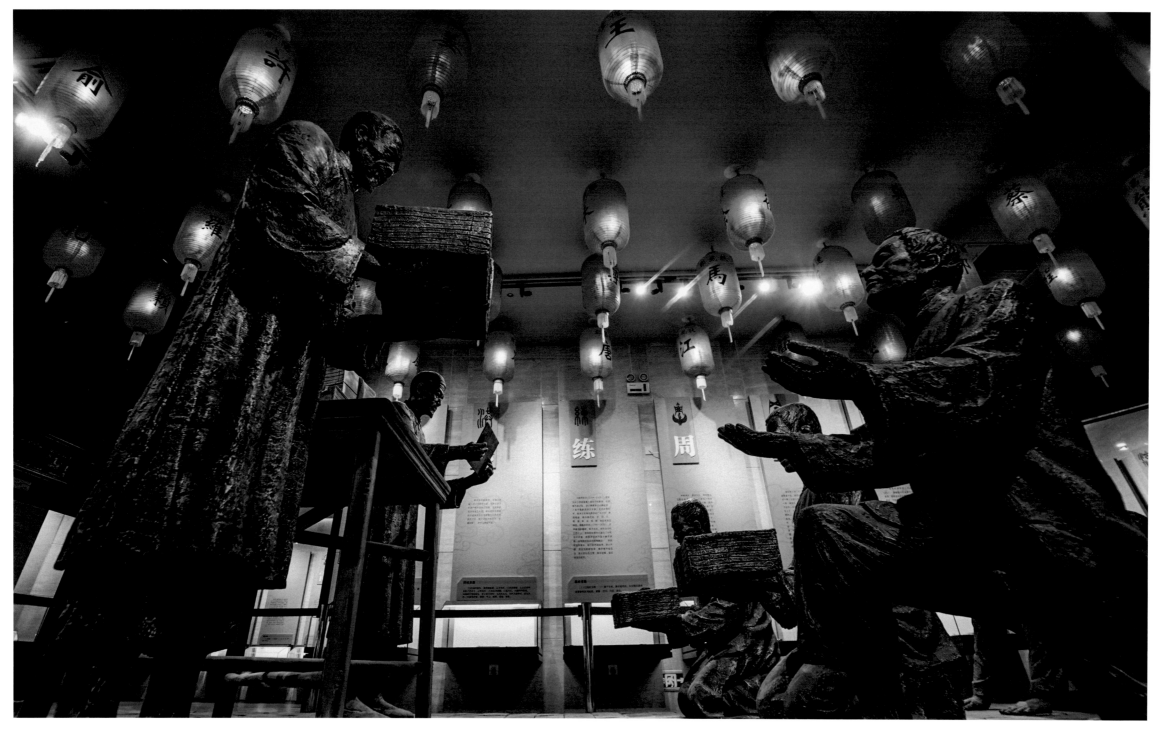

客家族谱博物馆介绍了客家人迁徙的历史 ／ 朱晨辉 摄
Hakka Genealogy Museum introduces the evolutionary history of Hakkas' migration /Photographed by Zhu Chenhui

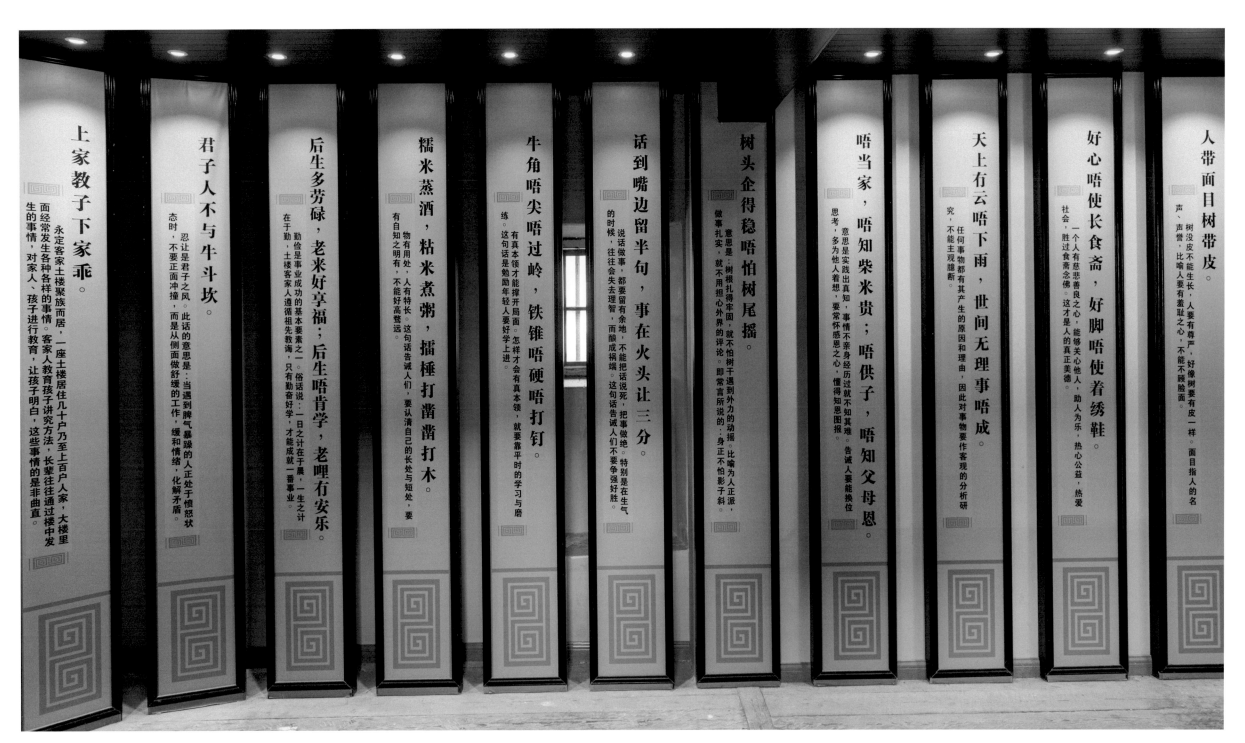

上家教子下家乖。

永定客家土楼聚族而居，一座土楼居住几十户乃至上百户人家，大楼里面经常发生各种各样的事情。客家人教育孩子讲究方法，长辈往往通过全楼中发生的事情，对家人、孩子进行教育，让孩子明白，这些事情的是非曲直。

君子人不与牛斗坎。

忍让是君子之风。此话的意思是：当遇到脾气暴躁的人正处于愤恨状态时，不要正面冲撞，而是从侧面做舒缓的工作，缓和情绪，化解矛盾。

后生多劳碌，老来好享福；后生唔肯学，老哩冇安乐。

勤俭是事业成功的基本要素之一。俗话说：一日之计在于晨，一生之计在于勤。土楼客家人遵循祖先教诲，只有勤奋好学，才能成就一番事业。

糯米蒸酒，粘米煮粥，擂棰打酱酱打木。

物有用处，人有特长。这句话告诫人们，要认清自己的长处与短处，要有自知之明有，不能好高骛远。

牛角唔尖唔过岭，铁锥唔硬唔打钉。

有真本领才能撑开局面。怎样才会有真本领，就要靠平时的学习与磨练。这句话是勉励年轻人要好学上进。

话到嘴边留半句，事在火头让三分。

说话做事，都要留有余地，不能把话说死，把事做绝。特别是在生气的时候，往往会失去理智，而酿成祸端。这句话告诫人们不要争强好胜。

树头企得稳唔怕树尾摇。

意思是：树根扎得牢固，就不怕树干遇到外力的动摇。比喻为人正派，做事扎实，就不用担心外界的评论。即常言所说的：身正不怕影子斜。

唔当家，唔知柴米贵；唔供子，唔知父母恩。

意思是实践出真知，事情不亲身经历过就不如其难。告诫人要能换位思考，多为他人着想，要常怀感恩之心，懂得知恩图报。

天上有云唔下雨，世间无理事唔成。

任何事情都有其产生的原因和理由，因此对事物要作客观的分析研究，不能主观臆断。

好心唔使长食斋，好脚唔使着绣鞋。

一个人有慈悲善良之心，能够关心他人，助人为乐、热心公益，热爱社会，胜过食斋念佛。这才是人的真正美德。

人带面目树带皮。

树没皮不能生长，人要有尊严，好像树要有皮一样，面目指人的名声、声誉，比喻人要有羞耻之心，不能不顾脸面。

客家家训馆展示了客家人坚韧不拔、开拓创新、爱国爱乡、团结互助、崇文重教的精神，收集了客家人最具代表性的家训、祖训等 / 赖小兵 摄

Hakka Family Instruction Hall shows the Hakka people's spirit of perseverance, innovation, patriotism and love for their hometown, solidarity and mutual assistance, and advocating literacy and education, and collects the most representative family instructions and ancestral instructions of the Hakka people /Photographed by Lai Xiaobing

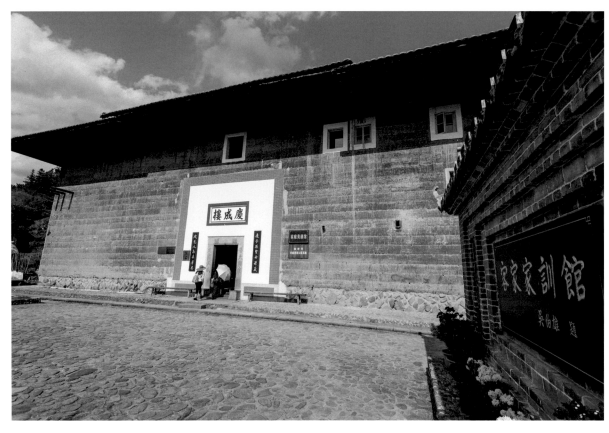

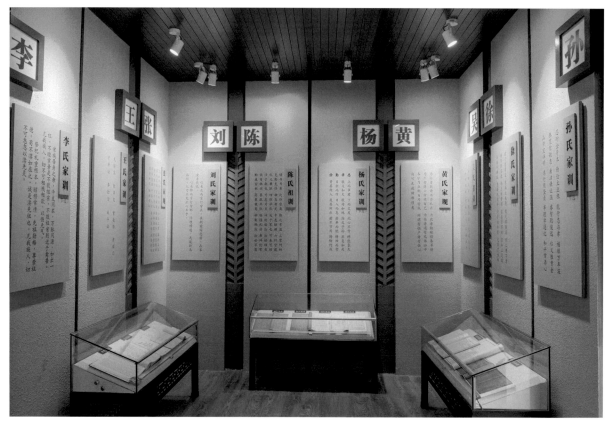

永定区湖坑镇庆成楼的客家家训馆由中国国民党名誉主席吴伯雄题写馆名 / 赖小兵 摄
The name of Hakka Family Instruction Hall in Qingcheng Building, Hukeng Town, Yongding is inscribed by Wu Boxiong, the honorary chairman of Kuomintang Party of China /Photographed by Lai Xiaobing

客家家训馆内展示的客家人族谱祖训和名人、名居家训、家规 / 严硕 摄
Ancestral instructions of Hakka genealogy and family instructions and family rules of celebrities and family residences displayed in Hakka Family Instruction Hall / Photographed by Yan Shuo

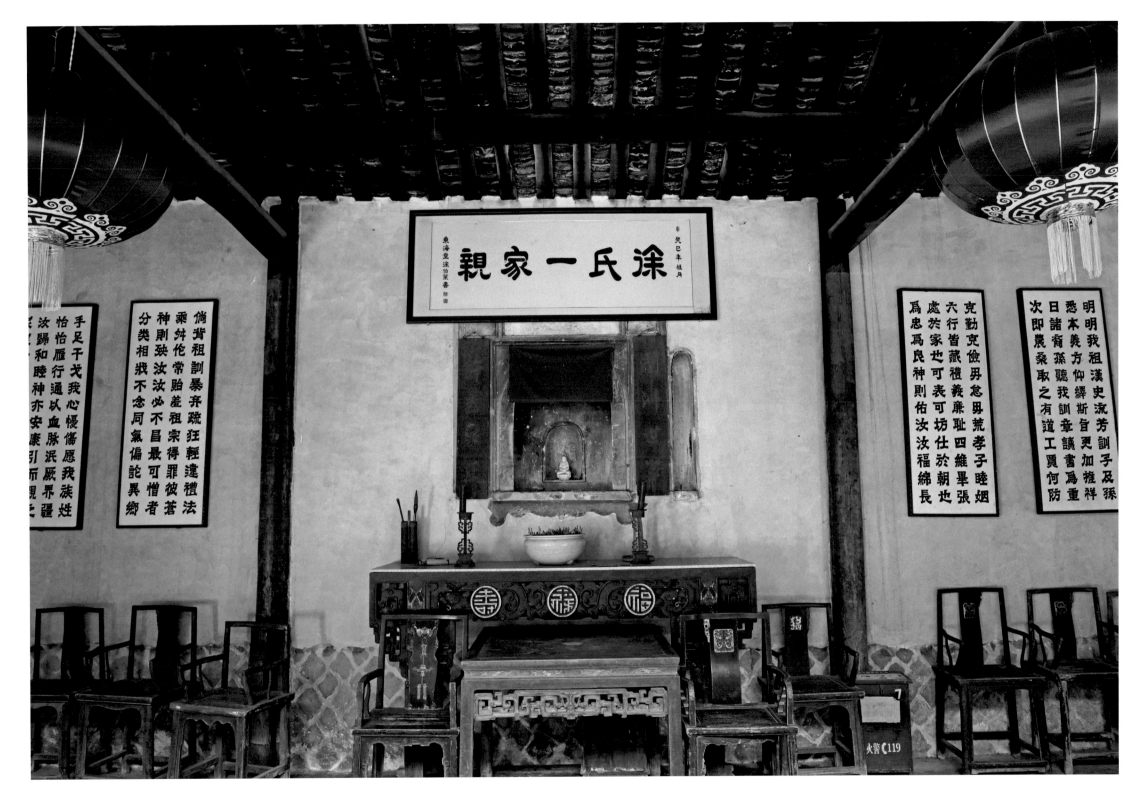

永定初溪村集庆楼大厅内高高悬挂着"徐氏一家亲"的牌匾，代表着客家人团结和睦的精神特质 / 焦红辉 摄
Chuxi Village of Yongding. The plaque of "The Xu Family" hung high in the hall of Jiqing Building represents the spiritual characteristics of unity and harmony of the Hakka people /Photographed by Jiao Honghui

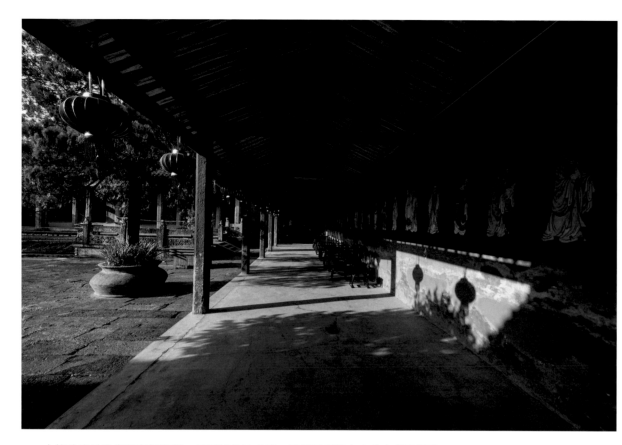 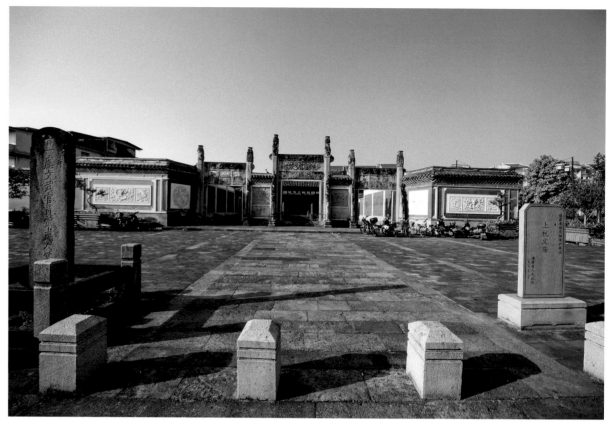

上杭孔庙是我省保存较完整、最具特色的文庙，是杭邑历代文人雅士尊孔祭孔、弘扬儒学、聚文会友的圣地 / 吴军 摄

Shanghang Confucian Temple is a well-preserved and most characteristic Confucian Temple in our province, which is a sacred place for refined scholars of various dynasties to respect and worship Confucius, carry forward Confucianism, gather scholars and meet friends /Photographed by Wu Jun

上杭孔庙的主要特点是在中轴线上布置主要建筑物，两旁布置陪衬的建筑物。上杭孔庙以大成殿为主体，分前、中、后三门（走廊） / 吴军 摄

The main feature of Shanghang Confucian Temple is that the main buildings are arranged on the central axis and the foil buildings are arranged on both sides. The main body of Shanghang Confucian Temple is Dacheng Hall, which is divided into three doors (corridors): front, middle and back /Photographed by Wu Jun

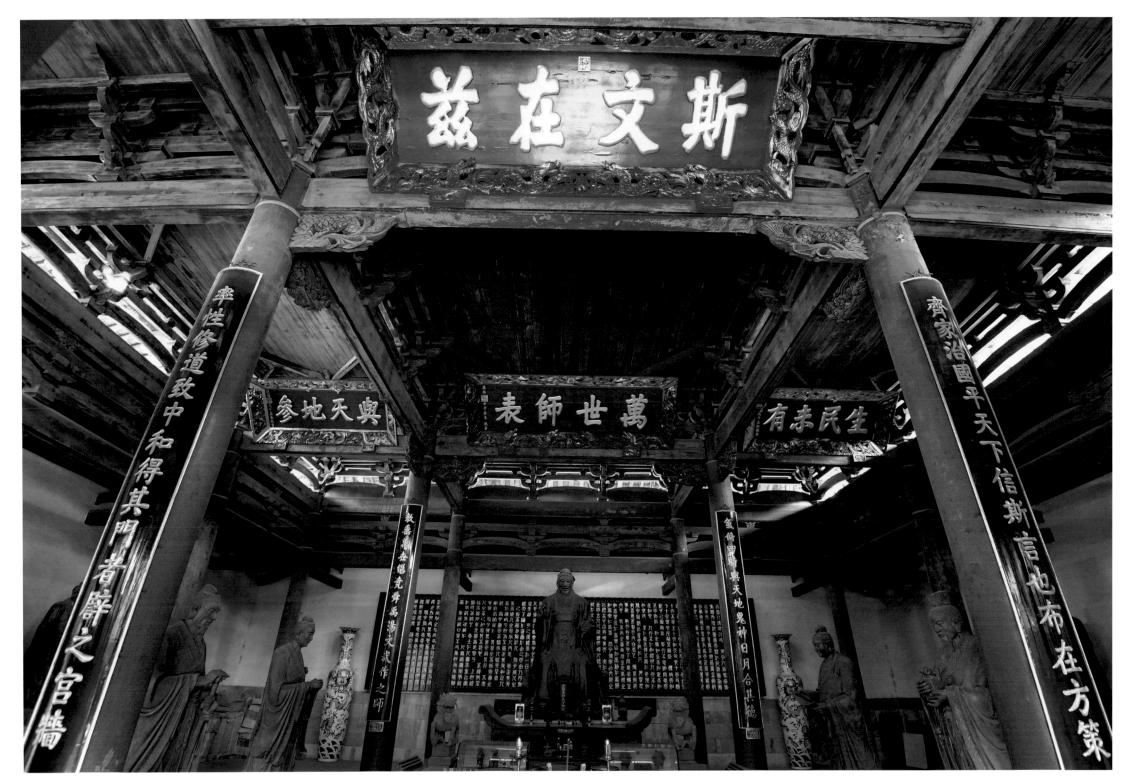

始建于漳平置县之年——明成化七年（1471）的漳平文庙 / 赖小兵 摄
Zhangping Confucian Temple was built in the 7th year of the Chenghua Period in the Ming Dynasty (1471) when Zhangping was set up as a county /Photographed by Lai Xiaobing

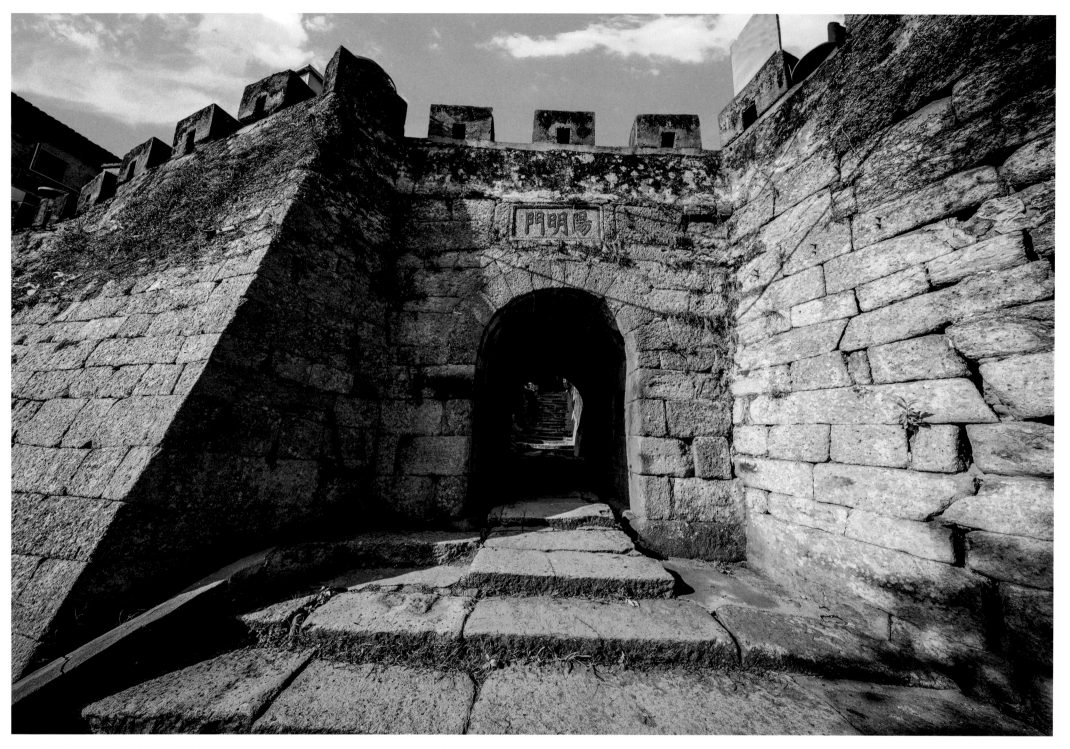

明朝巡抚王阳明在上杭建桥，平寇，祈雨有功，不久官拜兵部尚书。上杭人为纪念这位明代最著名的思想家，教育家，文学家和军事家，将南门渡口的城门改为"阳明门" ／ 蓝善祥 摄

The governor Wang Yangming of the Ming Dynasty built a bridge in Shanghang and rendered meritorious services to pacify the enemies and pray for rains, soon who was appointed as Director of Department of War in Feudal China. In honor of this most famous thinker, educator, litterateur and military strategist of the Ming Dynasty, the Shanghang people changed the gate of the South Gate Ferry to "Yangming Gate" /Photographed by Lan Shanxiang

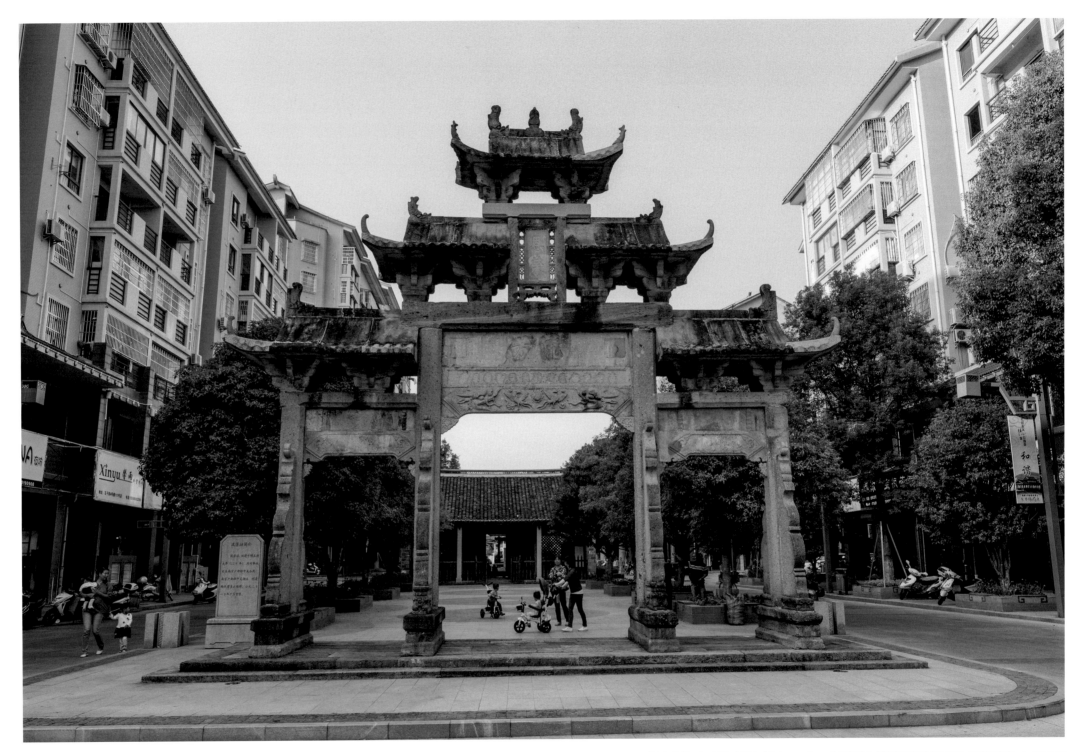

瓦子街流芳坊建于明正德九年（1514），记录了上杭吴氏客家近 500 年的影响 / 吴军 摄
The Liufang archway of Wazi Street was built in the 9th year of the period of Zhengde in the Ming Dynasty (1514), which has recorded the influence of Hakka Wu Family for almost 500 years in Shanghang /Photographed by Wu Jun

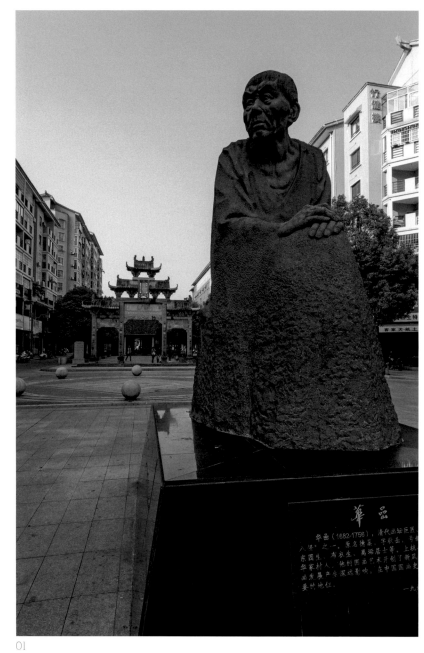

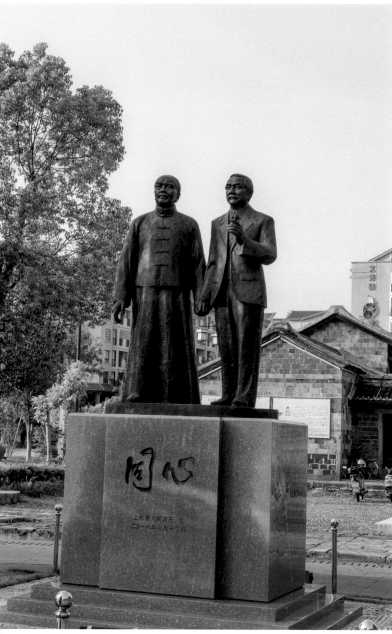

01　华嵒，福建上杭人，工画人物、山水、花鸟、草虫。善书，能诗，时称"三绝"，为清代杰出绘画大家，扬州画派的代表人物之一 / 吴军 摄

Hua Yan, a native of Shanghang, Fujian Province, was good at painting figures, mountains and waters, flowers and birds, grass and insects. He was good at calligraphy and poetry and was called "three wonders" at that time, who was one of the outstanding painting masters in the Qing Dynasty and one of the representatives of Yangzhou Painter Groups /Photographed by Wu Jun

02　上杭瓦子街竖立的以孙中山与丘逢甲共商国是的史实为题材创作的《同心》铜像 / 吴军 摄

Stood on the Wazi Street, Shanghang, the bronze statue of Tong Xing was created on the theme of the historical scene that Sun Yat-sen and Qiu Fengjia were discussing state affairs /Photographed by Wu Jun

03　丘氏总祠位于上杭县城瓦子街中段，建于明正德年间（1506-1521），是曾任督察御史丘道隆的故宅。上杭丘氏总祠曾是福建省最早的民立师范——"上杭师范传习所"旧址，1905 年著名的抗日保台爱国志士丘逢甲，在上杭丘氏总祠创办"上杭县师范传习所"，开设国文、英语、算学、史地、植物等课。这是上杭历史上第一所培养师资的学校，为兴办新学培养了骨干力量 / 吴军 摄

Located in the middle of Wazi Street, Shanghang County, the General Ancestral Hall of Qiu family was built in the reign of Zhengde in the Ming Dynasty (1506-1521),which is the former residence of Qiu Daolong, the former inspector. The General Ancestral Hall of Qiu family in Shanghang was the former site of "Shanghang Normal School", the earliest private normal school in Fujian Province. In 1905, Qiu Fengjia, the famous patriot who fought against Japanese aggression and protected Taiwan, founded "Shanghang County Normal School" at the General Ancestral Hall of Qiu family in Shanghang, offering courses of Chinese, English, Mathematics, History and Geography, and Plants, etc. This is the first school in the history of Shanghang to train teachers, which had trained the backbone for the establishment of new schools /Photographed by Wu Jun

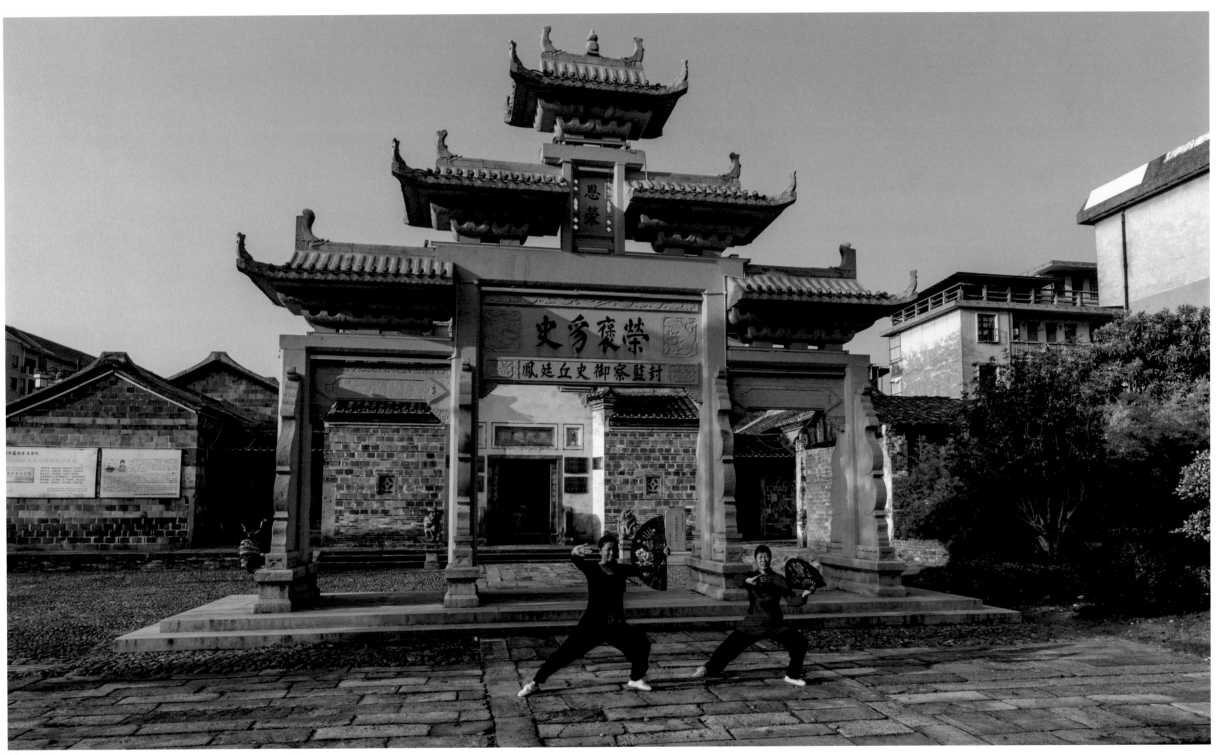

03

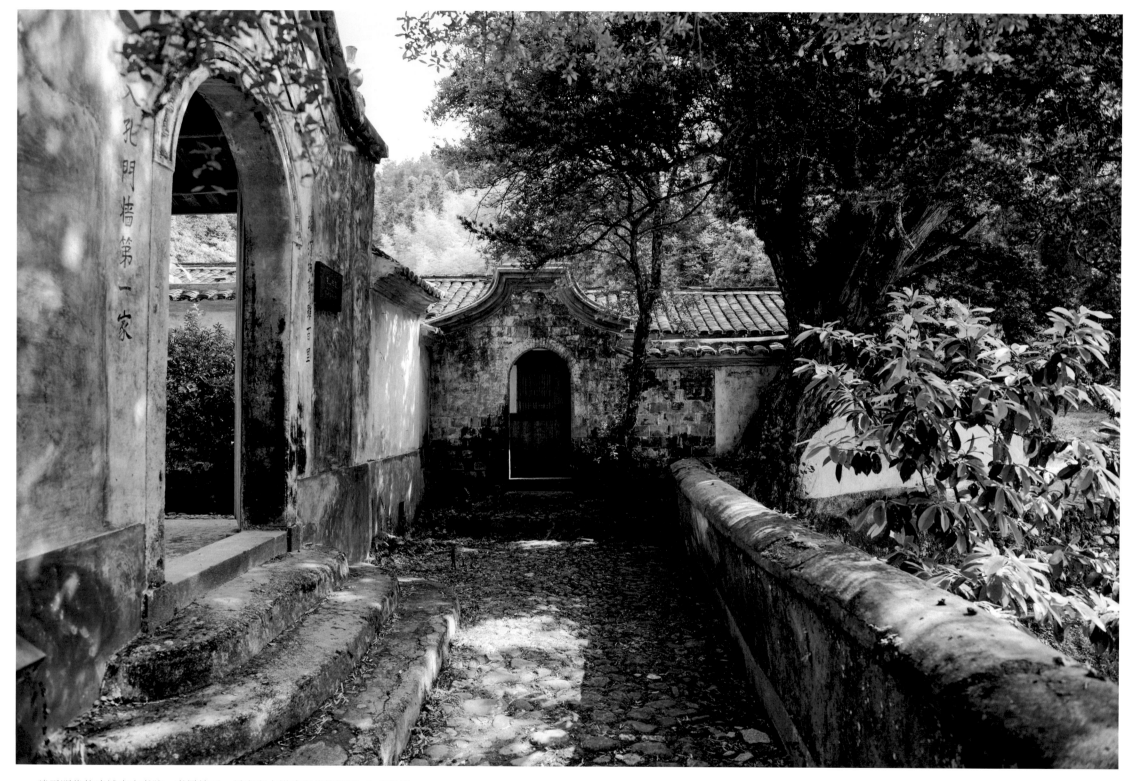

建于明代的连城南山书院，书风绵延，是客家人耕读文化的缩影 / 曾璜 摄

Liancheng Nanshan Academy built in the Ming Dynasty, has a long history of calligraphy, which epitomizes the farming-reading culture of the Hakka people /Photographed by Zeng Huang

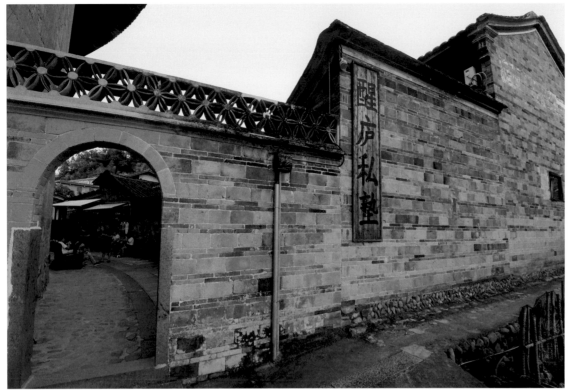

01

01 　　永定振成楼旁的醒庐私塾是教书育人的地方，寓意着客家人的崇文重教 ／
赖小兵 摄

　　Xinglu Old-Style Private School for imparting knowledge and educating
people beside Yongding Zhencheng Building is a symbol of the Hakka people's
emphasis on literacy and education /Photographed by Lai Xiaobing

02 　　永定初溪土楼群内的林氏蒙学堂——日新学堂，现在是洪坑小学和幼儿园所
在地。一个世纪以前，有钱的族长们在这个山沟里建了这么一个很西式的小学，
可以想见对教育的重视 ／ 赖小兵 摄

　　Rixin School—Meng School of Lin Family, in Chuxi earth building groups, in
Yongding is now the location of Hongkeng Primary School and Kindergarten.
One century ago, wealthy patriarchs built such a Western style primary school
in this gully that one could imagine the importance attached to education /
Photographed by Lai Xiaobing

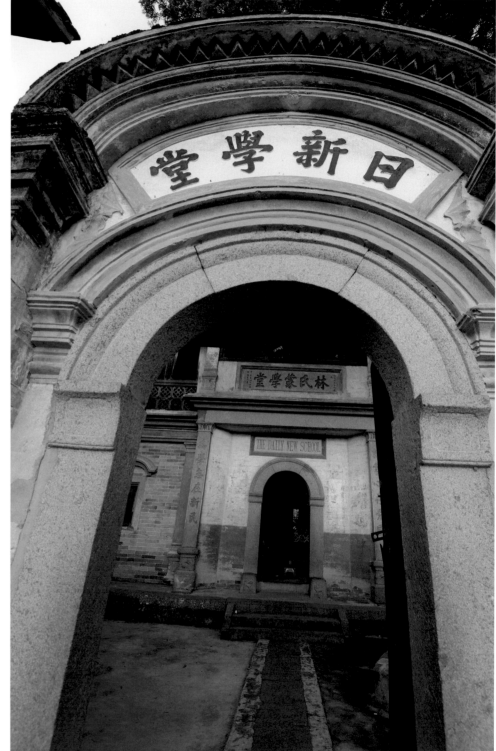

02

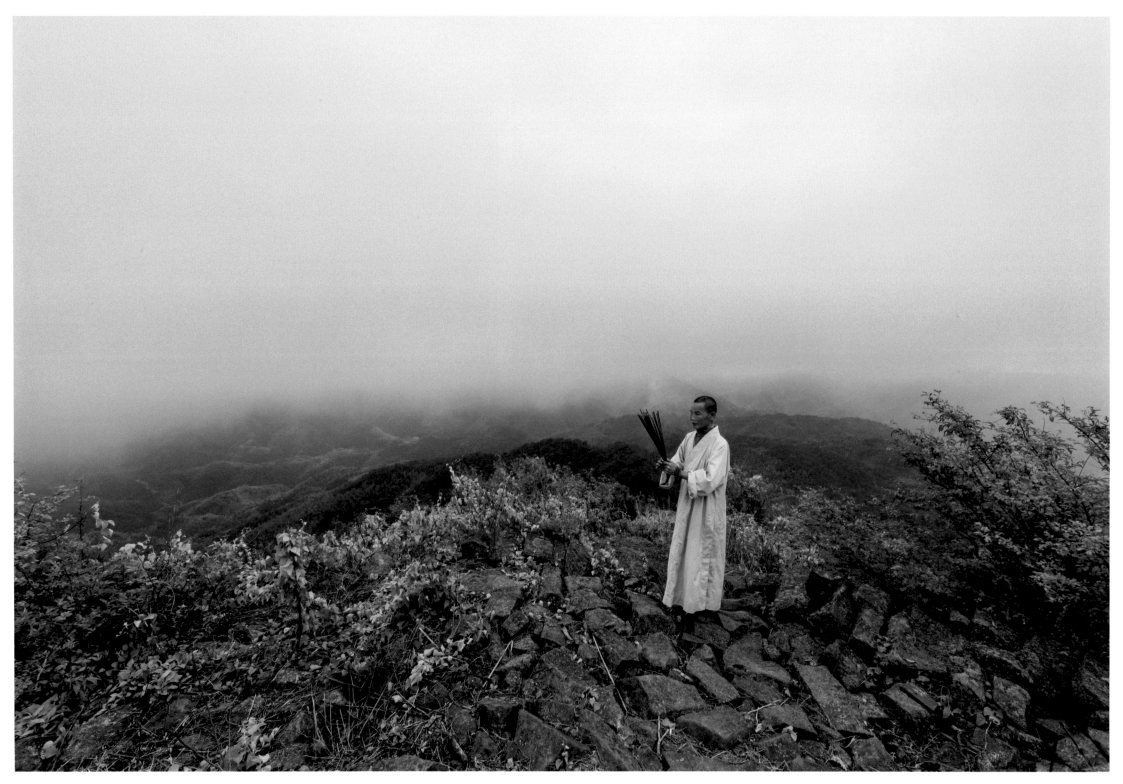

长汀大悲山上的莲峰寺主持正在向天祭拜，祈福平安 / 吴军 摄
The abbot of Lianfeng Temple on the Dabei Mountain in Changting is offering sacrifices to heaven to pray for peace /Photographed by Wu Jun

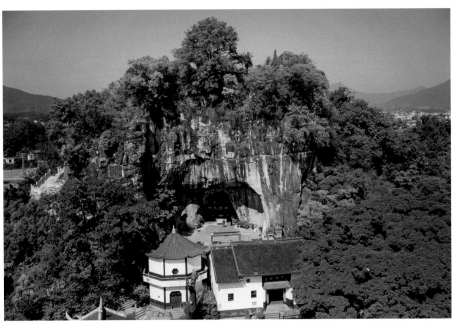

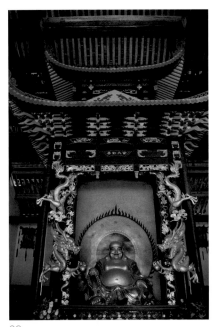

01

02

01　武平定光佛祖庙 / 朱晨辉 严硕 摄
Dingguang Buddha Temple in Wuping /
Photographed by Zhu Chenhui, Yan Shuo

02　武平均庆寺内上梁的柱子上写有大清年间重修的
字样 / 郭晓丹 摄
The pillars of the upper beam in Junqing
Temple in Wuping are marked with the words
"Rebuilt before the Qing Dynasty" /Photographed by
Guo Xiaodan

03　定光古佛，宋初僧人，是闽西汀州客家人之重要
守护神 / 吴军 摄
Dingguang Ancient Buddha, a monk in the
early Song Dynasty, was an important patron saint
of the Hakka people in Tingzhou, Western Fujian /
Photographed by Wu Jun

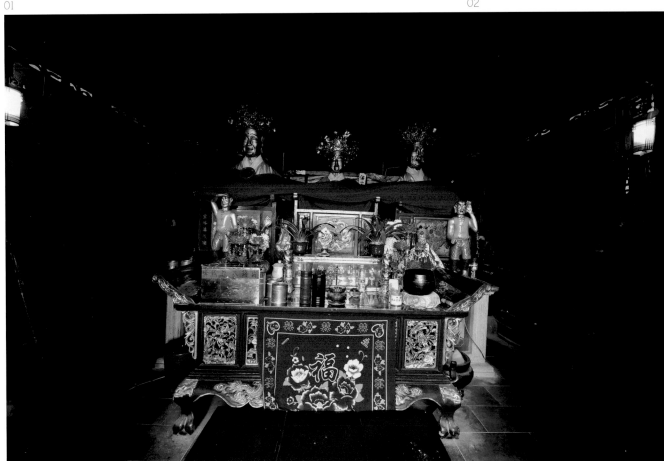

03

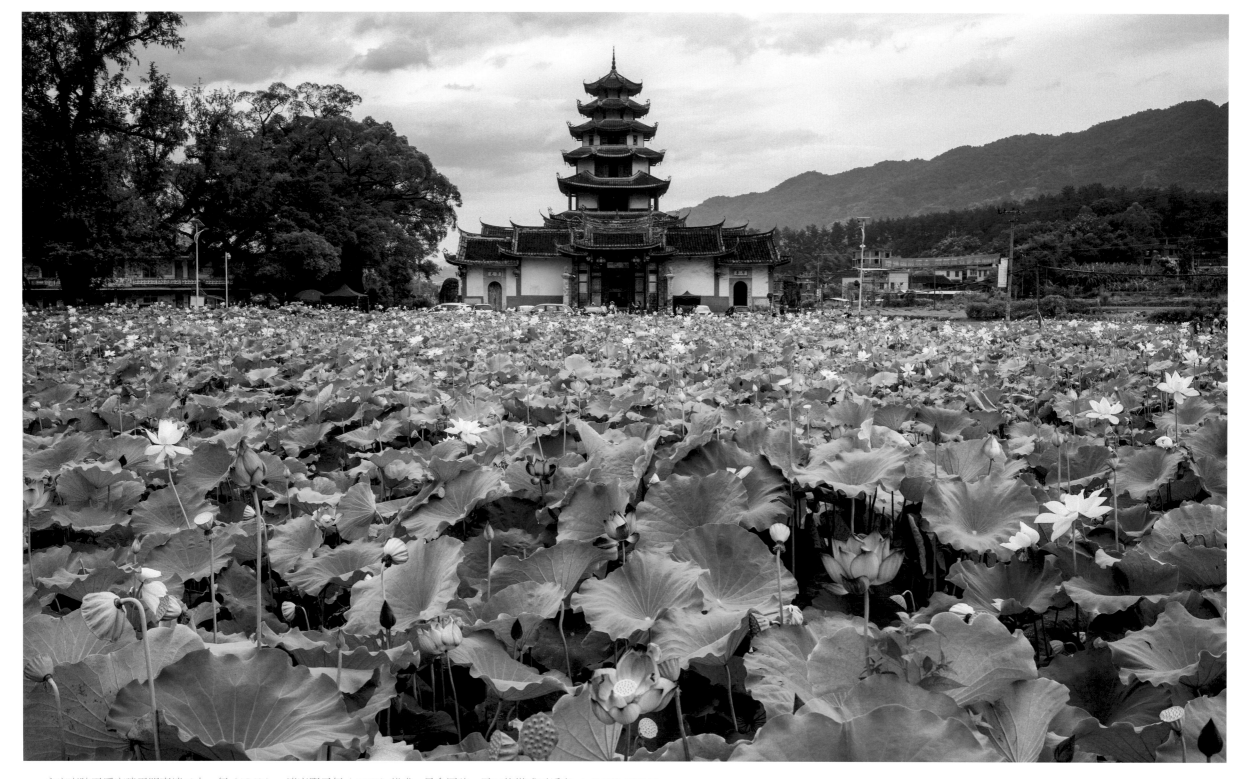

永定高陂天后宫建于明嘉靖二十一年（1542），清康熙元年（1662）落成，是全国独一无二的塔式天后宫 / 朱晨辉 严硕 摄

Tianhou Palace in Gaobei Town of Yongding District was built in the 21st year of the Jiajing Period of the Ming Dynasty (1542) and completed in the first year of the Kangxi Period of the Qing Dynasty (1662), which was the only tower-style Tianhou Palace in China /Photographed by Zhu Chenhui, Yan Shuo

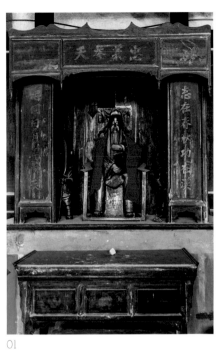

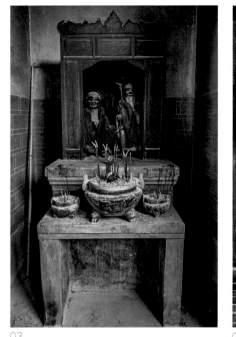

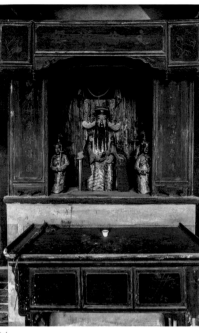

01 02 03 04

01 位于主塔二楼的关圣君

General Guan Yu in the second floor of the main tower

02 位于主塔四楼的魁星大帝

Emperor Kuixing (Daoist God of fate) in the fourth floor of the main tower

03 位于主塔一楼的土地公、土地婆

Earth God and Earth Grandmother in the first floor of the main tower

04 位于主塔三楼的文曲星

Legendary deity of imperial examinations and literary affairs in the third floor of the main tower

05 位于高陂镇西陂村的天后宫敬奉的各路神灵

Various gods worshipped in Tianhou Palace in Xibei Village, Gaobei Town

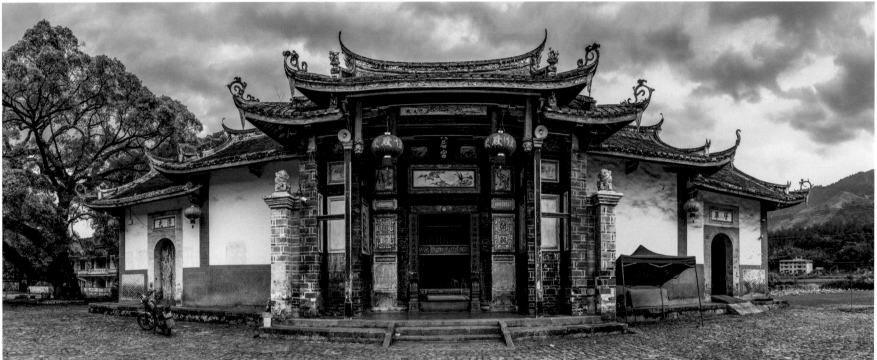

05

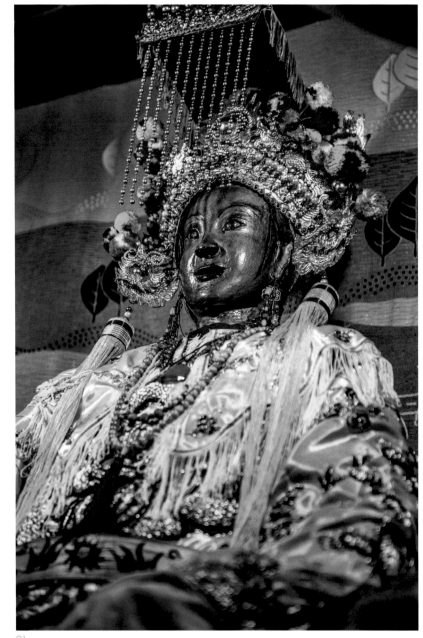

01

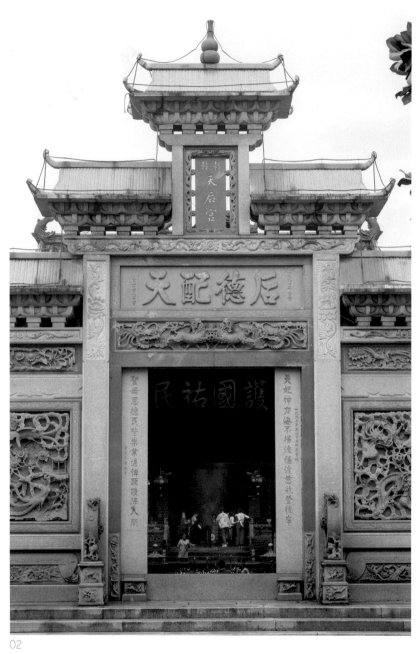

02

01 汀江开辟了航运之后，本地盛产的土纸、药材、木材和农产品得以对外输送。但是，汀江河道狭窄迂回曲折，滩多水急船运多有不便。为祈求平安，百姓在南宋理宗嘉熙（1237-1240）年间，依照潮州妈祖庙的样式创建了"三圣妃宫"供奉妈祖三圣妃 / 严硕 摄

After the opening of shipping in the Tingjiang River, the rich local handmade paper, medicinal materials, timber and agricultural products could be transported to the outside world. However, the streamway of the Tingjiang River is narrow and winding, with many shoals and rapids, which is very inconvenient for shipping. In order to pray for safety, the people during the Reign of Emperor Lizong in the reign of Jiaxi in the Southern Song Dynasty (1237-1240 AD), according to the style of Mazu Temple in Chaozhou, built the 'Three Holy Concubines 'Palace' to worship the 'Mazu Three Holy Concubines' /Photographed by Yan Shuo

02 长汀天后宫四面环水，是汀州八邑敬奉妈祖的场所和旅游观光胜地 / 赖小兵 摄

Surrounded by water on all sides, Tianhou Palace in Changting is a place for eight counties of Tingzhou to worship Mazu and is a tourist attraction /Photographed by Lai Xiaobing

03 长汀天后宫内妈祖塑像安放在正殿中央，容颜慈祥，金线锦绣龙袍、银质镂刻凤冠霞帔。据说这尊神像已有近400年历史 / 赖小兵 摄

The statue of Mazu in Tianhou Palace in Changting is placed in the center of the main hall, with a kind face, whose dragon robe is embroidered with gold thread and phoenix coronet and robes of rank are engraved in silver. It is said that this statue has a history of nearly 400 years / Photographed by Lai Xiaobing

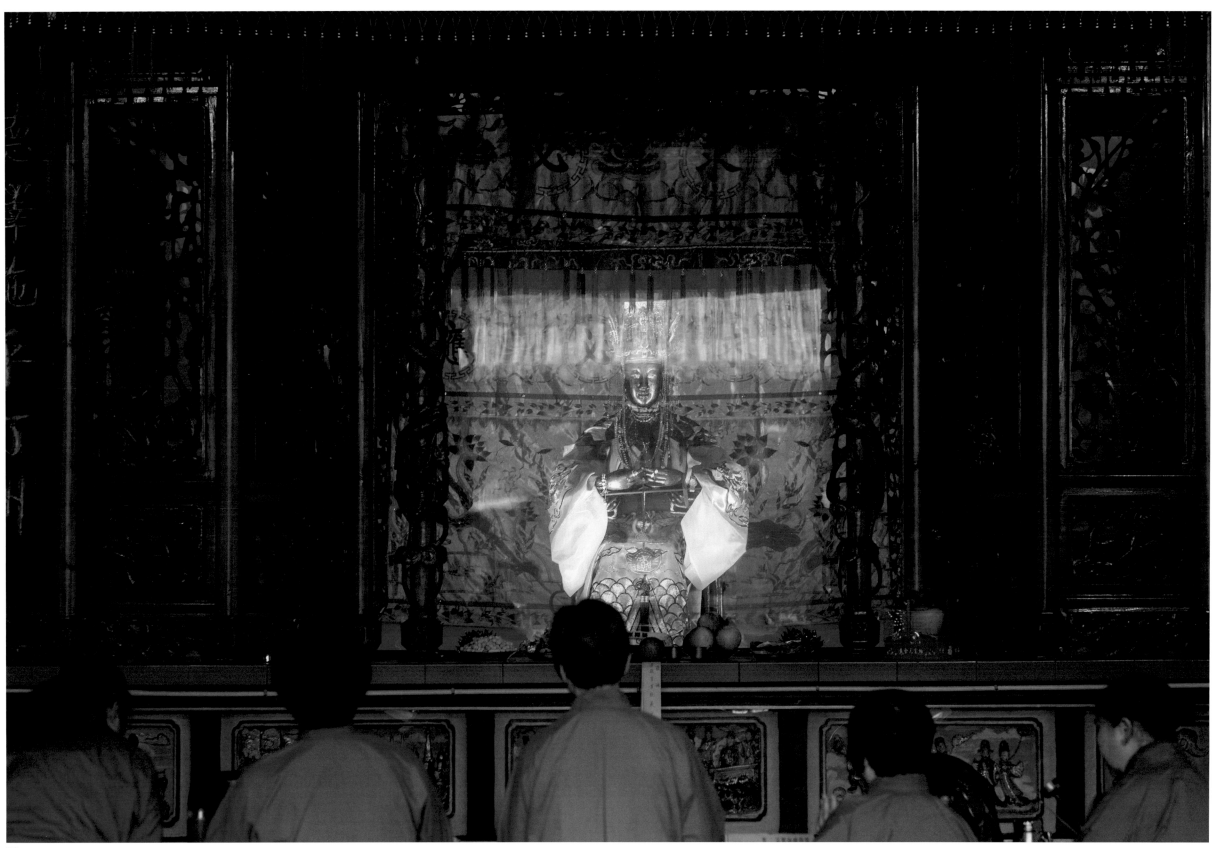

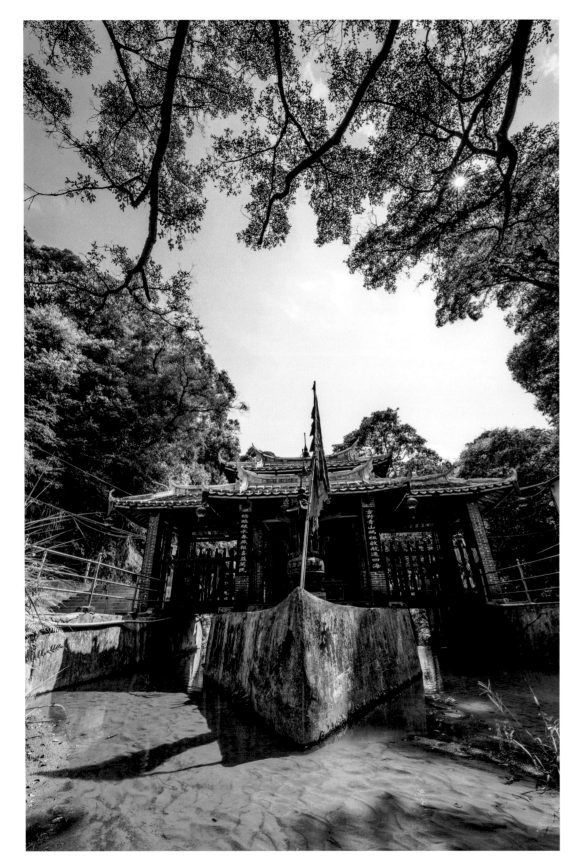

原中国国民党主席马英九、吴敦义曾向源兴桥天后宫各捐款一万元 / 严硕 摄
Ma Ying-jeou and Wu Den-yih, the former chairmen of Kuomintang Party of China, donated 10000 yuan each to Yuanxingqiao Tianhou Palace /Photographed by Yan Shuo

新罗区龙门镇的源兴桥天后宫建立在河道的中间，底座如船 / 严硕 摄
Yuanxingqiao Tianhou Palace in Longmen Town, Xinluo District was built in the middle of the river, with a base like a boat /Photographed by Yan Shuo

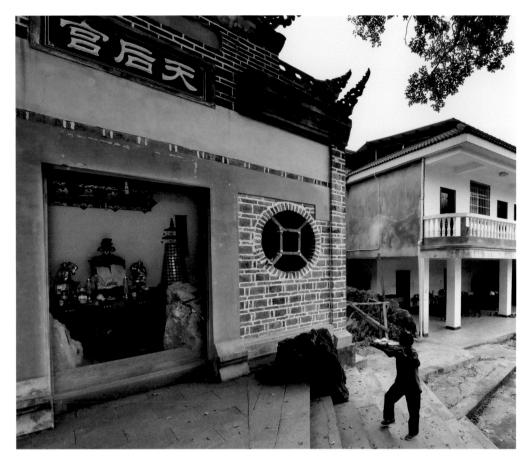

汀江源龙门山岗上的天后宫 / 吴军 摄
Tianhou Palace on Yuanlongmen Hill in the headstream of the Tingjiang
River /Photographed by Wu Jun

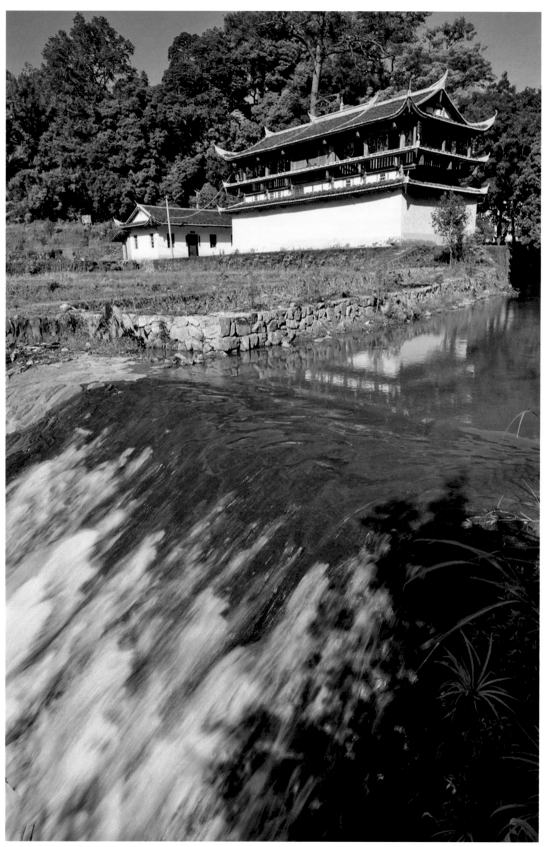

上杭白砂镇碧沙村的天后宫 / 赖小兵 摄
Tianhou Palace in Bisha Village, Baisha Town, Shanghang /
Photographed by Lai Xiaobing

Blessed
Residence

福地民居

由于是外地迁入，客家人对居住安全与相互照应，尤为重视。于是，自成一体的建筑格局出现了，围屋与土楼等是这种建筑的代表作。围屋或土楼，让一个家族的男女老少生活在一个相对封闭的空间里，但这个空间又是一个大千世界，生活的衣食起居、用水、排污、生育、死亡等都有一应的安排，包括读书、议事、宗教活动等，其中安全防卫则是第一位的。在此居住的客家人，其财富、人身都有保障，与那种村寨的一家一户的居住方式不同，有着明显的群体自卫功能。客家人是富有创造力的，土楼或围屋，不仅是一个安全的形体，一个多式功能的居住空间，而且吸纳了中原建筑的传统与工艺，如外在的形体造型与山水自然的关系，内部的结构与空间的分割等等，使得客家的建筑，达到了"建筑韵"（梁思成、林徽因语）的境界。

Hakka's residential safety and mutual communication are the primary consideration due to the immigration from other places. Thus, a self-contained architecture emerged, with enclosure and earthen building being the representative works of this kind of architecture. Through either enclosure or earthen building, a family of men, women, old and young lived in a relatively closed space but meanwhile a vast world, where natural demands of food, clothes, water, sewage, fertility, death, etc. were all considered, and meaningful activities such as reading, deliberation, and religious ceremonies were all arranged, and security ranked the first. This style of accommodation has obvious group self-defense function, guaranteeing the Hakka people's wealth and personal security, distinctive from the individual households of the village. Hakka people are creative. Earthen building or enclosure is not only a safe form, a multi-functional living space, but also exerts the tradition and craftsmanship of Central Plains architecture in its construction. The relationship between the exterior shape and natural landscape, the division of the interior structure and space, etc., make Hakka architecture the "architectural charm" (said by Liang Sicheng and Lin Huiyin).

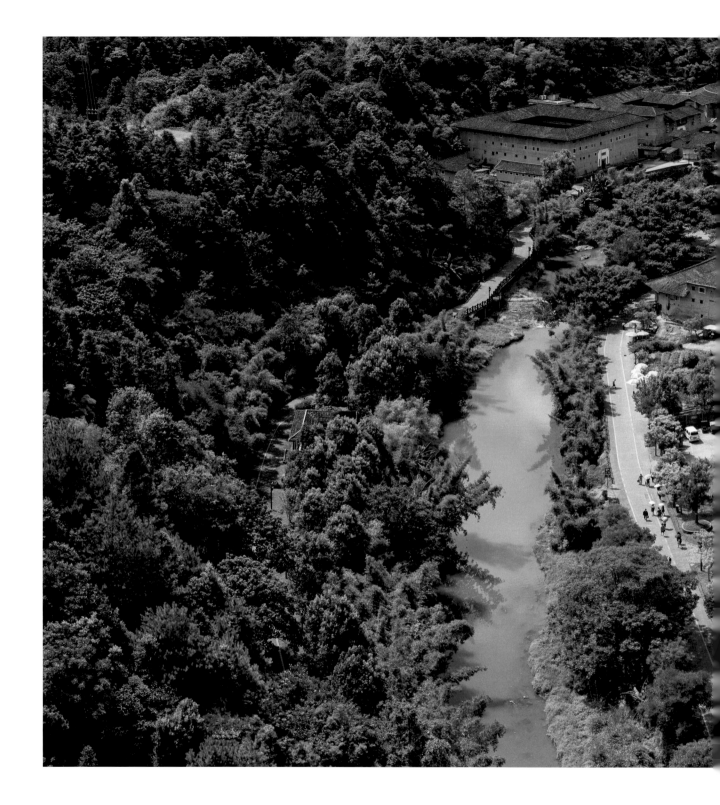

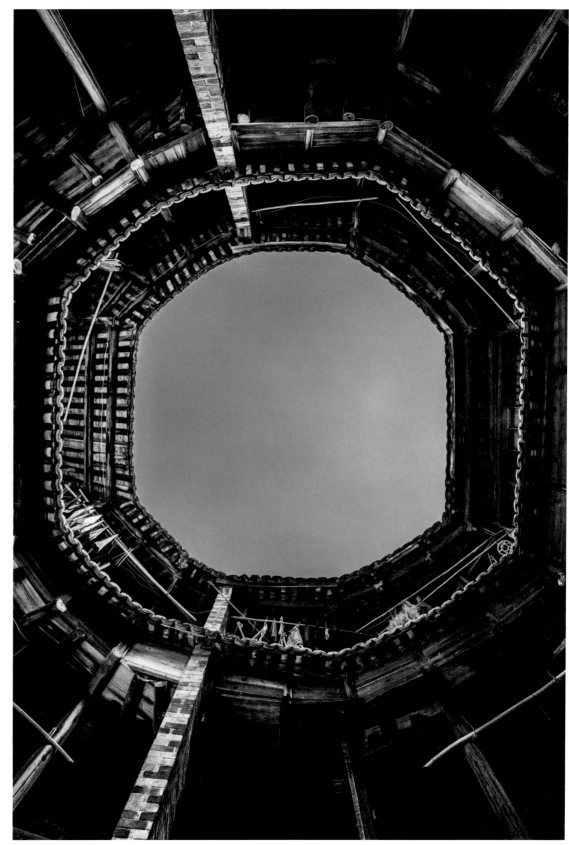

永定如升楼，俗称米升楼。清光绪年间（1875~1908）
建，林氏民居，为迄今所计最小的圆土楼 / 严硕 摄
　　Yongding Rusheng Building, is commonly called
Misheng Building. Built in the reign of Emperor
Guangxu in the Qing Dynasty (1875~1908), the
Lin Family's residence is the smallest round earth
building ever built / Photographed by Yan Shuo

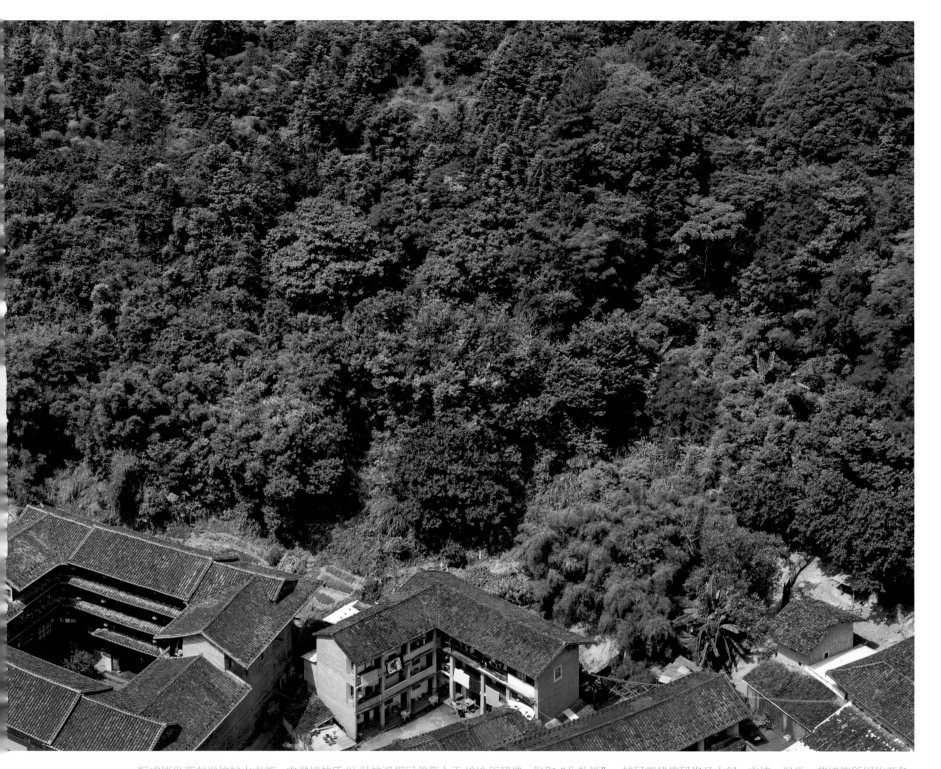

振成楼坐落在洪坑村中南部，由洪坑林氏 21 世林鸿超兄弟等人于 1912 年建造，俗称"八卦楼"。其局部建筑风格及大门、内墙、祖堂、花墙等所用的颜色，均采用了西方建筑美学所强调的多样统一原则，堪称中西合璧的生土民居建筑的杰作 / 朱晨辉 严硕 摄

Located in the south-central part of Hongkeng Village, Zhencheng Building was built in 1912 by Lin Hongchao and his brothers, who were the 21st generation of Lin family in Hongkeng. It is commoly known as "Eight Diagrams Building". The local architectural style and the colors used in the gates, interior walls, ancestral halls and tracery walls boldly adopt the principle of variety in unity emphasized by Western architectural aesthetics, which can be regarded as the architecture masterpiece of earth buildings with a combination of Chinese and Western elements /Photographed by Zhu Chenhui, Yan Shuo

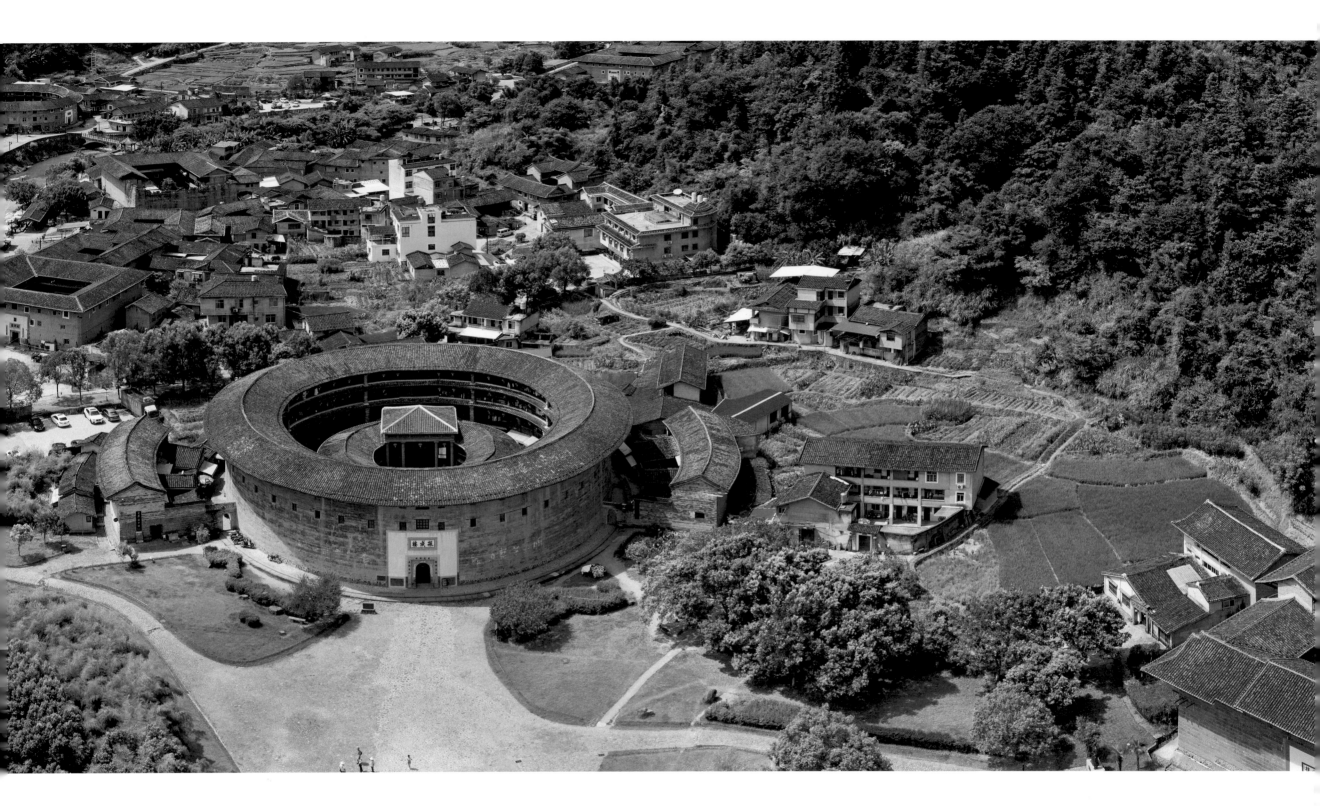

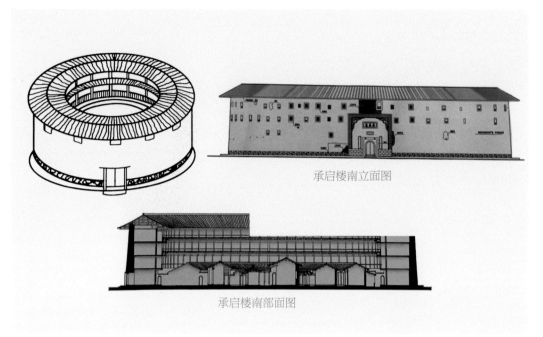

承启楼南立面图

承启楼南部面图

01

01 承启楼建筑结构图
Structural drawing of Chengqi Building

02 承启楼至今仍住有数十户人家，300余人过着共门户、共厅堂、共楼梯、共庭院、共水井的和睦生活 / 朱晨辉 摄
So far, there are still dozens of families living in Chengqi Building. More than 300 people live a harmonious life with a common door, a common hall, a common staircase, a common courtyard and a common well / Photographed by Zhu Chenhui

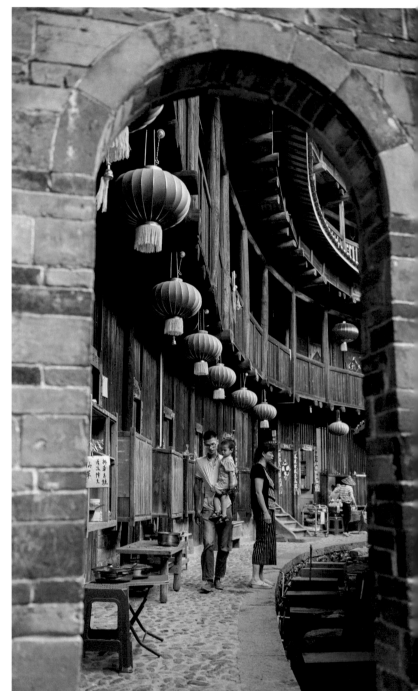

02

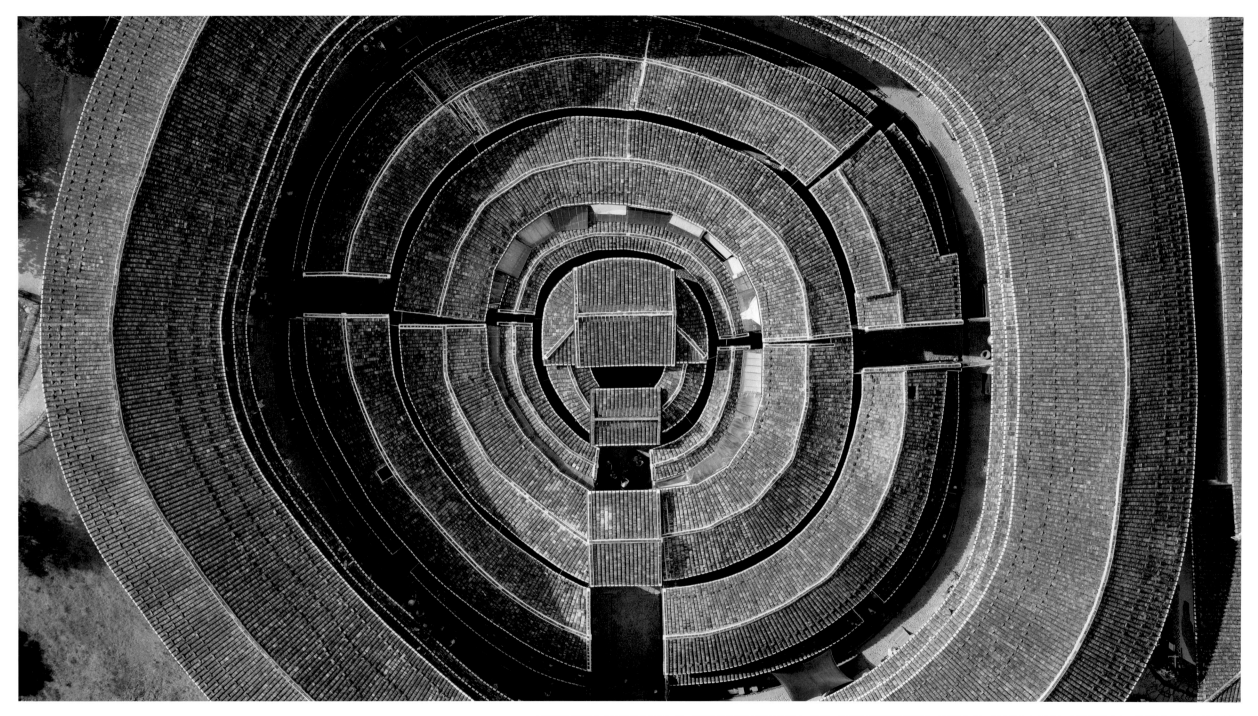

承启楼位于永定高头乡高北村，据传从明崇祯年间破土奠基，至清康熙年间竣工，历世3代，阅时半个世纪。其规模巨大，造型奇特，古色古香，充满浓郁的乡土气息。"高四层，楼四圈，上上下下四百间；圆中圆，圈套圈，历经沧桑三百年"，是对该楼的生动写照 / 朱晨辉 严硕 摄

Chengqi building is located in Gaobei Village, Gaotou Township, Yongding. It is said that it was built from the reign of Chongzhen in the Ming Dynasty, and was completed in the reign of Kangxi in the Qing Dynasty, which lasted for 3 generations and experienced half a century. It is huge in scale, peculiar in shape, antique and full of rich local flavor. "Four floors high, four-circles building, with four hundred rooms up and down; circle in circle, ring by ring, going through 300 years of vicissitudes", which is a vivid portrayal of this building /Photographed by Zhu Chenhui, Yan Shuo

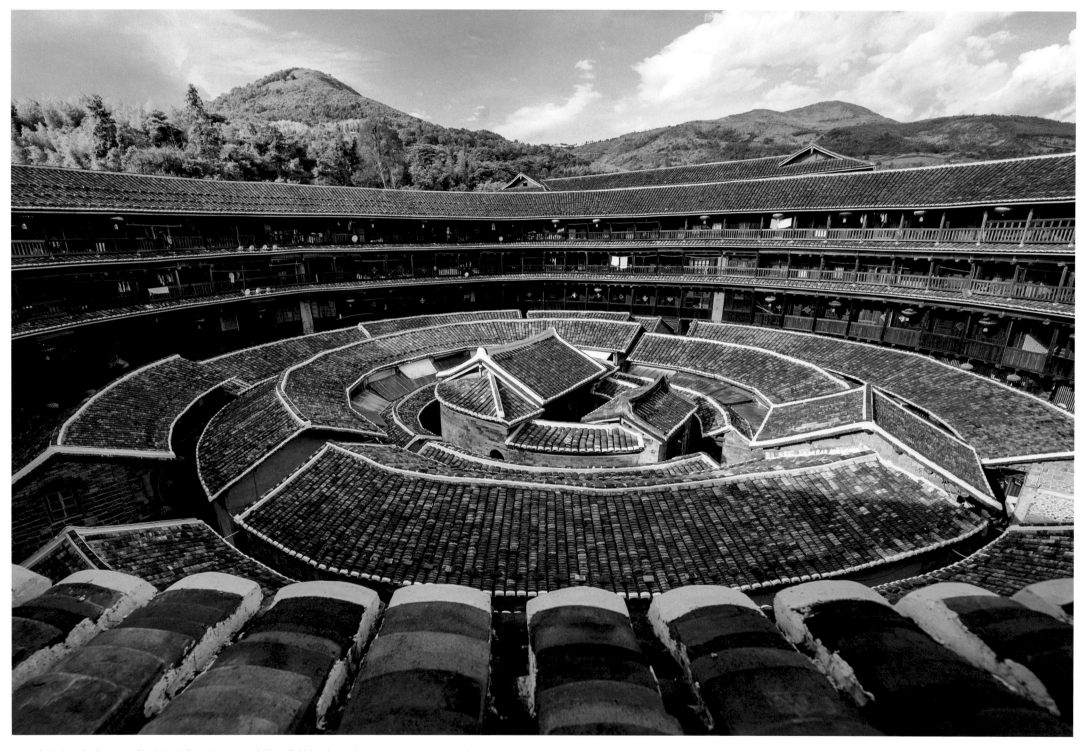

被誉为"土楼之王"的承启楼为三圈一中心结构。全楼住着60余户，400余人。其高大、厚重、粗犷、雄伟的建筑风格让无数参观者叹为观止 / 朱晨辉 摄

Known as the king of earth buildings, Chengqi Building has a three-circle and one-center structure. There are more than 60 families and 400 people living in the whole building. It combines poetic romantic charm of mountain areas with its tall, heavy, rugged, majestic architectural style and the dignified and beautiful malleable arts of its courtyard, which impresses countless visitors /Photographed by Zhu Chenhui

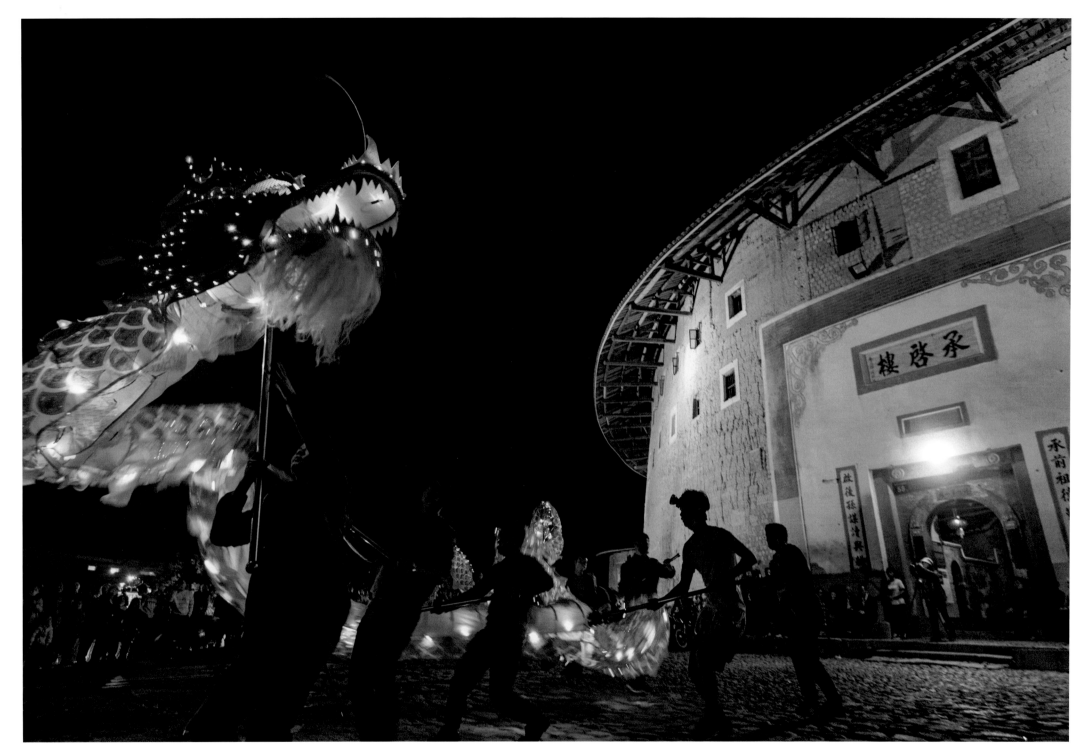

每当喜庆的节日，土楼人家总会舞起大龙，庆祝一番 / 赖小兵 摄
Whenever there is a festival, people in earth buildings always perform a dragon dance to celebrate it /Photographed by Lai Xiaobing

01　　　　遗经楼——"天下第一农家"。位于永定区高陂镇上洋村，由前中后三座五层方楼和左右两座四层方楼组成

Yijing Building——"The first farmhouse in the world". Located in Shangyang Village, Gaopi Town, Yongding County, it is composed of three five-storey square buildings in the front, middle and back and two four-storey square buildings in the left and right

02　　　　傍水而居的客家人，享受着与山水自然的亲近 / 陈军 摄

A countryside family enjoy the mountains and rivers /Photographed by Chen Jun

03　　　　夜幕下的土楼，星光灿烂 / 朱晨辉 摄

The earth building under the curtain of night, spangled with stars /Photographed by Zhu Chenhui

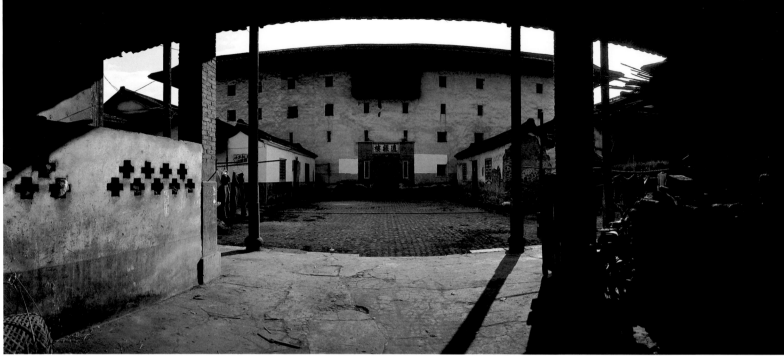

01

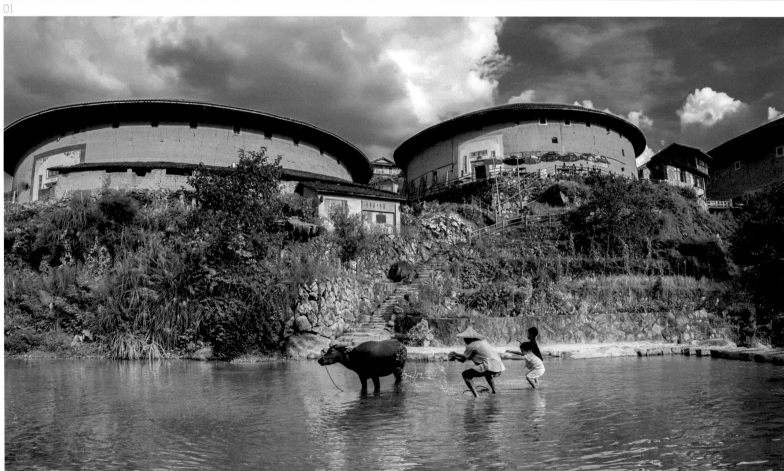

02

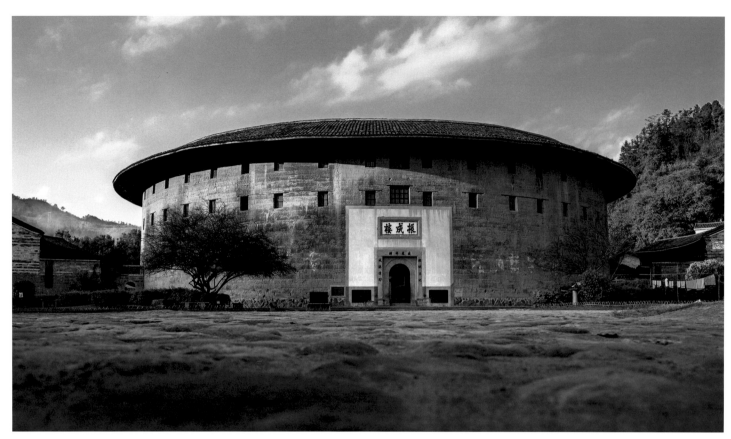

富丽堂皇的振成楼坐北朝南，按八卦概念结构建造，卦与卦之间设防火墙，每卦与内层一楼采用北方四合院格式。全楼的设施布局既有苏州园林的印迹，也有西方建筑的特点，堪称中西合璧的建筑奇葩。1995 年其建筑模型与北京天坛作为中国南北圆形建筑代表参加了美国洛杉矶世界建筑展览会，引起了轰动 / 陈军 摄

The magnificent Zhencheng Building faces south with the back to the north. It is built according to the concept structure of the Eight Diagrams, and the firewall is set between the diagrams, each diagram, and the first floor of the inner layer adopts the format of Northern courtyard house, which can be regarded as a wonderful architecture with a combination of Chinese and Western elements. In 1995, its architectural model and Beijing Temple of Heaven, as the representative of China's north and south circular architectures, took part in the World Architectural Exhibition in Los Angeles, USA, which caused a sensation /Photographed by Chen Jun

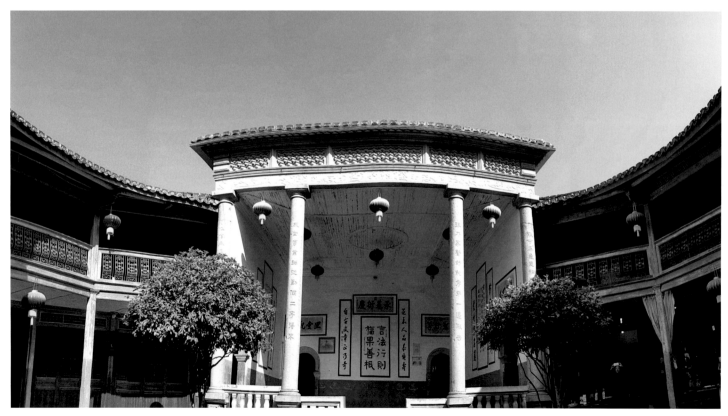

由烟草致富的林氏家族，修桥、筑路、办学校，为乡邻做了不少公益事业。1923 年民国总统黎元洪赠匾 "里党观型" 印挂于振成楼内 / 林如建 摄

The Lin family, who made their fortune from tobacco, repairing bridges, building roads and setting up schools, and did a lot of public works for their neighbors. In 1923, Li Yuanhong, President of the Republic of China, presented a plaque "Li Dang Guan Xing" hanging in Zhencheng Building /Photographed by Lin Rujian

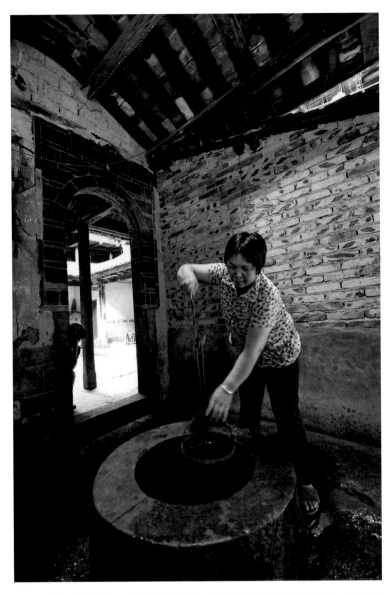

土楼内的水井，即便遇到不测，也可保证有充足的水源 / 关建东 摄
The wells in the earth buildings can ensure sufficient water supply even in case of accidents /Photographed by Guan Jiandong

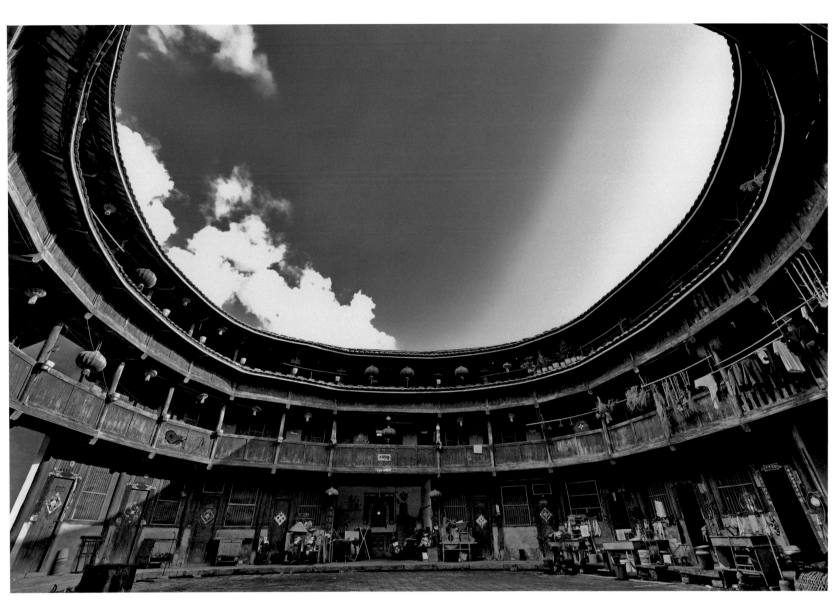

土楼建筑闪耀着客家人的智慧，也体现了客家人世代相传的团结友爱传统。数百人和睦共居，客家人淳朴敦厚的秉性于此也可见一斑 / 关建东 摄
The earth building shines with the wisdom of the Hakka people, but also reflects the Hakka tradition of solidarity and friendship passed down from generation to generation. Hundreds of people live together in harmony, and the simple and honest nature of the Hakka people can also be seen here /Photographed by Guan Jiandong

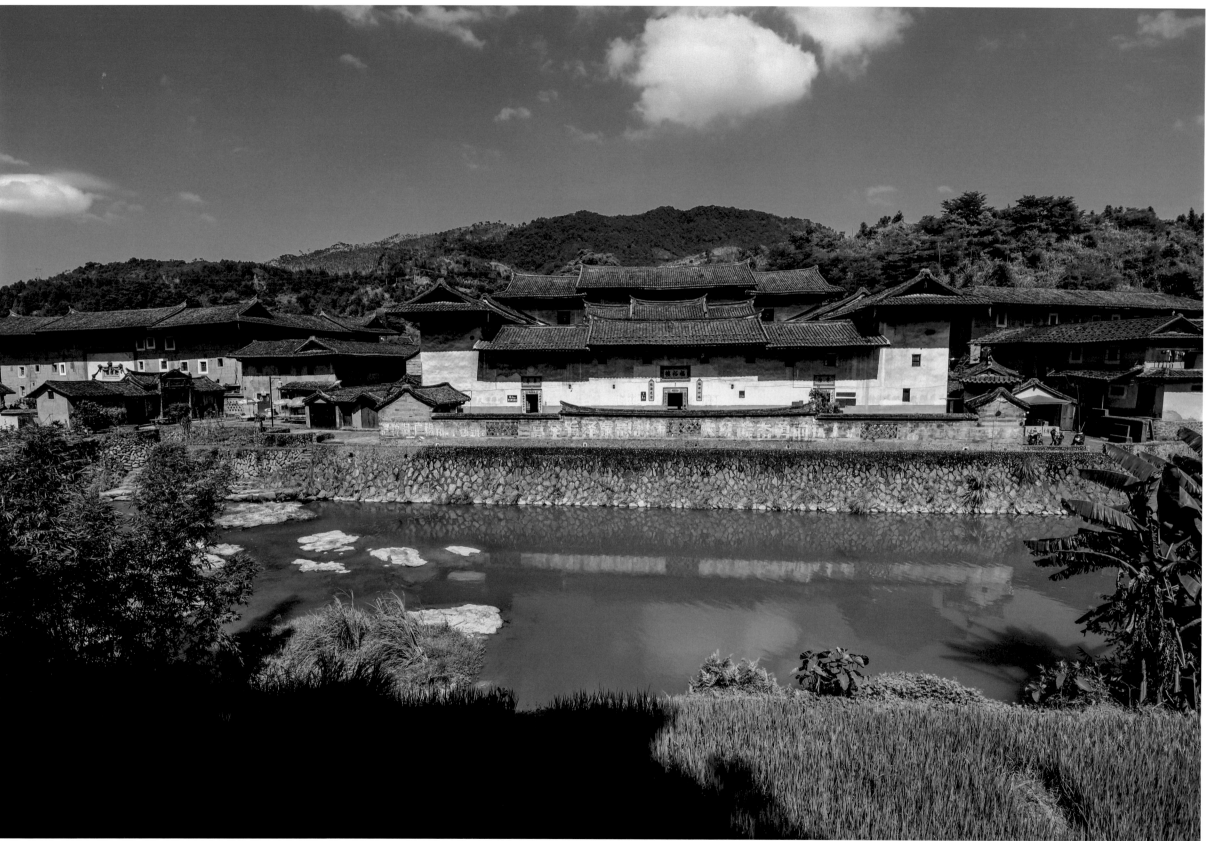

02

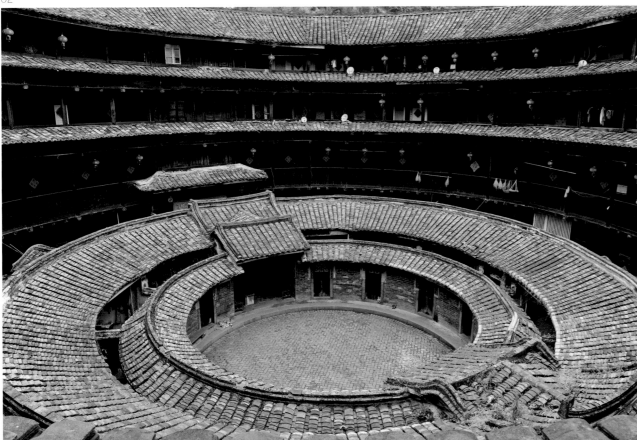

03

01 1880 年开始兴建的福裕楼，是永定府第式土楼的杰出代表，富丽堂皇。该楼历经 3 年时间才建成，占地面积 7000 余平方米。其结构特点是在主楼的中轴线上前低后高，两座横屋，高低有序，主次分明 / 赖小兵 摄

Fuyu Building, which began to be built in 1880, is an outstanding representative of mansion-style earth buildings in Yongding, which is splendid. It took three years to complete, covering an area of more than 7000 square meters. Its structural features are low in front and high in back on the central axis of the main building, the two houses on both sides in front of the main building are orderly in height with distinct priorities / Photographed by Lai Xiaobing

02 下洋镇水源楼已有 200 多年历史。经过改造，水源楼成为富川一甲土楼休闲度假村，接待来自省内外的客人 / 朱晨辉 摄

Shuiyuan Building has been already standing for more than 200 years. After proper renovation, the area around Shuiyuan Building has become a 1A Earth Building Leisure Resort in Fuchuan Village, which receives guests from inside and outside the province /Photographed by Zhu Chenhui

03 坐落于湖坑镇南中村的圆形土楼民居——环极楼，建于清康熙三十二年，其特别之处在于中心环无祠堂之设，而是空旷的院落，这在永定土楼中是绝无仅有的 / 赖小兵 摄

Huanji Building, a circular earth building located in Nanzhong Village, Hukeng Town, was built in the 32nd year of the Kangxi period of the Qing Dynasty. Its special feature is that there is no ancestral temple in the central ring, but an empty courtyard, which is unique in Yongding Earth Buildings /Photographed by Lai Xiaobing

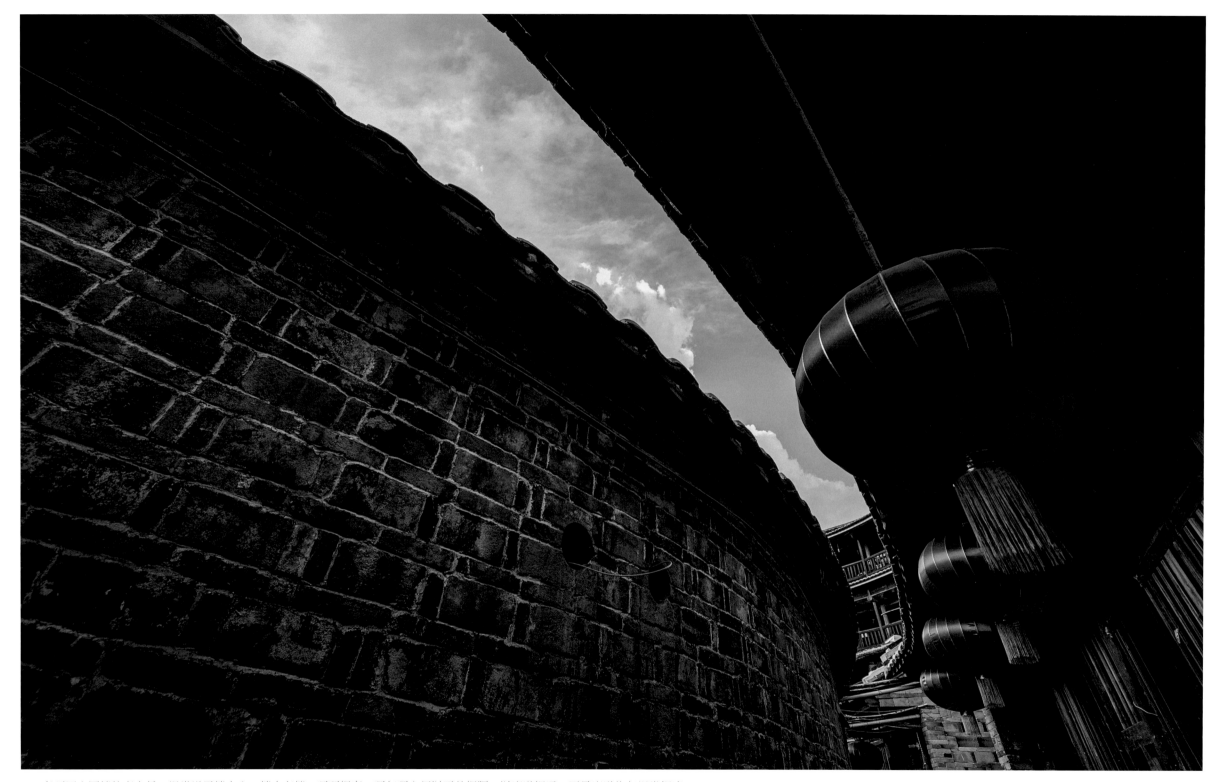

多环同心圆楼外高内低，祖堂设于楼中心，楼中有楼，环环相套，环与环之间以天井相隔，以廊道相通，而且廊道均与祖堂相连 / 朱晨辉 摄

The multi-ring concentric circular building is high outside and low inside. The ancestral hall is located in the center of the building. There are buildings in the building, ring by ring. The rings are separated by courtyards and connected by corridors, and the corridors are all connected with the ancestral hall /Photographed by Zhu Chenhui

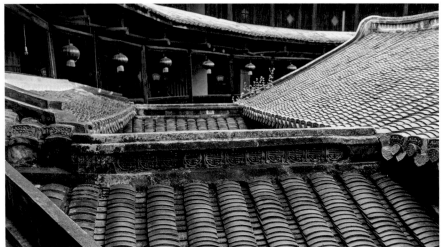

01

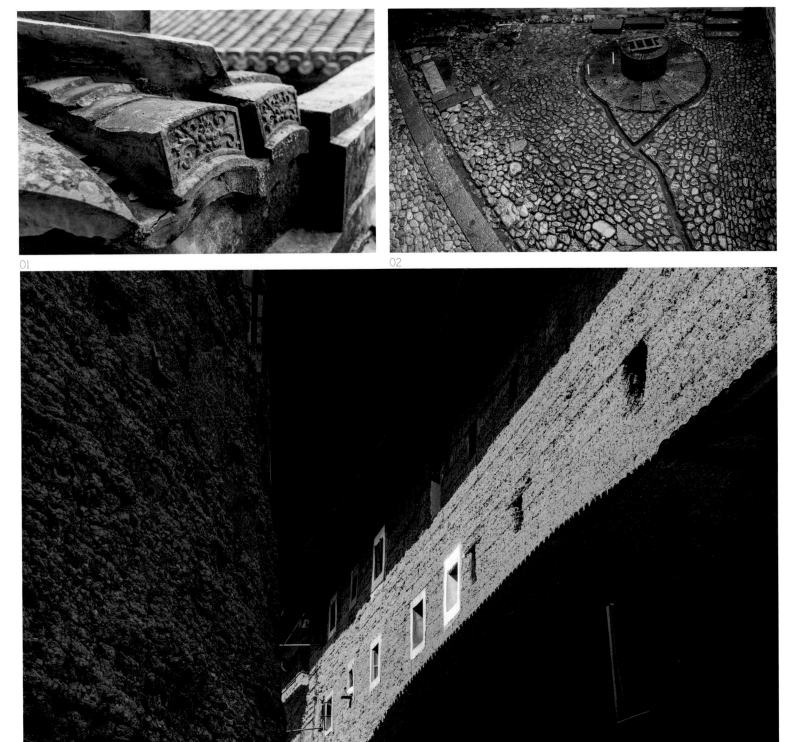

02

03

04

01 　瓦片上精美的雕花 / 朱晨辉 摄
Exquisite carvings on tiles /Photographed by Zhu Chenhui

02 　古时候人口迁徙，首先掘井汲泉，繁衍生息。土楼人也不例外，当土楼完工时，水井里也流淌着甘甜的泉水了 / 朱晨辉 摄
When people migrated in ancient times, they first dug wells to get springs for multiplying and living. People in earth buildings are no exception, when earth buildings were completed, the wells also flew with sweet springs /Photographed by Zhu Chenhui

03 　客家土楼的屋顶大都采用"人"字形的双坡屋顶，当雨季来临时，"人"字形屋顶有利于防止雨水下渗到土墙而引起的坍塌 / 朱晨辉 摄
Most of the roofs of Hakka earth buildings are double-pitch roofs with "herringbone" shape. When the rainy season comes, its "herringbone" roof is conducive to prevent the collapse caused by rainwater infiltration into the earth wall /Photographed by Zhu Chenhui

04 　永定土楼是以生土为主要建筑材料、生土与木结构相结合，并不同程度地使用石材的大型居民建筑 / 赖小兵 摄
Yongding Earth Building is a large-scale residential building with immature soil as the main building material, which combines immature soil with wood structure and uses stone materials to varying degrees / Photographed by Lai Xiaobing

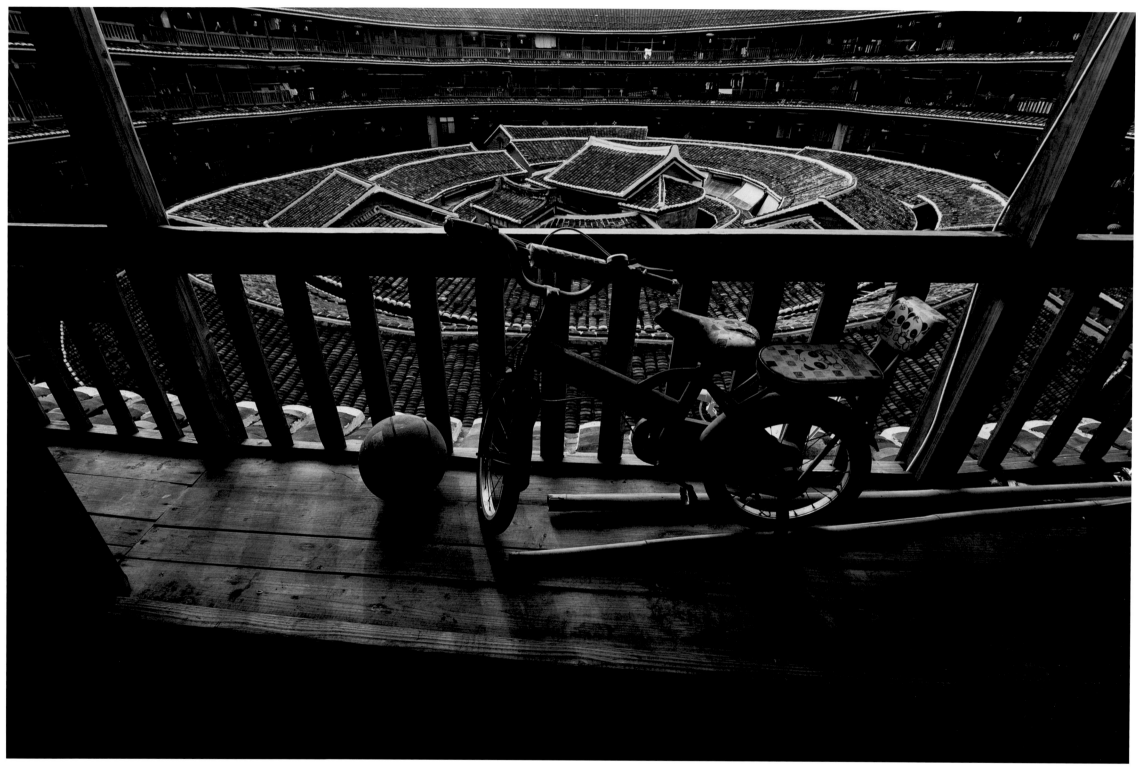

土楼产生于宋元，成熟于明末，最古老的有 700 多年了，至今仍有人居住 ／ 朱晨辉 摄

The earth building originated in the Song and Yuan Dynasties and matured in the late Ming Dynasty. The oldest
one is over 700 years old and still inhabited today /Photographed by Zhu Chenhui

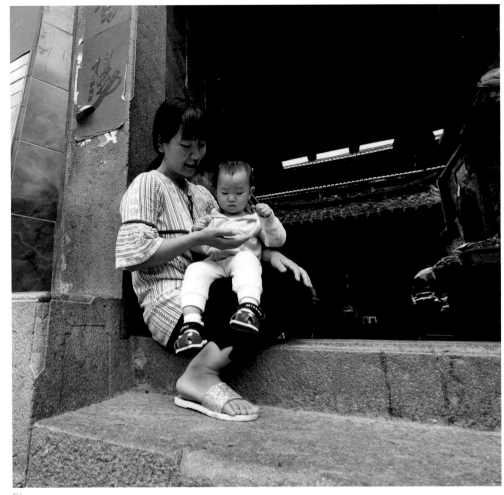

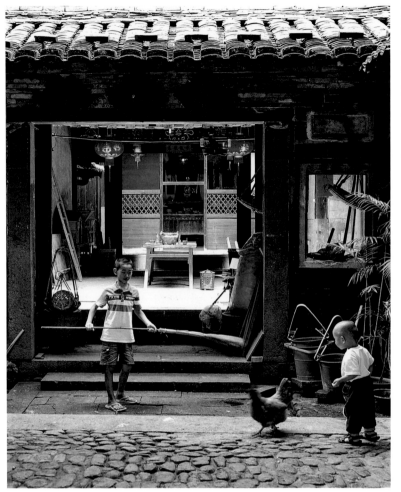

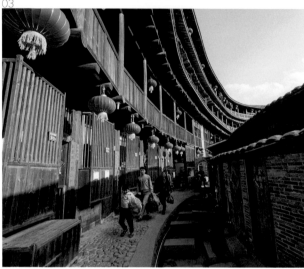

01

02

03

04

01　生生不息的客家人，在土楼内尽享天伦之乐 / 关建东 摄
The endless Hakka people enjoy the happiness of their families in the earth buildings /Photographed by Guan Jiandong

02　聚族而居的土楼内充满着生活情趣 / 胡文 摄
The earth buildings where people live together are full of life interest

03　土楼内的农家民宿深受年轻一族的喜爱 / 赖小兵 摄
Farmhouse inns in earth buildings are popular among young generations /Photographed by Lai Xiaobing

04　逢年过节，在外的游子都会回到土楼与家人团聚 / 赖小兵 摄
On Chinese New Year's Day or other festivals, outside wanderers always return to the Earth Building to reunite with their families / Photographed by Lai Xiaobing

汀江
THE TINGJIANG RIVER

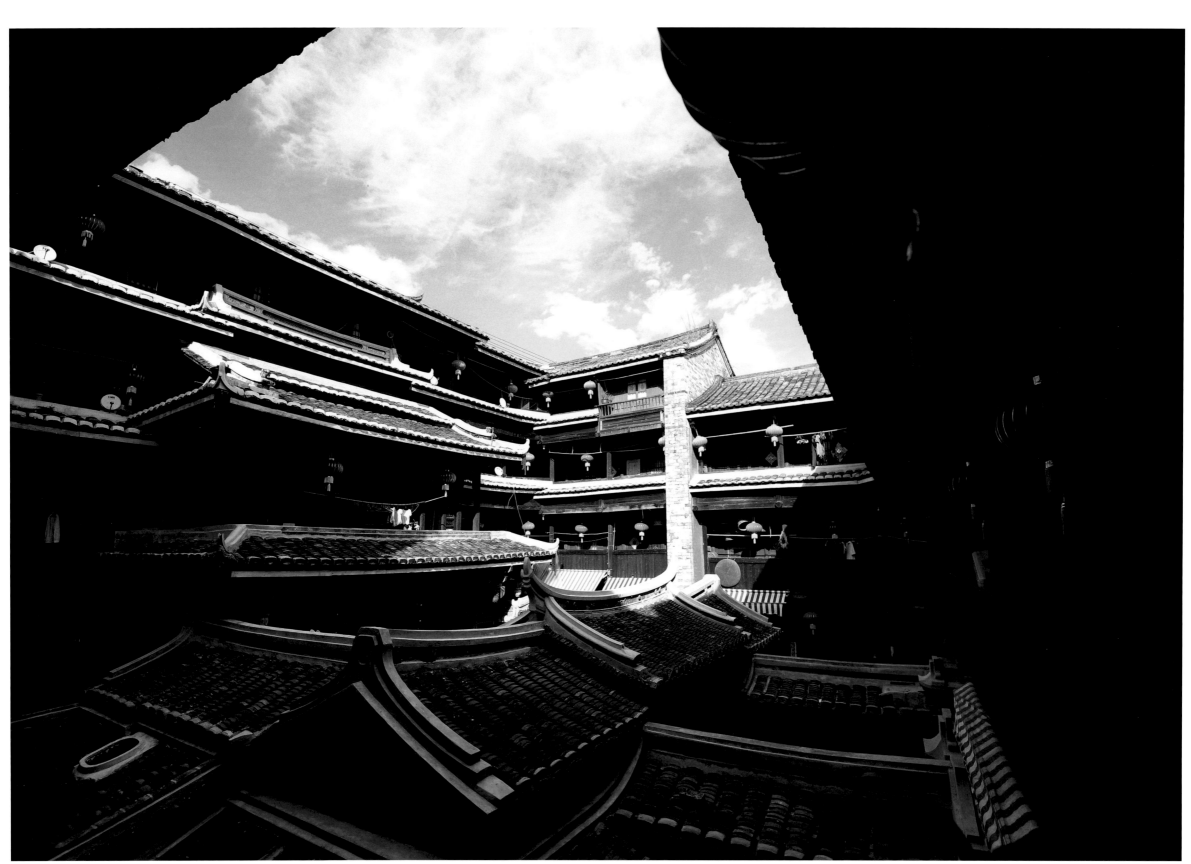

01　　建成于清道光十四年（1834）的奎聚楼是宫殿式结构的方形大土楼，远看颇有布达拉宫般的气势 / 胡玲霞 摄

　　Built in the 14th year of the Daoguang period in the Qing Dynasty (1834), Kuiju Building is a large square earth building with a palatial structure, which looks like Potala Palace from a distance /Photographed by Hu Lingxia

02　　如升楼为迄今所计最小的圆土楼，建于1901年，直径为17米，楼高3层，共有16个房间，为内通廊式的单圈圆楼，小巧玲珑。圆楼住6户人家，内院直径只有5米，虽楼内空间极小，但整座土楼家居聚凑，井然有序。如升楼也是国产动漫《大鱼海棠》的灵感来源 / 严硕 摄

　　As the smallest circular earth building so far, Rusheng Building was built in 1901 with a diameter of 17 meters, a height of 3 floors and 16 rooms in total, which is a inner corridor-style single-circle circular building, small and elegant. There are 6 families live in the circular building, where the diameter of the inner courtyard is only 5 meters. Although the space in the building is very small, homes in the whole earth building gather together in good order. Rusheng Building is also the inspiration source of domestic animation "Big Fish&Begonia" / Photographed by Yan Shuo

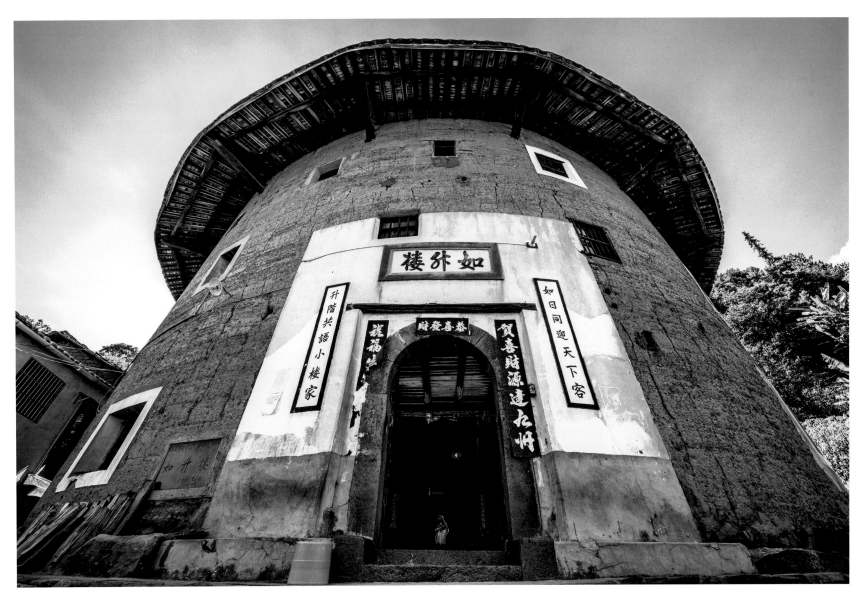

02

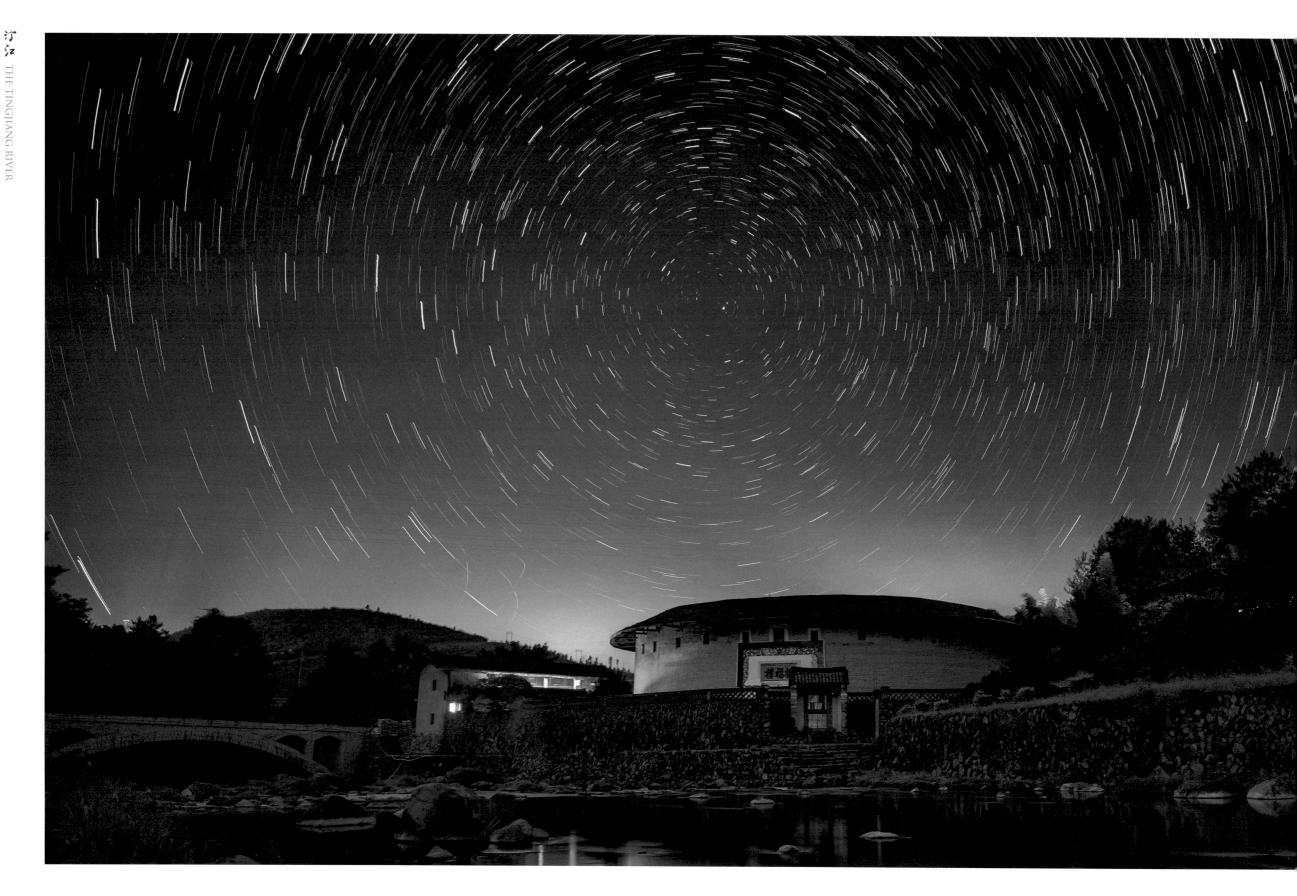

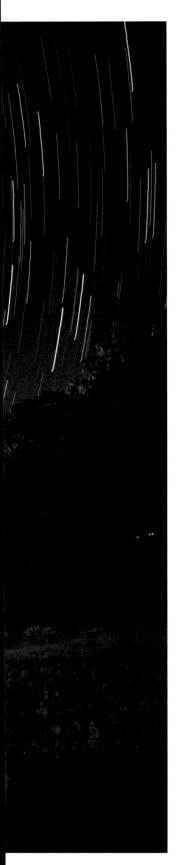

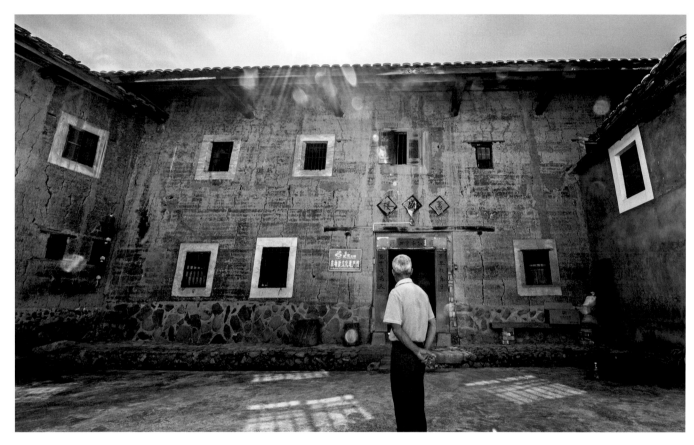

湖坑土楼景区万盛楼前的老人 / 严硕 摄
An elder in front of Wansheng Building in Hukeng Earth Building Scenic Spot /Photographed by Yan Shuo

夜空下的振福楼 / 陈军 摄
Zhenfu Building at night /Photographed by Chen Jun

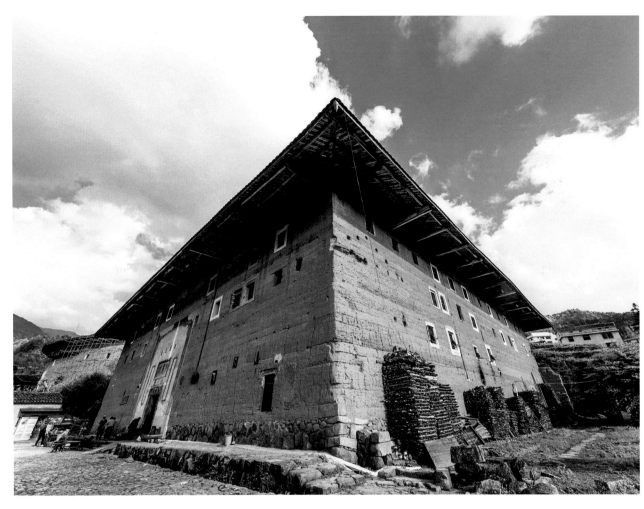

初溪土楼群绳庆楼外景 / 严硕 摄
Outside Scene of Shengqing Building of Chuxi Earth Building Group /Photographed by Yan Shuo

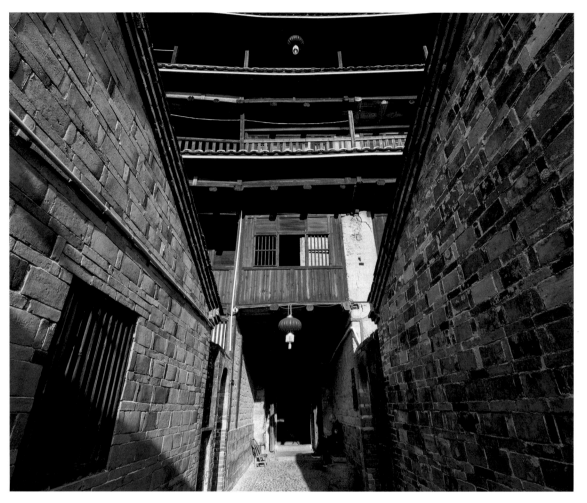

土楼建筑兼具防震、防火、防御多种功能，通风和采光良好，且冬暖夏凉 / 赖小兵 摄
The earth buildings have the functions of earthquake prevention, fire prevention and defense, with good ventilation and daylighting, which are warm in winter and cool in summer /
Photographed by Lai Xiaobing

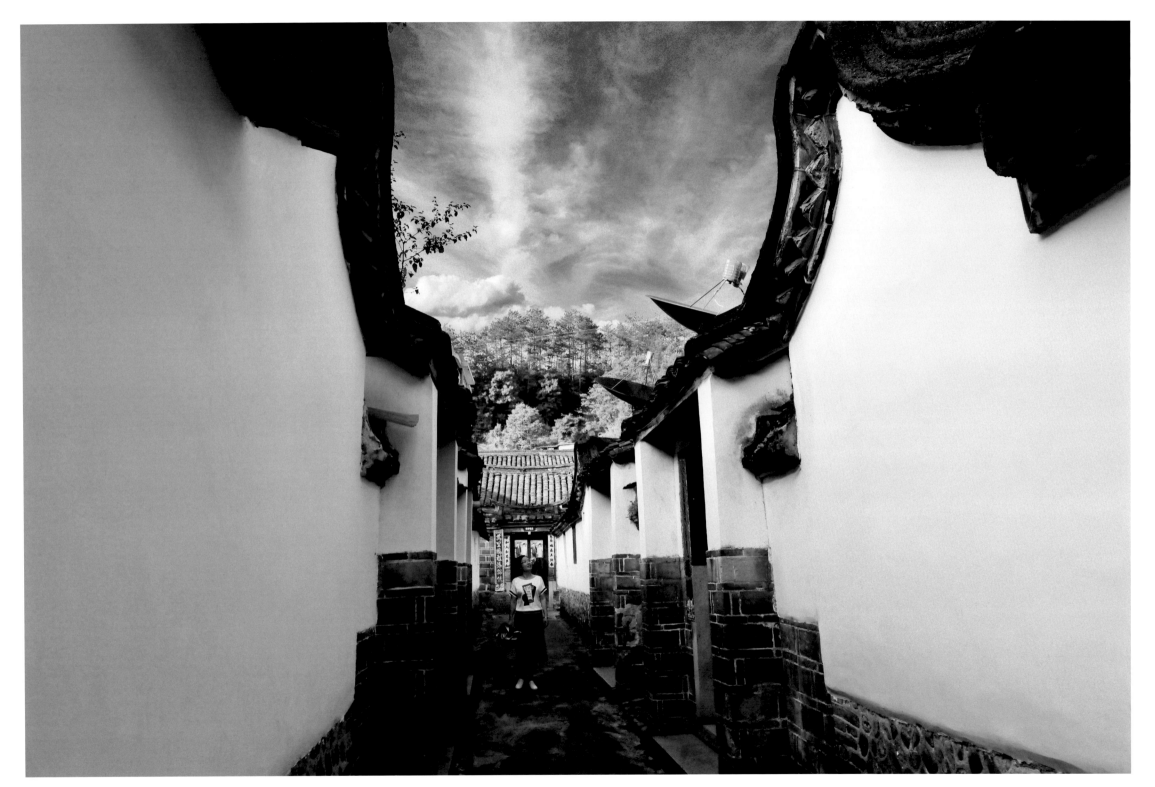

下洋中川村的富紫楼是按"富"字形而建的传统民居 / 赖小兵 摄
Fuzi Building in Zhongchuan Village, Xiayang Town is a traditional residence built according to Fu(富)-shape /Photographed by Lai Xiaobing

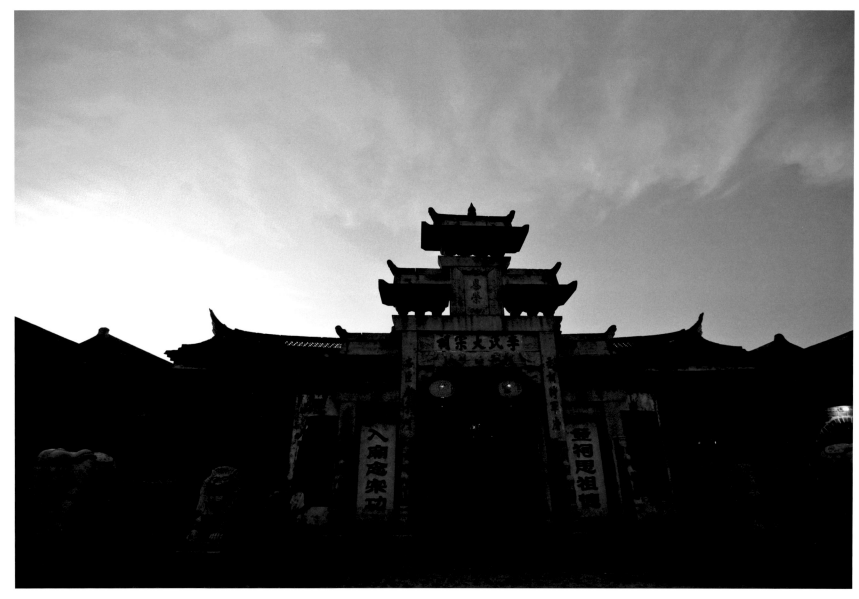

李氏大宗祠始建于清道光十六年，是李氏后裔为纪念其入闽始祖李火德公建造的宗祠 / 关建东 摄

The great ancestral hall of Li family was built in the 16th year of the Daoguang period in the Qing Dynasty, which was built by the descendants of Li family to commemorate their first ancestor Li Huode in Fujian /Photographed by Guan Jiandong

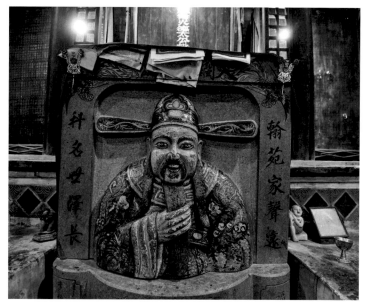

李火德入闽至今 800 余年，其后裔遍布闽、台、粤、赣、桂等地及东南亚各国。近年来海外李氏子孙到此寻根谒祖者络绎不绝 / 赖小兵 摄

Li Huode has been in Fujian for more than 800 years and his descendants spread all over Fujian, Taiwan, Guangdong, Jiangxi, Guangxi and Southeast Asian countries. In recent years, many overseas descendants of Li family have come here to seek their roots and visit their ancestors /Photographed by Lai Xiaobing

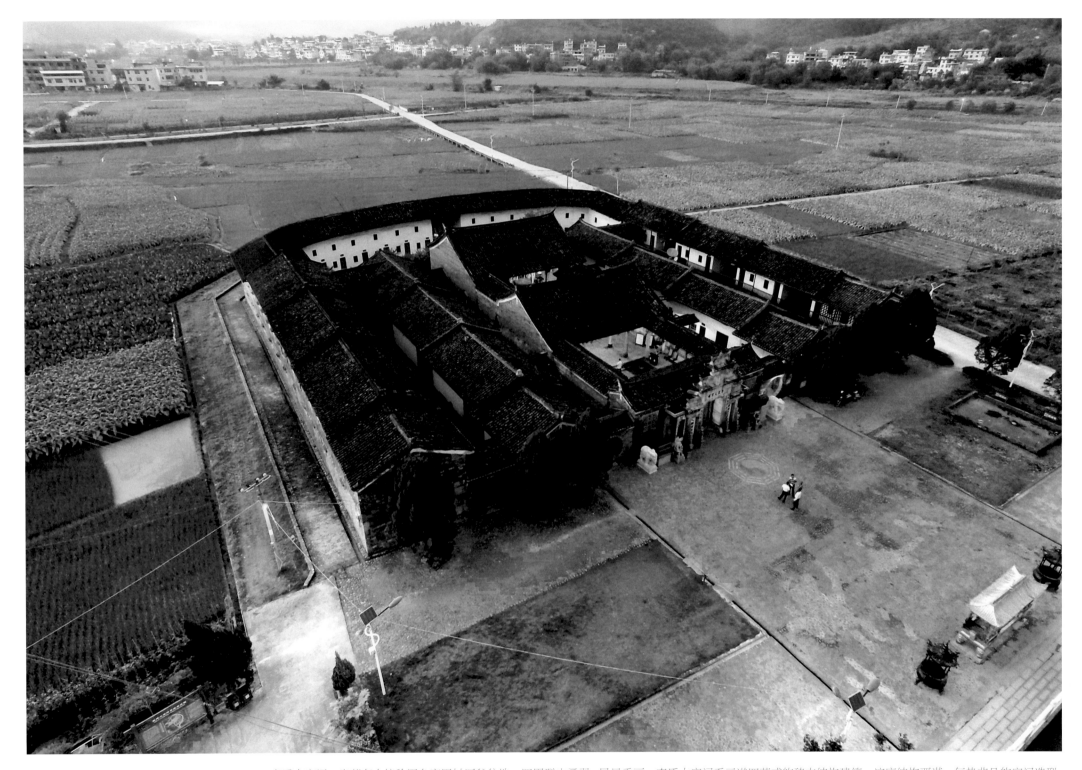

李氏大宗祠，坐落在上杭稔田乡官田村河谷盆地，四周群山叠翠，风景秀丽。李氏大宗祠系三进四落式的砖木结构建筑。这座结构严谨、气势非凡的宗祠造型，充分体现了客家宗法制度的建筑艺术 / 王东明 摄

The great ancestral hall of Li family, located in the valley basin of Guantian Village, Rentian Township, Shanghang County, is surrounded by verdant mountains with beautiful scenery. The great ancestral hall of Li family is a brick-wood structure building with three rows and four courtyards. This ancestral hall with rigorous structure and extraordinary momentum fully embodies the architectural art of Hakka patriarchal system /Photographed by Wang Dongming

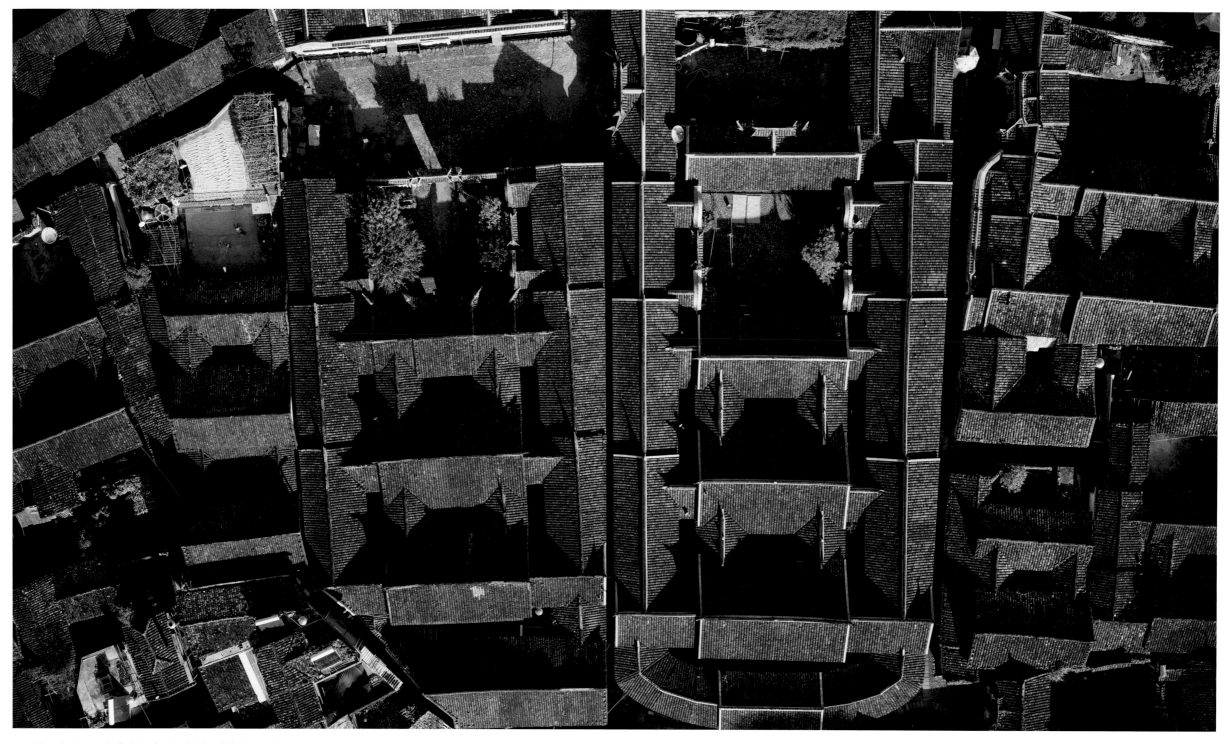

培田古民居是迄今南方地区保存最完整的古代民居群落之一，是中国客家建筑文化的经典之作，被誉为"福建民居第一村" / 朱晨辉 严硕 摄
Peitian Ancient Residence is one of the most well-preserved ancient residential communities in South China. It is a classic work of Hakka architectural culture in China, known as "the First Village of Fujian Residences" /photographed by Zhu Chenhui, Yan Shuo

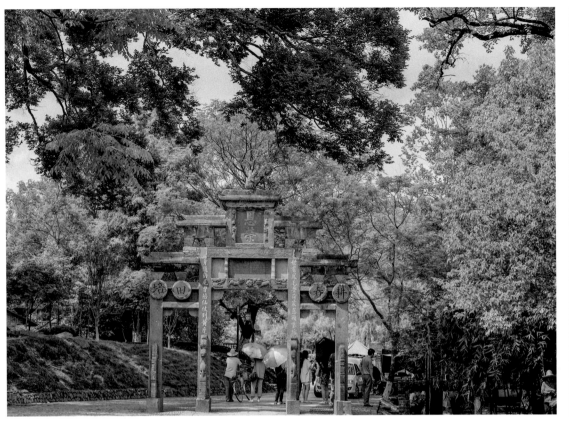

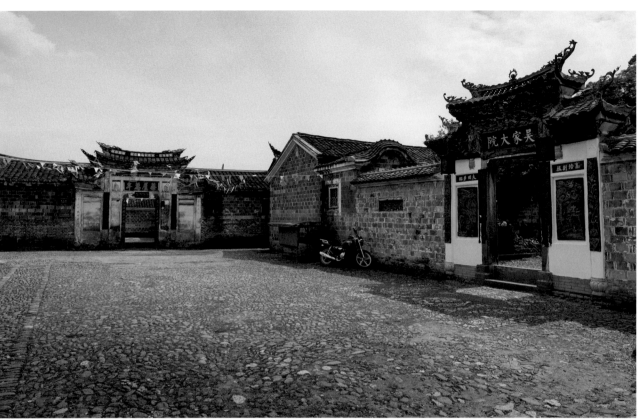

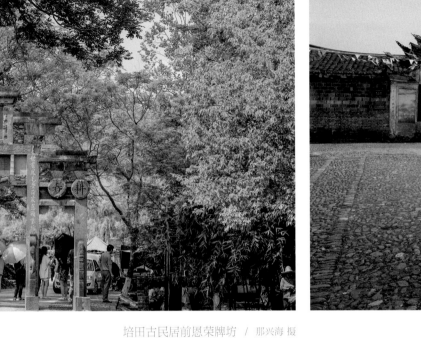

培田古民居前恩荣牌坊 / 那兴海 摄
Enrong Memorial Archway in front of Peitian Acient Residence
/Photographed by Na Xinghai

培田古民居因其保存完好的明清古建筑群而闻名 / 郭晓丹 摄
Peitian Ancient Residence is famous for its well-preserved ancient buildings of
the Ming and Qing Dynasties /Photographed by Guo Xiaodan

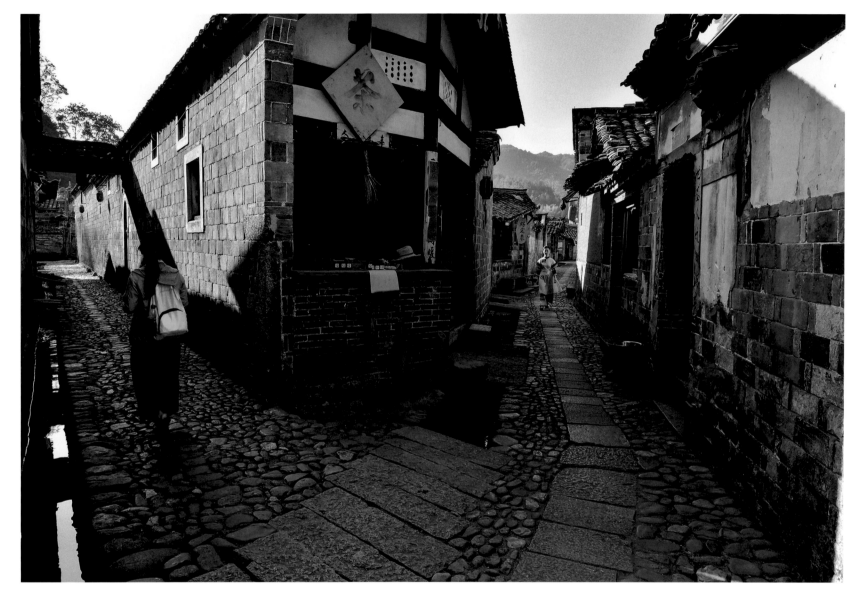

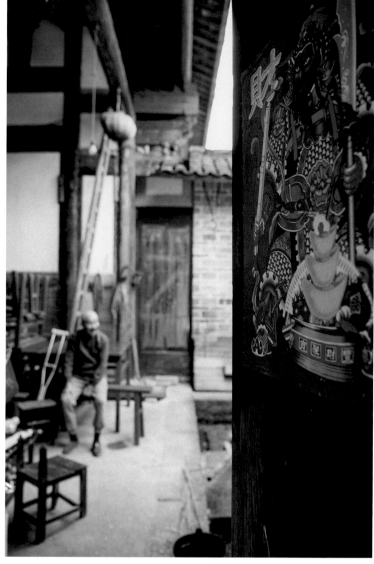

培田石板路，被人踩得光亮，记载着曾经的喧闹和繁华 / 吴军 摄

The road paved with stone slabs in Peitian was trodden bright, recording the noise and prosperity of the past /
Photographed by Wu Jun

培田民居的老宅 / 郭晓丹 摄

An old house of Peitian Residence /Photographed by Guo Xiaodan

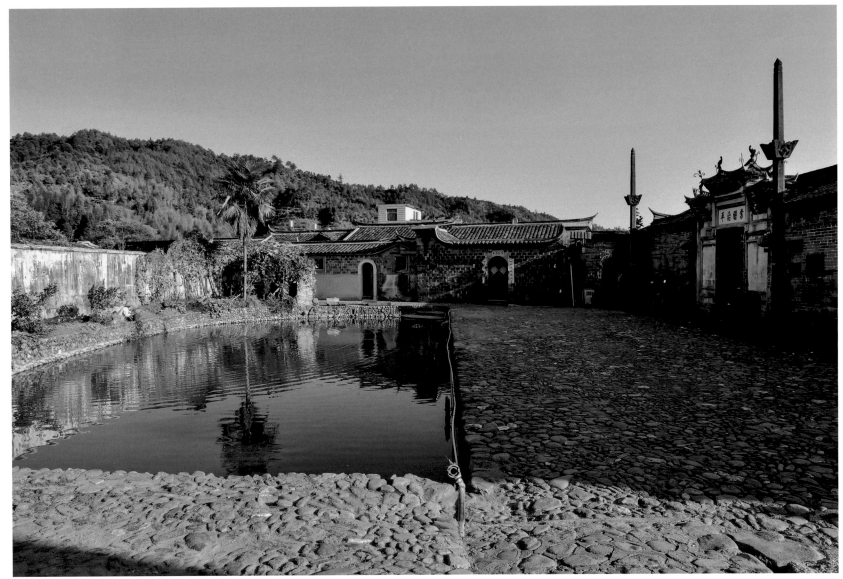

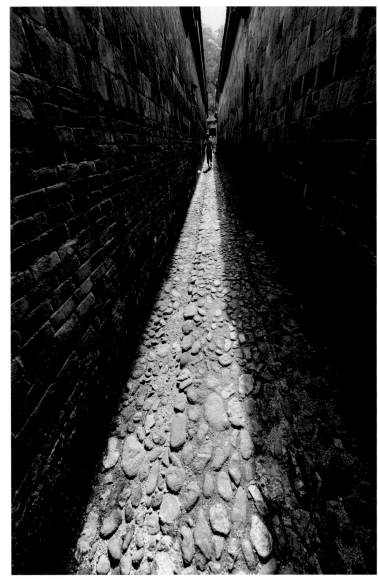

民居前的水塘，是典型的客家建筑特色，也是百姓的风水信仰 / 吴军 摄
A pond in front of the residence is not only a typical Hakka architectural feature, but also the geomancy belief of the people /Photographed by Wu Jun

曲折的古街、巷道，互为连通，把错落的明清古建筑有机连为一体 / 吴军 摄

The zigzag ancient streets and lanes are connected with each other, organically connecting the scattered ancient buildings of the Ming and Qing Dynasties as a whole / Photographed by Wu Jun

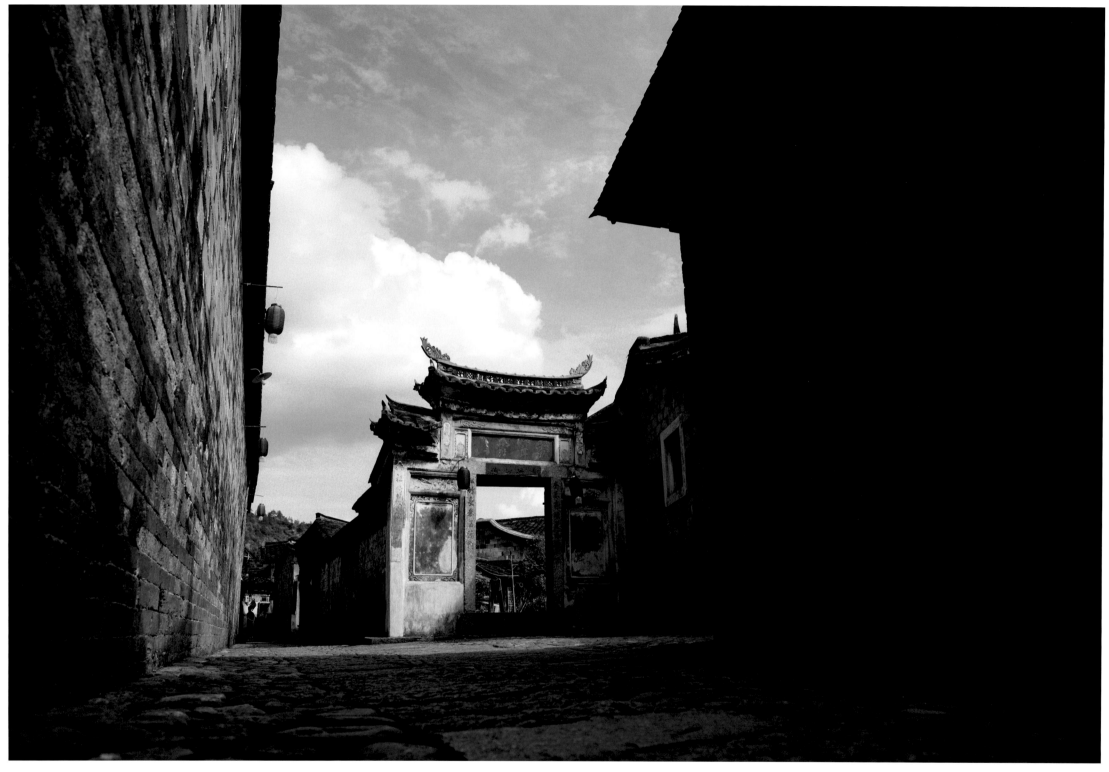

培田的建筑风格相较于永定土楼，显得开放优雅 / 那兴海 摄

Compared with Yongding Earth Building, Peitian's architectural style is more open and elegant /Photographed by Na Xinghai

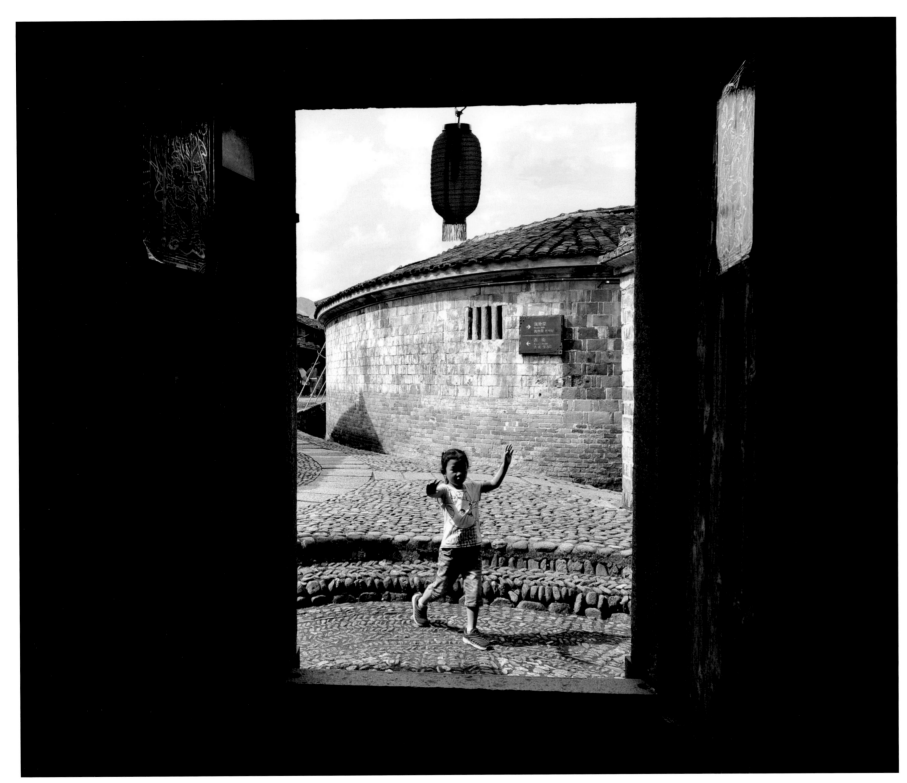

深深庭院，幽幽小巷，孩子们在这里度过独
一无二的童年 / 陈扬富 摄

With deep courtyards and quiet alleys and
ridged rice fields, children spend their unique
childhood here /Photographed by Chen Yangfu

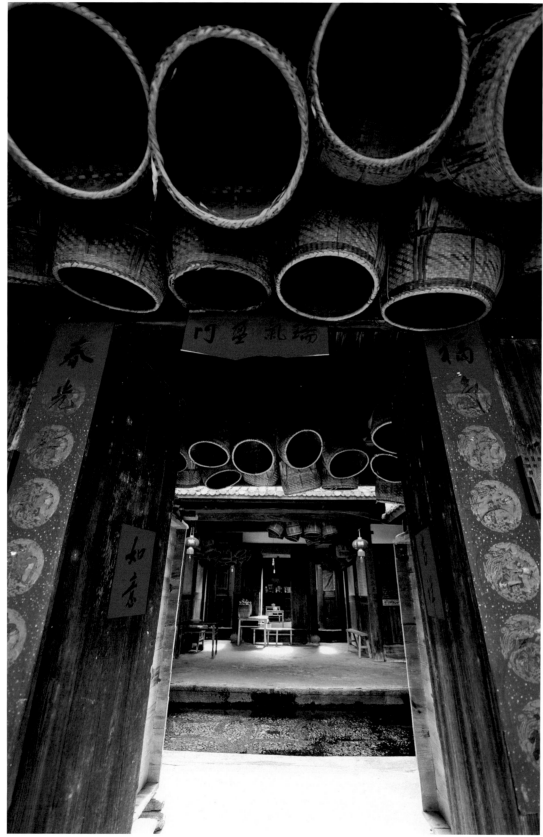

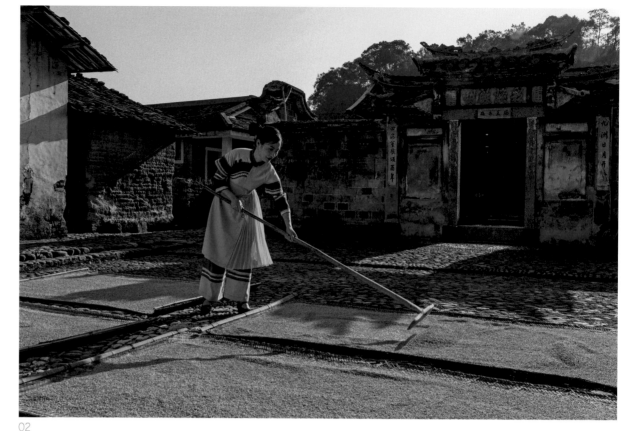

01

01 培田古村大夫第 / 陈扬富 摄
Scholar-Bureaucrat Mansion in Peitian Ancient Village

02 培田全村 300 余户人家、1400 多口人，清一色为吴姓同宗，故在民间被称为"吴家坊" / 吴军 摄
There are more than 300 households and more than 1,400 people in the whole village of Peitian, who are all surnamed Wu and of the same clan, so it is called "Wu Jia Fang" among the people / Photographed by Wu Jun

03 数百年前的建村者，极为讲究村落的治水。每一座古建筑都布有暗沟，用来排泄天井雨水、生活污水等。流下的雨水汇聚一处，顺沟而出，流入石砌水池，满足"四水归堂，财源滚滚而来"的聚财心理 / 吴军 摄
People who built the village hundreds of years ago paid great attention to the water control of the village. Every ancient building is equipped with underground drainage ditches to drain rainwater from the courtyards and domestic sewage of every household. The flowing rainwater converges at one place, flows out along the ditch and into the stone pool, meeting the money-gathering psychology of "waters gather together, and the source of wealth is rolling in" /Photographed by Wu Jun

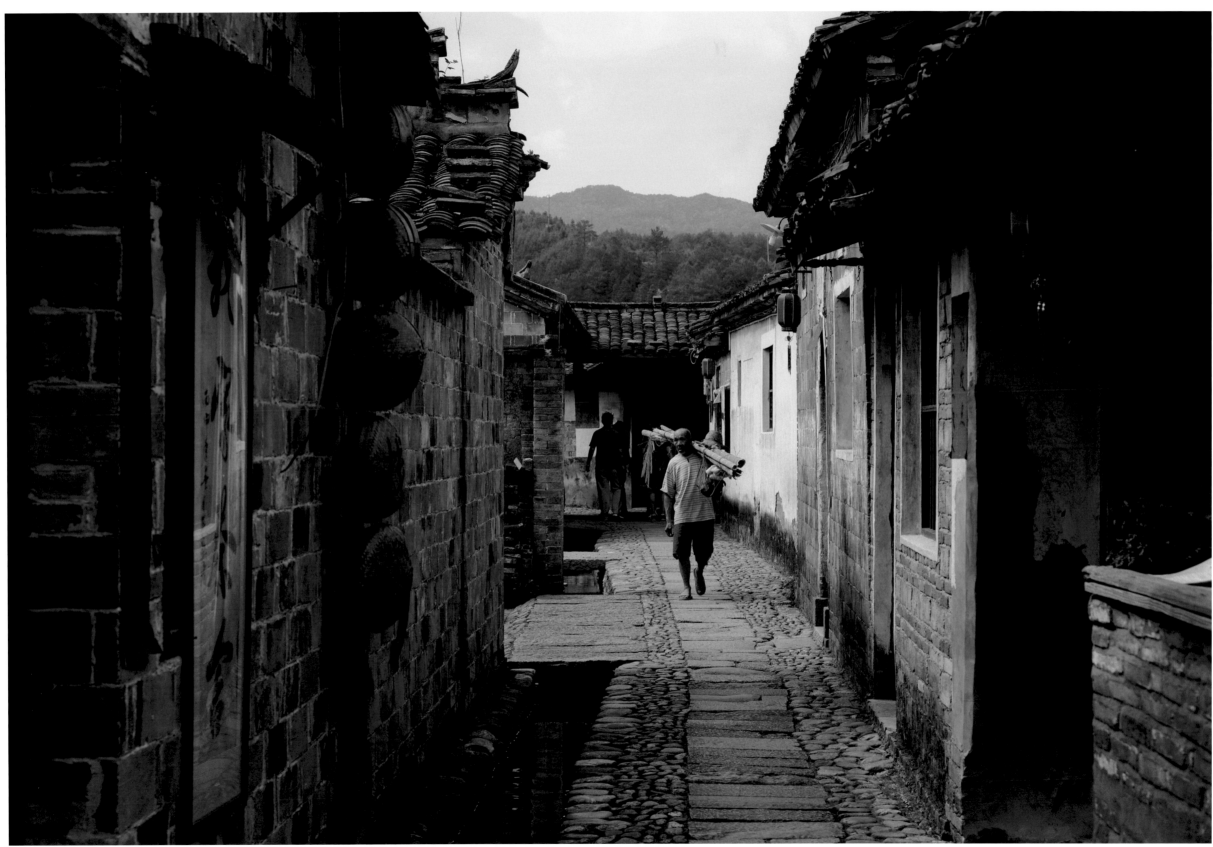

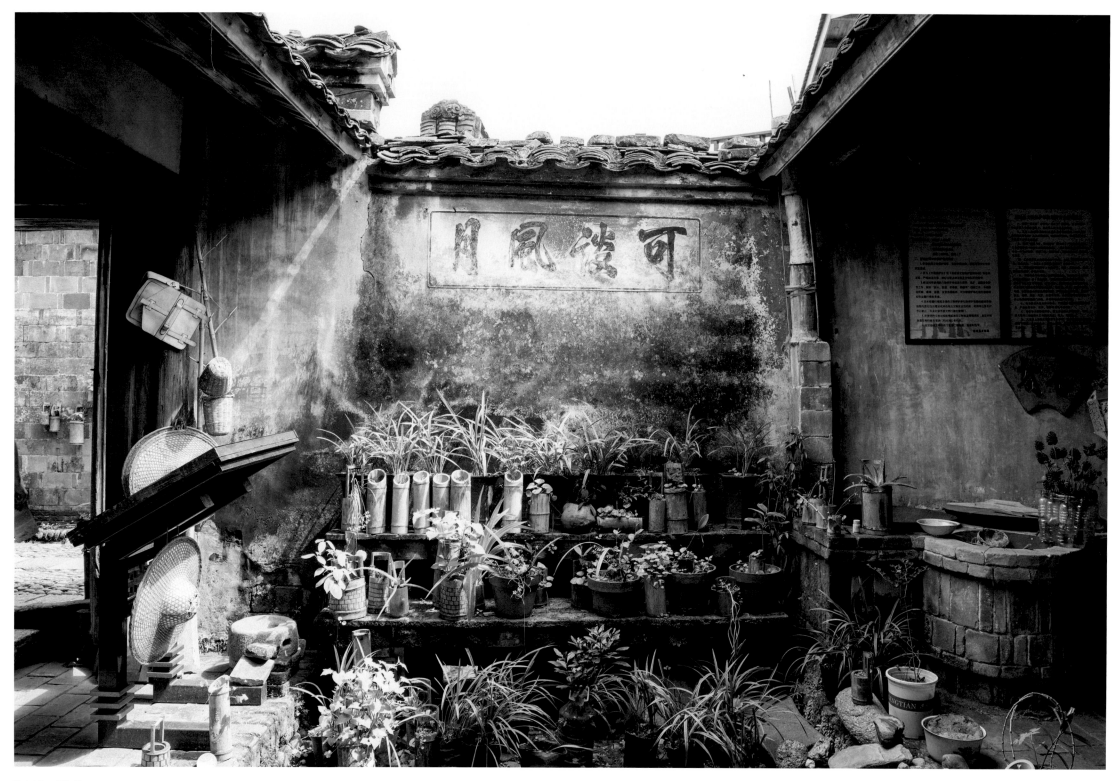

培田女子学堂 / 郭晓丹 摄
Peitian Women's School /Photographed by Guo Xiaodan

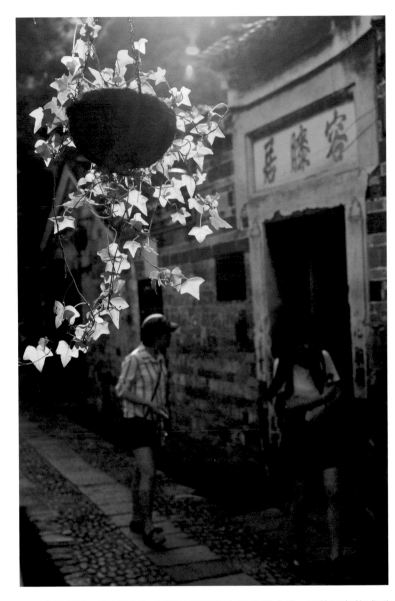

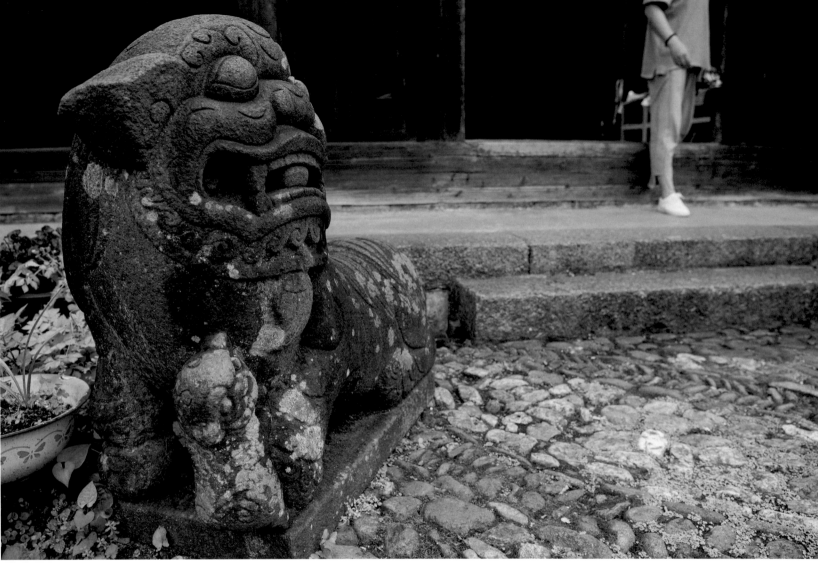

走进培田，处处是画。这里有高高的灰褐色风火墙，飞檐翘角的威严门楼，或花鸟虫鱼或历史深厚的深深庭院、幽幽小巷 / 郭晓丹 摄

Entering Peitian, you will feel that there are sceneries everywhere. There is a tall taupe fire wall and a majestic gateway with upturned eaves and rake angles; with deep courtyards with flowers, birds, insects and fish, or historical stories, and quiet alleys /Photographed by Guo Xiaodan

800 年的古村落，历史的遗痕随处可见 / 郭晓丹 摄
Historical traces of this 800-year ancient village can be seen everywhere /Photographed by Guo Xiaodan

武平抗日将领练惕生故居 / 郭晓丹 摄
Former residence of Lian Tisheng, the anti-Japanese general in Wuping /Photographed by Guo Xiaodan

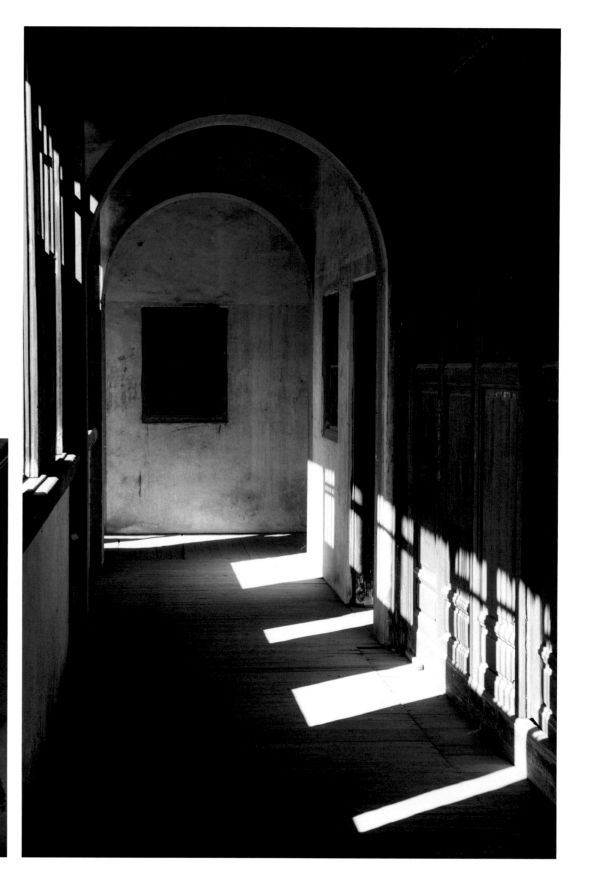

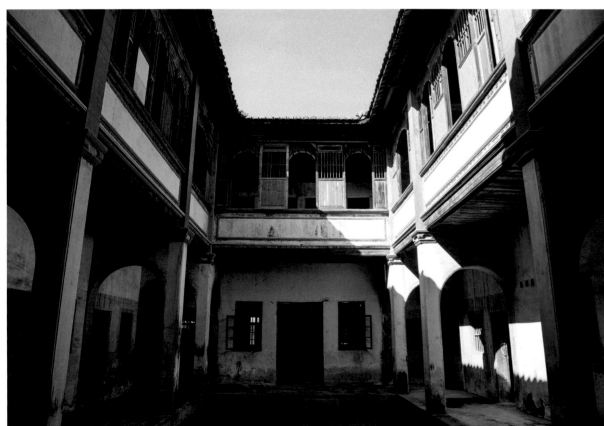

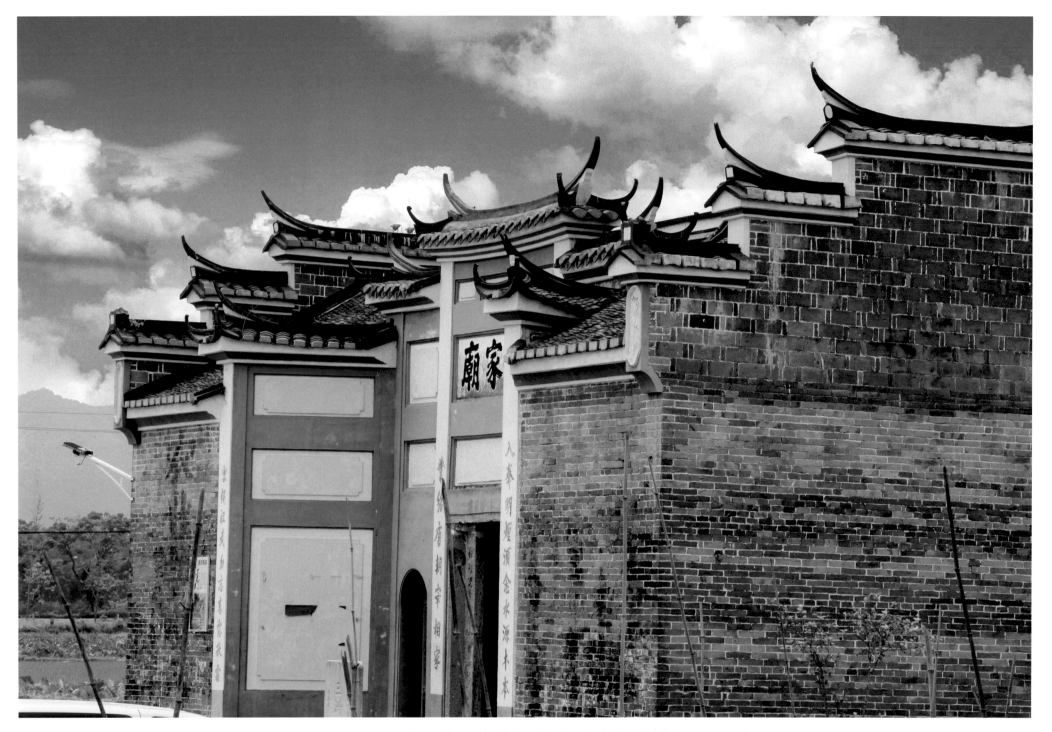

长汀戴氏家庙是三洲祠堂建筑的代表。外门楼为砖质牌楼式石门楼，飞檐翘角。门厅两侧风火墙五山跌落，大厅风火墙七山跌落，翼角飞翘，鳞次栉比。天际轮廓优美、灵动曼妙 / 陈扬富 摄

The Dai Family Temple in Changting is a representative of ancestral hall buildings in Sanzhou Town. The outer gatehouse consists of five stone gatehouse shaped like mountains falling, with upturned eaves and rake angles. Five mountains falls on fire walls of both sides of the entrance hall, while seven mountains falls on fire walls of the hall, with upturned roof-ridges, which are arranged in close order. The skyline is graceful and vivid /Photographed by Chen Yangfu

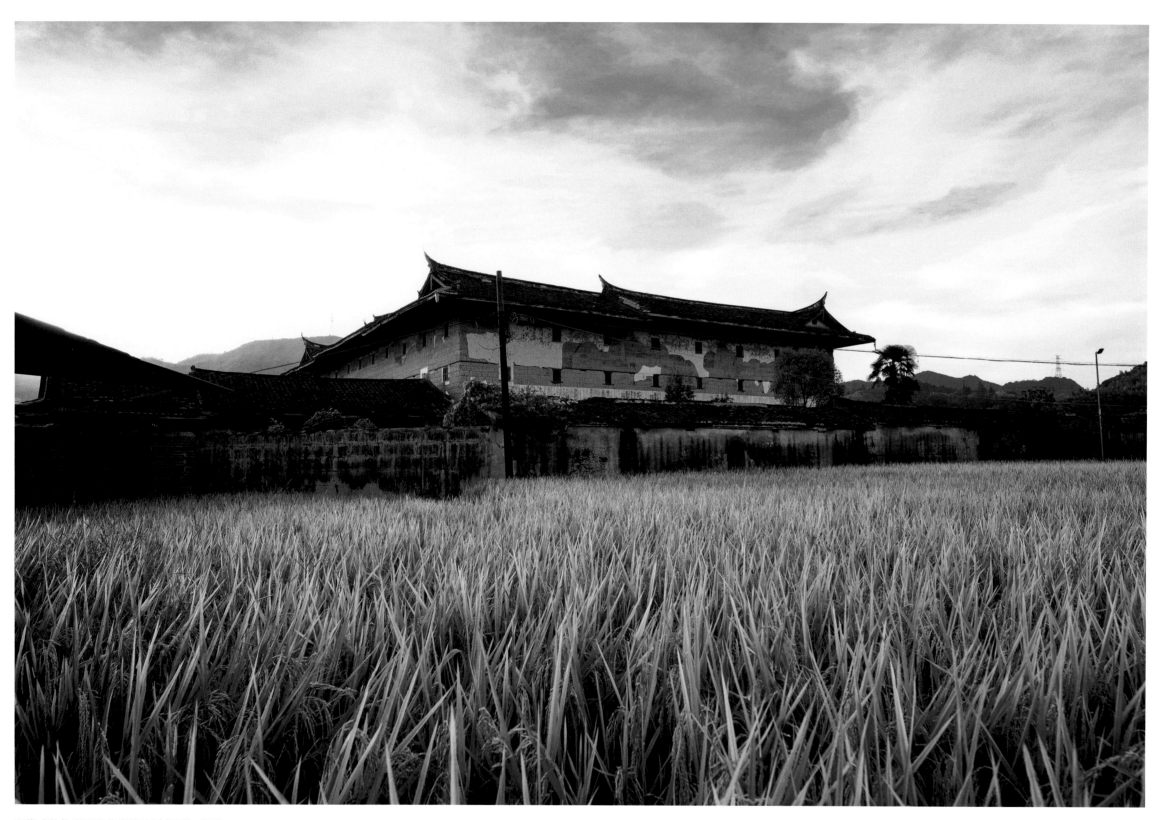

即将成熟的麦田将典常楼映衬得更加美丽 / 严硕 摄
Dianchang Building is more beautiful against the soon-to-be-ripe wheat fields /Photographed by Yan Shuo

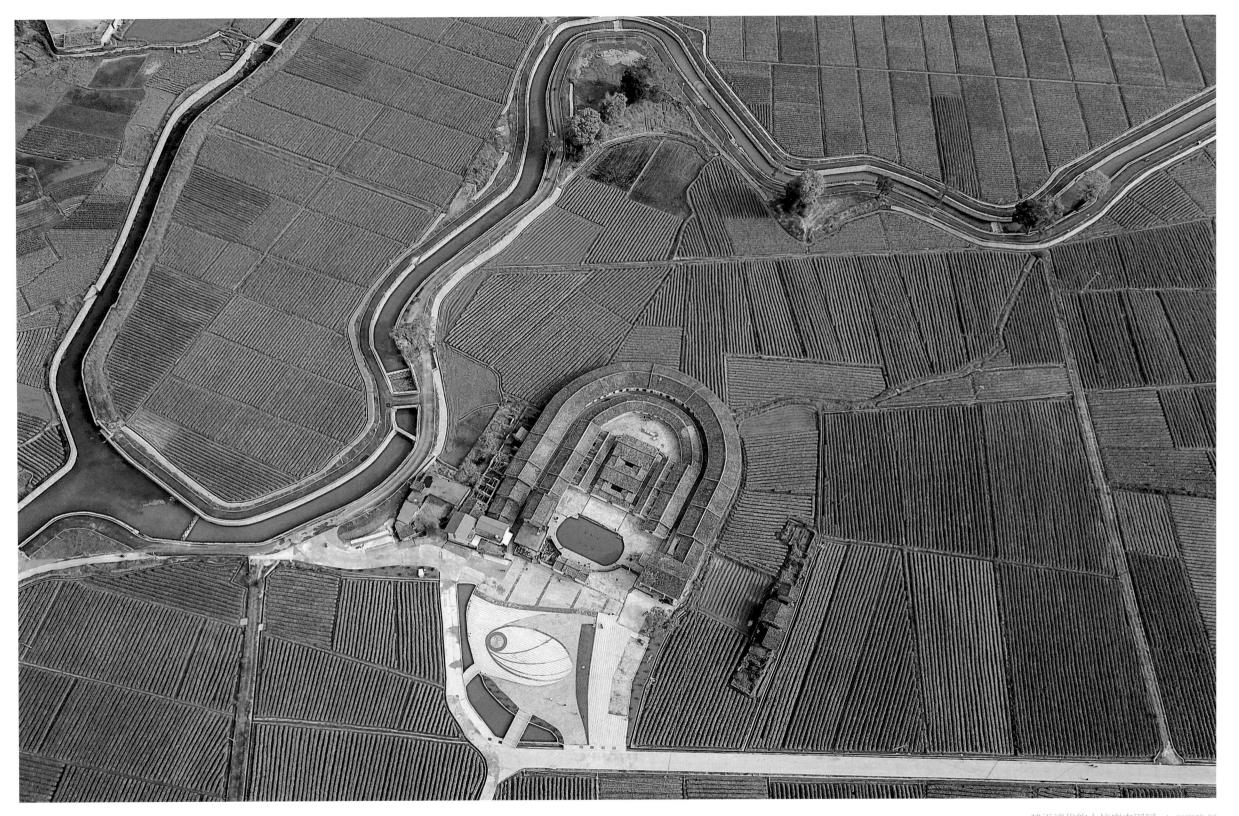

建于清代的上杭庐丰围屋 / 江宏瑞 摄
Round Houses in Lufeng Town, Shanghang built in the Qing Dynasty /Photographed by Jiang Hongrui

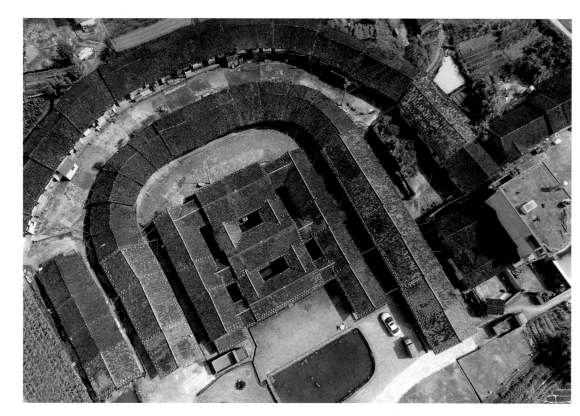

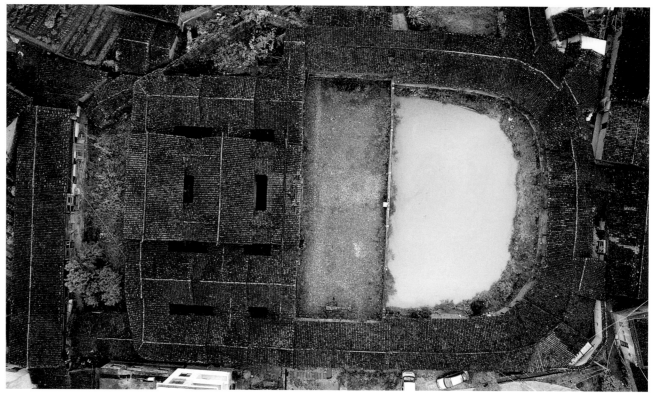

长汀中复村超坊围龙屋建于清代，是长汀县最大的一座围龙屋，占地 8000 多平方米，松毛岭阻击战的时候，这里是红军战地医院。客家围龙屋与永定土楼、培田古民居风格迥异，具有浓郁客家建筑风情 / 姜克红 摄

Chaofang Round-Dragon House in Zhongfu Village is the largest round-dragon house in Changting County, which was built in the Qing Dynasty and covers an area of more than 8000 square meters. During the Songmaoling Battle, it was the Red Army Field Hospital. The style of the Hakka round-dragon house is quite different from that of Yongding Earth Building and Peitian Ancient Residence, which has a strong Hakka architectural style /Photographed by Jiang Kehong

长汀涂坊围屋建于清乾隆年间，坐东南朝西北，建筑平面呈椭圆形，是客家民居中典型的全围式传统民居 / 吴军 摄

Built in the reign of Qianlong in the Qing Dynasty, Tufang Round-Dragon House in Changting faces northwest with the back to southeast with an oval-shaped architectural plane, which is a typical full-round traditional residence in Hakka residences /Photographed by Wu Jun

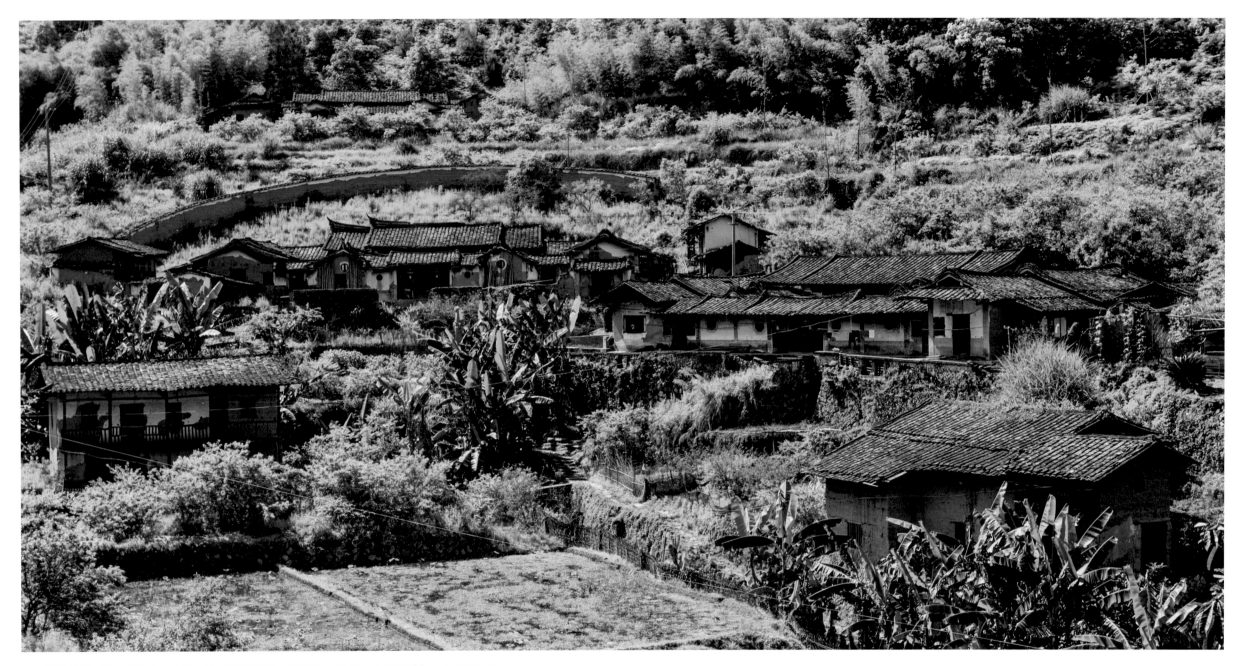

漳平东湖村沿山而居的古村落，似莲花环绕着一泓青田，因而又名"莲花村" ／ 朱晨辉 摄

The ancient village along the mountain in Donghu Village of Zhangping looks like lotuses surrounding a green field, so it is also called "Lotus Village" /Photographed by Zhu Chenhui

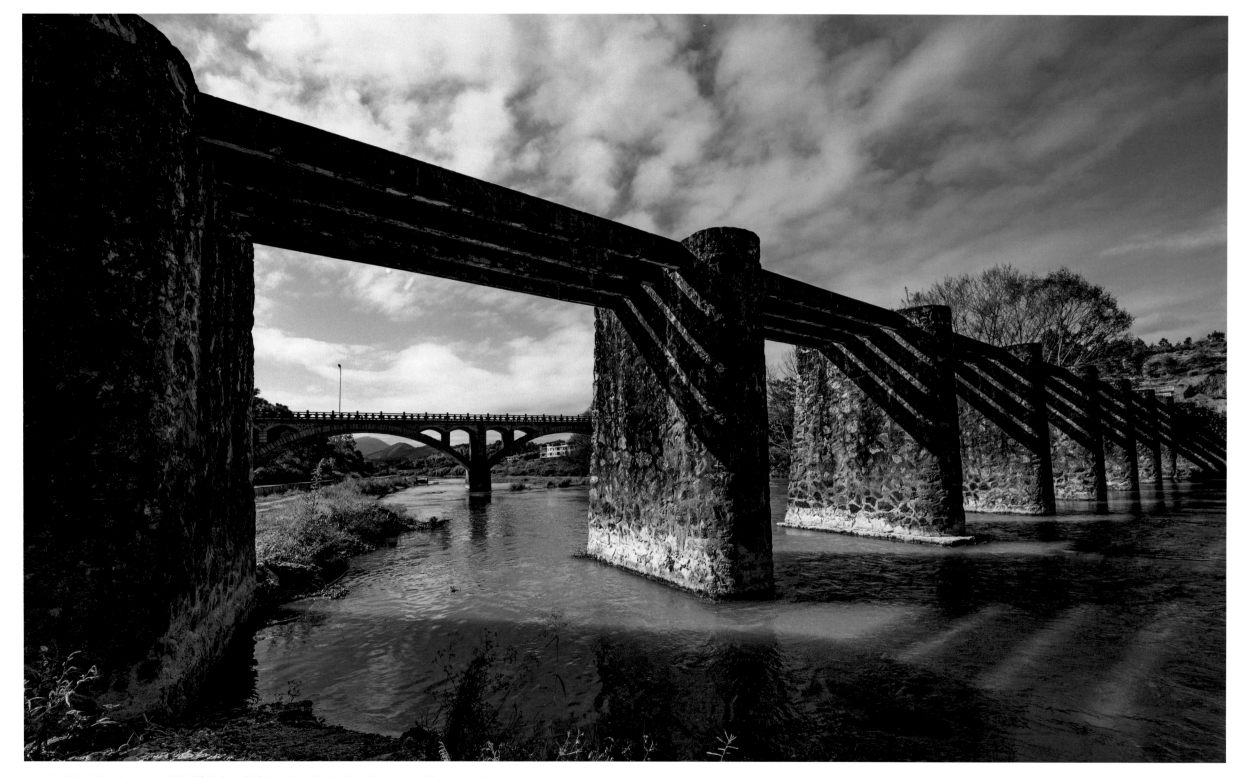

长汀策武镇，为了方便两岸百姓往来，当地政府在旧桥不远处又修了一座新桥 / 严硕 摄

In Cewu Town, Changting, in order to facilitate the people on both sides, the local government built the other new bridge not far from the old one /Photographed by Yan Shuo

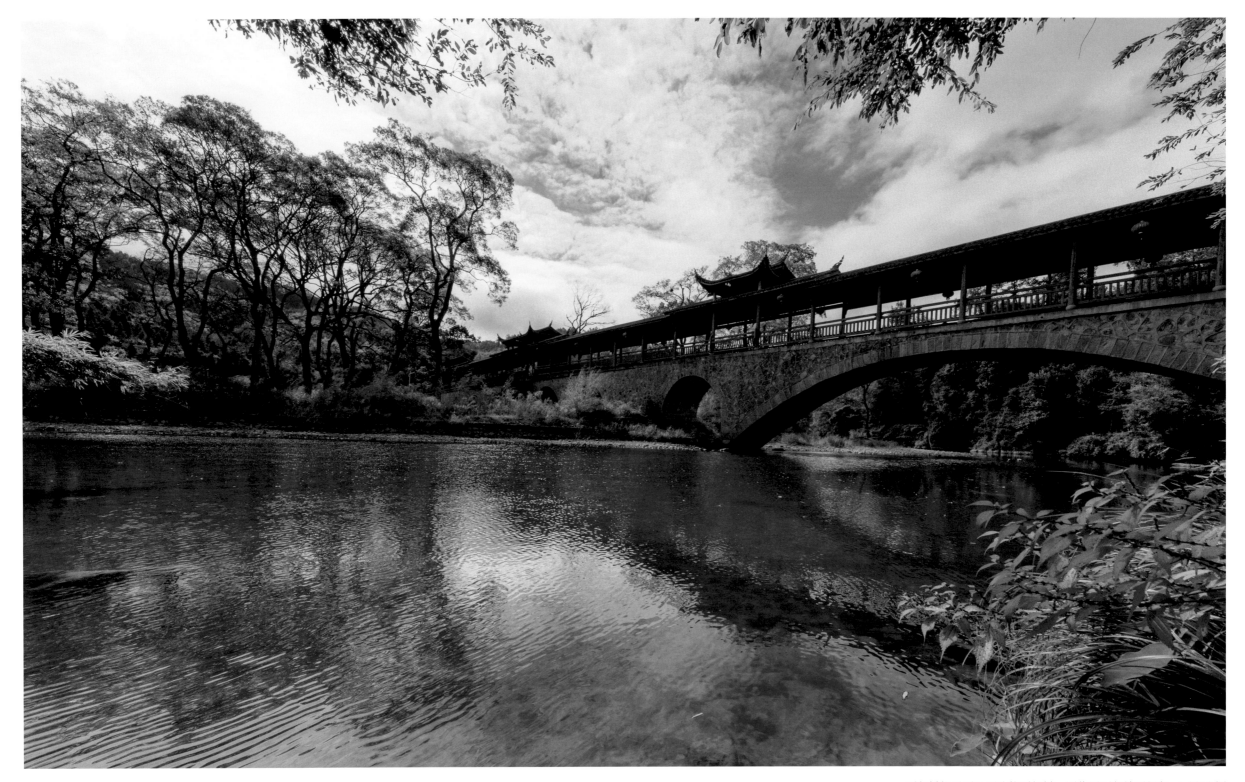

石鱼桥位于汀江源头的潭复村，因临近石鱼岭而得名 ／ 吴军 摄
Shiyu Bridge is located in Tanfu Village, the source of the Tingjiang River, which is named for its proximity to Shiyu Ridge /Photographed by Wu Jun

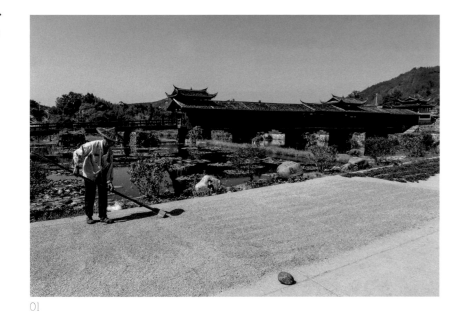

01

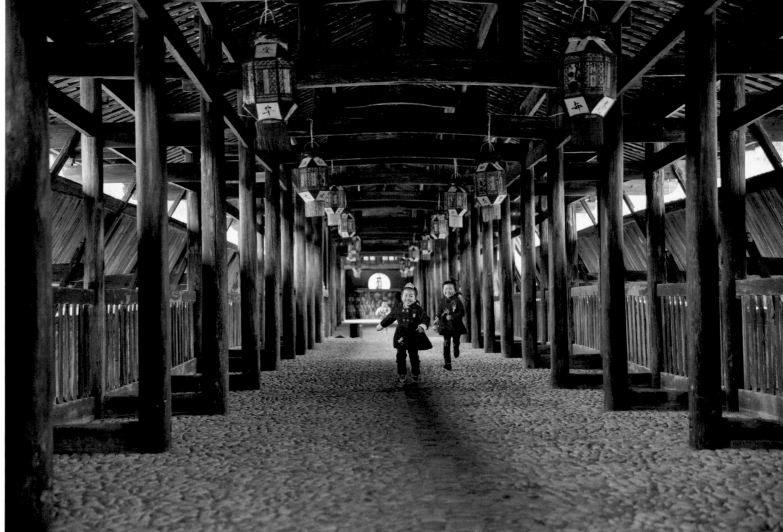

02

01　　　连城永隆桥系明洪武十年（1377）所建，距今已 600 多年，是闽西尚存的古屋桥中最古老的桥之一。距桥百步，是建于清康熙三十一年（1692）的文昌阁和天后宫，形成颇具特色的璧洲士庶古建筑群 ／ 吴军 摄

　　　　Yonglong Bridge in Liancheng, built in the 10th year of Hongwu period of the Ming Dynasty (1377), has a history of more than 600 years and is the oldest one of the existing ancient house bridges in Western Fujian. One hundred steps away from the bridge is Wenchang Pavilion and Tianhou Palace, built in the 31st year of the Kangxi period of the Qing Dynasty (1692), forming a distinctive ancient architectural group of scholars and ordinary people in Bizhou /Photographed by Wu Jun

02　　　每逢佳节，永隆桥上花灯高挂 ／ 蓝善祥 摄

　　　　Whenever there is a festival, festive lanterns are hung high on Yonglong Bridge /Photographed by Lan Shanxiang

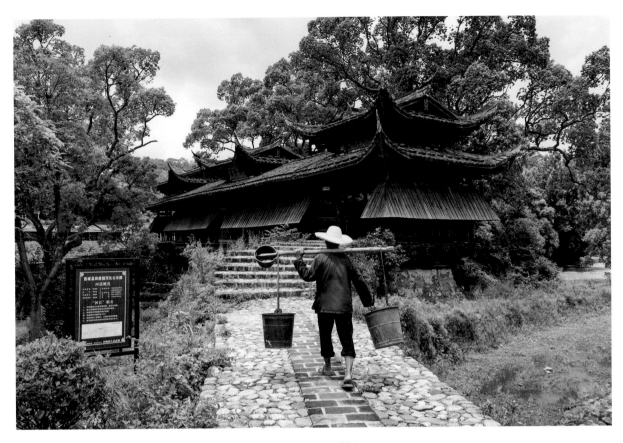

连城四堡镇玉砂桥建于清代，是连城现存较完整的四座古廊桥之一 ／ 郭晓丹 摄

Yusha Bridge in Sibao Town, Liancheng County is one of the most complete existing corridor bridges /Photographed by Guo Xiaodan

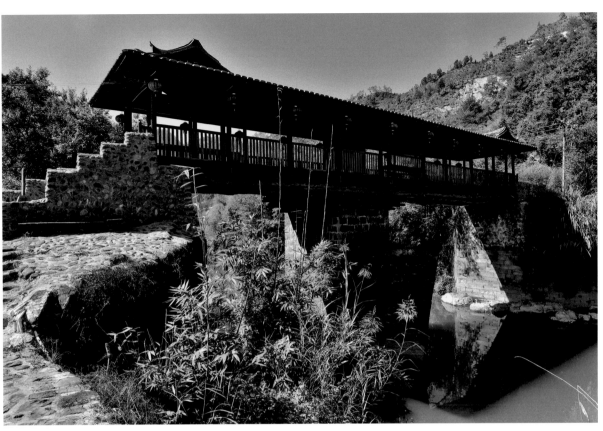

建于清乾隆年间的漳平双洋镇化龙桥 ／ 吴寿华 摄

Hualong Bridge in Shuangyang Town of Zhangping, built in the reign of Qianlong in the Qing Dynasty /Photographed by Wu Shouhua

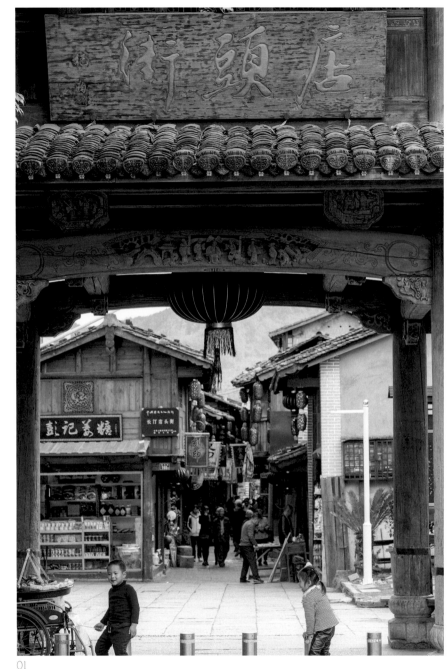

01

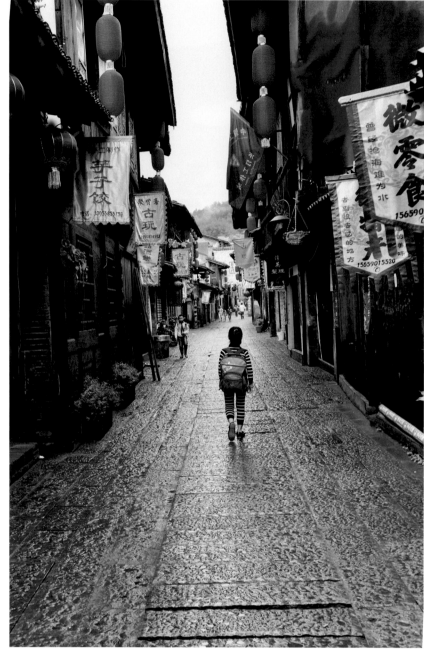

02

01　　　长汀店头街。店头，在客家语中是最好的集市商铺的意思。店头街历史悠久，临近汀江码头，零星的商贸交易最早可追溯到唐代，北宋时在此设店头市，明清时期成为繁华的集市 / 赖小兵 摄

Diantou, means the best fair shop in the Hakka dialect. Diantou Street in Changting has a long history, close to the wharf of the Tingjiang River, where sporadic business transactions can be traced back to the Tang Dynasty. In the Northern Song Dynasty, Diantou City was set up here, which became a prosperous fair in the Ming and Qing Dynasties / Photographed by Lai Xiaobing

02　　　雨后的店头街，充满着诗情古意 / 陈扬富 摄

Diantou Street after the rain is full of poetic charm and ancient style /Photographed by Chen Yangfu

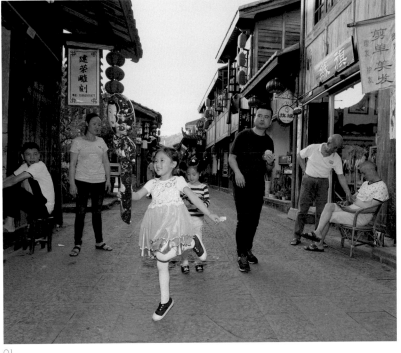

01

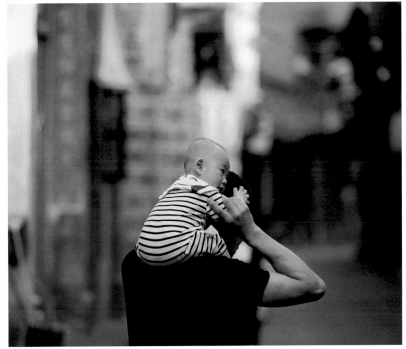

02

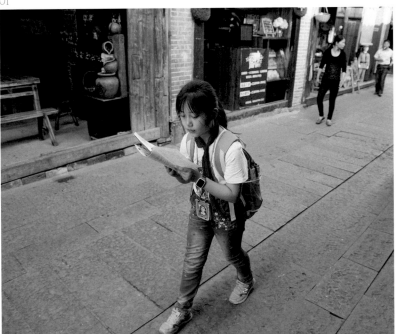

03

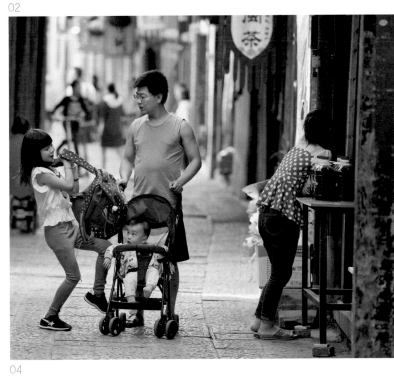

04

01/02/03/04　店头街的百姓日常 / 姜克红 摄
The daily life of the people in Diantou
Street /Photographed by Jiang Kehong

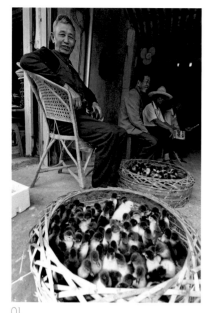

01

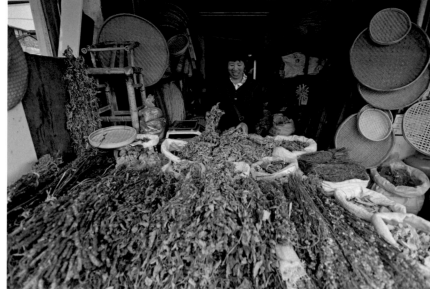

02

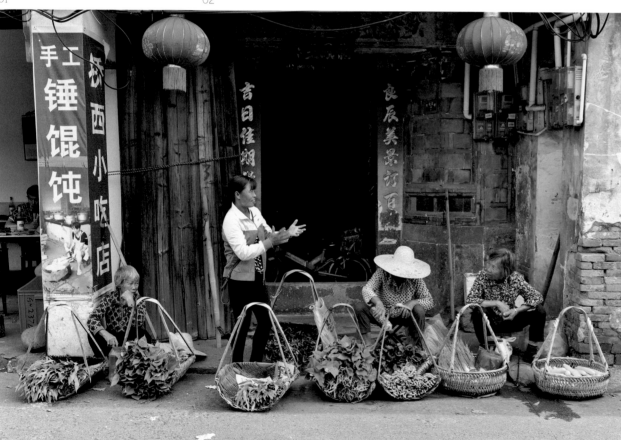

03

01 集市上的鸭苗 / 关建东 摄
 Ducklings in the fair /Photographed by Guan Jiandong

02 上杭的饮食里，多有各种药膳，夏秋季节，凉茶也是百
姓家中必备的去暑佳品 / 关建东 摄
 In Shanghang's diet, there are many kinds of
medicinal foods. In summer and autumn, herbal tea is also
a must-have delicacy for people to drive away summer
heat /Photographed by Guan Jiandong

03 西门老街上传统的早市 / 赖小兵 摄
 The traditional morning market in Ximen Old Street /
Photographed by Lai Xiaobing

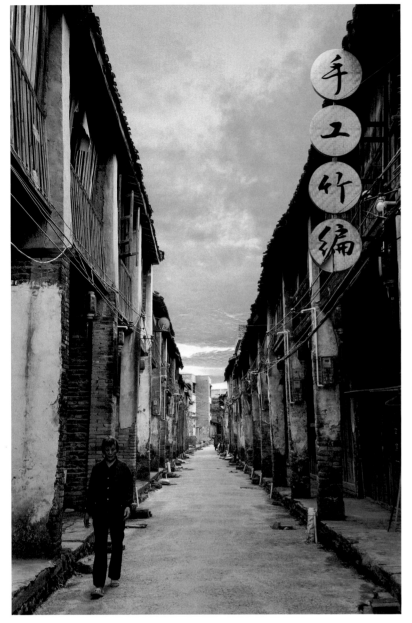

武平中山镇的百年老街 / 郭晓丹 摄
The centennial street in Zhongshan Town of Wuping /
Photographed by Guo Xiaodan

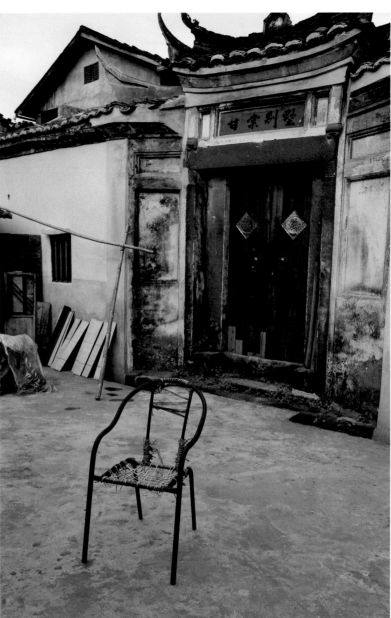

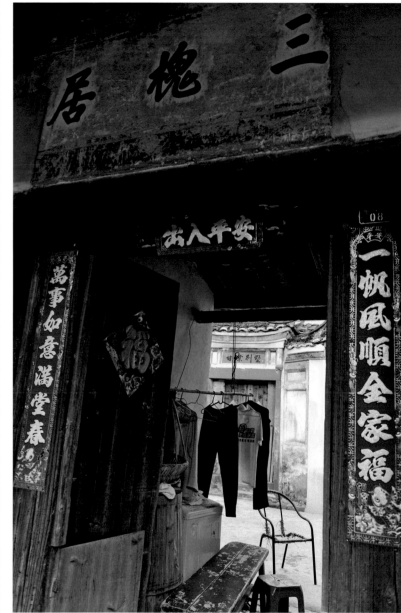

中山镇是全国罕见的典型客家"百姓镇"。这个地处闽粤赣三省结合部的千年古镇，为客家民系自中原辗转南迁中转站之一；由于地处三省结合部，历经驻军和战乱，最终形成五湖四海、兼容并蓄的"百姓镇"此一独特奇观

Zhongshan Town is a typical Hakka "Town of Hundred Surnames" that is rare in China. This millennium ancient town located at the junction of the three provinces of Fujian, Guangdong, and Jiangxi,which is one of the transfer stations of the Hakka people to move southward from the Central Plains; Because its location in the junction of the three provinces, going through garrisons and wars; it has finally formed a unique wonder of "Town of Hundred Surnames" that are compatible with each other from all corners of the country

"百姓镇"盛行姓氏门额氏联，千百年来流传不衰，每逢节庆喜事，各家各姓，均在大门贴上姓氏门额氏联，表达念祖追宗、饮水思源之情

Horizontal scrolls and antithetical couplets based on the surname of the head of household prevail in "Town of Hundred Surnames", which has been handed down for thousands of years. During festivals and happy events, each family of each surname is pasted on the gate with horizontal scrolls and antithetical couplets based on the surname of the head of household to express the feeling of remembering the ancestors and chasing the ancestors and gratitude for the source of benefit

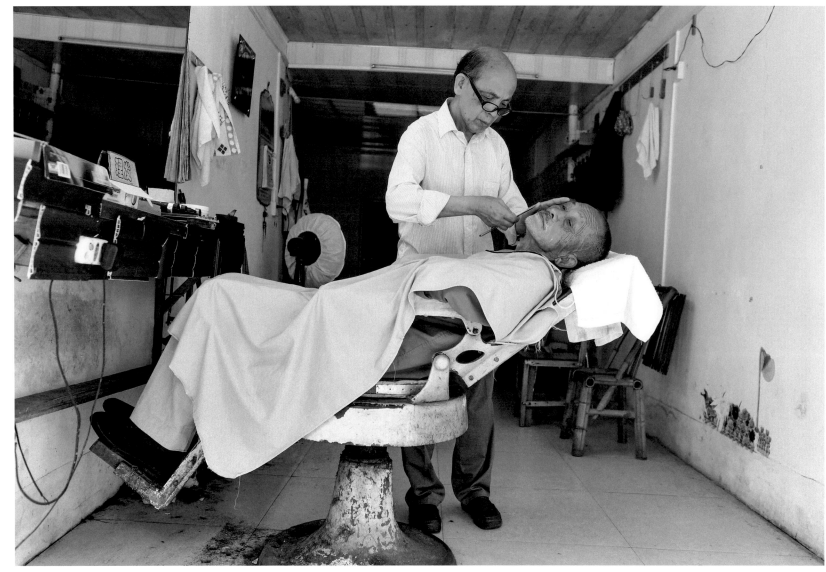

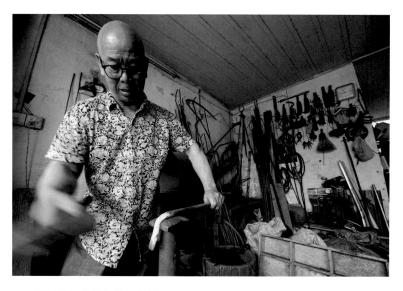

西门老街上的传统打铁铺 / 赖小兵 摄
The traditional blacksmith shop in Ximen old street /
Photographed by Lai Xiaobing

上杭县西门老街区的传统理发店，老人们依然喜欢旧式的剃头方式 / 赖小兵 摄
In the traditional barbershop in the old block of Ximen in Shanghang County, the elders still like the old-
fashioned haircut /Photographed by Lai Xiaobing

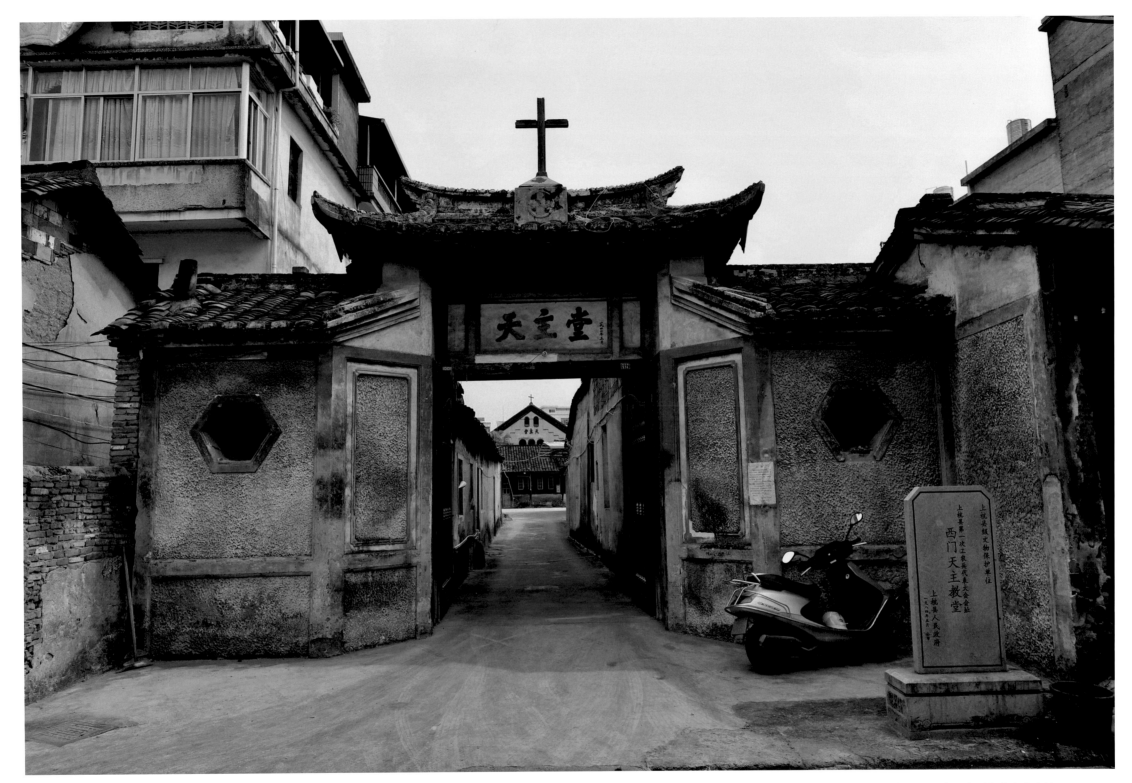

上杭县西门天主教堂也是上杭县第一次工农兵代表大会会址 / 赖小兵 摄
Ximen Catholic Church in Shanghang County is also the site of the First Congress of Workers, Peasants and Soldiers in Shanghang County /Photographed by Lai Xiaobing

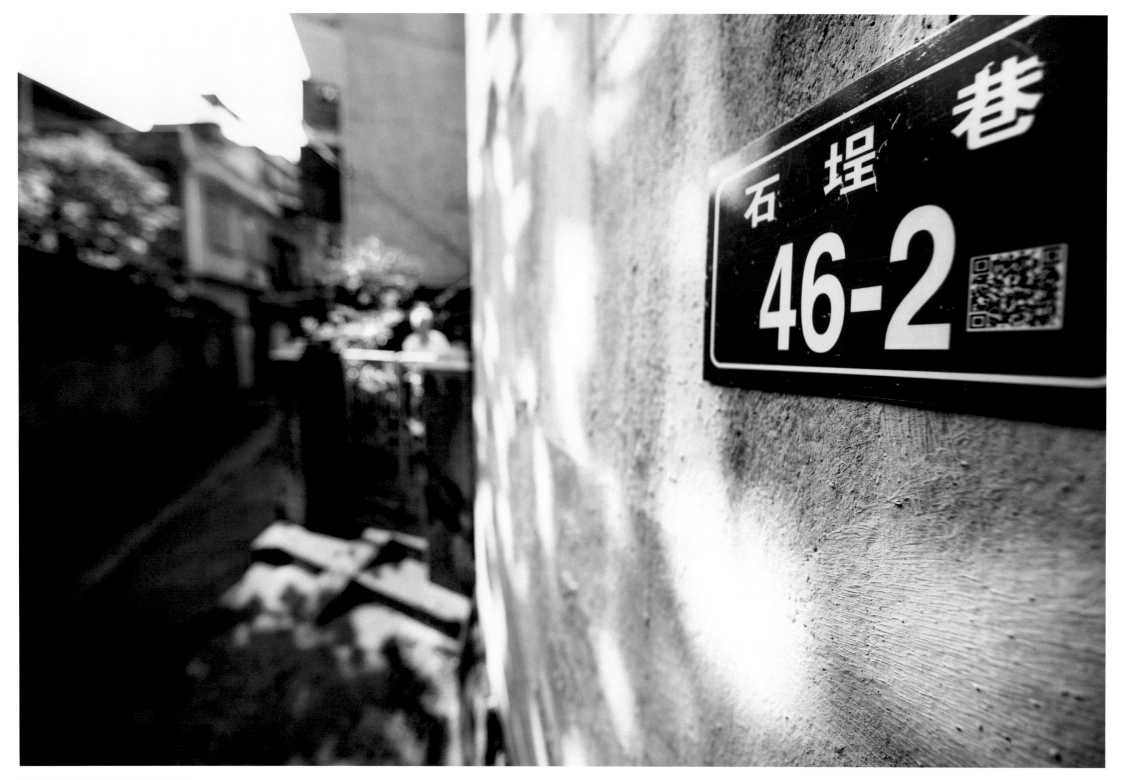

石埕巷 46-2

石埕巷曾经是新罗对外通商的要道 / 严硕 摄
Shicheng Lane used to be the thoroughfare for foreign trade in Xinluo /Photographed by Yan Shuo

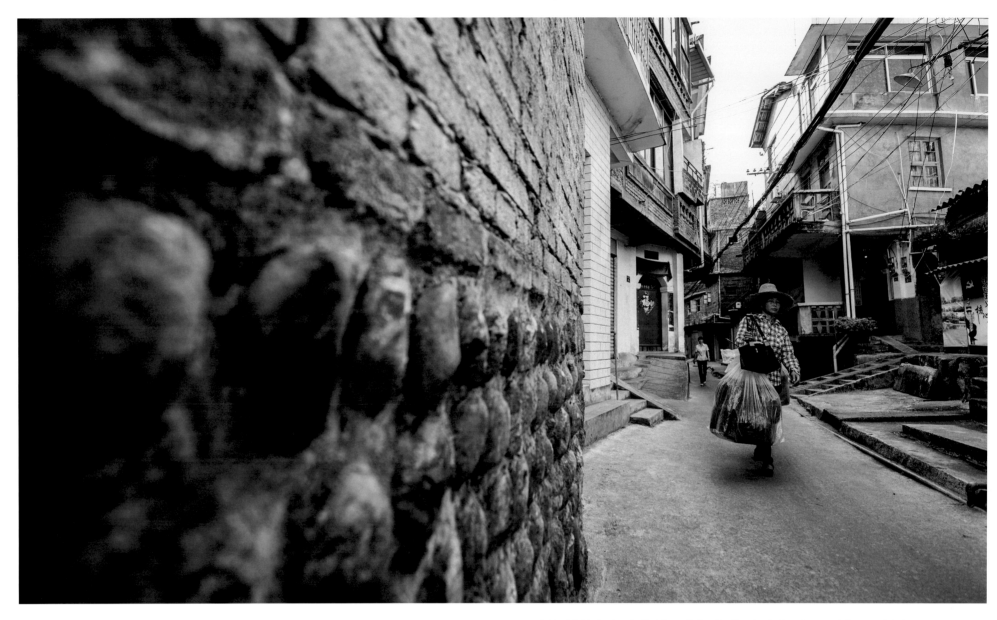

随着时代的变迁，有着千年历史的石埕巷，如今也只有这石墙镌刻着当年的记忆 / 严硕 摄
With the change of the times, the stone wall of Shicheng Lane, which has a history of thousands of years, is the only thing engraved with the memory of that year /Photographed by Yan Shuo

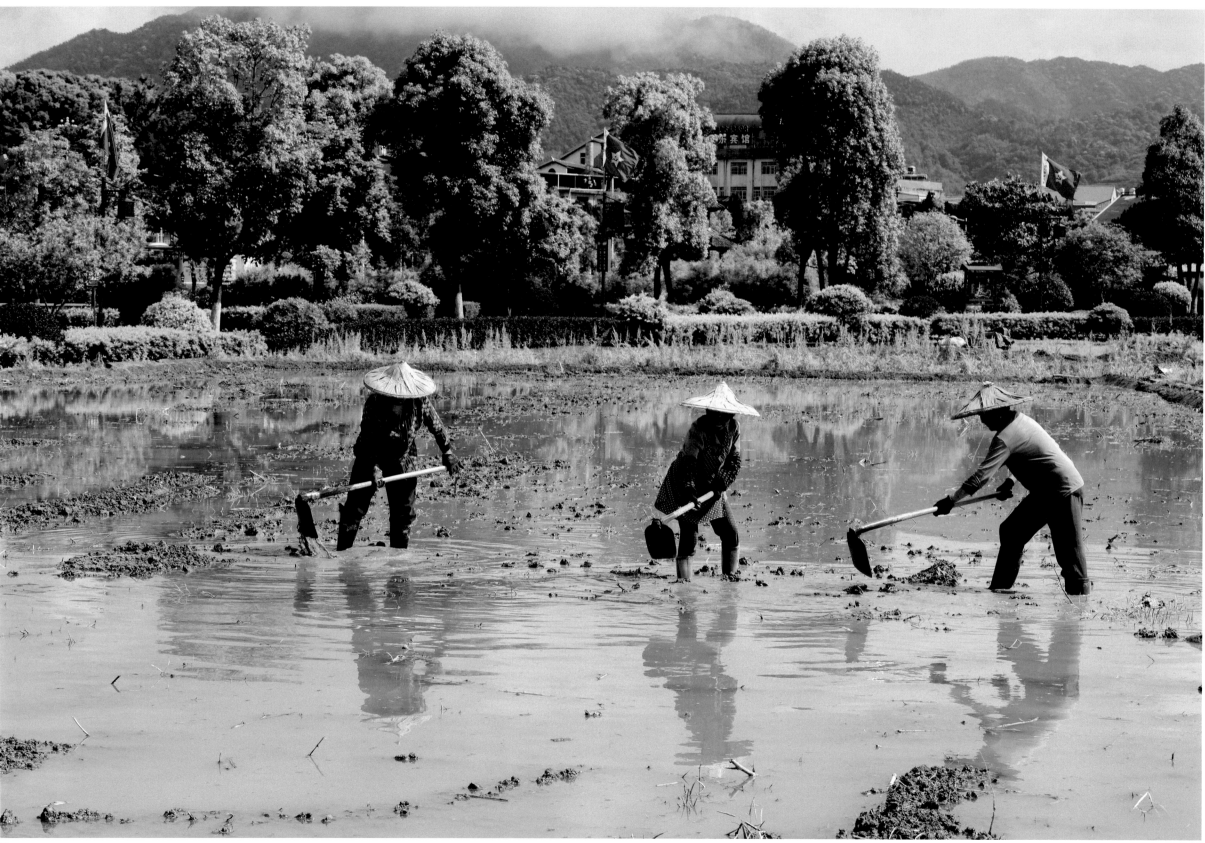

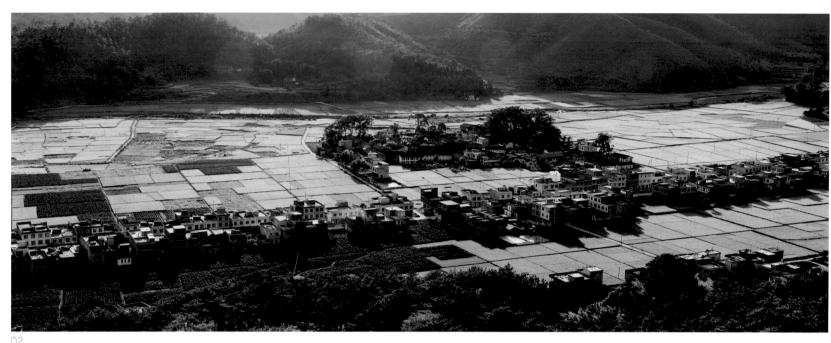

02

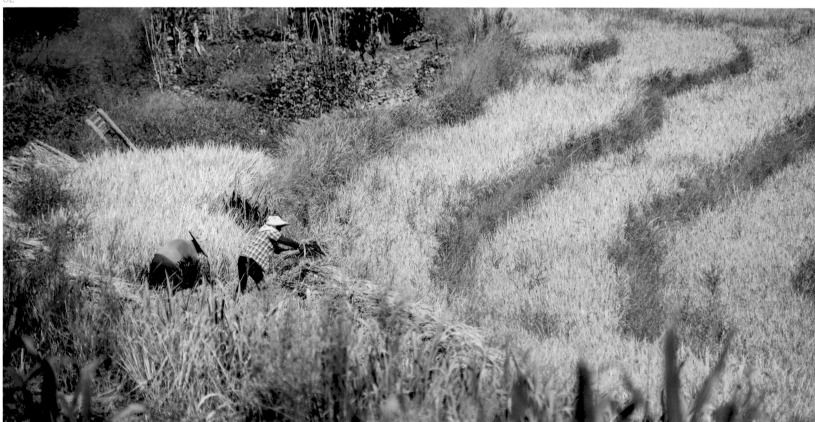

03

01　　上杭才溪乡，正在耕作的村民 / 陈杨富 摄
　　The villagers are farming in Caixi Town, Shanghang /
Photographed by Chen Yangfu

02　　汀江两岸沃野良田
　　The fertile farmlands along the both sides of the
Tingjiang River

03　　新罗区"江山睡美人"风景区下，农民正在收割入
　　秋后的第一批稻谷 / 严硕 摄
　　Farmers are reaping the first crop of rice after
autumn at the "Sleeping Beauty" Scenic Spot in Xinluo
District /Photographed by Yan Shuo

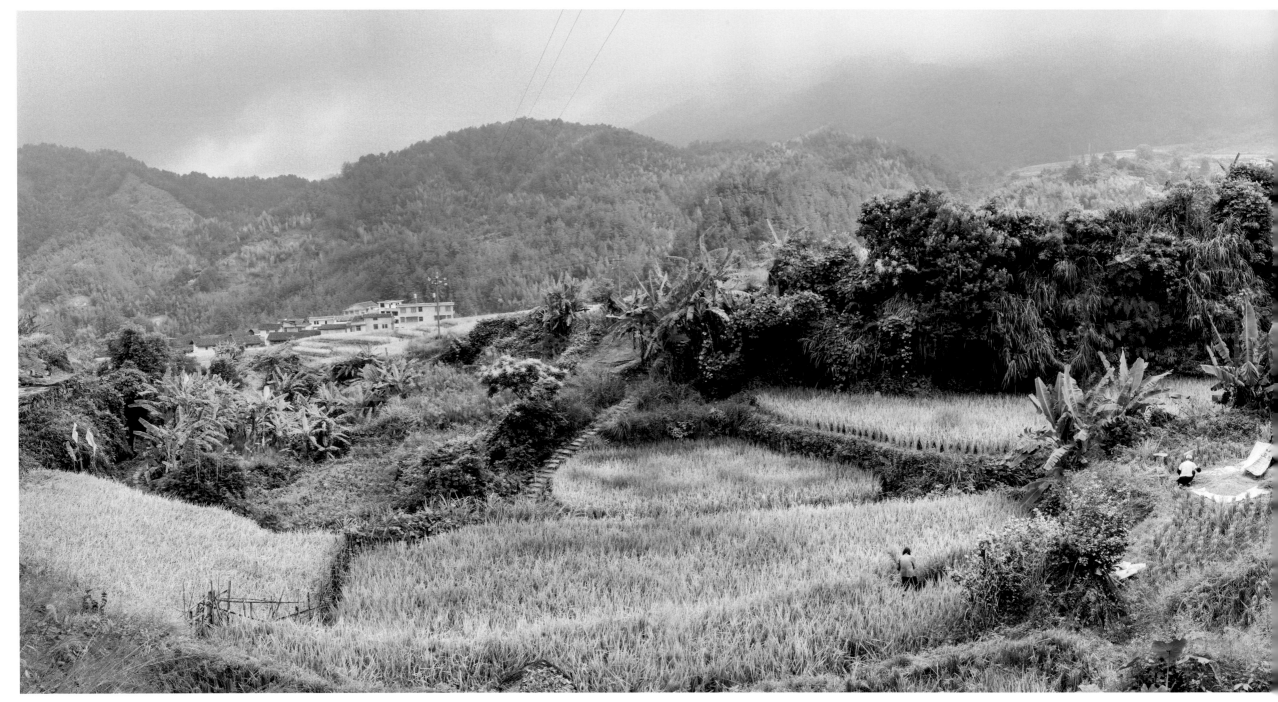

秋收时刻，永定初溪土楼前的层层麦田 / 赖小兵 摄
At the autumn harvest time, layers of wheat fields in front of Chuxi Earth Building in Yongding /Photographed by Lai Xiaobing

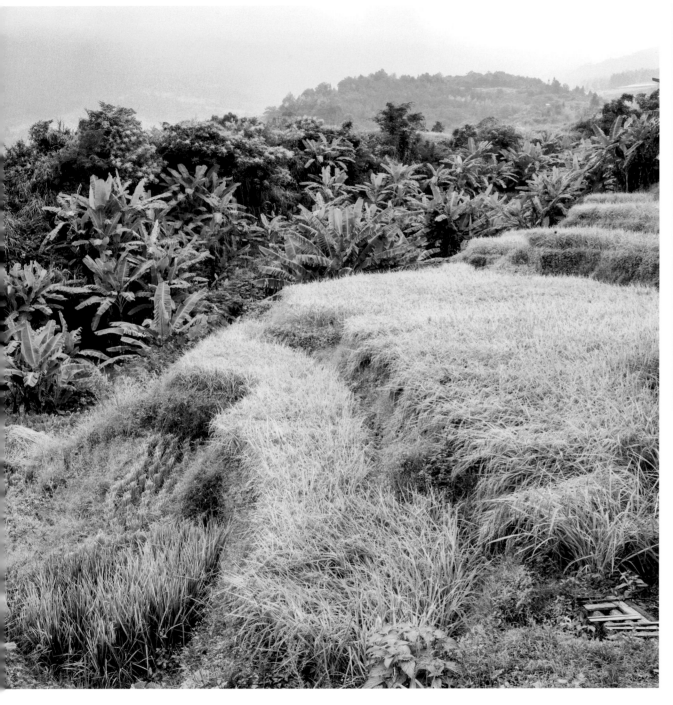

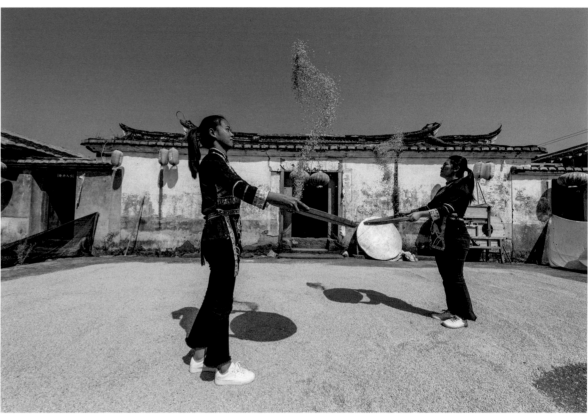

汀江自北向南纵贯上杭庐丰畲族乡，这里农田肥沃，是龙岩地区的产粮基地，图为畲族居民晒谷子 / 吴军 摄
The Tingjiang River runs through Lufeng She Nationality Township of Shanghang from north to south, which has fertile farmland and is the grain production base in Longyan area. The picture shows that residents of she nationality is drying the millet /Photographed by Wu Jun

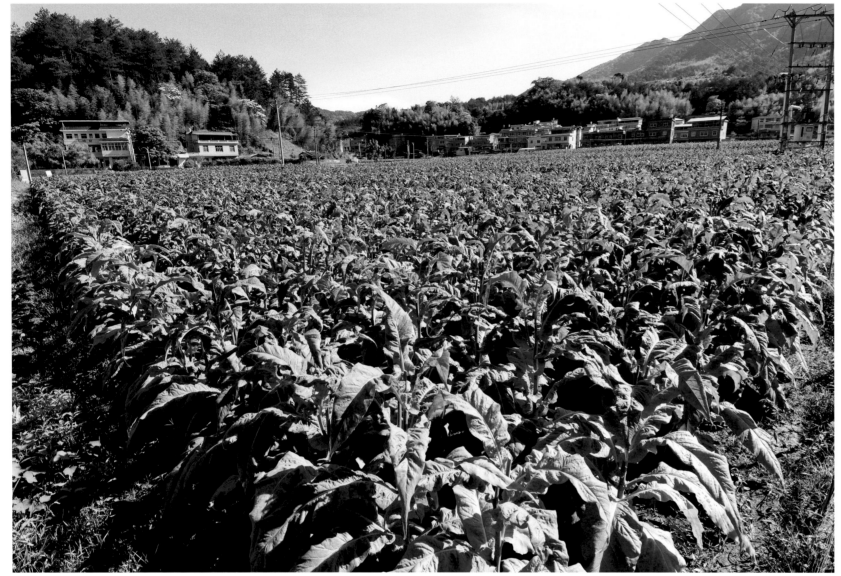

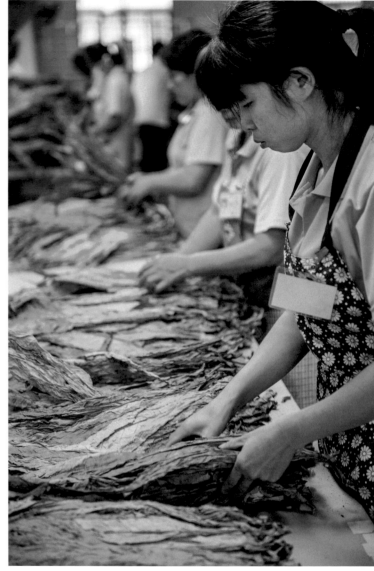

汀江流域具有优越的植烟自然条件，雨热同季，能为烟草提供有利的生长环境 / 赖小兵 摄
The Tingjiang River Basin has superior natural conditions for tobacco planting that the rain and heat are in the same season, which can provide favorable growth environment for tobacco /Photographed by Lai Xiaobing

永定区湖坑烟草站，工人们正在挑选上好的烟叶 / 严硕 摄
At Hukeng Tobacco Station in Yongding District, workers are picking the best tobacco leaves /Photographed by Yan Shuo

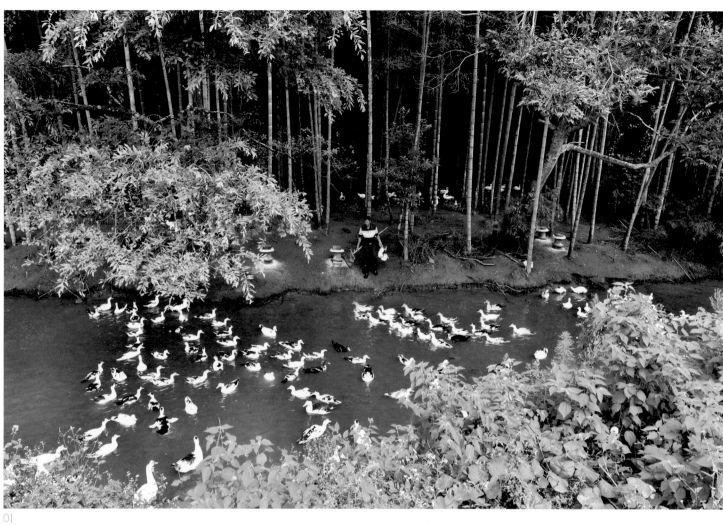

01

01 武平林改为百姓带来了经济上的大发展，林下经济多种多样 / 吴军 摄

Collective Forest Tenure Reform in Wuping has brought great economic development to the people, and and the under-forest economy is diversified / Photographed by Wu Jun

02 "全国林改第一县"武平，积极发展林下经济，成功开辟了一条"不砍树能致富，保护生态也得益"的绿色发展之路，图为村民采运春笋 / 李国潮 摄

Wuping, the first county of China's collective forest tenure reform, actively developed the under-forest economy, and successfully opened up a green development road that "making a fortune without cutting down trees, and also benefiting from the protection of ecology". The picture shows villagers picking and transporting bamboo shoots / Photographed by Li Guochao

03 三洲村劳动的客家妇女 / 陈扬富 摄

The Hakka women working in Sanzhou Village / Photographed by Chen Yangfu

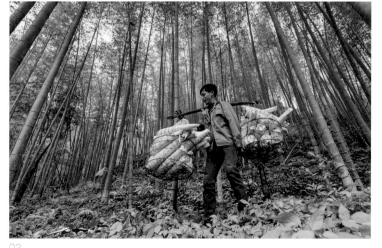

02

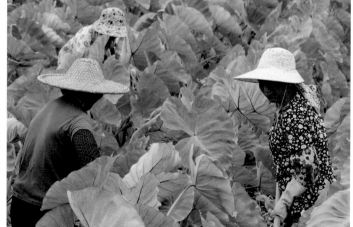

03

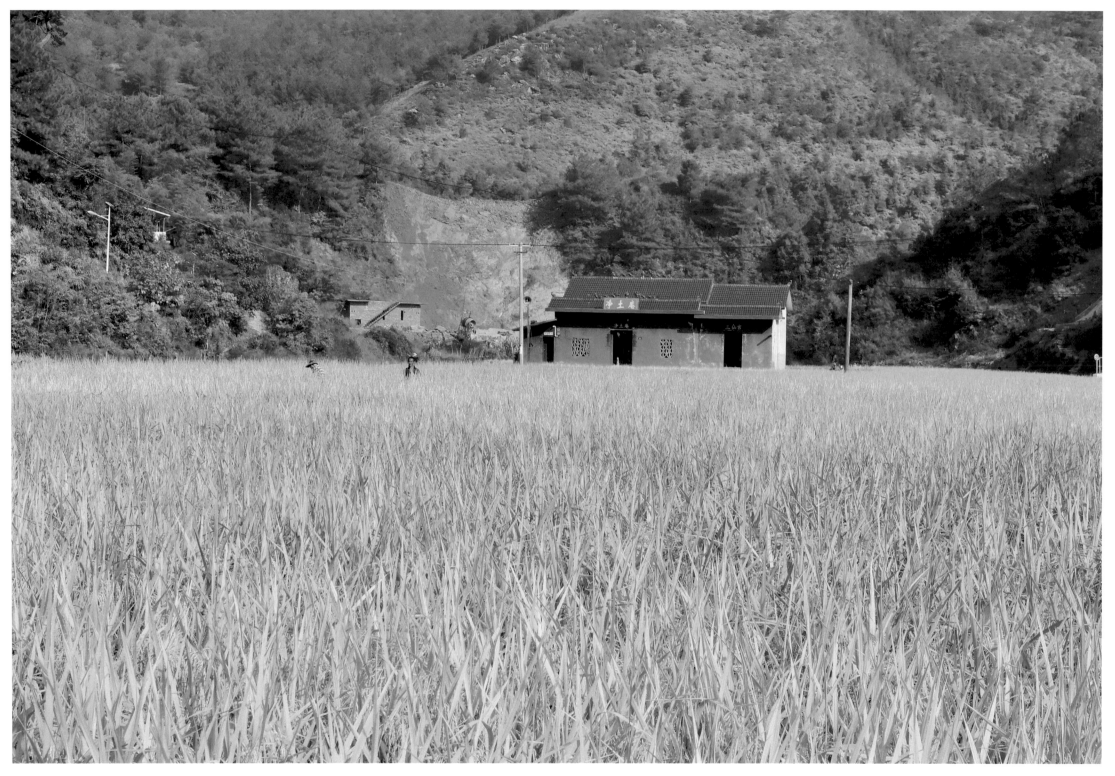

上杭庐丰乡，稻田中的净土庵格外醒目 / 吴军 摄
In Lufeng Township of Shanghang, Jingtu Nunnery in the rice field is particularly prominent /Photographed by Wu Jun

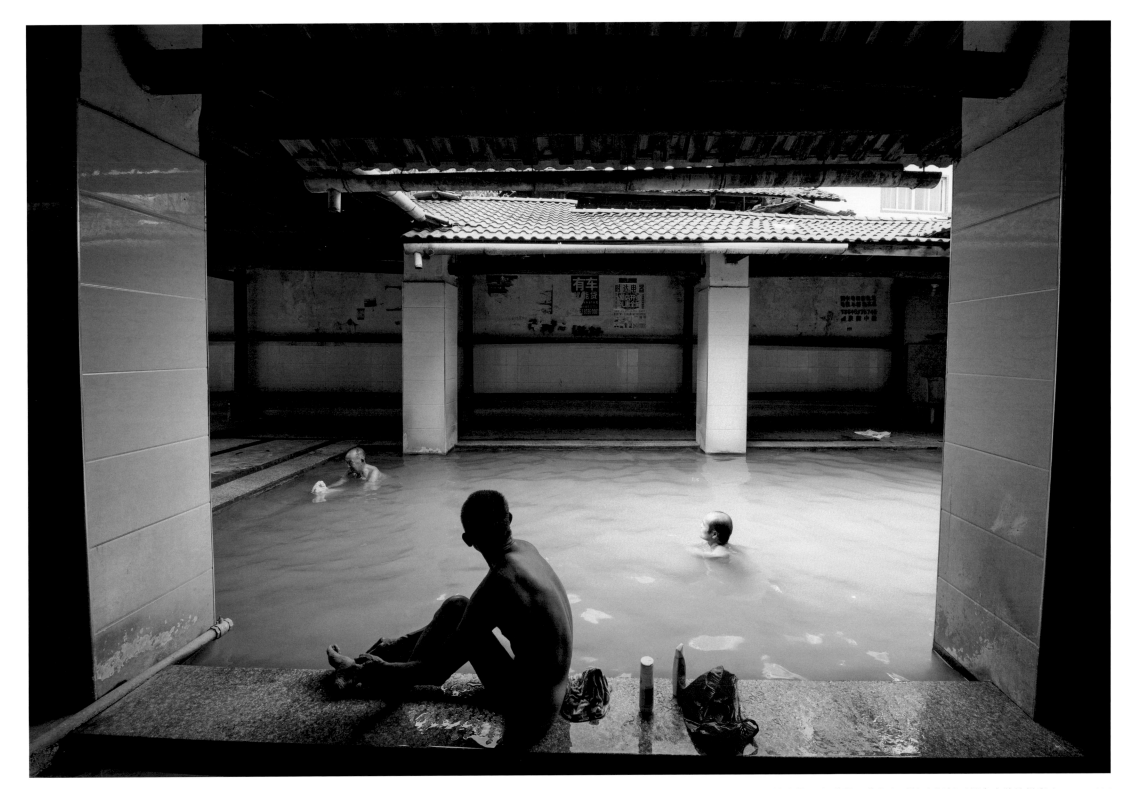

闽西地区的汀江流域，温泉资源丰富，各县区均有天然温泉，图为长汀县河田镇上的温泉澡堂，劳作之后的人们每天都会来此放松身心 / 严硕 摄
The Tingjiang River Basin of Western Fujian region is rich in hot spring resources, and all counties have natural hot springs. The picture shows the hot spring bathhouse in Hetian Town, Changting County. People come here every day to relax after their work /Photographed by Yan Shuo

Hakka
Carnival

客家狂欢

　　客家的民俗活动体现出中原浩大、壮观与彪悍的特点，由于与本土的结合，又造成了活动的多样形式。这一个章节中，淋漓尽致地表现了闽西客家不同的民俗样本。从记录的意义上说，这是需要积累的，绝非一日一时的采访拍摄所能得到。民俗活动又是在运动中展示，记录的时机、光线、技巧、设备等都十分重要。所以这个章节中的记录，十分珍贵，许多场景都是不可复制的。客家的精气神，在狂欢中得到了极致的释放与表现。

Hakka folk activities reflect the vast, magnificent and intrepid characteristics of the Central Plains. The combination of Hakka folk activities with the local customs has resulted in various forms of activities. In this chapter, the different samples of Western Fujian Hakka folk custom are incisively and vividly presented. In the sense of record, it needs to be accumulated, and it is not available from the day-to-day interview and shooting. To Photograph the folklore activities, there are strict requirements for recording time, light, skills, equipment and so on. Therefore, the records in this chapter is very precious, because many scenes are not reproducible. Abundantly the Hakka vitality is released and spirit expressed in the carnival.

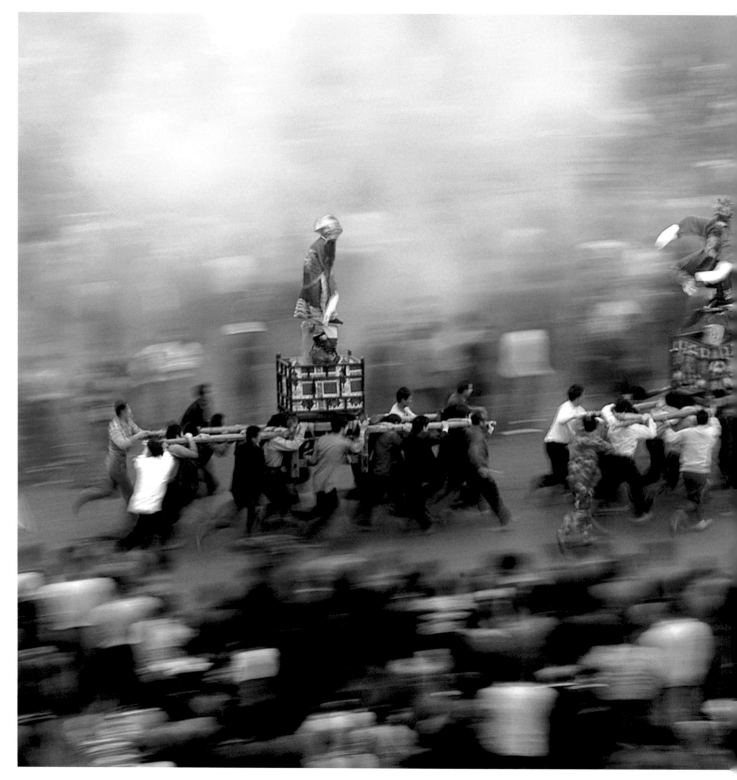

"客家狂欢节" ——连城罗坊 "走古事"
"Hakka Carnival"—"Zou Gu Shi (parade of ancient stories)" in Luofang Town of Liancheng

Zou Gu Shi
of
Liancheng

连城走古事

走古事是客家人每年正月十五举办的传统民俗文化活动，在连城、永定区、长汀县涂坊镇盛行，尤以连城罗坊为盛，被誉为"客家狂欢节"。据传在明朝，客家各乡常闹旱、涝两灾，当地百姓把流传北方的"走古事"移植到当地，以祈求风调雨顺、国泰民安，兼兴元宵民间娱乐活动，自此流传延续至今。

"Zou Gu Shi (parade of ancient stories)" is a traditional folk cultural activity held by Hakkas on the 15th day of the first lunar month each year. It prevails in Liancheng, Yongding County and Tufang Town of Changting County, especially in Luofang Town of Liancheng, which is known as "Hakka Carnival". It is said that in the Ming Dynasty, the Hakka townships often suffered from drought and flood, so the local people transplanted "Zou Gu Shi" popular in the north to the local to pray for favorable weather, peace and prosperity, and concurrently made folk entertainment activities during the Lantern Festival popular. Since then, it has continued to this day.

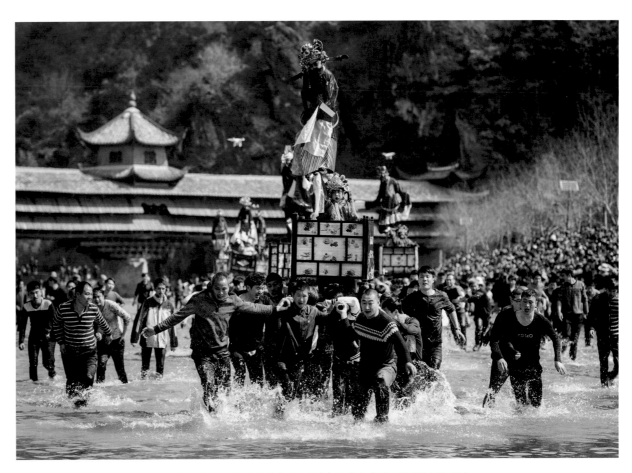

流行于福建龙岩连城县的"走古事"，是客家人每年正月十五举办的大型民俗竞技活动
Popular in Liancheng County, Longyan County, Fujian Province, "Zou Gu Shi (parade of ancient stories)" is a large-scale folk competitive activity held by Hakkas on the 15th day of the first lunar month of each year

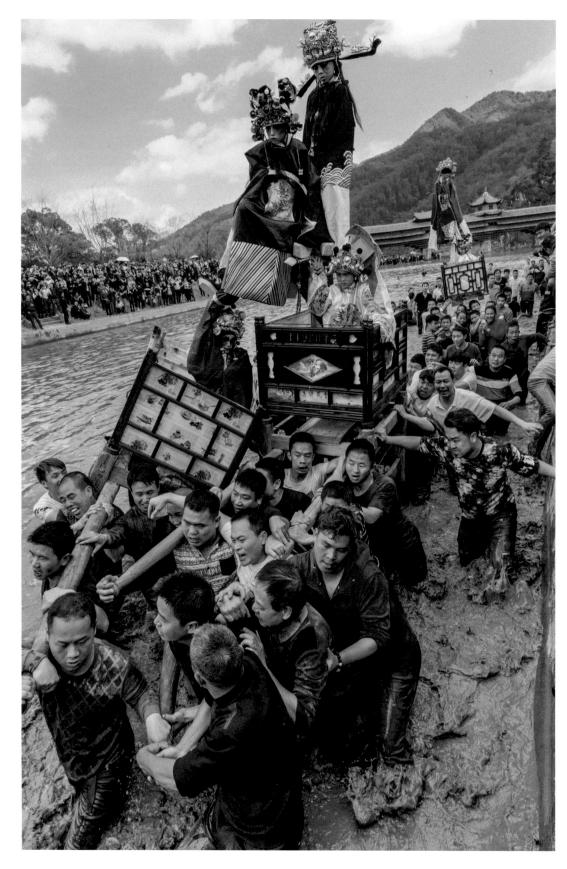

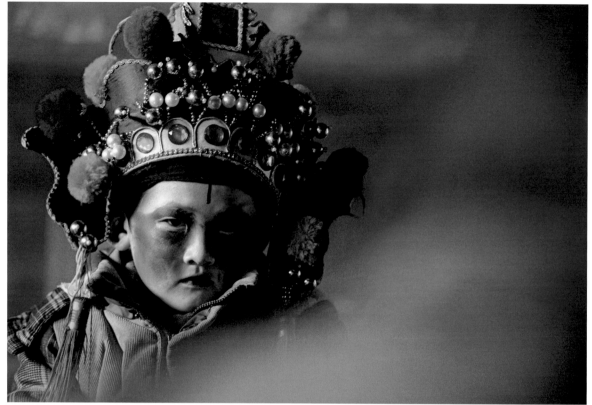

每棚古事由房族挑选身体健壮、胆量大的八岁左右男童两名，按戏剧内容装扮、幻画脸谱、身脊戏袍、一名扮主角，一名扮底座的护将 / 陈伟凯 摄

In each shed of ancient stories, the relative of the same clan selects two boys about eight years old who are strong and courageous. And they are dressed up according to the content of the drama, sketched facial makeup, dressed in drama robes, with one playing the leading role and the other playing the protector of the base /Photographed by Chen Weikai

同心协力 / 吴军 摄
Unite in a concerted effort /Photographed by Wu Jun

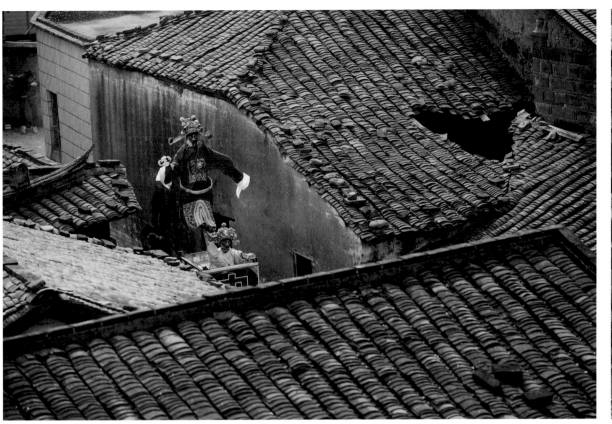

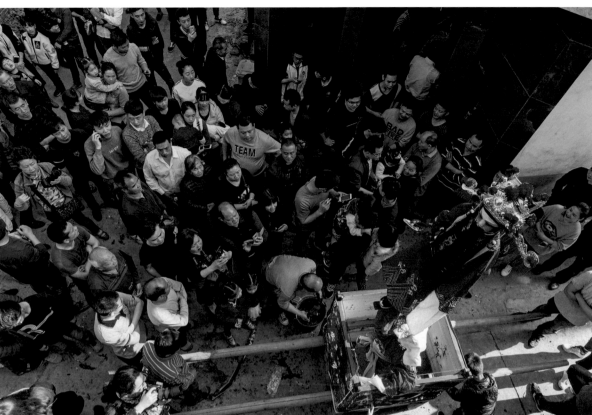

穿街走巷,祈求来年风调雨顺 / 陈伟凯 摄
Wandering about the streets and lanes, pray for favorable weather in the coming year /Photographed by Chen Weikai

在数以万计的乡民和游客的围观中,出棚各户一个个精神振奋,呼喊着开始竞赛 / 吴军 摄
Amid the onlookers of tens of thousands of villagers and tourists, each household giving a performance cheers up and shouts to start the competition /Photographed by Wu Jun

Linfang
Green
Lion
of Liancheng

连城林坊青狮

连城林坊青狮属北狮武功狮，其狮动作灵活敏捷，狮头内可藏兵刃作盾牌使用，可攻可防。掌狮头和掌狮尾两人，动作配合默契多变，模仿雄狮的各种姿态，惟妙惟肖展示力与美的结合，是客家人原生态传统武术文化遗产。

Linfang Green Lion of Liancheng belongs to Kong Fu Lions of the North Lion, whose movements are flexible and agile. A weapon blade hidden in the lion's head can be used as a shield to attack and defend. The two people who control the lion head and lion tail respectively, with tacit coordination and changeable movements, imitate various postures of the lion and vividly demonstrate the combination of strength and art, which is the original traditional martial arts cultural heritage of the Hakka people.

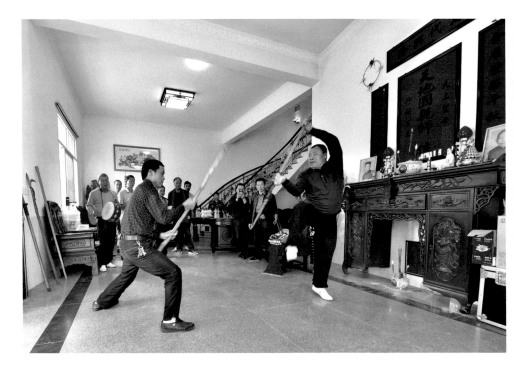

每逢佳节或集会庆典，连城县林坊镇都以舞狮来助兴 / 吴军 摄
Lion dance is used to enterta in Linfang Town in Liancheng County during festivals or celebrations /Photographed by Wu Jun

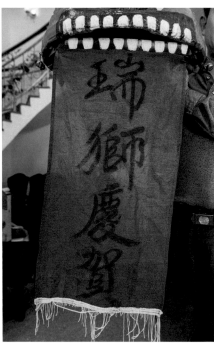

狮头上的吉祥祝福 / 吴军 摄
Theauspicious words on the head of a lion /Photographed by WuJun

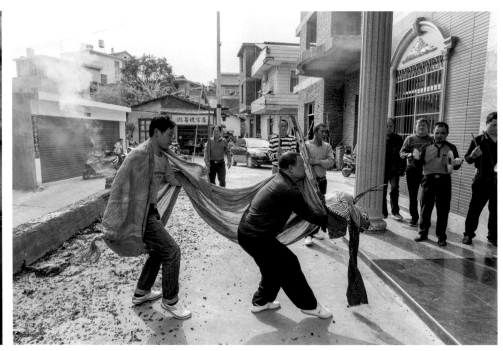

掌狮头和掌狮尾两人，在锣鼓音乐下，做出狮子的各种形态动作。在表演过程中，舞狮者要以各种招式来表现林坊武术，极富阳刚之气 / 吴军 摄
There are two people who control the lion head and lion tail. The performers make various shapes and movements of the lion under the music of gongs and drums. During the performance, the lion dancers use various movements to show Linfang martial arts, which is very masculine /Photographed by Wu Jun

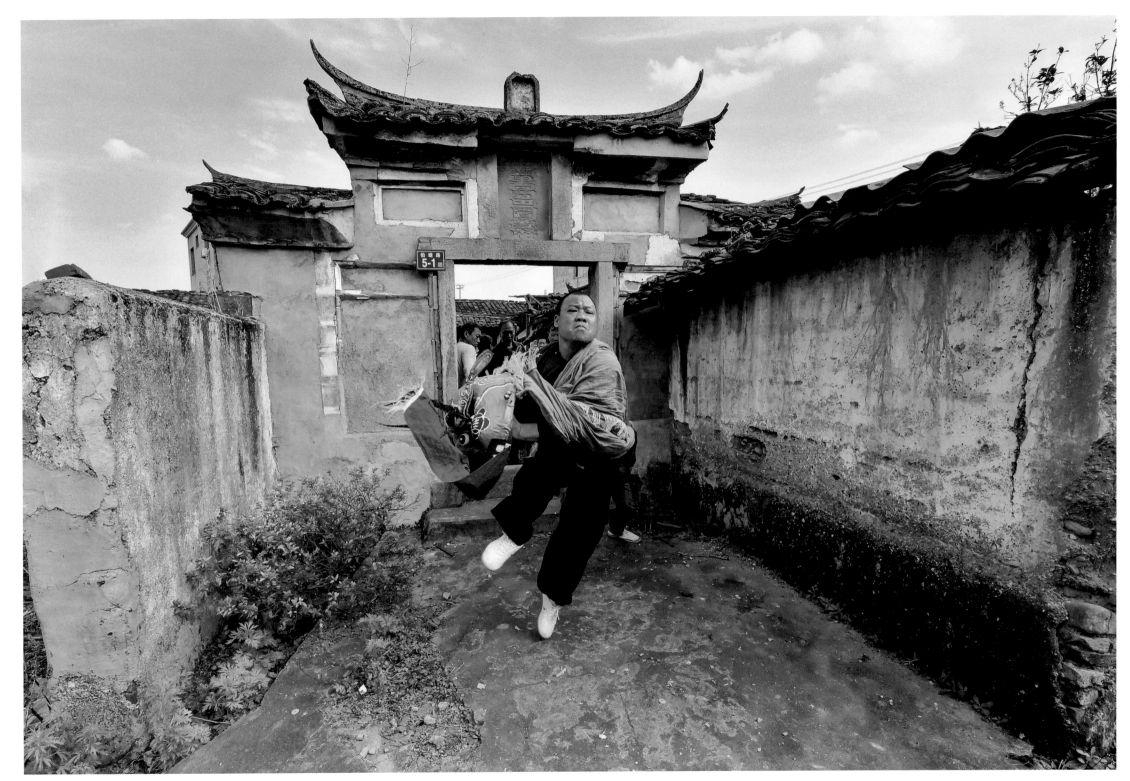

连城武术历史悠久，林坊青狮的盛行也正源于尚武之风世代相传 / 吴军 摄
Liancheng martial arts had a long history. The popularity of Linfang Green Lion is due to the tradition of advocating martial arts passed down from generation to generation /Photographed by Wu Jun

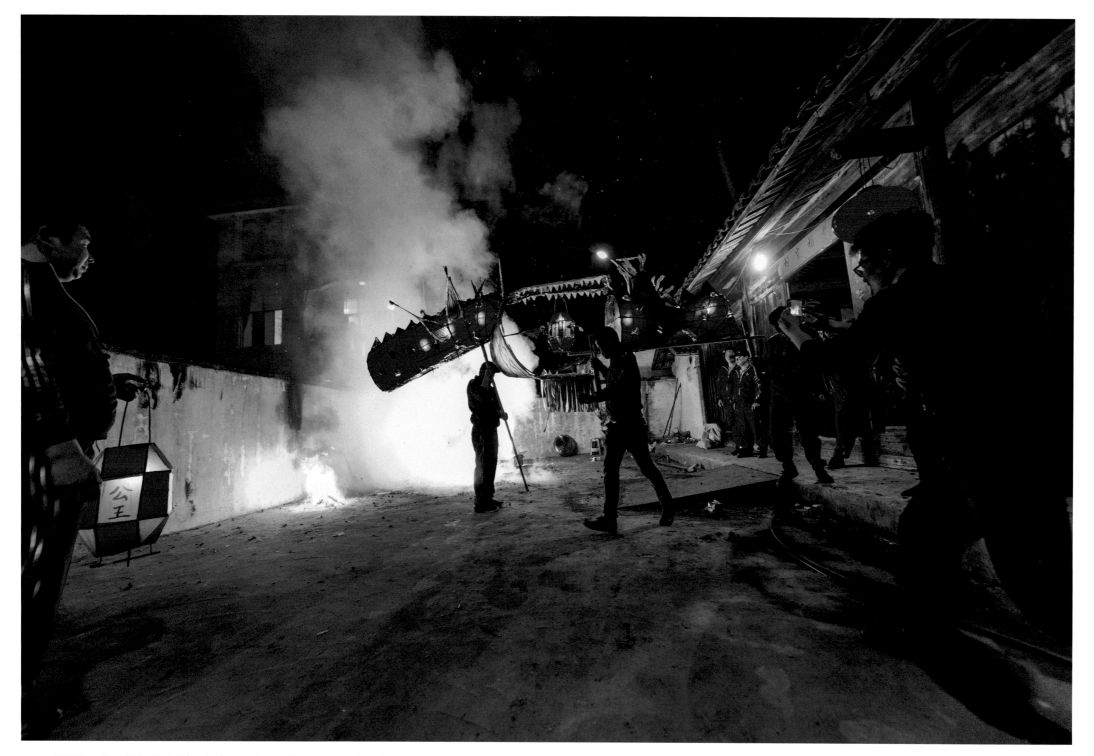

夜幕降临，拔龙活动正式开始。拔龙前，龙头和龙尾要在祖祠内装饰好，之后点烛焚香举行仪式祭告先祖，之后才能请
出祖祠与龙身拼接相连 ／ 朱晨辉 摄

As night falls, the Ba Long (pulling the dragon lantern) just begins. Before Ba Long, the dragon head and the dragon
tail should be decorated well in the ancestral hall, only after holding a ceremony for ancestor worship by lighting candles
and burning incense, it can be invited out of the ancestral hall to join the dragon body /Photographed by Zhu Chenhui

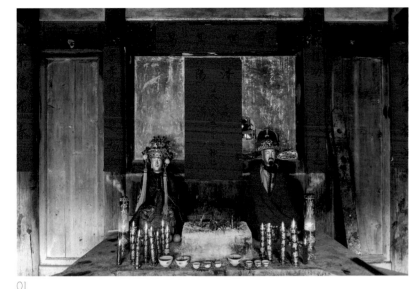

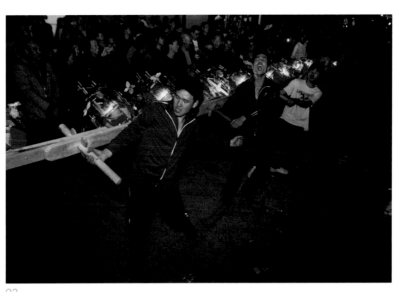

01

02

Ba Long (Pulling the Dragon
Lantern) of Beituan Town,
Liancheng

连城北团拔龙

每年农历正月十三至十五，龙岩市连城北团下江村都要"拔龙"闹元宵。"拔龙"即"拔龙灯""游龙灯"，是连城客家人元宵期间一项特别的民俗活动。"拔龙"不像别的游龙和舞龙悠然起舞，而是时进时退、时跑时停、前拖后拉，花样百出，煞是热闹好看。

Every year from the 13th to the 15th of the first month of the lunar calendar, People in Xiajiang Village, Beituan Town, Liancheng County, Longyan City, will "Ba Long (Pulling the Dragon Lantern)" to celebrate the Lantern Festival. "Ba Long" refers to "pulling dragon lantern" and "dragon lantern dance", which is a special folk activity of the Hakka people in Liancheng during the Lantern Festival. "Ba Long" doesn't dance leisurely like other dragon dances, but moves forward and backward, runs and stops, drags forward and pulls backward, full of tricks, which is really lively and interesting.

01 祭祀供奉的先祖牌位
 Memorial tablets of ancestors for sacrifice and worship

02 北团下江村的拔龙是一种很特别的闹元宵方式，它既不像红龙缠柱一样悠然起舞，也不像姑田大龙那样雍容大气，而是以"拔"为主要特点 / 朱晨辉 摄
 Ba Long (pulling out the dragon) in Xiajiang Village of Beituan Town is a very special way to celebrate the Lantern Festival. It is neither leisurely dancing like the red dragon wrapping around the column, nor natural and graceful like Gutian Big Dragon, but is characterized by "Ba (pulling)" as its main feature /Photographed by Zhu Chenhui

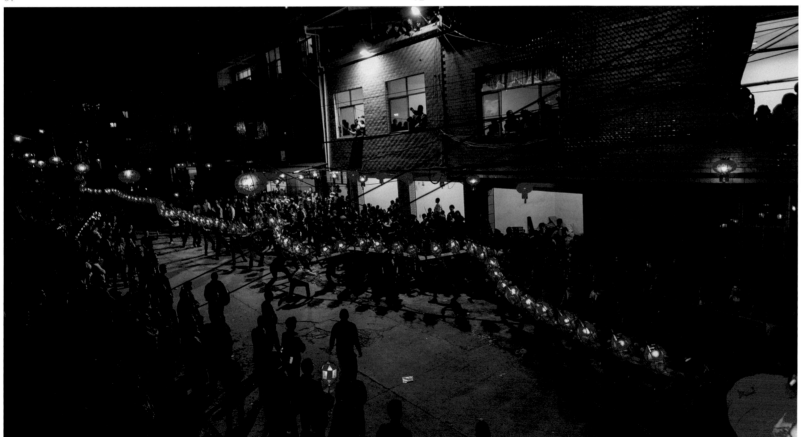

每家每户都在自己精心制作的龙灯中点上明亮的蜡烛，抬到大坪中一节一节地紧紧地拴在龙头和龙尾之间。大龙在神铳和锣鼓唢呐声中，绕村巡游。随后，缓缓地游到附近的一座山上。远远看去，犹如一条火红的巨龙在山头盘旋游动 / 朱晨辉 摄
Every household lights bright candles in their elaborate dragon lanterns, and carries them to the large plain land to be tightly tied between the dragon head and the dragon tail one by one. The dragon paraded around the village amid the sound of blunderbusses, gongs, drums and suonas. Then, it slowly parades to a nearby mountain. From a distance, it looks like a fiery red dragon circling and moving on the mountain top /Photographed by Zhu Chenhui

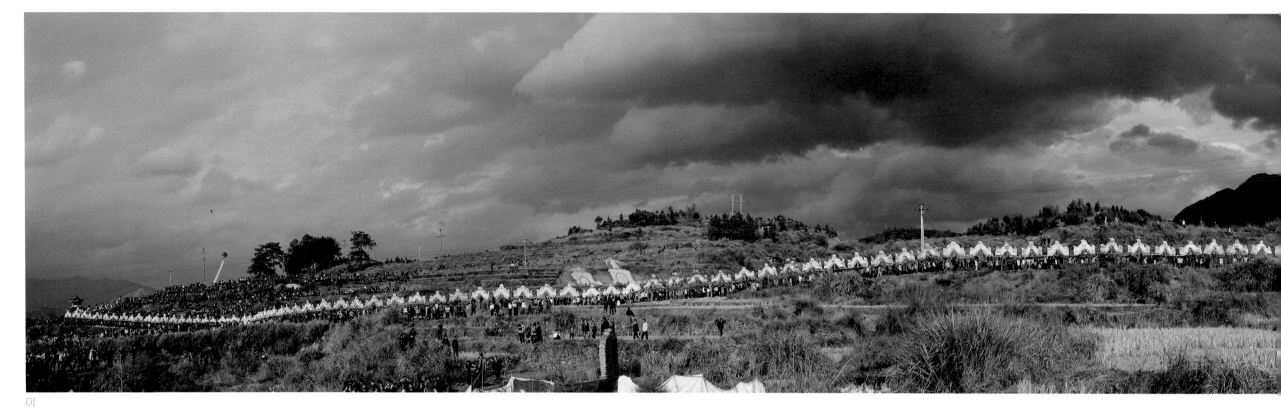

01

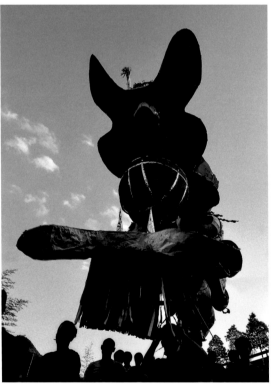

02

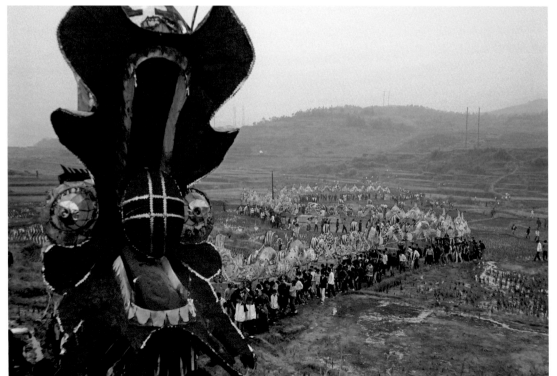

03

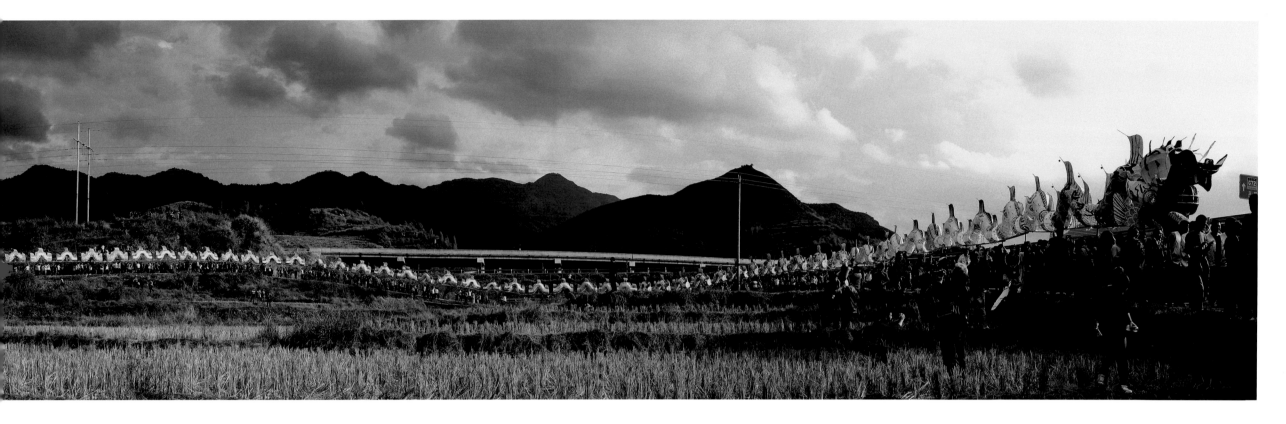

01　　姑田游大龙始于明代，至今已有 400 多年历史，意在祈求风
调雨顺、五谷丰登

Paper Dragon Dance in Gutian began in the Ming Dynasty
and has a history of more than 400 years, which is intended to
pray for favorable weather and good harvest

02　　龙头气势雄伟 / 吴军 摄

The magnificent dragon head /Photographed by Wu Jun

03　　大龙选用当地著名的姑田宣纸为材料，最主要的龙头及龙尾
由当年主办家族承担制作，龙身则以姓氏为单位，由各家各户分
别制作，最终出游的大龙就是由这一节节龙身相接而成

The paper dragon uses the famous local Gutian Xuan
Paper as the material. The main dragon head and dragon tail
are made by the host family in that year. The dragon body is
made by each family by taking the surname as the unit. The
final parading paper dragon is formed by connecting these
dragon bodies one after another

Paper Dragon
Dance in Gutian,
Liancheng

连城姑田游大龙

姑田游大龙是姑田镇的地方传统民俗活动。起源于明朝
万历年间，下堡村之邓屋。传说龙能行云布雨、消灾降福、
象征祥瑞，所以这里以舞龙的方式来祈求平安和丰收。

Paper Dragon Dance in Gutian is a local traditional folk
activity in Gutian Town, which originated from Dengwu Road
in Xiabao Village during the reign of Wanli in the Ming
Dynasty. It is said that the dragon can make clouds and
bring them rain, get rid of calamities and bring happiness,
and symbolize auspiciousness. Therefore, they pray for
peace and harvest by dragon dance.

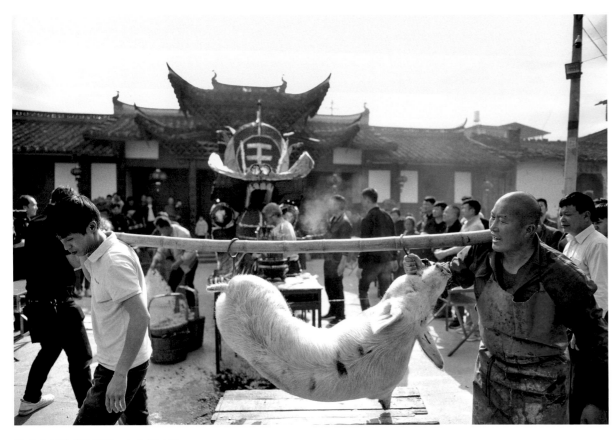

游龙之前的祭祀活动 / 朱晨辉 摄

Sacrificial activities before Paper Dragon Dance /Photographed by Zhu Chenhui

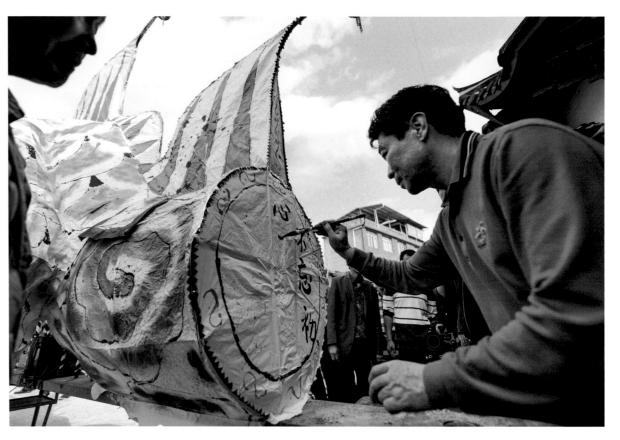

欣逢盛世，百姓的美好愿望跃然纸上 / 朱晨辉 摄

At this flourishing age, the people's good wishes vividly are revealed on the paper /Photographed by Zhu Chenhui

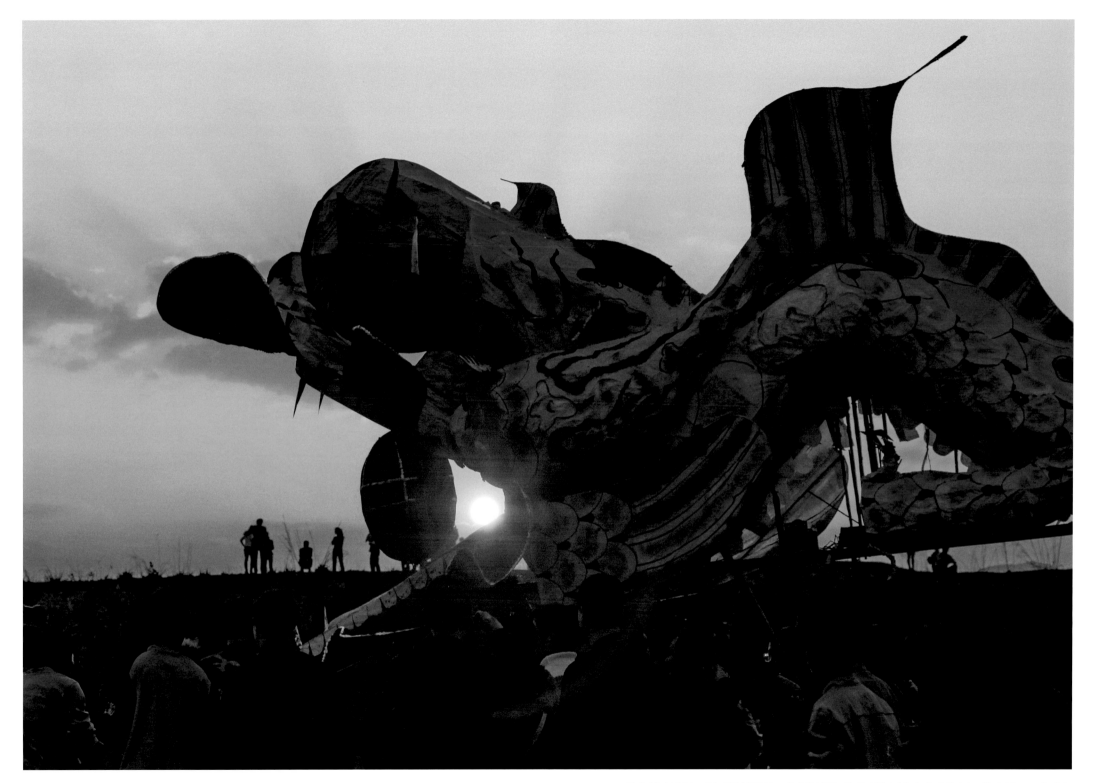

整个村庄游行一圈已是黄昏时，夕阳遇见如此壮观的巨龙也来凑热闹，扮演起了"龙珠"
After a parade around the whole village, it is already dusk, and the setting sun meet such a
spectacular dragon to join in the fun and play the role of "dragon ball"

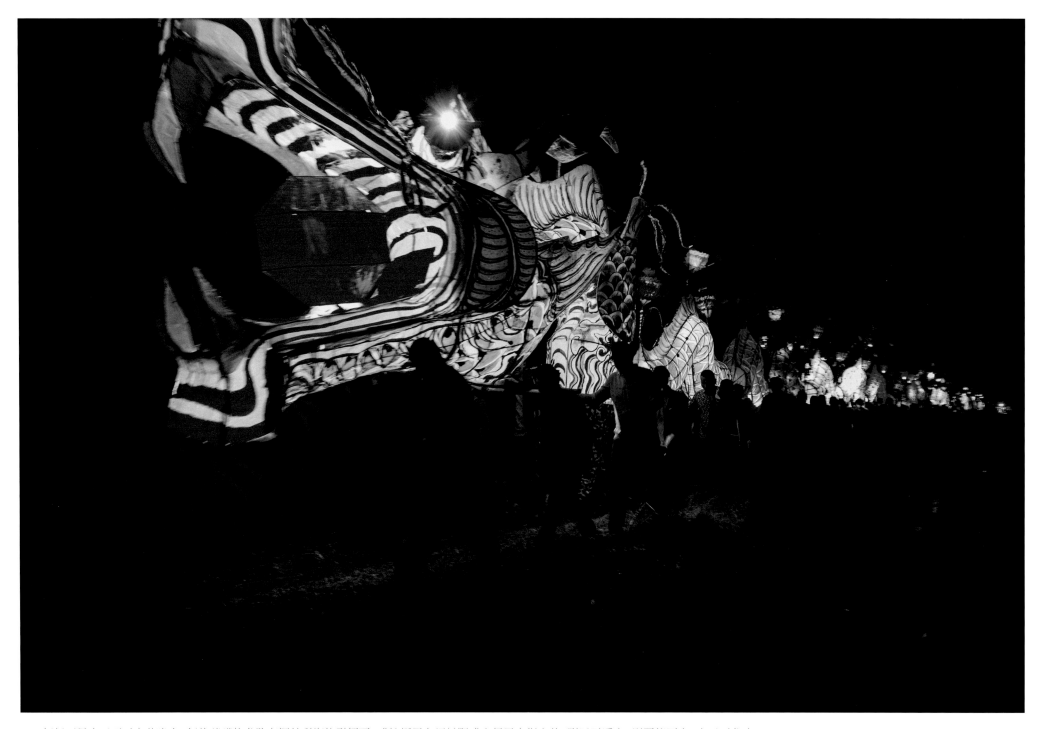

每年正月十三至元宵节晚上，气势磅礴的龙队在锣鼓彩旗的引领下，或蜿蜒于乡间村野或穿行于大街小巷，到了天后宫，则要停下来，点三下龙头，表示对妈祖的尊敬 / 吴军 摄

From the 13th day of the first month to the evening of the Lantern Festival of every lunar year, under the guidance of gongs, drums and colorful flags, the majestic dragon team winds through the countryside, villages and fields or walks through the streets and alleys. When it comes to the Tianhou Palace, it's necessary to stop and the dragon head nod three times to show its respect for Mazu /Photographed by Wu Jun

妈祖等神灵伴随龙队行游 / 吴军 摄
Mazu and other gods are parading with the dragon team /Photographed by Wu Jun

祭一柱香火，祈愿来年平安 / 吴军 摄
Sacrifice a stick of incense to pray for peace in the coming year /Photographed by Wu Jun

连城林坊游大龙

连城县林坊乡林氏家族游大龙习俗，发源于明朝初年，遐迩名扬。清朝年间，从湖南洪江市传入扎龙和制作技术，后经几代先辈对制作技术改进，林坊大龙更加别具一格。整条龙的组成代表九种动物特征：牛头、驴嘴、虎鼻、鹰爪、鹿角、猫耳、虾眼、蛇身、金鱼尾。每年游龙活动从正月十三至十六4个晚上，正月十四晚游到县城。游龙所到之处，热闹非凡，游龙队伍浩浩荡荡，场面壮观。大龙腾挪起伏，人群奔跑欢呼，鞭炮震耳欲聋，焰火映红夜空，令人叹为观止。

The custom of Paper Dragon Dance of the Lin family in Linfang Township, Liancheng County originated from the famous Linfang Dragon in the early Ming Dynasty. During the Qing Dynasty, the techniques of binding and manufacturing dragons were introduced from Hongjiang County, Hunan Province. After several generations' efforts of improving the techniques of manufacturing dragons, Linfang Dragon has a unique style. The composition of the entire dragon represents nine animal characteristics: bull head, donkey mouth, tiger nose, eagle claws, antlers, cat ears, shrimp eyes, snake body and goldfish tail. Every year, the paper dragon dance activity lasts from the 13th to the 16th night of the first month of the lunar year, and reach the county on the 14th night of the first month of the lunar year. Wherever the paper dragon dances, the scene is very lively. The dragon team is magnificent and the scene is spectacular. The dragon moved up and down, the crowd ran to the road and cheered, the sound of crackers were deafening, and the fireworks light the night sky in red, which made the viewer lost in wonder.

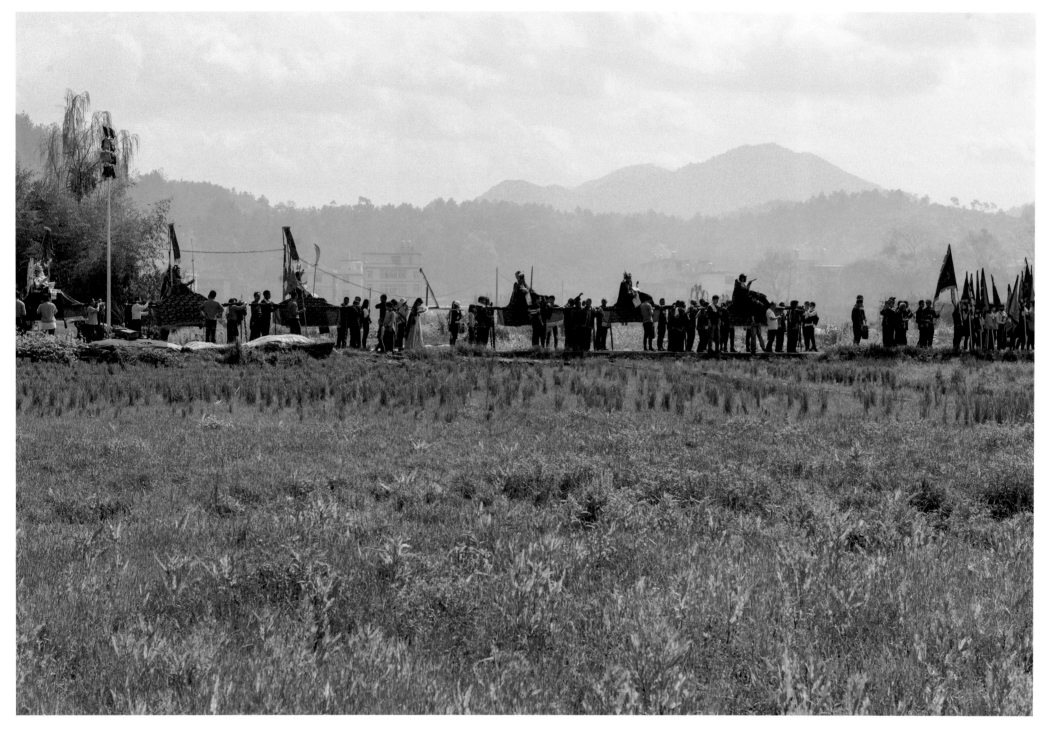

巡游的古事，沿村缓缓而行，古事队伍所选取的人物故事中，常见的有魁星点灯、桃园三结义、五虎将、六国拜相、七仙女下凡、八仙过海等 / 赖小兵 摄

The parading ancient stories walked slowly along the village. Among the character stories selected by the ancient stories team, the common ones are Kuixing (Daoist God of fate) lighting a lamp, Oath of the Peach Garden, Five Tiger Generals, Suqin holding a concurrent post of the Prime Minister of six states, Seven Fairies descending to the earth, Eight Immortals crossing the sea, etc. / Photographed by Lai Xiaobing

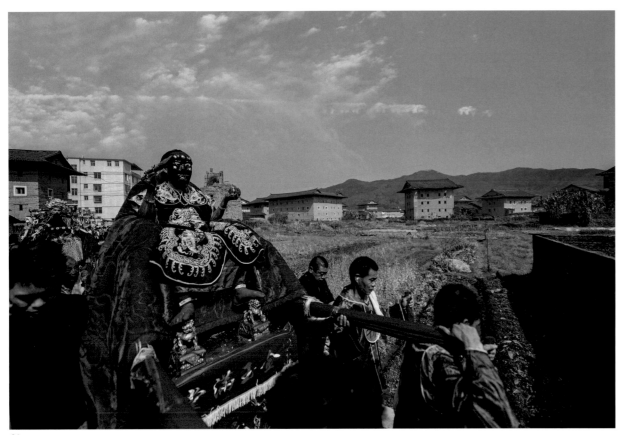

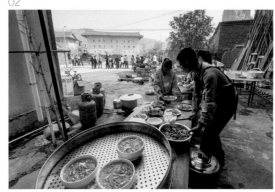

01　永定区抚市走古事，魁星与远处老旧的土楼交相呼应 / 严硕 摄

Zou Gu Shi (parade of ancient stories) in Fushi Town, Yongding District. Kuixing echoes with the old earth buildings in the distance /Photographed by Yan Shuo

02　"魁星"是抚市镇走古事闹元宵活动中最隆重的一个角色了，作为"魁星"的扮演者，需要花费不少 / 赖小兵 摄

"Kuixing (Daoist God of fate)" is the most ceremonious role of "Zou Gu Shi (parade of ancient stories)" among activities for celebrating the Lantern Festival in Fushi Town. As the role player of "Kuixing (Daoist God of fate)", it costs a lot /Photographed by Lai Xiaobing

03　每逢走古事活动，村民们都要大办宴席，款待十里八乡的来客 / 赖小兵 摄

Whenever there is a Zou Gu Shi (parade of ancient stories) activity, the villagers hold a big banquet to entertain visitors from all over the country /Photographed by Lai Xiaobing

Zou Gu Shi (parade of ancient stories) of Fushi Town, Yongding

永定抚市走古事

抚市走古事，也叫"闹古事"，是抚市镇民间闹元宵盛大传统民俗活动，从清朝乾隆嘉庆年间以来，传承不衰。人们通过这一活动，祈求风调雨顺、国泰民安。走古事多以历代传说故事、戏曲及现实生活中人物或情节装扮，车载或轿抬游行。

Zou Gu Shi (parade of ancient stories) in Fushi Town, Yongding, also known as "Nao Gu Shi", is a grand traditional folk activity in Fushi Town to celebrate the Lantern Festival. Since the reign of Qianlong and Jiaqing in the Qing Dynasty, it has been handed down. Through this activity, people pray for favorable weather, peace and prosperity. When Zou Gu Shi (parade of ancient stories), people dress up with legends, stories of the past dynasties, operas and characters or plots in real life and parade in vehicle or lift up in a sedan chair.

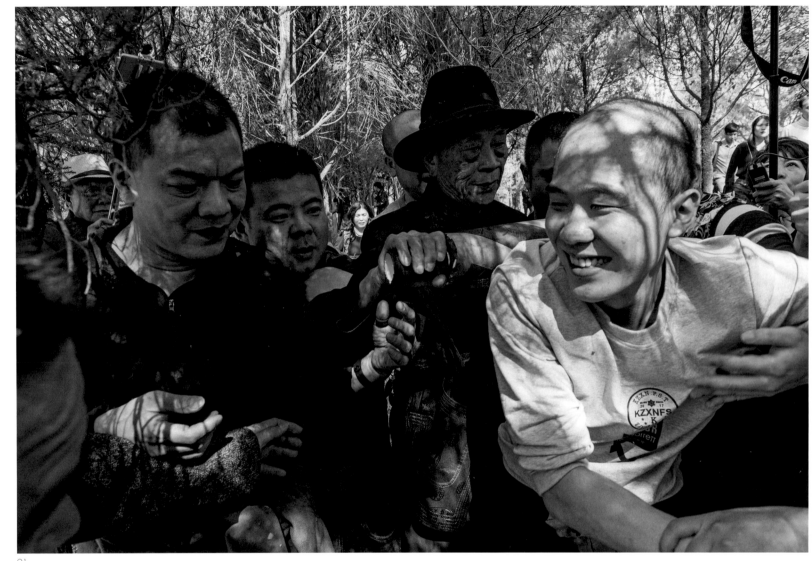

01

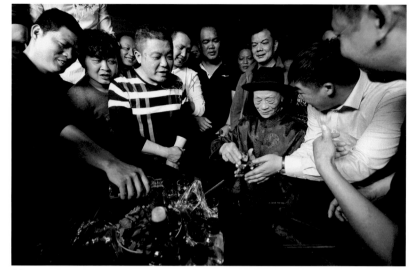

02

03

01 永定坎市 打新婚是客家人的独特民俗。500 余年来，这一民俗在此流传不断。每年农历正月十一日为打新婚日，以祈人丁兴旺、美满幸福 / 吴军 摄

 Da Xin Hun (beating newlyweds) in Kanshi Town of Yongding is a unique folk custom of Hakkas. For more than 500 years, this folk custom has been circulating here. Every year, on the 11th of the first month of the lunar calendar is the "Da Xin Hun (beating newlyweds)" day to pray for a prosperous population and happiness /Photographed by Wu Jun

02 "酒醉公" 需要喝下不少酒，待满面通红、醉态可掬之时方可开始 "打新婚" 活动/ 赖小兵 摄

 "Drunken old man" needs to drink a lot of wine, and can only start "Da Xin Hun (beating newlyweds)" when he is drunk and his face is red / Photographed by Lai Xiaobing

03 "酒醉公" 手持的 "早生贵子" 面槌 / 赖小兵 摄

 The rolling mallet of "early birth of a healthy baby" held by "drunken old man" / Photographed by Lai Xiaobing

Da Xin Hun
(beating newlyweds)
in Kanshi Town,Yongding

永定坎市打新婚

　　每年的农历正月十一，坎市镇有万丁之称的卢姓人都要举行"打新婚"活动。坎市"打新婚"习俗已有500年的历史。据说：坎市卢姓五世祖林婆太生前为人慈祥和善，平日喜欢和孩子在一起，临终时她特意嘱咐，以后祭扫时要让她再看到孩子们嬉闹的场面。后代子孙们便借一年一度的"新婚祭"活动让老祖宗高兴，既表示孝道，增添节日的喜庆气氛；同时，期盼来年人丁兴旺，平安吉利。因此，在"打新婚"过程中，让"酒醉公"手持的"早生贵子"面槌"打"一下，是很吉利的，是好彩头。这个"酒醉公"貌似"丑角"，却不是谁都可以充任的。他必须是年高德劭、子孙满堂，而且夫妻均健在的男性，即"多福、多寿、多子"之人。所谓"打"新婚，其实只是用纸做的写着"早生贵子"的"面槌"，往新婚者身上轻轻滚动几下而已。

　　Every year on the 11th of the first month of the lunar calendar, the people surnamed Lu, who is known as the population of ten thousand in Kanshi Town, will hold a "Da Xin Hun (beating newlyweds)" activity. The custom of "Da Xin Hun (beating newlyweds)" in Kanshi has a history of 500 years. It is said that great-grandmother Lin, the fifth ancestor of Lu family in Kanshi, was kind and genial before her death, who liked to be with her children generally. On her deathbed, she specially enjoined to let her see the children frolicking again during the sacrificial ceremony. So future generations use the annual "newly-marriage sacrifice" to make their ancestors happy, which not only shows filial piety, but also adds festive atmosphere to the festival. At the same time, looking forward to a prosperous population, peace and good luck in the coming year. Therefore, in the process of "Da Xin Hun (beating newlyweds)", it is very propitious to be beaten by the rolling mallet of "early birth of a healthy baby" held by the "drunken old man", meaning good luck. This "drunken old man" seems like a "clown", but not everyone can take up the role. He must be a man of venerable age and eminent virtue, having many children and grandchildren, with both husband and wife still alive, that is, a man with "more blessings, more longevity and more children". The so-called "beating" the newlyweds, in fact, is just using a "rolling mallet" made of paper that says "early birth of a healthy baby" to roll gently on the newlyweds for a few times.

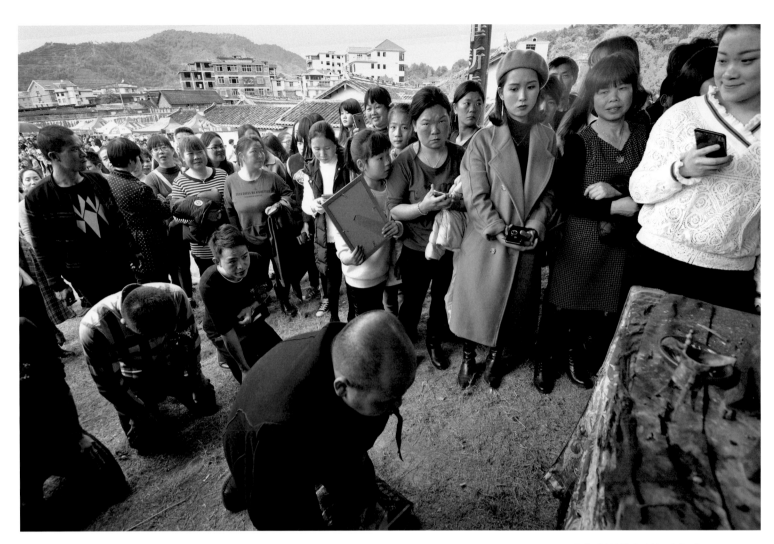

打新婚前的祭拜祖先仪式 / 赖小兵 摄
The ancestor worship ceremony before Da Xin Hun(beating newlyweds) /Photographed by Lai Xiaobing

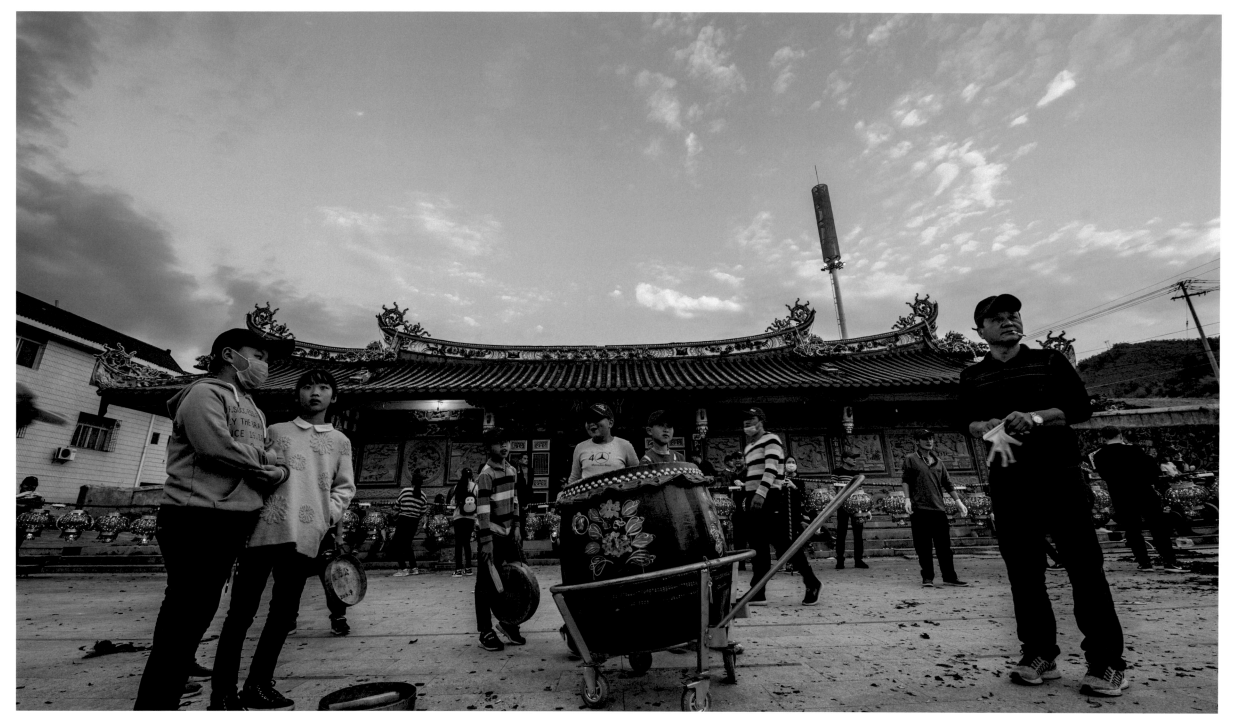

入夜前，永定区下洋镇曾氏家庙，当地的孩子们与大人一起，兴奋地等待着花灯节的正式开始 / 严硕 摄

Before nightfall, at Zeng Family Temple in Xiayang Town, Yongding County, local children with adults are excitedly waiting for the official start of the Rogers Chinese Lantern Festival /Photographed by Yan Shuo

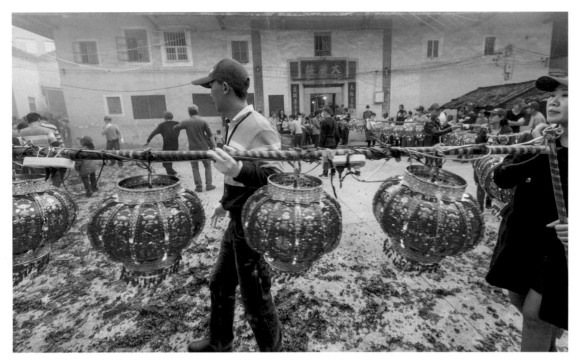

村民们在领头人的指挥下，井然有序地将花灯从大庆楼里抬出 / 严硕 摄
Under the command of the leader, the villagers carry the lanterns out of Daqing Building in
an orderly manner /Photographed by Yan Shuo

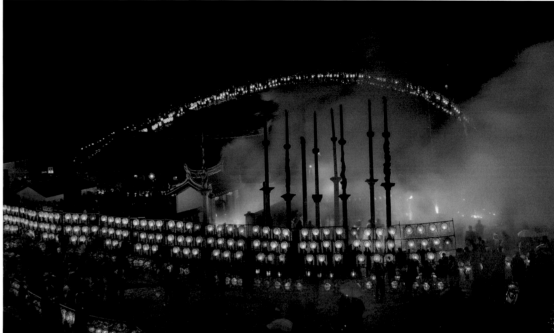

花灯队伍在下洋胡氏家庙前组成长龙，蔚为壮观
In front of Hu Family Temple in Xiayang Town, the people holding
festive lanterns make up a dragon, which is spectacular

Xiayang
Festive Lantern
of Yongding

永定下洋花灯

全国著名侨乡永定区下洋镇下洋村太平组举行的迎花灯闹元宵活动，全村6个房头1300多名村民组成了600多米长的花灯在大街小巷中穿梭，吸引了全镇及周边地区大量群众前来观看。元宵迎花灯是下洋镇一年中最重大的民俗活动，各村都有举办，持续时间一般从正月十三至正月十五。

Lantern Festival celebration is held in Taiping Group, Xiayang Village,
Xiayang Town, a famous hometown of overseas Chinese. At the scene, more than
1,300 villagers from six heads of relatives of the same clan form a 600-meter-long
lantern to shuttle through the streets, attracting a large number of people from
the whole town and surrounding areas to watch. The Lantern Festival is the most
important folk activity in Xiayang Town in the year. It is held in all villages and
lasts from the 13th to 15th of the first month of the lunar calendar.

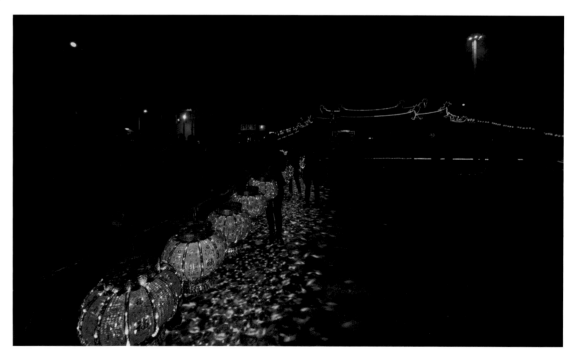

花灯发出五彩斑斓的光，在黑夜的衬托下越发美丽 / 严硕 摄
Festive lanterns give out colorful lights, which is more beautiful against the background of the
dark night /Photographed by Yan Shuo

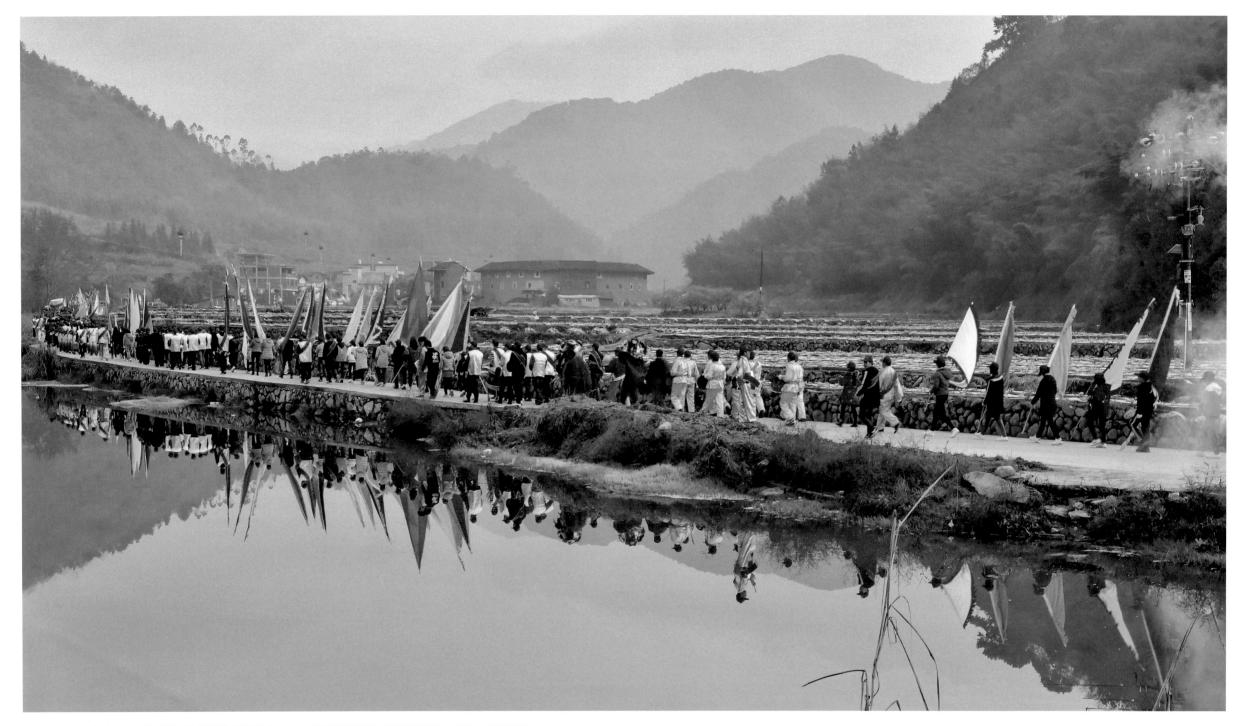

五显大帝在广东、福建等地是重要的民间信仰之一。在闽西龙岩永定区下洋镇，五显大帝被尊为财神，每年正月十五至十八是迎五显大帝的重要节日 / 吴军 摄

Emperor Wuxian is one of the important folk beliefs in Guangdong, Fujian and some other places. In Xiayang, Yongding County, Longyan, West Fujian Province, Emperor Wuxian is the God of wealth. From the 15th to 18th of the first month of each year, it is an important day for the people here to welcome Emperor Wuxian /Photographed by Wu Jun

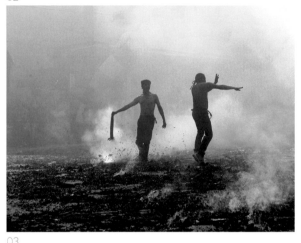

01
巡游回宫之后，乩童"神灵"附体 /
赖小兵 摄

After the parade back to the palace, the child medium is possessed by "God spirit" /Photographed by Lai Xiaobing

02
五显大帝巡安全村，队伍浩荡，热闹非常 / 赖小兵 摄

Wuxian Emperor parades around the village, with a mighty team, which is very lively /Photographed by Lai Xiaobing

03
在隆隆的炮阵中，乩童辗转腾挪，引得村民齐声赞叹 / 赖小兵 摄

In the rumbling of firecrackers, the child medium move around, drawing the villagers' chorus of admiration / Photographed by Lai Xiaobing

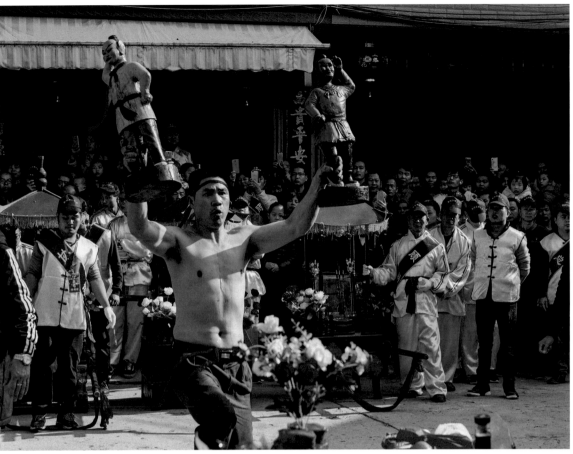

01

03

The Folk Custom of
Welcoming Gods in the Lantern Festival
in Xiayang, Yongding

永定下洋元宵迎神民俗

每年正月十五至十八，永定下洋迎五显大帝，是当地最重要的民间信仰活动。五显大帝在客家民俗中是由神到人，又由人到神的民间信仰。传说玉皇大帝封其为"玉封佛中上善王显头官大帝"，从此百姓尊崇。求男生男，求女得女，经商者大利，读书者金榜题名，农耕者五谷丰登，有求必应。在闽西龙岩永定区，五显大帝被尊为财神，特别获百姓虔诚礼拜。

Every year from the 15th to the 18th of the first month of the lunar calendar, welcoming Emperor Wuxian in Xiayang Town, Yongding County is the most important local folk belief activity. In Hakka folk customs, Emperor Wuxian is a folk belief from God to Man, and from Man to God. It's said that the Jade Emperor named him "Emperor of goodness, wealth and official career among Buddhas conferred by the Jade Emperor", who has been respected by the people ever since. Grant whatever is asked, for example, ask for a male baby and give birth to a male baby, ask for a female baby and give birth to a female baby, businessmen gain great profits, students succeed in the examination, and farmers have a good harvest. In Yongding County, Longyan City, Western Fujian, Emperor and Wuxian is the God of Wealth and received devout worship from the people.

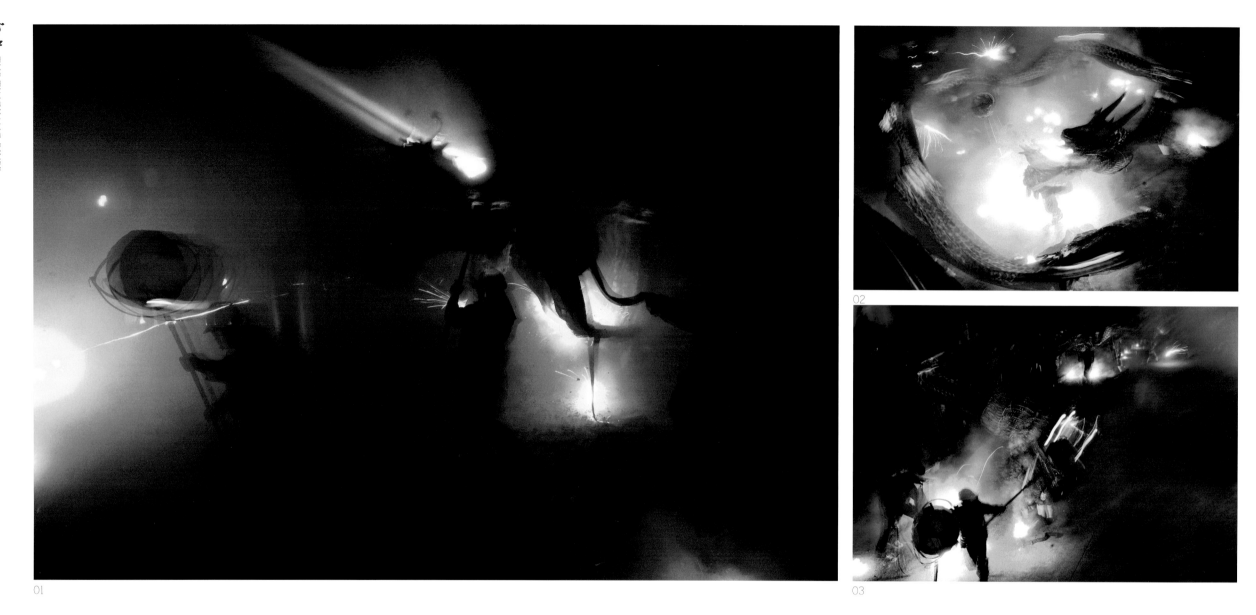

01

02

03

Dragon blasting in
Shuangyang Town,
Zhangping

漳平双洋炸龙

漳平双洋镇在明代隆庆元年（1567）置宁
洋县，是一个商贾云集的闹市县城。从那时起，
双洋就有了"闹火龙"的活动，距今已400多
年历史。开初，村民的爆竹是在各家门前迎龙
时燃放，后来村民变成把爆竹往龙身上丢，舞
龙者为避免价格不菲的龙被烧坏，只好摇头摆
尾躲着爆竹，这龙也就舞得更为壮观，很快就
形成爆竹炸龙的风俗。据说，龙身被炸得越烂
越吉利，意为图个彩头，祈祷一年风调雨顺、
吉祥如意。

Shaungyang Town in Zhangping City used to be under the administration of Ningyang
County in the Ming Dynasty during the reign of Emperor Longqing, where was a prosperous
county swarmed with merchants. From then, "Dragon Blasting" tradition has 400 years' history.
Originally, villagers only set off crackers at the gate when they greet dragons. Gradually, they
started to throw crackers onto dragons. Because these dragons were so expensive, dragon
dancers had to waggle around to prevent it from being blasted, which made the dragon
performance even more spectacular. Soon after, such performance evolved into dragon blasting
tradition. It is said that, the more damage caused by the blasting, the more luck would come. It
has became a way people pray for luck and delivers people's best wish for favorable weather
and good fortune.

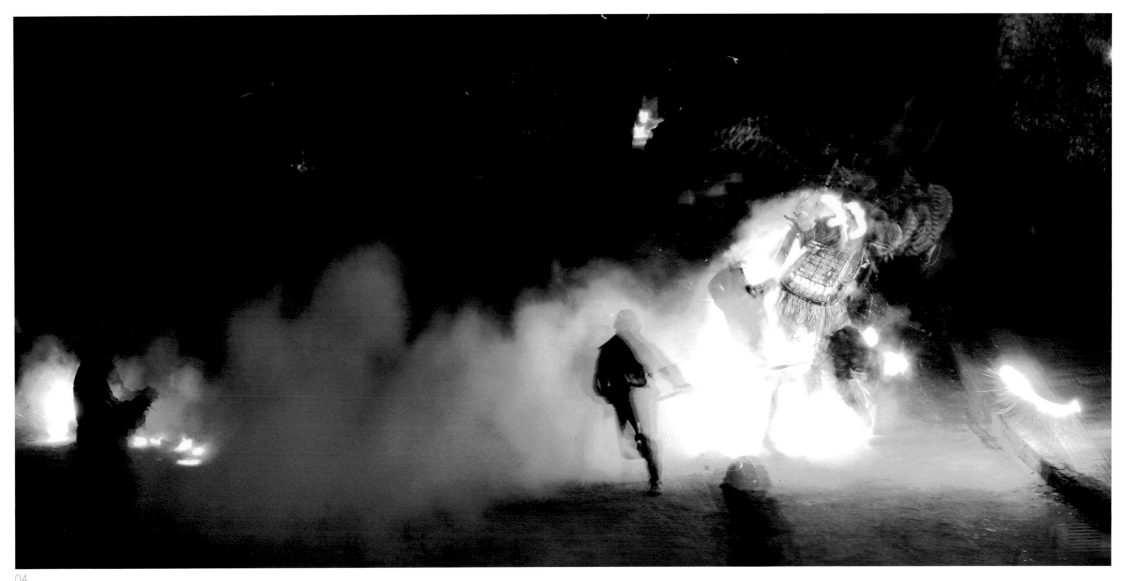

04

01　漳平双洋的"炸龙"独具特色，龙身由7至9节构成，每节由一人操控。迎龙时伴有排子灯、节桥灯、人物花卉等，绚丽多彩。舞龙时，龙节内点火，由龙珠引路，有团龙、穿龙等造型 / 福建楠 摄

'Dragon blasting' in Shuangyang Town, Zhangping is quite unique. The dragon body is normally consisted of 7 to 9 segments, with each of the segment controlled by one person. There are Paizi lanterns, Jieqiao lanterns, human figure and flower lanterns, when greeting the dragon, which is rather splendid. During dragon dance, fire will be set in these segments and a dragon ball will guide the way. There are various kinds of dragons, including encircling dragons and threading dragons /Photographed by Cui Jiannan

02　龙身在硝烟弥漫中飞舞，蔚为壮观 / 福建楠 摄

The dragon body is flying in the fume, which is magnificent /Photographed by Cui Jiannan

03　舞龙时龙珠引路，一路火光灿灿，银花耀眼 / 福建楠 摄

A dragon ball will guide the way during dragon dance, with the fire shining and silvery sparks dazzling all the way / Photographed by Cui Jiannan

04　舞龙者不畏炮火，龙身在硝烟弥漫中腾云驾雾 / 福建楠 摄

Dragon dancers are not afraid of the fire, and the dragon body is flying in the fume /Photographed by Cui Jiannan

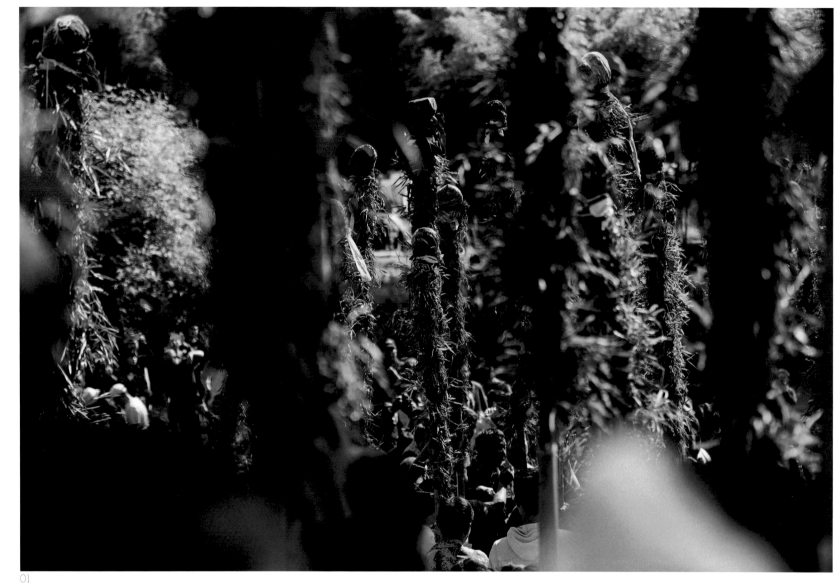

01

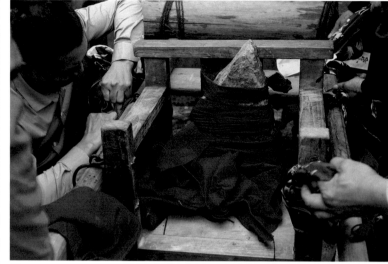

02

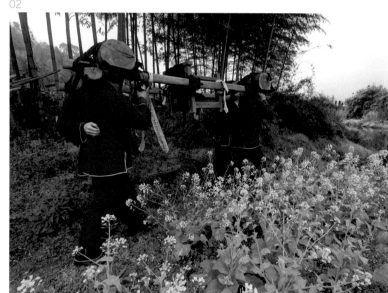

03

Beating Stone
Statue of Buddha in
Changting

长汀打石佛

在长汀四都渔溪村，保留了 500 多年的奇特民俗——打石佛，每年正月十四都要上演，热闹非凡。相传，很久以前，渔溪村久旱无雨，是一块神奇的石头显灵，帮助村民度过了旱情，此后人们便把这块石头当作"石佛公"，建庙"馈溪庵"供奉石佛。每年正月十四，用"打石佛"的形式闹元宵，纪念"石佛公"的滴水之恩。

In Yuxi Village, Sidu Town, Changting County, a peculiar folk custom of more than 500 years has been preserved-Beating Stone Statue of Buddha. Every year on the 14th of the first month of the lunar calendar, it is performed with great excitement. According to legend, a long time ago, Yuxi Village suffered from a severe drought. It was a magical stone that helped the villagers through the drought. Since then, people have regarded this stone as the "Stone Buddha" and built a temple "Zhenxi Buddhist Convent" to worship the stone Buddha. Every year on the 14th of the first month of the lunar calendar, the Lantern Festival is celebrated in the form of "Beating Stone Statue of Buddha", in memory of the grace of dripping water of "Stone Buddha".

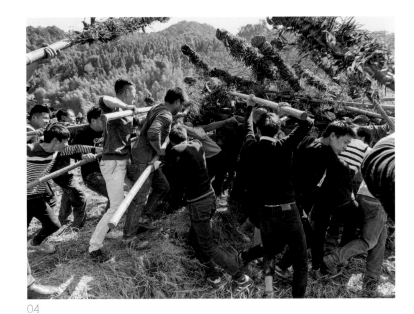

04

01　　两人高的长棍林立，为"打石佛"做准备 / 严硕 摄

Long sticks as high as two people stand in great numbers, are prepared for the later "beating stone Buddha" /Photographed by Yan Shuo

02　　供奉的"石佛公"要从镇溪庵中请出 / 赖小兵 摄

The "Stone Buddha" should be invited out of Zhenxi Buddhist Convent /Photographed by Lai Xiaobing

03　　几个身强力壮的村民抬着"石佛公"师巡游，准备越河进村 / 赖小兵 摄

Several strong villagers are carrying the stone statue of Buddha on a parade, preparing to cross the river into the village /Photographed by Lai Xiaobing

04　　石公开始冲坡，村里的青壮年们在坡上用长棍阻挠，一冲一拦之中体现了客家人不畏艰难的彪悍性格 / 严硕 摄

Stone Buddha begins to rush the slope. The young and middle-aged people in the village obstruct with long sticks. The Hakka people's tough character of defying difficulties is reflected in one rushing and one obstructing /Photographed by Yan Shuo

05　　"石佛公"需要闯关来到村中大坪，供全体村民敬奉，仪式才算结束 / 赖小兵 摄

The "Stone Buddha" needs to rush through the barriers and comes to the large plain land in the village to be worshiped by all the villagers /Photographed by Lai Xiaobing

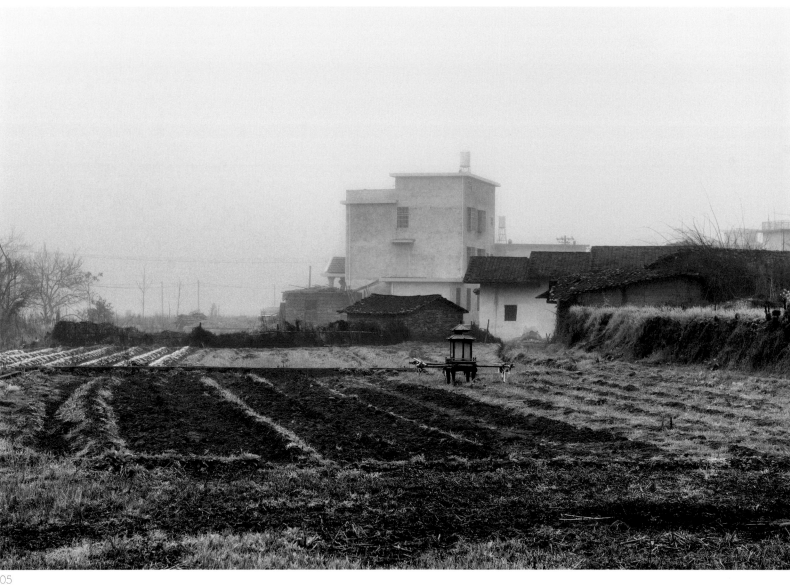

05

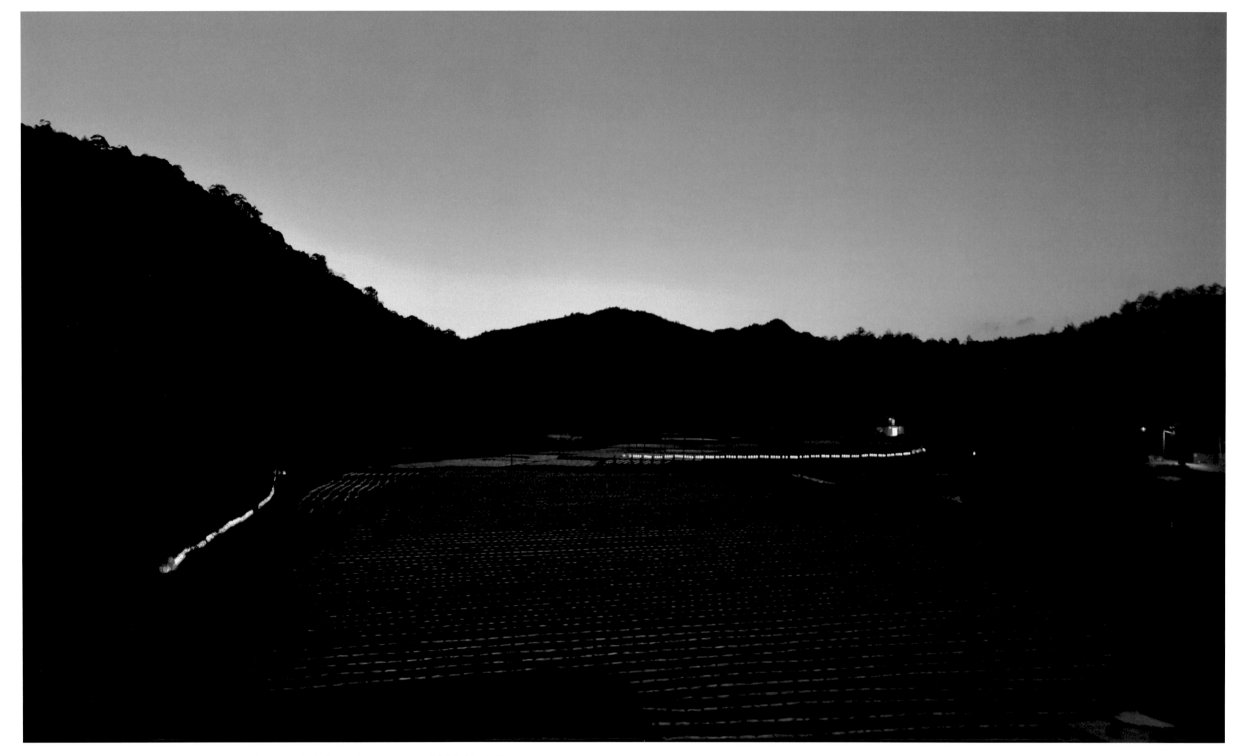

夜幕下，连接成龙的花灯在田间小路上游走摆动、穿花缠绕、盘旋团转，祈愿全村平安吉祥 / 赖小兵 摄

Under the curtain of night, the festive lanterns connected into a dragon move and sway on the path of the field, pass through flowers and twine, and circle around, to pray for peace and good luck of the whole village /Photographed by Lai Xiaobing

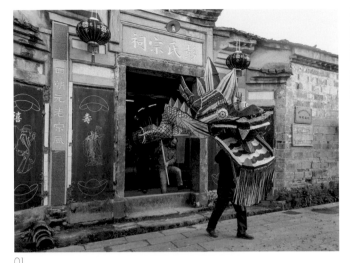

01

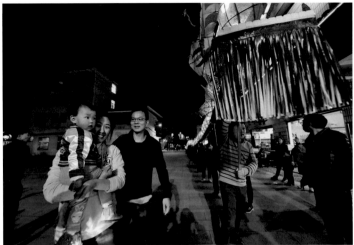

02

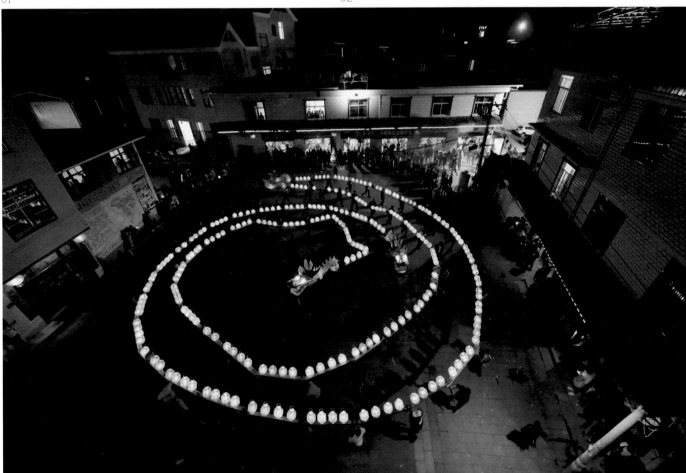

03

长汀童坊闹花灯

闽赣客家地区，盛行舞龙灯闹元宵的习俗。各地龙灯制作工艺迥异，各具特色。在众多的龙灯中，长汀县童坊镇彭坊村的刻纸龙灯，以独特的制作技法，最为著名。每年正月十三到十五，是彭坊舞龙灯的传统日子。夜幕下，龙灯在锣鼓和烟花爆竹声中进行表演，粗犷刚劲。

In the Hakka area of Fujian and Jiangxi, the custom of dragon lantern dance for celebrating the Lantern Festival is popular. The production techniques of dragon lanterns vary from place to place and each has its own characteristics. Among the numerous dragon lanterns, the paper carving dragon lantern in Pengfang Village, Tongfang Town, Changting County is most famous for its unique production techniques. From the 13th to 15th of the first month of each lunar year, it is the traditional day of dragon lantern dance in Pengfang. Under the curtain of night, the dragon lantern is performed in the sound of gongs, drums, fireworks and firecrackers, which is rough and vigorous.

01 制作精美的龙头从宗祠中请出 / 赖小兵 摄
The elaborate dragon head is invited out of the ancestral hall / Photographed by Lai Xiaobing

02 长汀县童坊镇彭坊村，村民们拖家带口出来迎接刻纸龙灯，为平安祈福 / 严硕 摄
In Pengfang Village, Tongfang Town, Changting County, villagers bring their families out to welcome the paper carving dragon lantern and pray for peace /Photographed by Yan Shuo

03 刻纸龙灯在夜色中就像两只游龙活了一样，嬉戏耍闹 / 严硕 摄
The paper carving dragon lantern seems to be alive, like two swimming dragons in the dim light of night, frolicking and playing / Photographed by Yan Shuo

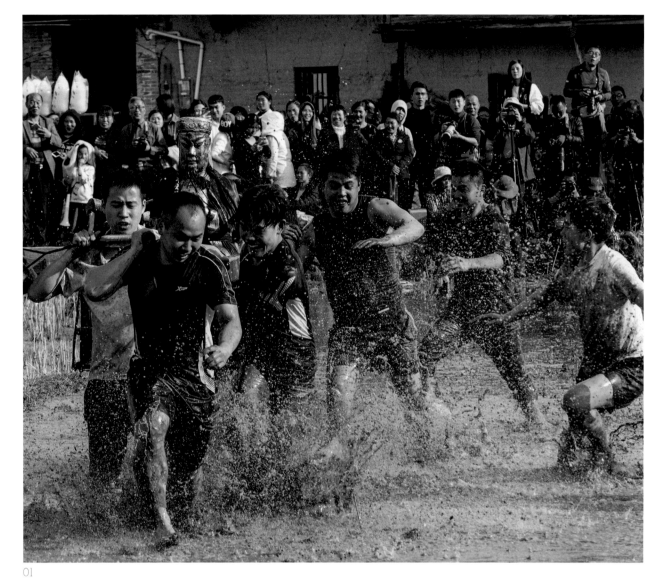

01

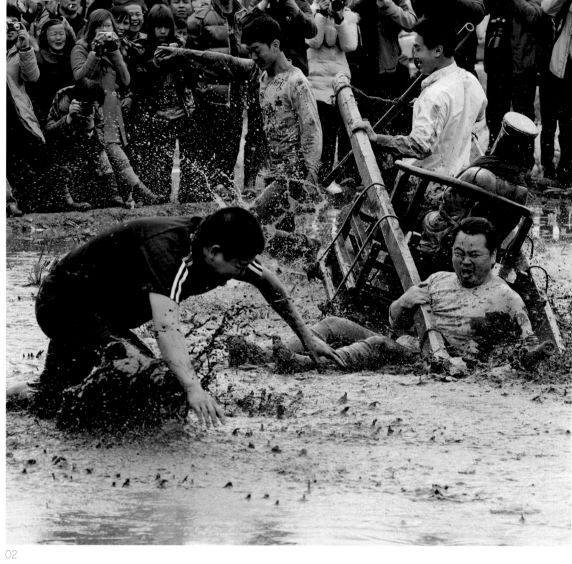

02

Celebration
in Springfield of
Changting

长汀闹春田

闹春田是闽西长汀童坊镇举河举林村特有的习俗，流传上百年。每年正月十二（举河村）、十四（举林村），村民都会把关公的塑像抬到泥田里，奔跑打转，祈求新的一年里五谷丰登，同时也借此增进村民间的感情。展示村民强健的体魄，并以此提醒人们，要下田开始新一年的劳作了。

Celebration in Springfield is a unique custom of Juhe and Julin Village in Tongfang Town, Changting County, West Fujian Province. It has been a custom for hundreds of years. On the 12th (Juhe Village) and 14th day (Julin Village) of the first month of every lunar year, the villagers will carry the statue of General Guan Yu in the mud field, run around, pray for a good harvest in the new year, and at the same time enhance the feelings of the villagers. In addition, it will show the strong physique of the villagers, and remind people that they are going to start a new year's business in the field.

01 相传上百年的习俗，每年的正月十二，村里身强体壮的男青年便会相约下田比试 / 吴军 摄

It's said that it's a custom for hundreds of years that on the 12th day of the first month of every lunar year, the strong young men in the village meet each other for a field competition /Photographed by Wu Jun

02 泥浆四溅，纵情欢闹 / 陈伟凯 摄

The mud flies off in all directions, and the people play noisily and heartily /Photographed by Chen Weikai

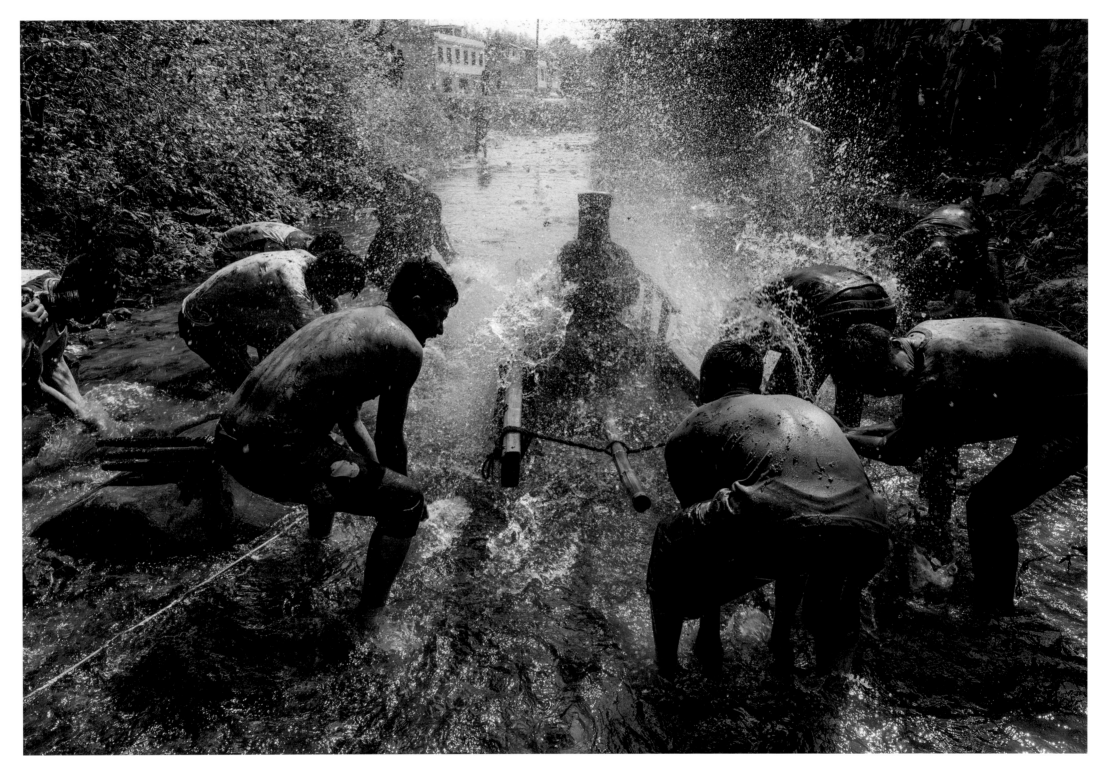

浴神的同时，祈愿新年风调雨顺，五谷丰登 / 吴军 摄
Pray for a favorable weather and a good harvest in the new year during bathing God /
Photographed by Wu Jun

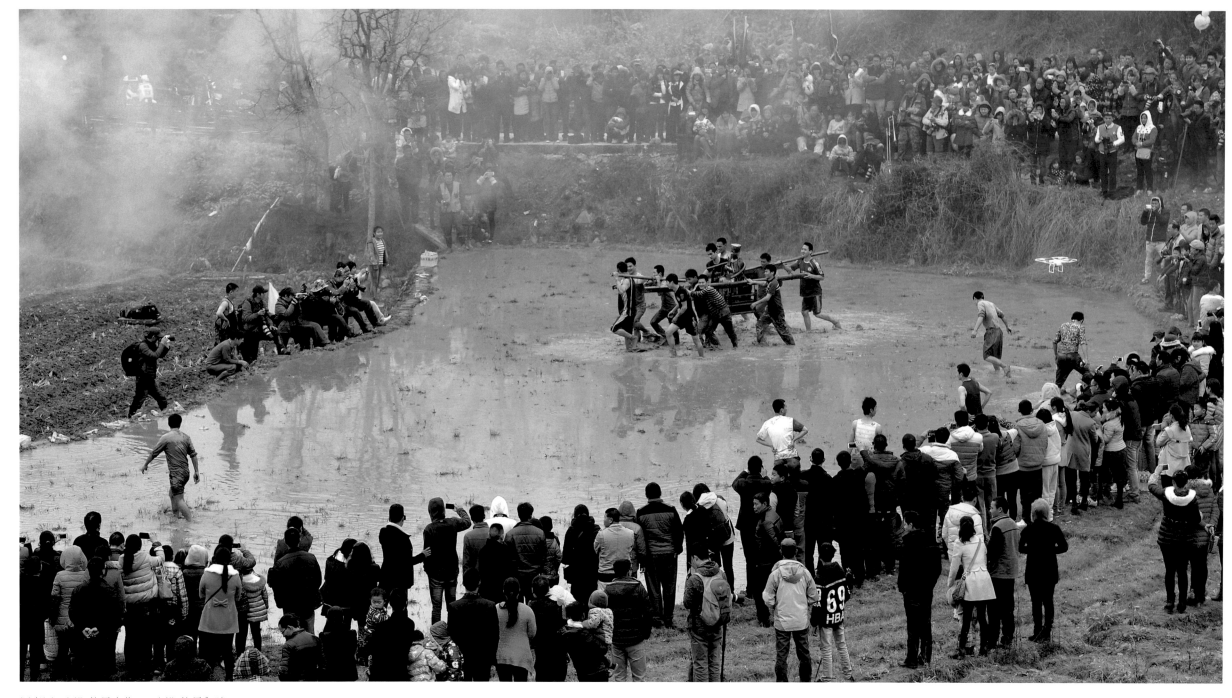

闹春田 "闹" 的是丰收、"闹" 的是和睦 / 胡晓刚 摄

What Celebration in Springfield celebrates is a good harvest, and also harmony /Photographed by Hu Xiaogang

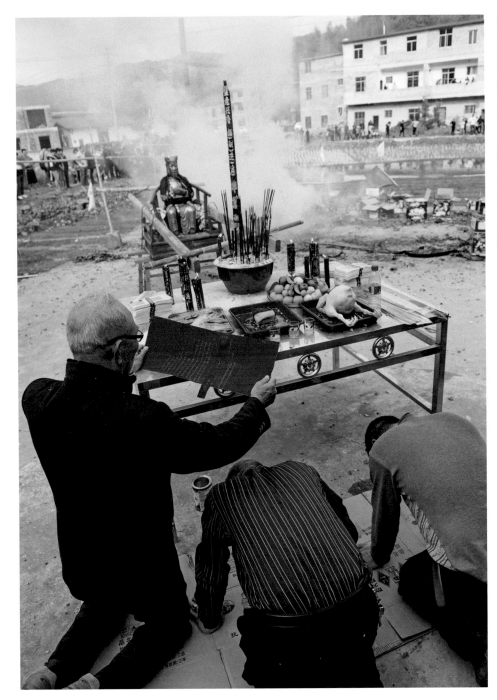

祭拜先祖，祈福平安 / 朱晨辉 摄
Worship ancestors and pray for peace /Photographed by Zhu Chenhui

神像绕境巡安 / 赖小兵 摄
The statue is parading around the border /Photographed by Lai Xiaobing

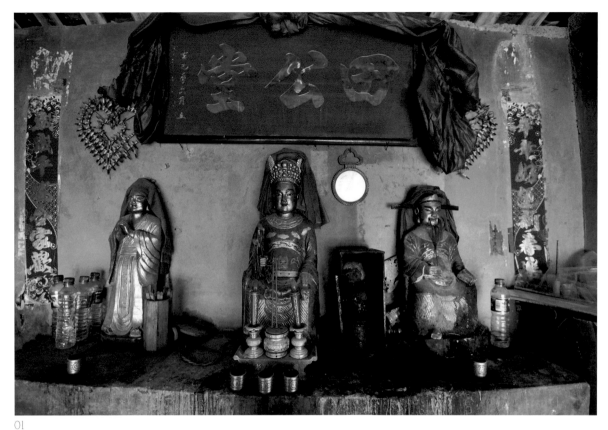

01

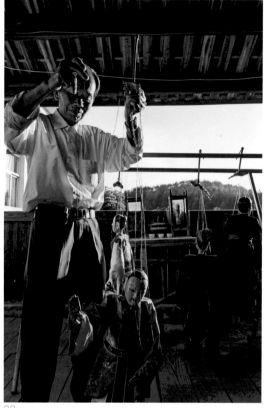

02

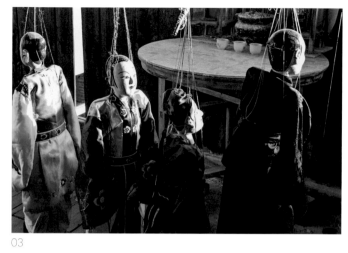

03

01　白砂镇水竹洋村是客家傀儡戏的发源地，图为戏神田公元帅 / 赖小兵 摄

Shuizhuyang Village in Baisha Town is the birthplace of Hakka puppet show. The picture shows God of Drama—Marshal Tiangong / Photographed by Lai Xiaobing

02　白砂镇水竹洋村木偶戏班的梁利忠老艺人展示古老的传统傀儡技艺 / 赖小兵 摄

The ancient traditional puppet skills showed by Liang Lizhong, an old artist from the puppet troupe in Shuizhuyang Village, Baisha Town /Photographed by Lai Xiaobing

03　白砂镇水竹洋村的木偶戏班还保留着许多清代的木偶头 / 赖小兵 摄

The puppet troupe in Shuizhuyang Village of Baisha Town still retains many puppet heads of the Qing Dynasty /Photographed by Lai Xiaobing

Hakka
Puppet Show of
Shanghang

上杭客家木偶戏

上杭客家木偶戏，俗称"傀儡戏"，自明朝初年传入上杭，形成独具特色的地方剧种，迄今已有500多年的历史。早期的上杭木偶戏表演形式较简单，只有十八个木偶，称为"十八罗汉"，演唱"九调十三腔"。后来逐渐发展为"双高腔"，俗称"三脚班"。清代是上杭木偶戏最鼎盛的时期，全县有120多个班社，上演剧目多达1000多本，演出活动扩展到浙江、江西、广东以及闽南等地。其表演艺术或以提线功夫精湛见长，或以角色生动、风格独特而著称。由于历代艺人不断丰富发展了木偶艺术的表现力，使闽西木偶戏流传数百年而更臻成熟，且形成了自己的风格和特征。2006年，"上杭傀儡戏"入选福建省首批非物质文化遗产。

Hakka Puppet Show of Shanghang, commonly known as "puppet show", was introduced into Shanghang in the early Ming Dynasty, forming a unique local opera with a history of more than 500 years. The performance form of the early Shanghang puppet show was relatively simple, with only 18 puppets, called "Eighteen Arhats", singing "Nine Tones and Thirteen Tunes". Later, it gradually developed into "double high tune", commonly known as "Harmonious drama". The Qing Dynasty was the heyday of Shanghang puppet show. There were more than 120 troupes in the county, with more than 1,000 plays performed. The performances were extended to Zhejiang, Jiangxi, Guangdong and Southern Fujian. Its performing arts are either good at strings or famous for vivid characters and unique style. Due to the continuous enrichment and development of the expressiveness of puppet art by artists of the past dynasties, the puppet show in Western Fujian has been spread for hundreds of years and becomes more mature, forming its own style and characteristics. In 2006, "Shanghang Puppet Show" became the first batch of intangible cultural heritage in Fujian Province.

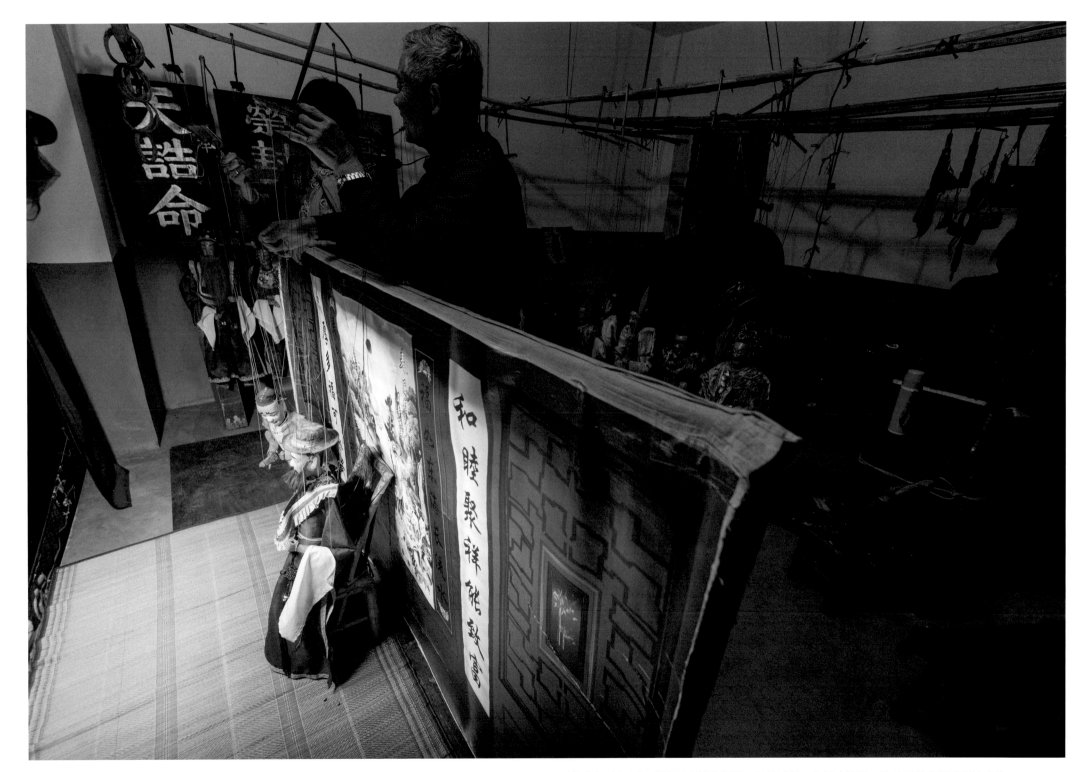

闽西的木偶戏与民间酬神活动紧密相关，逢年过节，在村头巷尾，随处可见木偶戏班的表演 / 赖小兵 摄
Puppet shows in Western Fujian are closely related to folk activities of offering sacrifices to gods. Puppet shows can be seen everywhere in
the streets and lanes at festivals /Photographed by Lai Xiaobing

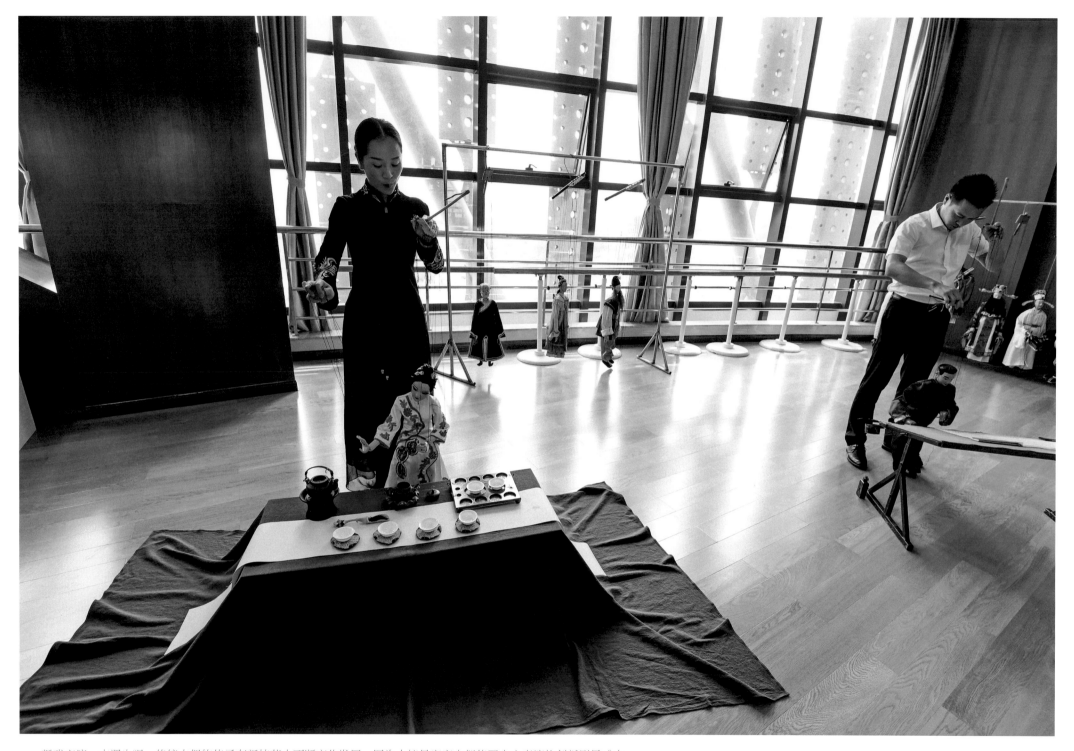

新戏亦演，古调也唱，传统木偶的传承在新技艺中不断变化发展，图为上杭县客家木偶传习中心表演的创新剧目《木偶茶艺》与《木偶书法》 / 赖小兵 摄

New dramas are performed and ancient tunes are also sung. The inheritance of traditional puppets is constantly changing and developing in new techniques. The picture shows the innovative plays *Puppet Tea Art* and *Puppet Calligraphy* performed by Shanghang Hakka Puppet Learning Center /Photographed by Lai Xiaobing

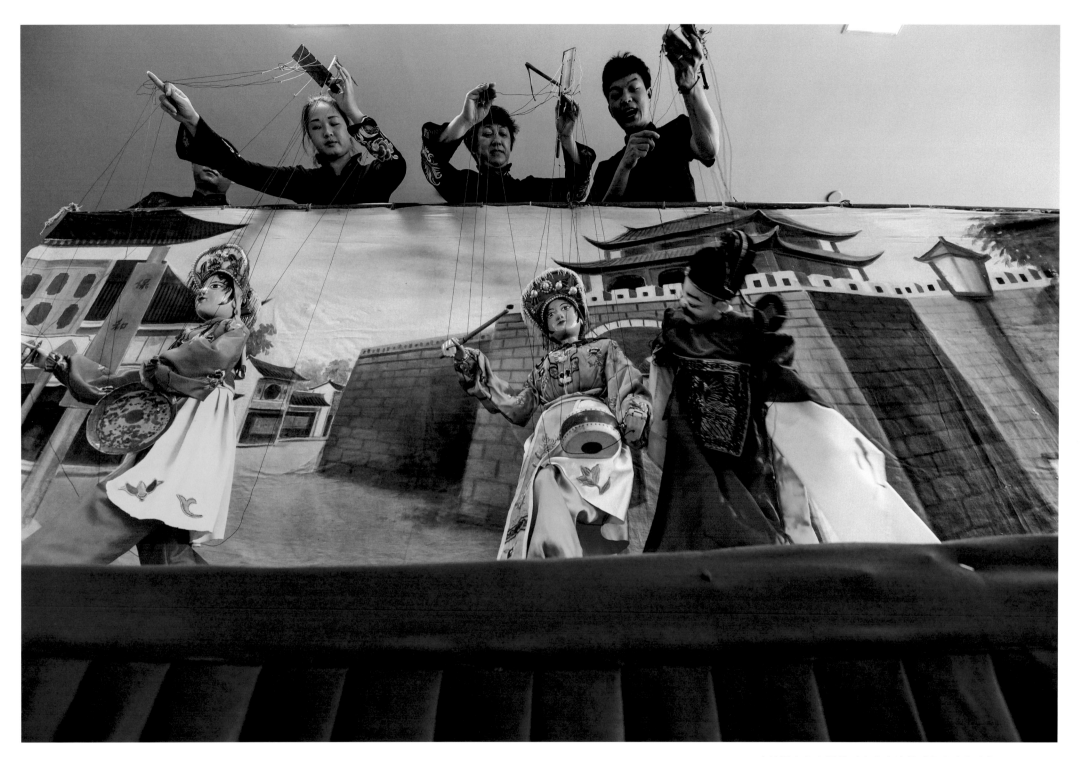

上杭县客家木偶传习中心表演的《智取大名府》 / 赖小兵 摄
Take Daming Prefecture by Strategy performed in Shanghang Hakka Puppet Learning Center /Photographed by Lai Xiaobing

Han Opera
in Western
Fujian

闽西汉剧

闽西汉剧是福建的地方戏曲剧种之
一，脱胎于外来剧种、吸收闽西客家方
言和民间音乐而逐步形成。2006 年，闽
西汉剧被列入第一批国家级非物质文化
遗产名录。

Han Opera in Western Fujian is one
of the local operas in Fujian. It was born
out of external operas and gradually
became a local opera by absorbing
Hakka dialect and folk music in Western
Fujian. In 2006, Han Opera in Western
Fujian was included in the first batch of
national intangible cultural heritage list.

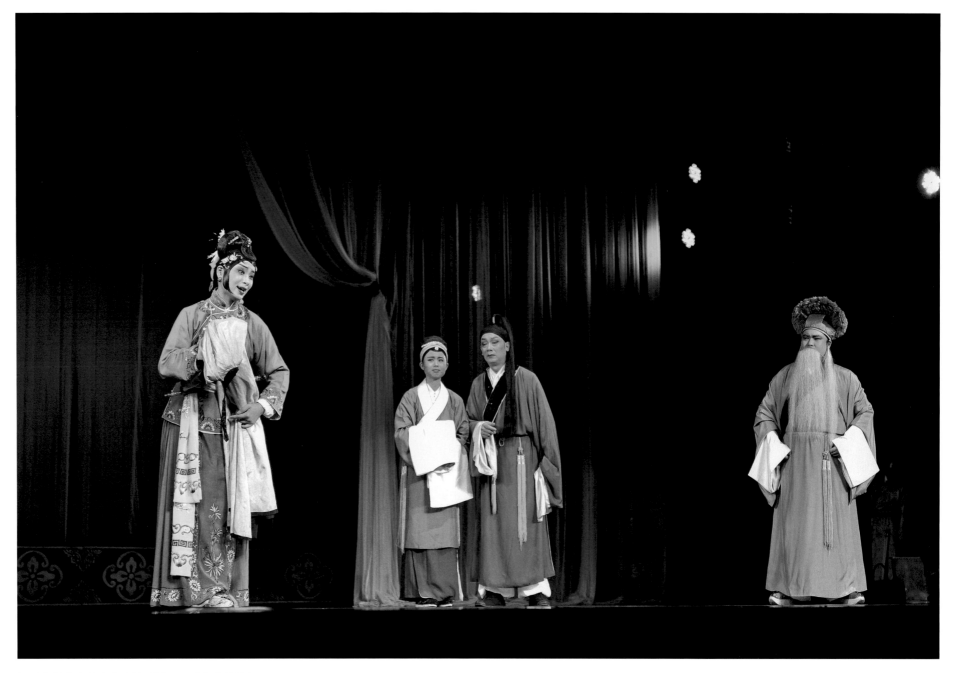

闽西文化艺术中心上演的剧目——《仇大姑娘》 / 朱晨辉 摄
The play performed in Culture and Art Center of Western Fujian—*Eldest Daughter of the Qiu Family* /Photographed by Zhu Chenhui

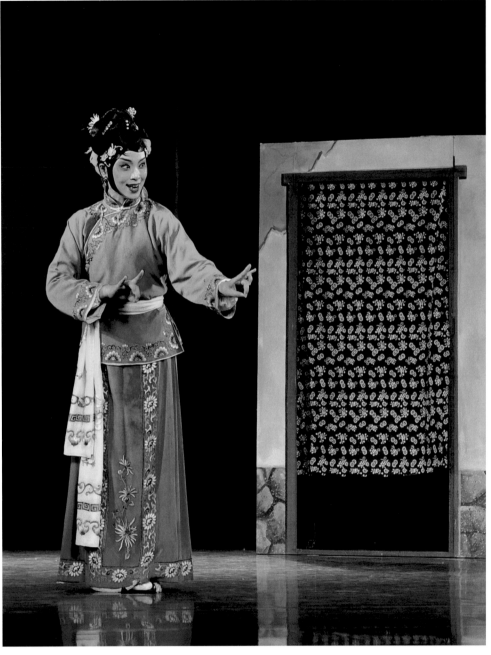

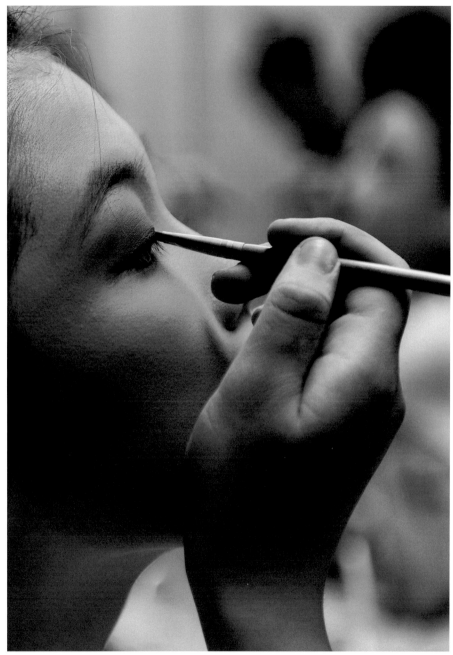

闽西汉剧角色行当分"生、旦、丑、公、婆、净"六个行头角色，唱腔以西皮、二黄为主，兼用部分昆腔、高腔、吹腔、南词北调，并吸收了广泛流行的民间小调和佛、道教曲调 / 朱晨辉 摄

The type of roles in Western Fujian is divided into six roles: "Sheng (male role), Dan (female role), Chou (clown), Gong, Po, Jing (painted face)", the vocal music is mainly Xipi and Erhuang, with part of Kun Tune, High Tune, Chui Tune and South and North Tune, and also absorbs widely popular folk tunes and Buddhist and Taoist melodies / Photographed by Zhu Chenhui

闽西汉剧是客家人情有独钟的古老剧种，被人们誉为"南国牡丹" / 朱晨辉 摄

Han Opera in Western Fujian is an ancient opera with a special affection for the Hakka people, known as "Southern Peony" /Photographed by Zhu Chenhui

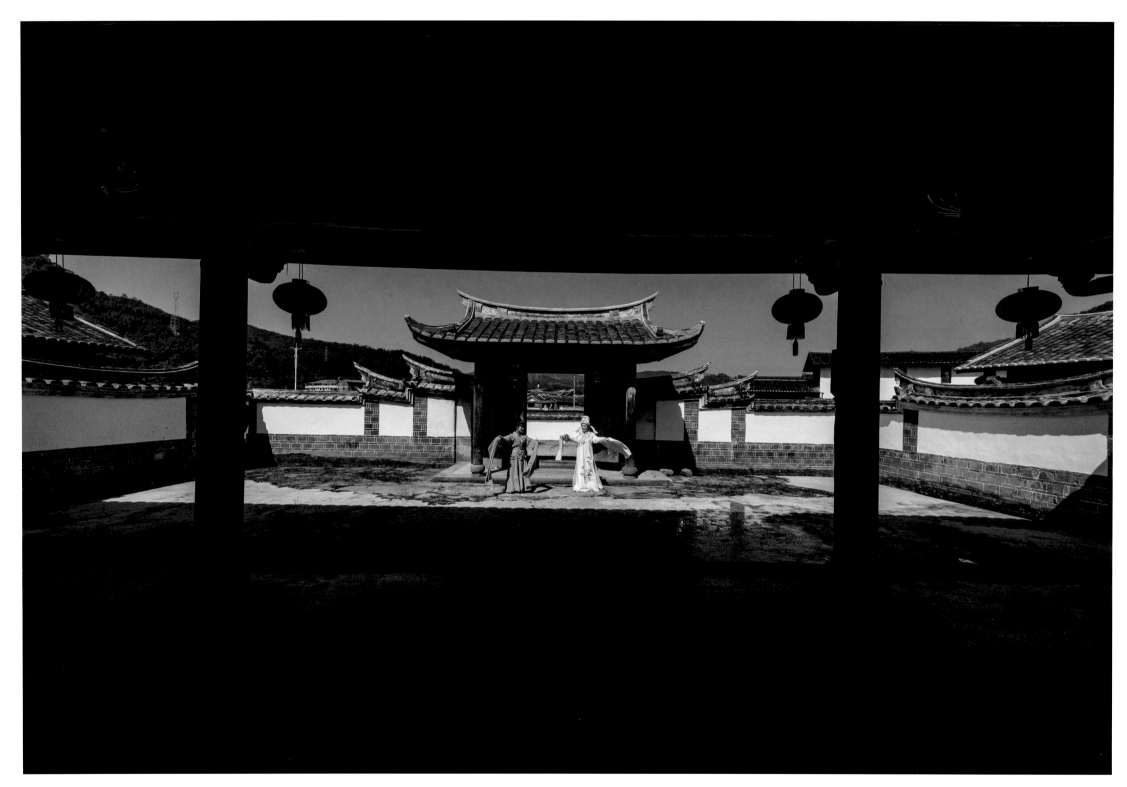

古厝唱新戏 / 吴军 摄

Acting in a new opera in the old house /Photographed by Wu Jun

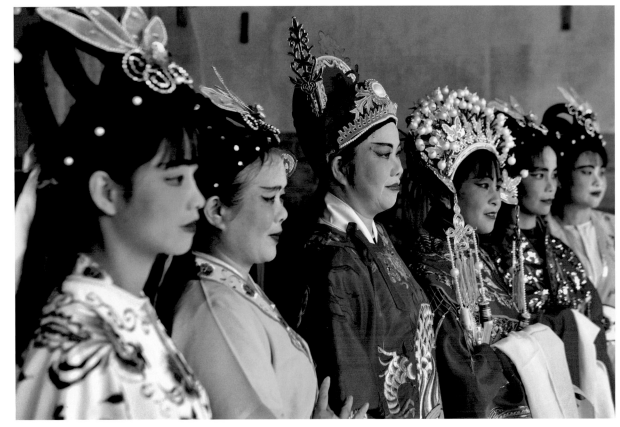

闽西汉剧因唱腔悦耳动听、韵味无穷、被客家人亲切地称为"家乡戏" / 吴寿华 摄
Han opera in Western Fujian is affectionately called "hometown opera" by Hakkas because of its melodious vocal music and endless lasting appeal /Photographed by Wu Shouhua

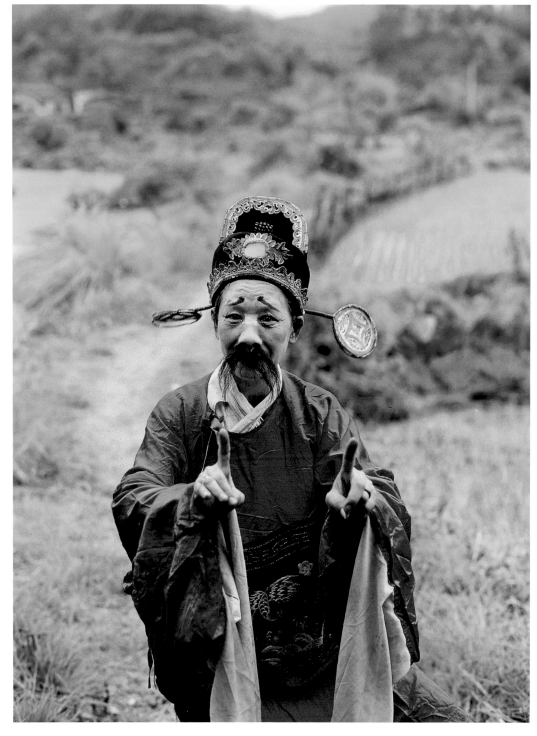

在闽西乡间还有众多的民间汉剧班社 / 赖小兵 摄
There are also many folk Chinese opera troupes in the countryside of Western Fujian / Photographed by Lai Xiaobing

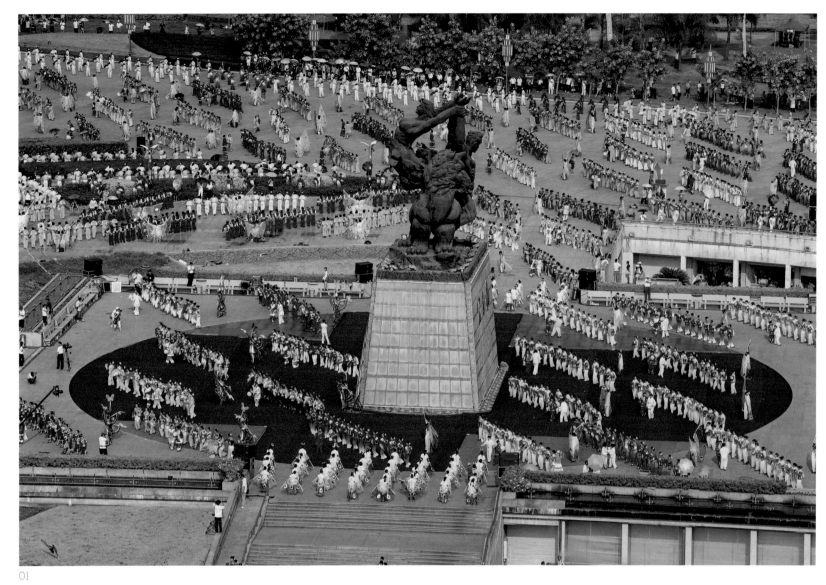

01

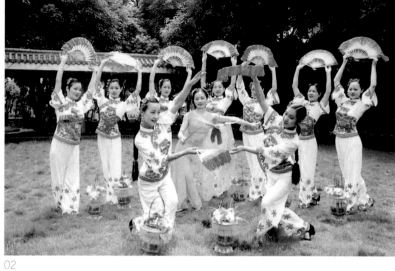

02

Tea-Picking
Lantern

采茶灯

采茶灯又名采茶扑蝶，流行于龙岩城乡的民间歌舞，是融说唱、戏曲、舞蹈为一体的综合性群众文娱活动形式。舞蹈表现了采茶时节的劳动场景：由茶婆领头，村姑们尾随着武生、男丑在采茶锣鼓的乐声中，来到茶园中采摘春茶。2005 年 11 月，龙岩采茶灯被福建省政府公布为省级非物质文化遗产保护项目。2014 年 12 月 3 日，龙岩采茶灯入选第四批国家级非物质文化遗产代表性项目名录。

Tea-Picking Lantern, also known as tea-picking and butterfly-capturing, is a popular folk song and dance in urban and rural areas of Longyan, which is a comprehensive form of mass recreational activities integrating rap, opera and dance. The dance shows the working scenes during the tea picking season: led by the tea lady, the village girls followed Wusheng (military) and the male Chou (clown) came to the tea garden to pick spring tea with the music of tea-picking gongs and drums. In November 2005, Longyan Tea-Picking Lantern was announced by Fujian Provincial Government as a provincial intangible cultural heritage protection project. On December 3rd, 2014, Longyan Tea-Picking Lantern was included in the List of the Fourth Batch of National Intangible Cultural Heritage Representative Projects.

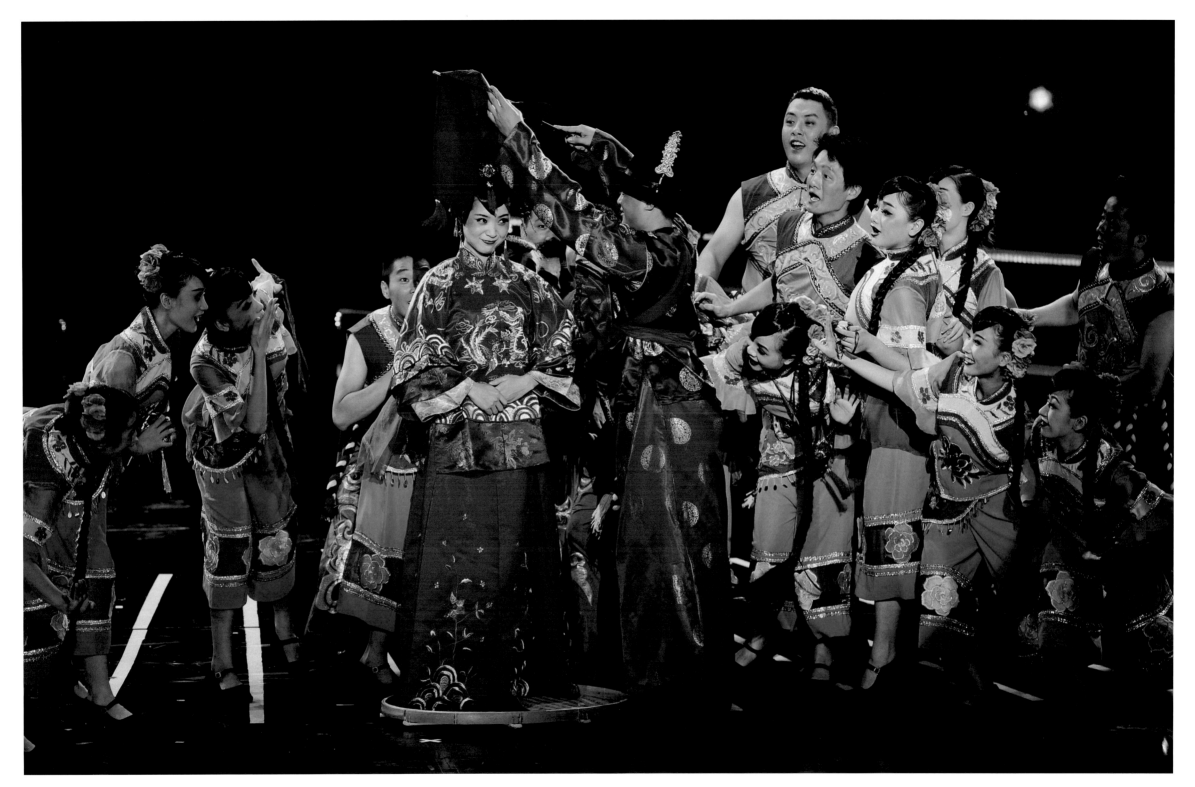

展现两岸及海外客家人拼搏开拓精神的晚会 "客家之歌·义薄云天" 在台湾新竹县隆重登场

The evening party "Song of Hakkas: High Morality Reaching up to the Clouds", which shows the pioneering spirit of Hakkas from both sides of the Taiwan Strait and overseas, was solemnly staged in Xinzhu County, a county with a large Hakkas population in Taiwan

Exquisite
Workmanship

天工绝技

客家相对封闭独立的生活，使他们在传承中，创造新的手工工艺，在不依赖外界的情况下，生活过得丰富多彩。连城的手工纸与武平古法造纸，均为就地取材，制造书写与生活用纸，满足客家生活与精神的需求。晴耕雨读是勤劳的中华民族传统，客家继承了这个美德，读书成为出人头地、报效国家的途径，四堡雕刻印刷在一个深山之中的村寨兴起，正是适应了这样一种美好理想。而芷溪花灯、传统打制锡壶、永定万应茶、长汀皮鼓、漳平版画、漳平水仙茶等，都是客家人将生活过得精致而又有滋有味的见证。

Hakka's relatively closed and independent life may enable them to create some new handicraft in their inheritance, so that they can live a rich and colorful life without relying on the outside world. Liancheng Handmade Paper and Wuping Ancient Paper Making adopt local materials, making writing and living paper to meet the needs of Hakka life and spirit. The Hakka people inherited the hardworking Chinese tradition of Clear Day Farming and Rainy Day Reading. Reading became the only way to get ahead, seek fame and serve the country. The rise of Sibao Block Printing in a village in a deep mountain was just adapted to such a beautiful ideal. And Zhixi lanterns, traditional tin pots, Yongding Wanying tea, Changting leather drum, Zhangping block painting, Zhangping narcissus tea and so on are all the witnesses of Hakka people's delicate and tasteful life.

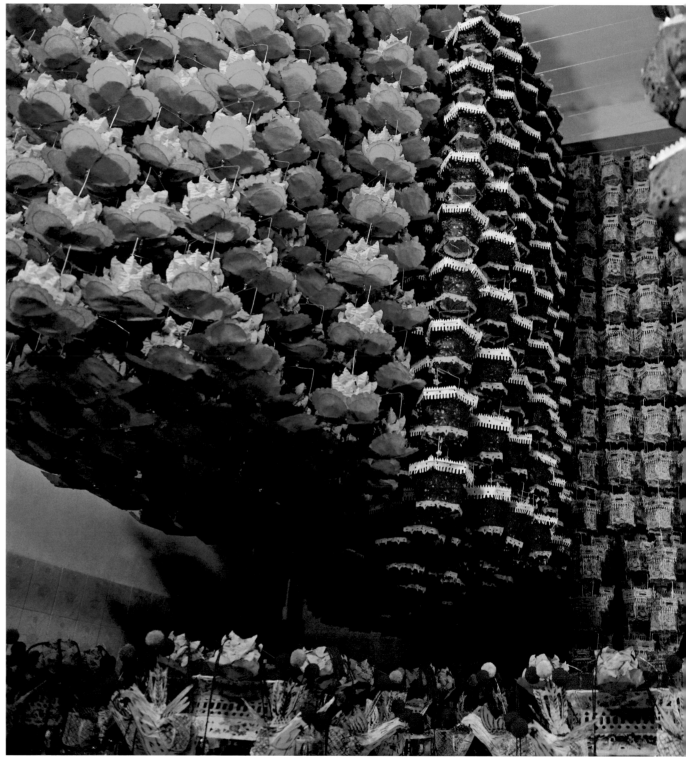

01

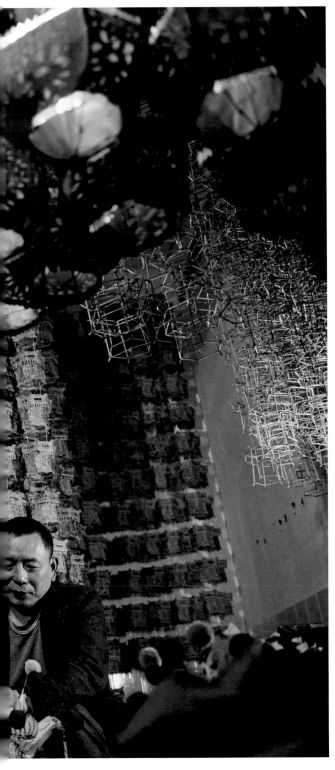

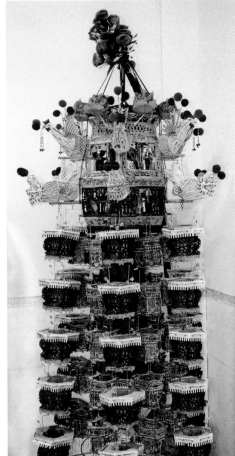

02

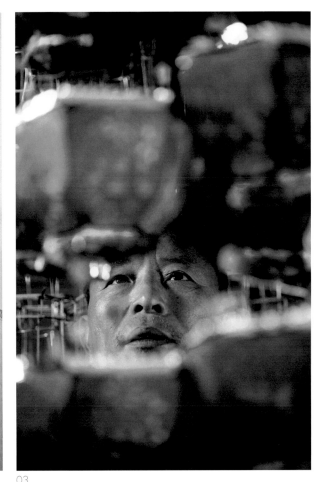

03

芷溪花灯

芷溪游花灯，是福建省客家古村落芷溪的传统民俗活动，源自姑苏，保留了古苏州的花灯技艺和锣鼓音乐。花灯整体以竹篾为骨架，裱糊通草纸，内置晶莹剔透琉璃杯。一个花灯的制作工艺涵盖了雕刻印刷、绘画剪纸、金属塑作、纺染漆艺、服饰制作、竹木器编织扎制等传统手工艺。

Zhixi Festive Lantern is a traditional folk activity in Zhixi, an ancient Hakka village in Fujian Province, which originates from Suzhou and retains the lantern art and gongs and drums music of ancient Suzhou. The festive lantern is made of bamboo strips as its skeleton and pasted with straw paper, with internal crystal-clear glass cups. The production of a festive lantern covers traditional handicrafts such as carving and printing, painting and paper cutting, metal sculpture, spinning and dyeing lacquer art, clothing manufacture, weaving and tying of bamboo and wood wares.

01　　做了近一年的花灯，在正月初四即将璀璨登场 / 陈伟凯 摄
　　These lanterns that have been made for nearly a year, will be on the stage on the 4th day of the first month of the lunar year /Photographed by Chen Weikai

02　　花团锦簇、琳琅满目、熠熠生辉的"纸包火"芷溪花灯 / 陈伟凯 摄
　　The various and brightly shining "paper wrapped fire" Zhixi festive lanterns with rich multicolored decorations /Photographed by Chen Weikai

03　　芷溪花灯的制作人黄世平 / 陈伟凯 摄
　　Huang Shiping, the producer of Zhixi Festive Lantern /Photographed by Chen Weikai

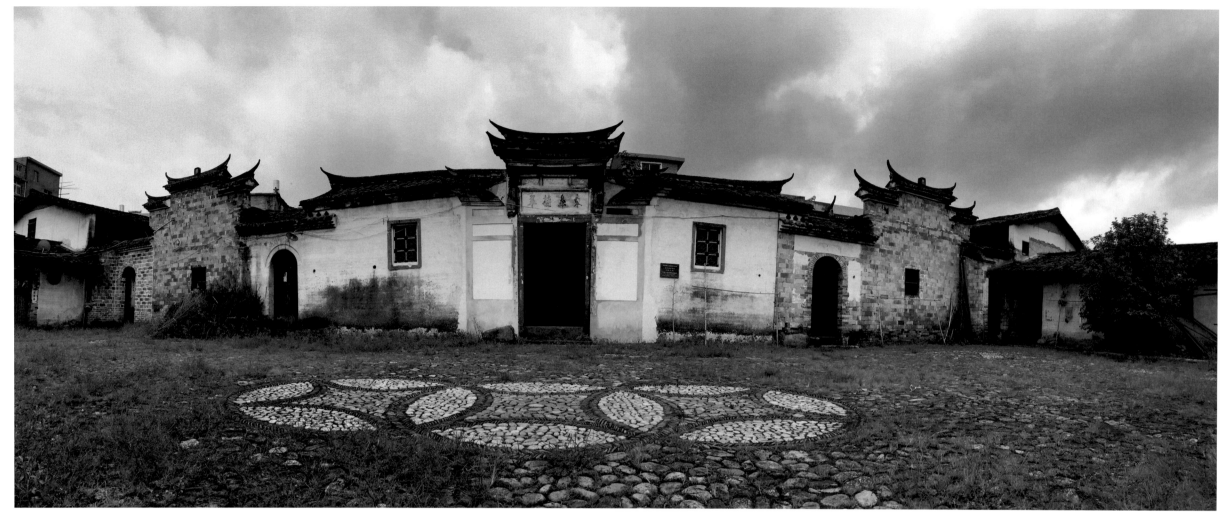

连城四堡书坊建筑群新林兰堂 / 阮任艺 摄
Bookshop Building Group in Sibao Town, Liancheng County—New Linlan Hall /Photographed by Ruan Renyi

Sibao
Block
Printing

四堡雕板印刷

连城四堡是中国明清两代著名的四大雕版印刷基地之一。现存的大量印坊、雕版、印刷工具和古书籍，是中国目前年代久远、保存完善、举世罕见的珍贵文物。其精湛的雕刻技艺和不朽的艺术价值，充分体现了古代劳动人民的卓越才能和和艺术创造力。

Sibao Town in Liancheng County is one of the four famous block printing bases in the Ming and Qing Dynasties in China. A large number of existing printing workshops, engravings, printing tools and ancient books are rare and precious cultural relics in China with a long history and perfect preservation. Its exquisite carving art and immortal artistic value fully embody the outstanding talents and artistic creativity of the ancient working people.

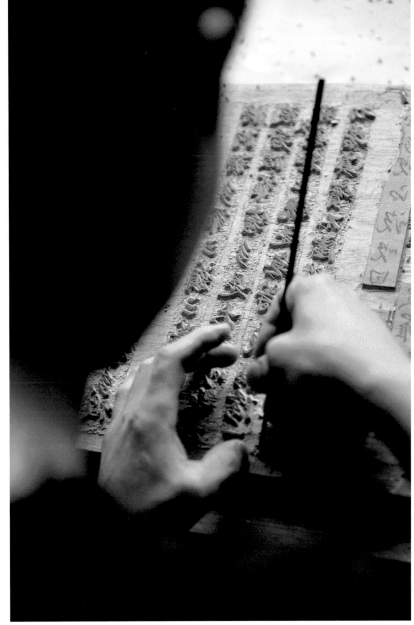

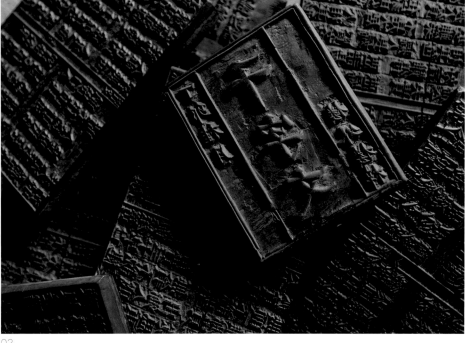

01

02

03

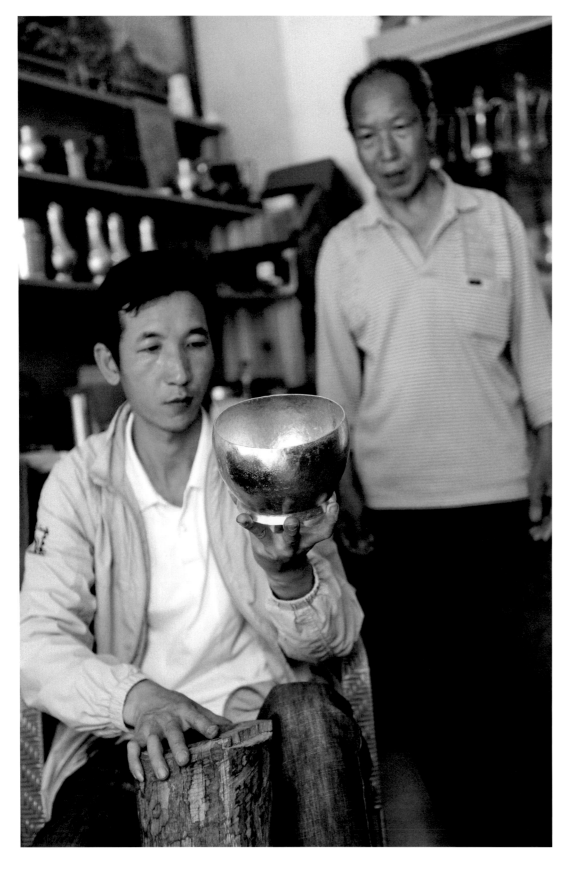

Traditional
Tin pot

传统锡壶

四堡锡器制作技艺有 700 多年历史，传承至今已 26 代。南宋末年，四堡枧头村青年吴一龙到杭州其岳父处学习打锡技艺，后将学来的锡器制作技艺结合四堡当地的民间民俗文化传统，摸索出一套具有浓郁四堡地方特色的锡器制作工艺。明代嘉靖、万历年间，吴一龙因制作的锡器坚固耐用、美观大方，被明万历皇帝所赏识，赞誉为"锡状元"，四堡遂成为福建有名的锡器之乡。

Manufacture skills of Sibao tin wares have a history of more than 700 years and have been passed down for 26 generations. At the end of the Southern Song Dynasty, Wu Yilong, a young man from Jiantou Village in Sibao, went to his father-in-law in Hangzhou to learn tin-striking skills. He combined the learned skills of manufacturing tin wares with the local folk cultural traditions in Sibao to explore a set of techniques for manufacturing tin wares with strong local characteristics of Sibao. During the reign of Jiajing and Wanli in the Ming Dynasty, Wu Yilong, was appreciated by the Emperor Wanli of the Ming Dynasty for his strong, durable, beautiful and elegant tin wares, and was praised as the "Top Tin Scholar". Then Sibao became the famous hometown of tin ware in Fujian.

"四堡锡器制作技艺"代表性传承人马恩明父子 / 陈杨富 摄
Ma Enming and his son, the representative inheritor of "Sibao techniques of manufacturing tin wares" /Photographed by Chen Yangfu

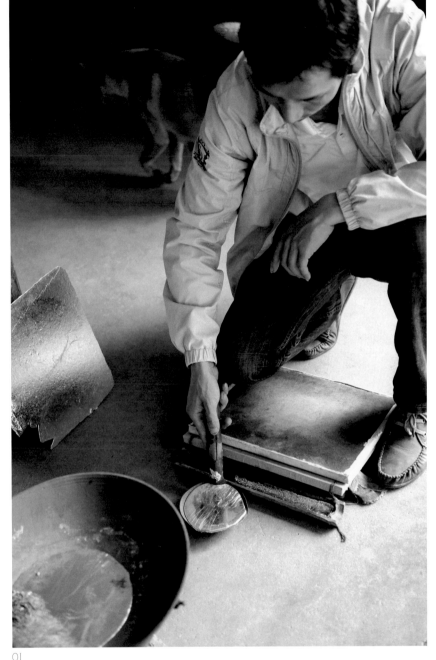

01

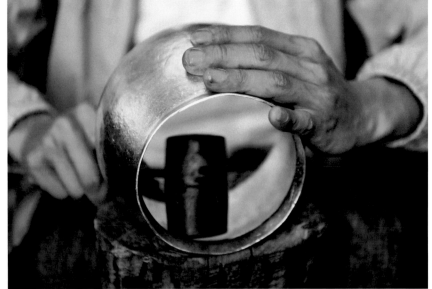

02

03

Liancheng
Handmade
Paper

连城手工纸

连史纸，又称连四纸、连泗纸，原产江西、福建。素有"寿纸千年"之称。其采用嫩竹做原料，碱法蒸煮，漂白制浆，手工竹帘抄造，有72道工艺，道道精湛。它纸白如玉，厚薄均匀，永不变色，防虫耐热，着墨鲜明，吸水易干，书写、图画均宜。所印刷的书籍，清晰明目，久看不倦。用于书写作画，着墨即晕，入纸三分，历来为国内外书画家所钟爱收藏。

Lianshi paper (a fine paper made from bamboo), also known as Liansi (四) paper and Liansi (泗) paper, originated in Jiangxi and Fujian, which has always been called "Paper with thousand years of life". It uses tender bamboo as raw material, alkaline cooking, bleaching and pulping, and hand-made bamboo curtains, and has 72 techniques, which are all exquisite. The paper is as white as jade, uniform in thickness, never changing color, insect-preventive and heat-resistant, bright in inking, easy to dry in water absorption, and suitable for drawings and paintings. The printed books are clear and can improve eyesight, and it is not easy to get tired after reading them for a long time. It is used for writing and painting. When inking, it is haloed immediately and the ink enters three-tenths into the paper. It has always been loved and collected by calligraphers and painters at home and abroad.

01　蒸煮黄坯 / 赖小兵 摄
Boiling yellow adobes /Photographed by Lai Xiaobing

02　推动纸帘捞纸，在纸槽内来回摇荡 / 赖小兵 摄
Push the paper curtain to drag the paper and shake it back and forth in the paper slot /Photographed by Lai Xiaobing

03　将一张张湿纸剥到纸板上，待干后收下放平 / 赖小兵 摄
Peel every piece of wet paper onto the cardboard and lay them flat after drying /Photographed by Lai Xiaobing

04　连史纸的制作过程中，从选料、制料、捞纸到焙纸等工序都需精挑细作，是一门耗时费力的手工技术 / 赖小兵 摄
It is a time-consuming and labor-consuming manual technology that the production process of Lianshi paper needs to be carefully selected from material selection, material preparation, paper draging, paper baking and other working procedures /Photographed by Lai Xiaobing

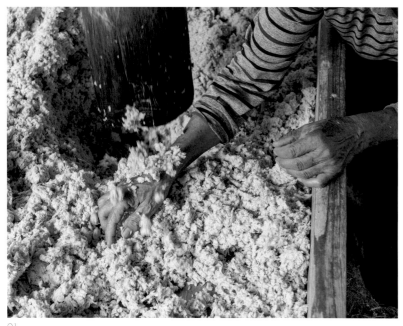

01

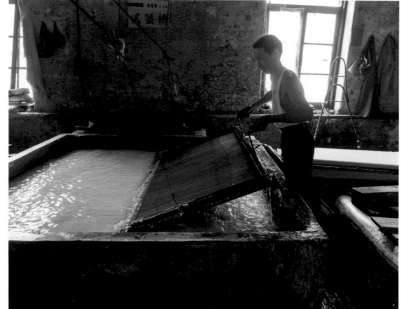

02

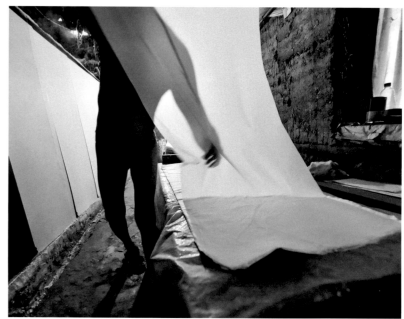

03

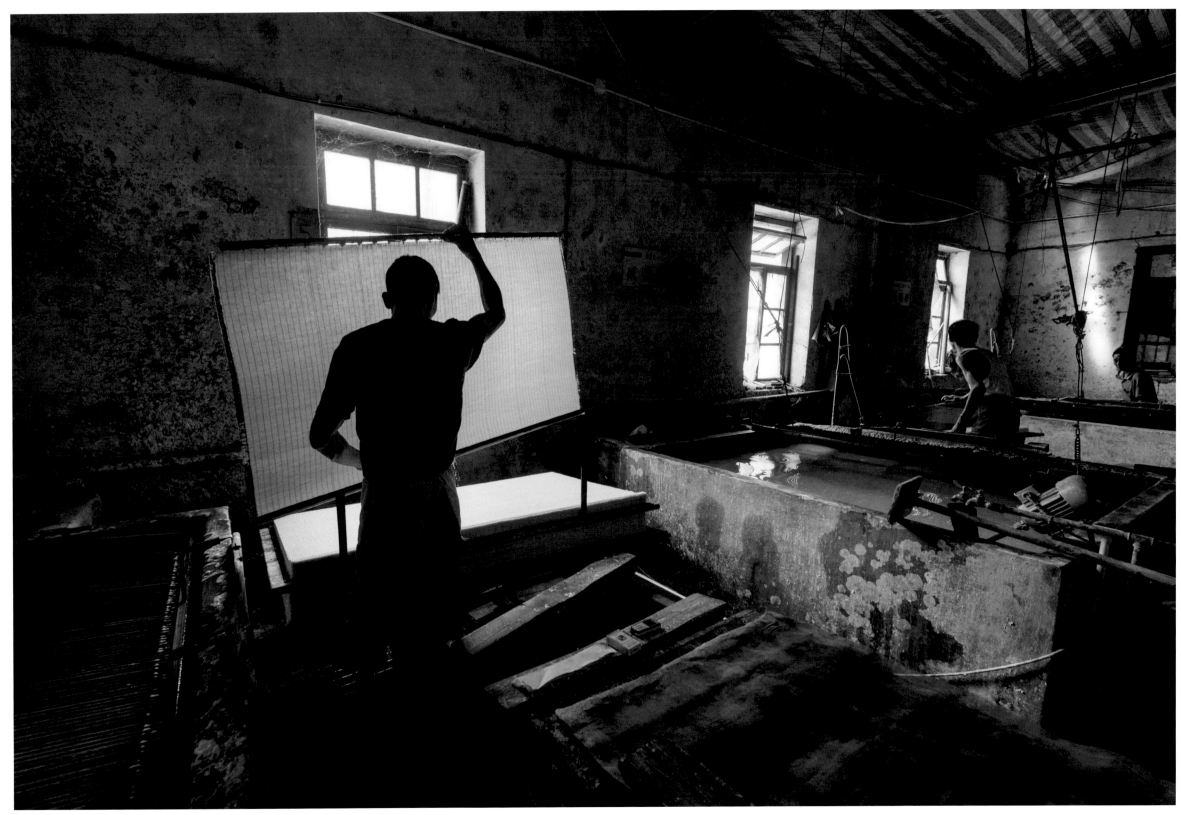

01 药材好，才能保证万应茶的品质 / 陈伟凯 摄
Only when the medicinal materials are good can Wanying tea be good /
Photographed by Chen Weikai

02 万应茶的原料需选择经乌龙茶工艺加工而成的铁观音干茶（高山茶） / 陈伟凯 摄
The raw material of Wanying tea should be selected from Tie Guanyin dried tea
[High Mountain Tea] processed by Oolong tea technology /Photographed by Chen
Weikai

03 万应茶制作工序之晾晒 / 陈伟凯 摄
Airing in the production process of Wanying tea /Photographed by Chen Weikai

04 晒药饼 / 陈伟凯 摄
Drying the medicinal cake in the sun /Photographed by Chen Weikai

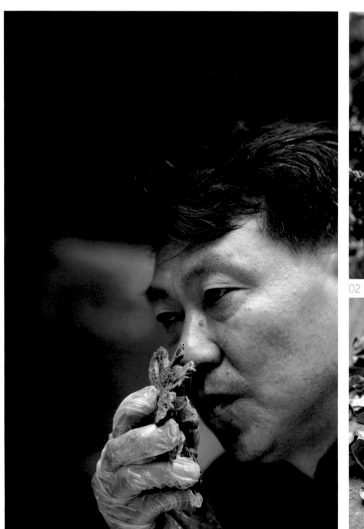

01

02

03

Yongding
Wangying
Tea

永定万应茶

永定万应茶，中国国家地理标志产品。永定万应茶创制历史已有 200 余年，采用 30 多种地道中药材，经过传统中药制剂工艺技术配制而成，具有纯正清檀的香味，味微苦、香气浓郁、回甘留香，饮用后有神清气爽、肠胃清新之功效。

Yongding Wanying tea, is a national geographical indication product of China. Yongding Wanying tea has a history for more than 200 years, which adopts more than 30 kinds of authentic traditional Chinese traditional medicinal crops and is formulated through traditional Chinese medicine preparation techniques. It has pure fragrance of pteroceltis tatarinowii, slightly bitter taste, rich fragrance, tastes sweet and retains fragrance after taste, refreshing feeling and fresh intestines and stomach after drinking.

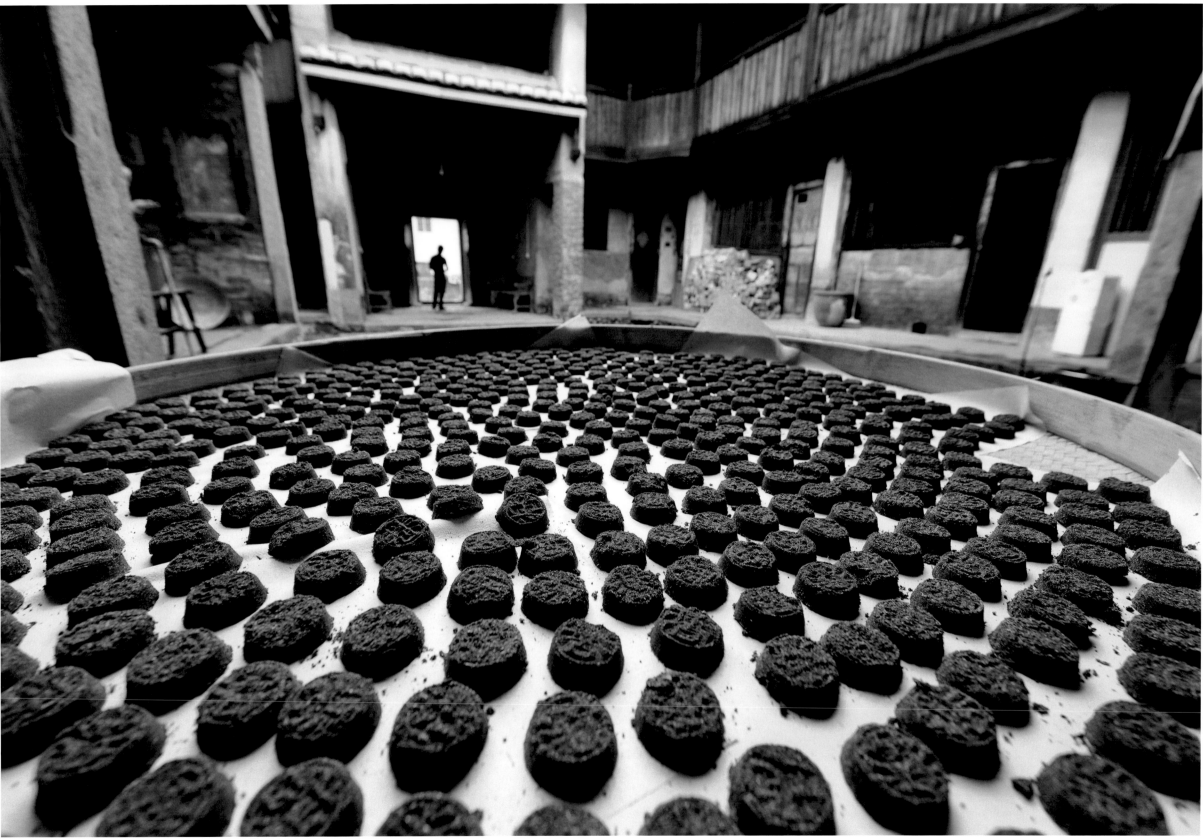

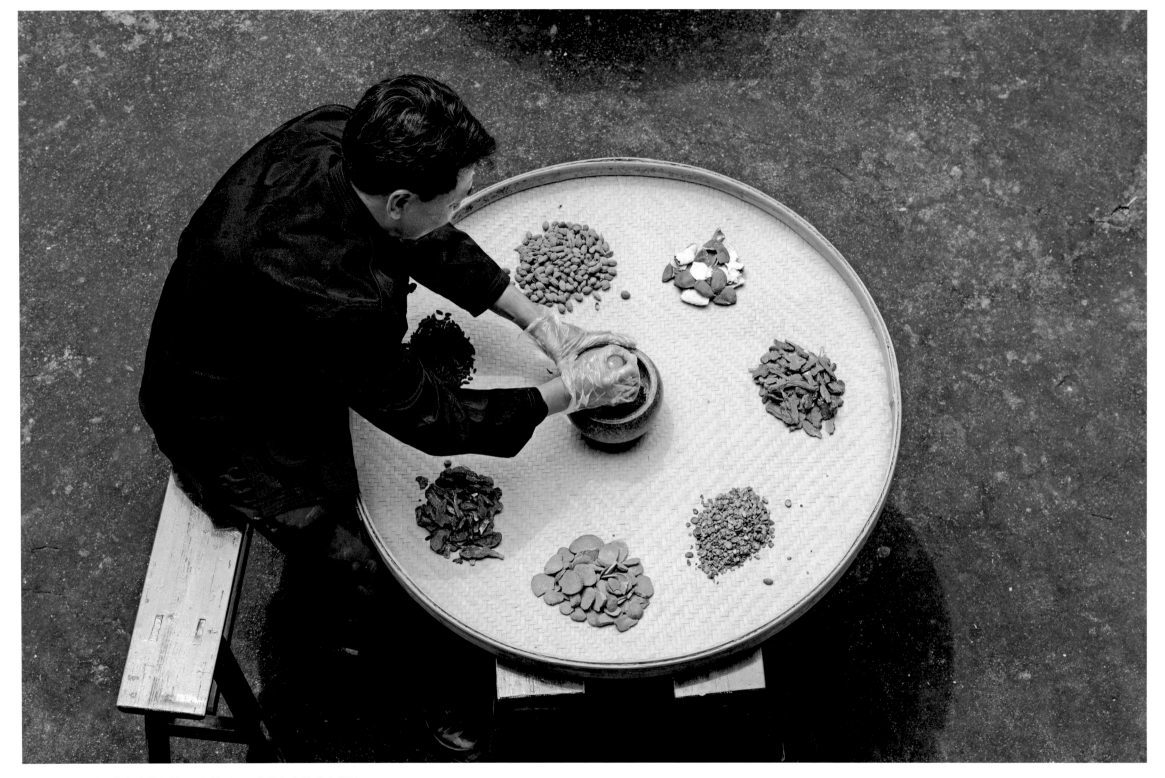

除了永定特有的高山茶之外，还需加入 30 多种名贵地道中药材 ／ 陈伟凯 摄

In addition to the unique High Mountain tea of Yongding, more than 30 rare authentic Chinese traditional medicinal crops need to be added /Photographed by Chen Weikai

01

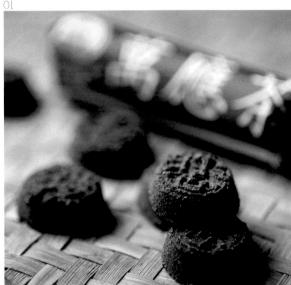

02

01　揭制药饼 / 陈伟凯 摄
Ramming the medicinal cakes /
Photographed by Chen Weikai

02　经独特工艺加工而作的茶饼对肠胃疾病有
显著疗效 / 陈伟凯 摄
The tea cake processed by unique
technology has significant curative effect on
gastrointestinal diseases /Photographed by
Chen Weikai

03　制作工坊 / 陈伟凯 摄
Production Workshop /Photographed by
Chen Weikai

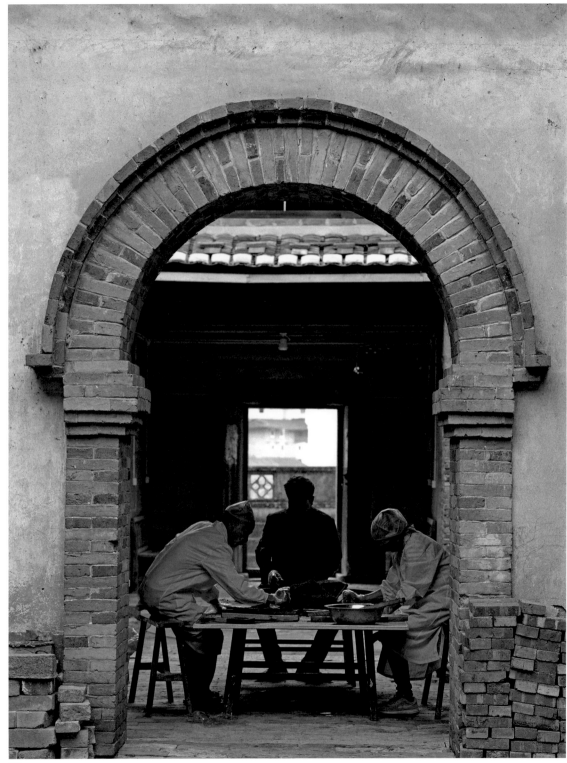

03

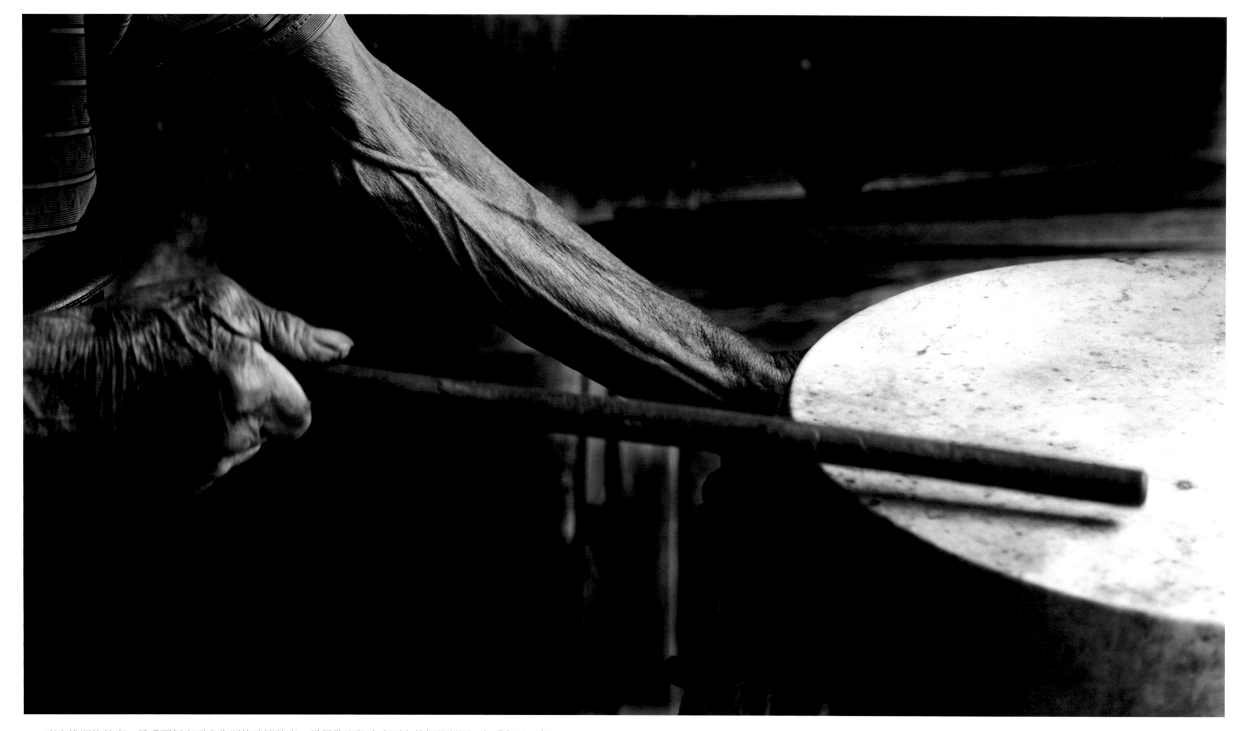

　　高亢雄浑的鼓声，是千百年来艰辛生涯的浓情伴奏，是骨骼血脉生生不息的炽热基因，如歌如乐，如泣如诉 / 陈伟凯 摄

　　The loud and heavy drums are the passionate accompaniment of the hard life for thousands of years. The blazing genes of the unceasing blood and bones sound likes songs and music, as if weeping and complaining /Photographed by Chen Weikai

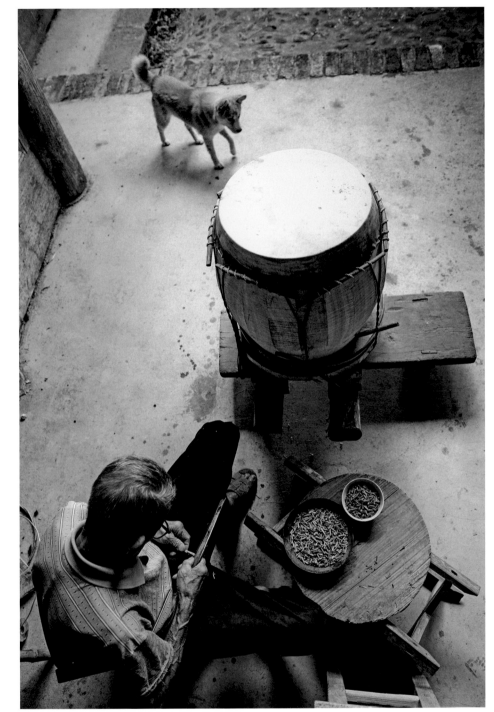

01

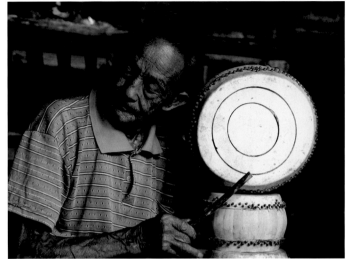

02

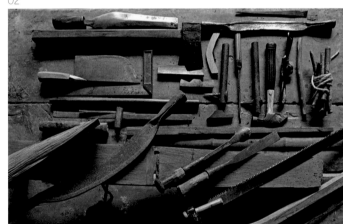

03

01 以邱振昌为代表的金龙皮鼓艺人，从业的初始目的是为了贴补家用，但在时光的淘洗浸淫中，逐渐演变成一种内在的情感和文化责任 / 陈伟凯 摄

The initial purpose of artists of Jinlong Leather Drum, represented by Qiu Zhenchang, is to supplement their family expenses. But in the elutriation and immersion of time, it gradually evolved into an internal emotional drive and cultural responsibility /Photographed by Chen Weikai

02 击鼓听音，判定音质 / 陈伟凯 摄

Gently beat the drum, listen to the sound and then you could judge the sound quality / Photographed by Chen Weikai

03 制鼓工具 / 陈伟凯 摄

Tools of manufacturing drums /Photographed by Chen Weikai

Changting
Leather
Drum

长汀皮鼓

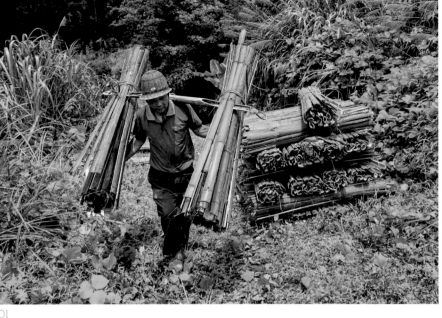

01

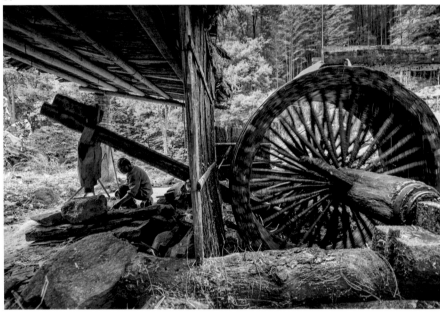

02

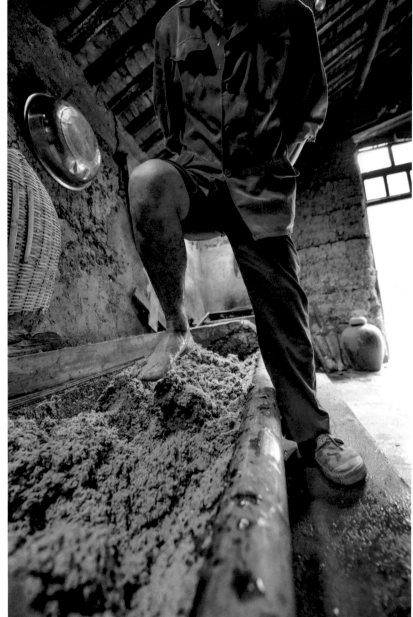

03

01 选用还未长叶的嫩竹麻为原料 / 李国潮 摄
Select the bamboo and linen from branches
without leaves as raw materials /Photographed by Li
Guochao

02 水碓竹麻 / 李国潮 摄
Water-Powered trip-hammer for bamboo and
linen /Photographed by Li Guochao

03 古法造纸保留着原汁原味的制作手法 / 李国潮 摄
The ancient papermaking retains the original
production technique /Photographed by Li Guochao

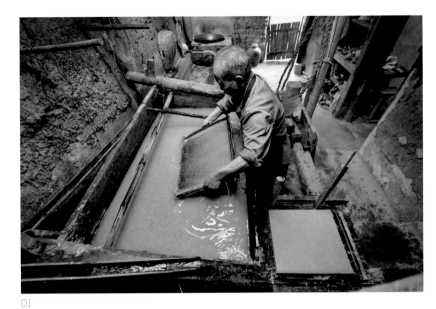

01

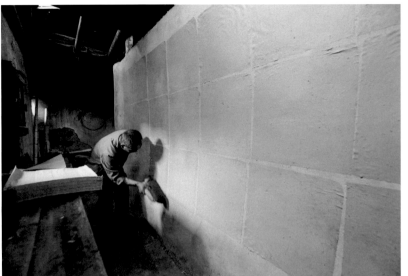

02

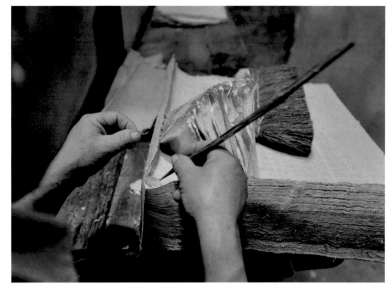

03

武平古法造纸

　　武平毛竹资源十分丰富，生产和销售量大，是县域内的第二大宗林产品。造纸技术从清朝中叶汀州（今长汀县）、莲城（今连城县）传入武平，人们将这种纸称为"土纸"。土纸通过汀江、梅江销往潮州、汕头一带。由于经济效益显著，直至二十世纪六十年代，县域内各乡镇都有规模大小不一的土纸造纸坊，成为当地财政和村民一笔重要的经济收入。

　　Wuping is rich in resources of moso bamboo. It is the second biggest commodity in the county. The papermaking technique began from Tingzhou (today Changting County) and Liancheng (today Liancheng County) in the middle of the Qing Dynasty to Wuping. This kind of paper was called "Tu Paper" (Earth Paper). Through the Tingjiang River and Meijiang River. Tu Paper is sold to Chaozhou and Shantou area. Because of the notable economical profits, people built various scale of Tuzhi workshops all over Wuping County until 1960s. Making Tu Paper became an important income of the villagers and local government.

01
捞纸，需重复撩起纸浆，轻揭纸帘 / 李国潮 摄
For dragging papers. it is necessary to repeatedly lift the paper pulp up and gently take the paper curtain off /Photographed by Li Guochao

02
焙纸，用排刷刷平整，数分钟后纸干收下 / 李国潮 摄
For baking papers. brush the paper flat with a smooth brush. collect it after a few minutes when it is dry /Photographed by Li Guochao

03
整个造纸过程工序繁多、复杂，做法没有文字记录，只有口传心授 / 李国潮 摄
The whole papermaking process has many and complicated procedures. and there is no written record of the process. only oral instruction and heart-to-heart teaching /Photographed by Li Guochao

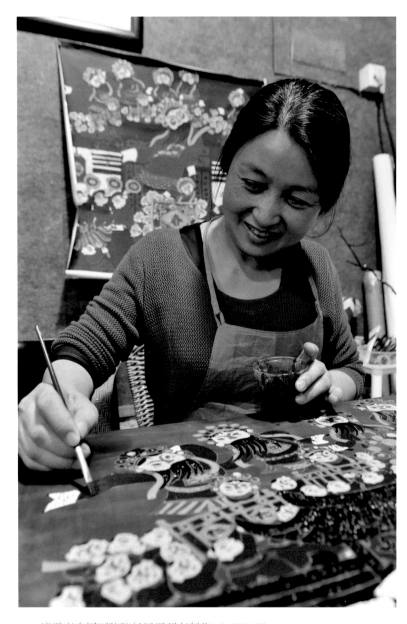

漳平市农民画院院长吴玉环在创作 / 吴军 摄
Wu Yuhuan, President of Zhangping Peasant Painting
Academy, is creating /Photographed by Wu Jun

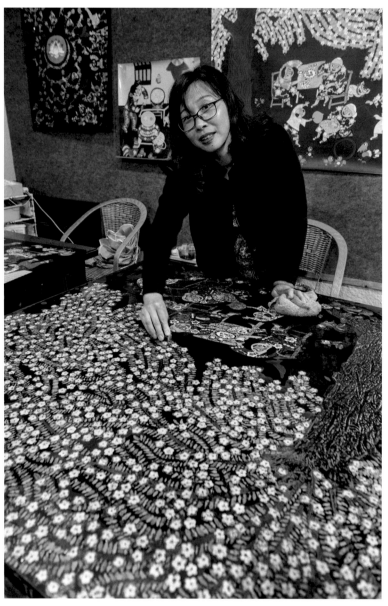

汤艺萍,漳平市农民画院副院长,其作品把漳平的民俗文化、民间技艺
融为一体,充满着浓郁的乡土气息 / 吴军 摄
Tang Yiping, vice President of Zhangping Peasant Painting Academy,
integrates Zhangping's folk culture and folk skills into a whole, making it
full of rich local flavor /Photographed by Wu Jun

Fujian
Zhangping
Peasant Paintings

漳平农民画

　　福建漳平农民画具有造型圆满夸张、勾线平涂、色彩鲜艳、对
比强烈、主观性极强、装饰意味浓厚的艺术特色,审美追求极具稚
拙之气与古朴淳厚,在福建省乃至全国美术界都享有较高的声誉。

　　Fujian Zhangping peasant paintings have a exaggerative
plump figure, show the skill of delineating, flat coloring and bright
high contrast color, and express the subjectivity of the artists. With
a great decorative characteristic, the art works have the aesthetic
feature of both immature beauty and antiquated profoundness,
and enjoy high reputation in Fujian art field, even around the
world.

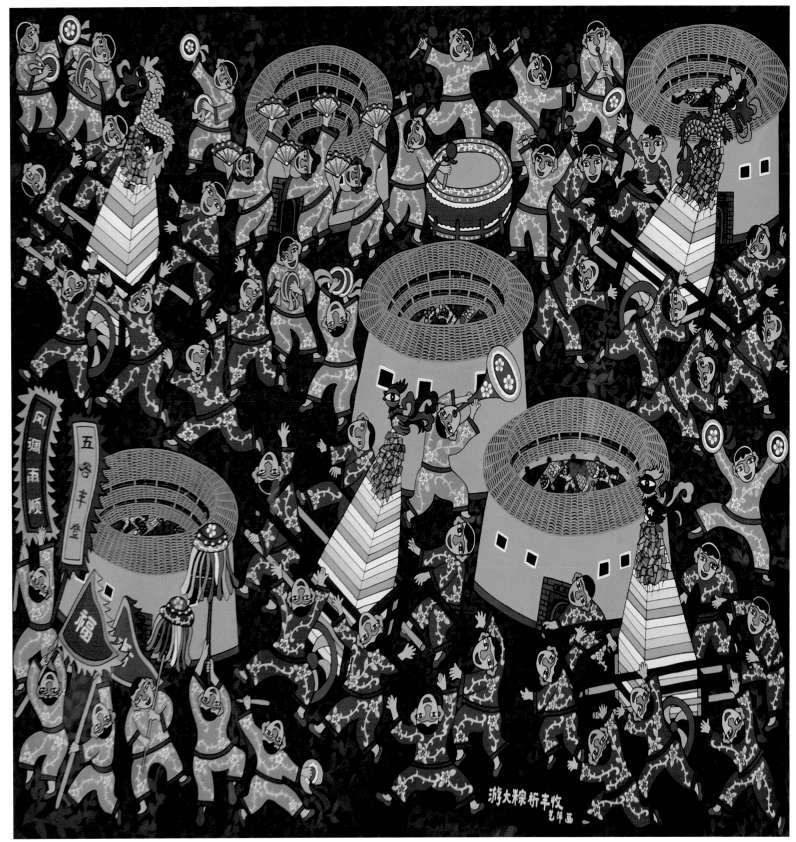

汤艺萍作品《游大粽 祈丰收》／ 吴军 摄
Tang Yiping' work—Parade of giant Zongzi (rice dumplings) and pray for a good harvest /Photographed by Wu Jun

01 水仙茶采摘 / 吴凯翔 摄
 The picking process of narcissus tea /Photographed by
 Wu Kaixiang

02 漳平茶厂制茶师正在摇青 / 严硕 摄
 Tea makers of Zhangping Tea Factory are stirring /
 Photographed by Yan Shuo

03 水仙茶的制作过程，从晒青、晾青、摇青，到做青、杀青、
 揉烘，除晒青外，其他基本都在车间中完成 / 朱晨辉 摄
 The production process of narcissus tea, from solar
 withering, air curing, stirring, to fine manipulation, fixation
 and rolling&baking, except for solar withering, is basically
 completed in the workshop /Photographed by Zhu Chenhui

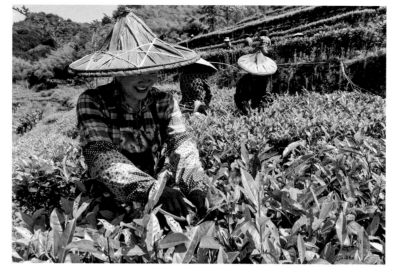

01

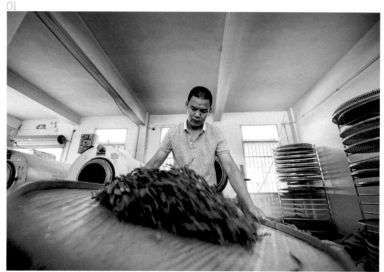

02

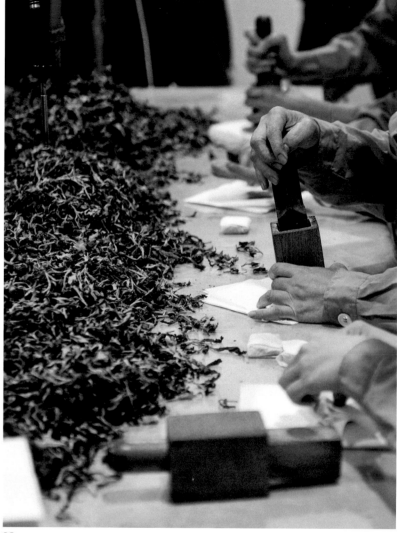

03

Zhangping
Narcissus Tea

漳平水仙茶

漳平水仙茶是漳平茶农创制的传统名茶。漳平九鹏溪地区是漳平水仙茶主产区，其优越的自然环境条件，形成了漳平水仙茶独特的品质。水仙茶饼更是乌龙茶类唯一紧压茶，品质珍奇，风格独一无二，极具浓郁的传统风味，香气清高幽长，畅销于闽西、厦门及广东一带，并远销东南亚国家和地区。

Zhangping narcissus tea is a traditional famous tea created by tea planters of Zhangping. Jiupengxi area is the main producing area of Zhangping narcissus tea, the superior natural environment of which has formed the special quality of Zhangping narcissus tea. As the only tight-pressed tea brick among Oolong teas, the narcissus tea brick is unique and rare. The taste of the narcissus teas is traditional and strong, while the smell of it is fresh and long-last. It is in great demand in Western Fujian, Xiamen and Guangdong Province, and also exports to Southeast Asia.

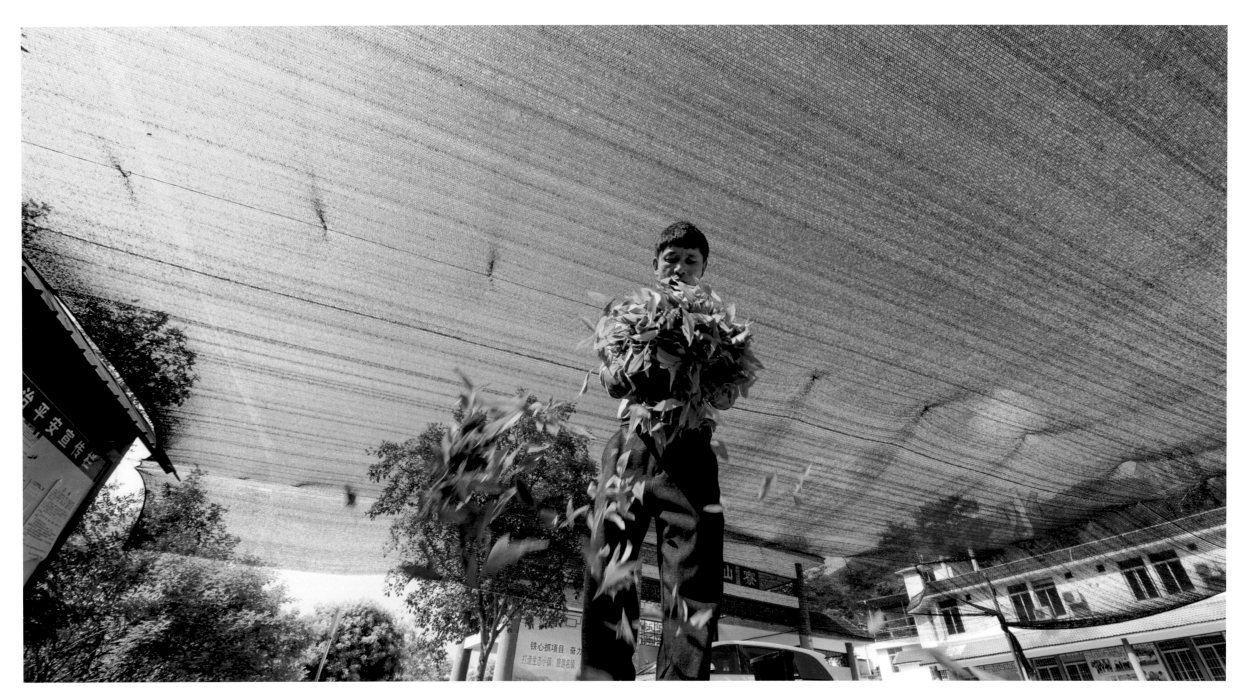

茶农正在晒青 / 严硕 摄
Farmers are doing the solar withering /Photographed by Yan Shuo

Hakka
Delicacies

乡土佳肴

　　客家的饮食最富特色，一桌酒席，几十道菜，道道美味可口。各种小吃更是琳琅满目，每条街的小吃、消夜，便是一个世界。同样的食材，鸡鸭鱼肉，一到客家的巧妇手上，总会做出万般姿容、千种花样，而这些花样，样样离不开客家的生活习惯与喜好。随着时间的推移，早前的私家菜渐成大众口味，客家的乡土佳肴，成了走南闯北者的最爱。

　　Hakka's diet is the most distinctive, a table of dozens of dishes being extremely delicious. All kinds of snacks are dazzling. Snacks and midnight snacks in every street are a world. The same food ingredients such as chicken, duck and fish, once in the hands of Hakka's skillful women, will always make all kinds of appearance and thousands of patterns, which are due to Hakka's habits and preferences. With the passage of time, private dishes have gradually become popular. Hakka's local cuisine has become the favorite of those who travel extensively.

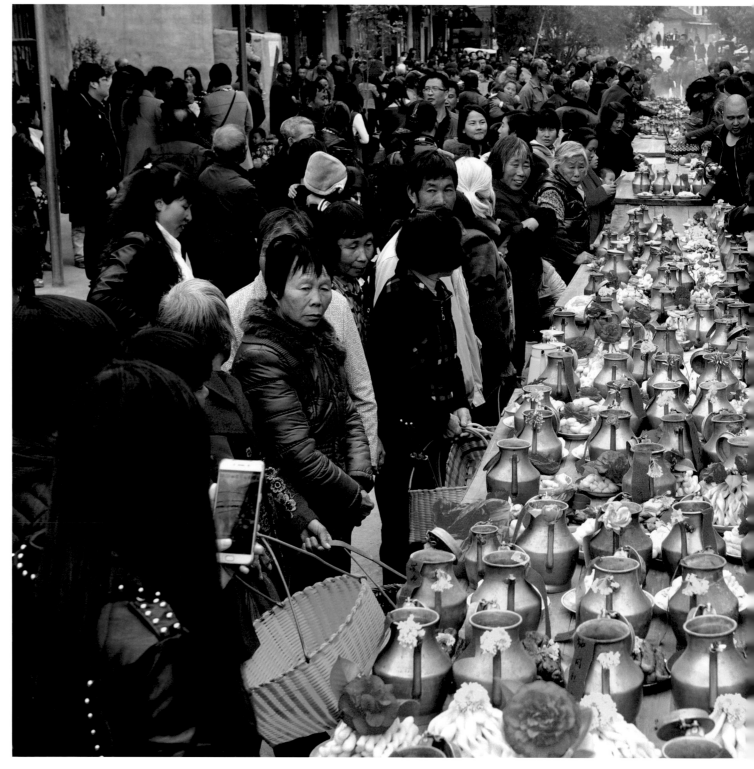

长汀百壶宴，每年在春天播种季节以民间最纯朴的方式祭祀天地神灵，祈求田禾大熟、五谷丰登 / 胡晓钢 摄
Changting Hundred Pot Banquet is a folk festival for worshiping to gods of heaven and earth in spring planting season when villagers pray for harvest /Photographed by Hu Xiaogang

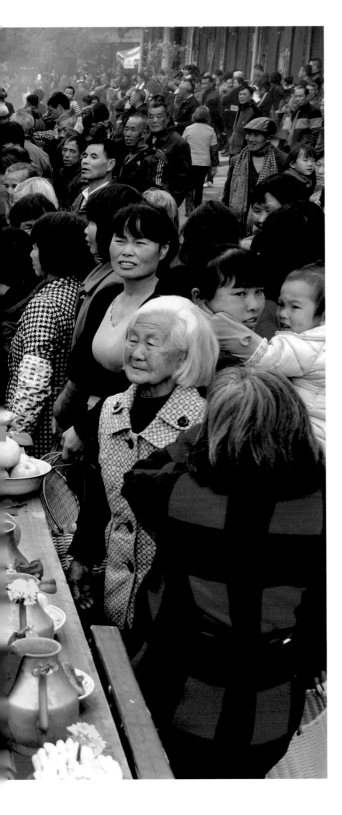

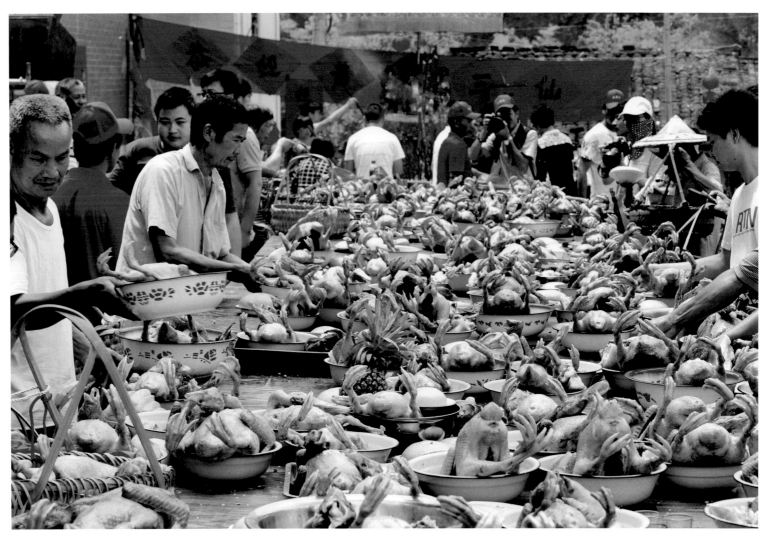

Chang
Ting

长汀

长汀县濯田镇上塘村一年一度传统民俗节日——"百鸭宴" / 胡晓钢 摄
The annual traditional folk festival in Shangtang Village, Zhuotian Town, Changting
County—"Hundred Duck Banquet" /Photographed by Hu Xiaogang

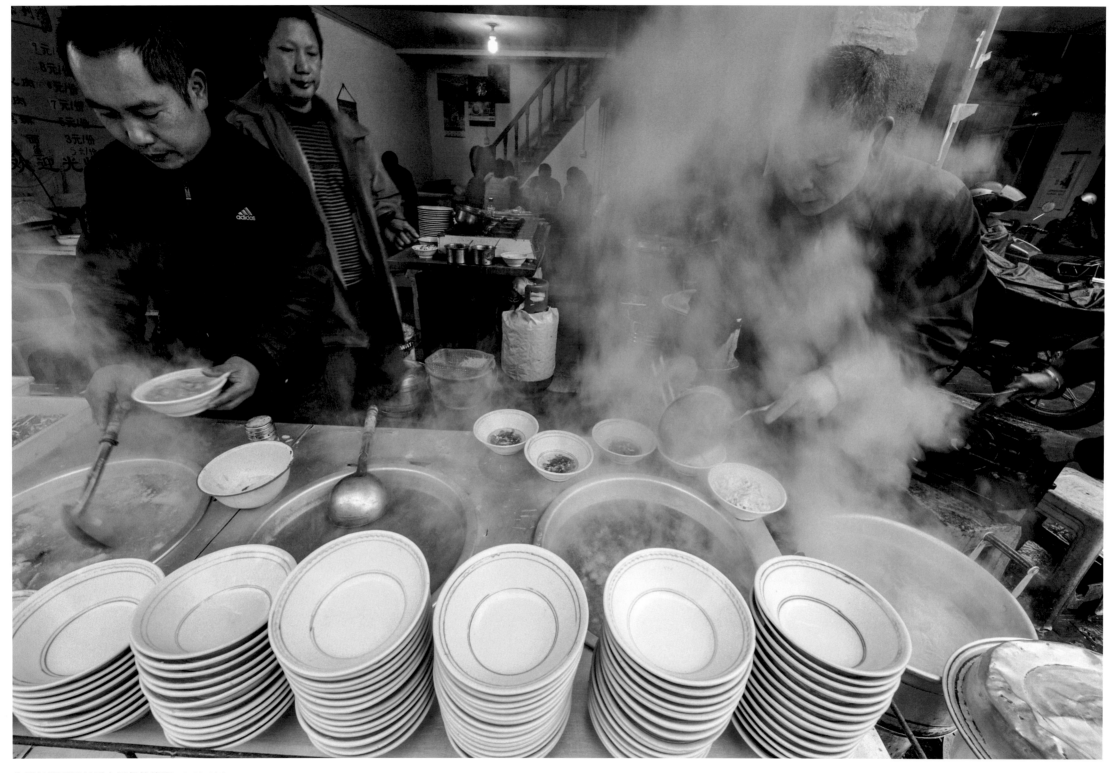

兜汤与拌面是长汀人早餐的绝配 / 吴军 摄
Dou soup (pocket soup) and noodles with soy sauce. sesame butter. etc. are the perfect match for Changting people's breakfast /Photographed by Wu Jun

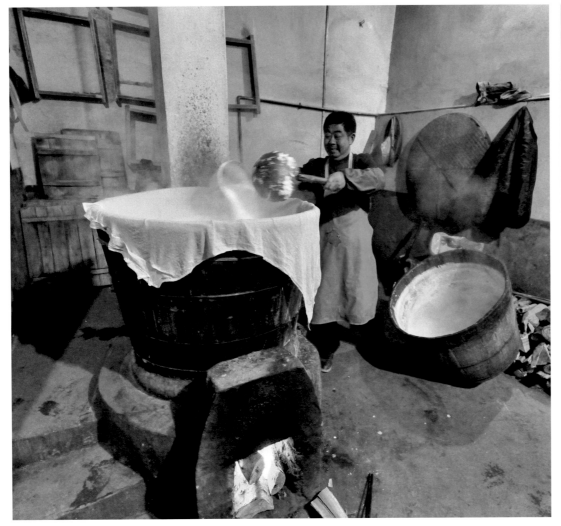

在客家地区有一句耳熟能详的谚语："蒸酒磨豆腐，矛（无）人敢称师傅"，可见酒和豆腐在客家人饮食中的经典地位 / 吴军 摄

There is a well-known proverb in Hakka area, "For steaming liquor and grinding soya beans to make bean curd, none dare to call himself master". This shows the classic status of liquor and bean curd (tofu) in Hakka diet /Photographed by Wu Jun

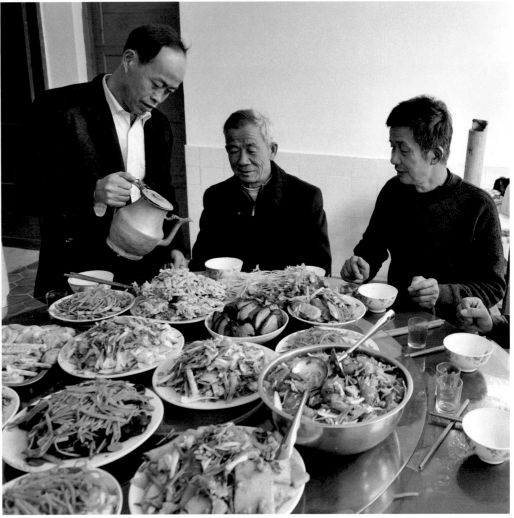

逢年过节是必须有酒的。客家人有句谣谚：男人喝正月，女人喝坐月（生孩子）。就是说，正月里男人可以开怀畅饮，整个正月浸泡酒中，而平常很少喝酒的女人生产后，也用米酒滋补身体、调理血脉 / 吴军 摄

It is necessary to have wine at festivals. There is a saying in Hakkas, "Men drink in the first month of the lunar year while women drink in confinement (childbirth)". That is to say, men can drink freely in the first month of the lunar year, while women who seldom drink wine but use rice wine to nourish their bodies and regulate their blood vessels after giving birth to children / Photographed by Wu Jun

Yong
Ding

永定

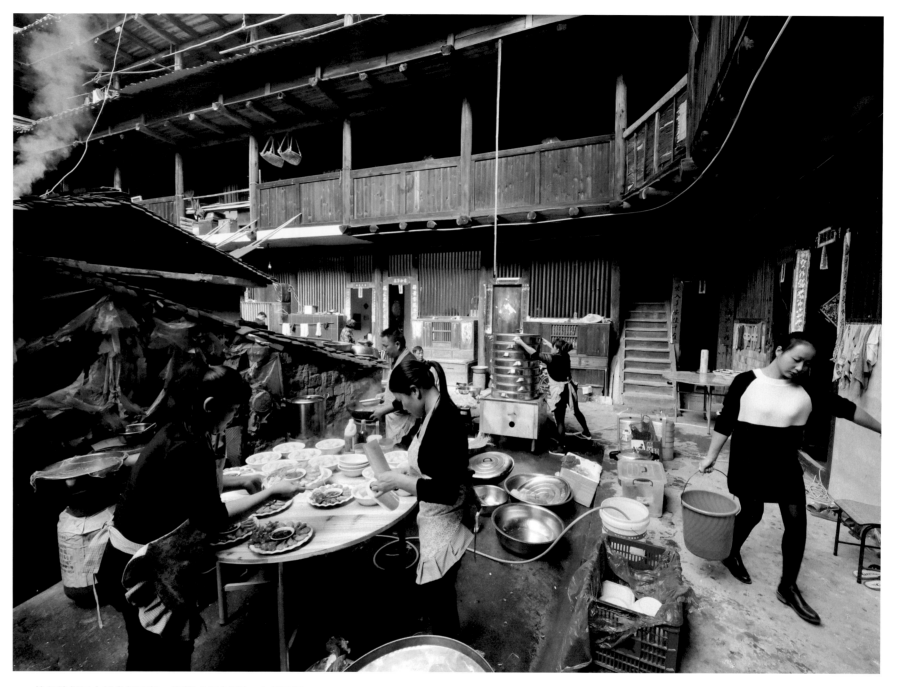

从各地赶回土楼参加三年一次的"作大福" / 吴军 摄

People rush back to the earth buildings from all over the country to take part in the "Zuo Da Fu (chant Taoist scriptures to expiate the sins of the dead)" held once every three years /Photographed by Wu Jun

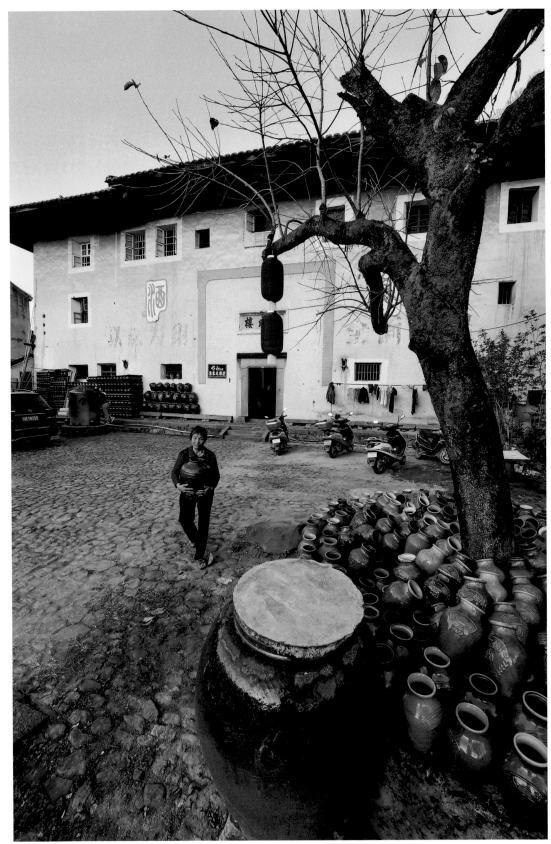

01

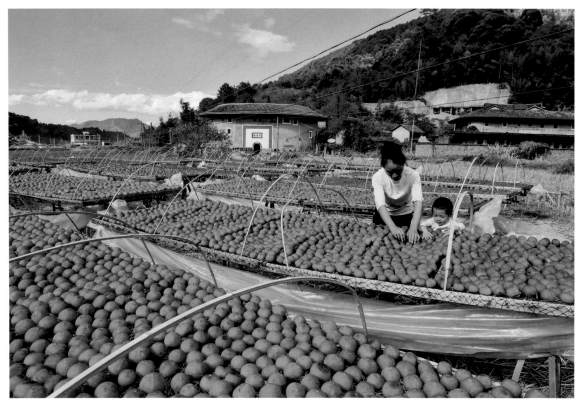

02

01　　　　永定下洋的酿酒历史悠久。客家人有一个传统习俗，若是亲朋好友家里有人生了娃崽要送去姜酒，娃崽满月后，生了娃崽的人家要做满月酒回敬亲朋好友。产妇在月子里的主要食物就是煮酒煎蛋。成堆的酒坛，让人看得咋舌 / 吴军 摄

Wine in Xiayang Town ,Yongding District has a long history. There is a grand etiquette in Hakkas, that is, if there is someone giving birth to a child among their relatives and friends,they need to send ginger wine. After the baby is one month old, his/her family will hold a ceremony to return to relatives and friends. The main food for a parturient woman during her confinement is fried eggs boiling wine. Piles and piles of wine jars are astonishing /Photographed by Wu Jun

02　　　　永定区有 500 余年的种柿历史，是华东地区最大的柿子生产基地 / 吴军 摄

Yongding County has the history of planting persimmons for more than 500 years, and Yongding County is the largest persimmon production base in East China /Photographed by Wu Jun

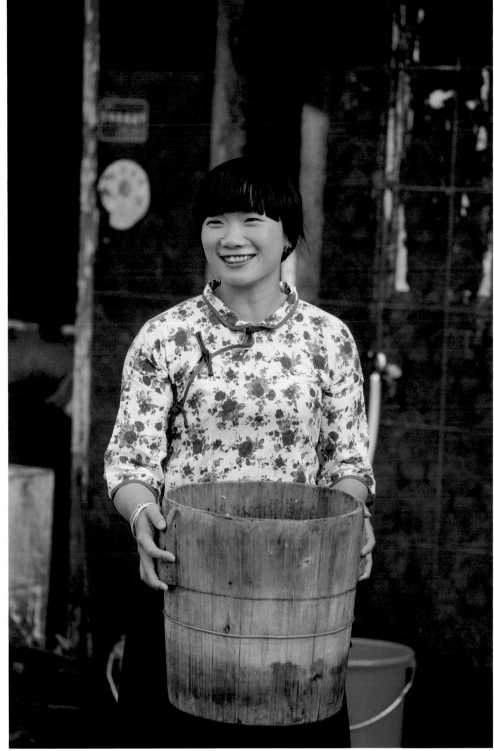

03

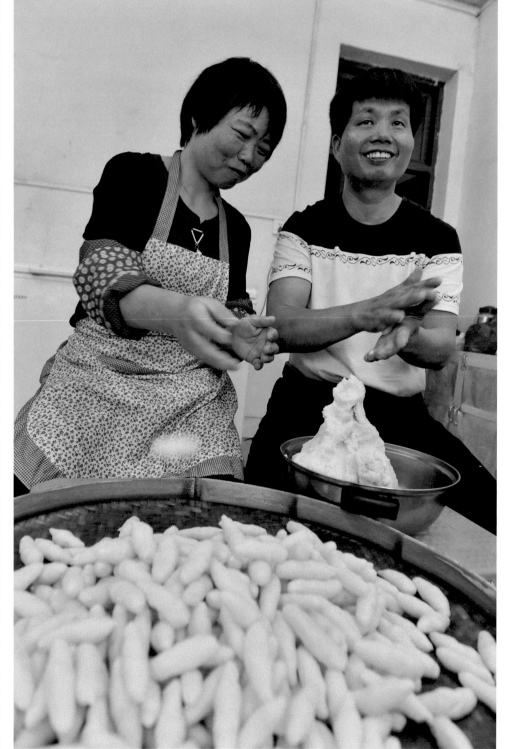

04

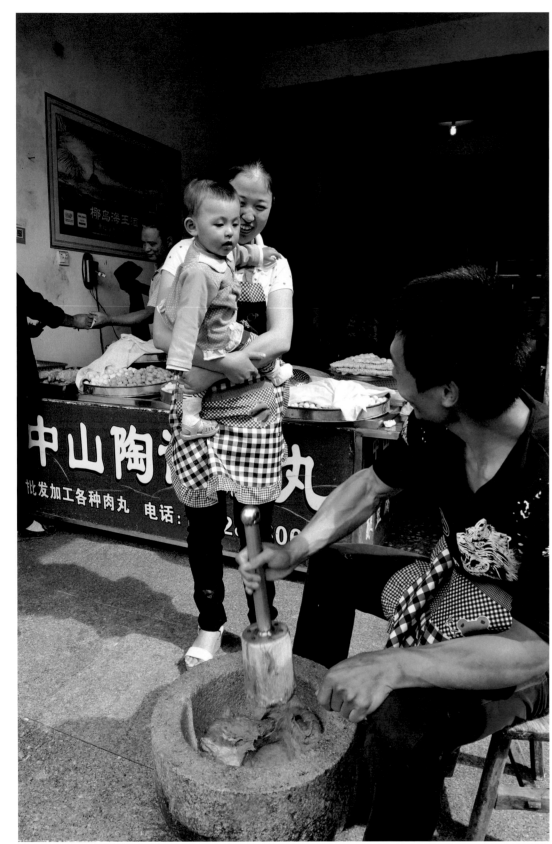

01

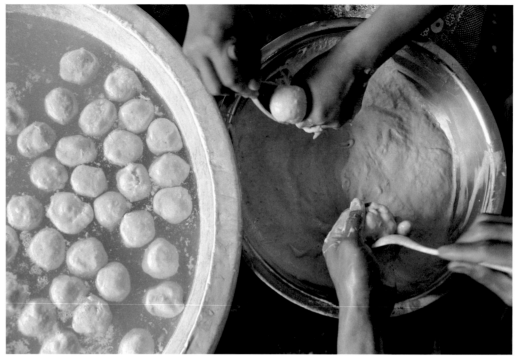

02

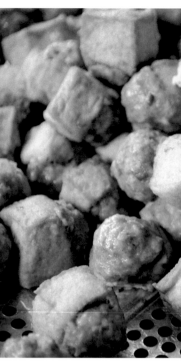

03

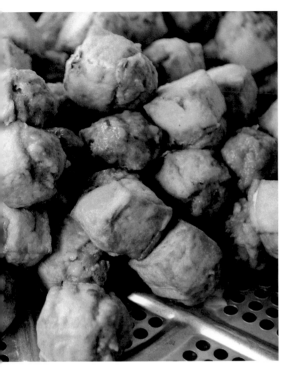

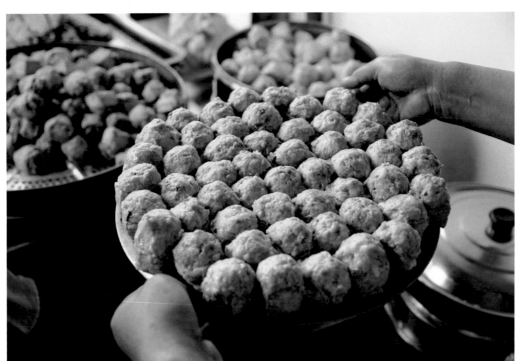

04

05

01　　　武平捶丸制作的关键是捶肉　/　吴军 摄
The key of making Wuping Chui Wan is hammering the meat /Photographed by Wu Jun

02　　　传统的客家肉丸都由手工捶捣而成，故称捶丸　/　吴军 摄
The traditional Hakka meatballs are made by handmade hammering and pounding, so they
are called "Chui Wan (hammering balls)" /Photographed by Wu Jun

03　　　蒸煮好的酿豆腐　/　曾璜 摄
Brewed bean curd (tofu) is well cooked /Photographed by Zeng Huang

04　　　酿豆腐　/　曾璜 摄
Brewed bean curd (tofu) /Photographed by Zeng Huang

05　　　武平猪胆肝是闽西八大干之一　/　吴军 摄
Wuping dried pig gall is one of eight dried foods in Western Fujian /Photographed by Wu Jun

Beautiful
Scenery
in Spring
Breeze

第三章 山水灵秀春风

福建是全国最绿省份，森林覆盖率达 66.8%，连续 40 年居全国第一。闽西龙岩市则达到 78.93%，为福建省第一位。40 年前，龙岩的森林覆盖率只有 37%，改革开放的春风，年年又绿闽西大地，时在福建省任职的习近平同志，在长汀亲手植树，在武平指点林改方向，使得这片灵秀山水，更加碧绿清澈。珍贵的亚热带动植物，在汀江两岸、闽西山水之间，自由竞放，繁荣生长。青山绿水就是金山银山，丰富的森林资源为闽西的林业产业发展，奠定了坚实的基础。闽西的商品木竹、人造板、纸浆、家具、松香、菌菇、茶叶等，使千家万户走向了致富之路，达到小康之家。森林旅游、花卉产业等更是方兴未艾。在绿色怀抱中的其他行业，也沐浴在春风里，欣欣向荣，蓬勃发展。

Fujian is the most green province in China. The forest coverage rate in Fujian exceeded 66.8%, ranking the first in the country fot 40 years. Longyan City in Western Fujian reached 78.93%, ranking the first in Fujian Province, compared with the rate of 37% 40 years ago. The spring breeze of the reform and opening up greens the land of Western Fujian every year. Comrade Xi Jinping, who served in Fujian Province, planted trees in Changting, and pointed out the direction of forest reform in Wuping, which makes this beautiful landscape more green and clearer. The precious subtropical animals and plants are freely released and thriving between the two sides of the Tingjiang River in the mountains and rivers of Western Fujian. Green mountains and waters are invaluable asset. The rich forest resources have laid a solid foundation for the development of forestry industry in Western Fujian. The commodities of wood and bamboo, manmade board, paper pulp, furniture, rosin, mushrooms, tea and so on in Western Fujian have led thousands of families to the road of richness and to a well-off home. Forest tourism, flower industries and so on are in the ascendant. Various enterprises in the green embrace are also bathed in the spring breeze, thriving and vigorous.

The Most
Beautiful
Changting

最美长汀

长汀设州，早在唐开元二十四年（736），即是福建著名的五大州之一，到了宋代，汀州府与福建其他七府构成了"八闽"。自唐代至清代的1000多年间，长汀一直是历朝历代州、郡、路、府的治所。悠久的历史留下了许多文物，始建于唐大历四年的汀州古城墙，至明清时期，总长已达5000多米，设有12个城门，朝天门、五通门、惠吉门、宝珠门等，具有"枕山临溪为城""山中有城，城中有水"，似"佛挂珠"的独特格局。今日长汀县城保留的那些古建筑，无不体现了它作为一个地区首府的格局与气派。路易·艾黎不仅是"中国工合之父"，同时他是活动家、旅行家，也是诗人和作家，他的足迹遍布大地，见多识广，他给长汀的评价是："中国有两座最美的小城，一个是湖南的凤凰，一个是福建的长汀。"长汀的商业在水运时代就很繁荣，现存的明清古街店头街便是明证。市井的内容虽然随着时代不断改变，但街道基本保持了古貌。人们像对待家园般地护卫着街道的古朴、宁静，使其与汀江、城楼融为一体。如今这座古老小城，经过改革开放四十年的发展，在绿水崇山之中，更是熠熠生辉。

As early as the 24th year of Kaiyuan in the Tang Dynasty (736), Changting was one of the five famous prefectures in Fujian. In the Song Dynasty, Tingzhou Prefecture and the other seven Fujian Prefectures constituted "Eight Prefectures of Fujian". For over one thousand years between the Tang Dynasty and the Qing Dynasty, Changting had been the administrative area of various government offices of successive dynasties. A long history has left many cultural relics. The ancient city wall of Tingzhou, which was built in the fourth year of the Tang Dynasty, had a total length of more than 5000 meters in the Ming and Qing Dynasties, with 12 gates such as Chaotian Gate, Wutong Gate, Huiji Gate, Baozhu Gate, etc. It had a unique pattern of "pillowing mountain and neighboring stream" and "city in mountain, water in city", resembling "Buddha hanging pearls". The comment on Changting given by Rewi Alley, "Father of China Gung Ho", activist, traveler, poet and writer, who had a wide range of footprints and knowledge, goes as follows, "There are two most beautiful small cities in China, one is Phoenix in Hunan, the other is Changting in Fujian Province." Changting's commerce flourished in the age of water transportation, as evidenced by the existing Diantou Street of ancient streets of the Ming and Qing Dynasties. The content of market have changed with the times, but the streets have basically maintained their ancient appearance. Being well-protected as a homeland by the people, with its simplicity and tranquility, the street, merging with the particular section of the Tingjiang River and the city buildings. Today, this ancient town, after 40 years of reform and opening up, is shining in green waters and high mountains.

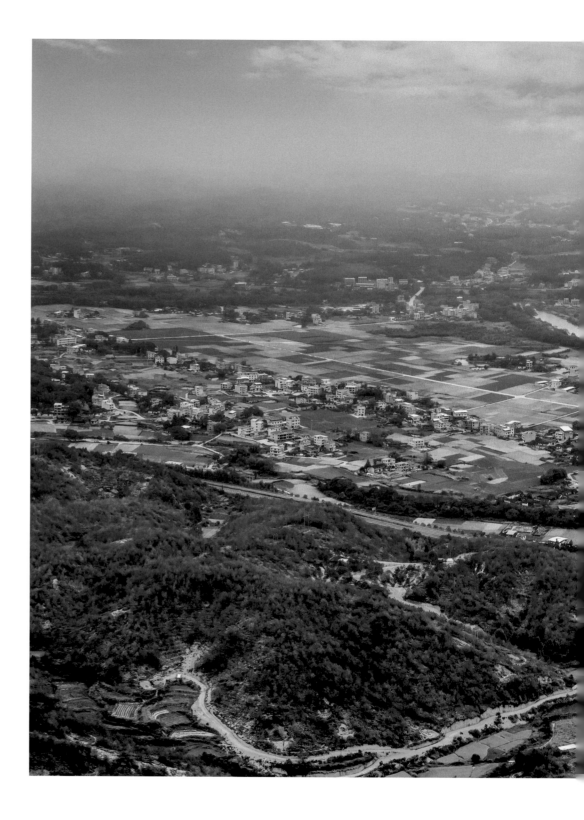

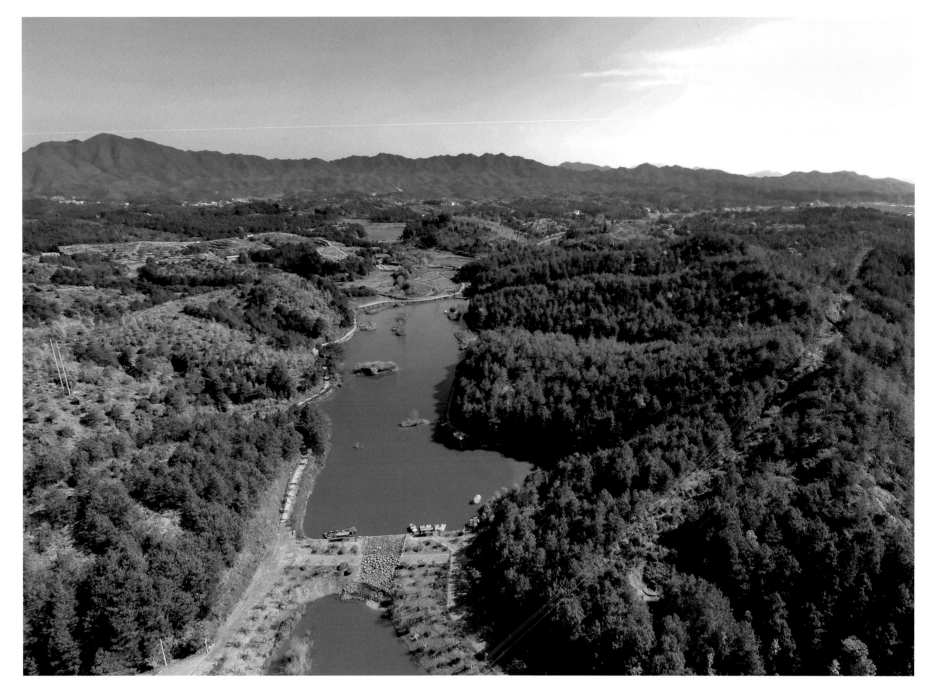

长汀汀江国家湿地公园 / 黄海 摄

Changting Tingjiang National Wetland Park /Photographed by Huang Hai

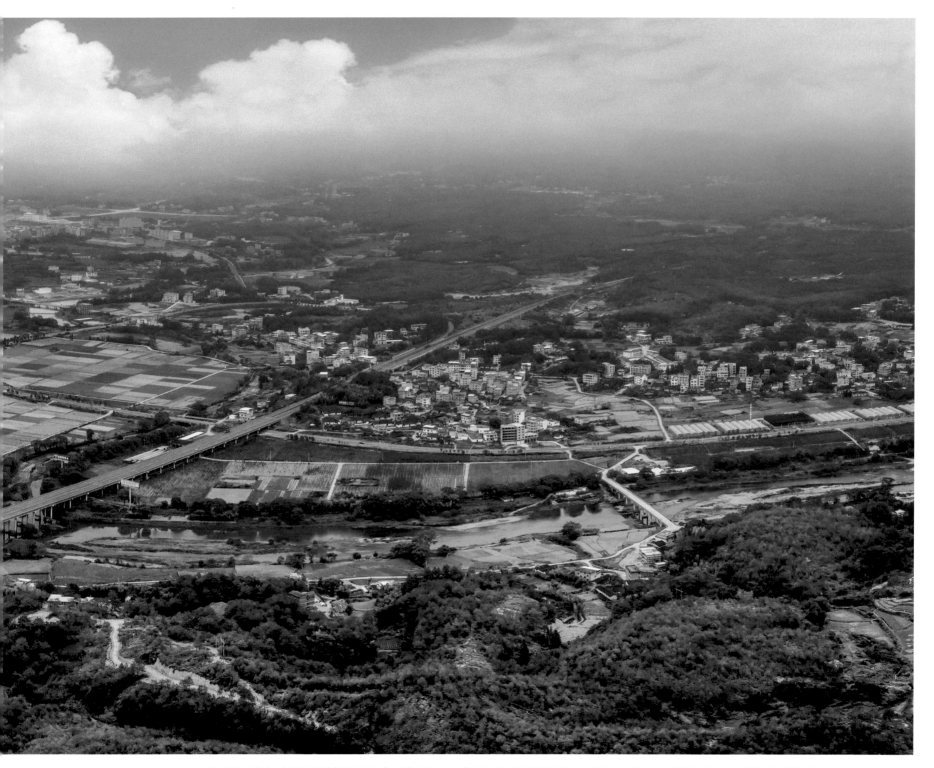

长汀是历史上最有代表性的客家人聚居城市之一，发源于长汀境内的汀江，哺育了一代又一代的客家人。随着汀江航运的开通，长汀成为海上丝绸之路的重要延伸地，无数客家先民顺着 800 里汀江下粤东，漂洋过海开基创业，播衍文明 / 朱晨辉　严硕 摄

Changting is one of the most representative Hakka-inhabited cities in history which originated from the Tingjiang River in Changting and nurtured generations of Hakkas. With the opening of shipping along the Tingjiang River, Changting has become an important extension of the Maritime Silk Road. Countless Hakka ancestors, along the 800-mile Tingjiang River to Eastern Guangdong, crossed the sea to start their own businesses and spread civilization /Photographed by Zhu Chenhui, Yan Shuo

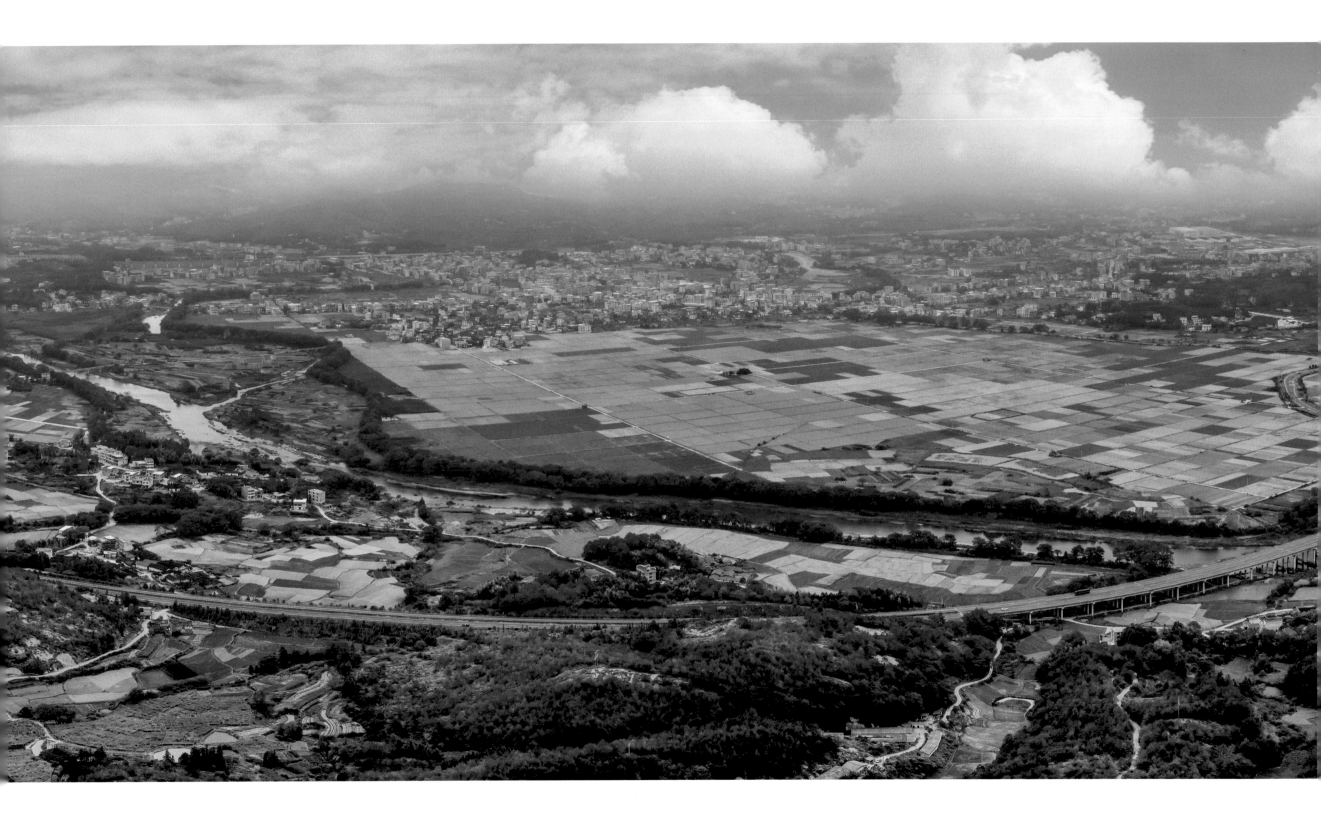

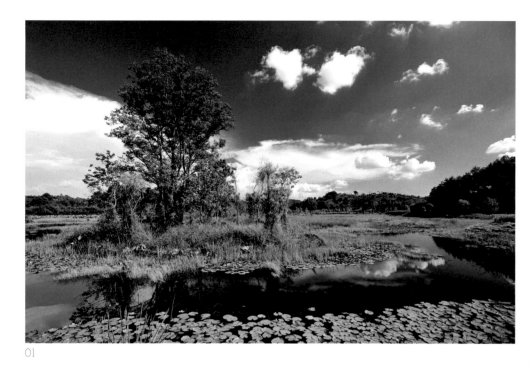

01

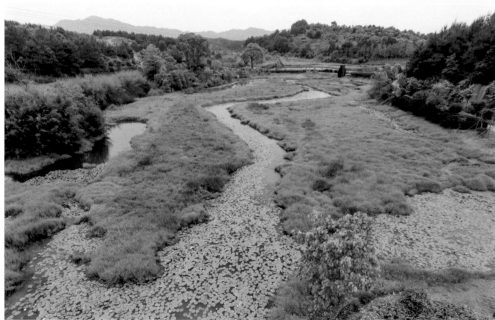

02

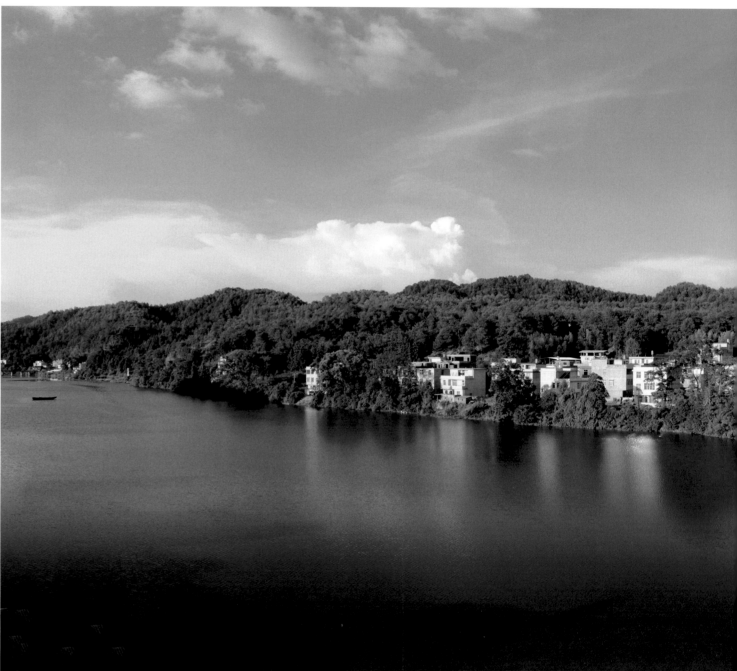

03

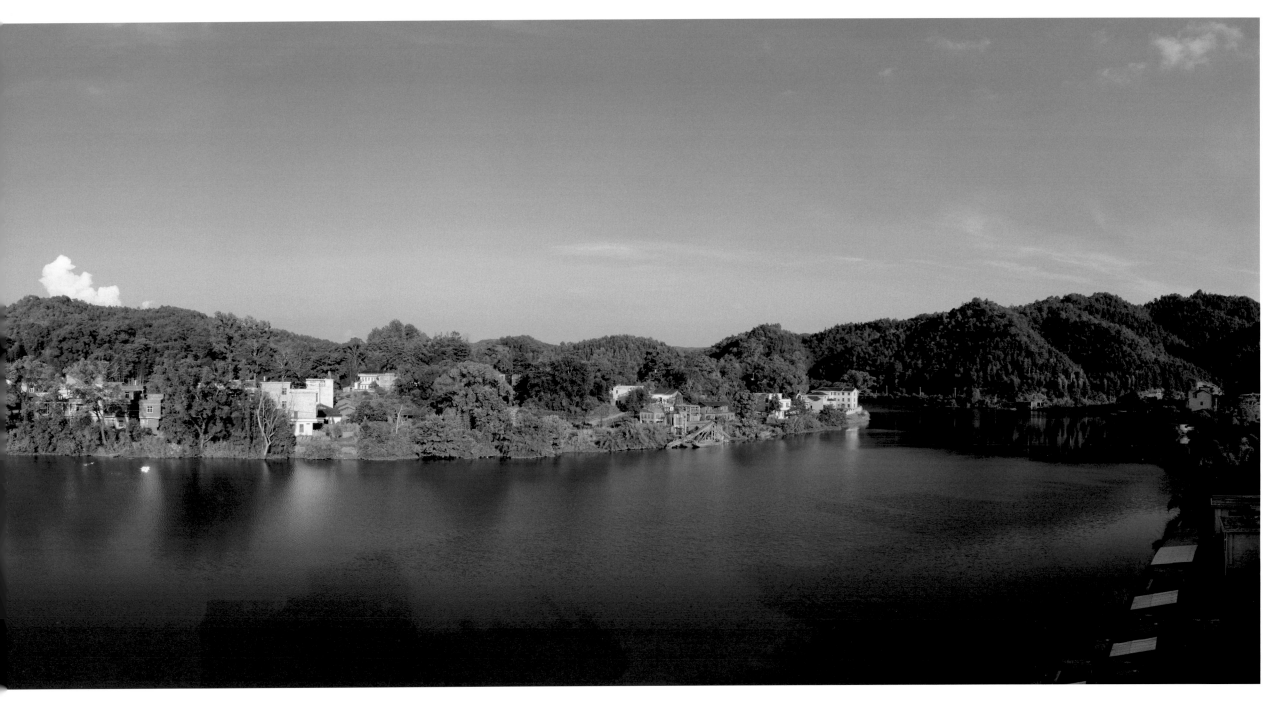

01　长汀三洲湿地公园绿水环绕 / 胡晓钢 摄
Changting Sanzhou Wetland Park is surrounded by green water /Photographed by Hu Xiaogang

02　汀江国家湿地公园，是福建省四个国家湿地公园中唯一的一个河滩湿地公园 / 陈扬富 摄
Tingjiang National Wetland Park is the only benchland wetland park among the four national wetland parks in Fujian Province /Photographed by Chen Yangfu

03　湘店乡汀江河口段
Estuary reach of the Tingjiang River in Xiangdian Township

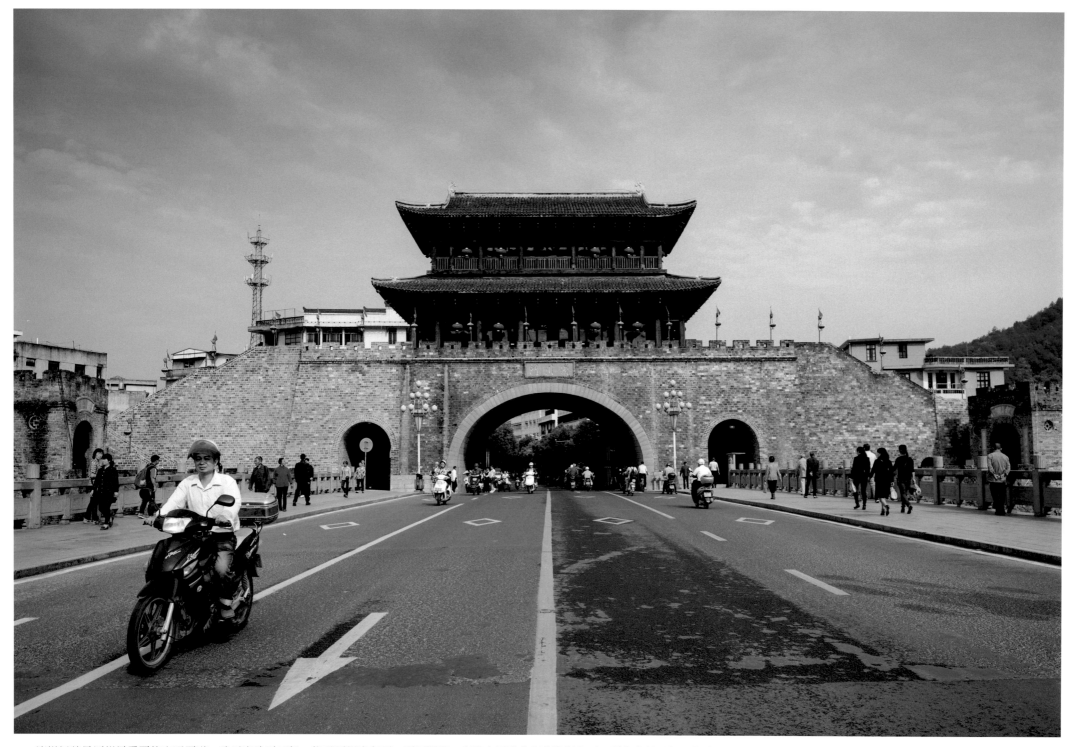

济川门曾是汀州最重要的交通要道，建于宋治平三年，位于汀州府东面、汀江西岸，宋代文天祥曾在此指挥抗元，明代大儒王阳明从此门入汀剿匪，清代才子纪晓岚也曾在此把酒临风 / 郭晓丹 摄

Jichuan Gate was once the most important transport artery in Tingzhou, which was built in the 3rd year of the reign of Emperor Zhiping in the Song Dynasty, located in the east of Tingzhou Prefecture and the west of the Tingjiang River. Wen Tianxiang of the Song Dynasty once commanded anti-Yuan struggle here; Wang Yangming, a famous scholar of the Ming Dynasty, entered Tingzhou to suppress bandits from this gate; Ji Xiaolan, a gifted scholar of the Qing Dynasty, also raised winebowls in the wind here /Photographed by Guo Xiaodan

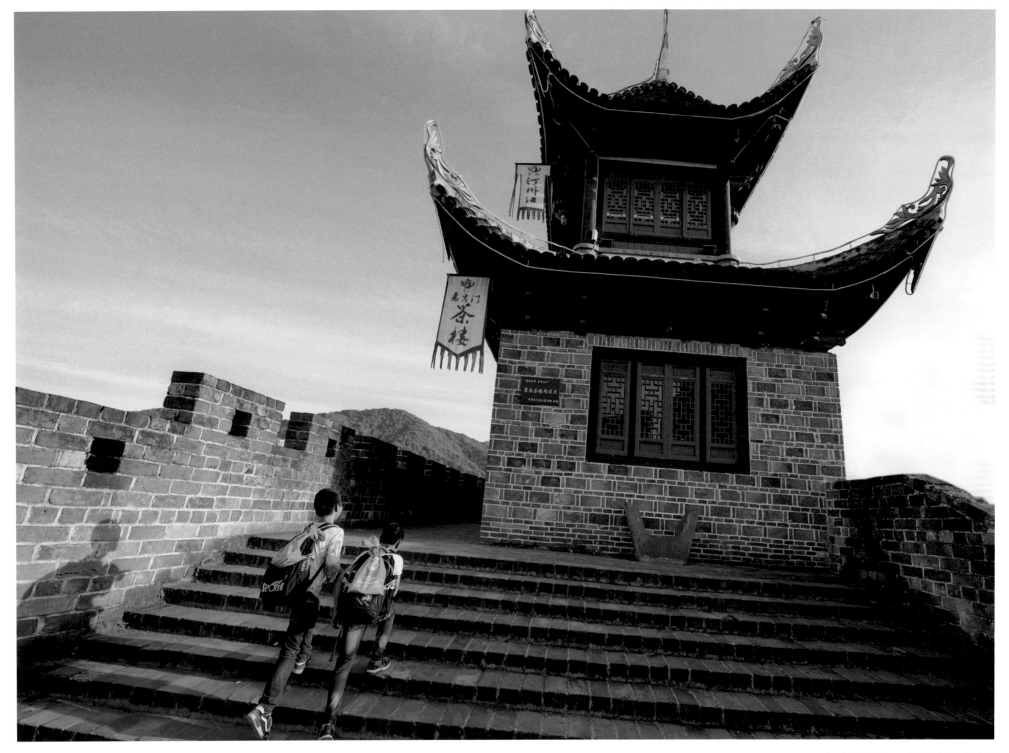

参照宋代风格，重新修复的古城墙
Referring to the style of the Song Dynasty, the ancient city wall was restored again

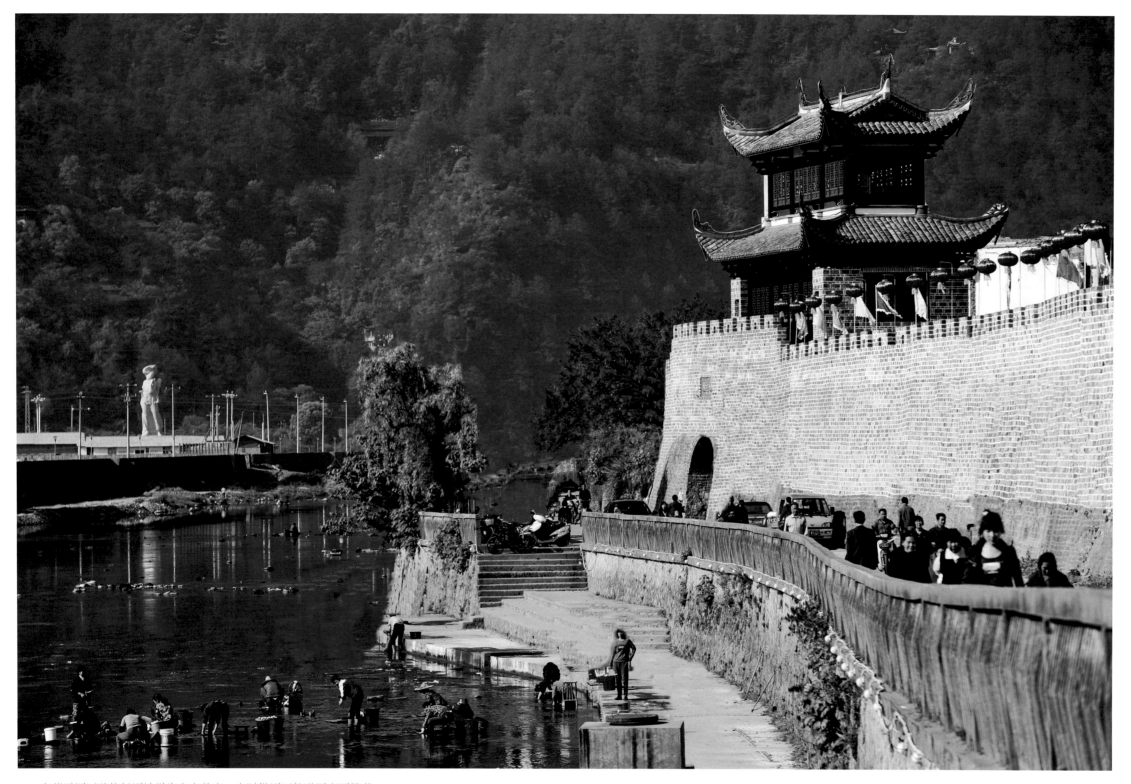

坐落于汀江畔的长汀被誉为客家首府，古时借汀江航道而商贾繁荣 / 胡晓钢 摄

Changting, located at the bank of the Tingjiang River, is praised as the capital of Hakka, where merchants flourished through the Tingjiang waterway in ancient times /Photographed by Hu Xiaogang

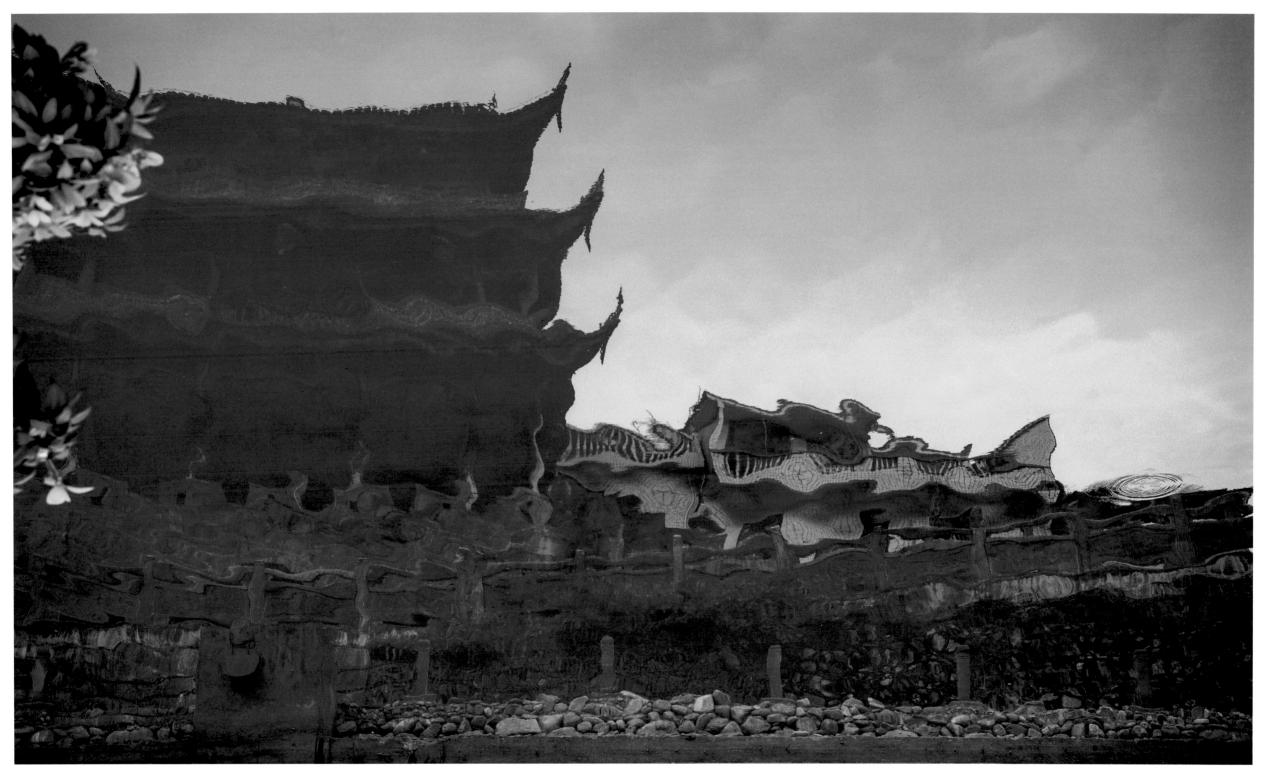

梦里的汀江几度繁华 / 郭晓丹 摄
How prosperous the Tingjiang River is in the dream /Photographed by Guo Xiaodan

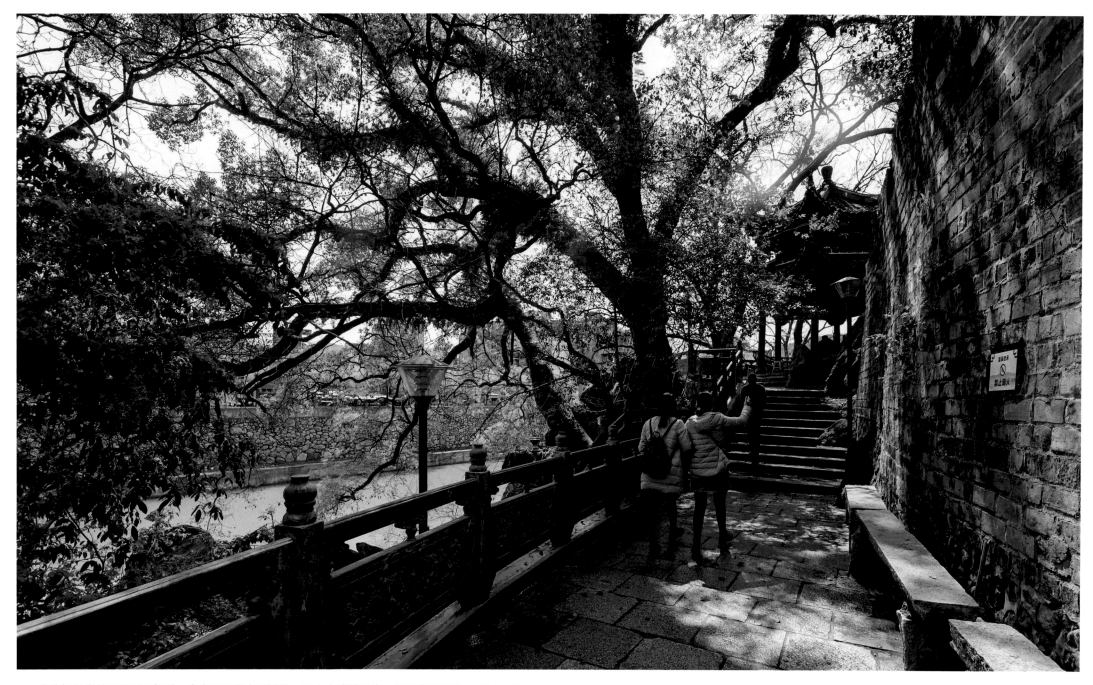

宋代知县宋慈开辟汀江航道，为古汀州带来了繁荣。后人为感其恩德，依江建宋慈亭 / 赖小兵 摄

Song Ci, a magistrate of the county in the Song Dynasty, opened up the Tingjiang Waterway, which brought prosperity to the ancient Tingzhou. In order to thank his kindness, later generations built Song Ci Pavilion along the river /Photographed by Lai Xiaobing

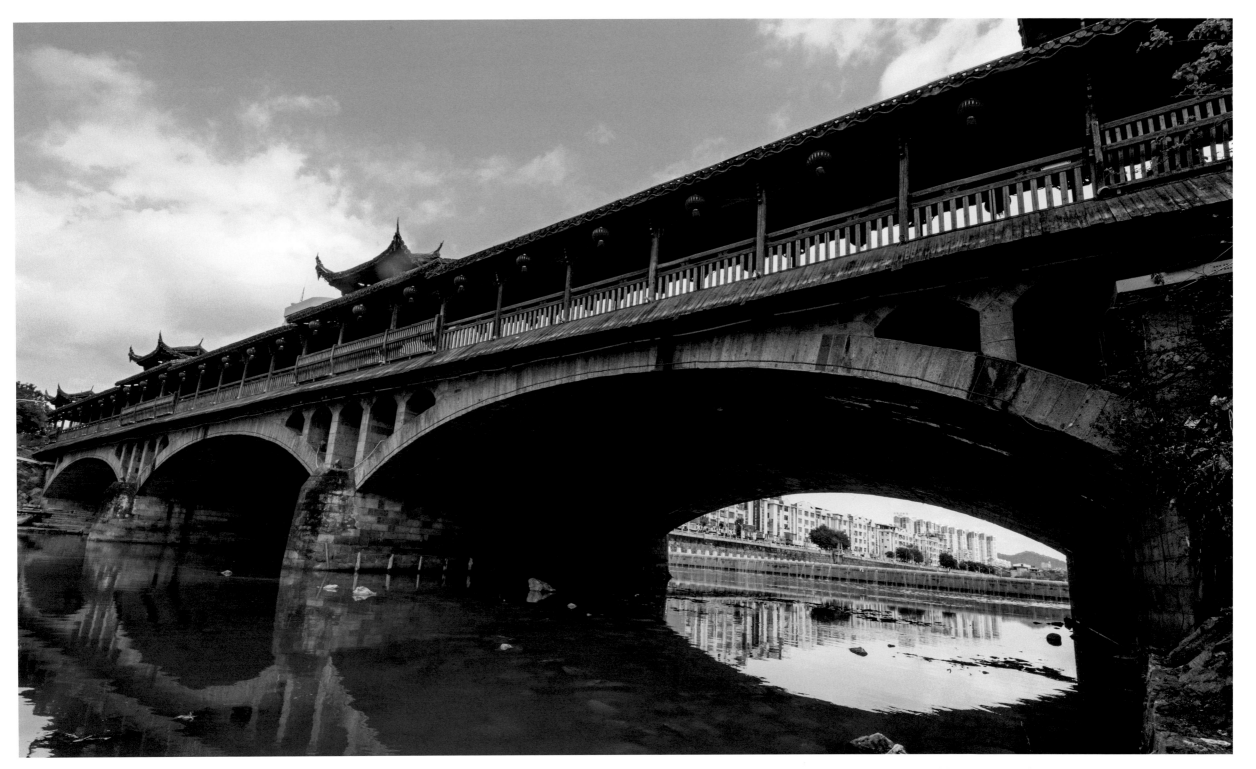

长汀太平桥，原名"有年桥"，始建于南宋，是长汀城关的交通要道，现今重修的大桥，建于 1993 年 / 赖小兵 摄
Changting Taiping Bridge, formerly known as "Younian Bridge", was built in the Southern Song Dynasty and is the main transport route of Changting's Chengguan (the area just outside a city gate). The current rebuilt bridge was built in 1993 /Photographed by Lai Xiaobing

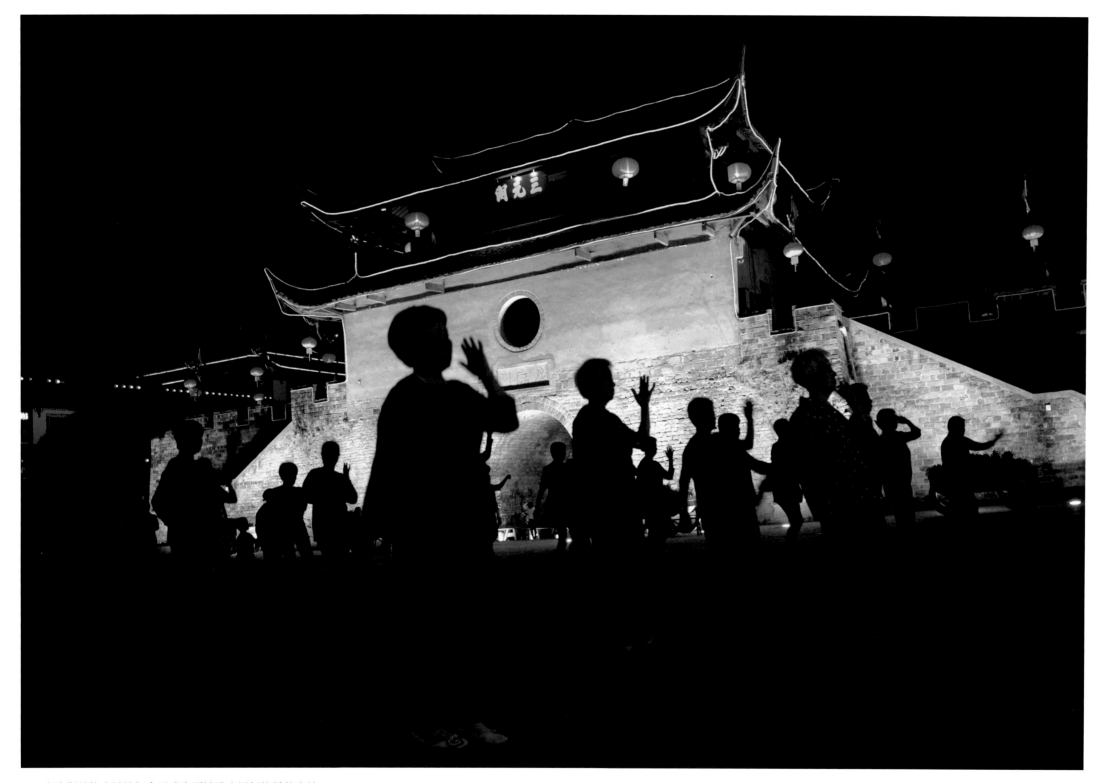

店头街前的古城墙如今已成为百姓跳广场舞的最佳去处 / 曾璜 摄
The ancient city wall in front of Diantou Street has now become the best place for people to dance
public square dancing /Photographed by Zeng Huang

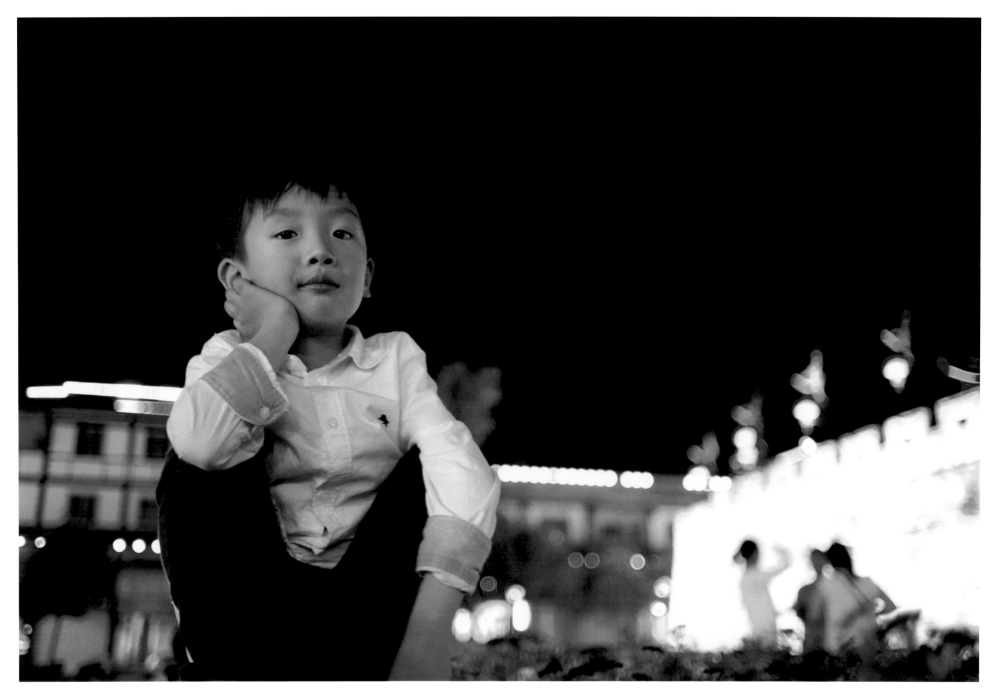

汀州古城墙下一脸稚嫩的孩子 / 姜克红 摄
Children under the ancient city wall of Tingzhou /Photographed by Jiang Kehong

01　　　汀州古城墙城楼巍巍，垛堞森森 / 那兴海 摄

The gate tower of the ancient city wall of Tingzhou are majestic, with dense buttresses /Photographed by Na Xinghai

02　　　古城墙前的广储门是长汀的标志性建筑 / 陈扬富 摄

Guangchu Gate in front of the ancient city wall is a landmark building in Changting /Photographed by Chen Yangfu

03　　　长汀古城墙除了保留中国城墙坚固的优点外，还根据汀城的山势地貌及民风民俗，因势造型、因地设关、因情定规 / 赖小兵 摄

In addition to preserving the strong advantages of the Chinese city wall, and based on the mountain landform and folk customs of Tingzhou city, Changting ancient city wall is also shaped according to the mountain situation, building Chengguan (the area just outside a city gate) according to local conditions and establishing regulations according to conditions of the people /Photographed by Lai Xiaobing

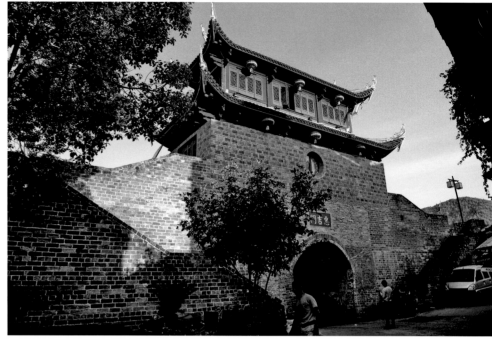

01

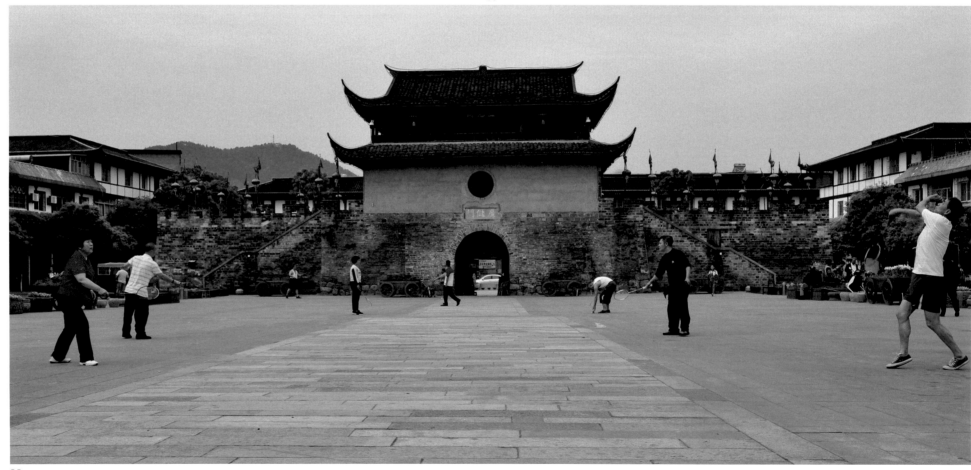

02

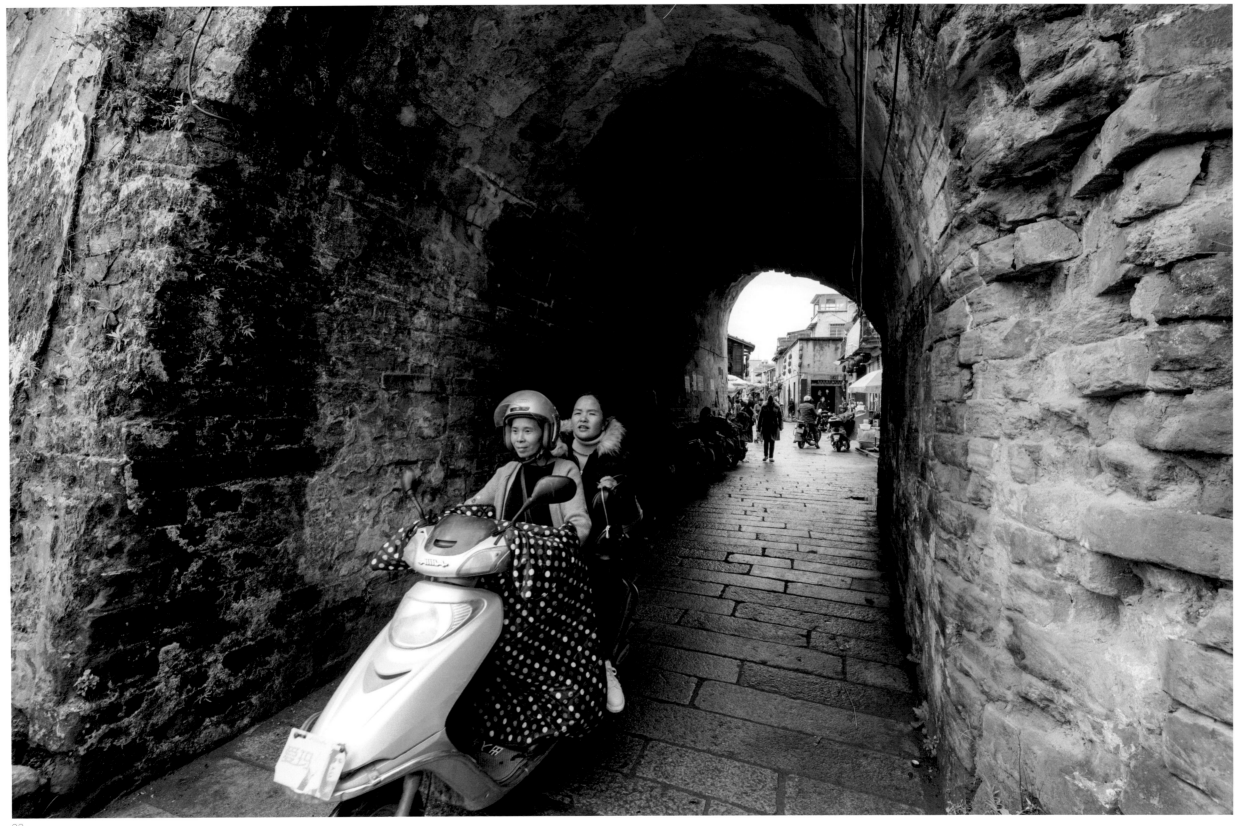

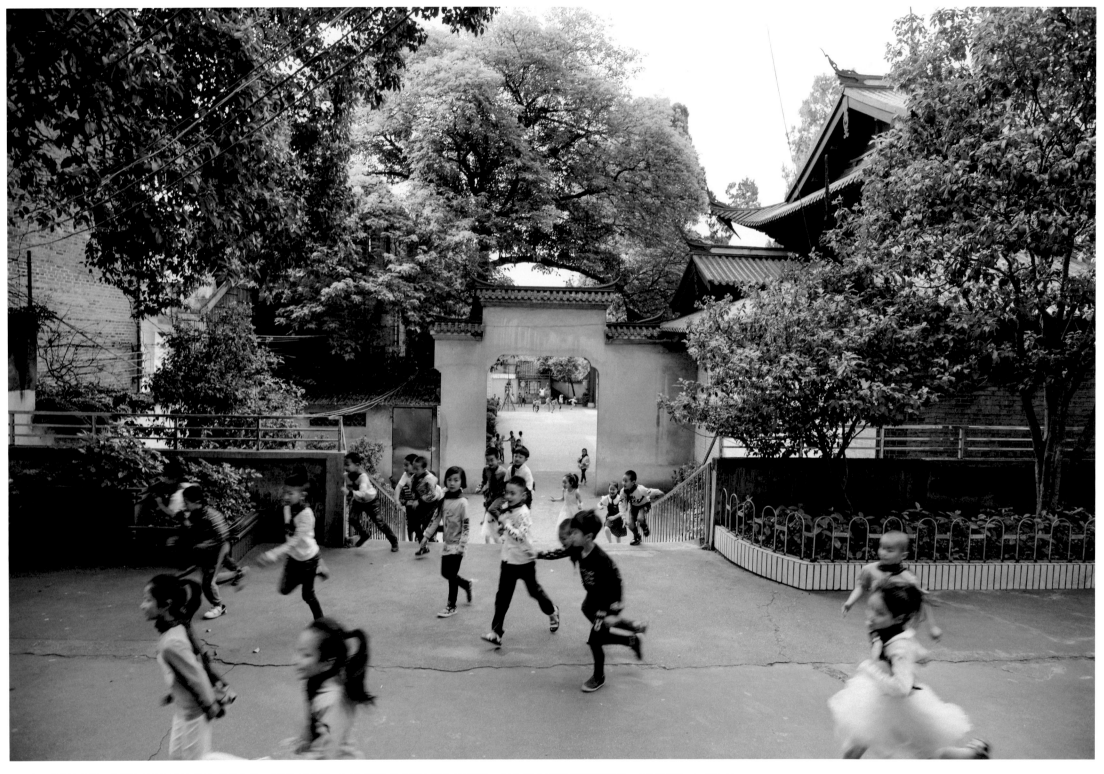

长汀城关小学，原是厦门大学抗战的庇荫之地。正是在这里，厦大有了"南方之强"的美誉。图为学生在课间追逐嬉戏、尽情玩耍 / 曾璜 摄
Changting Chengguan Primary School was originally the shelter of Xiamen University during the Anti-Japanese War. It is here that Xiamen University has a good reputation as "the strongest university in the South". The picture shows students are chasing, playing and enjoying themselves during recess /Photographed by Zeng Huang

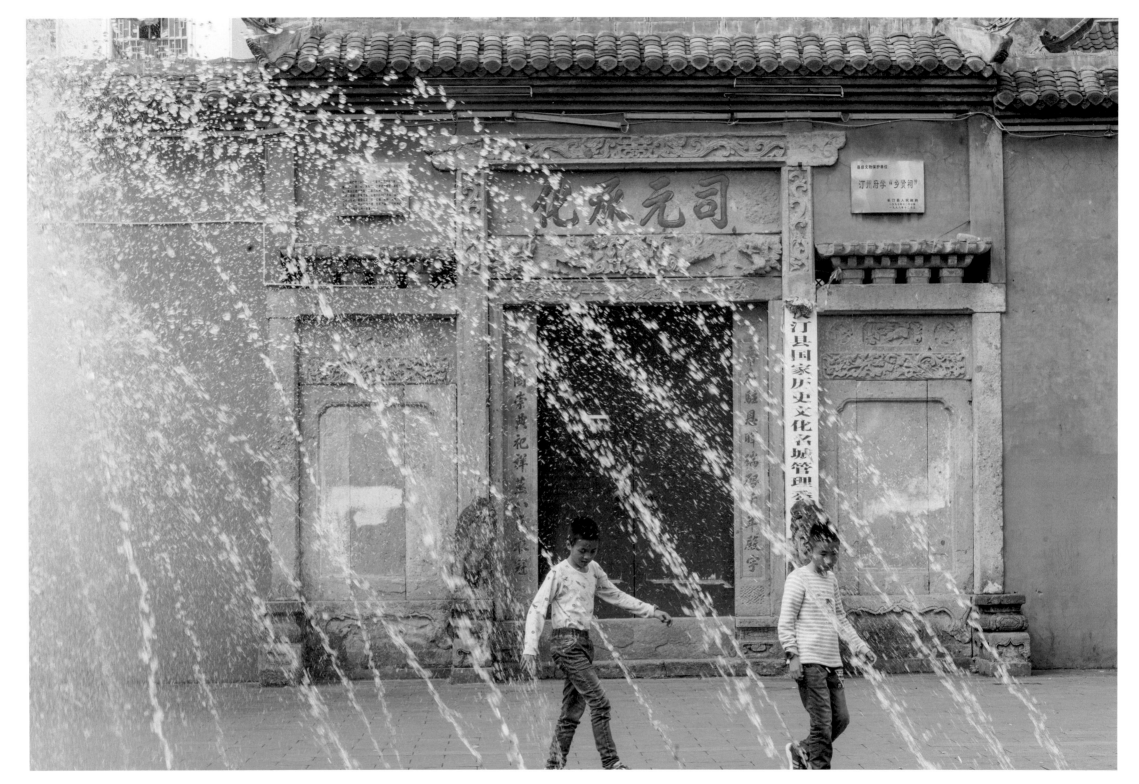

汀州府学乡贤祠是汀州文庙建筑群的一部分，建于宋绍兴三年，是汀属八县崇儒的重要场所 / 赖小兵 摄
Xiangxian Educational Ancestral Temple of Tingzhou Prefecture is a part of the Confucian Temple complex in Tingzhou. It was built in the 3rd year of the reign of Emperor Shaoxing in the Song Dynasty and is an important place for advocating Confucianism in the eight counties of Tingzhou /Photographed by Lai Xiaobing

Wuping
on the Border

边围武平

武平地处崇山峻岭，地势险要，同时又是闽粤赣的边界，朝廷为了闽地边围武平的安定，明朝时即在此设立千户所。但朝廷不相信本地人，外派将军并带来千人的军队，士兵中有不少就是来自江西、山东、江苏等地。明清两代驻军采取屯田制，即必须携带家眷，在当地分配土地，平时三分军士守城，七分军士种地，以供给武所，而军士的后代还是军士，渐渐地也就形成了"军家"。军家的到来，不仅带来了商贸繁荣，也带来了与本地不同的风俗与语言，但最终在与当地客家的利益矛盾与人际交往中，军家渐渐融入了客家的体系之中。走在中山古街，可以看到武溪河上的永安桥（最早叫通济桥），便是武所十座古桥中最大的一座。而新建的百姓宗祠中，则显示出军家与客家融为一体事实。

汀江流过的武平，同时拥有武溪河、中山河、大禾溪等。水流充沛、气候温湿、植被丰饶，山林茂密，自古就是武平得天独厚的资源。但在相当长的一段时间里，"靠山吃山"的古训，遇到了严峻的挑战。直到 21 世纪初，万安乡捷文村最先提出了"耕者有其山"的动议，将集体的山林"平均分给农户"，2002 年 6 月 21 日，时任福建省省长的习近平同志专程来到省际边围武平县调研林改。省领导在听取汇报、座谈调研，实地考察之后，对武平的林改给予了充分的肯定，从而激活林农的积极性，展示了建设美丽生态的前景。

Located in high mountains and dangerous terrains, Wuping is at the border of Fujian, Guangdong and Jiangxi. The court needed the stability of wuping on the border of Fujian. In the Ming Dynasty, the special military unit of 1120 warriors named Qianhusuo was set up. But the court did not believe in the local people, and sent out generals and soldiers to form troops of more than one thousand people, many of whom came from Jiangxi, Shandong, Jiangsu and other places. The stationing garrisons of the Ming and Qing Dynasties adopted the system of growing their own food, that is, they had to take their families to divide up the land in the local area, in peacetime with 30 percent soldiers guarding the city and 70 percent soldiers planting land for their food supply, and the descendants of soldiers or sergeants gradually formed "military family". The appearance of military families not only brought prosperity in business and trade, but also introduced different customs and languages to local Hakka. However, in the conflicts of interests and interpersonal contacts with local Hakka, military families gradually integrated into the Hakka system.

Wuping, run through by part of the Tingjiang River, are endowed with Wuxi River, Zhongshan River, Dahe River and so on. With rich water, warm and humid climate, abundant vegetation and dense mountains and forests, Wuping has been a unique resource since ancient times. However, for quite a long time, the ancient precept of "those living on a mountain live off the mountain" met with severe challenges. Until the beginning of this century, Jiewen Village of Wan'an Township first put forward the motion of "farmer has mountain" to "distribute collective mountain forests equally to peasant households". On June 21, 2002, Comrade Xi Jinping, then former governor of Fujian Province, made a special trip to Wuping County to investigate forest reform. After listening to reports, discussing and investigating, and on-the-spot investigation, the provincial leaders gave full affirmation to the forest reform in Wuping, thus activating the enthusiasm of forest farmers and showing the prospects for the construction of eco-friendly environment.

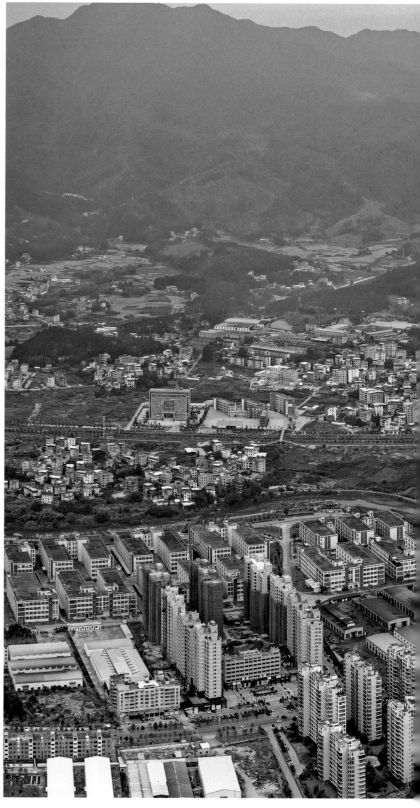

武平全景 / 朱晨辉 严硕 摄
Overall view of Wuping /Photographed by Zhu Chenhui, Yan Shuo

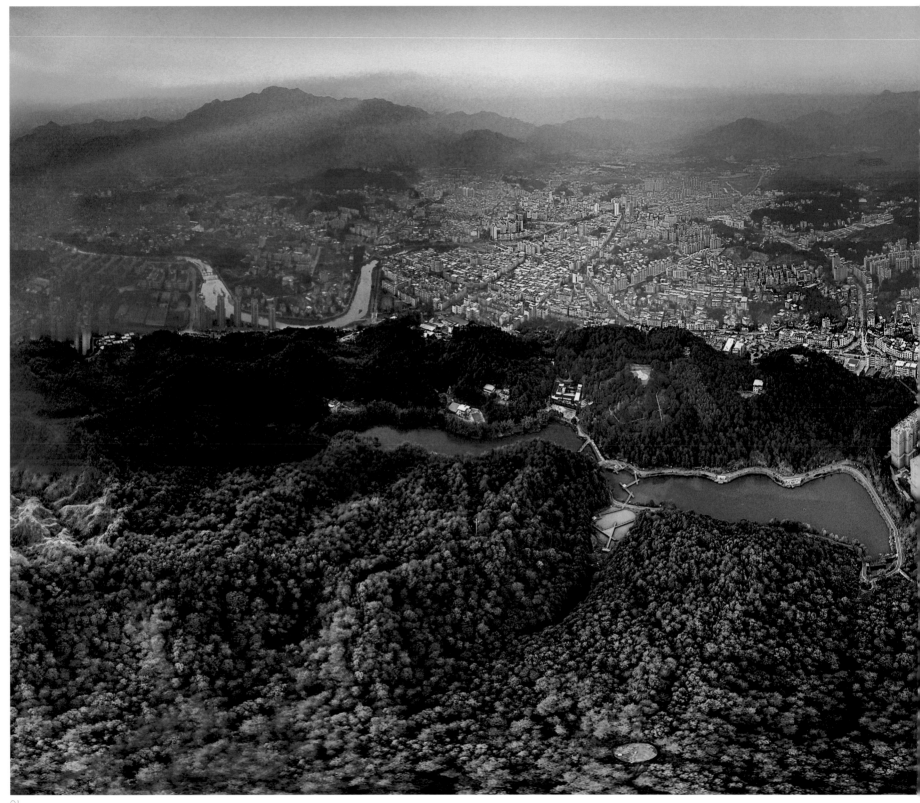

01

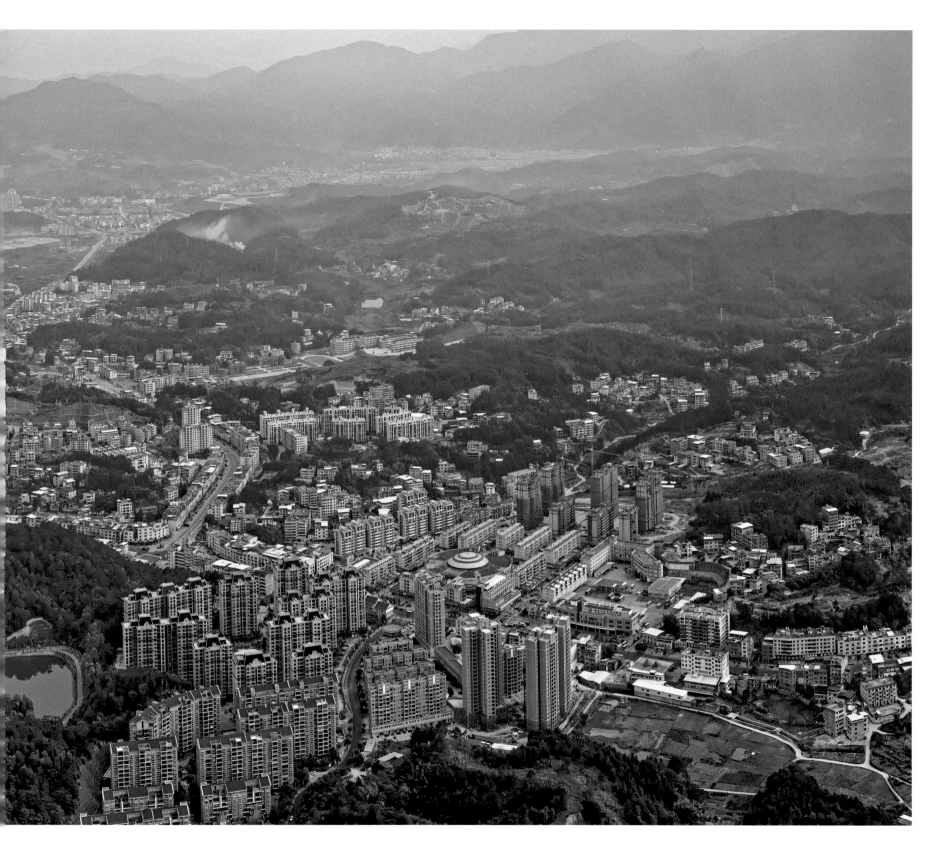

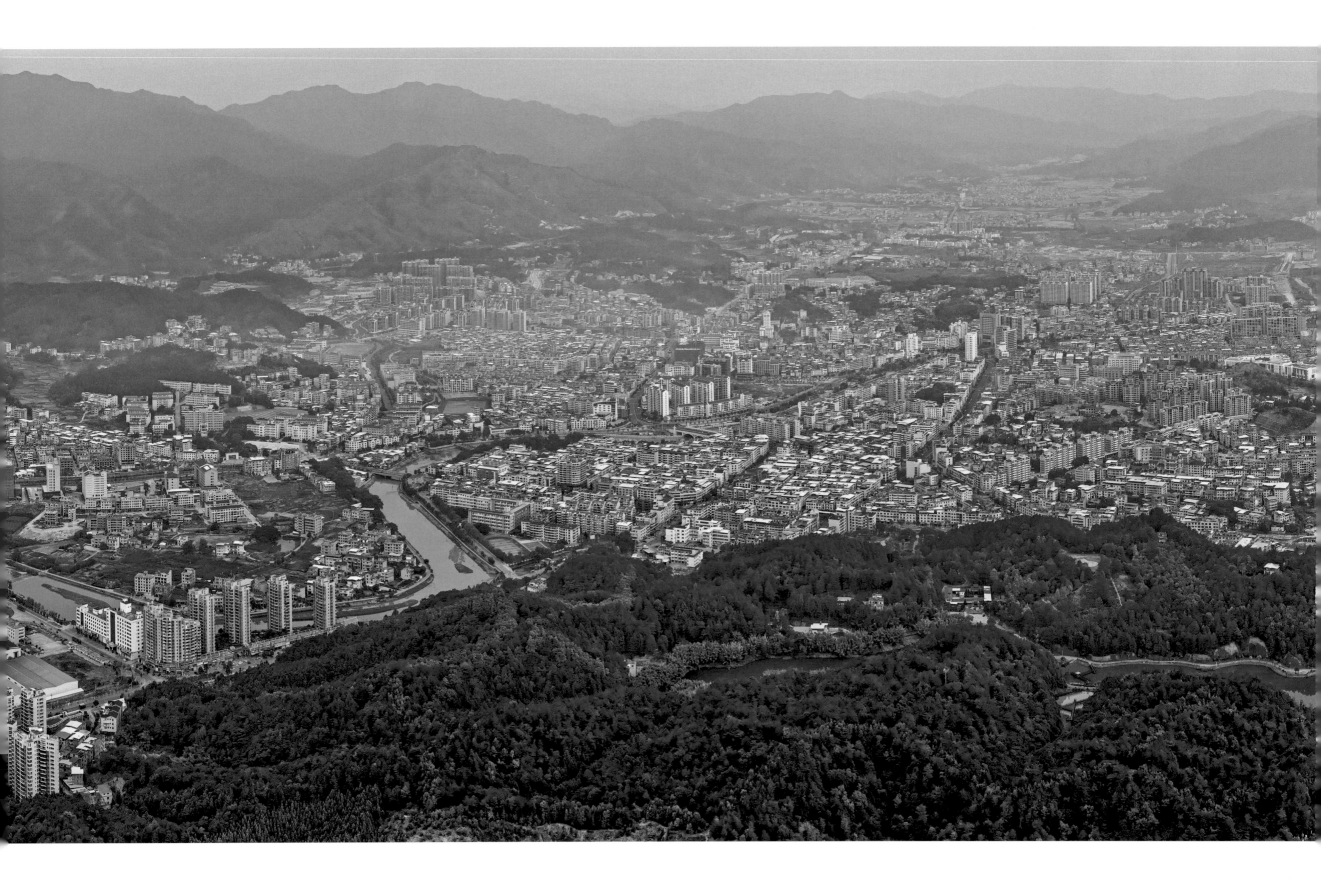

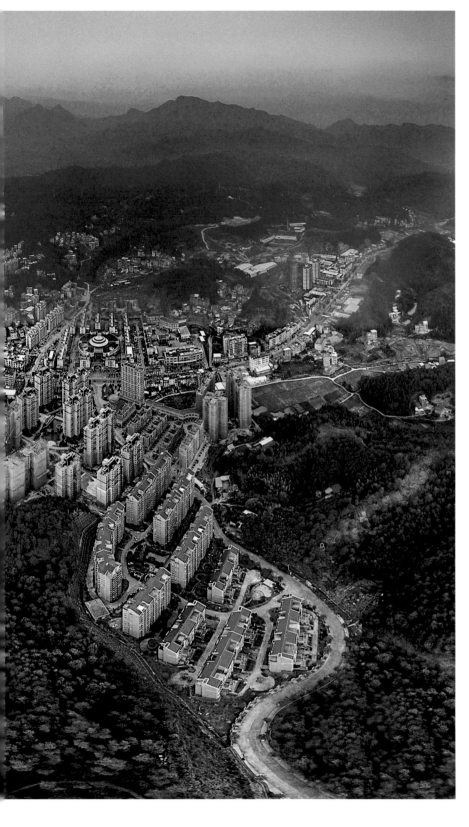

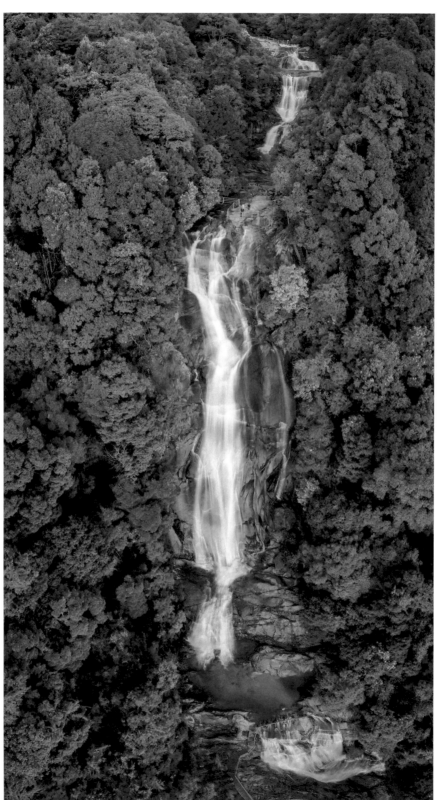

02

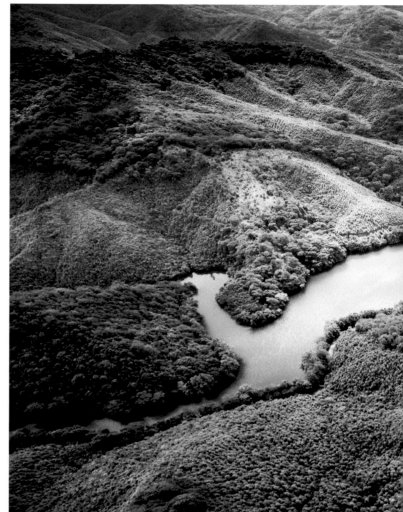

03

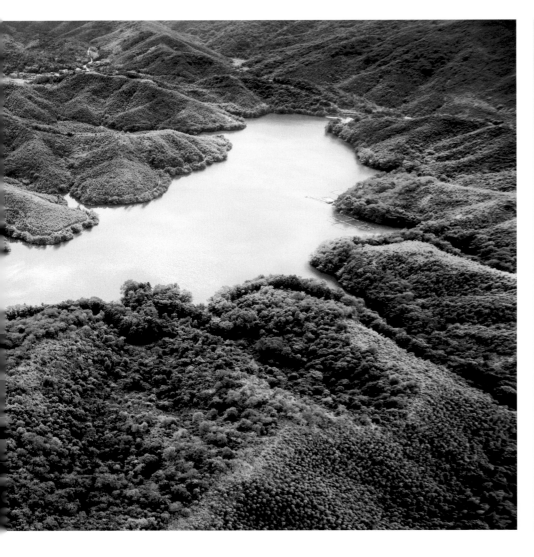

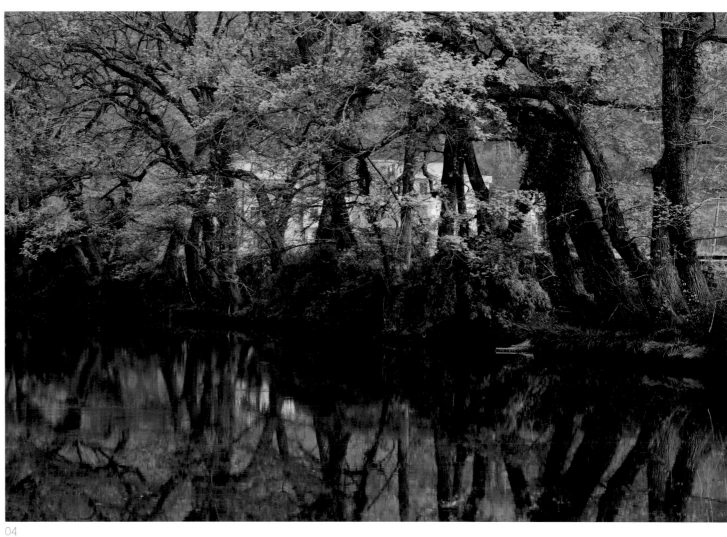

04

01　　武平水流充沛，植被丰饶，图为风景如画的碧水公园 / 修永清 摄
Wuping has abundant water flows, with rich and fertile vegetation. The picture shows the picturesque Bishui Park /Photographed by Xiu Yongqing

02　　梁野山瀑布 / 李国潮 摄
The waterfall in the Liangye Mountain /Photographed by Li Guochao

03　　得益于林改的成功经验，如今的武平满目青翠 / 修永清 摄
Thanks to the successful experience of forest tenure reform, Wuping is now full of green /Photographed by Xiu Yongqing

04　　汀江武平县境内两岸，古树参天，生态环境良好 / 李国潮 摄
On both sides of the Tingjiang River in Wuping County, there are towering ancient trees, with good ecological environment /Photographed by Li Guochao

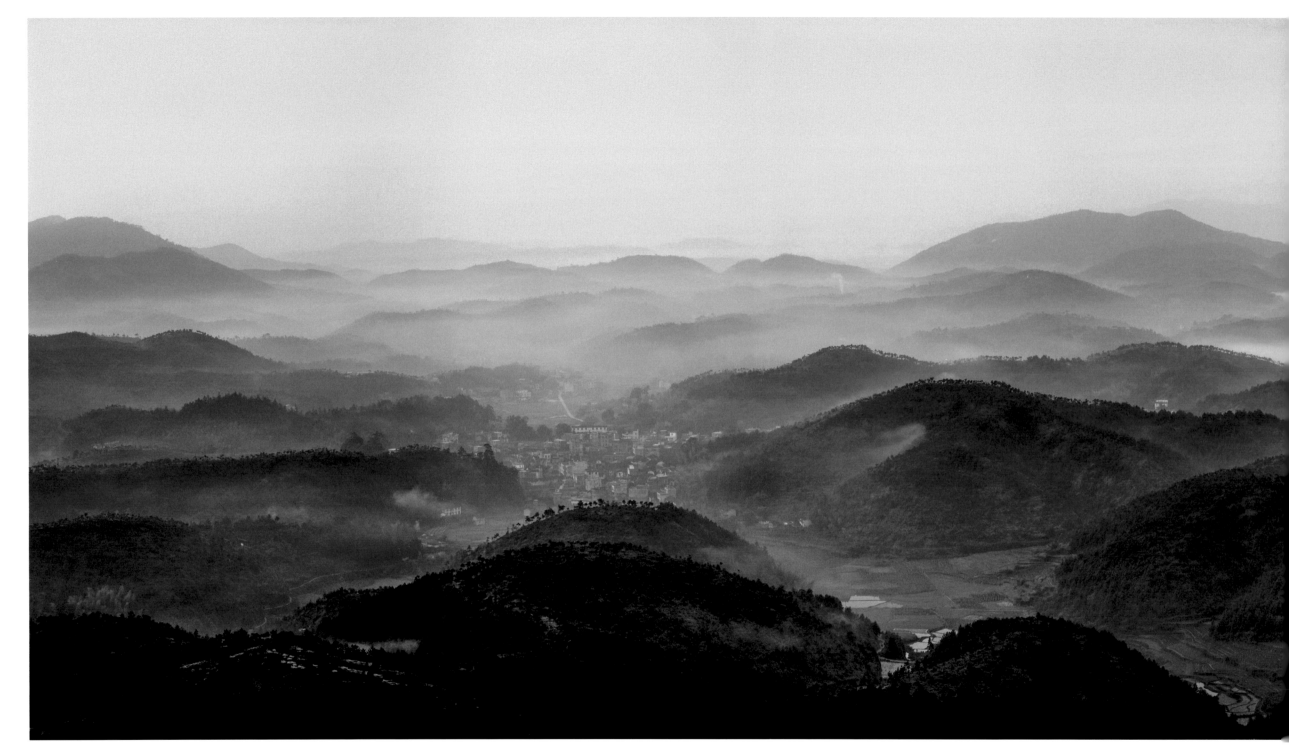

武平山脉连绵，群山环抱，溪流密布，是全国生态旅游大县
Wuping is a large ecotourism county in the country, surrounded by continuous
mountains and densely covered by streams

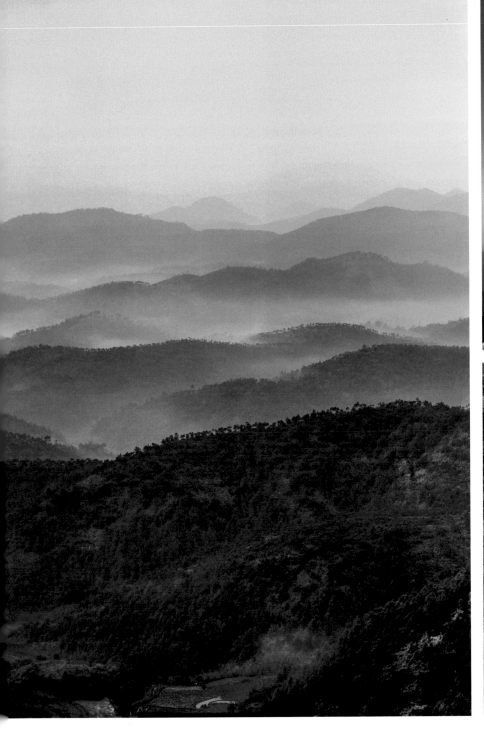

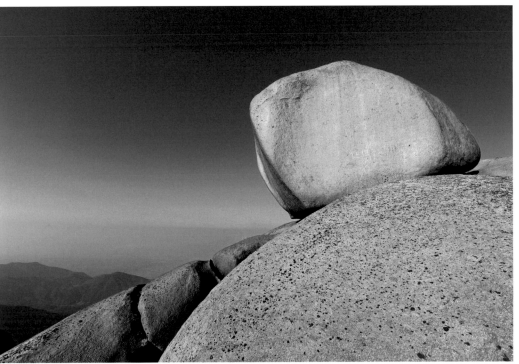

梁野山顶的古母石，悬空而立，被誉为梁野山的山魂 / 李国潮 摄
The ancient mother stone on the top of Liangye Mountain, standing in the air, is known as the soul of Liangye Mountain /Photographed by Li Guochao

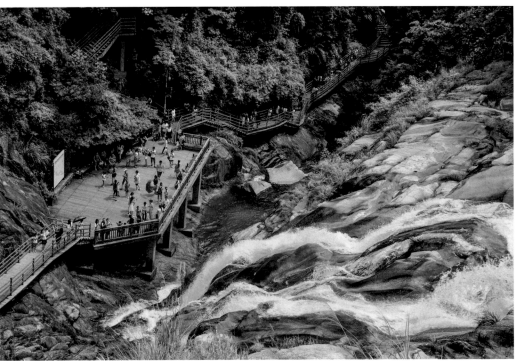

梁野山，松风竹韵，溪水潺潺，这里是福建省乃至全国保护最完好的天然原始森林群落 / 李国潮 摄
Liangye Mountain, covered with with pines and bamboos and gurgling streams, is the most well-protected natural primeval forest community in Fujian Province and even the whole country /Photographed by Li Guochao

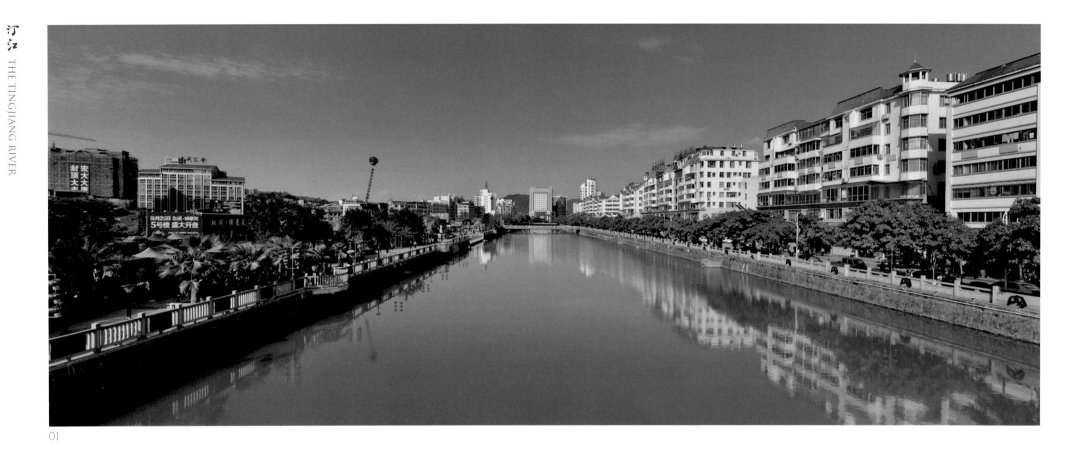

01

01　　汀江两岸水清岸绿、河畅景美 / 李国潮 摄
　　　　On both sides of the Tingjiang River, the water is clear and the bank is green, with smooth river course and beautiful scenery /Photographed by Li Guochao

02　　武平位于闽粤赣三省交界处，是闽西、粤东、赣南的重要交通和物资中转、集散地、素有闽西"金三角"之称 / 曾璜 摄
　　　　Located at the junction of Fujian, Guangdong and Jiangxi provinces, Wuping is an important transportation and material transit and distribution center in Western Fujian, Eastern Guangdong and Southern Jiangxi, which is known as the "Golden Triangle" of Western Fujian /Photographed by Zeng Huang

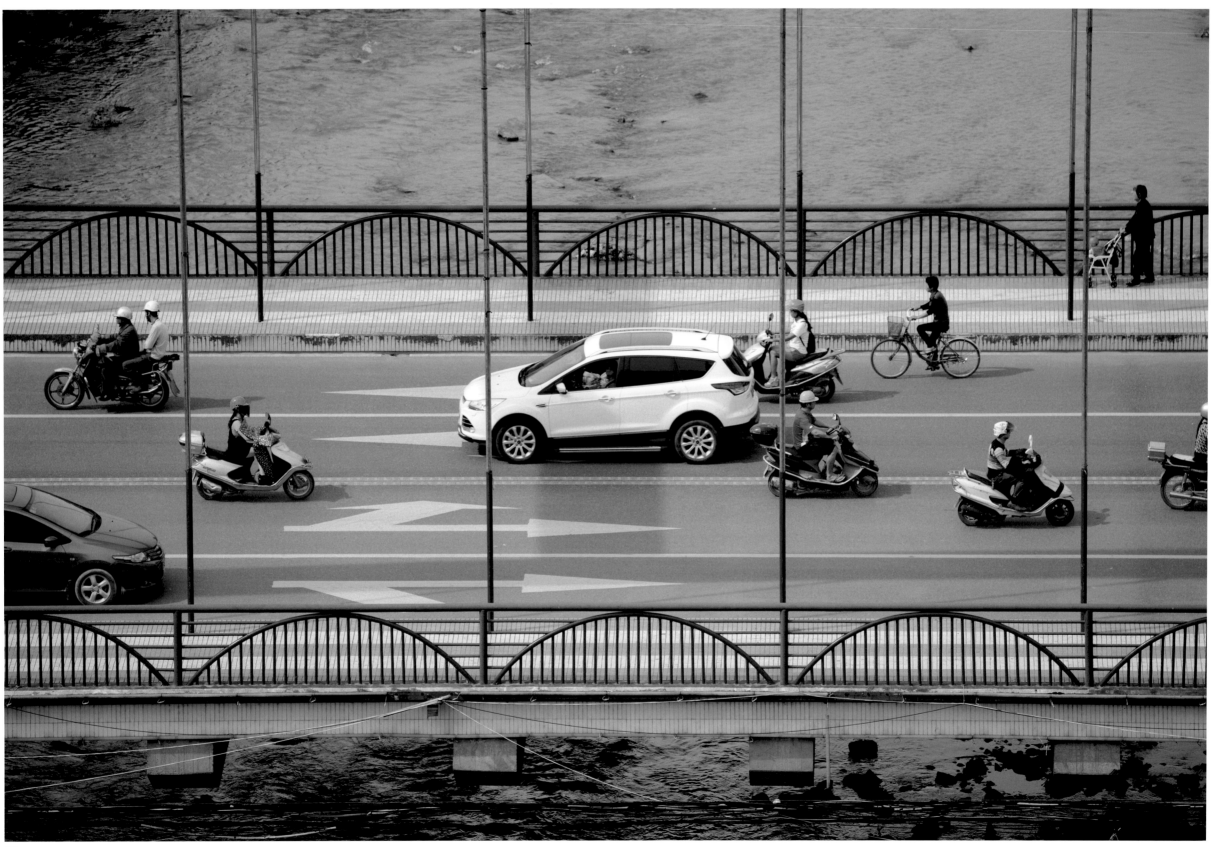

02

Shanghang
Landscape

山水上杭

上杭县名，据说出自《诗经·卫风·河广》"谁谓河广，一苇杭之"。二十世纪七十年代诗人舒婷曾在此插队落户，多在诗作款处落有"杭城"二字，这个杭城，不是杭州而为上杭。上杭素有"诗画之乡""山歌之乡"与"建筑之乡"的美誉。上杭山水最数梅花山，这里有国家级的自然保护区，植物与动物资源极其丰富。复杂的植物成分，具有中亚热带南缘向南亚热带过渡的特点，组成典型的亚热带森林植被，其中属国家重点保护的有红豆杉、福建柏、钟萼木、伞花木等20余种，珍稀植物60余种。在这里，同时蕴藏栖息着丰富的野生动物，华南虎是梅花山珍奇动物的代表。1998年，梅花山率先于全国启动华南虎拯救工程，该工程项目占地466公顷，区内设有华南虎野化繁育区，目前正在进行第二期的开发，以期让华南虎进入野化的生存状态。

The county of Shanghang got its name from the ancient literary work *The Book of Songs*. The correspondent line means "who said the river is too wide? It can be managed by even a small boat", expressing an intense feeling of homesickness. In the 1970s, the poetess Shu Ting lived and worked in a production team here. Some of her poems were signed "Hangcheng", which actually referred to Shanghang instead of Hangzhou City. Shanghang is known as "the land of poetry and painting", "the land of folk songs" and "the land of architecture". Meihuashan Mountain has the most beautiful natural scenery in Shanghang. There are national nature reserves with abundant plant and animal resources and complex plants. It has the characteristics of transition from the southern edge of the central subtropical zone to the southern subtropical zone. It constitutes typical subtropical forest vegetation. There are more than 20 species of taxus chinensis, Fujian cypress, bretschneidera sinensis, eurycorymbus cavaleriei and more than 60 species of rare plants under state protection. Here, at the same time, there are abundant wildlife. For example, South China tiger is the representative of the rare animals in Meihuashan Mountain. In 1998, Meihuashan Mountain took the lead in launching the South China Tiger Rescue Project in China. The project covers 466 hectares and has a wild breeding area for South China tigers. The second phase of development is currently under way to make South China tigers live in a wild state.

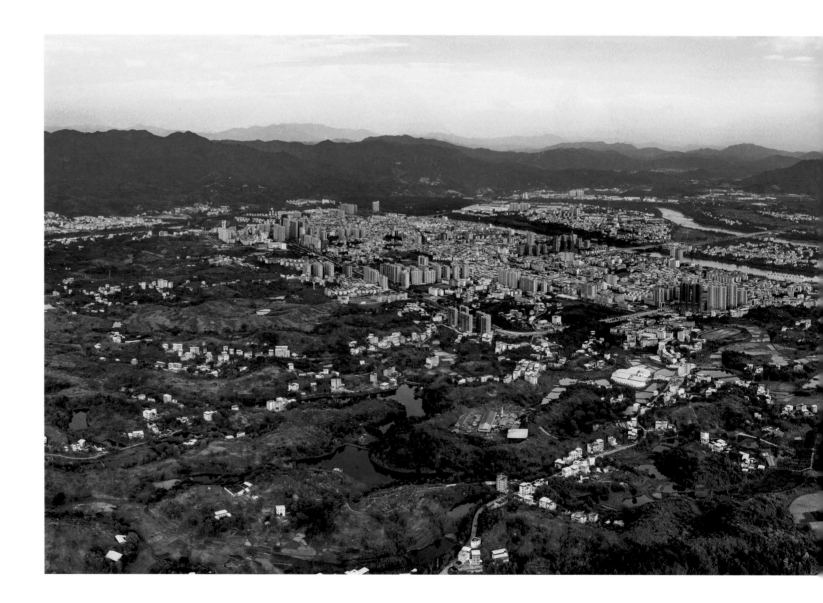

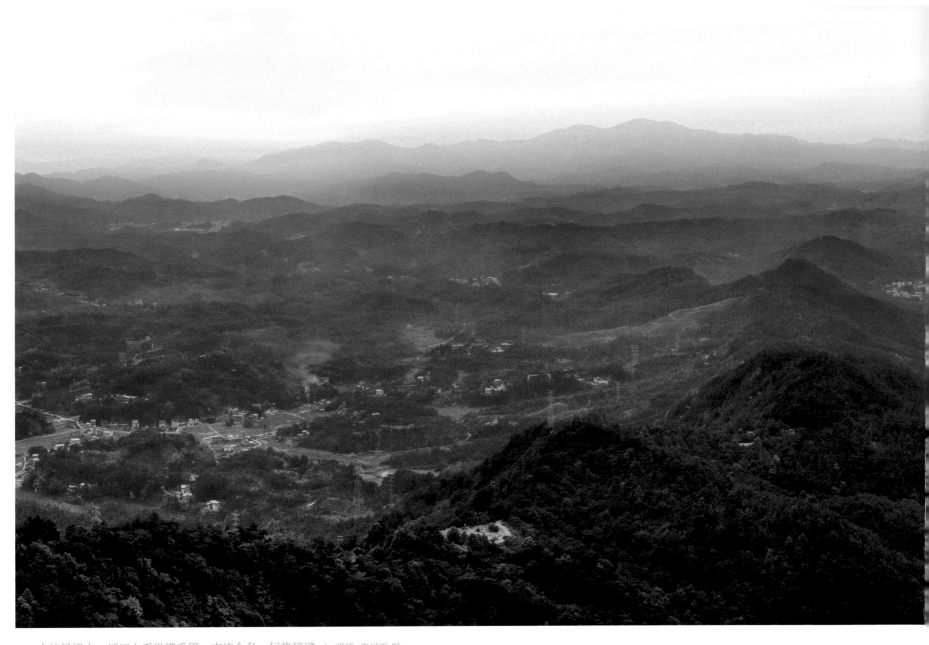

上杭县境内，汀江水系纵横千里，支流众多，气势磅礴 / 严硕 朱晨辉 摄
In Shanghang County, the grand and magnificent Tingjiang River system is criss-crossing and has numerous tributaries /Photographed by Zhu Chenhui, Yan Shuo

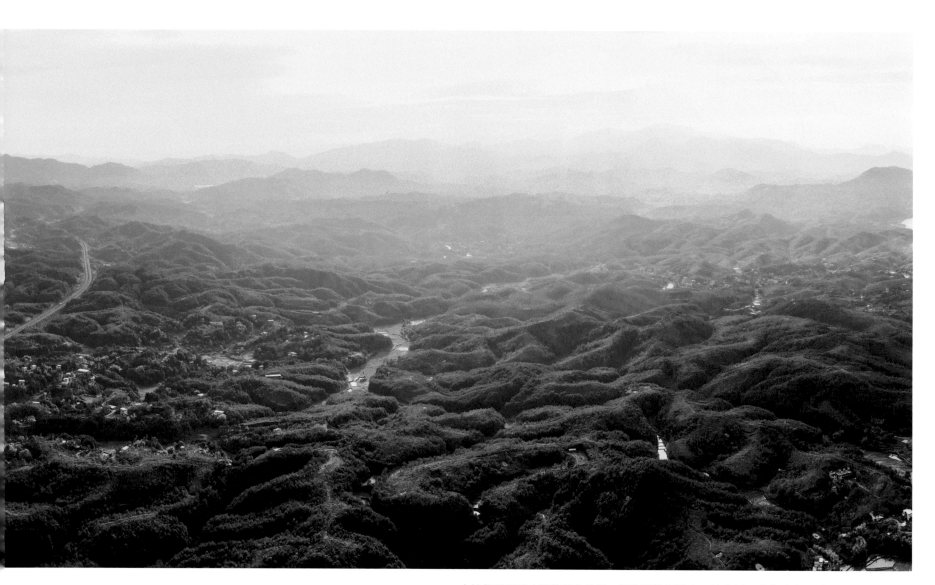

上杭位于汀江中游的黄金地段，因地形略似桃心，故称汀江上的璀璨明珠 / 朱晨辉 严硕 摄

Shanghang is located in the golden section of the middle reaches of the Tingjiang River, and it is also called the bright pearl of the Tingjiang River because its topography is slightly like a peach heart /Photographed by Zhu Chenhui, Yan Shuo

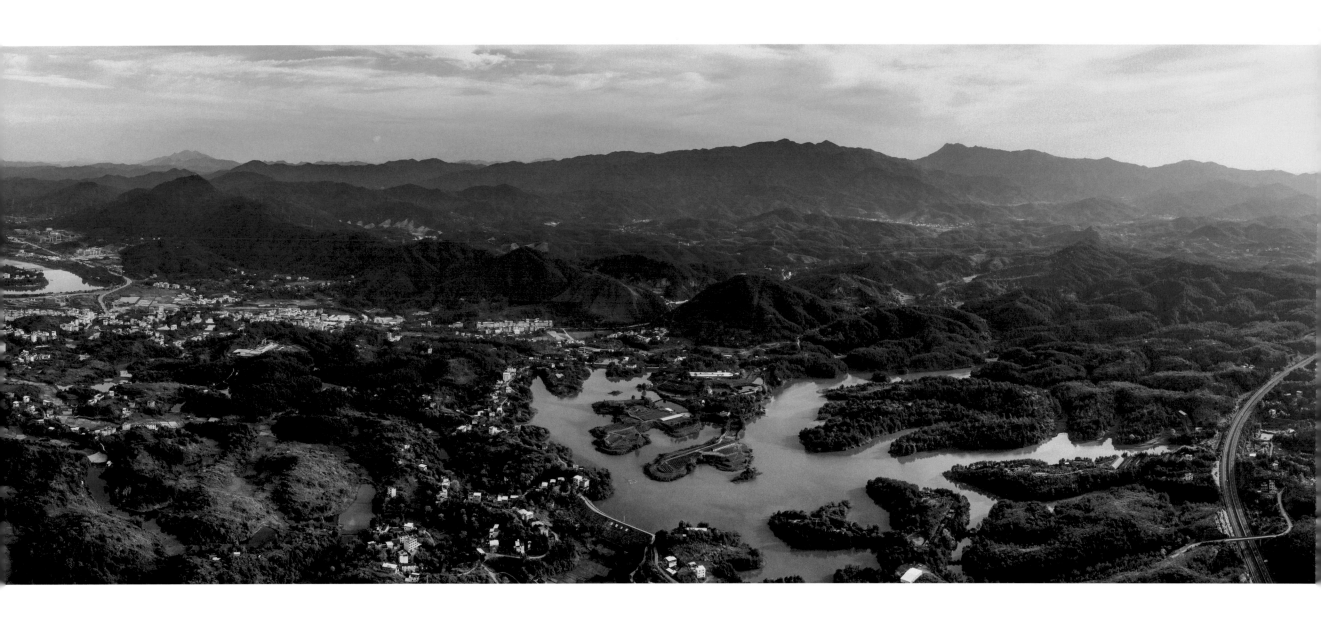

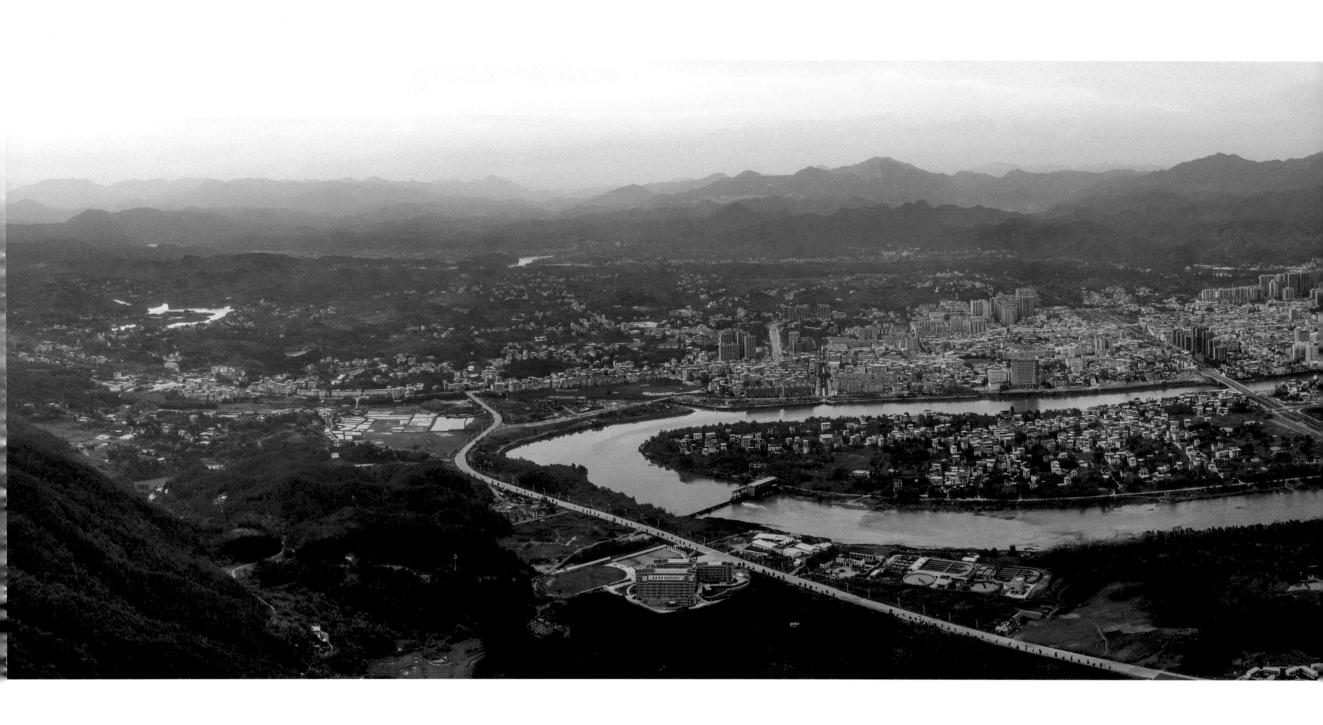

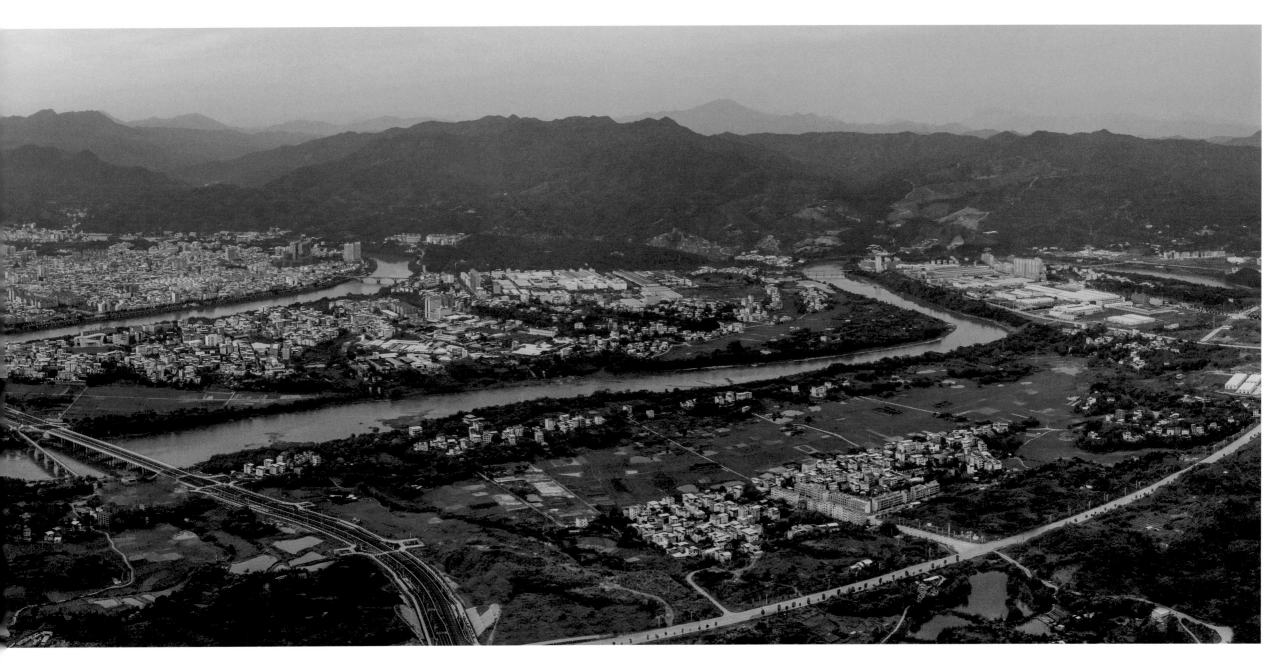

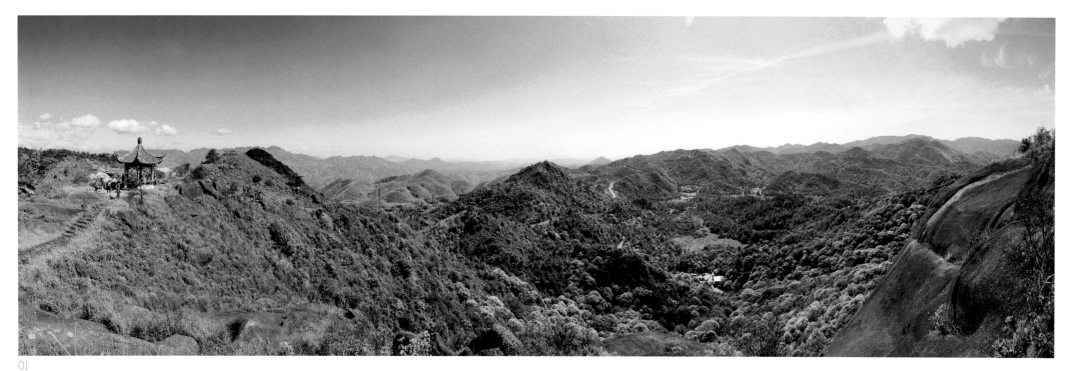

01

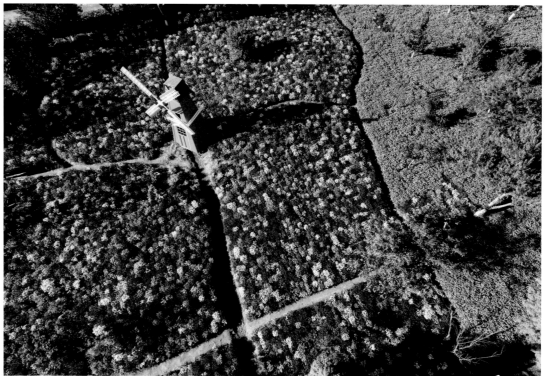

02

01 上杭境内的梅花山，山峦叠翠，绿海无边。这里汇集了许多珍贵的生物资源与物种，被誉为"回归荒漠带上的绿色翡翠" / 陈伟凯 摄

Meihua Mountain in Shanghang is covered with boundless green plants, which brings together many precious biological resources and species. It is praised as a "green emerald returning to desert belt" / Photographed by Chen Weikai

02 梅花山下百花齐放 / 王东明 摄

All flowers bloom together at the foot of Meihua Mountain / Photographed by Wang Dongming

03 由于独特的地理位置与生态环境，世界 A 级自然保护区梅花山被中外专家认定为"华南虎最理想的栖息地"。图为夜色下的梅花山虎园 / 王永安 摄

Due to its unique geographical location and ecological environment, Meihua Mountain, the world's A-level natural reserve, has been recognized as "the most ideal habitat for South China tiger" by Chinese and foreign experts. The picture shows the tiger garden of Meihua Mountain under the dim light of night /Photographed by Wang Yong'an

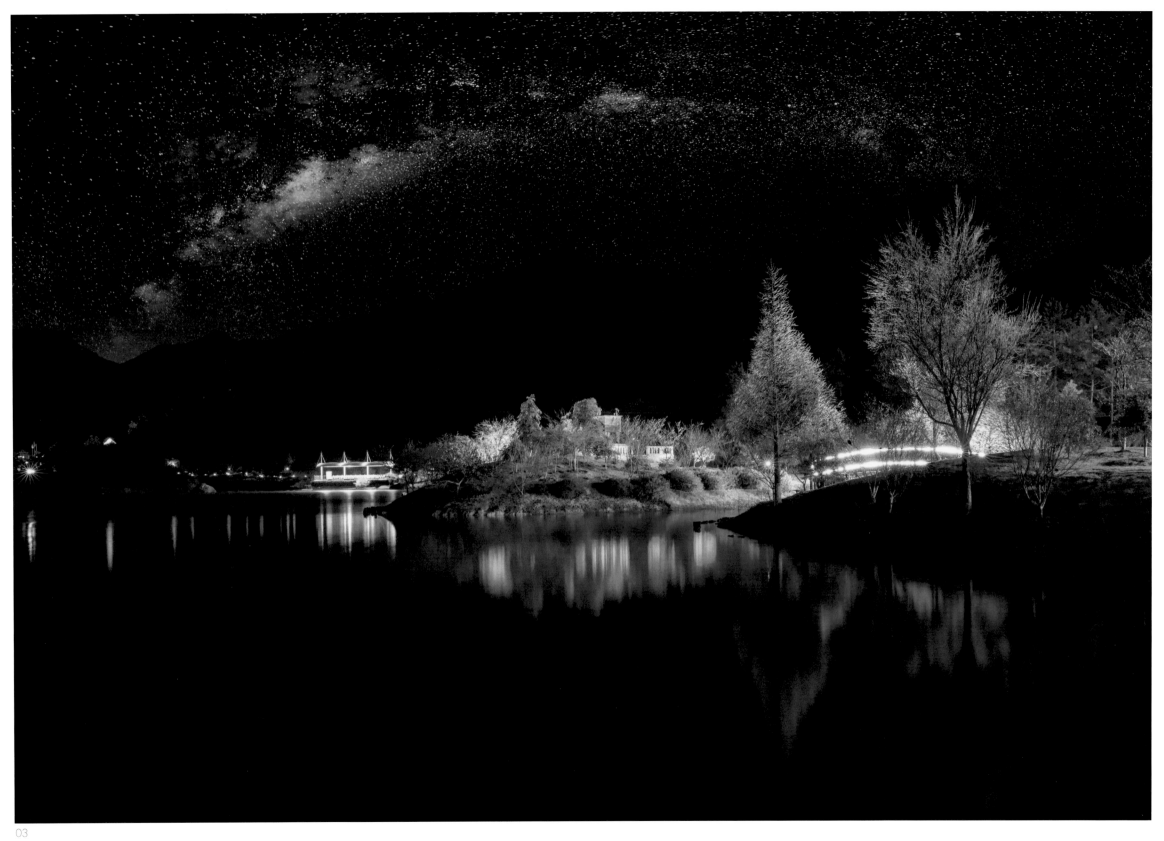

03

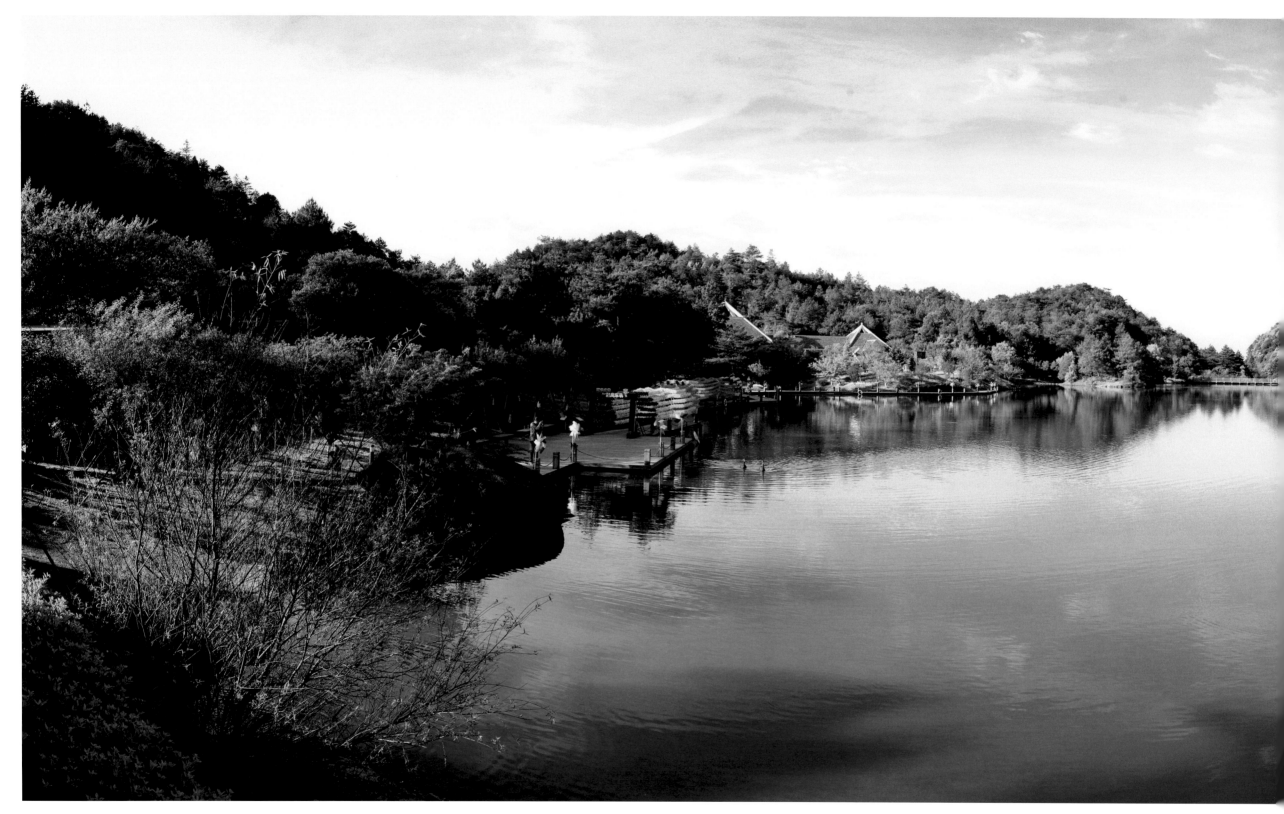

梅花山下青山绿水 / 陈伟凯 摄
Green hills and blue waters at the foot of Meihua Mountain /Photographed by Chen Weikai

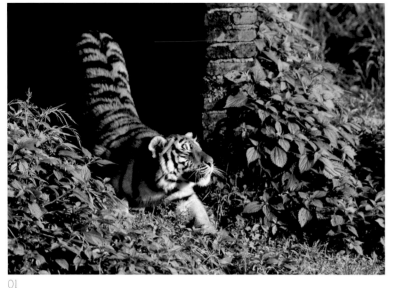

01

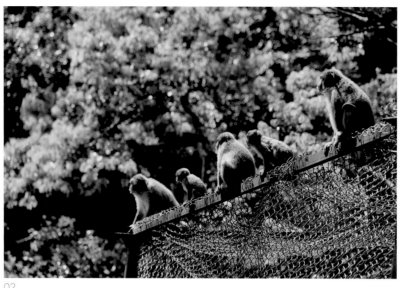

02

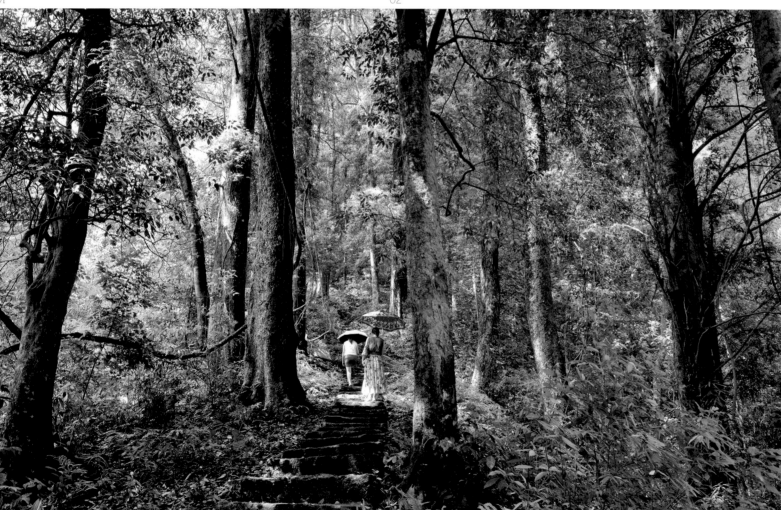

03

01　梅花山华南虎繁育基地 / 王东明 摄
The breeding base of South China tigers in the Meihua Mountain /Photographed by Wang Dongming

02　梅花山是世界 A 级自然保护区，有着丰富的动植物资源 /
王东明 摄
Meihua Mountain is a world's A-level natural reserve, with abundant animal and plant resources /Photographed by Wang Dongming

03　梅花山红豆杉生态园 / 黄海 摄
Taxus Chinensis Ecological Park in Meihua Mountain / Photographed by Huang Hai

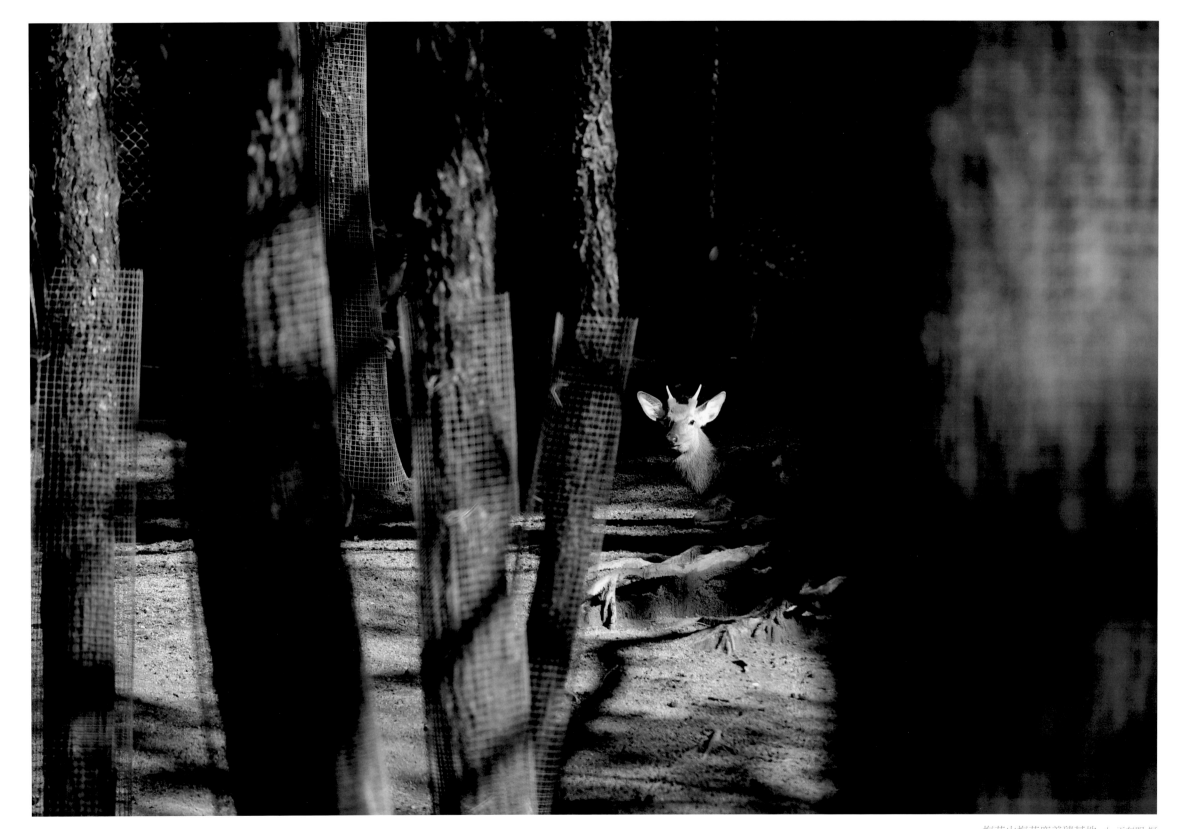

梅花山梅花鹿养殖基地 / 王东明 摄
The sika deer breeding base in Meihua Mountain /Photographed by Wang Dongming

Nice
Liancheng

秀色连城

连城有双冠，国家级风景名胜——冠豸山与石门湖，风景如画，秀色连天。有丹霞地貌的峻峭峰岩，有清泉穿石的苍玉峡，有清澄如镜的金字泉，还有两峰壁立间的一线天、独立天地的"照天烛"，远处姊妹岩风姿绰约，若登丹梯云栈至山顶远眺，则有"身疑上天游，摇荡白云里"的仙境感觉。乘舟石门湖，可见映山亭、思源亭、石门宿云旧址、太上老君岩、香兰亭、三叠潭、桃椰幽谷、老虎崖、采云峰等，进入湖心则有马鞍寨、国际悬崖跳水赛场、莲花峰、疯僧戴帽（又名酒坛峰）、神蛙照镜、观音绣花鞋、河马饮泉、千瀑岩、生命之门等。一山一湖，一柱一门，曾让多少游人流连忘返。只有在同时游览了石门湖和冠豸山后，才会顿生"北夷南豸，丹霞双绝"的真切体会。景区不光景色迷人，同时，冠豸山还有更深厚的文化沉淀，这得慢慢地体味。

Liancheng has the two excellent national scenic spots Guanzhai Mountain and Shimen Lake, which are extremely picturesque and beautiful. "Danxia" landform has steep peaks and rocks. Around Cangyu Gorge clear spring hits stones. Jinzi Spring is clearer. Between two peaks there is a line of sky. A candle shines in the sky. In the distant Sister Rock is graceful. If you climb the red ladder to the top of the mountain, you will have the feeling of wonderland of "suspecting to swim in the sky, swaying in the white clouds". In Shimen Lake, you can see Yingshan Pavilion, Siyuan Pavilion, Shimen Suyun Old Site, Taishang Laojun Rock, Xianglanting Pavilion, Sandietan Pond, Hanging Valley, Tiger Cliff and Caiyun Peak. In the center of the lake, there are Ma'anzhai, International Cliff Diving Stadium, Lianhua Peak, Mad Monk Hat (also known as Jiutan Peak), Mirror of Golden Frog, Guanyin Embroidered Shoes, Hippo Drinking Spring, Qianpuyan Rock and the Gate of Life. One mountain, one lake, one column, and one door made uncountable travelers reluctant to leave. Only after touring Guanzhai Mountain and Shimen Lake could the true experience of "north Yi south Zhai" and "Danxia Double" be born. In addition to gorgeous scenic spots, there is deep cultural deposit to appreciate and explore here.

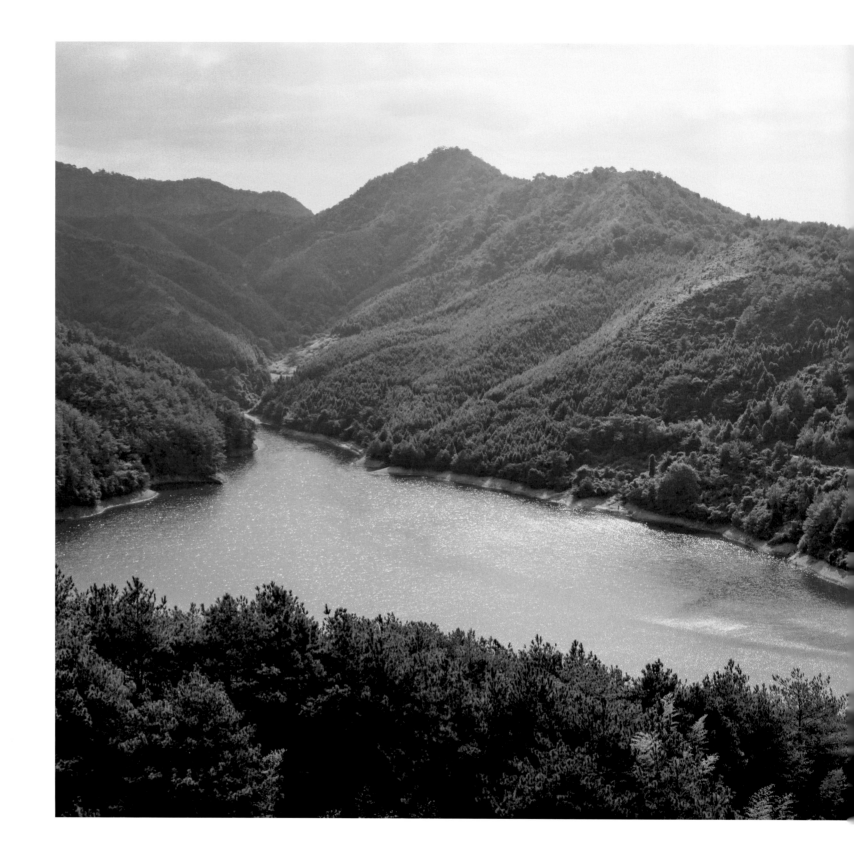

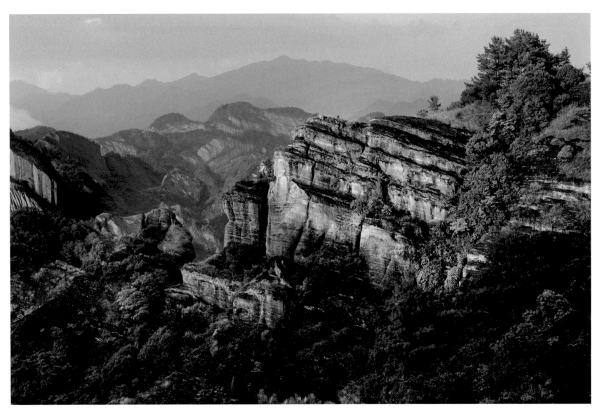

连城冠豸山国家级重点风景名胜区，山势雄奇险峻，景色壮美 / 胡文 摄
Liancheng Guanzhai Mountain is a national key scenic spot with majestic and precipitous mountain shape and magnificent scenery /Photographed by Hu Wen

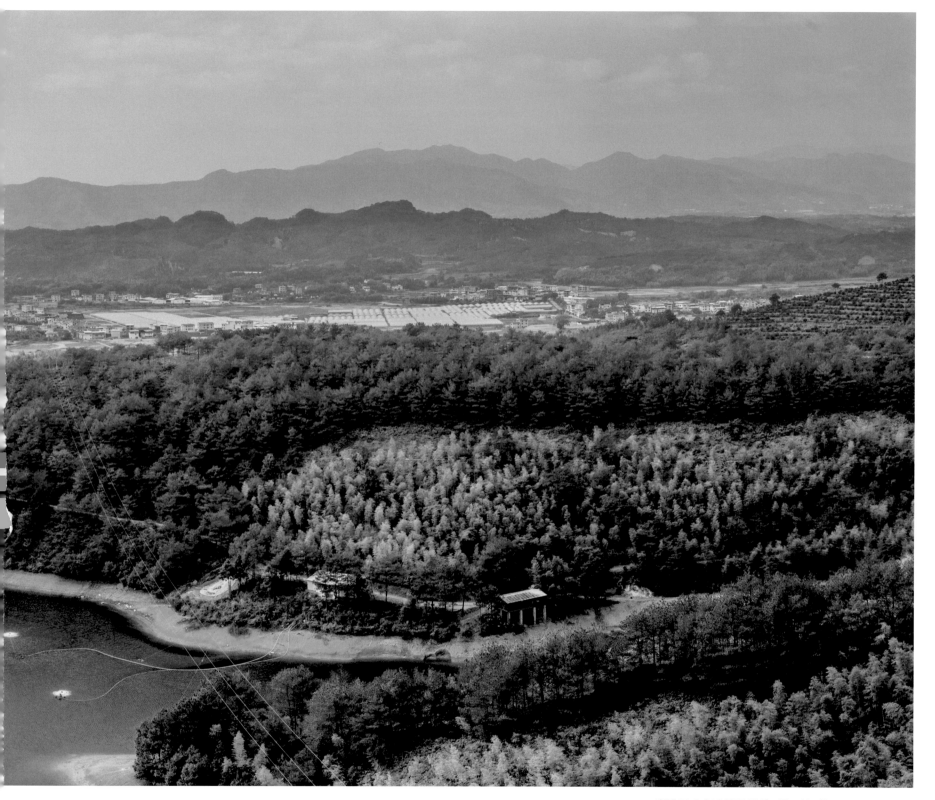

连城冠豸山后是温柔秀丽的石门湖 / 朱晨辉 严硕 摄
Behind Liancheng Guanzhai Mountain, there is beautiful Shimen
Lake /Photographed by Zhu Chenhui, Yan Shuo

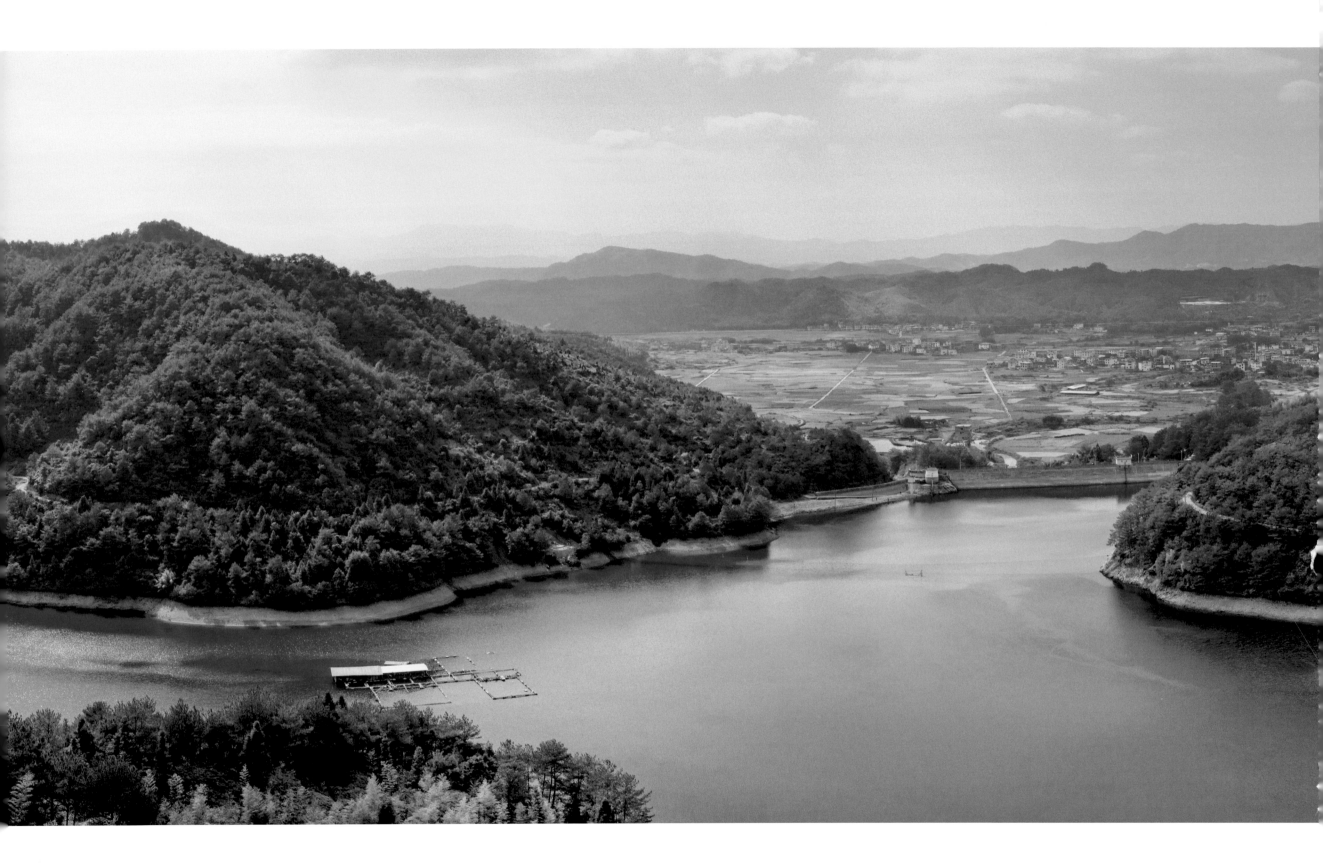

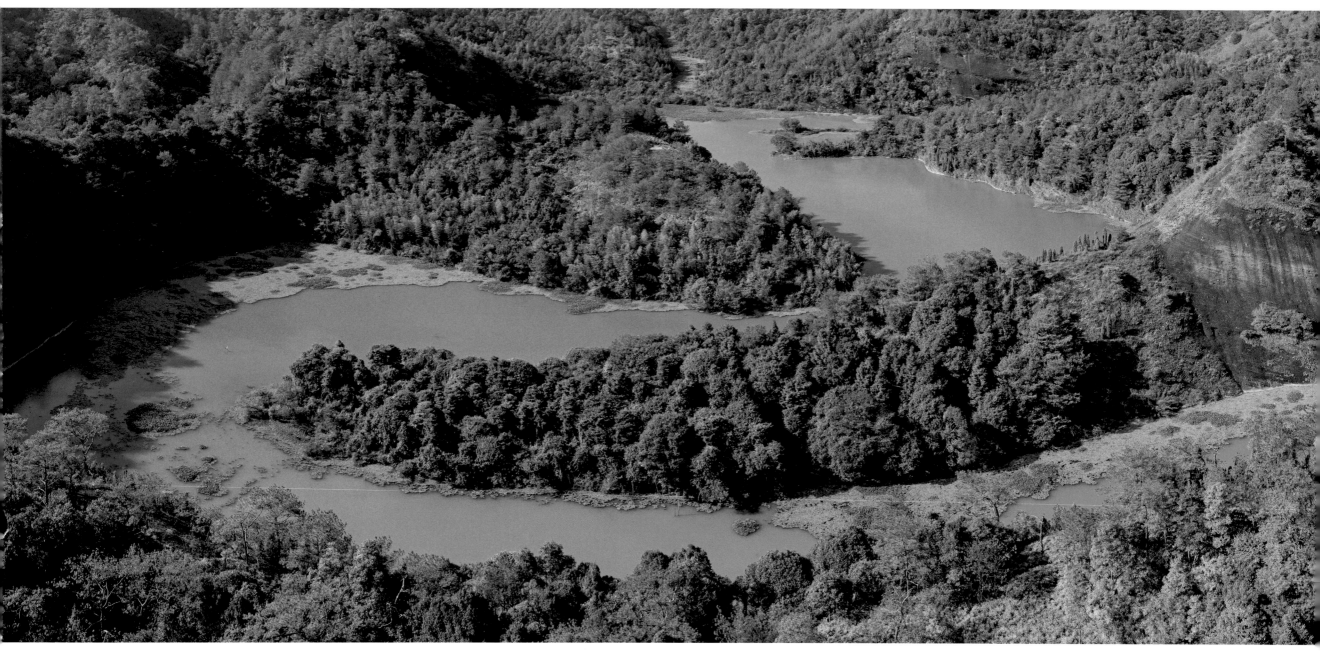

连城冠豸山为国家级重点风景名胜区，景区内奇峰满目，山水相映，与武夷山一起被称为"北夷南豸，丹霞双绝" / 朱晨辉 严硕 摄

Liancheng Guanzhai Mountain is a national key scenic spot full of grotesque peaks, with mountains and rivers setting each other off. Together with the Wuyi Mountain, they are called `Northern Wuyi Mountain and Southern Guanzhai Mountain are double wonders of Danxia landform` /Photographed by Zhu Chenhui, Yan Shuo

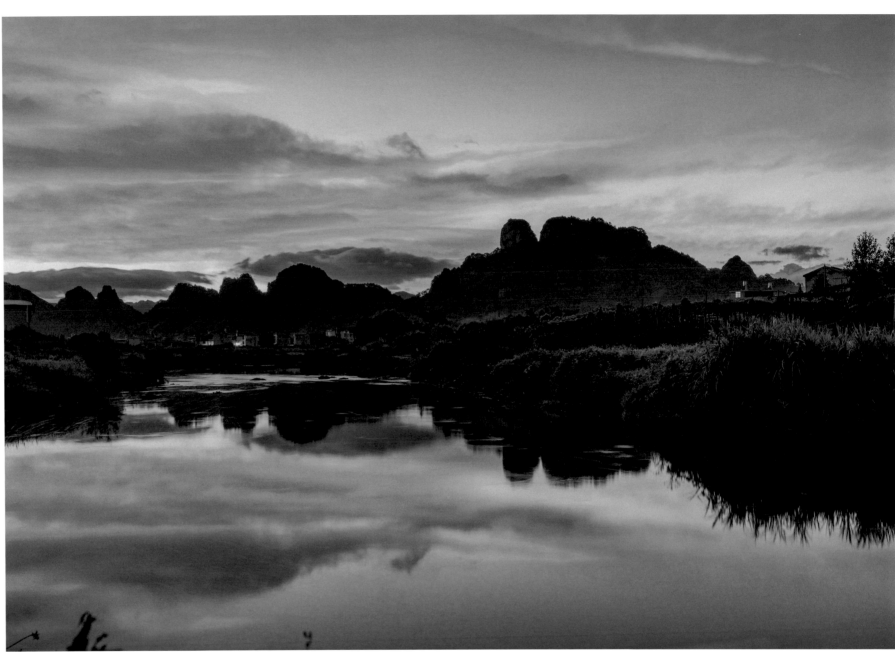

碧水映丹山，倒影幽幽

The clear water reflects the bright red mountain, and the reflection is faint

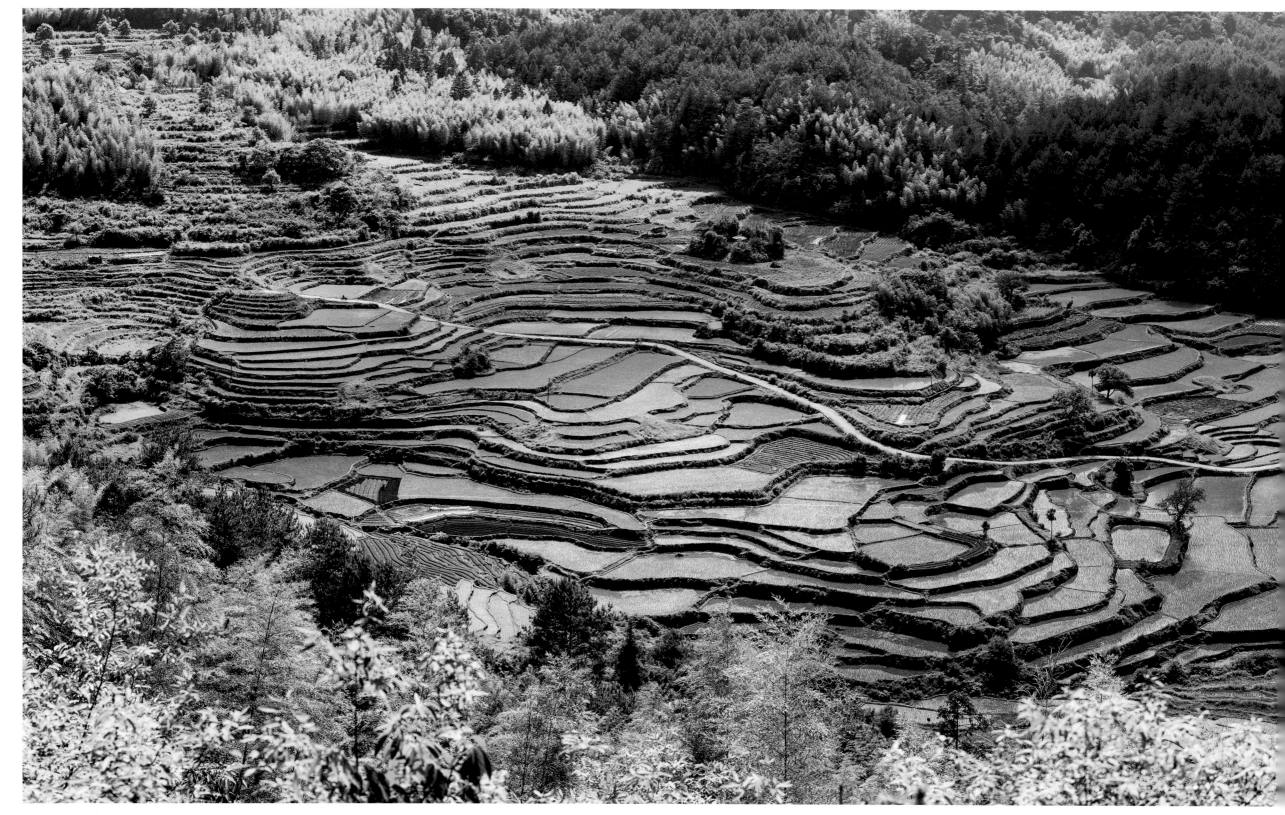

连城县赖源乡梯田 / 吴健衡 摄

Terraced fields in Laiyuan Township, Liancheng County /Photographed by Wu Jianheng

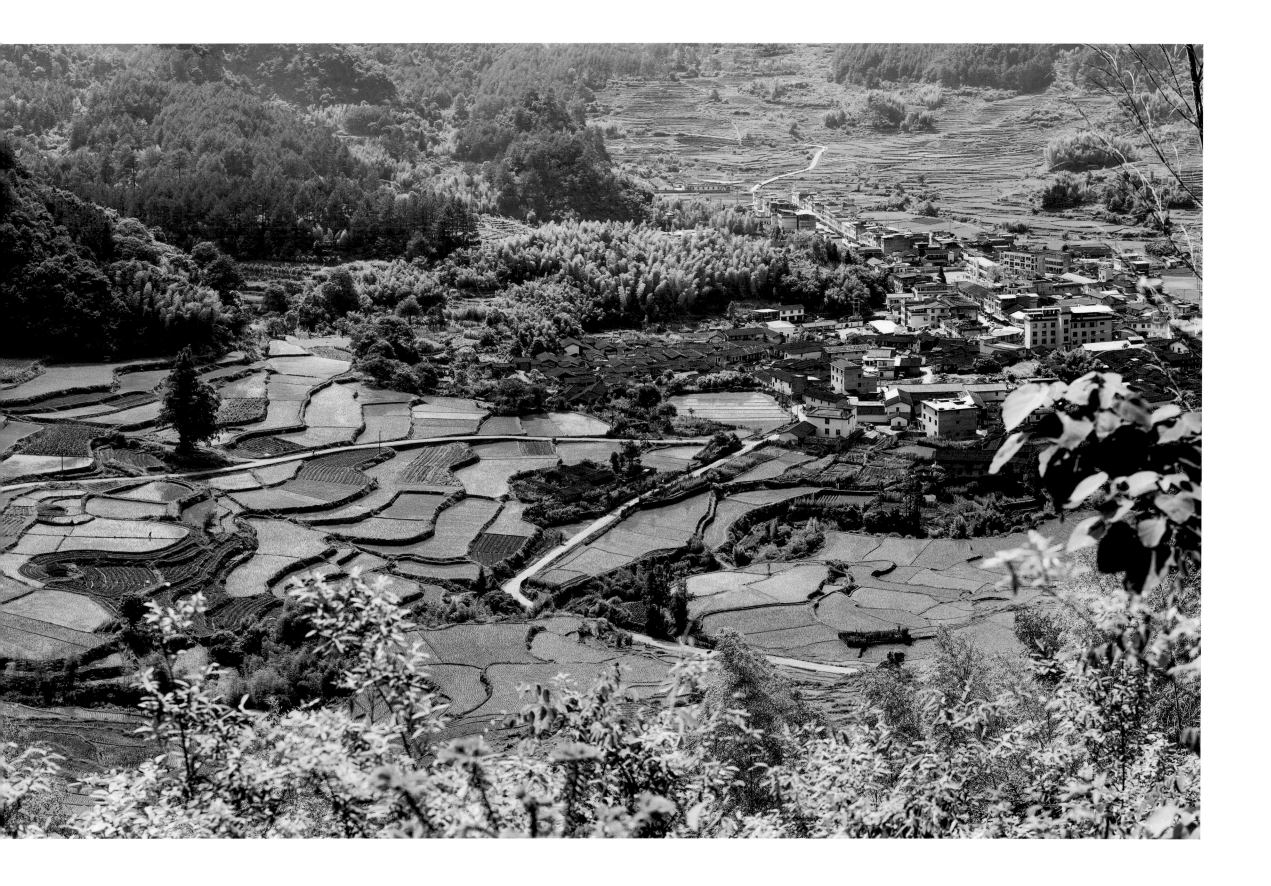

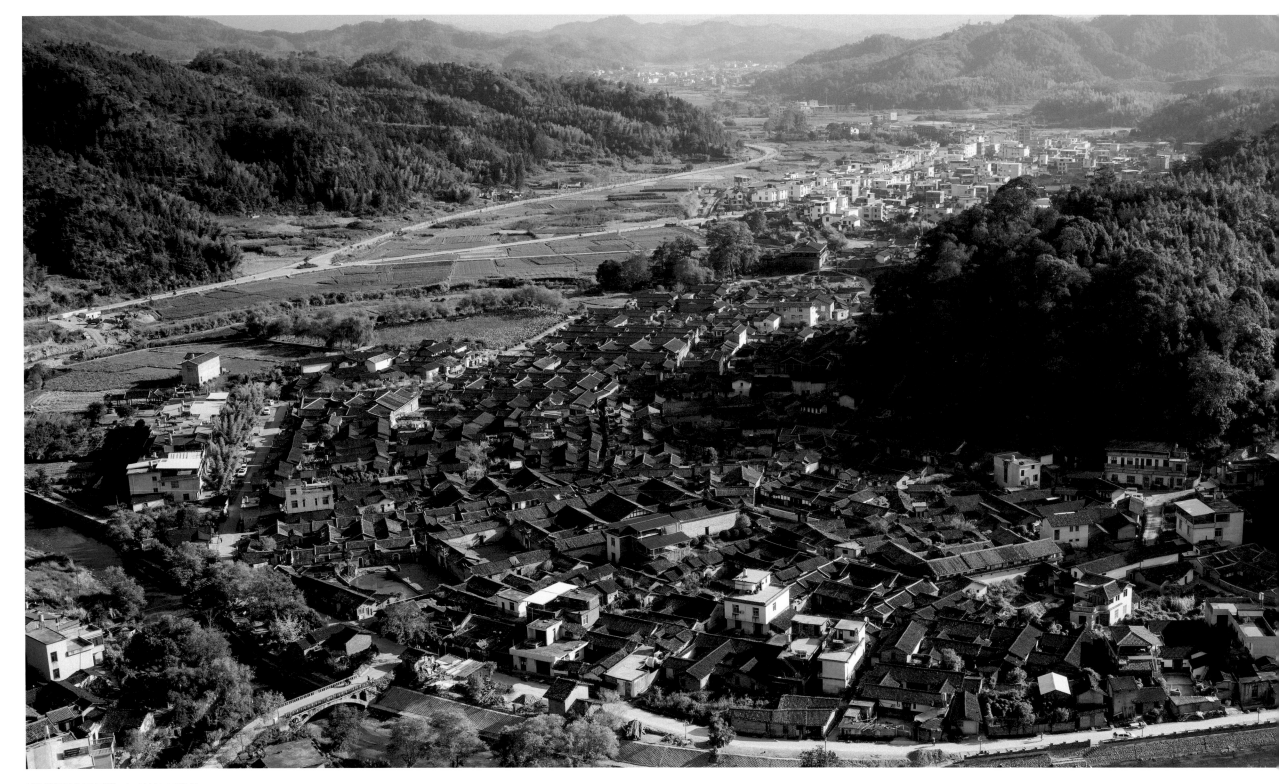

连城培田古民居群 / 朱晨辉 严硕 摄
Peitian Ancient Residence in Liancheng County /Photographed by Zhu Chenhui, Yan Shuo

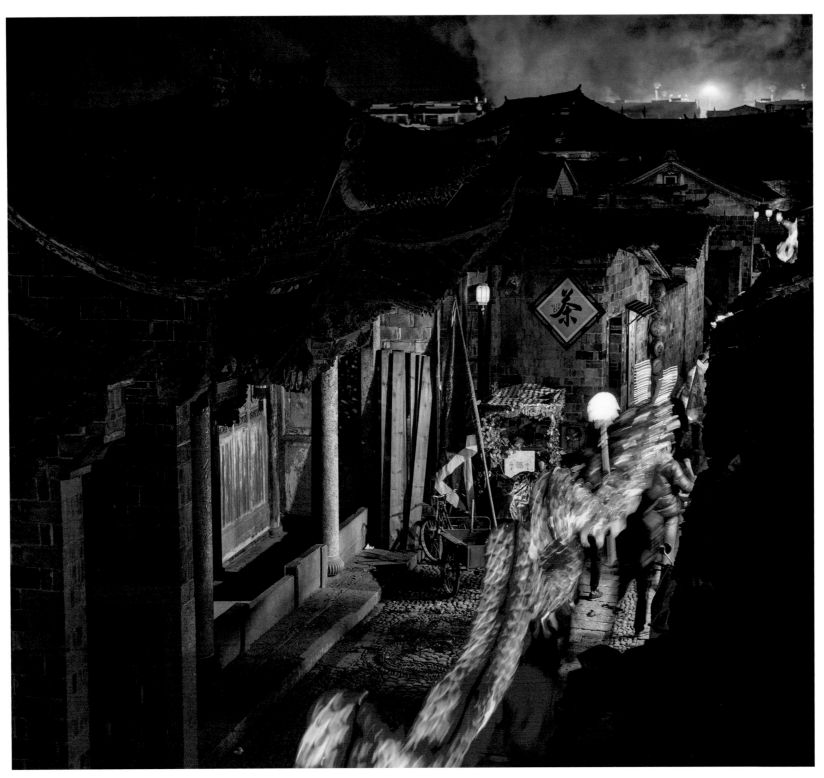

连城培田游龙灯
Peitian Paper Dragon Lantern in Liancheng County

Round or Square
Earthen Buildings
in Yongding

方圆永定

在永定的土地上，分布着 2 万多座土楼，其中三层以上的大型土楼近 5000，圆楼 300 余。这些土楼立面多姿、造型各异、阔大雄壮，以自然村落为单位，错落有致地与蓝天大地、青山绿水融为一体，组合成气势磅礴、壮丽非凡的土楼群，令人"销魂夺魄"。古人认为天是圆的，地是方的，因此以圆和方代表天和地，土楼中的圆形，更是契合了传统文化，因为古人认为圆具有无穷的神力，有万事和合、子孙团圆的寓意。有的土楼群则方圆并列，从空中航拍，匀称、协调而美观。美国哈佛大学建筑设计师克劳得说："土楼是客家人大胆、别具一格的力作，它闪烁着客家人的智慧，常常使我激动不已。"日本东京艺术大学教授茂木一郎所言："土楼像地下冒出的巨大蘑菇，又像白天而降的黑色飞碟。"每一座土楼就是一个艺术殿堂，每一座土楼，又如同一个"大家族，小社会"。这种聚族同楼而居的生活模式，典型地反映了客家人的传统家族伦理和亲和力。

On Yongding's land, there are more than 20,000 earthen buildings, including nearly 5,000 large earthen buildings with more than three floors and more than 300 round buildings. These earthen buildings with various facades, different shapes and magnificent features, taking natural villages as units, are scattered and integrated with the blue sky, the earth and the green mountains and waters, forming a magnificent and extraordinary group of earthen buildings. So 'soul-stirring'! The ancient people thought that the sky was round and the ground was square so they represented the sky and the earth with round and square. The round is more in line with the traditional Chinese culture, which holds that the round has infinite divine power, and has the implied meaning of harmony of all things and reunion of children and grandchildren. Some earthen buildings were side by side, symmetrical, coordinated and beautiful when they are recorded by aerial photography. Claude, an architect at Harvard University, said, "Tulou is a bold and unique work of the Hakka people. It shines with the wisdom of the Hakka people and often excites me." "Tulou is like a giant mushroom coming out of the ground and a black flying saucer coming down from the sky," said Ichiro Maki, a professor at Tokyo University of Art. Every earthen building is an art palace, and every earthen building is like a "big family, small society". This kind of life style of living together in the same building typically reflects the traditional family ethics and affinity of Hakka people.

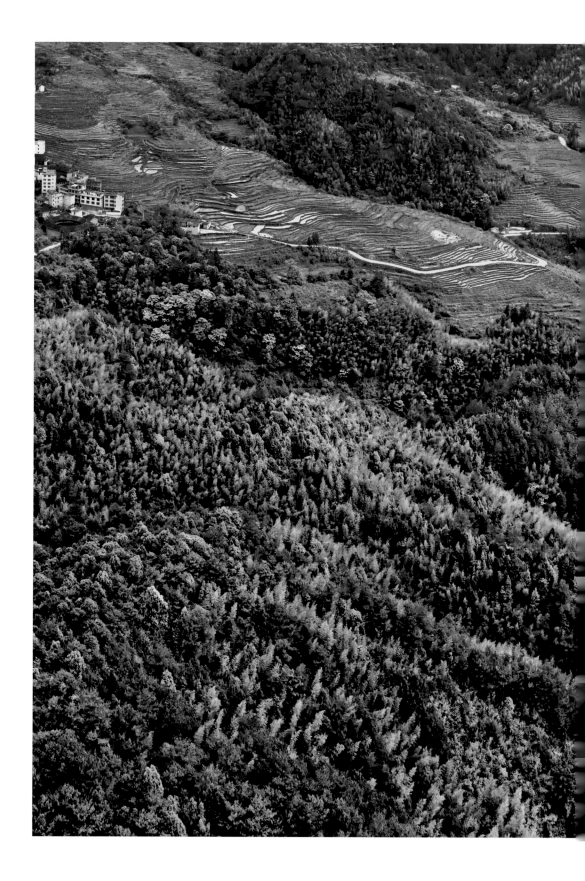

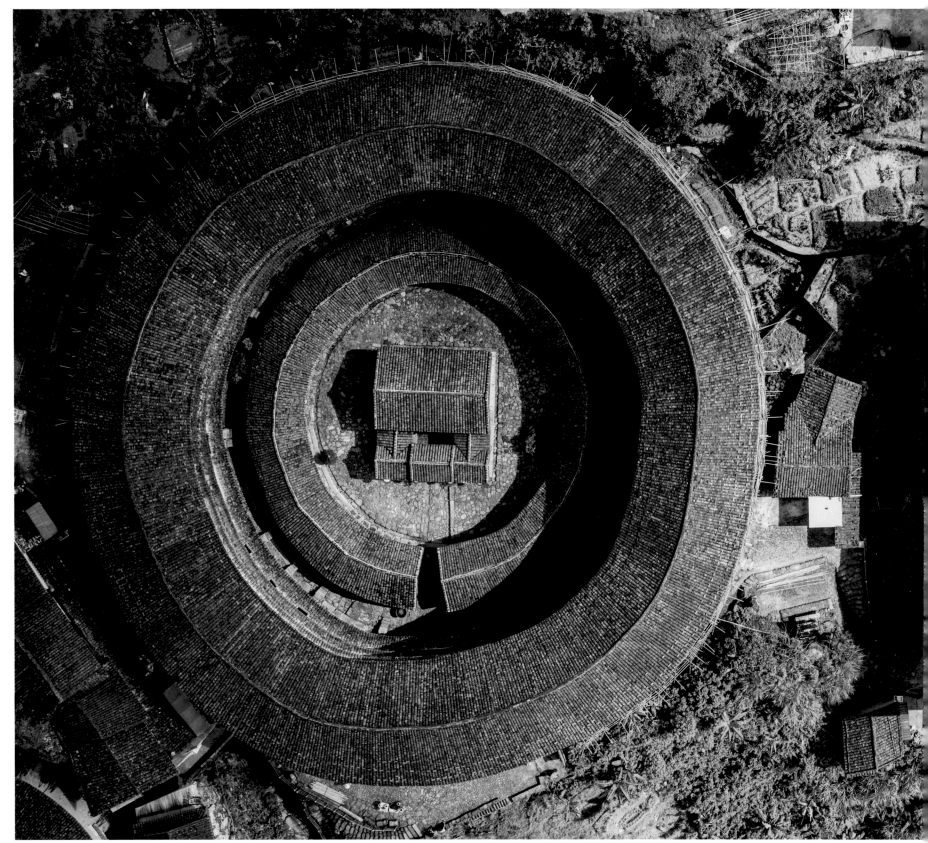

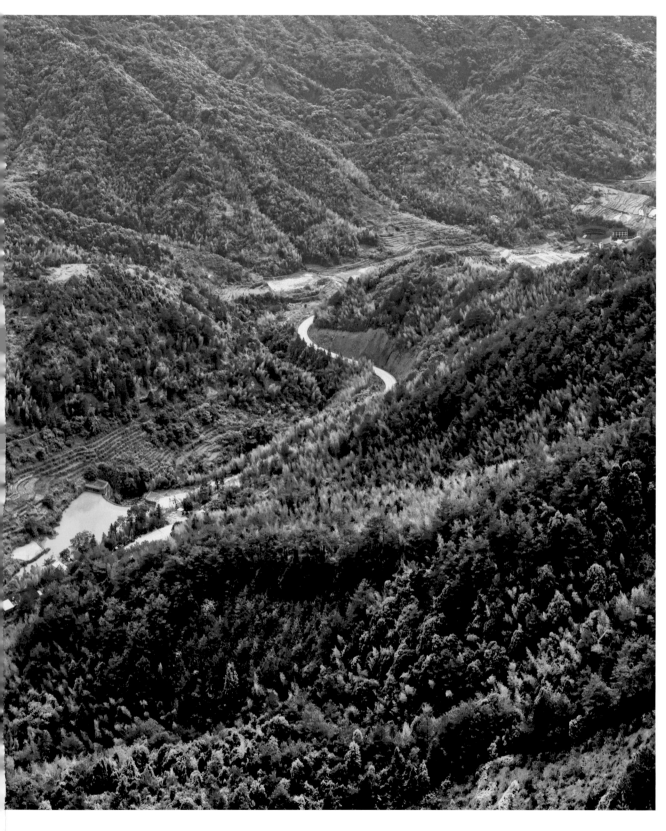

永定初溪土楼群依山傍水，错落有致
/ 朱晨辉 严硕 摄

Chuxi Earth Building Group in
Yongding is situated at the foot of the
mountain and beside a stream, and is
are well-spaced /Photographed by Zhu
Chenhui, Yan Shuo

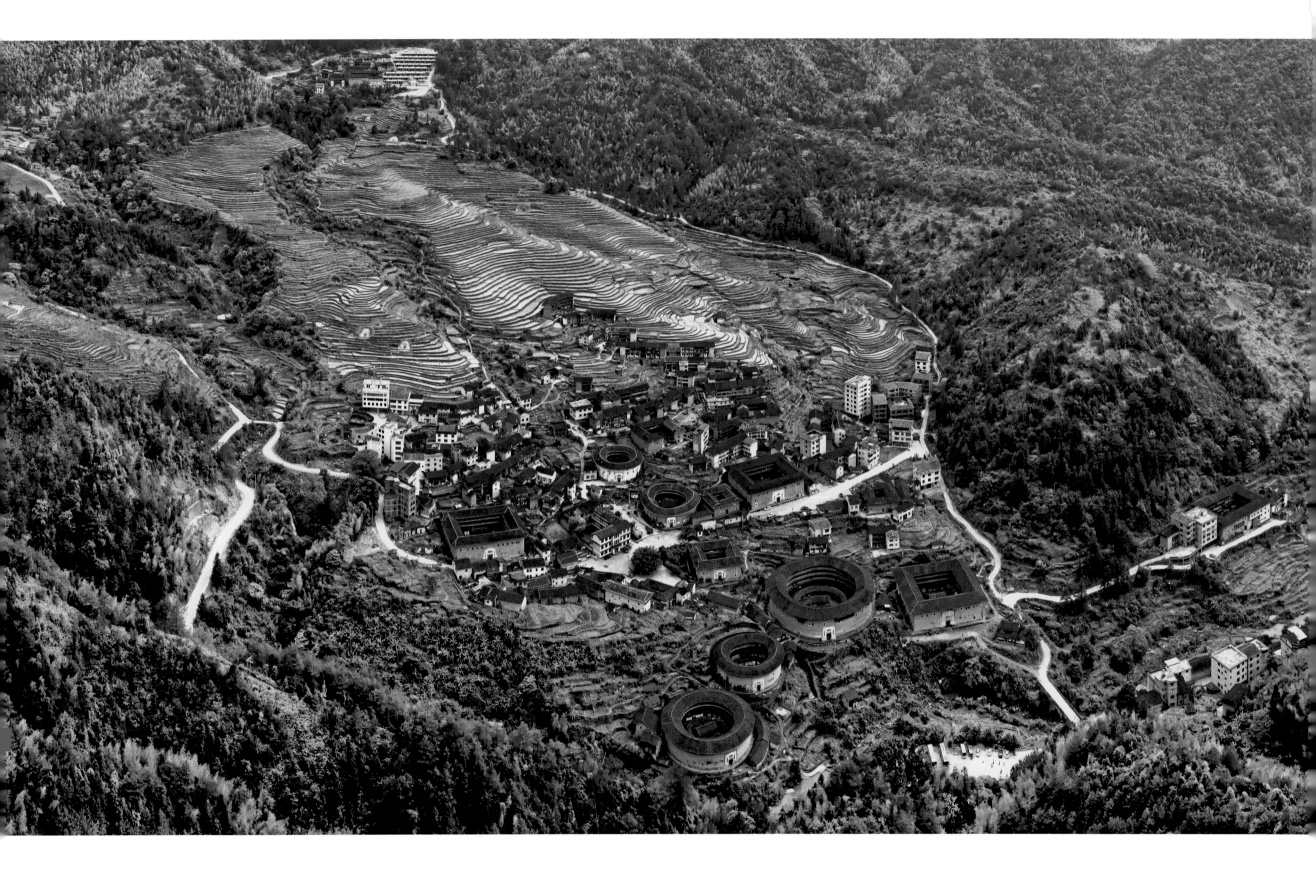

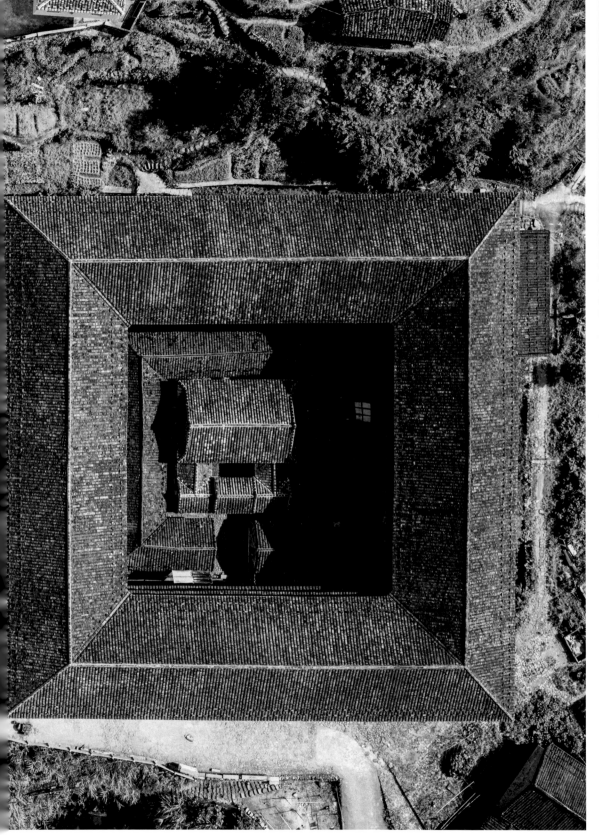
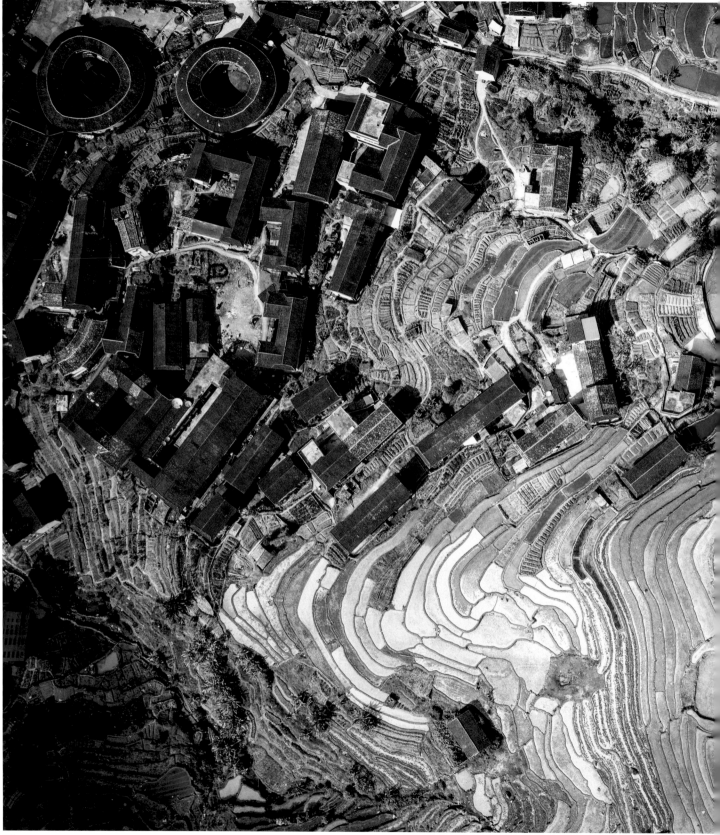

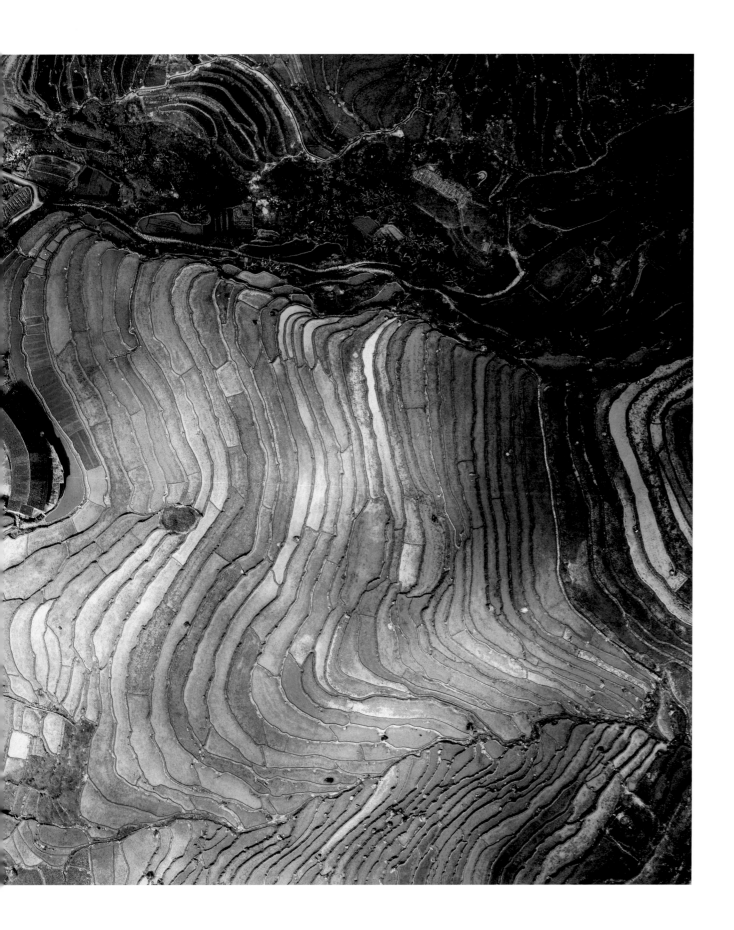

01 方圆之间，雄浑庄严，震撼人心 / 朱晨辉 严硕 摄
Between squareness and roundness, it is vigorous solemn, and shocking /Photographed by Zhu Chenhui, Yan Shuo

02 永定初溪土楼群的层层梯田 / 朱晨辉 严硕 摄
Layers of terraced fields in Chuxi Earth Building Group of Yongding /Photographed by Zhu Chenhui, Yan Shuo

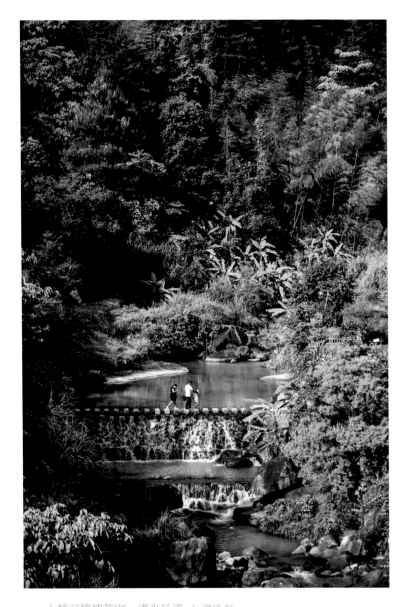

土楼前植被茂密，清水长流 ／ 严硕 摄

In front of earth buildings, there are dense vegetation and long flowing clear water /Photographed by Yan Shuo

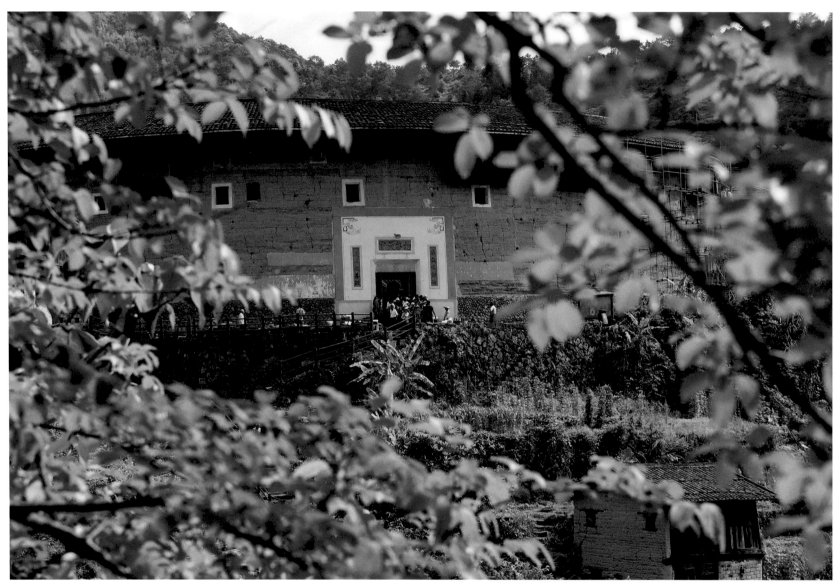

饱经沧桑的土楼，充满着敦厚的客家民风 ／ 严硕 摄

The earth building, which has experienced many vicissitudes of life, is full of sincere Hakka folk customs /Photographed by Yan Shuo

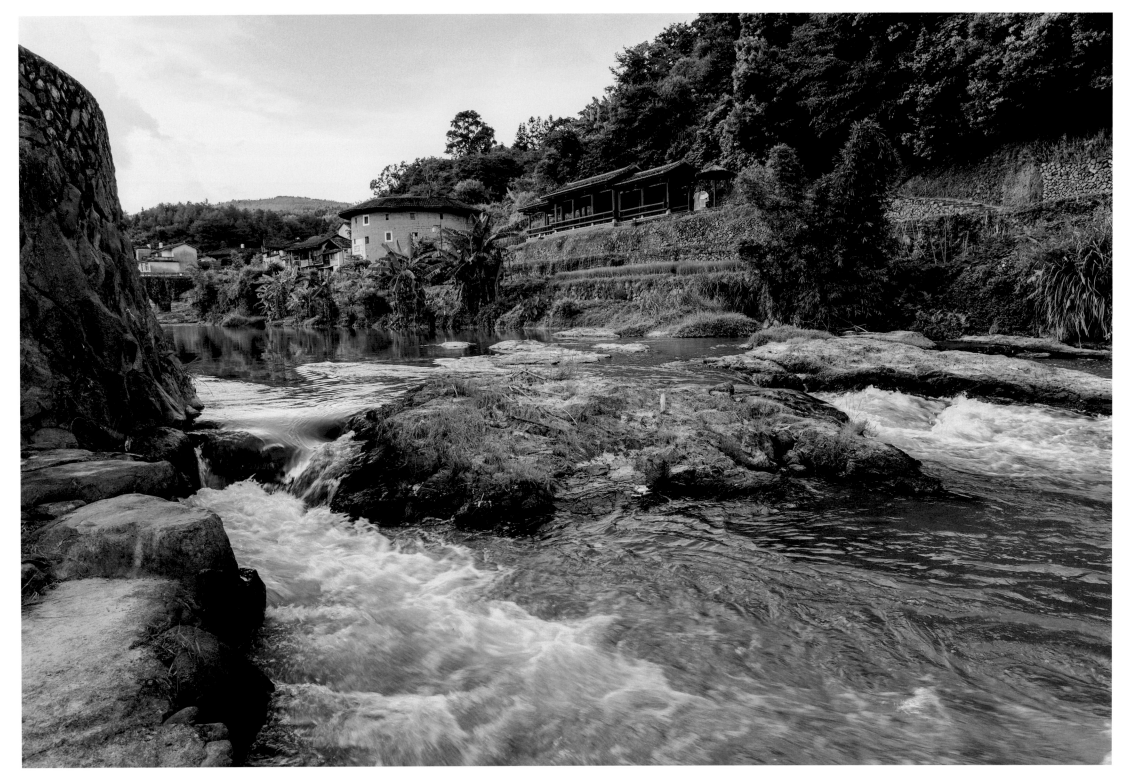

土楼的选址都在依山傍水之处，门前小河流水，屋后青山苍翠 / 赖小兵 摄
The earth buildings are situated at the foot of a mountain and beside a stream. The small river in front of the door is flowing and the green mountains behind the house are verdant /Photographed by Lai Xiaobing

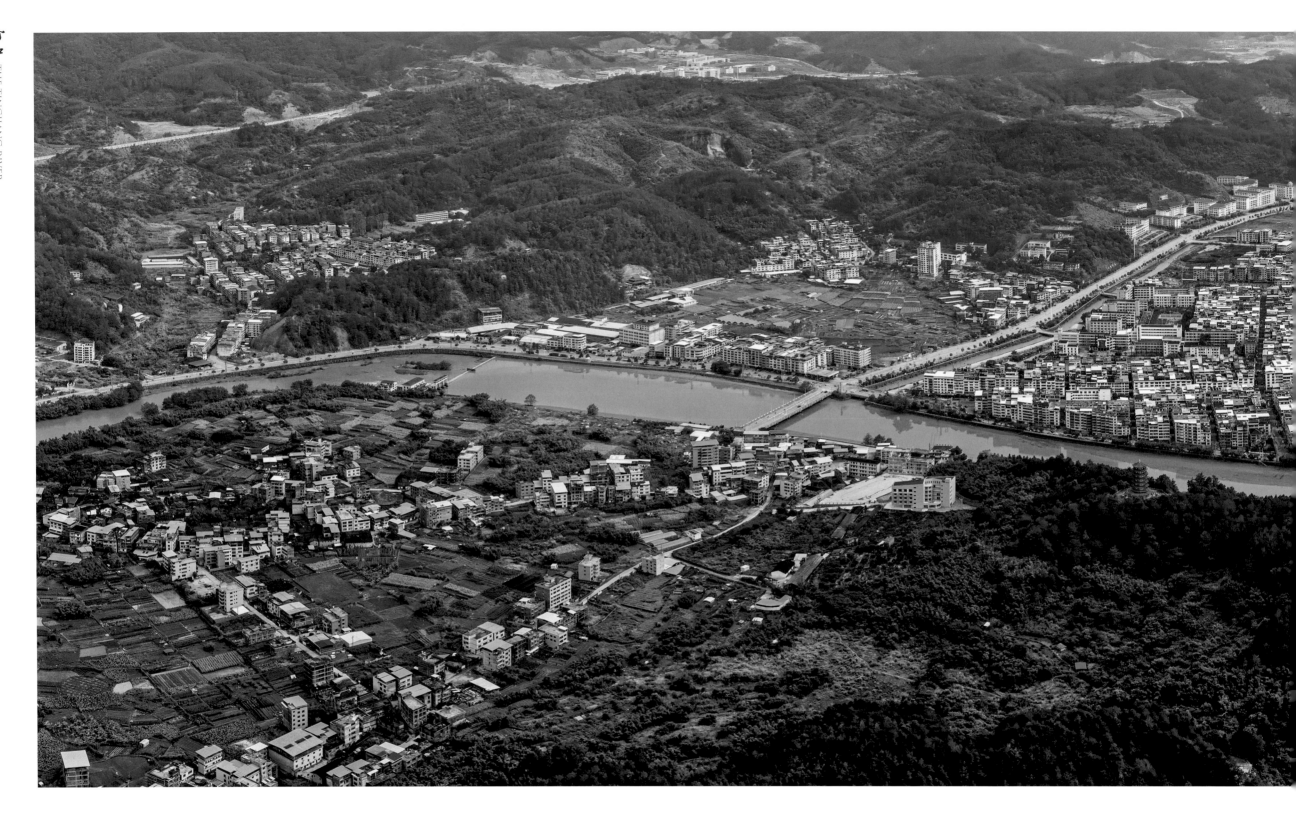

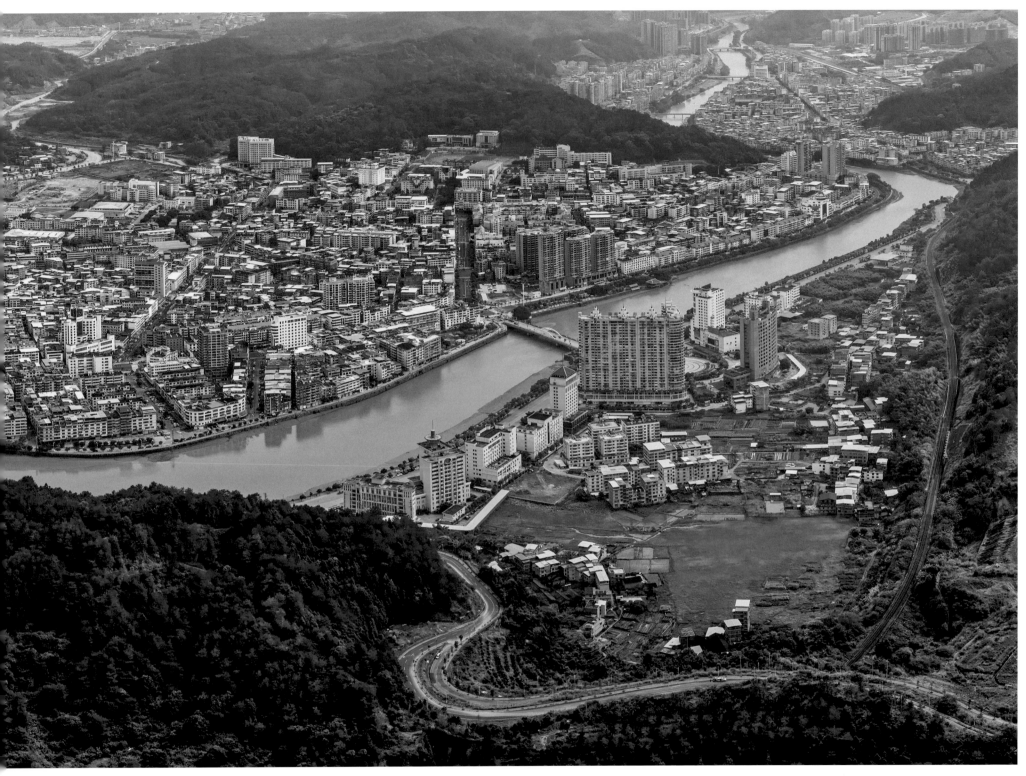

永定区位于闽西南部，是福建省的边陲县，汀江绕城而过。境内还有两条河，一条是从北往西南流向的永定河，一条是从东往南流向的金丰河 / 朱晨辉 严硕 摄

Yongding County, located in the south of Western Fujian, is a border county in Fujian Province. The Tingjiang River passes around the city. There are also two rivers in the territory: one is the Yongding River, which flows from north to southwest, the other is the Jinfeng River, which flows from east to south /Photographed by Zhu Chenhui, Yan Shuo

New
Xinluo

新罗新语

　　新罗区为1996年龙岩地区撤地建市后设立，此前为龙岩市。一般认为，新罗是个新名称，其实，新罗早于龙岩，并成为县名。新罗早先称"什罗"，先民来自洛水。在发现了龙岩洞和龙硿洞后，什罗改称龙岩。龙岩，即龙的传人生息的岩洞。中华民族历来称之为龙的传人，而以龙字命名某一地名，似乎仅有龙岩。然而，神奇的是，无论是龙岩洞还是龙硿洞，在发现之后又曾消失过，直到20世纪七十年代，才又被重新发现，对外开放则要更晚一些。龙硿洞大洞套小洞，迂回曲折，变化无穷，除主洞外，计有16个分洞，都是满目钟乳悬挂，千姿百态，是个天然的大迷宫。洞外还有龙井、龙蛋石、龙须瀑、睡狮岩，龙潭湖等景观。龙硿洞不仅是福建省罕见的天然石灰岩溶洞，还成了新罗的一张名片。

　　新罗区是福建省的重要林区，举目皆绿，森林的色彩呈现鲜明的块状，针叶林、阔叶林、竹林等，在阳光下呈现深绿、墨绿与淡绿，而在林间纷呈的色彩下，隐藏着的更是千姿百态。近年来，新罗区依托良好的生态环境资源，大力发展乡村生态游，适时开发生态旅游区，并创新旅游发展模式，成为"中国生态旅游百强区"。

In 1996, the former Longyan District became a prefecture-level city, and accordingly the former county-level Longyan City was renamed Xinluo District. It is generally believed that Xinluo is a new name. In fact, Xinluo was earlier than Longyan and was a county name, which was called "Shiluo" earlier. Its ancestors came from the Luoshui River Basin and brought Heluo civilization. After the discovery of Longyan Cave and Longkong Cave, Shiluo was changed into Longyan. Longyan means the cave where the descendants of the dragon live. The Chinese nation has always called itself the descendant of the dragon, but it seems that only Longyan has a place name named after the chinese counterpart of dragon. However, amazingly, both Longyan Cave and Longkong Cave disappeared for a period of time after their discovery, and were rediscovered only in the 1970s, and the opening up was later. Longkong Cave is a natural maze with 16 caves besides the main cave, all of which are hung with lava stalactite. Since small caves are contained in bigger ones, the overall scene is tortuous with endless changes. Outside the cave are Longjing, Longdanshi, Longxu Waterfall, Sleeping Lion Rock, Longtan Lake and other landscapes. Longkong Cave is not only a rare natural limestone cave in Fujian Province, but also a business card of Xinluo.

Xinluo District is an important forest area in Fujian Province. All eyes are green. The colors of forests show distinct blocks. Coniferous forests, broad-leaved forests, bamboo forests, etc. show dark green, blackish green and light green in the sunshine. Under the colors of forests, there are various hidden charming plants. In recent years, relying on good ecological environment resources, Xinluo District has vigorously developed rural eco-tourism, timely opened up eco-tourism areas, and innovated tourism development model, becoming "Top 100 eco-tourism areas in China".

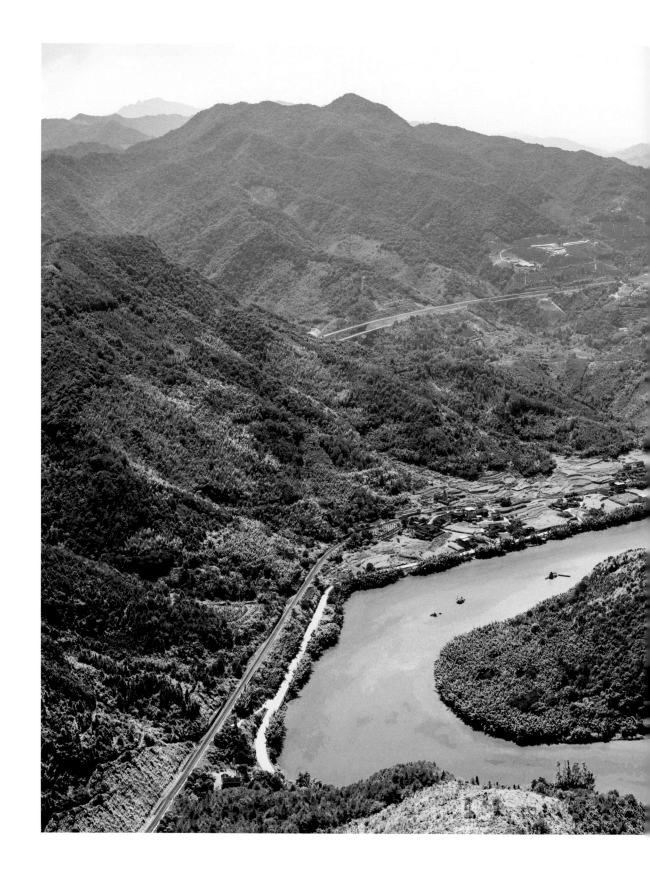

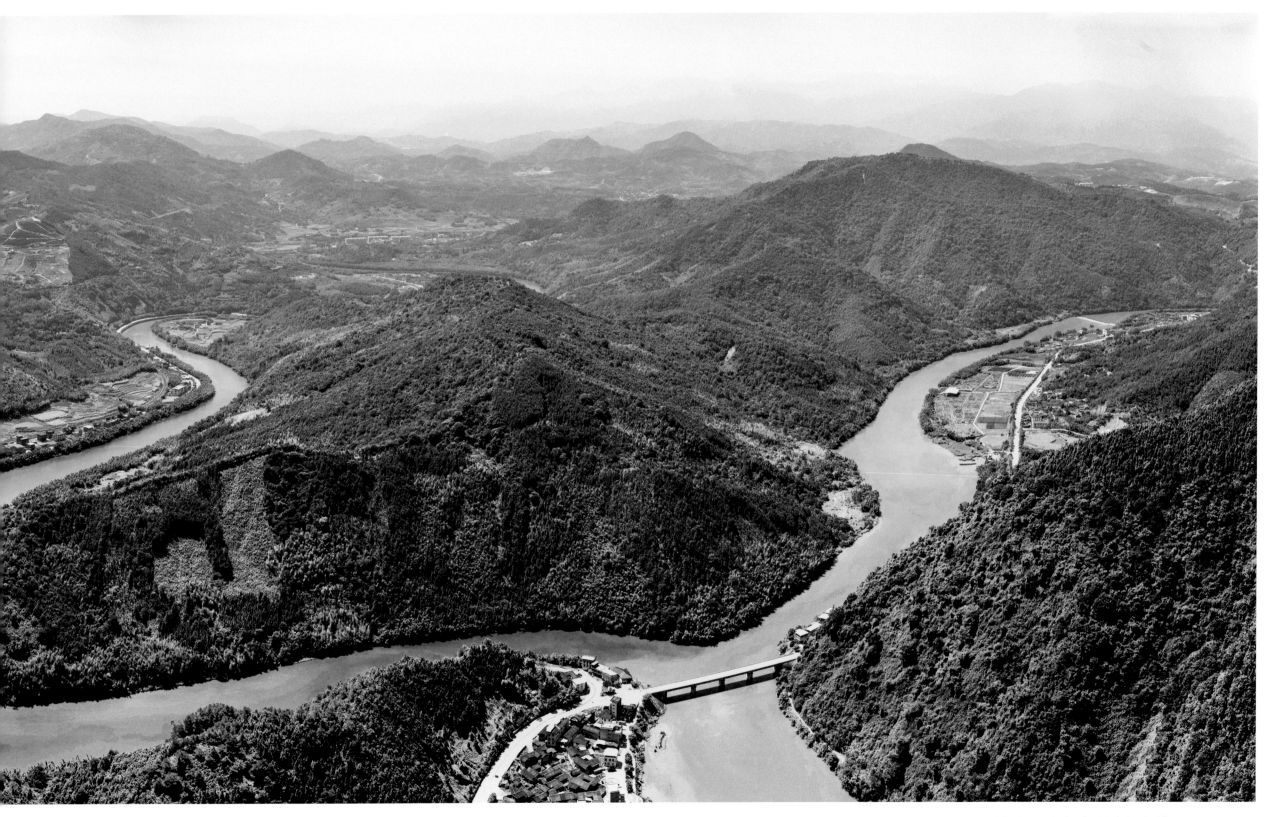

万安溪、雁石溪两大溪流在新罗汇合 / 朱晨辉 严硕 摄
The confluence of Wan'an and Yanshi streams in Xinluo /Photographed by Zhu Chenhui, Yan Shuo

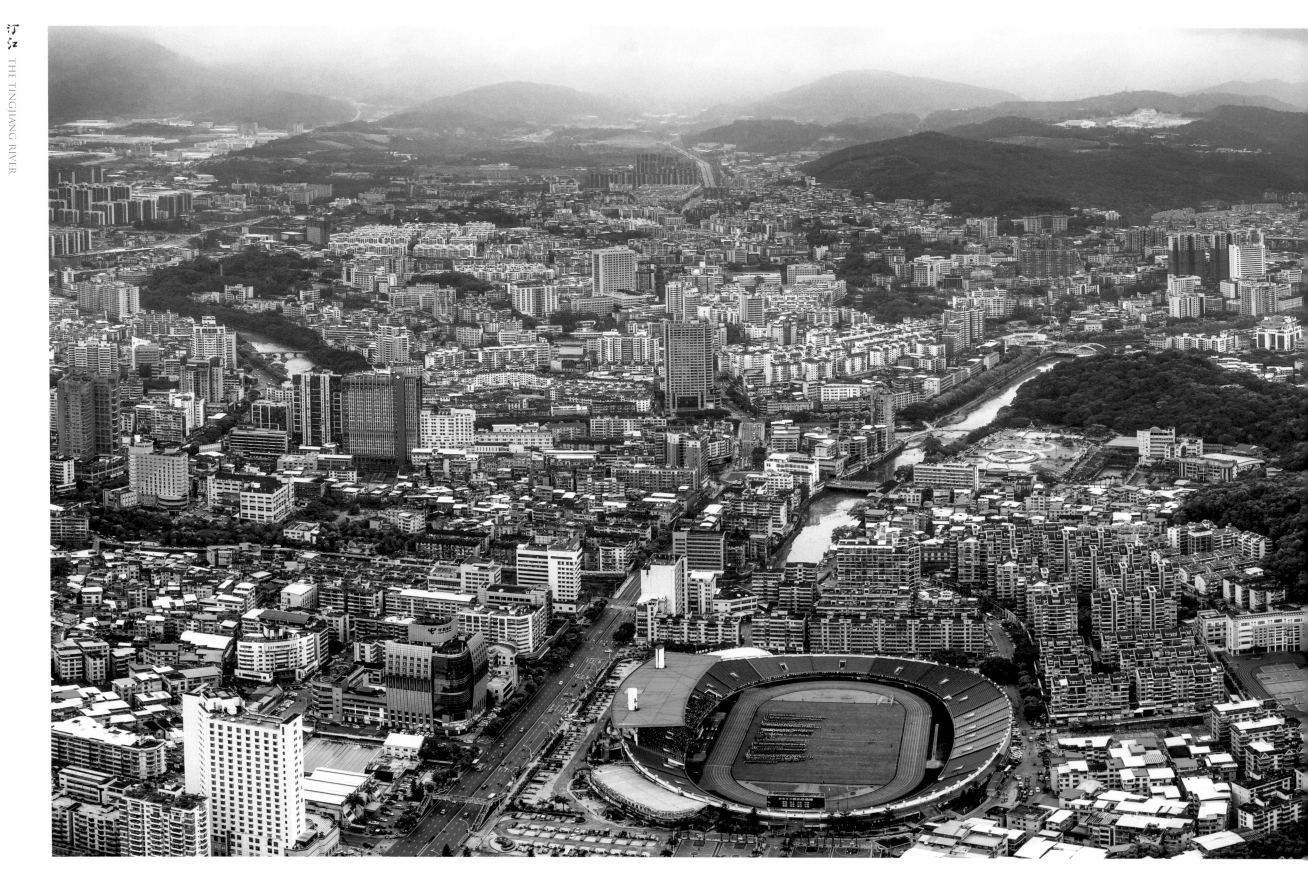

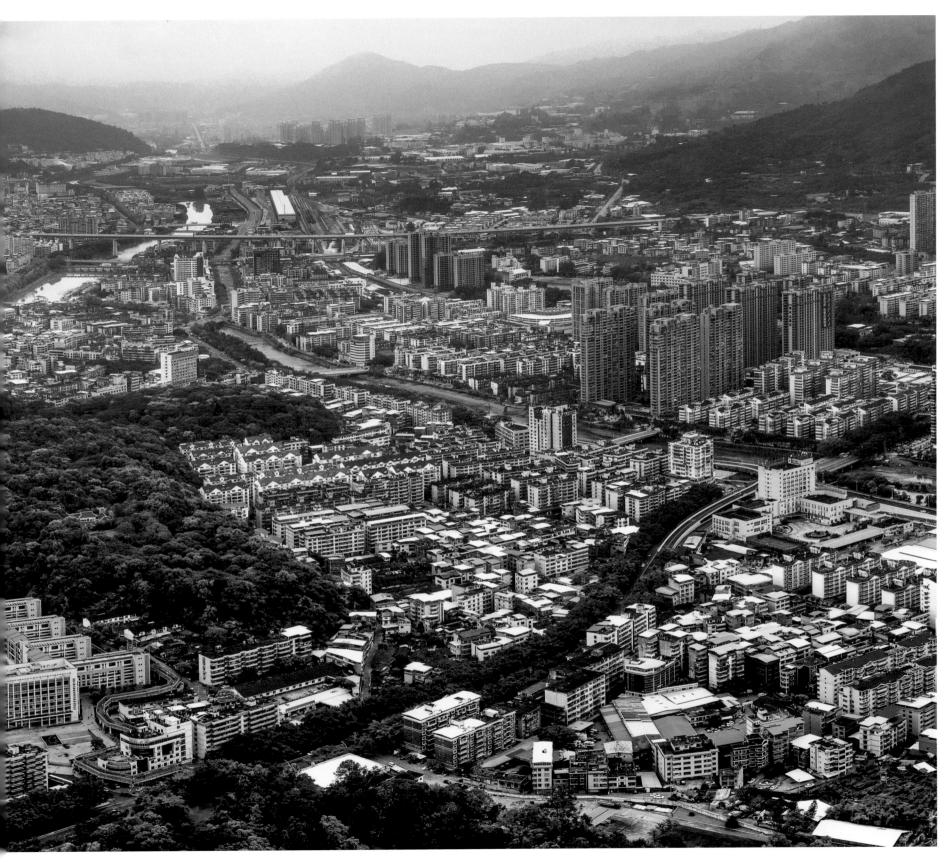

　　新罗区是闽西政治、经济、文化和交通中心，是闽、粤、赣区连接沿海，拓展腹地的重要枢纽 / 朱晨辉 严硕 摄

Xinluo District is the political, economic, cultural and transportation center of Western Fujian, and is also an important hub for Fujian, Guangdong and Jiangxi to connect with the coastal areas and expand the hinterland /Photographed by Zhu Chenhui, Yan Shuo

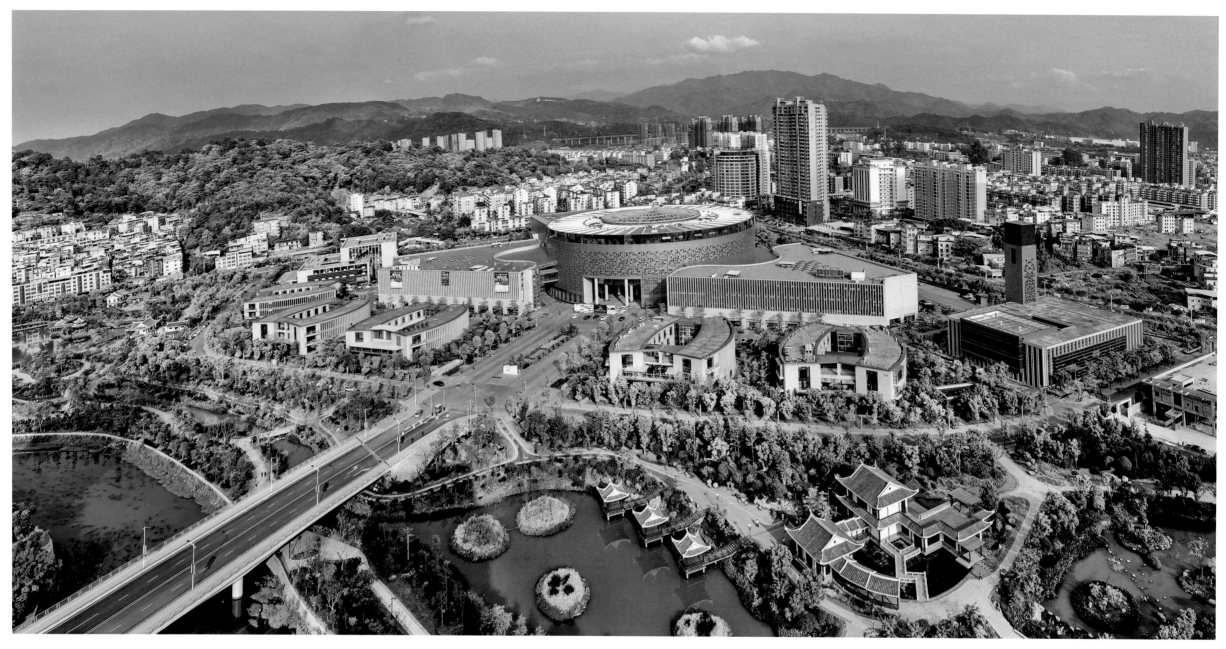

城在绿中、新罗区是中国生态旅游百强区 / 林健德 摄

The city is in the green. Xinluo District is one of the top 100 ecotourism districts in China /Photographed by Lin Jiande

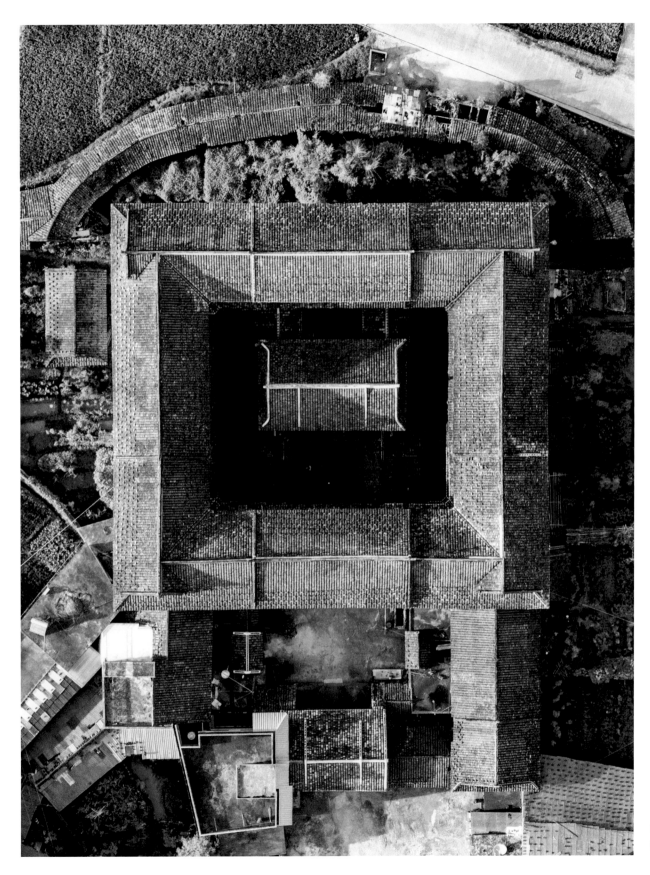

从空中俯瞰典藏楼 / 朱晨辉 严硕 摄
Overlooking Diancang Building from the air /Photographed by Zhu Chenhui, Yan Shuo

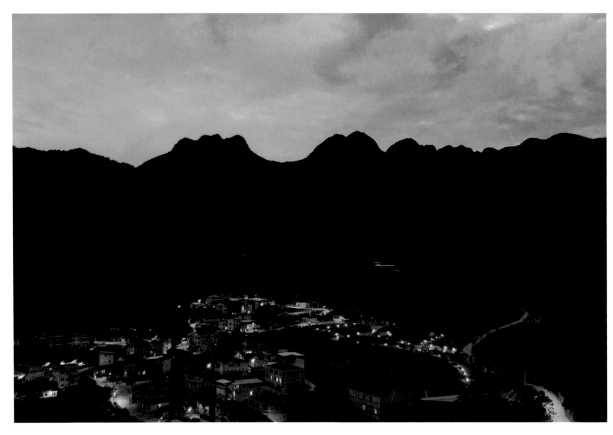

美丽的传说——江山睡美人 / 上官毅清 摄
Beautiful legend—Sleeping Beauty /Photographed by Shangguang Yiqing

龙岩洞摩崖石刻，福建省为数不多的地下大型刻，是龙岩历史发展的重要见证 / 郭军 摄
Inscriptions on precipices in Longyan Cave is one of the few large-scale underground carvings in Fujian Province and an important witness to Longyan's historical development /Photographed by Guo Jun

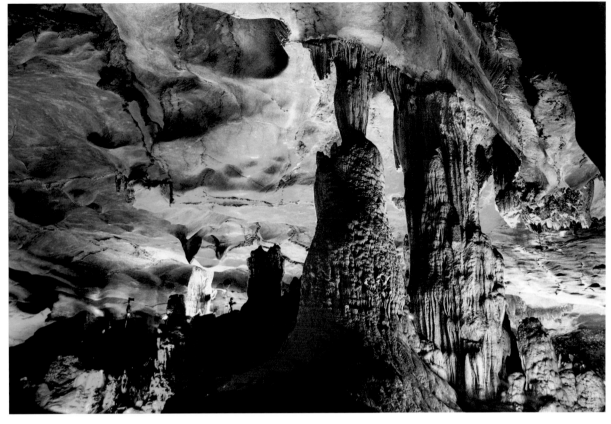

龙岩洞形成于三亿年前的古生代，有着丰富的山林景观和复杂独特的喀斯特地貌，洞内景色奇幻 / 郭军 摄
Longyan Cave was formed 300 million years ago in the Paleozoic era, which has rich mountain forest landscapes and complex and unique karst landform. The scenery inside the cave is fantastic /Photographed by Guo Jun

国家级东肖森林公园充满原始气息的"华东神秘桫椤谷" / 赖小兵 摄
The National Dongxiao Forest Park is full of the primitive flavor of "East China Mysterious Alsophila Valley" /Photographed by Lai Xiaobing

Blessed
Zhangping

福地漳平

漳平，主要为河洛裔的闽南人，亦有客家。300 多年前，徐霞客来漳平，将九鹏溪称之为宁洋溪。如今被赋予"水上茶乡"的九鹏溪，已是国家 AAAA 级旅游景区，为天台国家森林公园核心景区之一，以奇山、秀水、茶园、密林、珍禽（鸳鸯）见长，集观光、休闲、娱乐、度假等为一体。九鹏溪景区以"水上茶乡"为定位，此地产有历史悠久的水仙茶，其包装与韵味都独具特色。永福高山茶园是近年新建立的茶园，气势壮观，延绵几个山头，一眼望去，茶园连到了天边。这个茶园，不只是大，还有它的特色，茶园中种植樱花树，一到樱花盛开之时，成片的绿与路上弯曲而行的红，将整个茶园装点成蓝天白云下的巨幅油画。

奇和洞遗址位于漳平境内象湖镇灶头村，是一处旧石器时代晚期向新石器时代早期过渡的洞穴遗址。已发现 3 处旧石器时代晚期人工石铺活动面遗迹，有火塘、红烧土堆、灰坑、房址、灶、沟等。奇和洞遗址是福建地区最早的新石器时代土著文化，它的发现填补了福建乃至中国东南区域史前文化新、旧石器过渡阶段的空白，被评为 2011 年度全国十大考古新发现之一，2013 年先后被核定为福建省文物保护单位和第七批全国重点文物保护单位。

Residents of Zhangping are mainly the people of Southern Fujian of Heluo descent. Some other Zhangping residents are Hakkas. More than 300 years ago, Xu Xiake came to Zhangping and Jiupengxi was then called Ningyangxi. Nowadays, Jiupengxi, which enjoys the fame of "Water Tea Township", is one of the core scenic spots of Tiantai National Forest Park. It is famous for its unique mountains, beautiful waters, tea gardens, dense forests and rare birds (mandarin ducks). It integrates sightseeing, leisure, entertainment and vacation. Jiupengxi scenic spot is located as "water tea township", and accordingly the local specialty is narcissus tea with a long history, whose packaging and flavor are distinctive. Yongfu Alpine Tea Garden is newly established in recent years. It has a magnificent momentum and stretches over several hills. At a glance, the tea garden is connected to the horizon. This tea garden is not only big, but also characteristic. Cherry trees are planted in the tea garden. When the cherry blossoms are in full bloom, the whole tea garden is decorated with giant paintings under the blue sky and white clouds.

Qihe Cave Site, located in Zaotou Village, Xianghu Town, Zhangping, is a cave site transiting from late Paleolithic to early Neolithic. Three traces of artificial stone pavement in the late Paleolithic period have been found, including fire ponds, red burnt earth piles, ash pits, houses, stoves and ditches. Qihe Cave Site is the earliest Neolithic indigenous culture in Fujian Province. Its discovery fills in the gap of the transition period between the Neolithic and Paleolithic relics in the prehistoric culture of Fujian and southeastern China. It was appraised as one of the ten new archaeological discoveries in China in 2011. In 2013, it was approved as the cultural relics protection unit of Fujian Province and the seventh batch of national key cultural relics protection units.

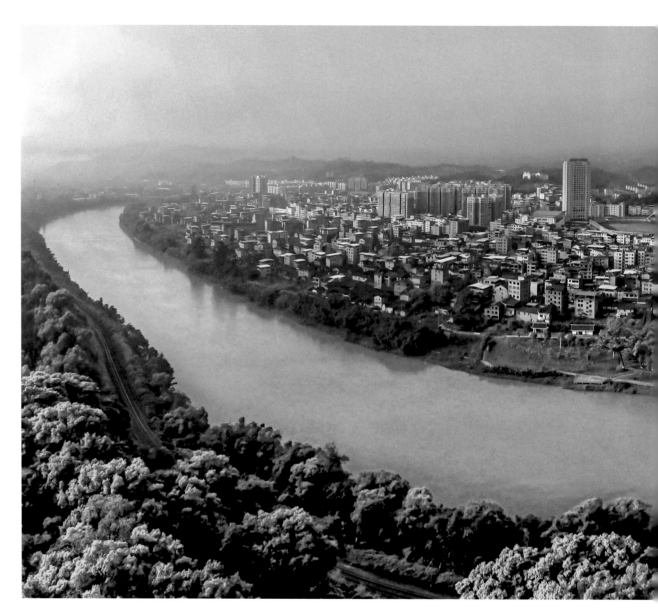

漳平市全景图　Panorama of Zhangping City

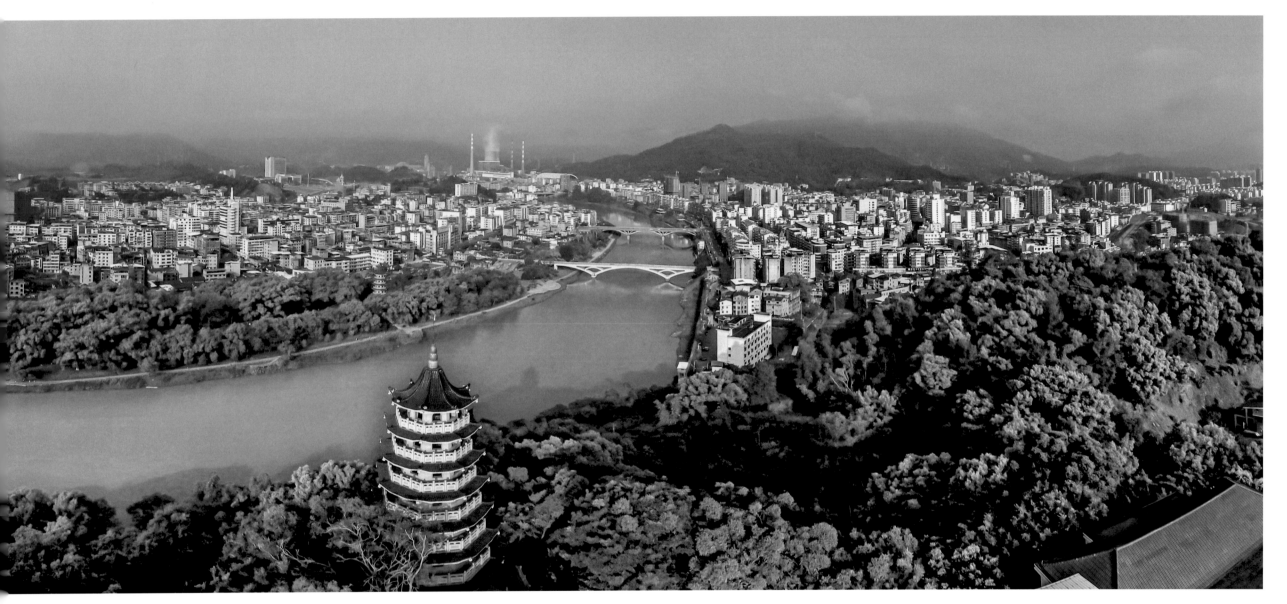

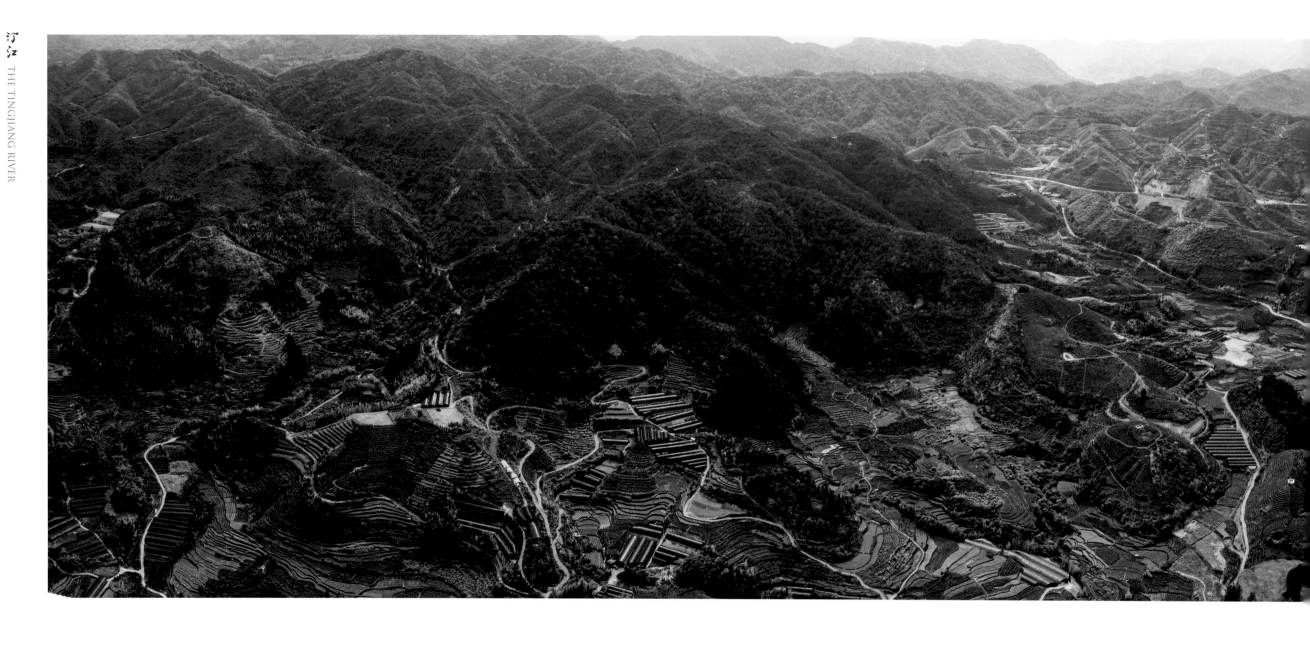

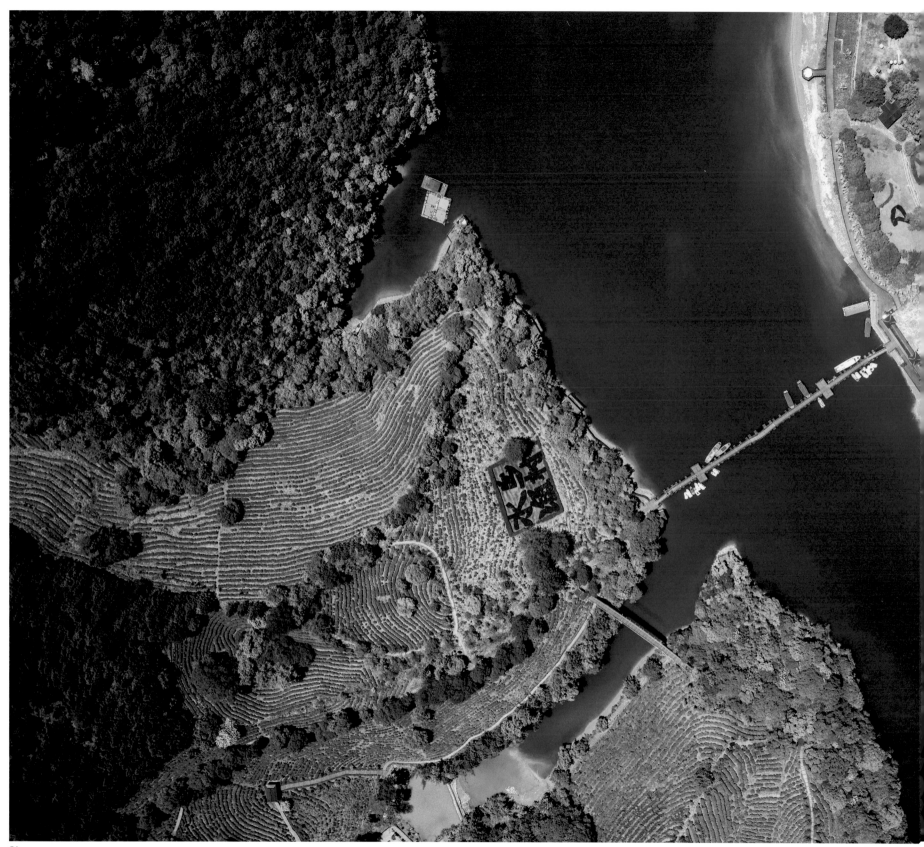

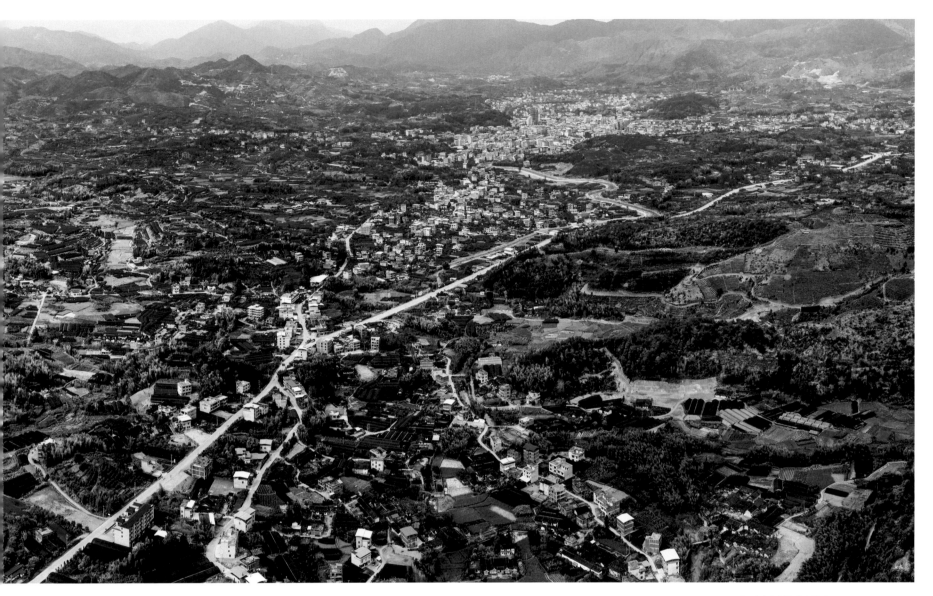

漳平永福镇全景图　/　朱晨辉　严硕 摄
Panorama of Yongfu Town, Zhangping City /Photographed by Zhu Chenhui, Yan Shuo

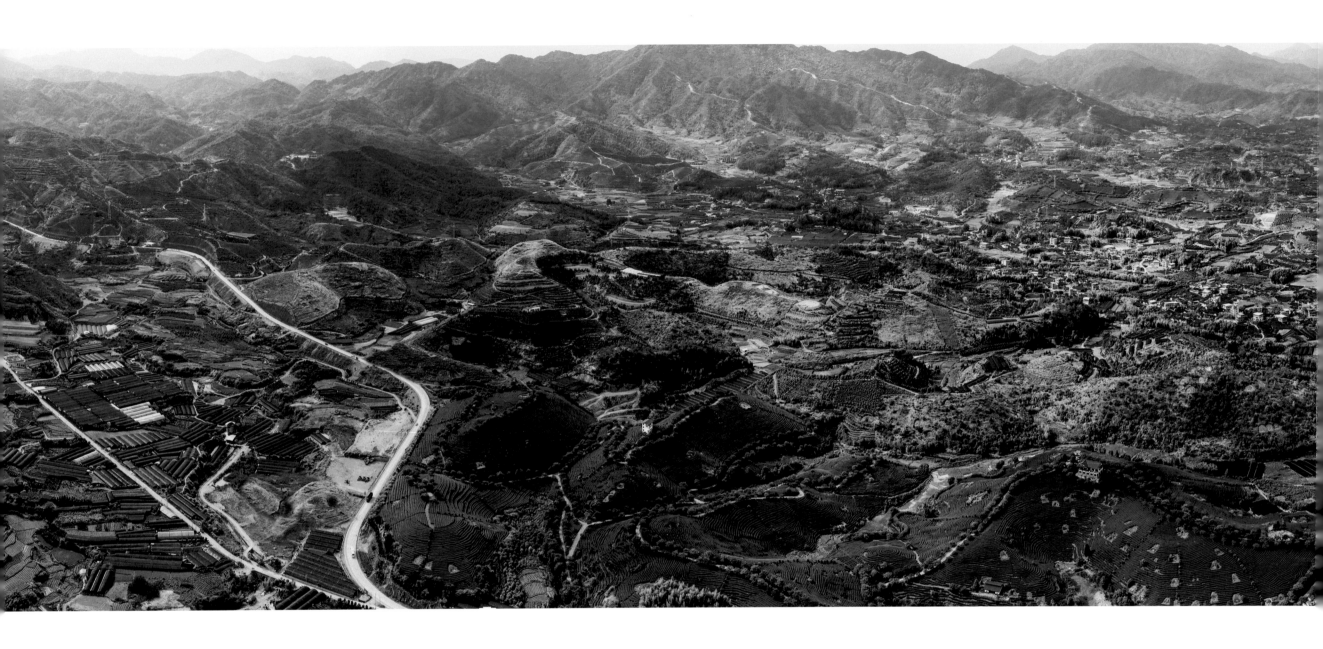

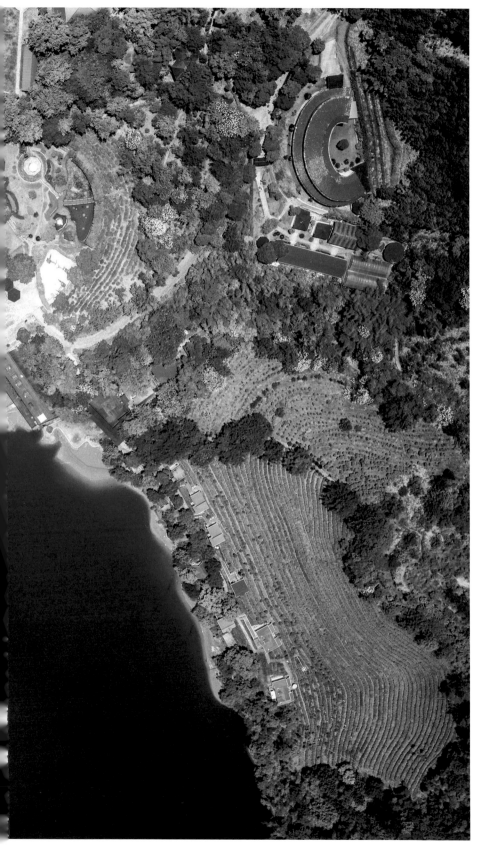

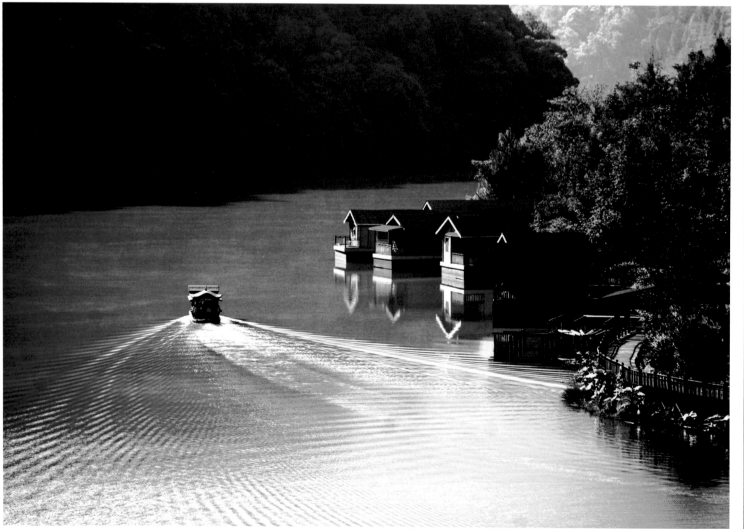

02

03

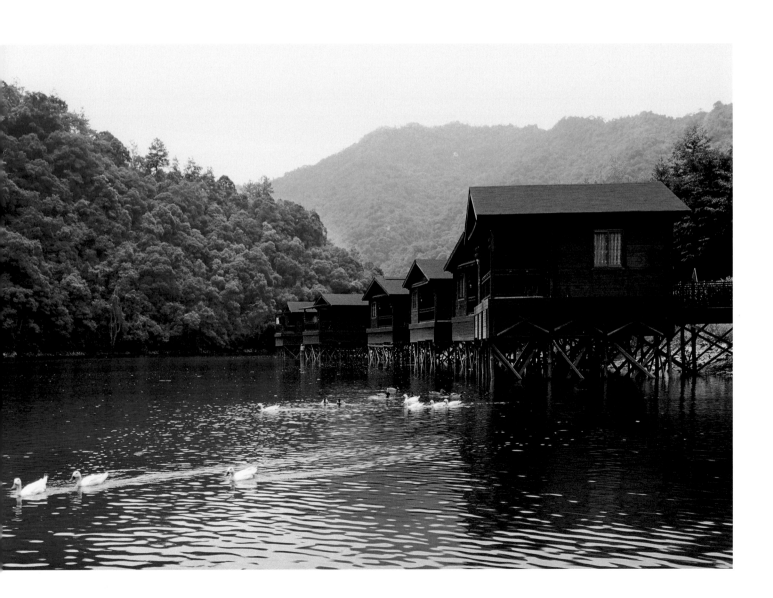

01　　漳平九龙溪国家森林公园 / 朱晨辉 严硕 摄
Zhangping Jiulong Stream National Forest Park /
Photographed by Zhu Chenhui, Yan Shuo

02　　九鹏溪风景区位于漳平市南洋乡，是天台国家森林公园核心景区之一。景区围绕"水上茶乡"定位，以水体景观为主体，融合森林旅游、人文旅游等形成山水特色。旅行家徐霞客曾两度泛舟九鹏溪 / 林天南 摄

Jiupeng Stream Scenic Spot, located in Nanyang Township, Zhangping City, is one of the core scenic spots of Tiantai National Forest Park. The scenic spot gives full play to the characteristics of the tea mountain and waterscape, focuses on the positioning of "hometown of tea on water", takes the water landscape as the main body, and integrates the characteristics of forest tourism and human tourism. Xu Xiake, a traveler, once boated twice in Jiupengxi /Photographed by Lin Tian' nan

03　　漳平九鹏溪森林人家 / 黄海 摄
Zhangping Jiupeng Stream Forest Home /
Photographed by Huang Hai

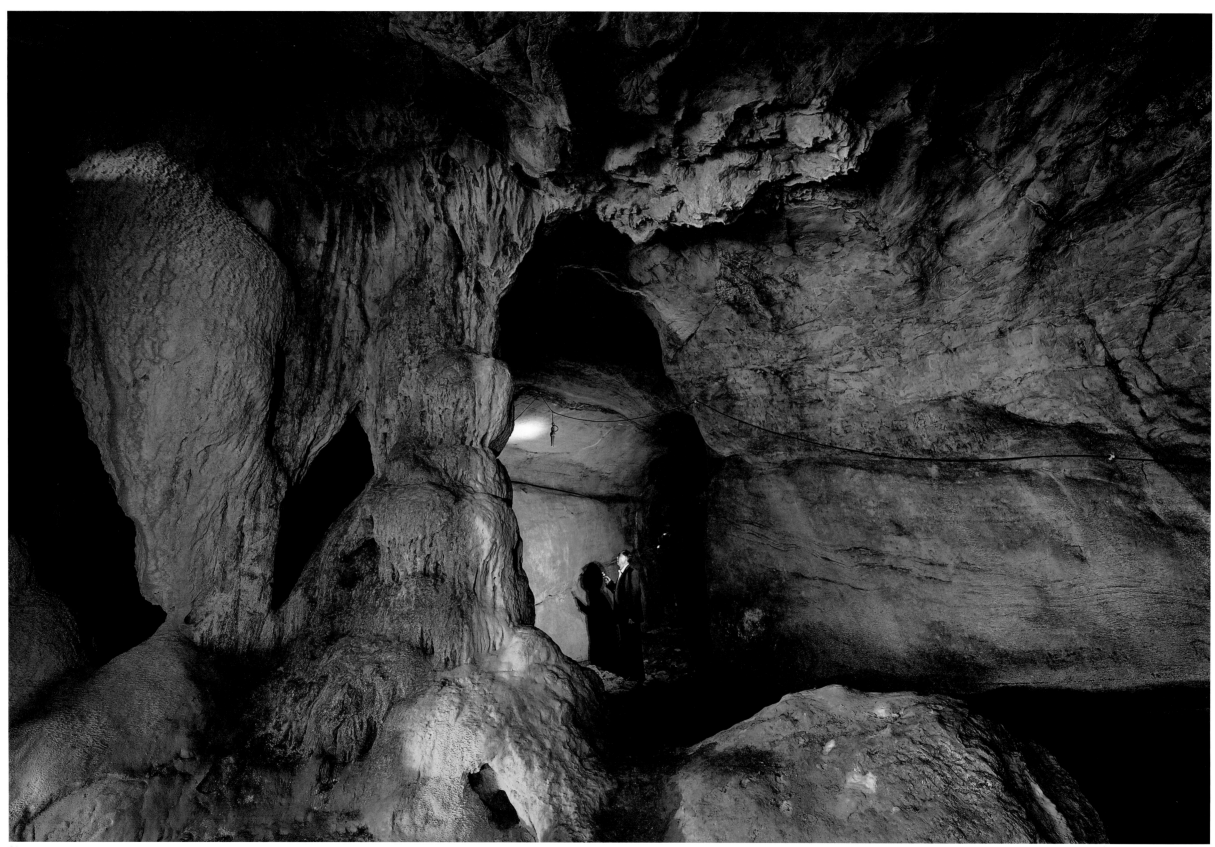

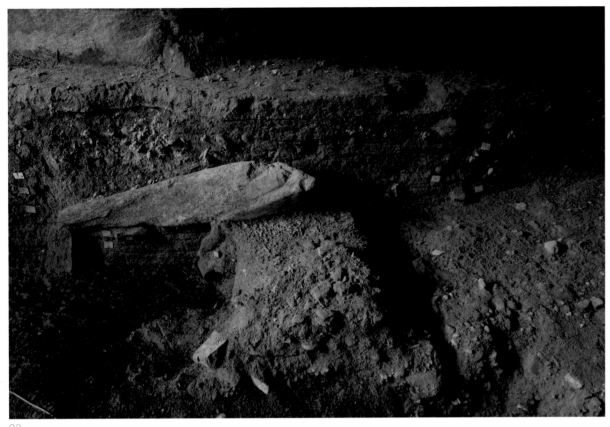

02

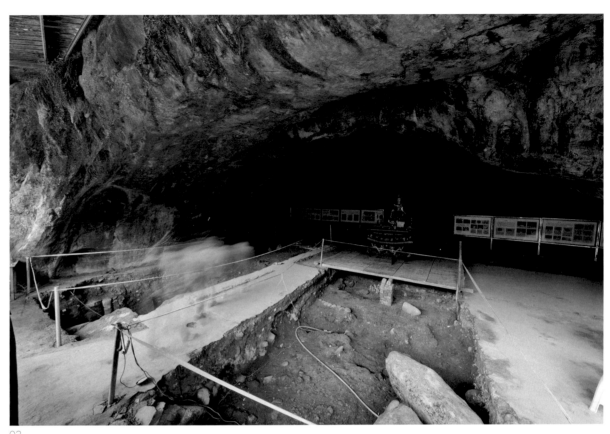

03

01 　　奇和洞遗址代表了福建地区最早的新石器时代土著文化，对研究海峡两岸古人群的迁徙和文化交流以及对南岛语族的起源与扩散等课题都具有重要的意义，被评为"2011年度全国十大考古新发现"之一 / 吴寿华 摄

The ruins of Qihe Cave represents the earliest indigenous culture of the Neolithic Age in Fujian area, which is of great significance to the analysis of the migration and cultural exchange of ancient people on both sides of the Taiwan Strait and the study of the origin and spread of Austronesian language family. It has been rated as one of the "Top Ten National New Archaeological Discoveries in 2011" /Photographed by Wu Shouhua

02 　　奇和洞遗址的断层结构 / 赖小兵 摄
The fracture of the Qihe Cave /Photographed by Lai Xiaobing

03 　　奇和洞洞穴遗址 / 赖小兵 摄
The ruins of Qihe Cave /Photographed by Lai Xiaobing

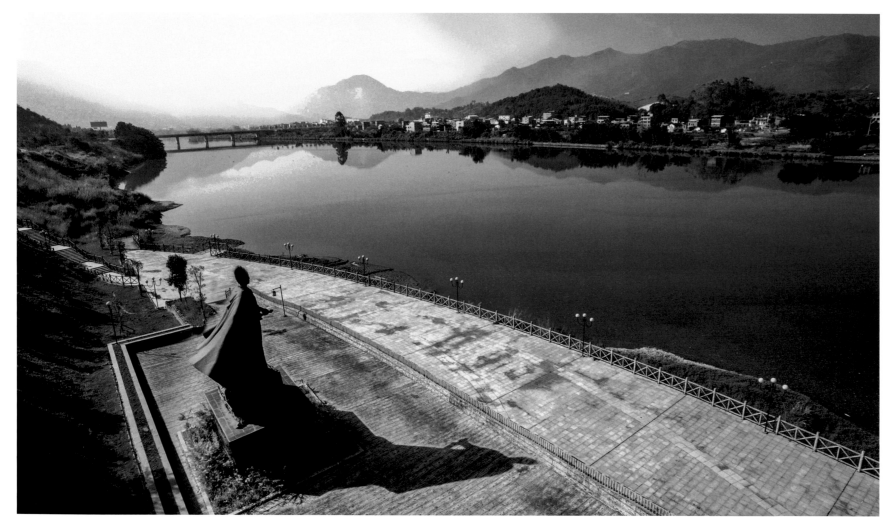

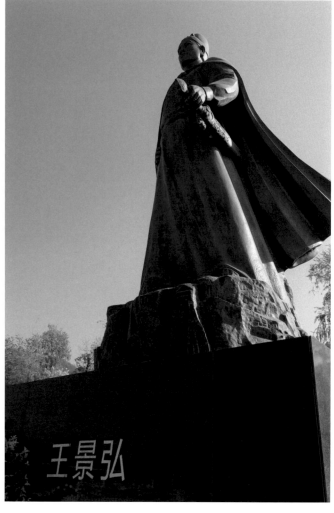

从明永乐三年（1405）到宣德八年（1433），郑和、王景弘先后 7 次率领船队下西洋，其中 5 次明确记载王景弘参与其中。另外，在史学界，还有人称明朝的远航壮举为"八下西洋"，最后一次出使苏门答腊的远航因郑和病逝而由王景弘独立指挥完成 ／ 吴军 摄

From the 3rd year of the reign of Emperor Yongle in the Ming Dynasty (1405) to the 8th year of the reign of Emperor Xuande (1433), Zheng He and Wang Jinghong successively led the fleet to the West for seven times, of which 5 times clearly recorded Wang Jinghong's participation. In addition, in the history circle, there were also people who called the voyage feat of the Ming Dynasty as "Eight Voyages to the West". The final voyage to Sumatra was completed under the independent command of Wang Jinghong due to Zheng He's death /Photographed by Wu Jun

王景弘雕像　The statue of Wang Jinghong

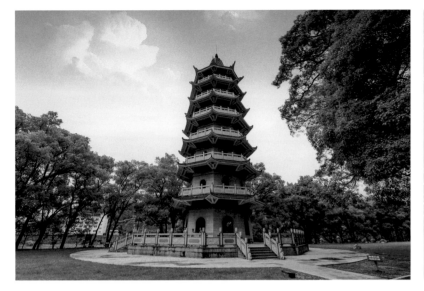

漳平市振文塔　Zhenwen Tower in Zhangping City

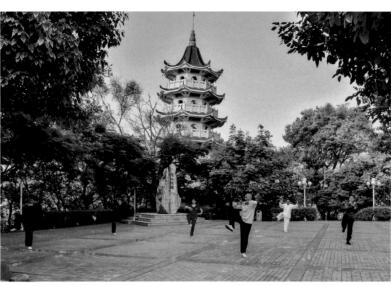

东山公园 / 吴军 摄　Dongshan Park /Photographed by Wu Jun

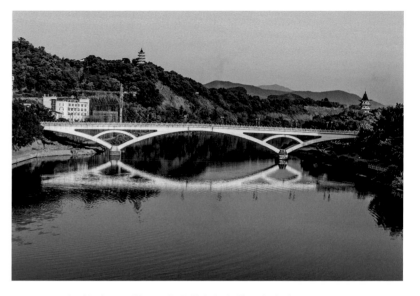

漳平市龙江双塔，即东山塔和振文塔，为漳平八景之一 / 吴军 摄
Two pagodas of the Longjiang River in Zhangping City, namely Dongshan Pagoda and Zhenwen Pagoda are one of the eight major sceneries in Zhangping /Photographed by Wu Jun

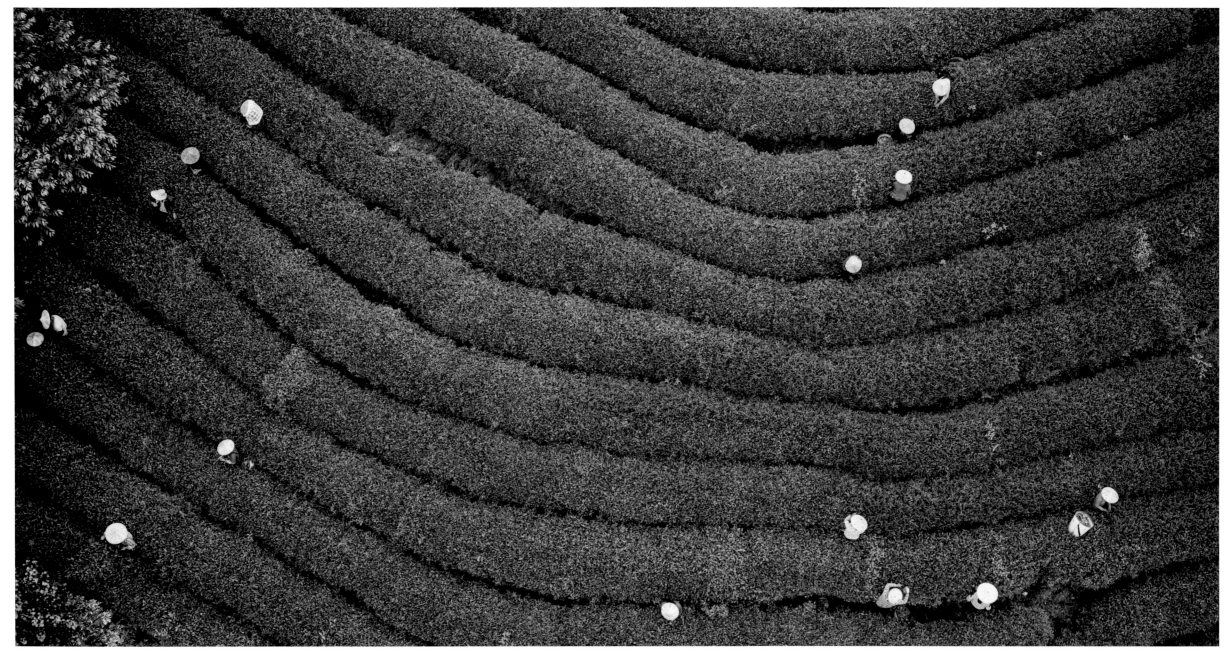

漳平永福茶园是大陆最大的台湾高山茶种植基地 / 朱晨辉 严硕 摄
Yongfu Tea Garden in Zhangping is the largest Taiwan high mountain tea planting
base in mainland China /Photographed by Zhu Chenhui, Yan Shuo

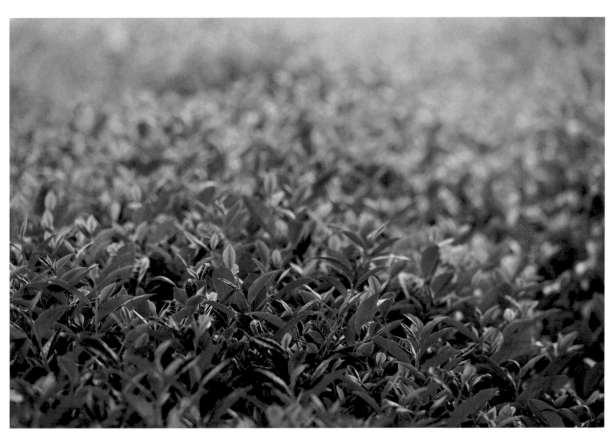

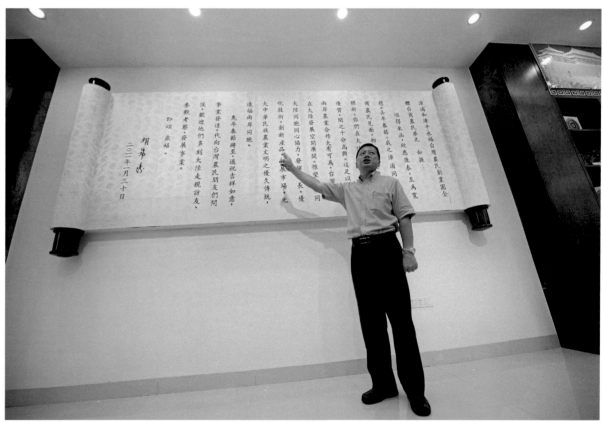

永福高山茶种植面积约 5.5 万亩，年产干茶 3000 多吨，主要以软枝乌龙、金萱、翠玉、四季春等四个茶树
品种种植加工生产而成，其中软枝乌龙种植面积最大 / 赖小兵 摄
Yongfu high mountain tea has a planting area of about 55,000 mu and an annual output of more
than 3,000 tons of dry tea, which is mainly produced by planting and processing four tea varieties such as
Ruanzhi Oolong, Jin Xuan, Cuiyu and Sijichun. Among them, Ruanzhi Oolong has the largest planting area /
Photographed by Lai Xiaobing

漳平永福台品樱花茶园总经理向来宾介绍胡锦涛同志给漳平、漳浦台商的回信 / 严硕 摄
The general manager of Taipin Sakura Tea Garden in Yongfu, Zhangping introduced Comrade
Hu Jintao's reply to the Taiwan businessmen in Zhangping and Zhangpu /Photographed by Yan
Shuo

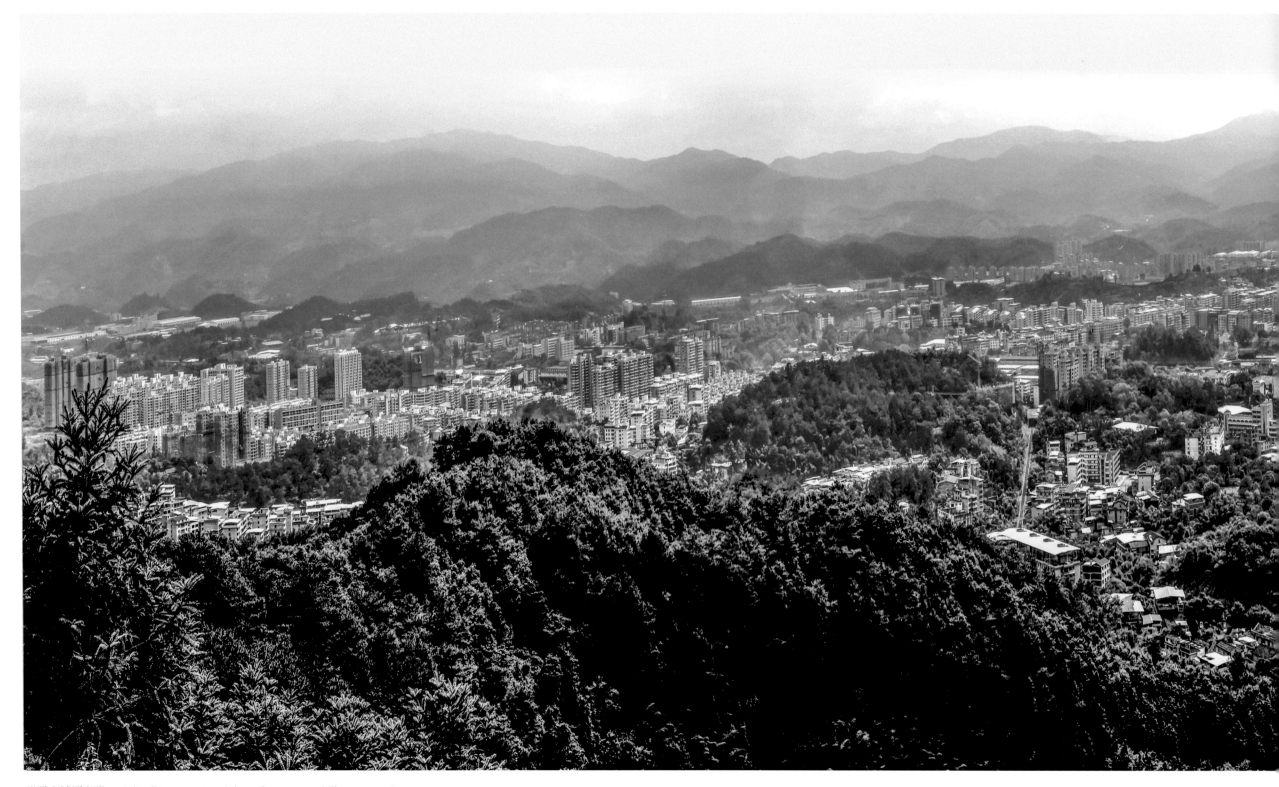

漳平市城区鸟瞰　A bird's-eye view of the urban area of Zhangping City

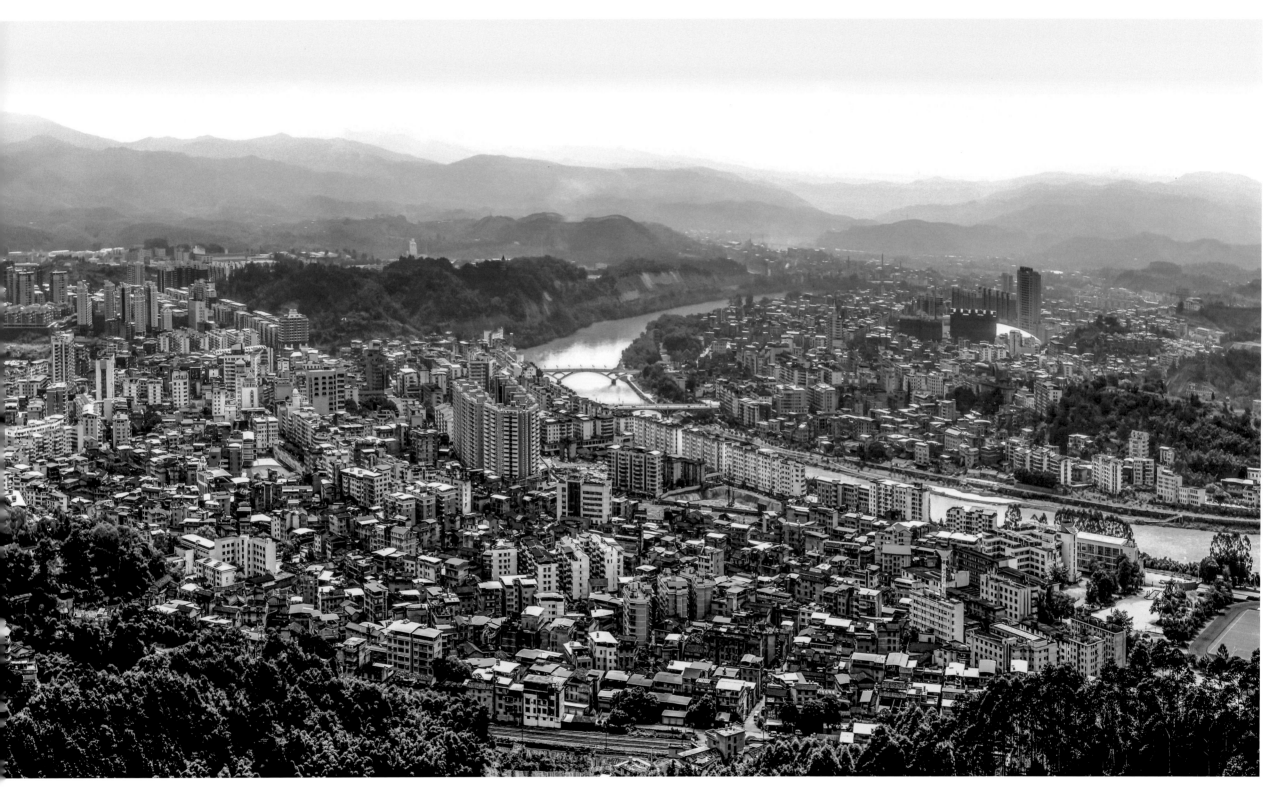

汀江大型影像文化创作
工程行走记录

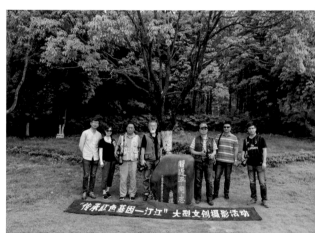

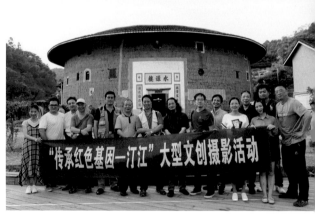

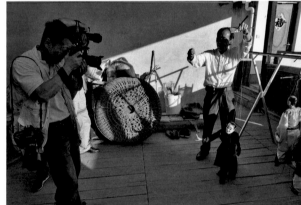

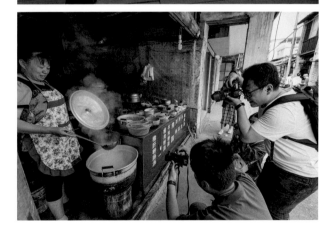

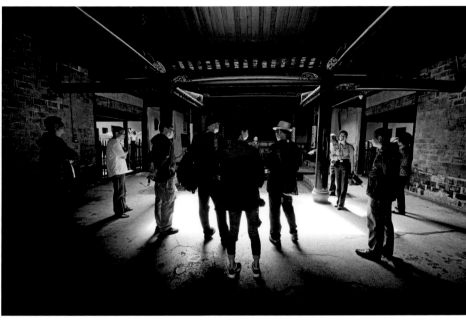

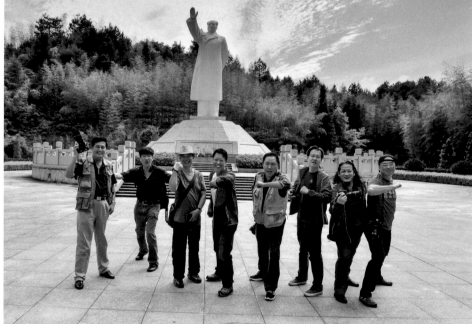

汀江大型影像文化创作工程主创人员
The Leading Creators of the Large-Scale Image Cultural Creation Project The Tingjiang River

曾璜，美国 Syracuse 大学传播摄影硕士；Corbis 图片社签约摄影师，新华社高级编辑。出版中国第一本个人战地新闻摄影作品集《波黑：战火浮生》，主编中国唯一的《图片编辑手册》和北京电影学院《报道摄影》教科书。

崔建楠，原福建画报社社长、总编辑。主编的《福建戏剧丛书》荣获首届"中国出版政府奖"提名奖。福建传统地方戏剧系列影像作品《千秋梨园》曾参加鼓浪屿摄影画廊 2010 年春季展、第二届大理国际影会、2010 年平遥国际摄影节，都得到了较高评价和较大的影响。

焦红辉，福建省摄影家协会副主席。1999 年出版个人纪实摄影集《客家祖地》。曾任海风出版社社长、总编辑，现为《两岸视点》杂志编委。

吴寿华，福建省摄影家协会副主席。2001 年获"首届福建杰出青年摄影家"称号，2002 年获"福建省新闻双十佳记者"称号。计有上百组摄影专题在全国评选中入选、获奖。

陈扬富，1955 年 6 月出生，湖北武汉人，公务员，中国摄影家协会会员。

那兴海，1957 年 3 月出生，知青、军人、中国摄影家协会会员。

姜克红，高级记者，新华社福建分社摄影室主任。2001 年毕业于中国人民大学哲学系，同年进入新华社福建分社工作至今，曾先后被公派至新华社亚欧总分社和台湾进行长期驻点采访工作，近年来参加了抗日战争胜利"九三"阅兵、庆祝中华人民共和国成立 70 周年阅兵、金砖国家领导人厦门会晤、上合组织青岛峰会、武汉军运会等国家重大活动报道。

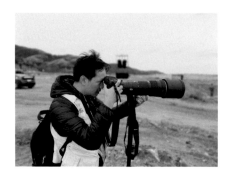

王东明，中国新闻社福建分社摄影部主任，福建省新闻摄影学会副会长。曾参加过国庆 70 周年阅兵、北京奥运会、全国两会、金砖五国厦门会晤、驻点台湾等重要采访活动。曾获中国新闻摄影年赛银奖、中国新闻摄影金镜头银奖、福建省新闻摄影一等奖、福建外宣好新闻一等奖等荣誉。

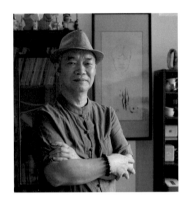

王炳根，中国冰心研究会、冰心文学馆创始人，福建省作家协会顾问、中国博物馆学会文学委员会副主任、名人故居委员会副主任、国家一级作家。

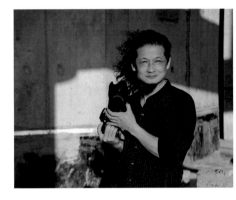

陈伟凯，中国摄影家协会会员、美国摄影学会会员、福建省旅游摄影协会副主席、厦门市摄影家协会副秘书长。获福建省摄影家协会授予"福建摄影十佳"称号和福建青年摄影协会"福建青年摄影十佳"称号。获福建省摄影家协会授予的"福建摄影五十年优秀工作者"称号。

关建东，福建日报社主任记者，长期从事新闻摄影工作，作品多次获得福建新闻奖。

郭晓丹，中国摄影家协会会员、福建省摄影家协会会员、福建青年摄影家协会常务理事、华夏针孔艺术影像委员会（CPPC）委员、中国全球图片总汇签约摄影师、新华社签约摄影师、福建画报特约摄影师。

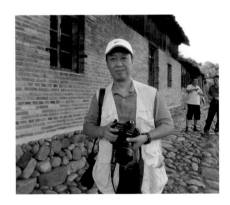

赖小兵，福建画报社副社长、副总编辑。福建省新闻摄影学会副会长。长期拍摄福建人文专题，拍摄、编辑的《福建戏剧丛书》获得首届"中国出版政府奖"提名奖。

吴军，福建画报社编辑部副主任、首席摄影，长期从事民俗摄影。先后在《福建画报》开设"小村""民间艺人""福建海岛""寻味"等栏目。著有图书《绝活》《寻味八闽》等。

朱晨辉，福建画报摄影记者

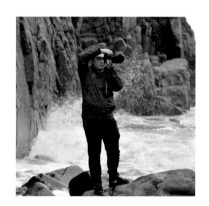

严硕，福建画报摄影记者

Postscripts

后记

发源于宁化县治平乡赖家山的汀江，流经的第一座城市便是长汀，这真是一个美妙的开头。新西兰人路易·艾黎是中国人民的朋友，他曾说过一句很著名的话："中国有两个最美丽的小城，一个是湖南的凤凰，一个是福建的长汀。"这是他发自内心的赞美，凤凰和长汀，都是他工作和生活过的地方。长汀曾经有一个骄傲的名字：汀州，它曾是闽西政治中心，也是近代红色革命早期重要的发祥地。因为工作的关系，我们曾多次赴长汀采访，但都匆匆而过，蕴含在小城中的那份美丽却无法真正领略。2017年，《汀江》大型文创摄影工程启动，我们有机会再次走进这座小城。

沿着兆征路往古城中心走，就可以看到汀州试院，这是历代客家学子的考试场所，当年福建省苏维埃政府所在地，今天的长汀县博物馆。汀州试院始建于宋代，庭院式结构，试院古朴，但规模宏大。院内环境清雅，两棵珍稀罕见的唐代双柏，参天繁茂，据说已有1200多年的历史。清代时纪晓岚曾经到汀州试院监考，写下"参天黛色常如此，点首朱衣或是君"的诗句，纪晓岚在他的《阅微草堂笔记》还详细记述了他与这两株唐代古柏的故事。

1932年3月18日至21日，汀州试院永久地镌刻上了红色印记，福建省第一次工农兵代表大会在汀州试院召开。福建省苏维埃政府正式宣告成立，标志着福建苏区的革命斗争和建设进入全盛时期。如今汀州试院的大堂还记录着当时召开会议的情景：大堂中央悬挂着"全世界无产者联合起来"的横幅，横幅下面是马克思及列宁画像，100多位意气风发的年轻人手挽着手高唱着《国际歌》，歌声雄壮有力，声震如雷，回荡在汀州试院.不远处繁盛的店头街，也能听到这划破历史的呐喊，随着奔流不息的汀江，一路向南。

汀州试院不仅仅是客家学子浮沉荣辱的舞台，也不仅仅有铿锵有力的红色宣言。言犹在耳的《国际歌》在闽西大地传唱的两年之后，即1934年，汀州试院成为国民党三十六师的师部。1935年的5月，曾担任过中国共产党最高领导人的瞿秋白因被叛徒出卖，被关押在离会堂右侧不足百米的一间小木屋内。国民党三十六师的师长宋希濂，对瞿秋白这样的领袖人物当然敬仰已久，在居住和生活上给予了外松内紧的待遇。关押的小院落里有两个小房间，简陋的中式木床，斑驳的门窗下有一张书桌，备有笔墨纸砚，据说关押期间的41天里，就在这一方囚室，瞿秋白写诗、刻字，在生命的最后一刻写下了并不"多余"的《多余的话》。

囚室之外有一小院，高墙耸立，瞿秋白可在小院内活动筋骨。院内有一百年石榴，那时石榴树的树龄估计和瞿秋白的年龄相仿，因为要寻找最佳的拍摄角度，我几度驻足。拘押他的房间依然保持着原样，狭小阴暗，只有透过窗棂能感觉到一点光亮，我透过窗棂看到那株石榴树，白墙映衬下的石榴花异常艳丽。

让我们的视角越过阻隔，越过时空。离汀州试院向东不到一公里的地方，便是汀江，在羁押的夜里，万籁俱寂，他应是可以听到汀江滔滔不绝的流水声的。几个月前，他正是在东渡汀江时，于水口乡不幸被捕，那是他最后一次与汀江交汇。长汀这座美丽的小城因他平添了一份悲壮。现在想来，一座不大的汀州试院在历史的长河里聚合了考场与战场，诗情与悲情，又呈现出这么丰富的色彩，不禁让人感叹。

如今，山水还在，试院依存，绕城而过的汀江，让这座美丽的小城变得更加灵动，也使得汀江充满着红色传奇。不仅仅是这些，历史上的汀江流域，土地肥沃，一代代躲避战乱的

北方百姓在此驻足、繁衍生息，汀江也成为南迁汉族移民群体客家民系的母亲河。根在河洛的客家民系为汀江带来了黄色精魂。这还不够，多彩的汀江又添一抹新绿，北纬25°35′12″，东经116°02′02″，这是汀江源国家级自然保护区，汀江源头重要的水源涵养林，是汀江生态建设和水土流失治理的重要成果，如今，汀江源国家级自然保护区已成为鸟类的天堂，植物的王国。这是汀江奔流向南的源泉，滋养万物的开始。

八闽山海之间，河流遍布，但走向多由西向东入海，唯汀江独向南流，出福建，汇广东韩江，入南海，成为横跨闽粤两省的省际河流。此次"汀江大型影像文化创作工程"的启动，是福建画报社继《闽江》工程之后的再出发。严格意义上说，这条哺育自然万物的汀江只流经长汀、武平、上杭、永定4县区，但汀江之水奔腾到海的脚步没有停留，我们的视角当然也不敢停滞，因此我们将"汀江"延展到了地理概念之外的闽西大地。为了全面展现闽西红色苏区的巨大变化，2017年5月8日，"汀江大型影像文化创作工程"在著名的古田会议会址举行，举办地考量再三，意在不忘初心。二十余位摄影师、数十家媒体，开始了汀江两岸的全记录，之后两年，数千公里，多次田野调查，数以万计的图片，就为这日夜奔腾的滔滔大江。

请跟随我们的无人机一起飞翔：上杭"黄金水段"江面宽阔，绿树成荫；武平梁野，溪流密布，山脉连绵；永定土楼，神奇巍峨，方圆有序；新罗新貌，闽西枢纽，举目皆绿；秀色连城，丹霞一绝，风景如画；福地漳平，永福茶园，樱花盛开。

请跟随我们的镜头一起穿越：河田世纪生态园，习近平总书记寄望殷切，香樟树前，一片绿意盎然；古田会议，再放光彩；临江楼前"岁岁重阳，今又重阳"；亚楼故里，边陲新城；

地下航线，革命血脉；官厅会议，后田暴动。

这一幅幅真实的画面串联了汀江波澜壮阔的前世今生。

感谢龙岩市委宣传部、新罗区委宣传部、永定区委宣传部、漳平市委宣传部、长汀县委宣传部、上杭县委宣传部、武平县委宣传部、连城县委宣传部，是他们周到的安排才使得"汀江影像工程"顺利完成。还要感谢参与本次活动的摄影家曾璜、崔建楠、焦红辉、陈扬富、那兴海、吴寿华、姜克红、王东明、关建东、陈伟凯、郭晓丹、吴凯翔的倾力支持与帮助，感谢黄海、胡晓钢、李国潮、练才秀、郭军、林长全、陈军、蓝善祥、吴健衡等为本画册提供图片。上杭老摄影家袁松树几十年以汀江为主题，拍摄了许多珍贵的历史画面，也为这本画册增添了几分厚重。原福建省作协副主席王炳根先生，全程参与采访，为《汀江》妙笔生花，在此一并感谢。

《汀江》是福建画报社"江海系列"影像工程的第二部，也是为庆祝新中国成立70周年，传承红色基因的具体实践。影像的力量不止于当下，江海之间几度风流，为时代记录，为历史留存，这是我们的愿望。

赖小兵

2019年10月

The first city that the Tingjiang River, which originated in Laijiashan, Zhiping Township, Ninghua County, flows through is Changting. This is really a wonderful beginning. New Zealander Rewi Alley, a friend of the Chinese people, once said, "China has two most beautiful small cities, one is Phoenix in Hunan and the other is Changting in Fujian", which is his heartfelt praise. Phoenix and Changting are both places where he worked and lived. Changting once had a proud name: Tingzhou, which was once the political center of Western Fujian and the important birthplace of the early modern Red Revolution. For the needs of our work, we once visited Changting many times, but we all left in a hurry. Therefore, the beauty contained in the small city could not be truly appreciated. In 2017, the large-scale image cultural creation project—*The Tingjiang River* was launched, so we had the opportunity to visit this small city again.

Walking along Zhaozheng Road to the center of the ancient city, you can see Tingzhou Examination Hall, which is the examination place for Hakka students of past dynasties, the site of the Soviet government in Fujian Province in those days, and today's Changting County Museum. Tingzhou Examination Hall was built in the Song Dynasty with a courtyard structure, which is of primitive simplicity but large in scale. The environment in the courtyard is elegant. Two precious and rare cypress trees of the Tang Dynasty in the courtyard are towering and luxuriant, which are said to have a history of more than 1200 years. Ji Xiaolan of the Qing Dynasty once went to Tingzhou Examination Hall for invigilation, and wrote a poem that "The cypress trees are always with luxuriant foliage and spreading branches, which maybe the man in red bowing to me ". In his *Sketches of Yuewei Humble Cottage*, Ji Xiaolan also recorded and narrated his story with these two old cypress trees of the Tang Dynasty in detail.

From March 18 to 21, 1932, Tingzhou Examination Hall was permanently engraved with a red imprint, where the First Congress of Workers, Peasants and Soldiers in Fujian Province was held. It officially announced the establishment of the Soviet government in Fujian Province, marking the heyday of the revolutionary struggle and construction of the Soviet Area in Fujian. Now the lobby of Tingzhou Examination Hall records the scene of the meeting at that time: the banner "Workers of the world, unite!" hangs in the center of the lobby and below the banner are the portraits of Marx and Lenin. Hundreds of high-spirited young people are singing *The Internationale* hand in hand. The sound of singing is magnificent, powerful and thunderous, which reverberates in Tingzhou Examination Hall. Not far from the prosperous Diantou Street, one can also hear this shout that cuts through history, which heads south with the endless-flowing Tingjiang River.

Tingzhou Examination Hall is not only the stage of Hakka students' ups and downs, and honors and disgraces, nor just has a powerful Red Declaration. Two years after *The Internationale* was still being sung in Western Fujian, that is, in 1934, Tingzhou Examination Hall became the headquarters of the 36th Division of the Kuomintang. In in May 1935, Qu Qiubai, a former supreme leader of the Communist Party of China, was betrayed by traitors and imprisoned in a cabin less than 100 meters to the right of the hall. Song Xilian, commander of the 36th Division of the Kuomintang, had certainly admired such leaders as Qu Qiubai for a long time and had given him partial freedom in his living and life. There were two small rooms, a simple and crude Chinese wooden bed and a desk under mottled doors and windows with pen, ink, paper and inkstone in the small courtyard where Qu Qiubai was imprisoned. It is said that during the 41 days of his captivity, Qu Qiubai wrote poems and carved characters in this cell. At the last moment of his life, he wrote *The Superfluous Words* which was not superfluous.

There is a small courtyard outside the cell with high walls, where Qu Qiubai could do some exercise. There is a 100-year-old pomegranate tree in the courtyard, the age of which was estimated to be similar to Qu Qiubai's age at that time. I stopped several times to find the best shooting angle. The room in which he was imprisoned remained the same, which was narrow and dark, and only the sunlight through the window lattice was felt. I saw the pomegranate tree through the window lattice, and the pomegranate flowers against the white wall were gorgeous.

Let's take the angle of view beyond barriers, beyond time and space. Less than a kilometre to the east of the Tingzhou Examination Hall is the Tingjiang River. During the night of captivity, all sounds were still, and he could hear the endless sound of running water on the Tingjiang River. A few months ago, when he just crossed eastward the Tingjiang River, he was unfortunately arrested in Shuikou Town. This was the last time he met the Tingjiang River. Changting, this beautiful small town, is added a solemn and stirring sense. Now that I think about it, a small Tingzhou Examination Hall has gathered examination rooms and battlefields in the long river of history, with poetry and sadness, and also has presented such rich colors, which is very amazing.

Today, the mountains and rivers are still there and the Examination Hall still exists. The Tingjiang River, which passes around the city, makes this beautiful small town more intelligent and also makes the Tingjiang River full of red legends. Not only these, the Tingjiang River Basin in history had fertile lands. Generations of northern people who escaped the war had stopped here, multiplied and lived here, and the Tingjiang River has also become the mother

river of the Hakka people, a group of Han immigrants who moved southward. The Hakka people rooted in Heluo brought yellow spirits to the Tingjiang River. This is not enough. The colorful Tingjiang River was added a stretch of new green. 25° 35'12" N, 116° 02'02" E, this is the Latitude and Longitude of Tingjiang Source National Nature Reserve, an important water conservation forest at the source of the Tingjiang River, and an important achievement in ecological construction and soil erosion control of the Tingjiang River. Today, Tingjiang Source National Nature Reserve has become a paradise for birds and a kingdom of plants. This is the source of the Tingjiang River flowing southward and the beginning of nourishing everything.

Between the mountains and seas in Fujian Province, there are many rivers, but most of which flow from west to east into the sea. Only the Ting River flows southward, exiting Fujian, converging with the Hanjiang River in Guangdong and entering the South China Sea, which then becomes an inter-provincial river crossing Fujian and Guangdong provinces. The launch of the large-scale image cultural creation project—*The Tingjiang River* is the second start of Fujian Pictorial after the project—*The Minjiang River*. Strictly speaking, the Tingjiang River, which nurtures all natural things, only flows through Changting, Wuping, Shanghang and Yongding counties. However, the pace of the Tingjiang River's water rushing

to the sea has not stopped, and our perspective certainly does not dare to stagnate. Therefore, we have extended the "Tingjiang River" to the land of Western Fujian beyond the geographical concept. In order to fully show the great changes in the Red Soviet Area in Western Fujian, on May 8, 2017, the large-scale image cultural creation activity of the Tingjiang River" was held on the former site of the famous Gutian Conference. The venue was carefully considered with the intention of remaining true to our original aspiration. More than 20 photographers and dozens of media started the full record of both sides of the Tingjiang River. In the following two years, thousands of kilometers, many field investigations and tens of thousands of pictures, are all just for the surging river that surges day and night.

Please follow our camera and fly together: The "Golden Water Section" of Shanghai has a wide river surface and is covered with green trees; Liangye Mountain in Wuping is densely covered with streams and continuous mountains; the earth building in Yongding is magical and lofty with order of squareness and roundness; the new appearance of Xinluo which is the hub of Western Fujian and is green everywhere; the beautiful Liancheng, is a wonder of Danxia land and has a picturesque scenery; in Yongfu Tea Garden of Zhangping, a promised land, cherry blossoms.

Please follow our camera and time-travel together: Hetian Century Ecological Park, on which President Xi Jinping places hopes eagerly, in front of camphor trees, there is full of

green: the Gutian Conference shines again; the poem "The Double Ninth Festival comes as before every year" in front of Linjiang Building; the hometown of General Liu Yalou is now the new border city; underground route and revolutionary blood; and there was the Guanting Conference and Houtian Rebellion.

The series of real pictures connects the magnificent past and present of the Tingjiang River.

Thanks to Publicity Department of Longyan Municipal Party Committee, Publicity Department of Xinluo District Party Committee, Publicity Department of Yongding District Party Committee, Publicity Department of Zhangping Municipal Party Committee, Publicity Department of Changting County Party Committee, Publicity Department of Shanghang County Party Committee, Publicity Department of Wuping County Party Committee, Publicity Department of Liancheng County Party Committee, it was their considerate arrangement that made this photography project *The Tingjiang River* successfully completed. Also thanks to the photographers who took part in this project for their support and help, they are Zeng Huang, Cui Jiannan, Jiao Honghui, Chen Yangfu, Na Xinghai, Wu Shouhua, Jiang Kehong, Wang Dongming, Guan Jiandong, Chen Weikai, Guo Xiaodan and Wu Kaixiang. Thanks to Huang Hai, Hu Xiaogang, Li Guochao, Lian Caixiu, Guo Jun, Lin Changquan, Chen Jun Lan Shanxiang, Wu Jianheng, etc. who provided pictures for

the book. Yuan Songshu, an old photographer from Shanghang, has taken many precious pictures of the Tingjiang River as the theme for decades, adding a bit of massiness to this picture album. Mr. Wang Binggen, the former vice-chairman of Fujian Writers' Association, participated in the whole interview and wrote ingeniously with exquisite description for this wonderful book *The Tingjiang River*. Thank him here at the same time.

The Tingjiang River is the second book of the "Jianghai Series" photography project of Fujian Pictorial, and it is also a concrete practice to celebrate the 70th anniversary of the founding of new China and to inherit the red gene. The power of photography is not only in the present. As there will be many distinguished and admirable events between rivers and seas, we will record them for the times and preserve for the history by photograph. This is our wish.

Lai Xiaobing
October 2019

汀江大型影像文化创作工程

The Tingjiang River——The large-scale image cultural creation project

福建文艺发展基金资助项目

The project supported by Fujian Literature and Art Development Fund

总 顾 问：蒋达德　詹昌建

　　　　　林 彬（女）　傅柒生

总 策 划：黄伟岸　吴福文

执　　行：赖小兵　龚祖灿

主　　编：赖小兵

撰　　文：王炳根

责任编辑：辛丽霞

助理编辑：吴承熹　罗坤荣

英文翻译：薇尔（北京）国际翻译有限公司

英文校对：罗坤荣

General counsels: Jiang Dade　Zhan Changjian
　　　　　　　　Lin Bin (female)　Fu Qisheng

Chief planners: Huang Wei'an　Wu Fuwen

Implementation: Lai Xiaobing　Gong Zucan

Editor in chief: Lai Xiaobing

Written by: Wang Binggen

Responsible editor: Xin Lixia

Editional assistants: Wu Chengxi　Luo Kunrong

English translator: Weier (Beijing) International
　　　　　　　　　Translation Co.,Ltd

English proofreader: Luo Kunrong

摄　　影：曾　璜　崔建楠　焦红辉　陈扬富　那兴海

　　　　　吴寿华　姜克红　王东明　关建东　陈伟凯

　　　　　郭晓丹　黄　海　袁松树　胡晓钢　李国潮

　　　　　练才秀　林长全　吴凯翔　吴健衡　陈　军

　　　　　钟炎生　邱开勇　阮任艺　王永安　林天南

　　　　　郭　军　张乃彬　林如建　胡　文　江宏瑞

　　　　　修永清　林天南　上官毅清

　　　　　赖小兵　吴　军　朱晨辉　严　硕

　　　　　（排名不分先后）

Photographer: Zeng Huang　Cui Jiannan　Jiao Honghui
　　　　　　　Chen Yangfu　Na Xinghai　Wu Shouhua
　　　　　　　Jiang Kehong　Wang Dongming　Guan Jiandong
　　　　　　　Chen Weikai　Guo Xiaodan　Huang Hai
　　　　　　　Yuan Songshu　Hu Xiaogang　Li Guochao
　　　　　　　Lian Caixiu　Lin Changquan　Wu Kaixiang
　　　　　　　Wu Jianheng　Chen Jun　Zhong Yansheng
　　　　　　　Qiu Kaiyong　Ruan Renyi　Wang Yongan
　　　　　　　Lin Tiannan　Guo Jun　Zhang Naibin
　　　　　　　Lin Rujian　Hu Wen　Jiang Hongrui
　　　　　　　Xiu Yongqing　Lin Tiannan　Shangguan Yiqing

　　　　　　　Lai Xiaobing　Wu Jun　Zhu Chenhui　Yan Shuo
　　　　　　　(All names are arranged in random order.)

出版：海峡书局

出品：福建画报社

Publication: The Straits Publishing House

Production: Fujian Pictorial

鸣 谢
Acknowlegements

福建省委宣传部

龙岩市委宣传部

海峡出版发行集团

Publicity Department of Fujian Provincial Party Committee

Publicity Department of Longyan Municipal Party Committee

The Straits Publishing & Distributing Group

鸣 谢
Acknowlegements

新罗区委宣传部　　永定区委宣传部

漳平市委宣传部　　长汀县委宣传部

上杭县委宣传部　　武平县委宣传部

连城县委宣传部

Publicity Department of Xinluo District Party Committee

Publicity Department of Yongding District Party Committee

Publicity Department of Zhangping Municipal Party Committee

Publicity Department of Changting County Party Committee

Publicity Department of Shanghang County Party Committee

Publicity Department of Wuping County Party Committee

Publicity Department of Liancheng County Party Committee

图书在版编目（CIP）数据

汀江 / 《汀江》编委会编 . — 福州 : 海峡书局，2019. 12

ISBN 978-7-5567-0560-3

Ⅰ . ①汀… Ⅱ . ①汀… Ⅲ . ①风光摄影—中国—现代—摄影集 Ⅳ . ① J424

中国版本图书馆 CIP 数据核字 (2018) 第 297749 号

责任编辑：辛丽霞

书　　名：汀江

主　　编：赖小兵

出版发行：海峡出版发行集团　海峡书局

地　　址：福州市鼓楼区五一北路 110 号 11 层

邮　　编：350001

设　　计：深圳市佳正航包装设计有限公司

印　　刷：雅昌文化（集团）有限公司

开　　本：787 毫米 × 1092 毫米　1/8

印　　张：46

版　　次：2019 年 12 月第 1 版

印　　次：2019 年 12 月第 1 次印刷

书　　号：ISBN 978-7-5567-0560-3

定　　价：1380.00 元

CIP Data

Tingjiang River / Cui Jiannan --Fuzhou: The Straits Publishing House, Dec, 2019

ISBN 978-7-5567-0560-3

Ⅰ. ① Ting… Ⅱ . ① Ting… Ⅲ . ① Tingjiang River - picture album Ⅳ . ① J424

China Archives of Publications (2018) No. 297749

Editor: Xin Lixia

Title: The Tingjiang River

Editor-in-chief: Lai Xiaobing

Publisher: The Straits Publishing & Distributing Group

The Straits Publishing House

Address: Floor 11, Northern Wuyi Road, Gu lou District, Fuzhou

Postcode: 350001

Designed by: Jiazhenghang Designing and Printing Co., Ltd.

Printed by: Artron Art (Group) Co., Ltd.

Format: 787 × 1092 mm　1/8

Pringting Sheets: 46

Edition: first published in Dec 2019

Impression: first printed in Dec 2019

ISBN 978-7-5567-0560-3

Price: RMB 1380.00